IMPERIAL LEATHER

IMPERIAL LEATHER

RACE, GENDER AND SEXUALITY
IN THE COLONIAL CONTEST

Anne McClintock

ROUTLEDGE
New York
London

Published in 1995 by

Routledge
29 West 35th Street
New York, NY 10001

Published in Great Britain by

Routledge
11 New Fetter Lane
London EC4P 4EE

Library of Congress Cataloging-in-Publication Data

 McClintock, Anne.
 Imperial leather : race, gender and sexuality
 in the colonial contest / by Anne McClintock.
 p. cm.
 Includes bibliographical references.
 ISBN 0-415-90889-2 — ISBN 0-415-90890-6 (pbk.)
 1. Great Britain — Colonies — History — 19th century.
 2. Man-woman relationships — Great Britain — Colonies —
 History. 3. Great Britain — Colonies — History — 20th century.
 4. Imperialism — Great Britain — Colonies — History. 5. Sex
 role — Great Britain — Colonies — History. 6. Great Britain —
 Colonies — Race relations. 7. Sex — Great Britain — Colonies —
 History. 8. Commonwealth of Nations — History.
 I. Title.
DA16.M37 1994 94-7593
305.3'0941 — dc20 CIP

British Library Cataloguing-in-Publication Data also available

for Rob
and
Valerie

CONTENTS

ACKNOWLEDGMENTS

In writing this book I have garnered many debts. I wish first thank my friends for their unfailing love and inspirational support. They are too many to name here, but they know who they are, and I thank them all.

Many people gave generously of their time in reading, editing or discussing parts of this manuscript in its various forms: Kwame Anthony Appiah, Nancy Armstrong, Adam Ashforth, Homi Bhabha, John Bird, Elleke Boehmer, Jerry Broughton, Carol Boyce-Davies, Neville Choonoo, Clara Connolly, Laura Chrisman, David Damrosch, Jean Franco, Henry Lewis Gates, Liz Gunner, Catherine Hall, Stuart Hall, Janet Hart, Kathleen Hill, Clifford Hill, Rachel Holmes, Qadri Ismail, Cora Kaplan, David Kastan, Dominic LaCapra, Neil Lazarus, David Lloyd, Melinda Mash, Aamir Mufti, Benita Parry, Ken Parker, Mary Louise Pratt, Bruce Robbins, George Robertson, Ellen Rooney, Trish Rosen, Andrew Ross, Lynne Segal, Ella Shohat, George Stade, Bob Stam, Michael Sprinker, Michael Taussig, Robert von Halberg, Penny von Eschen, Cherryl Walker, Cornel West and Patrick Williams. I thank them all.

I am deeply grateful to all my friends at Columbia, especially Marcellus Blount, Ann Douglas, Jean Howard, Priscilla Wald and Gauri Viswanathan, whose laughter, solidarity and intellectual vibrancy have meant more than I can say. Very special thanks must go to Edward Said for his inspirational blend of academic and political engagement, as well as to Zaineb Istrabadi for her friendship and help. I am also deeply grateful to Michael Seidel for his valued support and encouragement, while particularly heartfelt thanks go to Joy Hayton, for her kindness, sanity and unflagging help over the years.

My students at Columbia, many of whom are now good friends, have made teaching an exhilarating and unforgettable experience. I cannot overstate the value of their intellectual vivacity and enthusiasm. Affectionate appreciation also goes to Bill Dellinger, Evelyn Garcia, Nigel Gibson and Jon Roth for their help and good humor in coming to my administrative rescue on countless occasions.

During the lean years when Columbia was an inhospitable place for women, the Institute for Research on Women and Gender sustained a life-giving community. I owe a very special debt here to Miranda Pollard and

Martha Howell, for their wit and tenacity in creating an indispensible forum for intellectual engagement and support. George Bond and Marcia Wright at the Institute for African Studies also created an invaluable community and I am deeply grateful to them for their support over the years.

My editor, Cecilia Cancellaro, has been a delight to work with. Her unerring intelligence and enthusiasm are enormously appreciated. Stewart Cauley and Matthew DeBord, Maura Burnett and Claudia Gorelick patiently shepherded a wayward manuscript through the final stages and suffered uncomplainingly a host of last minute changes. My copyeditor, Connie Oehring, heroically marshalled a horde of unruly footnotes into docility, and Jerry Broughton's meticulous proofreading rescued me at a particularly critical time. His friendship, and that of Rachel Holmes, sustained me when I most needed it. Leslie Sharpe and Hermann Feldhaus' innovative interior design added a strong graphic dimension to the book, and Tom Zummer's provocative cover supplied a summary to my overall project.

This book could not have been completed without the invaluable support of the SSRC-MacArthur International Peace and Security Program. I am deeply indebted to the stimulation, scholarship and intellectual community made available by their generous financial support.

Everyone at the Institute of Commonwealth Studies made my stay in London unforgettably rewarding. Very special thanks go to Shula Marks, for her intellectual inspiration and generosity. I have met few people so gifted with the capacity to blend acute insight with unstinting generosity and personal warmth. Loving thanks also go to Joan Rofe for her good humor and kindness; as well as to David Blake, Irene Ammah and Rowena Kochanowska for their support. I am indebted to the ICS reading group on nationalism and gender, from whose discussions and ideas I greatly benefitted.

Special thanks go to the African National Congress for their kindness in making available to me the logo of the ANC Women's League. Robert Opie was very generous in giving me access to his marvellous collection of advertisements at the Museum of Advertising and Packaging, Gloucester; I am very grateful for his kindness. I am also deeply grateful to Ronald Milne and the Master and Fellows of Trinity College, Cambridge for allowing me access to the wonderful Arthur Munby archive. Warm thanks go to John Botia and Gary Collins for allowing me access to the A. and F. Pears Ltd. advertisements at the Unilever Historical Archives. I would like in addition to acknowledge the indispensible help of the librarians and photographic staff at the British Library and the British Museum; I thank them for their patience, ingenuity and expertise. The librarians at the University of London Library, the Public Record Office

and Columbia University offered invaluable information and help. I am also grateful to Shuter and Shooter, Nationale Pers, *Die Burger* and *The Guardian* for their photographic help. May I finally extend heartfelt thanks to Gerald Ackerman for his efforts and generosity in making the cover image available, as well as to Deborah Lorenzen of the Indianapolis Museum of Art.

Portions of this book appeared previously in various forms in the British Writers and European Writers Series (Scribners); in Patrick Williams and Laura Chrisman, eds. *Colonial Discourse/Post-Colonial Theory* (London: Harvester Wheatsheaf, 1993); Francis Barker, Peter Hulme and Margaret Iverson, eds. *Essays in Colonial and Post-Colonial Theory* (Manchester: Manchester University Press, 1993); George Robertson, et al., eds. *Travelers' Tales*, (London: Routledge, 1994); *Feminist Review*, #44, (Summer), 1993; *New Formations* (Spring) 1993; *Transition* #54, 1991; *Social Text*, 25, 26. 1990; Dominic LaCapra, ed. *The Bounds of Race* (Ithaca: Cornell University Press, 1991); Cherryl Walker, ed. *Women and Gender in Southern Africa* (Cape Town: David Philip, 1990); Reginald Gibbons, ed. *Writers From South Africa. Culture, Politics and Literary Theory in South Africa Today* (Chicago: Northwestern University Press, 1989); *Critical Inquiry*, March 1987; *Poetry and Politics*, ed. Robert von Halberg, (Chicago: University of Chicago Press, 1988); *Social Text*, Spring, 1992; *South Atlantic Quarterly*, Winter, 1988, Vol. 87, 1. I thank all the editors and editorial staff concerned. I am particularly grateful to Henry Finder and Scott Malcomson not only for their superb editing skills, but also for their valued friendships. Warm thanks also go to the entire Social Text Collective.

In completing this book, I owe a unique debt to Valerie Phillips, healer and friend. Finally, and above all, there are no words to fully express the depth of my admiration, gratitude and love for Rob.

INTRODUCTION

POSTCOLONIALISM AND
THE ANGEL OF PROGRESS

There are many maps of one place, and many
histories of one time.

—*Julie Fredrikse*

RACE, MONEY AND SEXUALITY

In the opening pages of Henry Rider Haggard's bestselling
novel *King Solomon's Mines*, we discover a map. The map, we are told, is a
copy of one that leads three white Englishmen to the diamond mines of
Kukuanaland somewhere in southern Africa (Fig.A.1).[1] The original map
was drawn in 1590 by a Portuguese trader, Jose da Silvestre, while he was
dying of hunger on the "nipple" of a mountain named Sheba's Breasts.
Traced on a remnant of yellow linen torn from his clothing and inscribed
with a "cleft bone" in his own blood, da Silvestre's map promises to reveal
the wealth of Solomon's treasure chamber, but carries with it the obligatory
charge of first killing the black "witch-mother," Gagool.

In this way, Haggard's map assembles in miniature three of the
governing themes of Western imperialism: the transmission of white, male

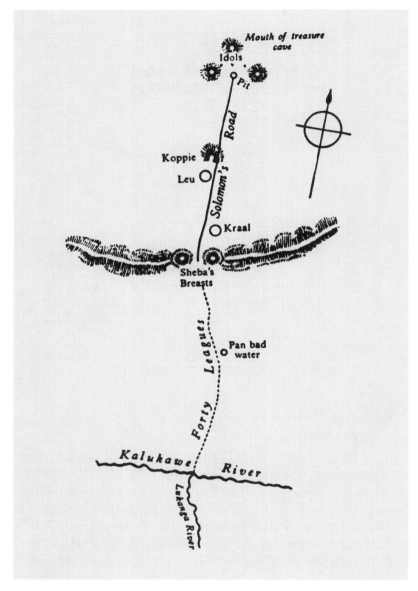

Figure A.1. The Lay of the Land.
 Haggard's sketch map of the Route to King Solomon's Mines.

power through control of colonized women; the emergence of a new global order of cultural knowledge; and the imperial command of commodity capital—three of the circulating themes of this book.

What sets Haggard's map apart from the scores of treasure maps that emblazon colonial narratives is that his is explicitly sexualized. The land, which is also the female, is literally mapped in male body fluids, and da Silvestre's phallic cleft bone becomes the organ through which he bequeaths the patrimony of surplus capital to his white heirs, investing them with the authority and power befitting the keepers of sacred treasure. At the same time, male colonial inheritance takes place within a necessary exchange. Da Silvestre's demise on the bad (frozen) nipple is avenged and white patrilineal inheritance assured, only with the death of Gagool, the "Mother, old mother" and "evil genius of the land."[2] Haggard's map thereby hints at a hidden order underlying industrial modernity: the conquest of the sexual and labor power of colonized women.

The map also reveals a paradox. On the one hand, it is a rough sketch of the ground the white men must cross in order to secure the riches of the diamond mines. On the other hand, if the map is inverted, it reveals at once the diagram of a female body. The body is spread-eagled and truncated— the only parts drawn are those that denote female sexuality. In the narrative, the travelers cross the body from the south, beginning near the head, which is represented by the shrunken "pan bad water"—the mutilated syntax depicting the place of female intelligence and creativity as a site of degeneration. At the center of the map lie the two mountain peaks called Sheba's Breasts—from which mountain ranges stretch to either side as handless arms. The body's length is inscribed by the right royal way of Solomon's Road, leading from the threshold of the frozen breasts over the navel *koppie* straight as a die to the pubic mound. In the narrative, this mound is named the "Three Witches" and is figured by a triangle of three hills covered in "dark heather."[3] This dark triangle both points to and conceals the entrances to two forbidden passages: the "mouth of treasure cave"—the vaginal entrance into which the men are led by the black mother, Gagool—and, behind it, the anal pit from which the men will eventually crawl with the diamonds, in a male birthing ritual that leaves the black mother, Gagool, lying dead within.

On the map, the female genitalia are called the Three Witches. If the Three Witches signal the presence of alternative female powers and of alternative African notions of time and knowledge, these challenges to imperial power are denied by inversion and control. Haggard wards off the threat of a resistant female and African power, not only by violently dispensing with the powerful mother figure in the narrative but by placing alongside the Three Witches on the map the four points of the compass: the

icon of Western "reason," technical aggression and the male, militarized possession of the earth. The logo of the compass reproduces the spread-eagled figure of the woman as marked by the axes of global containment.

Clambering from the mine laden with gems the size of "pigeon eggs," the white Englishmen give birth to three orders—the male, *reproductive* order of patriarchal monogamy; the white *economic* order of mining capital; and the global, *political* order of empire. At the same time, both map and narrative reveal that these orders, far from being distinct, take intimate shape in relation to each other. In this way, the adventure of mining capital reinvents the white patriarch—in the specific class form of the English, upper-middle class gentleman—as the heir to imperial "Progress" at the head of the "Family of Man"—a family that admits no mother.

Haggard's map abstracts the female body as a geometry of sexuality held captive under the technology of imperial form. Yet it also reveals a curious *camera obscura*, for neither reading of the map is complete on its own, but each reveals the shadowy inversion beneath it of its other, repressed side. If one aligns oneself with the male authority of the printed page, the points of the colonial compass and the bloody labels, the map can be read and the treasure reached but the colonized woman will be stood on her head. If, on the other hand, one turns the male book upside down and sets the female body to rights, the crimson words on her body—indeed the male colonial venture as a whole—become incoherent. Yet neither version exists without the other. *Imperial Leather* sets out to explore this dangerous and contradictory liaison—between imperial and anti-imperial power; money and sexuality; violence and desire; labor and resistance.

GENDER, RACE AND CLASS
ARTICULATED CATEGORIES

> It was a while before we came to realize that our place
> was the very house of difference, rather than the secu-
> rity of any one particular difference.
>
> —*Audre Lorde*

I begin with Haggard's map because it offers a fantastic conflation of the themes of gender, race and class that are the circulating concerns of this book. *Imperial Leather* offers three related critiques. In many respects, the book is a sustained quarrel with the project of imperialism, the cult of domesticity and the invention of industrial progress. Haggard's map intrigues me, moreover, because it offers a miniature parable for one of the central tenets of this book. Throughout the chapters that follow, I argue

that race, gender and class are not distinct realms of experience, existing in splendid isolation from each other; nor can they be simply yoked together retrospectively like armatures of Lego. Rather, they come into existence *in and through* relation to each other—if in contradictory and conflictual ways. In this sense, gender, race and class can be called articulated categories. This, then, is the triangulated theme that animates the chapters that follow: the intimate relations between imperial power and resistance; money and sexuality; race and gender.

In Haggard's map, the diamond mines are simultaneously the place of female sexuality (gendered reproduction), the source of treasure (economic production) and the site of imperial contest (racial difference). Da Silvestre's phallic cleft bone is not only the tool of male insemination and patriarchal power but also the insignia of racial dispossession. Gender here, then, is not simply a question of sexuality but also a question of subdued labor and imperial plunder; race is not simply a question of skin color but also a question of labor power, cross-hatched by gender. Let me hasten to add that I do not mean to imply that these domains are reducible to, or identical with, each other; instead, they exist in intimate, reciprocal and contradictory relations.

A central claim of *Imperial Leather* is that imperialism is not something that happened elsewhere—a disagreeable fact of history external to Western identity. Rather, imperialism and the invention of race were fundamental aspects of Western, industrial modernity. The invention of race in the urban metropoles, which I explore in more detail below, became central not only to the self-definition of the middle class but also to the policing of the "dangerous classes": the working class, the Irish, Jews, prostitutes, feminists, gays and lesbians, criminals, the militant crowd and so on. At the same time, the cult of domesticity was not simply a trivial and fleeting irrelevance, belonging properly in the private, "natural" realm of the family. Rather, I argue that the cult of domesticity was a crucial, if concealed, dimension of male as well as female identities—shifting and unstable as these were—and an indispensable element both of the industrial market and the imperial enterprise.

One might think it could go without saying by now that European men were the most direct agents of empire. Yet male theorists of imperialism and postcolonialism have seldom felt moved to explore the gendered dynamics of the subject.[4] Even though it was white men who manned the merchant ships and wielded the rifles of the colonial armies, white men who owned and oversaw the mines and slave plantations, white men who commanded the global flows of capital and rubber-stamped the laws of the imperial bureaucracies; even though it was white, European men who, by the close of the nineteenth century, owned and managed 85 percent of the earth's surface, the crucial but concealed relation between

gender and imperialism has, until very recently, been unacknowledged or shrugged off as a fait accompli of nature.

In the last decade a good deal of evidence has emerged to establish that women and men did not experience imperialism in the same way.[5] European imperialism was, from the outset, a violent encounter with preexisting hierarchies of power that took shape not as the unfolding of its own inner destiny but as untidy, opportunistic interference with other regimes of power. Such encounters in turn transformed the trajectories of imperialism itself. Within this long and conflictual engagement, the gendered dynamics of colonized cultures were contorted in such ways as to alter, in turn, the irregular shapes that imperialism took in various parts of the world.

Colonized women, before the intrusions of imperial rule, were invariably disadvantaged within their societies, in ways that gave the colonial reordering of their sexual and economic labor very different outcomes from those of colonized men. As the slaves, agricultural workers, houseservants, mothers, prostitutes and concubines of the far-flung colonies of Europe, colonized women had to negotiate not only the imbalances of their relations with their own men but also the baroque and violent array of hierarchical rules and restrictions that structured their new relations with imperial men and women.[6]

Colonial women were also ambiguously placed within this process. Barred from the corridors of formal power, they experienced the privileges and social contradictions of imperialism very differently from colonial men. Whether they were shipped out as convicts or conscripted into sexual and domestic servitude; whether they served discreetly at the elbow of power as colonial officers' wives, upholding the boundaries of empire and bearing its sons and daughters; whether they ran missionary schools or hospital wards in remote outposts or worked their husbands' shops and farms, colonial women made none of the direct economic or military decisions of empire and very few reaped its vast profits. Marital laws, property laws, land laws and the intractable violence of male decree bound them in gendered patterns of disadvantage and frustration. The vast, fissured architecture of imperialism was gendered throughout by the fact that it was white men who made and enforced laws and policies in their own interests. Nonetheless, the rationed privileges of race all too often put white women in positions of decided—if borrowed—power, not only over colonized women but also over colonized men. As such, white women were not the hapless onlookers of empire but were ambiguously complicit both as colonizers and colonized, privileged and restricted, acted upon and acting.[7]

I argue throughout this book that imperialism cannot be fully understood without a theory of gender power. Gender power was not the superficial patina of empire, an ephemeral gloss over the more decisive

mechanics of class or race. Rather, gender dynamics were, from the outset, fundamental to the securing and maintenance of the imperial enterprise. In my view, however, gender was not the only—nor the dominant—dynamic of industrial imperialism. Since the late 1970s, an impassioned and compelling feminist critique has emerged—largely from women of color— that challenges certain Eurocentric feminists who claim to give voice to an essential womanhood (in universal conflict with an essential masculinity) and who privilege gender over all other conflicts.

Hazel Carby, for one, offered an early critique of white feminists who "write their herstory and call it the story of women but ignore our lives and deny their relation to us." That is the moment, she argues, "in which they are acting within the relations of racism and writing *history*."[8] In the United States, likewise, bell hooks has argued powerfully and influentially for the recognition of racial difference and diversity among women as well as for the politics of alliance.[9] In Britain, Valerie Amos and Pratibha Parmar, amongst others, followed Carby in accusing white feminists of the "historical amnesia of white male historians, by ignoring the fundamental ways in which white women have benefitted from the oppression of Black people."[10]

I argue, moreover, that gender is not synonymous with women. As Joan Scott puts it: "To study women in isolation perpetuates the fiction that one sphere, the experience of one sex, has little or nothing to do with the other."[11] Unlike Catherine MacKinnon—for whom "sexuality is to feminism what work is to Marxism"—I argue that feminism is as much about class, race, work and money as it is about sex. Indeed, one of the most valuable and enabling moves of recent feminist theory has been its insistence on the separation of sexuality and gender and the recognition that gender is as much an issue of masculinity as it is of femininity. As Cora Kaplan argues, the focus on gender as the privileged category of analysis tends to "represent sexual difference as natural and fixed—a constant, transhistorical femininity in libidinized struggle with an equally 'given' universal masculinity."[12]

Michel Foucault argues that, in the nineteenth century, the idea of sexuality gave a fictitious unity to a host of "anatomical elements, biological functions, conducts, sensations and pleasures."[13] The fictitious unity of sexuality, he says, became a "causal principle, an omnipresent meaning, a secret to be discovered everywhere: sex was thus able to function as a universal signifier and as a universal signified."[14] By privileging sexuality, however, as the invented principle of social unity, Foucault forgets how an elaborate analogy *between* race and gender became, as I argue in Chapter 1, an organizing trope for other social forms.

At the same time, I do not see race and ethnicity as synonymous with black or colonized. Indeed, the first part of this book is written in sympathy with bell hooks' wry challenge: "One change in direction that would be real

cool would be the production of a discourse on race that interrogates whiteness."[15] The invention of whiteness, here, is not the invisible norm but the problem to be investigated.[16]

I remain unconvinced, however, by arguments that race is a mere affect of floating signifiers as well as by claims that "there must be some essence which precedes and/or transcends the fact of objective conditions."[17] I am in agreement here with Paul Gilroy's cogent argument that "the polarization between essentialist and anti-essentialist theories of black identity has become unhelpful."[18] Exploring the historical instability of the discourse on race—embracing as it did in the nineteenth century not only colonized peoples but also the Irish, prostitutes, Jews and so on—by no means entails a spin into the vertigo of undecidability. To dispute the notion that race is a fixed and transcendent essence, unchanged through the ages, does not mean that "all talk of 'race' must cease," nor does it mean that the baroque inventions of racial difference had no tangible or terrible effects.[19] On the contrary, it is precisely the inventedness of historical hierarchies that renders attention to social power and violence so much more urgent.

Imperial Leather is thus situated where a number of discourses — feminism, Marxism and psychoanalysis, among them—merge, converge and diverge. An abiding concern of the book is to refuse the clinical separation of psychoanalysis and history. All too often, psychoanalysis has been relegated to the (conventionally universal) realm of private, domestic space, while politics and economics are relegated to the (conventionally historical) realm of the public market. I argue that the disciplinary quarantine of psychoanalysis from history was germane to imperial modernity itself. Instead of genuflecting to this separation and opting theoretically for one side or the other, I call for a renewed and transformed investigation into the disavowed relations between psychoanalysis and socio-economic history.

Imperial Leather attempts to rethink the circulation of notions that can be observed between the family, sexuality and fantasy (the traditional realm of psychoanalysis) and the categories of labor, money and market (the traditional realm of political and economic history). Perhaps it is fitting that such an investigation take place as a critique of imperial modernity, for it was precisely during the era of high imperialism that the disciplines of psychoanalysis and social history diverged.

Because I do not believe that imperialism was organized around a single issue, I wish to avoid privileging one category over the others as the organizing trope. Indeed, I spend some time questioning genesis narratives that orient power around a single, originary scene. On the other hand, I do not wish to be complicit in a commonplace, liberal pluralism that generously embraces diversity all the better to efface the imbalances in power that adjudicate difference. Certainly, one of the founding assumptions of this

book is that no social category exists in privileged isolation; each comes into being in social relation to other categories, if in uneven and contradictory ways. But power is seldom adjudicated evenly—different social situations are overdetermined for race, for gender, for class, or for each in turn. I believe, however, that it can be safely said that no social category should remain invisible with respect to an analysis of empire.

PITFALLS OF THE POSTCOLONIAL

Almost a century after the publication of *King Solomon's Mines*, in November 1992—the year of quincentennial triumph in the United States—a postcolonial exhibit called the Hybrid State opened on Broadway. To enter the Hybrid State exhibit, you enter The Passage. Instead of a gallery, you find a dark antechamber, where one white word invites you forward: COLONIALISM. To enter colonial space, you stoop through a low door, only to be closeted in another black space—a curatorial reminder, however fleeting, of Frantz Fanon: "The native is a being hemmed in."[20] But the way out of colonialism, it seems, is forward. A second white word, POSTCOLONIALISM, invites you through a slightly larger door into the next stage of history, after which you emerge, fully erect, into the brightly lit and noisy HYBRID STATE.

I am fascinated less by the exhibit itself, than by the paradox between the idea of history that shapes The Passage and the quite different idea of history that shapes the Hybrid State exhibit itself. The exhibit celebrates "parallel history":

> Parallel history points to the reality that there is no longer a mainstream view of American art culture, with several "other," lesser important cultures surrounding it. Rather there exists a parallel history which is now changing our understanding of our transcultural understanding.[21]

Yet the exhibit's commitment to "hybrid history"—multiple time—is contradicted by the linear logic of The Passage, "A Brief Route To Freedom," which, as it turns out, rehearses one of the most tenacious tropes of colonialism. In colonial discourse, as in The Passage, movement through space becomes analogous to movement through time. History becomes shaped around two opposing directions: the progress forward of humanity from slouching deprivation to erect, enlightened reason. The other movement presents the reverse: regression backward to what I call anachronistic space (a trope I discuss in more detail below) from white, male adulthood to a primordial, black degeneracy usually incarnated in

women. The Passage rehearses this temporal logic: progress through the ascending doors, from primitive prehistory, bereft of language and light, through the epic stages of colonialism, postcolonialism and enlightened hybridity. Leaving the exhibit, history is traversed backward. As in colonial discourse, the movement forward in space is backward in time: from erect, verbal consciousness and hybrid freedom—signified by the (not very free) white rabbit called "Free" that roams the exhibit—down through the historic stages of decreasing stature to the shambling, tongueless zone of the precolonial, from speech to silence, light to dark.

The paradox structuring the exhibit intrigues me, because it is a paradox, I suggest, that shapes the term postcolonialism. I am doubly interested in the term, because the almost ritualistic ubiquity of "post" words in current culture (postcolonialism, postmodernism, poststructuralism, post-cold war, post-Marxism, postapartheid, post-Soviet, post-Ford, postfeminism, postnational, posthistoric, even postcontemporary) signals, I believe, a widespread, epochal crisis in the idea of linear, historical progress.

Charles Baudelaire called the idea of progress and perfectibility "the grand idea of the twentieth century." In 1855, the year of the first imperial Paris exposition, Victor Hugo announced: "Progress is the footstep of God himself."[22] In many respects, this book is dedicated to challenging both the idea of progress and that of the Family of Man, and is written in sympathy with Walter Benjamin's injunction to "drive out any trace of 'development' from the image of history" and to overcome the "ideology of progress . . . in all its aspects."[23]

A good deal of postcolonial studies has set itself against the imperial idea of linear time. Yet the term postcolonial, like the exhibit, is haunted by the very figure of linear development that it sets out to dismantle. Metaphorically, the term postcolonialism marks history as a series of stages along an epochal road from "the precolonial," to "the colonial," to "the postcolonial"—an unbidden, if disavowed, commitment to linear time and the idea of development. If a theoretical tendency to envisage "Third World" literature as progressing from "protest literature" to "resistance literature" to "national literature" has been criticized for rehearsing the Enlightenment trope of sequential, linear progress, the term postcolonialism is questionable for the same reason. Metaphorically poised on the border between old and new, end and beginning, the term heralds the end of a world era but by invoking the very same trope of linear progress which animated that era.

If postcolonial *theory* has sought to challenge the grand march of Western historicism and its entourage of binaries (self-other, metropolis-colony, center-periphery, etc.), the *term* postcolonialism nonetheless reorients the globe once more around a single, binary opposition: colonial-postcolonial. Moreover, theory is thereby shifted from the binary axis of

power (colonizer-colonized—itself inadequately nuanced, as in the case of women) to the binary axis of *time*, an axis even less productive of political nuance because it does not distinguish between the beneficiaries of colonialism (the ex-colonizers) and the casualties of colonialism (the ex-colonized). The postcolonial scene occurs in an entranced suspension of history, as if the definitive historical events have preceded our time and are not now in the making. If the theory promises a decentering of history in hybridity, syncreticism, multidimensional time and so forth, the singularity of the term effects a recentering of global history around the single rubric of European time. Colonialism returns at the moment of its disappearance.

The prefix post-, moreover, reduces the cultures of peoples beyond colonialism to prepositional time. The term confers on colonialism the prestige of history proper; colonialism is the determining marker of history. Other cultures share only a chronological, prepositional relation to a Eurocentered epoch that is over (post-), or not yet begun (pre-). In other words, the world's multitudinous cultures are marked, not positively by what distinguishes them but by a subordinate, retrospective relation to linear, European time.

The term also signals a reluctance to surrender the privilege of seeing the world in terms of a singular and ahistorical abstraction. Rifling through the recent flurry of articles and books on postcolonialism, I am struck by how seldom the term is used to denote multiplicity. The following proliferate: "*the* postcolonial condition," "*the* postcolonial scene," "*the* postcolonial intellectual," "*the* emerging disciplinary space of postcolonialism," "postcoloniality," "*the* postcolonial situation," "postcolonial space," "*the* practice of postcoloniality," "postcolonial discourse," and that most tedious, generic hold-all: "*the* postcolonial Other." Sara Suleri, for one, confesses herself weary of being treated as an "Other-ness Machine."[24]

I am not convinced that one of the most important emerging areas of intellectual and political enquiry is best served by inscribing history as a single issue. Just as the singular category "Woman" has been discredited as a bogus universal for feminism, incapable of distinguishing between the varied histories and imbalances in power among women, so the singular category "postcolonial" may too readily license a panoptic tendency to view the globe through generic abstractions void of political nuance.[25] The arcing panorama of the horizon becomes thereby so expansive that international imbalances in power remain effectively blurred. Historically voided categories such as "the other," "the signifier," "the signified," "the subject," "the phallus," "the postcolonial," while having academic clout and professional marketability, run the risk of telescoping crucial geo-political distinctions into invisibility.

The authors of the recent book *The Empire Writes Back*, for example, defend the term "postcolonial literature" on three grounds: it "focuses on

that relationship which has provided the most important creative and psychological impetus in the writing"; it expresses the "rationale of the grouping in a common past" and it "hints at the vision of a more liberated and positive future."[26] Yet the inscription of history around a single "continuity of preoccupations" and "a common past," runs the risk of a fetishistic disavowal of crucial international distinctions that are barely understood and inadequately theorized. Moreover, the authors decide, idiosyncratically to say the least, that the term postcolonialism should not be understood as everything that has happened since European colonialism but rather everything that has happened from the very beginning of colonialism, which means turning back the clocks and unrolling the maps of postcolonialism to 1492 and earlier.[27] At a stroke, Henry James and Charles Brockden Brown, to name only two on their list, are awakened from their tête-à-tête with time and ushered into the postcolonial scene alongside more regular members such as Ngũgĩ Wa Thiong'O and Salman Rushdie.

Most problematically, the historical rupture suggested by the prefix post- belies both the continuities and discontinuities of power that have shaped the legacies of the formal European and British colonial empires (not to mention the Islamic, Japanese, Chinese and other imperial powers). At the same time, political differences *between* cultures are subordinated to their temporal distance from European colonialism. Postcolonialism, however, like postmodernism, is unevenly developed globally. Argentina, formally independent of imperial Spain for over a century and a half, is not "postcolonial" in the same way as Hong Kong (destined not to be independent of Britain until 1997). Nor is Brazil postcolonial in the same way as Zimbabwe. Can most of the world's countries be said, in any meaningful or theoretically rigorous sense, to share a single common past, or a single common condition, called the postcolonial condition, or postcoloniality? The histories of African colonization are certainly, in part, the histories of the collisions among European and Arab empires and the myriad African lineage states and cultures. Can these countries now best be understood as shaped exclusively around the "common" experience of European colonization? Indeed, many contemporary African, Latin American, Caribbean and Asian cultures, while profoundly affected by colonization, are not necessarily primarily preoccupied with their erstwhile contact with European colonialism.

On the other hand, the term postcolonialism is, in many cases, prematurely celebratory. Ireland may, at a pinch, be postcolonial but for the inhabitants of British-occupied Northern Ireland, not to mention the Palestinian inhabitants of the Israeli Occupied Territories and the West Bank, there may be nothing "post" about colonialism at all. Is South Africa postcolonial? East Timor? Australia? Hawaii? Puerto Rico? By what fiat

of historical amnesia can the United States of America, in particular, qualify as postcolonial—a term that can only be a monumental affront to the Native American peoples currently opposing the confetti triumph of 1992? One can also ask whether the emergence of Fortress Europe in 1992 may not also signal the emergence of a new empire, as yet uncertain of its boundaries and global reach.

My misgivings, therefore, are not about the theoretical substance of postcolonial theory, much of which I greatly admire.[28] Rather, I question the orientation of the emerging discipline and its concomitant theories and curricula changes around a singular, monolithic term, used ahistorically and haunted by the nineteenth-century image of linear progress. Nor do I want to banish the term to some chilly, verbal gulag; there seems no reason why it should not be used judiciously in appropriate circumstances, in the context of other terms, if in a less grandiose and global role.

Most importantly, orienting theory around the temporal axis colonial-postcolonial makes it easier not to see and therefore harder to theorize, the *continuities* in international imbalances in imperial power. Since the 1940s, the U.S.' imperialism-without-colonies has taken a number of distinct forms (military, political, economic and cultural), some concealed, some half-concealed. The power of U.S. finance capital and huge multinational corporations to command the flows of capital, research, consumer goods and media information around the world can exert a coercive power as great as any colonial gunboat. It is precisely the greater subtlety, innovation and variety of these forms of imperialism that make the historical rupture implied by the term postcolonial especially unwarranted.

The term postcolonialism is prematurely celebratory and obfuscatory in more ways than one. While some countries may be postcolonial with respect to their erstwhile European masters, they may not be postcolonial with respect to their new colonizing neighbours. Yet neocolonialism is not simply a repeat performance of colonialism, nor is it a slightly more complicated, Hegelian merging of tradition and colonialism into some new, historic hybrid. More complex terms and analyses of alternative times, histories and causalities are required to deal with complexities that cannot be served under the single rubric of postcolonialism.

The term becomes especially unstable with respect to women. In a world where women do two-thirds of the world's work, earn 10 percent of the world's income and own less than 1 percent of the world's property, the promise of "postcolonialism" has been a history of hopes postponed. It has generally gone unremarked that the national bourgeoisies and kleptocracies that stepped into the shoes of postcolonial progress and industrial modern-ization have been overwhelmingly and violently male. As I explore in chapter 10 on gender and nationalism, no postcolonial state anywhere has granted

women and men equal access to the rights and resources of the nation state. Not only have the needs of postcolonial nations been largely identified with male conflicts, male aspirations and male interests, but the very representation of national power has rested on prior constructions of gender power.

The global militarization of masculinity and the feminization of poverty have ensured that women and men do not live postcoloniality in the same way, nor do they share the same singular postcolonial condition. The blame for women's continuing plight cannot be laid only at the door of colonialism or footnoted and forgotten as a passing neo-colonial dilemma. The continuing weight of male economic self-interest and the varied undertows of patriarchal Christianity, Confucianism and Islamic fundamentalism continue to legitimize women's barred access to the corridors of political and economic power, their persistent educational disadvantage, the domestic double workday, unequal childcare, gendered malnutrition, sexual violence, genital mutilation and domestic battery. The histories of these male policies, while deeply implicated in colonialism, are not reducible to colonialism and cannot be understood without distinct theories of gender power.

Edward Said has famously argued that the sexual subjection of Oriental women to Western men "fairly stands for the pattern of relative strength between East and West and the discourse about the Orient that it enabled."[29] For Said, Orientalism takes perverse shape as a "male power-fantasy" that sexualizes a feminized Orient for Western power and possession. But sexuality comes close, here, to being no more than a metaphor for other, more important (that is, male) dynamics played out in what Said calls "an exclusively male province."[30] Sexuality as a trope for other power relations was certainly an abiding aspect of imperial power. The feminizing of the "virgin" land, as I explore in more detail below, operated as a metaphor for relations that were very often not about sexuality at all, or were only indirectly sexual. Eve Kosofsky Sedgwick has explored in important ways how the triangulations of male-female-male space often served to structure male homosocial relations.[31] But seeing sexuality only as a metaphor runs the risk of eliding *gender* as a constitutive dynamic of imperial and anti-imperial power. I make this point not to diminish the enormous importance and influence of Said's work on male imperial relations but rather to regret that he does not systematically explore the dynamics of gender as a critical aspect of the imperial project.

Bogus universals such as "the postcolonial woman," or "the postcolonial other" obscure relations not only between men and women but also among women. Relations between a French tourist and the Haitian woman who washes her bed linen are not the same as the relations between their husbands. Films like *Out of Africa*, clothing chains like *Banana Republic*

and perfumes like *Safari* peddle neocolonial nostalgia for an era when European women in brisk white shirts and safari green supposedly found freedom in empire: running coffee plantations, killing lions and zipping about the colonial skies in aeroplanes—a misbegotten commercialization of white women's "liberation" that has not made it any easier for women of color to form alliances with white women anywhere, let alone parry criticisms by male nationalists already hostile to feminism.

In my view, imperialism emerged as a contradictory and ambiguous project, shaped as much by tensions within metropolitan policy and conflicts within colonial administrations—at best, ad hoc and opportunistic affairs—as by the varied cultures and circumstances into which colonials intruded and the conflicting responses and resistances with which they were met. For this reason, I remain unconvinced that the sanctioned binaries—colonizer-colonized, self-other, dominance-resistance, metropolis-colony, colonial-postcolonial—are adequate to the task of accounting for, let alone strategically opposing, the tenacious legacies of imperialism. Drawn historically from the metaphysical Manicheanism of the imperial enlightenment itself, such binaries run the risk of simply inverting, rather than overturning, dominant notions of power. I am thus concerned with the overdeterminations of power, for, I believe, it is at the crossroads of contradictions that strategies for change may best be found.

Throughout this book, I am deeply interested in the myriad forms of both imperial and anti-imperial agency. I am less interested, however, in agency as a purely formal or philosophical question than I am in the host of difficult ways in which people's actions and desires are mediated through institutions of power: the family, the media, the law, armies, nationalist movements and so on. From the outset, people's experiences of desire and rage, memory and power, community and revolt are inflected and mediated by the institutions through which they find their meaning—and which they, in turn, transform. *Imperial Leather* is, for this reason, as deeply concerned with questions of violence and power as it is with questions of fantasy, desire and difference.

I wish to open notions of power and resistance to a more diverse politics of agency, involving the dense web of relations between coercion, negotiation, complicity, refusal, dissembling, mimicry, compromise, affiliation and revolt. Seeking only the fissures of formal ambivalence (hybridity, ambiguity, undecidability and so on) cannot, in my view, explain the rise to dominance of certain groups or cultures, nor the dereliction and obliteration of others. To ask how power succeeds or fails—despite its provisionality and despite its constitution in contradiction and ambiguity—involves investigating not only the tensions of conceptual form but also the torsions of social history.

I wish to emphasize from the outset, however, that I do not regard imperialism as an inherently British power that impelled itself outward from a European center to subjugate the peripheral territories of "the Other."[32] As I see it, imperial power emerged from a constellation of processes, taking haphazard shape from myriad encounters with alternative forms of authority, knowledge and power. I am thus deeply interested in what Gilroy calls "the processes of cultural mutation and restless (dis)continuity that exceed racial discourse and avoid capture by its agents."[33] Imperialism was a situation under constant contest, producing historical effects that were neither predetermined, uncontested nor ineradicable—in the context, it cannot be forgotten, of extreme imbalances of power.

It seems important to me, therefore, not to read the contradictions of colonial discourse as a matter of textuality alone. What Gayatri Spivak calls, in an apt phrase, "the planned epistemic violence of the imperialist project" was also, all too often, backed up by the planned institutional violence of armies and law courts, prisons and state machinery.[34] The power of guns, whips and shackles, while always implicated in discourse and representation, is not reducible to the "violence of the letter."[35] If colonial texts reveal fissures and contradictions, the colonials themselves all too often succeeded in settling matters of indecision with a violent excess of militarized masculinity. The chapters that follow are thus deeply concerned with the intimate—if often conflictual—relations between textual and institutional power.

In this book, I hope to do more than point out that different power groups—women and men, colonized and colonizers, middle and working class—occupied different positions in the global arena of imperialism. The story, as Scott puts it, is not simply "about the things that have happened to women and men and how they have related to them; instead it is about how the subjective and collective meanings of women and men as categories of identity have been constructed."[36] In other words, the story is not simply about relations between black and white people, men and women, but about how the categories of whiteness and blackness, masculinity and femininity, labor and class came historically into being in the first place.

In the first part of this book, I explore how Victorian metropolitan space became reordered as a space for the exhibition of imperial spectacle and the reinvention of race. In the process, I investigate a number of circulating themes: commodity racism and fetishism, the urban explorers, the emergence of photography and the imperial exhibitions, the cult of domesticity, the invention of the idea of the idle woman, the disavowal of women's work, cross-dressing and gender ambiguity, the invention of the idea of degeneration, panoptical time and anachronistic space.

In the second part of the book, I explore how the colonies—in particular Africa—became a theater for exhibiting, amongst other things,

the cult of domesticity and the reinvention of patriarchy. Here, I explore some of the stalwart themes of colonial discourse: the feminizing of the land, the myth of the empty lands, the crisis of origins, domestic colonialism, the soap saga and the emergence of commodity fetishism, the reordering of land and labor, the invention of the idea of racial idleness — as well as the complex and myriad forms of resistance to these processes. By exploring the intricate filaments among imperialism, domesticity and money, I suggest that the mass-marketing of empire as a global system was intimately wedded to the Western reinvention of domesticity, so that imperialism cannot be understood without a theory of domestic space and its relation to the market. At the same time, the following chapters explore the beleaguered strategies of refusal, negotiation and transformation that were flung up in resistance to the imperial enterprise. In the last section of the book, in particular, I focus on the tumultuous events in South Africa, from the late 1940s until the current, bloodied contest over national power.

I have chosen, in this way, to tell a series of overlapping and contradictory stories — of black and white working-class women, of white middle-class men and women and of black working-class and middle-class men and women. The genres I address are diverse — photography, diaries, ethnographies, adventure novels, oral histories, performance poetry and the myriad forms of national culture. Amongst others, these cultural forms include the extraordinary diaries and photographs of Hannah Cullwick, a white Victorian maid-of-all-work and her secret marriage to the Victorian barrister and poet, Arthur Munby; the bestselling imperial fantasies by Rider Haggard; the imperial Exhibitions and photography; soap advertising; the political writing and novels of the feminist Olive Schreiner; the narrative of a South African domestic worker "Poppie Nongena"; black cultural politics in South Africa since the Soweto uprising; the writings of Frantz Fanon; and the varied, conflicting voices of Afrikaner and African nationalists in South Africa.

These narratives have many sources and do not promise the unearthing of a pristine past, in any event a utopian task. Rather, this book is an engagement — motivated, selective and oppositional — with both imperial and anti-imperial narratives of fathers and families, labor and gold, mothers and maids.

EMPIRE OF THE HOME

THE LAY OF THE LAND

GENEALOGIES OF IMPERIALISM

I

I am not the wheatfield.
Nor the virgin land.

—Adrienne Rich

PORNO-TROPICS

Consider, to begin with, a colonial scene.

In 1492, Christopher Columbus, blundering about the Caribbean in search of India, wrote home to say that the ancient mariners had erred in thinking the earth was round. Rather, he said, it was shaped like a woman's breast, with a protuberance upon its summit in the unmistakable shape of a nipple — toward which he was slowly sailing.

Columbus' image feminizes the earth as a cosmic breast, in relation to which the epic male hero is a tiny, lost infant, yearning for the Edenic nipple. The image of the earth-breast here is redolent not with the male bravura of the explorer, invested with his conquering mission, but with an uneasy sense of male anxiety, infantilization and longing for the female body. At the same time, the female body is figured as marking the boundary of the cosmos and the limits of the known world, enclosing the ragged men, with their dreams of pepper and pearls, in her indefinite, oceanic body.

Columbus' breast fantasy, like Haggard's map of Sheba's Breasts, draws on a long tradition of male travel as an erotics of ravishment. For centuries, the uncertain continents—Africa, the Americas, Asia—were figured in European lore as libidinously eroticized. Travelers' tales abounded with visions of the monstrous sexuality of far-off lands, where, as legend had it, men sported gigantic penises and women consorted with apes, feminized men's breasts flowed with milk and militarized women lopped theirs off. Renaissance travelers found an eager and lascivious audience for their spicy tales, so that, long before the era of high Victorian imperialism, Africa and the Americas had become what can be called a porno-tropics for the European imagination—a fantastic magic lantern of the mind onto which Europe projected its forbidden sexual desires and fears.

The European porno-tropics had a long tradition. As early as the second century A.D., Ptolemy wrote confidently of Africa that "the constellation of Scorpion, which pertains to the pudenda, dominates that continent."[1] Leo Africanus agreed that there was "no nation under heaven more prone to venerie" than "the Negros."[2] Francis Bacon's Hermit was visited by the Spirit of Fornication, who turned out to be a "little foule, ugly Aethiope."[3] John Ogilby, adapting the writings of Olfert Dapper, rather more tactfully informed his readers that west Africans were distinguished by "large propagators,"[4] while the planter Edward Long saw Africa as "the parent of everything that is monstrous in nature."[5] By the nineteenth century, popular lore had firmly established Africa as the quintessential zone of sexual aberration and anomaly—"the very picture," as W. D. Jordan put it, "of perverse negation."[6] The *Universal History* was citing a well-established and august tradition when it declared Africans to be "proud, lazy, treacherous, thievish, hot and addicted to all kinds of lusts."[7] It was as impossible, it insisted, "to be an *African* and not lascivious, as it is to be born in *Africa* and not be an African."[8]

Within this porno-tropic tradition, women figured as the epitome of sexual aberration and excess. Folklore saw them, even more than the men, as given to a lascivious venery so promiscuous as to border on the bestial. Sir Thomas Herbert observed of Africans "the resemblance they bear with Baboons, which I could observe kept frequent company with the Women."[9]

Long saw a lesson closer to home in the African spectacle of female sexual excess, for he identified British working-class women as inhabiting more naturally than men the dangerous borders of racial and sexual transgression: "The lower class of women in *England*," he wrote ominously, "are remarkably fond of the blacks."[10] The traveler William Smith likewise warned his readers of the perils of traveling as a white man in Africa, for, on that disorderly continent, women "if they meet with a Man they immediately strip his lower Parts and throw themselves upon him."[11]

During the Renaissance, as the "fabulous geography" of ancient travel gave way to the "militant geography" of mercantile imperialism and the triangular trade, so the bold merchant ships of Portugal, Spain, Britain and France began to draw the world into a single skein of trade routes.[12] Mercantile imperialism began to be emboldened by dreams of dominating not only a boundless imperium of commerce but also a boundless imperium of knowledge. Francis Bacon (1561–1626) gave exemplary voice to the immodesty of intellectual Renaissance expansionism. "My only earthly wish," he wrote, "is . . . to stretch the deplorably narrow limits of man's dominion over the universe to their promised bounds."[13] But Bacon's vision of a world-knowledge dominated by Europe was animated not only by an imperial geography of power but also by a gendered erotics of knowledge: "I come in very truth," he proclaimed, "leading to you Nature with all her children to bind her to your service and make her your slave."[14]

All too often, Enlightenment metaphysics presented knowledge as a relation of power between two gendered spaces, articulated by a journey and a technology of conversion: the male penetration and exposure of a veiled, female interior; and the aggressive conversion of its "secrets" into a visible, male science of the surface. Bacon deplored the fact that "while the regions of the material globe . . . have been in our times laid widely open and revealed, the intellectual globe should remain shut up within the narrow limits of old discoveries."[15] Voyaging into the enigma of infinity, there to unlock "Nature's secrets," Faust likewise cried out:

> New roads lie open to me. I
> Shall pierce the veil that hides what we desire,
> Break through to realms of abstract energy.[16]

Knowledge of the unknown world was mapped as a metaphysics of gender violence — not as the expanded recognition of cultural difference — and was validated by the new Enlightenment logic of private property and possessive individualism. In these fantasies, the world is feminized and spatially spread for male exploration, then reassembled and deployed in the interests of massive imperial power. Thus, for Rene Descartes, the expansion of male knowledge amounted to a violent property arrangement that made men

"masters and possessors of nature."[17] In the minds of these men, the imperial conquest of the globe found both its shaping figure and its political sanction in the prior subordination of women as a category of nature.

WOMEN AS THE BOUNDARY MARKERS OF EMPIRE

What is the meaning of this persistent gendering of the imperial unknown? As European men crossed the dangerous thresholds of their known worlds, they ritualistically feminized borders and boundaries. Female figures were planted like fetishes at the ambiguous points of contact, at the borders and orifices of the contest zone. Sailors bound wooden female figures to their ships' prows and baptized their ships—as exemplary threshold objects—with female names. Cartographers filled the blank seas of their maps with mermaids and sirens. Explorers called unknown lands "virgin" territory. Philosophers veiled "Truth" as female, then fantasized about drawing back the veil. In myriad ways, women served as mediating and threshold figures by means of which men oriented themselves in space, as agents of power and agents of knowledge.

The following chapters explore, in part, the historically different but persistent ways in which women served as the boundary markers of imperialism, the ambiguous mediators of what appeared to be—at least superficially—the predominantly male agon of empire. The first point I want to make, however, is that the feminizing of terra incognita was, from the outset, a strategy of violent containment—belonging in the realm of both psychoanalysis and political economy. If, at first glance, the feminizing of the land appears to be no more than a familiar symptom of male megalomania, it also betrays acute paranoia and a profound, if not pathological, sense of male anxiety and boundary loss.

As Columbus' and Haggard's images suggest, the erotics of imperial conquest were also an erotics of engulfment. At one level, the representation of the land as female is a traumatic trope, occurring almost invariably, I suggest, in the aftermath of male boundary confusion, but as a historical, not archetypal, strategy of containment. As the visible trace of paranoia, feminizing the land is a compensatory gesture, disavowing male loss of boundary by reinscribing a ritual excess of boundary, accompanied, all too often, by an excess of military violence. The feminizing of the land represents a ritualistic moment in imperial discourse, as male intruders ward off fears of narcissistic disorder by reinscribing, as natural, an excess of gender hierarchy.

Mary Douglas points out that margins are dangerous.[18] Societies are most vulnerable at their edges, along the tattered fringes of the known world. Having sailed beyond the limits of their charted seas, explorers enter what Victor Turner calls a liminal condition.[19] For Turner, a liminal condition is ambiguous, eluding "the network of classifications that normally locate states and positions in cultural space."[20] There on the margins between known and

unknown, the male conquistadors, explorers and sailors became creatures of transition and threshold. As such, they were dangerous, for, as Douglas writes: "Danger lies in transitional states. . . .The person who must pass from one to another is himself in danger and emanates danger to others."[21] As figures of danger, the men of margins were "licensed to waylay, steal, rape. This behaviour is even enjoined on them. To behave anti-socially is the proper expression of their marginal condition."[22] At the same time, the dangers represented by liminal people are managed by rituals that separate the marginal ones from their old status, segregating them for a time and then publicly declaring their entry into their new status. Colonial discourse repeatedly rehearses this pattern —dangerous marginality, segregation, reintegration.

IMPERIAL "DISCOVERY" AND GENDER AMBIVALENCE

Consider, in this respect, another colonial scene. In a famous drawing (ca. 1575), Jan van der Straet portrays the "discovery" of America as an eroticized encounter between a man and a woman [Fig.I.1].[23] A fully armored Vespucci stands erect and masterful before a naked and erotically

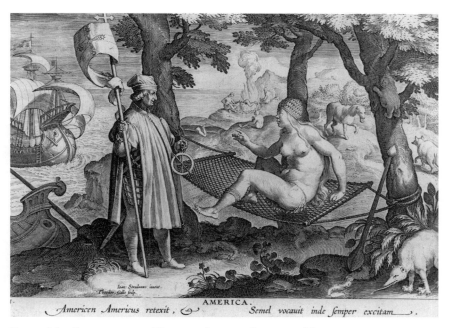

AMERICA.

Americen Americus retexit, & *Semel vocauit inde femper excitam.*

FIGURE 1.1 PORNO-TROPICS: WOMEN AS IMPERIAL BOUNDARY MARKERS.
America, ca. 1600 engraving by Theodore Galle after a drawing
by Jan van der Straet (ca. 1575).

inviting woman, who inclines toward him from a hammock. At first glance, the imperial lessons of the drawing seem clear. Roused from her sensual languor by the epic newcomer, the indigenous woman extends an inviting hand, insinuating sex and submission. Her nakedness and her gesture suggest a visual echo of Michelangelo's "Creation." Vespucci, the godlike arrival, is destined to inseminate her with the male seeds of civilization, fructify the wilderness and quell the riotous scenes of cannibalism in the background. As Peter Hulme puts it in a fine essay: "Land is named as female as a passive counterpart to the massive thrust of male technology."[24] America allegorically represents nature's invitation to conquest, while Vespucci, gripping the fetish instruments of imperial mastery—astrolabe, flag and sword—confronts the virgin land with the patrimony of scientific mastery and imperial might. Invested with the male prerogative of naming, Vespucci renders America's identity a dependent extension of his and stakes male Europe's territorial rights to her body and, by extension, the fruits of her land.

On closer examination, however, van der Straet's drawing, like Haggard's map and Columbus' breast fantasy, tells a double story of discovery. The inaugural scene of discovery is redolent not only of male megalomania and imperial aggression but also of male anxiety and paranoia. In the central distance of the picture, between Amerigo and America, a cannibal scene is in progress. The cannibals appear to be female and are spit-roasting a human leg. A pillar of flame and smoke issues into the sky, conjoining earth, fire, water and air in an elemental scene, structured as a visual assembly of opposites: earth-sky; sea-land; male-female; clothed-unclothed; active-passive; vertical-horizontal; raw-cooked. Situated on the shore, the threshold between land and sea, the drawing is, in almost every sense, a liminal scene.

Most notably, the boundary figures are female. Here, women mark, quite literally, the margins of the new world but they do so in such a way as to suggest a profound ambivalence in the European male. In the foreground, the explorer is of a piece—fully armored, erect and magisterial, the incarnation of male imperial power. Caught in his gaze, the woman is naked, subservient and vulnerable to his advance. In the background, however, the male body is quite literally in pieces, while the women are actively and powerfully engaged. The dismembered leg roasting on the spit evokes a disordering of the body so catastrophic as to be fatal.

This anxious vision marks one aspect, I suggest, of a recurrent doubling in male imperial discourse. This may be seen as the simultaneous dread of catastrophic boundary *loss* (implosion), associated with fears of impotence and infantilization and attended by an *excess* of boundary order and fantasies of unlimited power. In this way, the augural scene of discovery becomes a scene of ambivalence, suspended between an imperial megalomania, with its

fantasy of unstoppable rapine—and a contradictory fear of engulfment, with its fantasy of dismemberment and emasculation. The scene, like many imperial scenes, is a document both of paranoia and of megalomania.

As such, the scene is less about the soon-to-be-colonized "Other," than it is about a crisis in male imperial identity. Both Amerigo and America, I suggest, are split aspects of the European intruder, representing disavowed aspects of male identity, displaced onto a "feminized" space and managed by recourse to the prior ordering of gender.

Suspended between a fantasy of conquest and a dread of engulfment, between rape and emasculation, the scene, so neatly gendered, represents a splitting and displacement of a crisis that is, properly speaking, male. The gendering of America as simultaneously naked and passive *and* riotously violent and cannibalistic represents a doubling within the conqueror, disavowed and displaced onto a feminized scene.

As in many imperial scenes, the fear of engulfment expresses itself most acutely in the cannibal trope. In this familiar trope, the fear of being engulfed by the unknown is projected onto colonized peoples as *their* determination to devour the intruder whole. Haggard's map and van der Straet's discovery scene are no exceptions, for they both implicitly represent female sexuality as cannibalistic: the cannibal scene, the "mouth of treasure cave."

In 1733, Jonathan Swift observed:

So geographers in Afric maps
With savage pictures fill their gaps
and o'er uninhabitable downs
Place elephants instead of towns.[25]

Later, Graham Greene noted how geographers traced the word "cannibals" over the blank spaces on colonial maps. With the word cannibal, cartographers attempted to ward off the threat of the unknown by naming it, while at the same time confessing a dread that the unknown might literally rise up and devour the intruder whole. Colonial documents are replete with reminders of the fetish fascination that the blank spaces of maps cast over the lives of explorers and writers. However, the implosive anxieties suggested by the cannibal trope were just as often warded off by fantastical rites of imperial violence.

The colonial map vividly embodies the contradictions of colonial discourse. Map-making became the servant of colonial plunder, for the knowledge constituted by the map both preceded and legitimized the conquest of territory. The map is a technology of knowledge that professes to capture the truth about a place in pure, scientific form, operating under the guise of scientific exactitude and promising to retrieve and reproduce

nature exactly as it is. As such, it is also a technology of possession, promising that those with the capacity to make such perfect representations must also have the right of territorial control.

Yet the edges and blank spaces of colonial maps are typically marked with vivid reminders of the failure of knowledge and hence the tenuousness of possession. The failure of European knowledge appears in the margins and gaps of these maps in the forms of cannibals, mermaids and monsters, threshold figures eloquent of the resurgent relations between gender, race and imperialism. The map is a liminal thing, associated with thresholds and marginal zones, burdened with dangerous powers. As an exemplary icon of imperial "truth," the map, like the compass and the mirror, is what Hulme aptly calls a "magic technology," a potent fetish helping colonials negotiate the perils of margins and thresholds in a world of terrifying ambiguities.[26]

It seems crucial, therefore, to stress from the outset that the feminizing of the land is both a *poetics* of ambivalence and a *politics* of violence. The "discoverers"—filthy, ravenous, unhealthy and evil-smelling as they most likely were, scavenging along the edges of their known world and beaching on the fatal shores of their "new" worlds, their limbs pocked with abscess and ulcers, their minds infested by fantasies of the unknown—had stepped far beyond any sanctioned guarantees. Their unsavory rages, their massacres and rapes, their atrocious rituals of militarized masculinity sprang not only from the economic lust for spices, silver and gold, but also from the implacable rage of paranoia.

MAPPING THE "VIRGIN" LAND AND THE CRISIS OF ORIGINS

"Discovery" is always late. The inaugural scene is never in fact inaugural or originary: something has always gone before. Van der Straet's drawing confesses as much in its subtitle: "Americus *Re*discovers America." Louis Montrose suggests that the scene was probably understood at the time as referring to a nasty incident that reputedly occurred during one of Vespucci's earlier voyages. A young Spaniard, who was being inspected by a curious group of women, was suddenly felled with a terrific blow from behind by a woman, summarily slain, cut into pieces and roasted, in full view of his fellow countrymen.[27] This tale, with its unseemly burden of female menace and resistance to intrusion contradicts the myth of women's invitation to conquest. At the same time, it contradicts Vespucci's claim to be first.

Vespucci is, in fact, late. Nonetheless, he disavows his belatedness and claims a privileged relation to the moment of "discovery" and the scene of origins by resorting to a familiar strategy: he *names* "America," after himself. The desire to name expresses a desire for a single origin alongside a desire to control the issue of that origin. But the strategy of

naming is ambivalent, for it expresses both an anxiety about generative power and a disavowal.

Luce Irigaray suggests that the male insistence on marking "the product of copulation with *his own name*" stems from the uncertainty of the male's relation to origins.[28] "The fact of being deprived of a womb," she suggests, is "the most intolerable deprivation of man, since his contribution to gestation—his function with regard to the origin of reproduction—is hence asserted as less than evident, as open to doubt."[29] The father has no visible proof that the child is his; his gestative status is not guaranteed. The name, the patrimony, is a substitute for the missing guarantee of fatherhood; it is only the father's name that marks the child as his.

Historically, the male desire for a guaranteed relation to origin—securing, as it does, male property and power—is contradicted by the sexual doubling of origins, by women's visibly active role in producing a child and men's uncertain and fleeting contribution. To compensate for this, men diminish women's contribution (which, as Irigaray notes, can hardly be questioned) by reducing them to vessels and machines—mere bearers—without creative agency or the power to name. The insistence on the patrimony marks a denial: that something different (a woman) is needed to guarantee the reproduction of the same—the son with the same name as the father.[30]

The sexual scene of origins, I suggest, finds an analogy in the imperial scene of discovery. By flamboyantly naming "new" lands, male imperials mark them as their own, guaranteeing thereby, or so they believe, a privileged relation to origins—in the embarrassing absence of other guarantees. Hence the imperial fixation on naming, on acts of "discovery," baptismal scenes and male birthing rituals.

The imperial act of discovery can be compared with the male act of baptism. In both rituals, western men publicly disavow the creative agency of others (the colonized/women) and arrogate to themselves the power of origins. The male ritual of baptism—with its bowls of holy water, its washing, its male midwives—is a surrogate birthing ritual, during which men collectively compensate themselves for their invisible role in the birth of the child and diminish women's agency. In Christianity, at least, baptism reenacts childbirth as a male ritual. During baptism, moreover, the child is named—after the father, not the mother. The mother's labors and creative powers (hidden in her "confinement" and denied social recognition) are diminished, and women are publicly declared unfit to inaugurate the human soul into the body of Christ. In the eyes of Christianity, women are incomplete birthers: the child must be born again and named, by men.

Like baptism, the imperial act of discovery is a *retrospective* birthing ritual: the lands are already peopled, as the child is already born. Discovery, for this reason, is a *retrospective* act. As Mary Louise Pratt points out, the discovery

has no existence on its own: "It only gets 'made' for real after the traveler (or other survivor) returns home and brings it into being through texts: a name on a map, a report to the Royal Geographical Society, the Foreign Office, the London Mission Society, a diary, a lecture, a travel book."[31] Discovery, as Pratt remarks, usually involves a journey to a far-flung region, asking the local inhabitants if they know of a nearby river, lake or waterfall, paying them to take one there, then "discovering" the site, usually by the passive act of seeing it. During these extravagant acts of discovery, imperial men reinvent a moment of pure (male) origin and mark it visibly with one of Europe's fetishes: a flag, a name on a map, a stone, or later perhaps, a monument. I will return, in due course, to the question of the fetish and its relation to the crisis of origins.

THE MYTH OF THE EMPTY LANDS

> Guiana is a countrey that hath yet her maydenhead,
> never sackt, turned, nor wrought
>
> — *Walter Raleigh*

The myth of the virgin land is also the myth of the empty land, involving both a gender and a racial dispossession. Within patriarchal narratives, to be virgin is to be empty of desire and void of sexual agency, passively awaiting the thrusting, male insemination of history, language and reason.[32] Within colonial narratives, the eroticizing of "virgin" space also effects a territorial appropriation, for if the land is virgin, colonized peoples cannot claim aboriginal territorial rights, and white male patrimony is violently assured as the sexual and military insemination of an interior void. This doubled theme—the disavowed agency of women and the colonized— recurs throughout the following chapters.

 The colonial journey into the virgin interior reveals a contradiction, for the journey is figured as proceeding forward in geographical space but backward in historical time, to what is figured as a prehistoric zone of racial and gender difference. One witnesses here a recurrent feature of colonial discourse. Since indigenous peoples are not supposed to be spatially there—for the lands are "empty"—they are symbolically displaced onto what I call *anachronistic space*, a trope that gathered (as I explore in more detail below) full administrative authority as a technology of surveillance in the late Victorian era. According to this trope, colonized people—like women and the working class in the metropolis—do not inhabit history proper but exist in a permanently anterior time within the geographic space of the modern empire as anachronistic humans, atavistic, irrational, bereft of human agency—the living embodiment of the archaic "primitive."

A presiding dilemma faced colonials, however, for the "empty" lands were visibly peopled, while traces of the peoples' antiquity lay obviously to hand in the form of ruins, ancient settlements, skulls and fossils. Here lies at least one reason for the Victorian obsession with survivals and traces, ruins and skeletons—allegorical reminders of the failure of a single narrative of origins. In Chapters 4, 5 and 10, I explore the ramifications of these colonial dilemmas in more detail.

For women, the myth of the virgin land presents specific dilemmas, with important differences for colonial or colonized women, as I argue in Chapters 9 and 10. Women are the earth that is to be discovered, entered, named, inseminated and, above all, owned. Symbolically reduced, in male eyes, to the space on which male contests are waged, women experience particular difficulties laying claim to alternative genealogies and alternative narratives of origin and naming. Linked symbolically to the land, women are relegated to a realm beyond history and thus bear a particularly vexed relation to narratives of historical change and political effect. Even more importantly, women are figured as property belonging to men and hence as lying, by definition, outside the male contests over land, money and political power.

It is important to stress from the outset, however, that the gendering of imperialism took very different forms in different parts of the world. India, for one, was seldom imaged as a virgin land, while the iconography of the harem was not part of Southern African colonial erotics. North African, Middle Eastern and Asian women were, all too often, trammeled by the iconography of the veil, while African women were subjected to the civilizing mission of cotton and soap. In other words, Arab women were to be "civilized" by being undressed (unveiled), while sub-Saharan women were to be civilized by being dressed (in clean, white, British cotton). These sumptuary distinctions were symptomatic of critical differences in the legislative, economic and political ways in which imperial commodity racism was imposed on different parts of the world.

DOMESTICITY AND COMMODITY RACISM

> *domest\ic*, a. & n. 1. Of the home, household, or
> family affairs.
> *domestic\ate*, v.t. Naturalize
> (colonists, animals) . . .
> civilize
> (savages)
>
> *— The Concise Oxford Dictionary of Current English*

In 1899, the year that the Anglo-Boer War broke out in South Africa, an advertisement for Pears' Soap in *McClure's Magazine* [Fig. 1.2] announced:

> The first step towards lightening THE WHITE MAN'S BURDEN is through teaching the virtues of cleanliness. PEARS' SOAP is a potent factor in brightening the dark corners of the earth as civilization advances, while amongst the cultured of all nations it holds the highest place—it is the ideal toilet soap.[33]

The advertisement shows an admiral decked in pure imperial white, washing his hands in his cabin as his steamship crosses the oceanic threshold into the realm of empire. In this image, private domesticity and the imperial market—the two spheres vaunted by middle-class Victorians as entirely and naturally distinct—converge in a single commodity spectacle. The domestic sanctum of the white man's bathroom gives privileged vantage onto the global realm of commerce, so that imperial progress is consumed at a glance—as *panoptical time*.

The porthole is both window and mirror. The window, icon of imperial surveillance and the Enlightenment idea of knowledge as penetration, opens onto public scenes of economic conversion. One scene depicts a kneeling African gratefully receiving the Pears' soap as he might genuflect before a religious fetish. The mirror, emblem of Enlightenment selfconsciousness, reflects the sanitized image of white, male, imperial hygiene. Domestic hygiene, the ad implies, purifies and preserves the white male body from contamination in the threshold zone of empire. At the same time, the domestic commodity guarantees white male power, the genuflection of Africans and rule of the world. On the wall, an electric light bulb signifies scientific rationality and spiritual advance. In this way, the household commodity spells the lesson of imperial progress and capitalist civilization: civilization, for the white man, advances and brightens through his four beloved fetishes—soap, the mirror, light and white clothing. As I explore in more detail below, these domestic fetishes recur throughout late Victorian commodity kitsch and the popular culture of the time.

The first point about the Pears' advertisement is that it figures imperialism as coming into being through *domesticity*. At the same time, imperial domesticity is a domesticity without women. The commodity fetish, as the central form of the industrial Enlightenment, reveals what liberalism would like to forget: the domestic is political, the political is gendered. What could not be admitted into male rationalist discourse (the economic value of women's domestic labor) is disavowed and projected onto the realm of the "primitive" and the zone of empire. At the same time, the economic value of colonized cultures is domesticated and projected onto the realm of the "prehistoric."

A characteristic feature of the Victorian middle class was its peculiarly intense preoccupation with rigid boundaries. In imperial fiction and commodity kitsch, boundary objects and liminal scenes recur ritualistically. As colonials traveled back and forth across the thresholds of their known world, crisis and boundary confusion were warded off and contained by fetishes, absolution rituals and liminal scenes. Soap and cleaning rituals became central to the demarcation of body boundaries and the policing of social hierarchies. Cleansing and boundary rituals are integral to most cultures; what characterized Victorian cleaning rituals, however, was their peculiarly intense relation to money.

I am doubly interested in the Pears' Soap ad because it registers an epochal shift that I see as having taken place in the culture of imperialism in the last decades of the nineteenth century. This was the shift from *scientific racism*—embodied in anthropological, scientific and medical journals, travel writing and ethnographies—to what I call *commodity racism*. Commodity racism—in the specifically Victorian forms of advertising and photography, the imperial Expositions and the museum movement—converted the narrative of imperial Progress into mass-produced *consumer spectacles*.

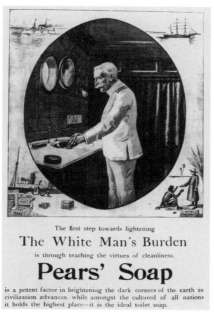

The first step towards lightening

The White Man's Burden

is through teaching the virtues of cleanliness.

Pears' Soap

is a potent factor in brightening the dark corners of the earth as civilization advances. while amongst the cultured of all nations it holds the highest place—it is the ideal toilet soap.

FIGURE 1.2 IMPERIAL DOMESTICITY.

During the eighteenth century, what Pratt calls "planetary consciousness" emerged.[34] Planetary consciousness imagined drawing the whole world into a single "science of order," in Foucault's phrase. Carl Linne provided the impetus for this immodest idea with the publication in 1735 of *Systema Natura*, which promised to organize all plant forms into a single genesis narrative.[35] For Linne, moreover, *sexual* reproduction became the paradigm for natural form in general.

Inspired by Linne, hosts of explorers, botanists, natural historians and geographers set out with the vocation of ordering the world's forms into a global science of the surface and an optics of truth. In this way, the Enlightenment project coincided with the imperial project. As Pratt puts it: "For what were the slave trade and the plantation system if not massive experiments in social engineering and discipline, serial production, the systematization of human life, the standardizing of persons?"[36] The global science of the surface was a *conversion* project, dedicated to transforming the earth into a single economic currency, a single pedigree of history and a universal standard of cultural value — set and managed by Europe.

What concerns me here, however, is that, if the imperial science of the surface promised to unroll over the earth a single "Great Map of Mankind," and cast a single, European, male authority over the whole of the planet, ambition far outran effect for quite some time. The project was fissured with intellectual paradox, incompletion and ignorance. The technological capacity to map and catalog the earth's surface remained, for some time, haphazard, shoddy and downright inept. The promoters of the global project sorely lacked the technical capacity to formally reproduce the optical "truth" of nature as well as the economic capacity to distribute this truth for global consumption. In order for this to happen, the global project had to wait until the second half of the nineteenth century, with the emergence, I suggest, of commodity spectacle — in particular photography.

The following chapters are concerned with this shift from scientific racism to commodity racism, by which evolutionary racism and imperial power were marketed on a hitherto unimaginable scale. In the process, the Victorian middle-class home became a space for the display of imperial spectacle and the reinvention of race, while the colonies — in particular Africa — became a theater for exhibiting the Victorian cult of domesticity and the reinvention of gender.

Domesticity denotes both a *space* (a geographic and architectural alignment) and a *social relation to power*. The cult of domesticity — far from being a universal fact of "nature" — has an historical genealogy. The idea of "the domestic" cannot be applied willy-nilly to any house or dwelling as a universal or natural fact.[37] So often vaunted as involving a naturally occurring, universal space — ensconced within the innermost interiors of

society, yet lying theoretically beyond the domain of political analysis—the cult of domesticity involves processes of social metamorphosis and political subjection of which gender is the abiding but not the only dimension.

Etymologically, the verb to domesticate is akin to dominate, which derives from *dominus*, lord of the *domum*, the home.[38] Until 1964, however, the verb to domesticate also carried as one of its meanings the action "to civilize."[39] In the colonies (as I explore in more detail in Chapter 6), the mission station became a threshold institution for transforming domesticity rooted in European gender and class roles into domesticity as controlling a colonized people. Through the rituals of domesticity, increasingly global and more often than not violent, animals, women and colonized peoples were wrested from their putatively "natural" yet, ironically, "unreasonable" state of "savagery" and inducted through the domestic progress narrative into a hierarchical relation to white men.

The historical idea of domesticity thus bears an ambivalent relation to the idea of imperial nature, for "domestication" bears energetically upon nature in order to produce a social sphere that is considered to be natural and universal in the first place. In the colonies, in other words, European *culture*

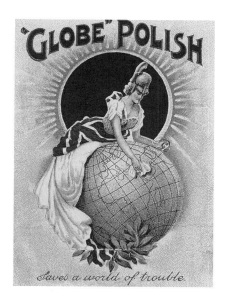

FIGURE 1.3 DOMESTICATING THE EMPIRE.

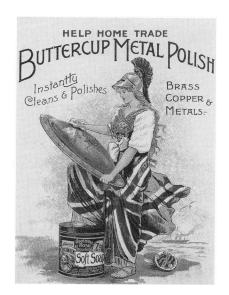

FIGURE 1.4 BRITAIN'S NATIONAL IDENTITY
TAKES IMPERIAL FORM.

(the civilizing mission) became ironically necessary to reproduce *nature* (the "natural" divisions of domestic labor), an anomaly that took much social energy—and much domestic work—to conceal. The idea of progress—"nature" improving itself through time— was crucial to managing this anomaly.

The cult of domesticity, I argue, became central to British imperial identity, contradictory and conflictual as that was, and an intricate dialectic emerged. Imperialism suffused the Victorian cult of domesticity and the historic separation of the private and the public, which took shape around colonialism and the idea of race. At the same time, colonialism took shape around the Victorian invention of domesticity and the idea of the home.[40] [Fig. 1.3, Fig. 1.4.]

This, then, is a central theme of this book: as domestic space became racialized, colonial space became domesticated. Certainly, commodity spectacle was not the only cultural form for the mediation of domestic colonialism. Travel writing, novels, postcards, photographs, pornography and other cultural forms can, I believe, be as fruitfully investigated for this crucial relation between domesticity and empire. Commodity spectacle, however, spread well beyond the literate and propertied elite and gave domestic colonialism particularly far-reaching clout.

PANOPTICAL TIME

> We need no longer go to History to trace (human Nature) in all its stages and periods . . . now the Great Map of Mankind is unrolld at once; and there is no state or Gradation of barbarism and no mode of refinement which we have not at the same instant under our View.
>
> —*Edmund Burke*

The imperial science of the surface drew on two centralizing tropes: the invention of what I call *panoptical time* and *anachronistic space*. With the publication of *On the Origin of Species*, Charles Darwin bestowed on the global project a decisive dimension—secular time as the agent of a unified world history. Just as Linne attempted to classify the fragmentary botanical record into a single archive of natural form, so social evolutionists after 1859 undertook the massive attempt of reading from the discontinuous natural record (which Darwin called "a history of the world imperfectly kept") a single pedigree of evolving world history. Now not only natural space but also historical time could be collected, assembled and mapped onto a global science of the surface.

Johannes Fabian's important meditation on time and anthropology, *Time and the Other: How Anthropology Makes Its Object,* shows how the social evolutionists broke the hold of Biblical chronology—that is, chronicle time—by secularizing time and placing it at the disposal of the empirical project—that is, chronological time.[41] In order to do this, he points out, "they *spatialized* Time." "The paradigm of evolution rested on a conception of Time that was not only secularized and naturalized but also thoroughly spatialized." The axis of time was projected onto the axis of space and history became global. With social Darwinism, the taxonomic project, first applied to nature, was now applied to cultural history. Time became a geography of social power, a map from which to read a global allegory of "natural" social difference. Most importantly, history took on the character of a spectacle.

In the last decades of the nineteenth century, panoptical time came into its own. By panoptical time, I mean the image of global history consumed—at a glance—in a single spectacle from a point of privileged invisibility. In the seventeenth century, Bossuet, in *Discours sur l'histoire universelle,* argued that any attempt to produce a universal history depended on being able to figure "the order of times" ("*comme d'un coup d'oeil*") at a glance.[42] To meet the "scientific" standards set by the natural historians and empiricists of the eighteenth century, a visual paradigm was needed to display evolutionary progress as a measurable spectacle. The exemplary figure that emerged was the evolutionary family Tree of Man.

Renaissance nature—divine nature—was understood as cosmological, organized according to God's will into an irrevocable chain of being. By contrast, the social evolutionist Herbert Spencer envisioned evolution not as a chain of being but as a tree. As Fabian puts it: "The tree has always been one of the simplest forms of constructing classificatory schemes based on subsumption and hierarchy."[43] The tree offered an ancient image of a natural genealogy of power. The social evolutionists, however, took the divine, cosmological tree and secularized it, turning it into a switchboard image mediating between nature and culture as a natural image of evolutionary human progress.

Mantegazza's "Morphological Tree of the Human Races," for example, shows vividly how the image of the tree was put at the disposal of the racial scientists [Fig. 1.5]. In Mantegazza's image of global history, three principles emerge. First, mapped against the tree, the world's discontinuous cultures appear to be marshaled within a single, European Ur-narrative. Second, human history can be imaged as naturally teleological, an organic process of upward growth, with the European as the apogee of progress. Third, disobliging historical discontinuities can be ranked, subdued and subordinated into a hierarchical structure of branching time—the differential progress of the races mapped against the tree's self-evident boughs.

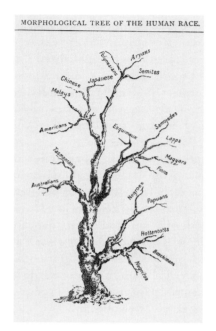
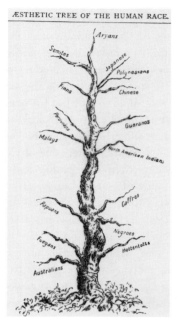

FIGURE 1.5 INVENTING PROGRESS: THE RACIAL FAMILY TREE.

In the tree of time, racial hierarchy and historical progress became the fait accomplis of nature.

The tree image, however, was attended by a second, decisive image: the Family of Man. The "Family Group of the Katarrhinen" offers a good example [Fig. 1.6]. In this family group, evolutionary progress is represented by a series of distinct anatomical types, organized as a linear image of progress. In this image, the eye follows the evolutionary types up the page, from the archaic to the modern, so that progress seems to unfold naturally before the eye as a series of evolving marks on the body. Progress takes on the character of a spectacle, under the form of the family. The entire chronological history of human development is captured and consumed at a glance, so that anatomy becomes an allegory of progress and history is reproduced as a technology of the visible [Fig. 1.7].[44]

Social evolutionism and anthropology thus gave to politics and economics a concept of natural time as *familial*. Time was not only

secularized, it was *domesticated*, a point Fabian, for one, does not address. The merging of tree and family into the family Tree of Man provided scientific racism with a *gendered* image for popularizing and disseminating the idea of *racial* progress. There is a problem here, however, for the family Tree represents evolutionary time as a *time without women*. The family image is an image of disavowal, for it contains only men, arranged as a linear frieze of solo males ascending toward the apogee of the individual *Homo sapiens*. Each epoch is represented by a single male type, who is characterized in turn by visible anatomical stigmata. From the outset, the idea of racial progress was gendered but in such a way as to render women invisible as historical agents.

In this way, the figure of the Family of Man reveals a persistent contradiction. Historical progress is naturalized as an evolving family, while women as historical actors are disavowed and relegated to the realm of nature. History is thus figured as *familial*, while the family as an institution is seen as beyond history. The chapters that follow (in particular Chapter 11) are centrally concerned with the historical implications of this paradox.

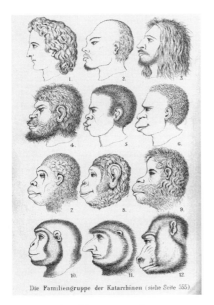

FIGURE 1.6 "THE FAMILY GROUP OF THE KATARRHINEN": INVENTING THE FAMILY OF MAN.

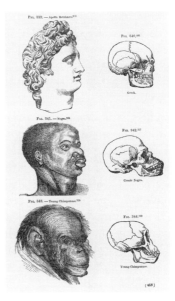

FIGURE 1.7 PANOPTICAL TIME: PROGRESS CONSUMED AT A GLANCE.

Walter Benjamin notes that a central feature of nineteenth century industrial capitalism was "the use of archaic images to identify what is historically new about the 'nature' of commodities."[45] In the mapping of progress, images of "archaic" time—that is, non-European time—were systematically evoked to identify what was historically new about industrial modernity. The middle class Victorian fixation with origins, with genesis narratives, with archaeology, skulls, skeletons and fossils—the imperial bric-a-brac of the archaic—was replete with the fetishistic compulsion to collect and exhibit that shaped the *musée imaginaire* of middle class empiricism. The museum—as the modern fetish-house of the archaic— became the exemplary institution for embodying the Victorian narrative of progress. In the museum of the archaic, the anatomy of the middle-class took visible shape [Fig. 1.8].

Yet in the compulsion to collect and reproduce history whole, time— just when it appears most historical—stops in its tracks. In images of panoptical time, history appears static, fixed, covered in dust. Para-doxically, then, in the act of turning time into a commodity, historical change—especially the *labor* of changing history—tends to disappear.

At this point, another trope makes its appearance. It can be called the invention of anachronistic space, and it reached full authority as an admin-istrative and regulatory technology in the late Victorian era. Within this trope, the agency of women, the colonized and the industrial working class are disavowed and projected onto anachronistic space: prehistoric, atavistic and irrational, inherently out of place in the historical time of modernity.

According to the colonial version of this trope, imperial progress across the space of empire is figured as a journey backward in time to an anachronistic moment of prehistory. By extension, the return journey to Europe is seen as rehearsing the evolutionary logic of historical progress, forward and upward to the apogee of the Enlightenment in the European metropolis. Geographical difference across *space* is figured as a historical difference across *time*. The ideologue J.-M. Degerando captured this notion concisely: "The philosophical traveller, sailing to the ends of the earth, is in fact travelling in time; he is exploring the past."[46] The stubborn and threatening heterogeneity of the colonies was contained and disciplined not as socially or geographically different from Europe and thus equally valid, but as *temporally* different and thus as irrevocably superannuated by history.

Hegel, for example, perhaps the most influential philosophical proponent of this notion, figured Africa as inhabiting not simply a different geographical space but a different temporal zone, surviving anachronis-tically within the time of history. Africa, announces Hegel, "is no Historical

part of the world . . . it has no movement or development to exhibit."[47] Africa came to be seen as the colonial paradigm of anachronistic space, a land perpetually out of time in modernity, marooned and historically abandoned. Africa was a fetish-land, inhabited by cannibals, dervishes and witch doctors, abandoned in prehistory at the precise moment before the *Weltgeist* (as the cunning agent of Reason) manifested itself in history.

In the industrial metropolis, likewise, the evocation of anachronistic space (the invention of the archaic) became central to the discourse of racial science and the urban surveillance of women and the working class. Racial scientists and, later, eugenicists saw women as the inherently atavistic, living archive of the primitive archaic.

In order to meet the empirical standards of the natural scientists, it was necessary to invent visible stigmata to represent—as a commodity spectacle—the historical anachronism of the degenerate classes. As Sander Gilman has pointed out, one answer was found in the body of the African woman, who became the prototype of the Victorian invention of primitive atavism. "In the nineteenth century," Gilman notes, "the black female was widely

PUNCH, OR THE LONDON CHARIVARI—December 31, 1881.

TIME'S WAXWORKS.
(1881 *JUST ADDED TO THE COLLECTION.*)
Mr. P. "HA! YOU'LL HAVE TO PUT HIM INTO THE CHAMBER OF HORRORS!"

FIGURE 1.8 Anachronistic Space: Inventing the Archaic.

perceived as possessing not only a 'primitive' sexual appetite but also the external signs of this temperament—primitive genitalia."[48] In 1810, the exhibition of the African woman Saartjie Baartman became the paradigm for the invention of the female body as an anachronism. The supposedly excessive genitalia of this woman (represented as they were as an excess of *clitoral* visibility in the figure of the "Hottentot apron") were overexposed and pathologized before the disciplinary gaze of male medical science and a voyeuristic public.[49] Cuvier, in his notorious medicalizing of her skeleton, compared the female of the "lowest" human species with the "highest ape" (the orangutan), seeing an atavistic affinity in the "anomolous" appearance of the black woman's "organ of generation." As with Linne, sexual reproduction served as the paradigm of social order and disorder.

In the overexposure of African genitalia and the medical pathologizing of female sexual pleasure (especially clitoral pleasure, which stood outside the reproductive teleology of male heterosexuality), Victorian men of science found a fetish for embodying, measuring and embalming the idea of the female body as anachronistic space. Thus, a contradiction within the middle class formation (between clitoral sexuality—sex for female pleasure—and reproductive sexuality—sex for male pleasure and childbearing) was projected onto the realm of empire and the zone of the primitive. As an inherently inadequate organ, says Freud, "the female genitalia are more primitive than those of the male" and the clitoris "is the normal prototype of inferior organs."[50] As a historical anachronism, moreover, the "immature" clitoris must be disciplined and subordinated within a linear narrative of heterosexual, reproductive progress—the vaginal task of bearing a child with the same name as the father.

As I argue in Chapters 2, 3 and 4, Victorian domestic space was also brought under the disciplinary figure of anachronistic space. Women who transgressed the Victorian boundary between private and public, labor and leisure, paid work and unpaid work became increasingly stigmatized as specimens of *racial* regression. Such women, it was contended, did not inhabit history proper but were the prototypes of anachronistic humans: childlike, irrational, regressive and atavistic, existing in a permanently anterior time within modernity. Female domestic servants were frequently depicted in the iconography of degeneration—as "plagues," "black races," "slaves" and "primitives."

INVENTING RACE AND THE FAMILY OF MAN

In 1842, Friedrich Engels, maverick son of a German manufacturer, crossed the North Sea to investigate the "true condition" of the working people who powered his father's mills.[51] A few years later, he announced

that amidst the calamities of that first great industrial crisis, he had found "more than mere Englishmen, members of a single, isolated nation." He had found "MEN, members of the great and universal family of Mankind."[52] Yet Engels' remarks belie a paradox. Venturing through the labyrinth of urban woe into the verminous hovels and alleys, past the belching dye-works and bone-mills of an industrializing Britain, Engels finds the "family of Mankind" to be everywhere in disarray. Rather than the "Family of 'One and Indivisible' Mankind" to which he appeals in his preface, Engels discovers "the universal decadence of family life among the workers."[53] Indeed, the distinctive tragedy of the universal, working class "Family of Man" was that "family life . . . is almost impossible."[54] Moreover, as Engels sees it, there is one cause of the confusion: "It is inevitable that if a married woman works in a factory, family life is inevitably destroyed."[55]

What interests me here is that Engels, in delivering his revolutionary "bill of indictment" to the English, figures the familial crises besetting the urban poor through the iconography of race and degeneration. Living in slums that were little more than "unplanned wildernesses," the working class, he feels, has become utterly degraded and degenerate: "A physically degenerate race, robbed of all humanity, degraded, reduced morally and intellectually to bestiality."[56] The working class is a "race wholly apart," so that it and the bourgeoisie are now "two radically dissimilar nations, as unlike as difference of race could make them."[57]

Engels figures the first great crises of industrialism through the two tropes of racial degeneration and the Family of Man—one trope drawn from the realm of domesticity, the other from the realm of empire. One witnesses here the figure of a double displacement: global history is imaged as a universal family (a figure of private, *domestic* space), while domestic crises are imaged in racial terms (the public figure of *empire*). After the 1850s, I suggest, presiding contradictions within industrial modernity— between private and public, domesticity and industry, labor and leisure, paid work and unpaid work, metropolis and empire—were systematically mediated by these two dominant discourses: the trope of degeneration (reversible as the progress trope) and the trope of the Family of Man.

By the latter half of the nineteenth century, the analogy between race and gender degeneration came to serve a specifically modern form of social domination, as an intricate dialectic emerged—between the domestication of the colonies and the racializing of the metropolis. In the metropolis, the idea of racial deviance was evoked to police the "degenerate" classes—the militant working class, the Irish, Jews, feminists, gays and lesbians, prostitutes, criminals, alcoholics and the insane—who were collectively figured as racial deviants, atavistic throwbacks to a primitive moment in human prehistory, surviving ominously in the heart of the modern, imperial metropolis.

In the colonies, black people were figured, among other things, as gender deviants, the embodiments of prehistoric promiscuity and excess, their evolutionary belatedness evidenced by their "feminine" lack of history, reason and proper domestic arrangements. The dialectic between domesticity and empire, however, was beset by contradiction, anomaly and paradox. This book inhabits the crossroads of these contradictions.

After mid century, I suggest, a triangulated analogy among racial, class and gender degeneration emerged. The "natural" male control of reproduction in heterosexual marriage and the "natural" bourgeois control of capital in the commodity market were legitimized by reference to a third term: the "abnormal" zone of racial degeneration. Illicit money and illicit sexuality were seen to relate to each other by negative analogy to race. In the symbolic triangle of deviant money—the order of class; deviant sexuality—the order of gender; and deviant race—the order of empire, the degenerate classes were metaphorically bound by a regime of surveillance and were collectively figured as transgressing the proper distributions of money, sexuality and property. Seen as fatally threatening the fiscal and libidinal economy of the imperial state, they became subject to increasingly vigilant and violent policing.

THE PARADOX OF THE FAMILY

After 1859 and the advent of social Darwinism, the welter of distinctions of race, class and gender were gathered into a single narrative by the image of the Family of Man. The evolutionary "family" offered an indispensable metaphoric figure by which often contradictory hierarchical distinctions could be shaped into a global genesis narrative. A curious paradox thus emerges. The family as a *metaphor* offered a single genesis narrative for global history, while the family as an *institution* became void of history. As the nineteenth century drew on, the family as an institution was figured as existing, naturally, beyond the commodity market, beyond politics and beyond history proper. The family thus became both the antithesis of history and history's organizing figure.

At the same time, technologies of knowledge had to be found to give the family figure an institutional shape. The central technologies that emerged for the commodity display of progress and the universal family were, I suggest, those quintessentially Victorian institutions of the museum, the exhibition, photography and imperial advertising.

In an important observation, Edward Said has pointed to the transition in Victorian upper-middle-class culture from "filiation" (familial relations) to "affiliation" (non-familial relations): showing how failure to produce children took on the aspect of a pervasive cultural affliction.[58] For Said, the decay of filiation is typically attended by a second moment—the turn to a

compensatory order of affiliation, which might be an institution, a vision, a credo or a vocation. While retaining the powerful distinction between filiation and affiliation, I wish to complicate the linear thrust of Said's story. As the authority and social function of the great service families (invested in filiative rituals of patrilineal rank and subordination) were displaced onto the bureaucracy, the anachronistic, filiative image of the family was projected onto emerging affiliative institutions as their shadowy, naturalized form.

The filiative (familial) order, in other words, did not disappear. Rather, it flourished as a metaphoric afterimage, reinvented within the new orders of the industrial bureaucracy, nationalism and colonialism. Moreover, filiation would take an increasingly imperial shape as the image of the evolutionary family was projected onto the imperial nation and colonial bureaucracies as their natural, legitimizing shape.

The power and importance of the family trope was twofold. First, the family offered an indispensable figure for sanctioning social hierarchy within a putative organic unity of interests. Because the subordination of woman to man and child to adult were deemed natural facts, other forms of social hierarchy could be depicted in familial terms to guarantee social *difference* as a category of nature. The family image came to figure *hierarchy within unity* as an organic element of historical progress, and thus became indispensable for legitimizing exclusion and hierarchy within nonfamilial social forms such as nationalism, liberal individualism and imperialism. The metaphoric depiction of social hierarchy as natural and familial thus depended on the prior naturalizing of the social subordination of women and children.

Second, the family offered an invaluable trope for figuring *historical time*. Within the family metaphor, both social hierarchy (synchronic hierarchy) and historical change (diachronic hierarchy) could be portrayed as natural and inevitable, rather than as historically constructed and therefore subject to change. Projecting the family image onto national and imperial progress enabled what was often murderously violent change to be legitimized as the progressive unfolding of natural decree. Imperial intervention could thus be figured as a linear, nonrevolutionary progression that naturally contained hierarchy within unity: paternal fathers ruling benignly over immature children. The trope of the organic family became invaluable in its capacity to give state and imperial intervention the alibi of nature.

After the 1850s, the image of the natural, patriarchal family, in alliance with pseudoscientific social Darwinism, came to constitute the organizing trope for marshaling a bewildering array of cultures into a single, global narrative ordered and managed by Europeans. In the process, the idea of divine nature was superceded by the idea of imperial nature, guaranteeing henceforth that the "universal" quintessence of Enlightenment individualism belongs only to propertied men of European descent.

DEGENERATION

A TRIANGULATED DISCOURSE

From the outset, the idea of progress that illuminated the nineteenth century was shadowed by its somber side. Imagining the degeneration into which humanity could fall was a necessary part of imagining the exaltation to which it could aspire. The degenerate classes, defined as departures from the normal human type, were as necessary to the self-definition of the middle class as the idea of degeneration was to the idea of progress, for the distance along the path of progress traveled by some portions of humanity could be measured only by the distance others lagged behind.[59] Normality thus emerged as a product of deviance, and the baroque invention of clusters of degenerate types highlighted the boundaries of the normal.

The poetics of degeneration was a poetics of social crisis. In the last decades of the century, Victorian social planners drew deeply on social Darwinism and the idea of degeneration to figure the social crises erupting relentlessly in the cities and colonies. By the end of the 1870s, Britain was foundering in severe depression, and throughout the 1880s class insurgency, feminist upheavals, the socialist revival, swelling poverty and the dearth of housing and jobs fed deepening middle class fears. The crises in the cities were compounded by crises in the colonies as Britain began to feel the pinch of the imperial rivalry of Germany and the United States. The atmosphere of impending catastrophe gave rise to major changes in social theory, which drew on the poetics of degeneration for legitimation. Suffused as it was with Lamarckian thinking, the eugenic discourse of degeneration was deployed both as a regime of discipline imposed on a deeply distressed populace, as well as a reactive response to very real popular resistance.

Biological images of disease and contagion served what Sander Gilman has called "the institutionalization of fear," reaching into almost every nook and cranny of Victorian social life, and providing the Victorian elite with the justification it needed to discipline and contain the "dangerous classes."[60] As the century drew to a close, biological images of disease and pestilence formed a complex hierarchy of social metaphors that carried considerable social authority. In *Outcast London* Gareth Stedman Jones shows how London became the focus of wealthy Victorians' growing anxieties about the unregenerate poor, variously described as the "dangerous" or "ragged" classes, the "casual poor," or the "residuum."[61] The slums and rookeries were figured as the hotbeds and breeding haunts of "cholera, crime and chartism."[62] "Festering" in dark and filthy dens, the scavenging and vagrant poor were described by images of putrefaction and organic debility. Thomas Plint described the "criminal class" as a "moral poison" and "pestiferous canker," a "non-indigenous" and predatory body preying

on the healthy.[63] Carlyle saw the whole of London as an infected wen, a malignant ulcer on the national body politic.

The image of bad blood was drawn from biology but degeneration was less a biological fact than it was a social figure. Central to the idea of degeneration was the idea of *contagion* (the communication of disease, by touching, from body to body), and central to the idea of contagion was the peculiarly Victorian paranoia about boundary order. Panic about blood contiguity, ambiguity and *metissage* expressed intense anxieties about the fallibility of white male and imperial potency. The poetics of contagion justified a politics of exclusion and gave social sanction to the middle class fixation with boundary sanitation, in particular the sanitation of sexual boundaries. Body boundaries were felt to be dangerously permeable and demanding continual purification, so that sexuality, in particular women's sexuality, was cordoned off as the central transmitter of racial and hence cultural contagion. Increasingly vigilant efforts to control women's bodies, especially in the face of feminist resistance, were suffused with acute anxiety about the desecration of sexual boundaries and the consequences that racial contamination had for white male control of progeny, property and power. Certainly the sanitation syndromes were in part genuine attempts to combat the "diseases of poverty," but they also served more deeply to rationalize and ritualize the policing of boundaries between the Victorian ruling elite and the "contagious" classes, both in the imperial metropoles and in the colonies.

Controlling women's sexuality, exalting maternity and breeding a virile race of empire-builders were widely perceived as the paramount means for controlling the health and wealth of the male imperial body politic, so that, by the turn of the century, sexual purity emerged as a controlling metaphor for racial, economic and political power.[64] In the metropolis, as Anna Davin shows, population was power and societies for the promotion of public hygiene burgeoned, while childrearing and improving the racial stock became a national and imperial duty. State intervention in domestic life increased apace. Fears for the military prowess of the imperial army were exacerbated by the Anglo-Boer war, with the attendant discovery of the puny physiques, bad teeth and general ill health of the working class recruits. Motherhood became rationalized by the weighing and measuring of babies, the regimentation of domestic schedules and the bureaucratic administration of domestic education. Special opprobrium fell on "nonproductive" women (prostitutes, unmarried mothers, spinsters) and on "nonproductive men" (gays, the unemployed, the impoverished). In the eyes of policymakers and administrators, the bounds of empire could be secured and upheld only by proper domestic discipline and decorum, sexual probity and moral sanitation.

If, in the metropolis, as Ann Stoler writes, "racial deterioration was conceived to be a result of the moral turpitude and the ignorance of working class mothers, in the colonies the dangers were more pervasive, the possibilities of contamination worse."[65] Towards the end of the century, increasingly vigilant administrative measures were taken against open or ambiguous domestic relations, against concubinage, against mestizo customs. "*Metissage* (interracial unions) generally and concubinage in particular, represented the paramount danger to racial purity and cultural identity in all its forms. Through sexual contact with women of color European men 'contracted' not only disease but debased sentiments, immoral proclivities and extreme susceptibility to decivilized states."[66] In the chapters that follow, I explore how women who were ambiguously placed on the imperial divide (nurses, nannies, governesses, prostitutes and servants) served as boundary markers and mediators. Tasked with the purification and maintenance of boundaries, they were especially fetishized as dangerously ambiguous and contaminating.

The social power of the image of degeneration was twofold. First, social classes or groups were described with telling frequency as "races," "foreign groups," or "nonindigenous bodies," and could thus be cordoned off as biological and "contagious," rather than as social groups. The "residuum" were seen as irredeemable outcasts who had turned their backs on progress, not through any social failure to cope with the upheavals of industrial capitalism, but because of an organic degeneration of mind and body. Poverty and social distress were figured as biological flaws, an organic pathology in the body politic that posed a chronic threat to the riches, health and power of the "imperial race."

Second, the image fostered a sense of the legitimacy and urgency of state intervention, not only in public life but also in the most intimate domestic arrangements of metropolis and colony. After the 1860s, there was a faltering of faith in the concepts of individual progress and perfectibility.[67] If Enlightenment philosophy attempted to rewrite history in terms of the individual subject, the nineteenth century posed a number of serious challenges to history as the heroics of individual progress. Laissez-faire policies alone could not be trusted to deal with the problems of poverty or to allay fears of working class insurgence. "In such circumstances, the problem of degeneration and its concomitant, chronic poverty, would ultimately have to be resolved by the state."[68] The usefulness of the quasi-biological metaphors of "type," "species," "genus" and "race" was that they gave full expression to anxieties about class and gender insurgence without betraying the social and political nature of these distinctions. As Condorcet put it, such metaphors made "nature herself an accomplice in the crime of political inequality."[69]

DEGENERATION AND THE FAMILY TREE

> The day when, misunderstanding the inferior occu-
> pations which nature has given her, women leave the
> home and take part in our battles; on this day a social
> revolution will begin and everything that maintains the
> sacred ties of the family will disappear.
>
> —*Le Bon*

In the poetics of degeneracy we find two anxious figures of historical time, both elaborated within the metaphor of the family. One narrative tells the story of the familial progress of humanity from degenerate native child to adult white man. The other narrative presents the converse: the possibility of racial decline from white fatherhood to a primordial black degeneracy incarnated in the black mother. The scientists, medical men and biologists of the day tirelessly pondered the evidence for both, marshaling the scientific "facts" and elaborating the multifarious taxonomies of racial and sexual difference, baroque in their intricacy and flourish of detail.

Before the 1850s two narratives of the origins of the races were in play. The first and more popular account, monogenesis, described the genesis of all races from the single creative source in Adam. Drawing on the Plotinian notion of corruption as distance from the originary source, scientists saw different races as having fallen unevenly from the perfect Edenic form incarnated in Adam. Simply by dwelling in different climates, races had degenerated unequally, creating an intricately shaded hierarchy of decline. By midcentury, however, a second, competing narrative had begun to gain ground—polygenesis, according to which theory different races had sprung up in different places, in different "centers of creation."[70] In this view, certain races in certain places were seen to be originally, naturally and inevitably degenerate.[71] Freedom itself came to be defined as an unnatural zone for Africans. Woe betide the race that migrated from its place.

After 1859, however, evolutionary theory swept away the creationist rug that had supported the intense debate between monogenists and polygenists, but it satisfied both sides by presenting an even better rationale for their shared racism. The monogenists continued to construct linear hierarchies of races according to mental and moral worth; the polygenists now admitted a common ancestry in the prehistoric mists but affirmed that the races had been separate long enough to evolve major inherited differences in talent and intelligence.[72]

At this time, evolutionary theory entered an "unholy alliance" with the allure of numbers, the amassing of measurements and the science of statistics.[73] This alliance gave birth to "scientific" racism, the most authoritative attempt to place social ranking and social disability on a biological and "scientific" footing. Scientists became enthralled by the magic of measurement.

Anatomical criteria were sought for determining the relative position of races in the human series.[74] Francis Galton (1822–1911), pioneer statistician and founder of the eugenics movement, and Paul Broca, clinical surgeon and founder of the Anthropological Society of Paris (1859) inspired other scientists who followed them in the vocation of measuring racial worth off the geometry of the human body. To the earlier criterion of cranial capacity as the primary measure of racial and sexual ranking was now added a welter of new "scientific" criteria: the length and shape of the head, protrusion of the jaw, the distance between the peak of the head and brow, flatheadedness, a "snouty" profile, a long forearm (the characteristic of apes), underdeveloped calves (also apelike), a simplified and lobeless ear (considered a stigma of sexual excess notable in prostitutes), the placing of the hole at the base of the skull, the straightness of the hair, the length of the nasal cartilage, the flatness of the nose, prehensile feet, low foreheads, excessive wrinkles and facial hair. The features of the face spelled out the character of the race.

Increasingly, these stigmata were drawn on to identify and discipline atavistic "races" within the European race: prostitutes, the Irish, Jews, the unemployed, criminals and the insane. In the work of men such as Galton, Broca and the Italian physician, Cesare Lombroso, the geometry of the body mapped the psyche of the race.

What is of immediate importance here is that the welter of invented criteria for distinguishing degeneracy was finally gathered up into a dynamic, historical narrative by one dominant metaphor: the Family of Man. What had been a disorganized and inconsistent inventory of racial attributes was now drawn together into a genesis narrative that offered, above all, a figure of historical change.

Ernst Haeckel, the German zoologist, provided the most influential idea for the development of this metaphor.[75] His famous catchphrase, "ontogeny recapitulates phylogeny," captured the idea that the ancestral lineage of the human species could be read off the stages of a child's growth. Every child rehearses in organic miniature the ancestral progress of the race. The theory of recapitulation thus depicted the child as a type of social bonsai, a miniature family tree. As Gould put it, every individual as it grows to maturity "climbs its own family tree."[76] The irresistible value of the idea of recapitulation was that it offered an apparently absolute biological criterion not only for racial but also for sexual and class ranking. If the white male child was an atavistic throwback to a more primitive adult ancestor, he could be scientifically compared with other living races and groups to rank their level of evolutionary inferiority. A vital analogy had thus appeared:

> The adults of inferior groups must be like the children of superior groups, for the child represents a primitive adult ancestor. If adult blacks and women are like white male children, then they are living

representatives of an ancestral stage in the evolution of white males. An anatomical theory for ranking races — based on entire bodies — had been found.[77]

Haggard summed up the analogy: "In all essentials the savage and the child of civilization are identical." Mayhew, likewise, described the London street-seller as an atavistic regression, a racial "child," who would "without training, go back to its parent stock — the vagabond savage."[78] G. A. Henty, like Haggard a popular and influential author of boy's stories, argued similarly: "The intelligence of an average negro is about equal to that of a European child of ten years old."[79] Thus the family metaphor and the idea of recapitulation entered popular culture, children's literature, travel writing and racial "science" with pervasive force.

The scope of the discourse was enormous. A host of "inferior" groups could now be mapped, measured and ranked against the "universal standard" of the white male child — within the organic embrace of the family metaphor and the Enlightenment regime of "rational" measurement as an optics of truth. In sum, a three-dimensional map of social difference had emerged, in which minute shadings of racial, class and gender hierarchy could be putatively measured across space: the measurable space of the empirical body [Fig. 1.9].

FIGURE 1.9 RACIAL MEASUREMENT AS AN OPTICS OF TRUTH.
Nast's cartoon in *Harper's Weekly* (9 December 1876)
stages an analogy between the racial and political
weight of a freed slave and an Irishman.

> He was a young Irishman . . . he had the silent enduring
> beauty of a carved ivory mask . . . that momentary but
> revealed immobility . . . a timelessness . . . which negroes
> express sometimes without ever aiming at it; something
> old, old, old and acquiescent in the race!
>
> —*D. H. Lawrence*

In the last decades of the nineteenth century, the term "race" was used in shifting and unstable ways, sometimes as synonymous with "species," sometimes with "culture," sometimes with "nation," sometimes to denote biological ethnicity or sub-groups within national groupings: the English "race" compared, say, with the "Irish" race. A small but dedicated group of doctors, antiquarians, clergymen, historians and geologists set out to uncover the minute shadings of difference that distinguished the "races" of Britain. Dr John Beddoe, founding member of the Ethnological Society, devoted thirty years of his life to measuring what he called the "Index of Nigrescence" (the amount of residual melanin in the skin, hair and eyes) in the peoples of Britain and Ireland and concluded that the index rose sharply from east to west and south to north.[80]

In 1880, Gustave de Molinari (1819–1912) wrote that England's largest newspapers "allow no occasion to escape them of treating the Irish as an inferior race—as a kind of white negroes [sic]."[81] Molinari's phrase "white negroes" appeared in translation in a leader in *The Times* and was consistent with the popular assumption after the 1860s that certain physical and cultural features of the Irish marked them as a race of "Celtic Calibans" quite distinct from the Anglo-Saxons. As a visitor to Ireland commented: "Shoes and stockings are seldom worn by these beings who seem to form a different race from the rest of mankind."[82]

But Ireland presented a telling dilemma for pseudo-Darwinian imperial discourse. As Britain's first and oldest colony, Ireland's geographic proximity to Britain, as David Lloyd points out, resulted in its "undergoing the transition to hegemonic colonialism far earlier than any other colony."[83] But, as Claire Wills notes, the difficulty of placing the pale-skinned Irish in the hierarchy of empire was "compounded by the absence of the visual marker of skin colour difference which was used to legitimate domination in other colonized societies."[84] The English stereotype of the Irish as a simianized and degenerate race also complicates postcolonial theories that skin color (what Gayatri Spivak usefully calls "chromatism") is the crucial sign of otherness. Chromatism, Wills notes, is a difference "which naturally does not apply to the relationship between the Irish and their English colonizers."[85]

Certainly, great efforts were made to liken the Irish physiognomy to those of apes but, Wills argues, English racism concentrated primarily on the "barbarism" of the Irish accent.[86]

I suggest, however, that English racism also drew deeply on the notion of the *domestic* barbarism of the Irish as a marker of racial difference. In an exemplary image, an Irishman is depicted lazing in front of his hovel—the very picture of domestic disarray [Fig. 1.10]. The house is out of kilter, the shutter is askew. He lounges cheerily on an upturned wash-basin, visible proof of a slovenly lack of dedication to domestic order. What appears to be a cooking pot perches on his head. In the doorway, the boundary between private and public, his wife displays an equally cheerful slothfulness. In both husband and wife, the absence of skin color as a marker of degeneration is compensated for by the simianizing of their physiognomies: exaggerated lips, receding foreheads, unkempt hair and so on. In the chapters that follow, I suggest that the iconography of *domestic degeneracy* was widely used to mediate the manifold contradictions in imperial hierarchy—not only with respect to the Irish but also to the other "white negroes": Jews, prostitutes, the working-class, domestic workers, and so on, where skin color as a marker of power was imprecise and inadequate.

FIGURE 1.10 "CELTIC CALIBANS."
Puck, Vol. 10, #258, 15 Feb 1882,
p. 378. The title of Frederick B. Opper's
cartoon "The King of A Shantee" suggests
an analogy between the Irish and Africans.

FIGURE 1.11 FEMINIZING AFRICAN MEN.

Racial stigmata were systematically, if often contradictorily, drawn on to elaborate minute shadings of difference in which social hierarchies of race, class and gender overlapped each other in a three-dimensional graph of comparison. The rhetoric of race was used to invent distinctions between what we would now call *classes*.[87] T. H. Huxley compared the East London poor with the Polynesian savage, William Booth chose the African pygmy, and William Barry thought that the slums resembled nothing so much as a slave ship.[88]

White women were seen as an inherently degenerate "race," akin in physiognomy to black people and apes. Gustave le Bon, author of the influential study of crowd behavior *La Psychologie des Foules*, compared female brain size with that of the gorilla and evoked this comparison as signaling a lapse in development:

> All psychologists who have studied the intelligence of women, as well as poets and novelists, recognize today that they represent the most inferior forms of human evolution and that they are closer to children and savages than to an adult, civilized man.[89]

At the same time, the rhetoric of *gender* was used to make increasingly refined distinctions among the different *races*. The white race was figured as the male of the species and the black race as the female.[90] Similarly, the rhetoric of *class* was used to inscribe minute and subtle distinctions between other *races*. The Zulu male was regarded as the "gentleman" of the black race, but was seen to display features typical of females of the white race [Fig. 1.11]. Carl Vogt, for example, the preeminent German analyst of race in the midcentury, saw similarities between the skulls of white male infants and those of the white female working class, while noticing that a mature black male shared his "pendulous belly" with a white woman who had had many children.[91] On occasion, Australian aborigines, or alternatively Ethiopians, were regarded as the most debased "lower class" of the African races, but more often than not the female Khoisan (derogatorily known as "Hottentots" or "Bushmen") were located at the very nadir of human degeneration, just before the species left off its human form and turned bestial [Fig. 1.12].[92]

In cameo, then, the English middle-class male was placed at the pinnacle of evolutionary hierarchy (generally, the middle- or upper-middle-class male was regarded as racially superior to the degenerate aristocrat who had

ZULU WOMAN RETURNING FROM WORK IN THE FIELDS.

FIGURE 1.12 MILITANT WOMAN
AS DEGENERATE.

FIGURE 1.13 WORKING WOMAN
AS DEGENERATE.

lapsed from supremacy). White English middle-class women followed. Irish or Jewish men were represented as the most inherently degenerate "female races" within the white male gender, approaching the state of apes.[93] Irish working-class women were depicted as lagging even farther behind in the lower depths of the white race.

Domestic workers, female miners and working-class prostitutes (women who worked publicly and visibly for money) were stationed on the threshold between the white and black races, figured as having fallen farthest from the perfect type of the white male and sharing many atavistic features with "advanced" black men [Fig. 1.13]. Prostitutes—as the metropolitan analogue of African promiscuity—were marked as especially atavistic and regressive. Inhabiting, as they did, the threshold of marriage and market, private and public, prostitutes flagrantly demanded money for services middle-class men expected for free.[94] Prostitutes visibly transgressed the middle-class boundary between private and public, paid work and unpaid work, and in consequence were figured as "white Negroes" inhabiting anachronistic space, their 'racial' atavism anatomically marked by regressive signs: "Darwin's ear," exaggerated posteriors, unruly hair and other sundry "primitive" stigmata.[95]

At this time, the idea of the Family of Man was itself confirmed through ubiquitous metaphoric analogies with science and biology. Bolstered by pseudo-scientific racism after the 1850s and commodity racism after the 1880s, the monogamous patriarchal family, headed by a single, white father, was vaunted as a biological fact, natural, inevitable and right, its lineage imprinted immemorially in the blood of the species—during the same era, one might add, when the social functions of the family household were being replaced by the bureaucratic state.

A triangulated, switchboard analogy thus emerged between racial, class and gender deviance as a critical element in the formation of the modern, imperial imagination. In the symbolic triangle of deviant money, deviant sexuality and deviant race, the so-called degenerate classes were metaphorically bound in a regime of surveillance, collectively figured by images of sexual pathology and racial aberration as atavistic throwbacks to a primitive moment in human prehistory, surviving ominously in the heart of the modern, imperial metropolis. Depicted as transgressing the natural distributions of money, sexual power and property and as thereby fatally threatening the fiscal and libidinal economy of the imperial state, these groups became subject to increasingly vigilant and violent state control.

IMPERIALISM AS COMMODITY SPECTACLE

In 1851, the topoi of progress and the Family of Man, panoptical time and anachronistic space found their architectural embodiment in the World Exhibition at the Crystal Palace in London's Hyde Park. At the Exhibition,

the progress narrative began to be consumed as mass spectacle. The Exhibition gathered under one vaulting glass roof a monumental display of "the Industry of All Nations." Covering fourteen acres of park, it featured exhibitions and artifacts from thirty-two invited members of the "family of Nations." Crammed with industrial commodities, decorative merchandise, ornamental gardens, machinery, musical instruments and industrial ore and thronged by thousands of marveling spectators, the Great Exhibition became a monument not only to a new form of mass consumption but also to a new form of commodity spectacle.

The Crystal Palace housed the first consumer dreams of a unified world time. As a monument to industrial progress, the Great Exhibition embodied the hope that all the world's cultures could be gathered under one roof—the global progress of history represented as the commodity progress of the Family of Man. At the same time, the Exhibition heralded a new mode of marketing history: the mass consumption of time as a commodity spectacle. Walking about the Exhibition, the spectator (admitted into the museum of modernity through the payment of cash) consumed history as a commodity. The dioramas and panoramas (popular, naturalistic replicas of scenes from

FIGURE 1.14 GLOBAL PROGRESS CONSUMED AT A GLANCE.

empire and natural history) offered the illusion of marshaling all the globe's cultures into a single, visual pedigree of world time. In an exemplary image, the Great Exhibition literally drew the world's people toward the monumental display of the commodity: global progress consumed visually in a single image [Fig 1.14]. Time became global, a progressive accumulation of panoramas and scenes arranged, ordered and catalogued according to the logic of imperial capital. At the same time, it was clearly implicit, only the west had the technical skill and innovative spirit to render the historical pedigree of the Family of Man in such perfect, technical form.

The Exhibition had its political equivalent in the Panopticon, or Inspection House. In 1787, Jeremy Bentham proposed the Panopticon as the model for an architectural solution to social discipline. The organizing principle of the Panopticon was simple. Factories, prisons, workhouses and schools would be constructed with an observation tower as the center. Unable to see inside the inspection tower, the inhabitants would presume they were under perpetual surveillance. Daily routine would be conducted in a state of permanent visibility. The elegance of the idea was the principle of self-surveillance; its economy lay, supposedly, in its elimination of the need for violence. The inmates, thinking they were under constant observation, would police themselves. The Panopticon thus embodied the bureaucratic principle of dispersed, hegemonic power. In the Inspection House, the regime of the spectacle (inspection, observation, sight) merged with the regime of power.

As Foucault observed, the crucial point of the Panopticon is that anyone, in theory, can operate the Inspection House. The inspectors are infinitely interchangeable and any member of the public may visit the Inspection House to inspect how affairs are run. As Foucault notes: "This Panopticon, subtly arranged so that an observer may observe, at a glance, so many individuals, also enables everyone to come and observe any of the observers. The seeing machine . . . has become a transparent building in which the exercise of power may be supervised by society as a whole."

The innovation of the Crystal Palace, that exemplary glass inspection house, lay in its ability to merge the pleasure principle with the discipline of the spectacle. In the glass seeing-machine, thousands of civic inspectors could observe the observers: a voyeuristic discipline perfectly embodied in the popular feature of the panorama. Seated about the circular observation-tower of the panorama, spectators consumed the moving views that swept before them, indulging the illusion of traveling at speed through the world. The panorama inverted the panoptical principle and put it at the disposal of consumer pleasure, converting panoptical surveillance into commodity spectacle—the consumption of the globe by voyeurs. Yet, all the while caught in the enchantment of surveillance, these imperial monarchs-of-all-they-survey offered their immobile backs to the observation of others.[96]

The Crystal Palace converted panoptical surveillance into consumer pleasure. As Susan Buck-Morss points out: "The message of the world exhibitions was the promise of social progress for the masses without revolution."[97] The Great Exhibition was a museum without history, a market without labor, a factory without workers. In the industrial booths, technology was staged as if giving birth effortlessly, ready-made, to the vast emporium of the world's merchandise.

At the same time, in the social laboratory of the Exhibition, a crucial political principle took shape: the idea of democracy as the voyeuristic consumption of commodity spectacle. Most crucially, an emerging national narrative began to include the working class into the Progress narrative as consumers of national spectacle. Implicit in the Exhibition was the new experience of *imperial* progress consumed as a *national* spectacle [Fig 1.15]. At the Exhibition, white British workers could feel included in the imperial nation, the voyeuristic spectacle of racial "superiority" compensating them for their class subordination [Fig. 1.16].[98]

During what Luke Gibbons calls "the twilight of colonialism," a child's toy was manufactured for the "Big Houses" of the Irish ascendancy, which promised to give the "British Empire at a Glance."[99] Gibbons describes the

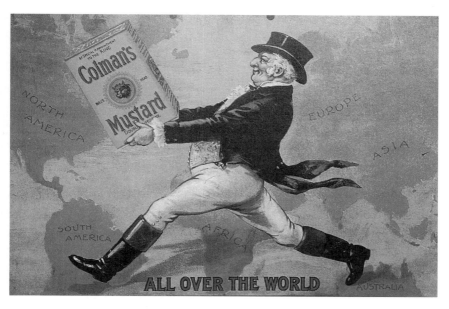

FIGURE 1.15 COMMODITY FETISHISM GOES GLOBAL.

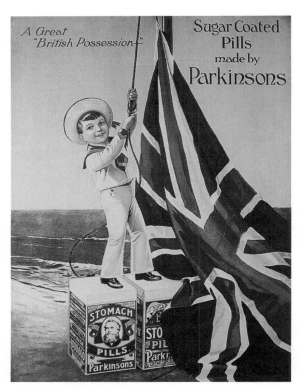

FIGURE 1.16. SUGAR-COATING IMPERIALISM.

toy thus: "It took the form of a map of the world, mounted on a wheel complete with small apertures which revealed all that was worth knowing about the most distant corners of the Empire. One of the apertures gave a breakdown of each colony in terms of its "white" and "native" population, as if both categories were mutually exclusive."[100] This toy-world perfectly embodies the scopic megalomania that animates the panoptical desire to consume the world whole. It also embodies its failure, for, as Gibbons adds: "When it came to Ireland, the wheel ground to a halt for here was a colony whose subject population was both "native" and "white" at the same time. This was a corner of the Empire, apparently, that could not be taken in at a glance."[101] The toy-world marks a transition— from the imperial science of the surface to commodity racism and imperial kitsch. Imperial kitsch and commodity spec-

tacle made possible what the colonial map could only promise: the mass marketing of imperialism as a global system of signs [Fig. 1.17].

COLONIAL MIMICRY AND AMBIVALENCE

I write, then, in the conviction that history is not shaped around a single privileged social category. Race and class difference cannot, I believe, be understood as sequentially derivative of sexual difference, or vice versa. Rather, the formative categories of imperial modernity are articulated categories in the sense that they come into being in historical relation to each other and emerge only in dynamic, shifting and intimate interdependence. The idea of racial "purity," for example, depends on the rigorous policing of women's sexuality; as an historical notion, then, racial "purity" is inextricably implicated in the dynamics of gender and cannot be understood without a theory of gender power. However, I do not see race, class, gender and sexuality as structurally equivalent of each other. The Victorian fetishizing of soap and white clothes, say, cannot be reduced to phallic fetishism as a secondary effect along a signifying chain that progresses from sexuality to race. Rather, these categories converge, merge

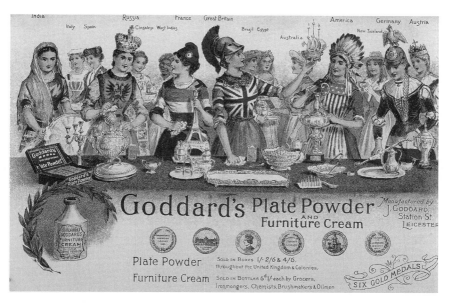

FIGURE 1.17 THE EMPIRE OF FETISHES.

and overdetermine each other in intricate and often contradictory ways. In an important essay, Kobena Mercer cautions us against invoking the mantra of "race, class and gender" in such a way as to "flatten out the complex and indeterminate relations by which subjectivity is constituted in the overdetermined spaces *between* relations of race, gender, ethnicity, and sexuality."[102] Mercer urges us to be alert to the shifting and unsteady antinomies of social difference "in a way that speaks to the messy, ambivalent, and incomplete character of the 'identities' we actually inhabit in our lived experiences."[103]

Consider, in this regard, Irigaray's idea of gender mimicry and Homi Bhabha's idea of colonial ambivalence. In her brilliant and incendiary challenge to orthodox psychoanalysis, Luce Irigaray suggests that in certain social contexts women perform femininity as a necessary masquerade.[104] For Irigaray, women learn to mimic femininity as a social mask. In a world colonized by male desire, women stage heterosexuality as an ironic performance that is no less theatrical for being a strategy for survival. At certain moments, Irigaray suggests, women must deliberately assume the feminine roles imposed on us, but we can do so in such a way as to "convert a form of subordination into an affirmation."[105] By the "playful repetition" of the invisible norms that sustain heterosexuality, women artfully disclose the lack of equivalence between "nature" and gender performance. We are "such good mimics" precisely because femininity does *not* come naturally.[106] Nonetheless, mimicry exacts a price; born of necessity, it is double-edged and double-tongued, a provisional strategy against oblivion. In Irigaray's own theory, however, the idea of mimicry also exacts a price, for Irigaray herself runs the risk of privileging mimicry as an essentially female strategy and thus paradoxically reinscribes precisely those gender binaries that she so brilliantly challenges. In the process, Irigaray also elides the theatrical and strategic possibilities of *male* masquerade: camp, voguing, drag, passing, transvestism and so on.

Bypassing Irigaray's gendered intervention, Homi Bhabha takes the idea of mimicry into the colonial arena and in turn subtly explores mimicry as "one of the most elusive and effective strategies of colonial power and knowledge."[107] In Bhabha's schema, mimicry is a flawed identity imposed on colonized people who are obliged to mirror back an image of the colonials but in imperfect form: "almost the same, but not white."[108] Subjected to the civilizing mission, the mimic men (for Bhabha they seem to be only men) serve as the intermediaries of empire; they are the colonized teachers, soldiers, bureaucrats and cultural interpreters whom Fanon describes as "dusted over with colonial culture."[109] The lineage of these mimics—Anglicized men who are not English—can be traced through the writings of Macaulay, Kipling, Forster, Orwell and Naipaul, and comprise,

in Macaulay's words, "a class of interpreters between us and the millions whom we govern."[110]

Bhabha's originality lies in his provocative deployment of aesthetic categories (irony, mimesis, parody) for psychoanalytic purposes in the context of empire. For Bhabha, colonial discourse is ambivalent in that it seeks to reproduce the image of a "reformed, recognizable Other . . . *that is almost the same but not quite*."[111] The mimic men are obliged to inhabit an uninhabitable zone of ambivalence that grants them neither identity nor difference; they must mimic an image that they cannot fully assume. Herein lies the failure of mimicry as Bhabha sees it, for in the slippage between identity and difference the "normalizing" authority of colonial discourse is thrown into question. The dream of post-Enlightenment civility is alienated from itself because in the colonial state it can no longer parade as a state of nature. Mimicry becomes "at once resemblance and menace."[112]

I do not question the rich insightfulness of Bhabha's notion of colonial mimicry, nor his valuable insistence, following Fanon, on the elusive play of fantasy, desire and the unconscious in colonial contests. What interests me for the moment, however, is the politics of agency implicit in the mimetic schema. As Bhabha sees it, in this essay at least, the menace of mimicry stems from its ambivalence—an epistemological splitting that discloses the double vision of colonial discourse and thereby disrupts its authority.[113] Colonialism is flawed by a self-defeating and *internal* subversion: the formal subversion, the "rupture," the "disruption," the "ambivalence," the "in-between" of discourse. Seen in this way, colonial mimicry is an "ironic compromise" that ensures its own "strategic failure."[114]

The "strategic failure" of "colonial appropriation" becomes in this view a structural effect ensured by discursive ambivalence. "How," asks Bhabha, "is desire disciplined, authority displaced?" This is fundamentally a question about power; it is also a question about historical agency. Contrary to some critics, I do not believe that Bhabha means to suggest that mimicry is either the only, or the most important, colonial phenomenon, just as Irigaray does not suggest that mimicry is the only strategy available to women. Nonetheless, for Bhabha here colonial authority appears to be displaced less by shifting social contradictions or the militant strategies of the colonized than by the formal ambivalence of colonial representation itself.

While recognizing the vital importance of the concept of ambivalence in both Irigaray and Bhabha (crucial as it is to the tradition of dialectical thinking), the question is whether it is sufficient to locate agency in the internal fissures of discourse.[115] Locating agency in ambivalence runs the risk of what can be called a fetishism of form: the projection of historical agency onto formal abstractions that are anthropomorphized and given a life of their

own. Here abstractions become historical actors; discourse desires, dreams and does the work of colonialism while also ensuring its demise. In the process, social relations between humans appear to metamorphize into structural relations between forms—through a formalist fetishism that effectively elides the messier questions of historical change and social activism.

An important question raised by both Irigaray and Bhabha's work, though in different ways, is whether ambivalence is inherently subversive. In a subsequent essay, Bhabha usefully complicates his idea of mimicry and suggests that the ambivalences of colonized subjectivity need not pose a threat to colonial power after all: "caught in the Imaginary as they are, these shifting positionalities will never seriously threaten the dominant power relations, for they exist to exercise them pleasurably and productively."[116] Bhabha here sees dominant power as shielded from the play of ambivalence, but not because of the greater military, political or economic strength of those in power. Rather, the "shifting positionalities" of colonized subjectivity are "caught in the 'Imaginary.'" Once again, however, agency is displaced onto a structural abstraction (the Imaginary) that guarantees a fluctuating, indeterminate condition of stasis.

In another essay, "Signs Taken for Wonders," Bhabha further develops the idea of mimicry, this time less as a self-defeating colonial strategy than as a form of anti-colonial refusal. Mimicry now "marks those moments of civil disobedience within the discipline of civility: signs of spectacular resistance."[117] This offers the important promise of a theory of resistance and, at the same time, new areas for historical elaboration. This also brings Bhabha closer to Irigaray, for whom mimicry is seen as a strategy of the disempowered. But if mimicry always betrays a slippage between identity and difference, doesn't one need to elaborate how colonial mimicry differs from anti-colonial mimicry; if colonial and anti-colonial mimicry are formally identical in their founding ambivalence, why did colonial mimicry succeed for so long? Indeed, if all discourses are ambivalent, what distinguishes the discourse of the empowered from the discourse of the disempowered? Between colonial and anti-colonial, and male and female, mimicry there falls a theoretical shadow.

If Irigaray challenges Lacan's masculinism and argues for mimicry as a specifically female strategy (an essentialist gesture that elides race and class), Bhabha, in turn, bypasses Irigaray and refers only to race, eliding in the process gender and class. Returning to an ungendered mimicry, Bhabha effectively reinscribes mimicry as a male strategy without acknowledging its gendered specificity. The ironically generic "Man" in Bhabha's title ("Of Mimicry and Man") both conceals and reveals that Bhabha is really only talking about men. By eliding gender difference, however, Bhabha implicitly ratifies gender power, so that masculinity becomes the

invisible norm of postcolonial discourse. By eliding racial difference, Irigaray, in turn, ratifies the invisibility of imperial power.

The more one insists on the transhistorical ubiquity of ambivalence, the less powerful a concept it becomes. In the compulsion to repeat, the everywhere of the ambivalent becomes the scene of the same. If ambivalence is everywhere, at what point does it become subversive? Above all, how does one explain how dominant powers become dominant in the first place? In order to answer these questions, doesn't one need a more demanding engagement with social and economic power than a deconstruction of the ruptures of form? Let me emphasize, however, that I pose these questions not in order to dispense with the notion of ambivalence—far from it—but instead to historically complicate it. As Gayatri Spivak puts it best: "the most serious critique in deconstruction, is the critique of something useful."

HYBRIDITY, CROSS-DRESSING AND RACIAL FETISHISM

In the chapters that follow, I argue that concepts such as mimicry and ambivalence are less powerful if reduced to a single, privileged social category (whether gender, as in Irigaray, or race, as in Bhabha). Racial mimicry may be akin to gender mimicry in important ways, but they are not socially interchangeable. Indeed, mimicry as a term requires considerable elaboration.

Different forms of mimicry such as passing and cross-dressing deploy ambiguity in different ways; critical distinctions are lost if these historically variant cultural practices are collapsed under the ahistorical sign of the same. Racial passing is not the same as gender cross-dressing; black voguing is not the same as whites performing in blackface; black minstrelsy is not the same as lesbian drag. In the fetish scene, transvestism often involves the flagrant *exhibition* of ambiguity (the hairy knee under the silk skirt); indeed, much of the scandal of transvestism resides in its theatrical parading of *identity as difference*. Passing, by contrast, more often involves the careful *masking* of ambiguity: *difference as identity*.

In the context of colonialism, the global changes wrought by imperialism reveal that colonials were able, all too often, to contain the ambivalences of the civilizing mission with appalling effect. In Conrad's *Heart of Darkness*, for instance, Marlow is attended upstream by an African who serves as a vivid example of a hybrid mimic man. The African who works the ship's boiler inhabits that impossible threshold between colonizer and colonized; Marlow represents him as an historical anomaly: "the savage who was fireman."[118] An initiate into modernity, he is also a belated denizen of the anachronistic time of witchcraft, fetish and charm. In Marlow's eyes,

this "improved specimen" is "as edifying as . . . a dog in a parody of breeches and a feather hat, walking on his hindlegs."[119] In Bhabha's term, he is mimicry's "ironic compromise"; the same, but not white.

But Conrad's mimic man is less disruptive of colonial authority than he might at first appear, since his parodic imperfection is consistent with the colonial narrative of African degeneration. Pushing upstream, the colonials are figured as traveling backward into anachronistic space: "Going up that river was like travelling back to the earliest beginnings of the world. . . .We were wanderers on prehistoric earth. . . . We were travelling in the night of first ages, of those ages that are gone."[120] Within the trope of anachronistic space, the boilerman's mimetic failure is less a discursive dilemma than a familiar element of the colonial progress narrative. Inhabiting the cusp of prehistory and imperial modernity, the "improved specimen" is seen as the living measure of how far Africans must still travel to attain modernity. In other words, the slippage between difference and identity is rendered non-contradictory by being projected onto the axis of *time* as a natural function of imperial progress.

In effect, Conrad's mimic man does not fatally disrupt the post-Enlightenment image of man nor ensure its strategic failure; his mimetic incoherence is, rather, indispensible to the narrative of the historical belatedness of the colonized. What is more, his ambivalence is violently foreclosed by his death, a narrative obliteration that offers a sobering reminder that colonials were both willing and able to foreclose the poetics of ambivalence by resorting to the technologies of violence.

The opening page of Rudyard Kipling's *Kim* is another case in point. We enter Kipling's narrative flanked by the colonial museum and the colonial gun. The mimic man, Kim, having just unseated an Indian boy, sits aloft the "fire-breathing" cannon, Zam-Zammah; opposite Kim is the Lahore Museum. Kim's phallic potency is also a question of racial legitimacy: for Kipling, Kim has "some justification" in usurping the Indian boy "since the English held the Punjab and Kim was English."[121] In this inaugural scene, colonialism is figured both as a poetics of cultural ambivalence (embodied in the fetish Wonder House of the European museum) but also a politics of military violence: "Who hold Zam-Zammah . . . hold the Punjab." Controlling both gun and wonder-house, Kipling suggests, is necessary for mastery of the Great Game.

Taking the question of historical agency seriously ("How . . . is authority displaced?") entails interrogating more than the ambivalences of form; it also entails interrogating the messy imprecisions of history, the embattled negotiations and strategies of the disempowered, the militarization of masculinity, the elision of women from political and economic power, the decisive foreclosures of ethnic violence and so on.

Ambivalence may well be a critical aspect of subversion, but it is not a sufficient agent of colonial failure.

Cross-dressing, as a culturally variant example of mimicry, is a case in point. Clothes are the visible signs of social identity but are also permanently subject to disarrangement and symbolic theft. For this reason the cross-dresser can be invested with potent and subversive powers. In her groundbreaking book, *Vested Interests*, Marjorie Garber refuses the traditional narrative of the transvestite as biologically aberrant or pathological and invites us instead to take cross-dressers on their own terms—as the transgressive embodiment of ambiguity.[122]

Garber brilliantly challenges the progress narrative that presumes a "real" identity (male or female) under the transvestite mask. She proposes instead that the transvestite throws into question the binary categories of "male" and "female" and becomes as a result the "figure that disrupts."[123] Garber's book is of great importance, not least for her attempt to include questions of race in the cross-dressing scene. Nonetheless, as I argue in more detail in Chapters 3 and 5, by universalizing all cross-dressers as transgressive ("the figure that disrupts") and by inscribing all fetishes as originating in the Lacanian castration scene ("the phallus is the fetish, the fetish is the phallus") Garber does not do theoretical justice to the rich diversity of cultural cross-dressers and historical fetishes that she herself reveals.[124]

Reducing all fetishes and all cross-dressers to a single genesis narrative founded in phallic ambiguity prevents one from accounting for the differences among subversive, reactionary or progressive fetish practices. The pink triangle, for example, is an ambivalent sign that has been deployed by radically alternative political practices. Cross-dressing can likewise be mobilized for a variety of political purposes, not all of them subversive. That fetishism is founded in contradiction does not necessarily guarantee its transgressiveness; that cross-dressing disrupts stable social identities does not guarantee the subversion of gender, race or class power. When marines in the United States army deck themselves in drag or put on blackface, white power is not necessarily subverted nor is masculinity thrown into disarray. If, by contrast, lesbians in the army cross-dressed on a daily basis or gay black men staged nightly voguing houses, the effect might not be seen as quite so hilarious or innocent.

Culturally enforced ethnic passing (Jewish or Irish immigrants assimilating in the United States, say) or brutally enforced hybridity (the deliberate impregnation of Muslim women by rape in Bosnia-Herzegovina) entail very different relations to hybridity and ambiguity. The slippage between difference and identity is present in all these cases, but the psychic toll and political consequences vary dramatically. The lyrical glamour cast

by some postcolonial theorists over ambivalence and hybridity is not always historically warranted.

It is important to emphasize, in this regard, that cross-dressing does not only involve gender ambiguity; a wealth of evidence exists of racial, class and ethnic cross-dressing. Reducing all fetishes and all cross-dressers to a single genesis narrative founded in phallic ambiguity prevents one from adequately accounting for racial, national and ethnic fetishes that cannot be subsumed under the phallic sign of sexual difference without considerable loss of theoretical subtlety and historical depth. In Lacanian theory (which I question in Chapter 4), linguistic and cultural difference is founded in sexual difference, and is ordered under the Symbolic and embodied in the Law of the Father. As a result, racial and class difference become theoretically derivative of sexual difference along a signifying chain that privileges male heterosexuality. Garber, for one, reads the fetish as "a figure for the undecidability of castration."[125] As I argue in more detail in Chapter 3, she thereby risks reducing racial transvestism to a secondary function of sexual ambiguity, as when she notes "the paradox of the black man in America as simultaneously a sign of sexual potency and a sign of emasculation or castration."[126] Here black women vanish — necessarily, perhaps, since their role in white fetishism and in their own forms of fetishism (barred in any case from the Lacanian scene) cannot be accounted for under the phallic sign of castration.

While cross-dressing, drag, passing, camp and voguing are all, generally speaking, forms of mimicry, they also tend to enact very different cultural possibilities. These differences are lost if they are obediently marshaled under the transhistorical sign of phallic ambivalence. What Lacanians call the transcendent "phallic signifier" does not, in my view, enjoy a privileged or governing status over what Stuart Hall usefully distinguishes as the "ethnic signifier."[127] Challenging the white phallocracy of the Lacanian castration scene allows one to elaborate a more culturally nuanced and historically empowering genealogy of such phenomena than is currently allowed in the heterosexual progress narrative.

The disruption of social norms is not always subversive, especially in postmodernist commodity cultures where formal fluidity, fragmentation and marketing through difference are central elements. Indeed, privileged groups can, on occasion, display their privilege precisely by the extravagant display of their *right to ambiguity*. When the English football star, Paul Gascoigne, returned triumphant from the World Cup, he paraded the streets in plastic women's breasts, as if his excess of heterosexual prowess on the football field licensed his privileged display of gender ambiguity. In the Monty Python television series, men ritually cross-dress as women (very often across class boundaries), but women seldom appear on the show, let

alone as men. People of color are singularly absent. In this way, the show's irreverent disruption of social norms effectively affirms a privileged white male heterosexuality. In short, the staging of symbolic disorder by the privileged can merely preempt challenges by those who do not possess the power to stage ambiguity with comparable license or authority.

COLONIAL PASSING

Rudyard Kipling's *Kim* offers a rich example of mimicry and cross-dressing as a technique not of colonial subversion, but of surveillance. In many respects, Kipling's tale can be read as a narrative of racial passing. Kim's origins are in almost every sense ambivalent, for he perfectly embodies the colonial crisis of origins. Orphaned son of an English nursemaid and an Irish sergeant, he is raised in the teeming bazaars of Lahore by a "half-caste woman" who keeps him out of the hands of the missionaries by herself passing as white. Kim, by contrast, spends much of his time passing as Indian. "Burned as black as any native," speaking "the vernacular by preference" (7), sleeping and squatting "as only the natives can" (137), able to "lie like an Oriental" (36) and drinking water "native fashion" (25), Kim passes for "native" in a way that no Indian in the book is able to pass for white. On the cusp of cultures, denizen of the threshold zones of bazaar, street, rooftop and road, Kim is both cultural hybrid and racial mimic man.

One reason, of course, why he can pass so successfully is that he is half-Irish, which, in colonial discourse, places him racially closer to the Indians than if he had been wholly English. Kim's racial ambiguity is enhanced by his talent for cross-dressing; he finds it "easier to slip into Hindu or Muhammedan garb when engaged on certain business" (10). More precisely, Kim is a switcher. Throughout the narrative, he switches effortlessly from "a complete suit of Hindu kit" (10), to the clothes and identity of a white sahib, back to "the likeness of a low-caste Hindu boy — perfect in every detail" (171), then back to sahib, "he would be a sahib again for a while" (142). Then again "it needs only to change his clothing, and in a twinkling he would be a low-caste Hindu boy" (147). Kim's talent for racial transvestism lets him dive easily "into the happy Asiatic disorder," playing and plotting the colonial game unnoticed (89). With the aid of the kindly prostitute, "a little dye-stuff and three yards of cloth," Kim the mimic man joins the Great Game as a colonial spy, turning the British/Russian competition for control of India into a "stupendous lark" (114).

As a cultural hybrid, Kim is what Kipling called a "two-sided man" (176). But here mimicry is neither a flawed identity imposed on the colonized, nor is it a strategy of anti-colonial resistance. The transvestite Kim blurs the distinction between colonizer and colonized but only in order

to suggest a reformed colonial control. The urchin mimic man embodies symbolic ambiguity and ethnic hybridity, but employs his ambiguity not to subvert colonial authority but to enhance it. He is the Indianized sahib: Indian but not quite.

Kim's passing is the privilege of whiteness. As an Anglo-Irish transvestite, he embodies contradictory notions of racial identity: white or black? colonizer or colonized? His passing and cross-dressing raises serious "speculation as to what is called personal identity" (247). Nevertheless, his "white blood" and Irish wits assert themselves at critical moments; race, it seems, runs deeper than skin or clothes alone. "Where a native would have laid down, Kim's white blood set him on his feet" (65). The babu, by contrast, is a risible mimic-man, derided by the Russians as embodying "the monstrous hybridism of East and West" (318). Like Conrad's "improved specimen," the babu is mimicry gone wrong: "Never was so unfortunate a product of English rule in India more unhappily thrust upon aliens" (316). He is Bhabha's Anglicized man who is not English; Kim, on the other hand, is the Indianized man who is not Indian. Evidently, passing "down" the cultural hierarchy is permissible; passing "up" is not.

Kim's "white blood" allows him to contain the ambiguities of culture and gain a privileged universalism that puts him "beyond all castes" (262). Transcending the ethnic hurlyburly of ungovernable India, he is better fitted to rule. Kim is the other side of mimicry: the colonial who passes as Other the better to govern. In this way, the regeneration of the Anglo-Irish orphan becomes an exemplary allegory for a reformed and more discreet style of imperial control.

It should not go unnoticed that in *Kim* the privilege of passing is uniquely male. Throughout the narrative, women are figures of abjection, repudiated but indispensable. "'I had no mother, my mother,' said Kim" (367). Women serve as boundary markers and threshold figures; they facilitate the male plot and the male transformations, but they are not the agents of change, nor are they conceivable heirs to political power. Female sexuality, in this context, serves as a continual threat to male power: "How can a man follow the Way or the Great Game when he is so-always pestered by women?" frets Kim. Sexual reproduction marks a turbulence in the narrative, a site of impossible irresolution, as if Kipling simply does not know what to do with it. Nonetheless, disavowed and repudiated, it recurs as a necessary element in the containment of the ambiguities of race.

Although female sexuality is disavowed in *Kim*, it is a precariously stabilized heterosexuality that contains the instabilities of race. Toward the end of the narrative, Kim's polymorphous ethnicity threatens to spiral out of control: "Who is Kim—Kim—Kim?" (248). "... What am I? Mussulman, Hindu, Jain, or Buddhist?" (192). "... I am Kim. I am Kim. And what is Kim?"

(374). Engulfed by ethnic vertigo and unmanned by the mortifying discovery that he is a very dispensable "cog-wheel" in the Great Game, Kim reclaims his identity through a curious ritual of restored heterosexuality. Having warded off the threatening sexuality of the women in the hills, he flings himself down on the earth and enacts a displaced, incestuous merging with "Mother Earth," an ambiguous act in which sexuality is both repudiated and confirmed.

> He . . . laid him down full length. . . . And Mother Earth . . . -
> breathed through him to restore the poise he had lost lying so
> long on a cot cut off from her good currents. His head lay
> powerless upon her breast, and his opened hands surrendered
> to her strength (374).

Once more, the disavowed mother returns as the indispensible limit of male identity. This is what Julia Kristeva calls abjection.[128]

ABJECTION AND A SITUATED PSYCHOANALYSIS

Abjection (Latin, *ab-jicere*) means to expel, to cast out or away. In *Totem and Taboo* and *Civilization and its Discontents* Freud was the first to suggest that civilization is founded on the repudiation of certain pre-oedipal pleasures and incestuous attachments. Following Freud, and Mary Douglas' brilliant work on boundary rituals, Kristeva argues that a social being is constituted through the force of expulsion. In order to become social the self has to expunge certain elements that society deems impure: excrement, menstrual blood, urine, semen, tears, vomit, food, masturbation, incest and so on. For Kristeva, however, these expelled elements can never be fully obliterated; they haunt the edges of the subject's identity with the threat of disruption or even dissolution. She calls this process abjection.

The abject is everything that the subject seeks to expunge in order to become social; it is also a symptom of the failure of this ambition. As a compromise between "condemnation and yearning," abjection marks the borders of the self; at the same time, it threatens the self with perpetual danger.[129] Defying sacrosanct borders, abjection testifies to society's precarious hold over the fluid and unkempt aspects of psyche and body. "We may call it a border," she writes. "Abjection is above all ambiguity."[130]

Abjection traces the silhouette of society on the unsteady edges of the self; it simultaneously imperils social order with the force of delirium and disintegration. This is Kristeva's brilliant insight: the expelled abject haunts the subject as its inner constitutive boundary; that which is repudiated forms the self's internal limit. The abject is "something rejected from which one does not part."[131]

Imperial Leather explores, in part, the paradox of abjection as a formative aspect of modern industrial imperialism. Under imperialism, I argue, certain groups are expelled and obliged to inhabit the impossible edges of modernity: the slum, the ghetto, the garret, the brothel, the convent, the colonial bantustan and so on. Abject peoples are those whom industrial imperialism rejects but cannot do without: slaves, prostitutes, the colonized, domestic workers, the insane, the unemployed, and so on. Certain threshold zones become abject zones and are policed with vigor: the Arab Casbah, the Jewish ghetto, the Irish slum, the Victorian garret and kitchen, the squatter camp, the mental asylum, the red light district, and the bedroom. Inhabiting the cusp of domesticity and market, industry and empire, the abject returns to haunt modernity as its constitutive, inner repudiation: the rejected from which one does not part.

Abjection is richly suggestive for my purposes for it is that liminal state that hovers on the threshold of body and body politic—and thus on the boundary between psychoanalysis and material history. As I argue in Chapters 2 and 4, the disciplinary cordon sanitaire between psychoanalysis and history is itself a product of abjection. All too often, traditional Freudian psychoanalysis seeks to expunge certain elements from the family romance: the working-class nurse, female sexuality (especially the clitoris), economics and class, homosexuality, race and empire, cultural difference and so on; but these abjected elements haunt psychoanalysis as the pressure of a constitutive, inner limit. Likewise, material history, especially in its more economistic Marxist form, repudiates unruly elements such as the unconscious, sexual desire and identity, the irrational, fetishism, and so on; these elements return to structure Marxist economics as an insistent inner repudiation. Abjection shadows the no-go zone between psychoanalysis and material history, but in such a way as to throw their historical separation radically into question.

In the chapters that follow, I propose the development of a *situated psychoanalysis*—a culturally contextualized psychoanalysis that is simultaneously a psychoanalytically informed history. With respect to abjection, distinctions can be made, for example, between abject *objects* (the clitoris, domestic dirt, menstrual blood) and abject *states* (bulimia, the masturbatory imagination, hysteria), which are not the same as abject *zones* (the Israeli Occupied Territories, prisons, battered women's shelters). Socially appointed *agents* of abjection (soldiers, domestic workers, nurses) are not the same as socially abjected *groups* (prostitutes, Palestinians, lesbians). *Psychic* processes of abjection (fetishism, disavowal, the uncanny) are not the same as *political* processes of abjection (ethnic genocide, mass removals, prostitute "clean ups"). These comprise interdependent but also distinct dimensions of abjection that do not constitute the transhistorical replication

of a single, universal form (let alone the transcendent phallus), but rather emerge as interrelated if contradictory elements of an immensely intricate process of social and psychic formation.

When a white South African man disavows identification with the black nurse who raised him, the process is suggestive of—but not identical with—the forced removal of black women to the barren bantustans. Surely, the processes are enmeshed: the definition of black South African women as the "superfluous appendages" of their men, and their expulsion from the white national narrative is inextricably related to—but not identical with—masculine fears of the archaic mother. The notion of an archetypal male fear of the mother is inadequate for fully understanding the expulsion of women, for it cannot explain the historical torsions of race: why it is black and not white women who are territorially expelled. As I explore in Chapter 10, the narratives of national motherhood play themselves out very differently for black women and white women in South Africa.

The question of historical variance also raises the question of the critic's role in the scene of ambivalence. As Robert Young asks:

> What, if anything, is specific to the colonial situation if colonial texts only demonstrate the same properties that can be found in any deconstructive reading of European texts? . . . How does the equivocality of colonial discourse emerge, and when—at the time of its enunciation or with the present day historian or interpreter?[132]

If the subversive play of ambivalence is merely latent in the discourse, waiting for the critic to activate it, is the relation between postcolonial critic and colonial discourse itself a form of mimicry, miming the relation between psychoanalyst and client—the same, but not quite? If the task of postcolonial criticism is to activate the uncertainties and in-betweens of discourse, well and good, but this could remain a formalist exercise unless one also undertakes the more demanding historical task of interrogating the social practices, economic conditions and psychoanalytical dynamics that motivate and constrain human desire, action and power.

In sum, *Imperial Leather* is written with the conviction that psychoanalysis and material history are mutually necessary for a strategic engagement with unstable power. I propose the elaboration of narratives that interrogate the relations between psychoanalysis and material history without preserving on either side the shadow of their binary opposition. In exploring female and racial fetishism, cross-dressing and S/M, colonial paranoia, the erasure of domestic dirt, the invention of anachronistic space, panoptical time, and so on, I argue that psychoanalysis cannot be

imposed ahistorically on the colonial contest, if only because psycho-analysis emerged in historical relation to imperialism in the first place. Instead, I call for a mutual engagement that would comprise both a decolonizing of psychoanalysis and a psychoanalyzing of colonialism. Perhaps one can go so far as to say that there should be no material history without psychoanalysis and no psychoanalysis without a material history.

"MASSA" AND MAIDS

POWER AND DESIRE
IN THE IMPERIAL METROPOLIS

2

Tell me, Socrates, did you have a nanny?

—Plato

THE URBAN EXPLORER

On July 4, 1910, in concert with the rest of Fleet Street, the Daily Mirror trumpeted the discovery of a scandalous cross-class mésalliance:

ROMANCE OF BARRISTER'S MARRIAGE—Further Light on Remarkable Will Disclosure—Wife and Servant—Verses Upholding His Choice Against World's Criticism."[1]

FIGURE 2.1 THE ENCHANTMENT OF
GENDER AMBIGUITY.

The occasion for the titillated uproar was the "Remarkable Will Disclosure" of the late Arthur J. Munby, well-known Victorian barrister and man of letters (1828–1910). In his will Munby announced to the world that for forty-five years he had loved Hannah Cullwick, "servant born at Shifnal," and that for thirty-six of those years Cullwick had secretly been his "most dear and beloved wife and servant."[2] At Munby's behest and fearful of scandalous disclosures, his family put his private papers under lock and key for forty years. In 1950 a ceremonial opening of the deed-boxes at Trinity College finally yielded, as the Master for the Press dryly intoned: "diaries and poems by Mr. Munby and letters to him by his wife. Also photographs and studies of working women of the later Nineteenth century, in whose conditions of life Mr. Munby took a sociological interest."[3]

Yet the contents of Munby's voluminous papers—a secret diary, hundreds of pages of letters, numerous sketches and photographs of

women—reveal a compulsive infatuation with the spectacle of working women that was considerably more and considerably less than sociological. Indeed, Munby's secret papers are eloquent of an unflagging attempt to negotiate one of the deepest contradictions in the social formation of Victorian middle-class life: that peculiarly Victorian and peculiarly neurotic association between work and sexuality.

The curious life of Arthur Munby allows me to make the following argument. In the urban metropolis some of the formative ambiguities of gender and class were managed and policed by the discourses on race, so that the iconography of imperialism entered white middle- and upper-middle class identity with fundamental, if contradictory, force. Munby's strange peregrinations allow me, moreover, to explore the uncertain boundaries of gender and class, private and public, marriage and market, and in so doing, to investigate some of the formative relations among imperialism, industry and the cult of domesticity. I am particularly intrigued by the elided relations between psychoanalysis and social history, an elision most vividly embodied in the threshold figure of the Victorian nurse. Munby's life offers an exemplary parable, I suggest, for the lineaments of power and desire in the imperial metropolis.

The voyeuristic spectacle of working women was the infatuation of Munby's life. For nearly sixty years, an obscure need compelled him on long nocturnal walks through London's streets, driving him into foul-smelling sculleries and cellars, down to the dingy pits of the music halls, into hospitals and police courts, through the markets and wretched docklands—to inspect the female denizens of dirt and drudgery, the scullery maids and dustwomen, the milkwomen, prostitutes and street sellers of an industrializing Britain. Munby haunted bridges, particularly London Bridge, which held the libidinal attraction for him of being "the great thoroughfare for young working women and girls," where daily the filthy costergirls and female sackmakers, frail and delicate under immense piles of sacking, plied their trades.[4] He frequented the circuses, captivated by the half-naked female acrobats who looked for all the world like boys [Fig. 2.1]. Throughout his life he traversed thousands of miles to visit far-flung country villages, coal mines and coastal areas in search of new forms of "rough female labour" [Figs. 2.2, 2.3]. He read with avid absorption government censuses and reports on the conditions of working women and filled hundreds of pages with his encounters and discoveries. Everywhere he went, Munby accosted and importuned working women, touching them, questioning them about their work, annotating their appearances in intimate detail, sketching and photographing them as types, shadowing them through the streets and following them into their homes to bestow on them his not necessarily welcome philanthropic attentions—all the while

FIGURE 2.2 THE VOYEURISTIC SPECTACLE OF ROUGH FEMALE LABOR.

FIGURE 2.3 THE LIVING ARCHIVE OF WOMEN'S WORK.

seemingly unconscious of the social imbalances in power that gave him the freedom so to intrude upon their lives. Yet it was precisely these imbalances of social power that afforded him his compulsive and perpetually deferred pleasures. He was utterly indifferent to working men.

At the age of thirty-one, Munby voiced the peculiarly boundless and, one might add, peculiarly imperial hunger that governed his life: "If I had the means, I would investigate, being now old enough to do so without misconstruction, the moral and physical statistics of labouring women all over the world."[5] Nearly thirty years later, at the age of fifty-eight, he recorded: "For reasons of my own, I have for more than thirty years studied the subject of female labour, not merely in books and at second hand, but with my own eyes and on the spot."[6] An armature of empirical investigation and grave statistics shielded him, he believed, from "misconstruction."

Yet we might read here an alternative narrative: the unbidden story of class, gender and racial power that shaped the inherently imperial

project of Victorian empiricism. Munby's amassed photographs, sketches and diaries yield one of the major archives of working women's lives, replete with the aggressive desire for collection, rational rearrangement and voyeuristic display that marks the archive. Munby's curatorial obsessions are of considerable interest, for in them we can discern some of the lineaments of class and gender power that animated the Victorian riddle of "the subject of female labor." Indeed, one might say that the riddle of the gendered division of labor and the labored division of gender, inflamed Munby's life for the same reasons that they animated his age.

THE DOUBLE BIND
MOTHERS AND MAIDS

> My second mother, first wife,
> The angel of my infant life.
>
> —*Robert Louis Stevenson*

Munby was born in 1828 to the daughter of a well-to-do clergyman and a Yorkshire solicitor. His family thus inhabited that peculiarly liminal class position that mimicked the life-style of the landed gentry without being entitled to its privileges. Munby's father lacked land and title, but his work in the expanding industrial bureaucracy afforded him substantial comfort and security, and gave him sufficient means to employ for twenty-eight years that Victorian emblem of middle-class prosperity and social status: a nurse called Hannah Carter.

Munby's mother, by her adoring son's account, was delicate in health and prone to "weakness and hysteria"—true to that upper-class Victorian stereotype that Munby himself dubbed the "Dresden China woman."[7] Munby remembered her as "very old-fashioned": "Her fair delicate face and golden-auburn hair and dainty figure," her accomplishments in flower painting and the harp, recalled to his mind "the ladies of Miss Austen's day."[8] Yet Caroline Munby's anachronistic mimicry of the life-style of the class above her was made possible only by the contradictory presence within her family of a woman from the class below her.

For obvious and regrettable reasons, we know next to nothing about Hannah Carter. Munby kept in contact with her all his life, visiting her regularly until her death. Beyond that there is no record. Yet there is scant doubt that it was his working-class nurse who nursed, tended, caressed and disciplined Munby as infant and child. Munby's earliest class and gender identity took shape around two women: a beloved working-class woman, powerful and commanding, yet assigned by social edict to the "lower

orders," and a leisured upper-middle-class woman, physically delicate and adored from afar. Each woman represented different class aspects of the contradictory, doubled Victorian image of womanhood.

Fundamentally, their difference was marked by money: the one was (poorly) paid for her domestic service, the other was not. The class and gender contradictions of late Victorian society entered Munby's life with the force of an insoluble riddle. Mastering the riddle of doubled gender became the obsession that consumed his life. His chief strategy for managing the contradictions was, I suggest, the imperial discourse on race. In this respect, Munby was no eccentric, but was fully representative of his class.

"Little survives of Munby's infancy," writes his biographer Derek Hudson wistfully, "except a charming silhouette of him holding a whip."[9] Standing in erect profile, the infant strikes the pose of a miniature gentleman, holding a cocked whip before him. The whip marks the metamorphosis of infant into man and is eloquent of the social violence of male gendering. Protruding from just below the boy's waist, it symbolizes male mastery over two dimensions: the realm of sexuality and the realm of labor. At one and the same time, it is the peculiarly male emblem of phallic potency and violent mastery of the work both of servants and of beasts. In the precarious accession to masculinity, the whip marks the boundary between women and men and between men and animals, boundaries all the more imprecise for having so often to be reinscribed. In the logic of Munby's private (but far from idiosyncratic) iconography, the metaphoric affinity of women and horses is played out within scenarios that tirelessly equate female sexuality and servitude.[10]

It is not clear when Munby began to be conscious of his erotic hankerings for the spectacle of working women, but at Cambridge he began writing poems in praise of farm- and fisherwomen.[11] At Trinity he proved a lesser satellite, orbiting a large circle of more luminous acquaintances. By the time Munby turned twenty-two, his father had amassed sufficient capital to build an imitation manor, complete with the requisite architectural features of conspicuous display: "three handsome reception rooms on the ground floor; a breakfast room and a waiting room, a servant's hall, a butler's room and a coach house, stables and saddle room opening onto a large courtyard."[12] Nonetheless, Munby was still a civil servant's son and as such was obliged to work for a living. He qualified at the Bar in 1851 and, despite a decided lack of interest in law, moved into one of the Inner Temples, where he retained tenancy for the rest of his life.

Munby spent the best part of his life walking. No verb appears more often in his diaries than "went." Like Friedrich Engels, Henry Mayhew and the hosts of social explorers inspired by Mayhew's *London Labour and the London Poor*, Munby set out daily into the terra incognita of London's back

alleys, tirelessly charting the new "specimens" of female labor he found there, documenting their characteristics as *types* and bringing back to the private comfort of his rooms exotic and erotic memories of unexpected female sights. After expensive dinners, he descended to the scullery to observe the maid filthy with fat and water. Coming back from his clubs in the bitter frost, he accosted milkmaids setting out on their rounds. Everywhere in the streets he dogged women, watching and following them, importuning them with his questions. His intentions, he claimed, were purely sociological: to find the archetypes by which to represent the entirety of female labor.

THE FLÂNEUR
THE GENDERING OF URBAN SPACE

Munby was by no means eccentric in his wanderings. Walking bespoke leisure and male class power. At Cambridge he had acquired the habit of long strolls and nocturnal hours appropriate to the leisured class, of which he was not truly a member. The leisurely quality of his descriptions fits the style of the flâneur who, as Benjamin put it, "goes botanizing on the asphalt."[13] But Munby also was not truly a man of the city. He was quintessentially out of place. Like Benjamin's flâneur, Munby was in fact "as much out of place in an atmosphere of complete leisure as in the feverish turmoil of the city."[14] Munby inhabited the threshold between work and leisure, belonging to neither. According to Benjamin "the flâneur is still on the threshold, of the city as of the bourgeois class. Neither has yet engulfed him; in neither is he at home. He seeks refuge in the crowd."[15] Munby, too, found refuge in the crowd, into which he plunged daily. He was undone by precise boundaries, for reasons we will come to. The crowd was a threshold place. In its insolent promiscuity, merchants and clerks, prostitutes and streetsellers, bankers and beggars mingle, touch and pass each other. The polymorphous crowd was deeply attractive to Munby, whose life's project was to stage social ambiguity as controlled spectacle. Munby was intoxicated by the crowd because it was, by definition, the place where social boundaries were permanently on the edge of breakdown.

Munby's urban project and typologies were of a piece with the physiologues of Paris, who, as Benjamin notes, set themselves to investigate the social "types" that might be encountered "by a person taking a look at the marketplace." The project of the physiologues was "basically a petty-bourgeois genre."[16] But it was also an *imperial* genre, for the notation of types and specimens was characteristic of the travel ethnographies being written at the time by men who were taking a good look at the marketplace of empire. The urban and imperial projects were bound by a common

commitment to an optics of truth. Like the physiologues, Munby shared with imperial explorers the project of empiricism that sought to map the world according to a science of surface appearances.[17] Such men inherited from the Enlightenment the belief that a precise catalogue of visible surfaces — created by compass, caliper and camera — could guarantee both metaphysical and military mastery of the globe. Like the colonial map, Munby's notations offered a discourse of the surface and belonged — like the museum and exhibition hall — to the industrial archive of the spectacle.

Benjamin does not think it worth noting that the flâneur, the physiologue and the urban explorer are male. Yet he does recall that those who introduced him to the city were women. "Now let me call back those who introduced me to the city . . . the nursemaids," he writes.[18] Freud, too, recalls the memory of his nurse. In Munby's case, first his nurse, then the maids, milkwomen, prostitutes and streetsellers introduced him into the labyrinth of the city. A convergence might therefore be found in the project of psychoanalysis and the project of modernism. The first space explored by these uneasy men of the new bourgeoisie was the body of the nurse. It was also, by these men's accounts, their nurses who introduced them, as toddlers, to the shocks and sights of urban space. If, for Benjamin, the park was the scene of bourgeois domestic harmony, it was a scene governed by working-class nursemaids and nannies. In the park, toddlers played until roused "by the voice of the nursemaid from the bench of command; there she sits stern and studious."[19] It is therefore not surprising that, as adults, these men on the cusp of modernism, Zola, Freud, Baudelaire, sought the after-image of their nurses in the prostitutes, servants and actresses who served as their mistresses, muses and models. Nor is it surprising that they projected the female body onto the modern city as its first shape.

If the woman's body is the child's first space for knowledge and self-discovery, later the city, as the first space of modern self-knowledge, was mapped as a feminine space. Once feminized, the city was more easily represented and made docile for male knowledge and power, for such representations could depend on the prior fact of the social subordination of women. In the process, however, a conversion and a disavowal take place. The unsettling memory of female power and agency, embodied in the memory of the nurse, is projected onto the city as female surface. Woman as *agent* becomes woman as *spectacle*. Through the imperial discourse of the surface and the archive of the spectacle, the labyrinthine city is captured and reclaimed as a male, middle-class territory. Psychoanalysis therefore needs to take another, long look at the body of the working-class woman.

Benjamin speaks of the crowd as presenting the traumatic shock of a memory trace. For Munby the specific shock, the catastrophic and pleasurable memory, was the spectacle of female labor. Munby saw the

irrational, subversive and feminized crowd of the Victorian imagination as a refuge, but only insofar as he could control its contrasts through scopophilic power. Moving through the crowd as voyeur, Munby's identity was fluid and assured. In the crowd, he could survey unnoticed the dangerous contrasts of social identity, then catalogue and reassemble these contrasts in the private museum of his diary, mediating without decision or anguish between the disparate dimensions of his identity. Like Baudelaire, Munby loved solitude, but he wanted it in the crowd, where the individual's traces are obliterated. Baudelaire could have been referring to Munby when he noted: "An observer is a prince who is everywhere in possession of his incognito."[20]

THE FLÂNEUR AND THE RIDDLE OF CLASS ORIGINS

If the crowd offered an arena of scopophilic contrasts, Munby was really only interested in women. However, he was not equally enamored of all woman. He made little effort to conceal his disdain for the "sparkling froth atop of society."[21] The mincing, ornamental heiresses who paraded at balls held scant allure for him. "To have married Laura Matilda and all her relations and found life one vast platitude of tarlatan and small talk and pap!"[22] He was as slighting of factory women, seamstresses and dressy upper servants, whom he saw as nothing more than pale mimics of upper-class women with their "hybrid fineladyism"[23] and "would-be lady's clothes."[24] As Leonore Davidoff remarks, "in common with many upper middle class Victorians, not absolutely sure of their own position, he disliked those who tried to rise above themselves."[25] But as strong a reason for his uneasy disdain for these "hybrids" was that they could not offer the "delicious contrast" of working class and upper class that he restlessly sought.

Munby was tireless in pursuit of the women who did the filthiest, most sordid and most menial work: the scullery maids and milkwomen, the maids-of-all-work, the farm- and fisherwomen, the Wigan pit-brow women, the mudlarks, the prostitutes and the dustwomen. Munby's fetish was not simply work; it was menial work. And it was not simply menial work, but menial work in contrast to idle luxury.[26] "A strong homely simple woman, going about the hard work of common life in the midst of idleness and luxury, is to me an object of the highest interest."[27] Munby sought the class contrast embodied in the two mothers who had governed his childhood. The working women he sought all shared the class features of his nurse, Hannah Carter: women whose work was menial, visibly dirty, nonindustrial, poor, economically independent of marriage and physically powerful. These women presented a "suggestive contrast" with women from his mother's class: leisured, moneyed, economically dependent on marriage and physically delicate. It was the visual, involuntary shock of

this contrast (a word that recurs with fetishistic emphasis throughout his diaries) that compelled Munby with insatiable and irresistible force.

For Munby, the sight of a red-handed and muscular milkwoman, "a picture of ungainly strength," was made more piquant by the simultaneous spectacle of a lady "mincing past at the moment, with tiny hands cased in lavender kid: the contrast," he exults, "was delicious."[28] Again and again, his diaries retrospectively savor—as spectacle—the visible contrast of female classes. One entry recalls how, dining out, his eye indulged in the spectacle of how "all these young ladies, white-bosomed, fairylike with muslin and flowers, found a foil for their elegance in a pretty but coarsemade rustic & redhanded waitingmaid."[29] Roaming through Mayfair, he was fascinated by Kate O'Cagney, the "queen of the milkmaids," because of the "rustic contrast" she presented to the surrounding urban elegance.

The riddle that teased him was the riddle of origins, the origins of class difference and the potential fluidity of class identity expressed in the interchangeability of names: "Gentle and beautiful in the face as they—and her name Laura too—why should she have a life so different?" Yet Munby was no revolutionary. He had no desire to rescue the scullery maid from her drudgery. Rather, it was precisely the edicts of class contrast that afforded him endless small pleasures, endless "sad delights": "But always, to be thus among the sparkling froth atop of Society has one sad delight, in that it keeps vividly before me that gentle misplaced creature who lies grovelling among the dregs; that toiling maid of all work who might have been a drawingroom belle and is a kitchen drudge."

THE NURSE AND THE RIDDLE OF ORIGINS

> We can tell these persons (servant-girls) their story without having to wait for their contribution. They are willing to confirm what we tell them, but we can learn nothing from them.
>
> —*Sigmund Freud*

> It seems to have been my fate to discover only the obvious: that children have sexual feelings, that every nursemaid knows.
>
> —*Sigmund Freud*

If Munby's family situation predispositioned him for a life-long obsession with working-class women, he was not alone in this respect. Desire for the

nursemaid has a contradictory history. In the figure of the nursemaid, psychoanalysis and social history might converge, if only because it was at this historical point that they parted ways.

As the nineteenth century progressed, women were increasingly drawn into household service, until by mid-century two-thirds of all domestic servants were female. By 1851, 40 per cent of wage-earning women worked as domestic servants. Between 1851 and 1871 the number of female servants rose by over 56 per cent, twice as fast as the population itself increased, the greatest rise occurring during the 1860s. By the latter decades of the century, female domestic work was the largest labor category apart from agriculture. It has come to be regarded as a commonplace that no self-respecting middle- or upper-middle-class household could afford not to keep at least one female servant. As Eric Hobsbawm notes: "The widest definition of the middle class . . . was that of keeping domestic servants."[30]

It is therefore hardly surprising that male Victorian writings, pornography and memoirs abound with references to nursemaids and governesses, bearing vivid witness to the profound sway these working class women held over their young charges. More often than not, nurses and maids slept in the same rooms as their charges: they washed and clothed them; smacked their bottoms; washed their vaginas and penises; wiped up vomit; tended them when they were sick; cuddled them; disciplined and punished them; taught them how to speak; read and write; told them stories and instructed them in their class "manners."

By many accounts, sexual encounters between maids and their male charges were not uncommon. Sexual relations between maids and the daughters of the household most likely took place, but were, for obvious reasons, far less visible.[31] Eugene Talbot, for one, notes: "The sexual history of boys often demonstrates that their initiation into the sexual life was first at the instance of women older than themselves, often servants."[32] Freud agrees: "It is well known that unscrupulous nurses put crying children to sleep by stroking their genitals."[33] Freud talks of the "common phantasy which makes the mother or nurse into a seducer," and notes that "actual seduction . . . is common enough; it is initiated either by other children or someone in charge of the child who wants to soothe it, or send it to sleep or make it dependent on them."[34]

This suggests that power relations between working-class women and their young charges were not identical to the power relations between maids and their adult employers. If the children held potential social power over the servants in the household, it would appear, by many accounts, that female servants exercised considerable power and influence over the children. Many of the women, it seems, initiated the sexual encounters. It

is not at all improbable that sexually desirous young women, barred from intercourse outside the household, might have indulged in pleasurable forms of physical revenge and power over the young females and males in their keeping, in ways that offered compensation for their subjection before the adults in the family and before society at large. This is not to gain say the very real relations of disempowerment that held domestic workers in their masters' and mistresses' thrall. But by asserting sexual and psychological dominance over the children, or creating genuine emotional dependence, these women could have negotiated opportunities for acknowledgement, control or revenge.

In private, nurses and governesses held considerable power to judge and punish their charges. Lord Curzon, viceroy of India from 1898 to 1905 and foreign secretary in the governments of Lloyd George, Bonar Law and Stanley Baldwin, recorded bitterly in his biography how his nanny, Miss Paraman, in "her savage moments" was "a brutal and vindictive tyrant" who established over the children "a system of terrorism so complete that no one of us ever mustered up the courage to walk upstairs and tell our father and mother. She spanked us with the sole of her slipper on the bare back, beat us with her brushes, tied us for long hours to chairs . . . shut us up in darkness . . . forced us to confess to lies that we had never told, to sins that we had never committed and then punished us savagely, as being self-condemned."[35]

Nannies could also inspire the devotion and dependence of a lifetime. Winston Churchill, for one, recorded how his beloved nanny, Mrs. Everest, was his "dearest and most intimate friend during the whole of the twenty years I had lived." Until her death, as Churchill's son attested, she remained "the principle confidante of his joys, his troubles and his hopes . . . "[36] In unconscious tribute, perhaps, to the influence she had over his conceptions of gender difference, Churchill fondly nicknamed her "Woomany."

In a very real sense, these children grew up with two (or more) mothers, whom they learned to distinguish by learning the social scripts of *class* difference, the meaning of uniforms, curtseys and bows, the rituals of recognition and deference that separated the two most powerful figures in the child's life.[37] The contradictions were sharp. On the one hand, "in her sphere," as Gathorne-Hardy notes, "the Nanny's power was absolute."[38] On the other hand, she could be rebuked, demeaned or dismissed at a word from the mistress.

Surely no other culture has divided female sexuality so distinctly along class lines. Working-class women were figured as biologically driven to lechery and excess; upper-class women were naturally indifferent to the deliriums of the flesh. Mothers were often the objects of remote adoration or abstract awe. George Bernard Shaw, who was brought up almost

entirely by nurses and servants, said of his mother: "Her almost complete neglect of me had the advantage that I could idolize her to the utmost pitch of my imagination and had no sordid or disillusioning contacts with her."[39] Churchill wrote of his biological mother: "I loved her dearly—but at a distance." Mary Lutyens recalls that "intimate functions were performed by Nanny or by Annie our nursemaid . . . I did not like mother even to see me in the bath."[40] The Victorian splitting of women into whores and Madonnas, nuns and prostitutes has its origins, then, not in universal archetype, but in the class structure of the household.

FREUD AND THE NURSE
ABJECTION AND CLASS

Classical Freudian psychoanalysis has, for the most part, steadfastly refused to grant any theoretical status to the maidservant other than as a temporary intruder into the family romance, or as a parental surrogate. In an important article, Jim Swann argues that Freud's Oedipal theory was itself founded on the theoretical elision of the family nanny (*Kinderfrau*) from his own childhood development.[41] During the crucial period of Freud's self-analysis (May to October 1897), he revealed in a letter to Wilhelm Fliess on October 3 that, contrary to his theory of fathers as the founders of neurosis, his own father had played "no active role" in his case.[42] The "prime originator" was neither his father nor his mother, but his Catholic, Czech nurse, Monika Zajic.

"My prime originator," writes Freud, "was an ugly, elderly but clever woman who told me a great deal about God Almighty and hell and who instilled in me a high opinion of my own capacities."[43] Swann points to the sexual import of the term "originator (*Urheberin*)": Freud's nanny was "the first to raise up," that is, to excite him to an erection.[44] The boy's arousal, it seems, was occasioned not only by the daily, domestic cleaning of his genitals, but also by explicitly sexual attentions. On October 4, Freud continues writing to Fliess: "Today's dream produced the following: she was my teacher in sexual matters."[45] Zajic was not only the source of Freud's first erotic arousal; she was also the source of his first sexual humiliation: "(she) complained because I was clumsy and unable to do anything. Neurotic impotence always comes about in this way."[46] Freud's *Kinderfrau* remains, like most domestic workers, a shadowy figure at best. Nonetheless, as sexual teacher and judge, she deeply influenced the boy in both knowledge and power and according to Freud it was she, rather than his father or mother, who exerted the governing force over the early generative history of his sexual, psychological and economic identity; it was she who bequeathed him "the means for living and going on living."[47]

Between Freud's *memory* and his *theory*, however, a conversion takes place. In recording his childhood memories, Freud assigns the nanny a potent role as sexual agent, but when he elaborates his Oedipal theory a few days later, he not only banishes the "prime originator" from the scene altogether, but replaces his memory of sexual impotence (*lack* of sexual capacity with the *nurse*), with the theory of sexual aggression (*excess* of sexual capacity with the *mother*). A displacement across *class* ("later . . . libido towards *matrem* was aroused") effects an inversion of *gender* (from the nanny to Freud). In the 1897 letter to Fliess, Freud writes of the nanny: "She was my teacher in sexual matters." Yet when he finally writes "Femininity," the mother has ousted the nurse: "The seducer is generally the mother . . . who by her activities over the child's bodily hygiene inevitably stimulated and perhaps even aroused for the first time, pleasurable sensations in her genitals." In the earlier letter, Freud had revealed that this was not true in his own case, for his mother was a distant figure of idealized perfection: "To me she was the perfect mother. I would not have liked her to dose me, bathe me, comfort me or hold my head when I was sick. These intimate functions were performed by Nanny or by Annie our nursemaid."

By erasing the nurse's agency, Freud safeguards the male's historical role as sexual agent. Yet a theoretical residue remains, for the Oedipal theory does not in fact account for the memories and dreams it claims to explain. Indeed, it can be said that Freud's Oedipal theory is what remains once he elides the class divisions that structured the middle and upper-middle-class household. Subsequently, the nurse returns once more, only to be be once more banished, when Freud argues that "phylo-genetically inherited schemata" are "precipitates from the history of human civilization. The Oedipus complex . . . is one of them."[48] For Freud, here, the Oedipus complex is an "inherited" schema which overrides the child's own historically variant experience: "We are often able to see the schema triumphing over the experience of the individual Wherever experiences fail to fit in with the hereditary schema, they become remodeled in the imagination."[49] Freud takes as an example of "personal experience" overridden by the "hereditary" Oedipus complex the process that "is at work where a nurse comes to play the mother's part or where the two become fused together."[50] Here Freud's own knowledge of the formative power of the working-class nurse is overridden and dis-avowed by his invention of an invariant, inherited "precipitate from the history of civilization."

In this sense, the Oedipal theory is a screen theory, both concealing and revealing a fundamental dimension of power that Freud could neither ignore nor bring himself fully to realize: the historical role of the working-

class nurses and governesses who returned with ritualistic insistence to haunt his dreams, his analyses and his patients cases. The nurse (which Freud calls *"die Alte"* and *"das alte Weib"*) is the repudiated, working-class other: the expelled abject from which he could not part.

"Hysterics," wrote Freud, "suffer mainly from reminiscences." In his own case, he admitted, "If . . . I succeed in resolving my own hysteria, then I shall be grateful to the memory of the old woman who provided me at such an early age with the means for living and going on living."[51] The hysteria Freud refers to here is his fear of travel and his "Rome neurosis," that can be argued to arise from his incapacity to recognize and resolve his split maternal imago, a split emerging not from some archetypal division in the psyche but from the class doubling of the Victorian household. When Freud was separated from his mother during her confinement, his Catholic nurse took him frequently to Mass, giving him the means for enduring the loss of his mother during her confinement. Freud's sexual longing and incompetence with his nanny merged with Catholic tales of "God and hell," and in recurrent dreams, the Catholic city of Rome—the mother that was not his mother—became "the promised land seen from afar."

Caught in his earliest years between two religions, as between two mothers and two classes, Freud in his later years developed a deep "travel phobia" and a "Rome neurosis." In his October 3 letter to Fliess, Freud recorded that after being aroused by his nurse, "later . . . libido towards matrem was awakened, namely on the occasion of a journey with her from Leipzig to Vienna, during which we must have spent the night together and there must have been an opportunity of seeing her *nudam*."[52] Freud notes elsewhere that using a foreign language marks a repression; it is no accident that he reaches here for Latin, the ancient mother language of his nurse's church, to describe his arousal for his other mother, thereby marking the place of doubling and defense. Desire for the nurse/mother/religion and failure to enter her, shaped the "Rome neurosis" that beset his travels. Journeying often to Italy and yearning for Rome, Freud could not bring himself to enter the dreamed-of city, turning back within a few miles of his destination. At some level, his incapacity to merge with his nurse was displaced onto an incapacity to enter Rome. Unable, finally, to "thank the memory of the old woman" in his theory, Freud remained unable to resolve his hysteria.

PSYCHOANALYSIS AND THE DISAVOWAL OF CLASS

Barred from the theory of the Oedipal family romance, the nurse nonetheless returns insistently to the scene of memory with the irresistible force of a fetish. On February 9, 1898, Freud wrote to Fliess that it was

rumored that he was to be invested with the title of professor at the Emperor's Jubilee. The entitlement of male professional authority at once provoked anxiety and a dream. The dream, he wrote, "unfortunately cannot be published, because its background, its second meaning, shifts back and forth between my nurse (my mother) and my wife."[53] Kenneth Grigg has pointed out that in these and other passages Freud inseparably condenses his Amme (nanny) and his young mother, Amalie. Something of the inadmissible deeper meaning of the dream is revealed in the ambiguity: "my nurse (my mother)," that can mean either that it was the nurse who really "mothered" him and who was indeed his "true" mother, or that the nurse was simply a symbolic substitute for his "true" mother. The point is that the ambiguity is irresolvable, deriving as it does from the historical doubling within the domestic economy of the unwaged upper-middle-class mother and the waged working class "mother": *die Alte*, or *alte Weib*.

In the Oedipal theory, however, the "unpublishable" doubling of the mother figure by class is concealed by splitting and separately assigning to the father and mother both of the roles (the power of social punishment, and the power to evoke sexual desire) that Freud observes in the nanny. The historical double bind of *class* is thereby split and displaced onto the father and mother as a universal function of *gender*. Freud's dream and the burden of comprehension it reveals remain "unpublishable," for publishing would have meant publicly acknowledging the engendering power of the working-class nurse, upon whose subordinated labor the household depended and thereby necessitating an entire rewriting of the Oedipal drama he was about to disclose to the world.

In his October 4, 1897 letter to Fliess, Freud notes that his dream of the *Kinderfrau* intertwined her chiding references to his sexual incompetence with "the most mortifying allusions" to his current professional "impotence." In recounting this dream, Freud makes the standard Victorian identification of sexual performance and economic exchange.[54] The dream equates his inability to perform sexually with his inability to raise money, but it also reveals an inversion and a strategy for revenge. In the economic exchange of therapy, Freud's early relation of disempowerment with his nurse is inverted: "Just as the old woman got money from me for her bad treatment, so today I get money for the bad treatment of my patients."[55] Freud's "bad treatment" of his patients serves as deferred compensation for his nurse's "bad treatment" (sexual arousal and humiliation) of him as a child. Both sexual and economic roles are inverted in such a way as to give Freud apparent mastery over the contradictory relations of sexuality and economy within the family.

When Freud was two and a half years old, two crucial events precipitately followed one another: his nurse was dismissed as a thief and his

mother gave birth to his sister, Anna. Loss of the mother condenses with the memory of the prior loss of the nurse: "My mother was nowhere to be found; I was crying in despair. . . . When I missed my mother, I was afraid she had vanished from me, just as the old woman had a short time before."[56] But the accounts of the nurse's disappearance are contradictory. At first Freud writes: "She induced me to steal zehners (ten-kreuzer coins) and give them to her." The stolen money was found amongst her possessions, with some of Freud's toys, whereupon Zajic was summarily bundled off to prison for ten months. After verifying the event with his mother, Freud revises his view: "I wrote to you that she induced me to steal zehners and give them to her. In truth, the dream meant that she stole them herself."[57]

Freud then adds a remarkable sentence. "The correct interpretation is: I = She." In the first version, the money belongs by rights to the nurse in exchange for her "bad treatment," her sexual instruction to Freud. In the second version, the nurse is the thief and the boy is exonerated: imprisoning the *Kinderfrau* for ten months forecloses the "bad" circulation of money from son to *Kinderfrau* and of sex from *Kinderfrau* to son, outside the reproductive order of marriage. In the final, authoritative narrative, class and gender boundaries are redrawn. The working woman's cash is returned into the upper-class patrimony and the male prerogative of free sexual access to working-class women is restored. Nevertheless, the nanny haunts Freud as his abjected identification: "I = She."

"I = SHE"
FREUD'S IDENTIFICATION WITH FEMININITY

I propose that the equation "I = She" evokes a contradiction that Freud struggled to resolve throughout his career. The figure of the nanny raises a crucial problem in Freud's theory of identification. For Freud, as Swann brilliantly argues, the mother is identified as an object to possess and control rather than a social ideal with whom to identify. Relation with the mother is a dependent object relation. "In Freud's theory of identification, there is a set of contradictions, that he attempts to resolve by allocating object-relation dependency to women and active identification to men, splitting what is a complex, dynamic process into two distinct, gendered categories of identity relation."[58] In Freud's theory, loss of the mother is seen not as loss of one of the most profound personal relationships one can have, on which one is dependent for life itself, but as loss of an object. Women belong in the realm of object choice rather than the realm of social identification. Indeed, identification *with* the mother figure is seen as pathological, perverse, the source of fixation, arrest and hysteria. Yet the theoretical disjunction between women as object choice and women as desirable to identify *with*, is belied by the dream equation "I = She" that

suggests a far more complicated identification with the nurse as a social agent. The child's desire to be *like* the powerful, desirable nurse/mother (and have babies, female bodies and power) is steadfastly elided in the theory, but surfaces insistently in dreams at the time that the theory is being elaborated.

In an earlier letter to Fliess on May 31, 1897, Freud described a dream in which he was ascending a staircase "with very few clothes on," when he became erotically excited and "glued to the spot" by the discovery that a woman was following him up the stairs.[59] Yet when Freud later records this dream in *The Interpretation of Dreams*, a curious change takes place. In the new version, the woman is identified as a maidservant and instead of coming up the stairs behind Freud, she descends the stairs toward him. Half-dressed as he is, Freud is in the conventionally "feminine" position of being undressed and judged, while the maid is the voyeur observing his exposed vulnerability; she assumes the male position of superior height, descending upon Freud, fully clad.[60] This time, Freud records his response not as erotic excitement but as anxiety.

Put together, both versions reveal the doubled contradictions of class and gender that mark Freud's relation with the nurse: between women who are identified by their labor (maidservants) and those who are not; between the upstairs and downstairs class hierarchy within the domestic household; between erotic arousal and erotic inadequacy; between men who are socially empowered to gaze at half-clothed women and nurses who are socially empowered to gaze at half-clothed boys. In both versions, Freud's incapacity to resolve the contradictions is expressed as paralysis and impotence. But the second, public version ends, not with the maid ascending behind Freud (in the standard Victorian image of social evolution), but descending to her "nether world," while Freud's erotic excitement is disavowed and erased. Once more, Freud's public version represents an inversion and displacement: his class position affords him the power to subordinate the nurse, allowing him to bound on up the stairs to his "slim and beautiful" mother at the top.

The female servant recurs, unbidden, in the case histories. In the case of little Hans, the elision of identification with nurses and mothers (as privileged bearers of children) leads the case deeper and deeper into contradiction. In the narrative of the Rat Man, the topography of gendered desire is mapped on the body of a female servant. The Rat Man recalled Fräulein Peter, who looked after him when he was four or five: "I was lying beside her and begged her to let me creep under her skirt . . . she had very little on and I fingered her genitals and the lower part of her body."[61] The "Wolf Man" recalled his nursery maid, Grusha, kneeling on the floor with a short broom made of a bundle of twigs next to her. Later, the "Wolf Man" fell irresistibly and violently in love with a peasant woman he saw kneeling

and washing clothes. As Freud notes, it was "the posture of the maid, in that she is physically debased" on which he was fixated. Yet, as Peter Stallybrass and Allon White point out, "Freud is so intent upon demonstrating that the 'Wolf Man's' obsession with Grusha is the signifier of a primal scene in that 'Wolf Man' observes his father making love to his mother *a tergo* that he is forced to minimize the figure of the maid. Grusha (the 'dirty' object) will only be considered as long as she leads back to the family romance."[62] In other words, Freud brilliantly discerns the splitting in the subject, but cannot admit into his theory the class dimensions that give rise to this splitting in the first place. Instead, the maid has value only as a symbolic surrogate, a substitute for the bourgeois family romance.

REINVENTING THE FAMILY OF MAN

Freud's elision of the nurse from the Oedipal theory also elides the fact that family households are, above all, historically variant economic structures. To admit the power and agency of the nurse is to admit that the power of the paternal authority is invented and hence open to change.[63] By forgetting the nurse, Freud could forget the structuring of infant and social identity around economic imbalances in the family. The family romance is cleansed of class contamination and, most crucially, of money. Through the Oedipal theory, the multiplicity of family economies are reduced to an economy of one, naturalized and privatized as the universal unit of the monogamous family of man, a "hereditary scheme" transcending history and culture. The family is vaunted as lying beyond politics and hence beyond social change, at precisely the moment that Victorian middle-class women began to challenge the boundaries between private and public, waged work and unwaged work.

Freud's analysis is haunted by the presence of the governess, whom, like the prostitutes on the corner in Rome, he would like to forget, but of whom he is constantly reminded. "I should like to recall the governess," he murmurs in Dora's case; yet Freud cannot fully admit the historical presence of the governess into the family romance.[64] By eliding the nurse, Freud offered the world a universal theory of the Family of Man, in that male sexuality was inevitably more potent and authoritative than female sexuality, which was inherently deficient, anachronistic and "primitive." The Oedipal theory reinvented paternal, familial authority as a natural, universal and inevitable fait accompli, at the precise moment, I argue below, when the emergence of the imperial bureaucracy was depriving the image of the father of symbolic power as the designated symbol for all political power.

Jane Gallop has pointed out that the maid is "'at the door' inasmuch as she is a threshold figure: existing between 'within the family' and 'outside

the family.' Fucking her is a threshold act, somewhere between incest and exogamy."[65] In Ida Bauer's last dream, before she walked out on Freud as a maidservant might walk out on her master ("that sounds just like a maidservant or governess—a fortnight's warning"), Ida offers Freud, even at the last minute, the key, the picklock to the case. When Ida returns to the master's house, the maidservant opens the door. "The maidservant opened the door to me." The architectural image of the open door (on the threshold of private and public) by now signifies sexuality as well as the structure of the domestic economy. Yet Freud cannot see it, for a maidservant holds the door in her hands. He insisted, "We can learn nothing from them."[66]

Just as Freud identifies with his nurse ("I = She") so does he identify Ida with the maidservant in a symbolic equation of servitude and femininity that revealed how much the sexual identities of upper-class men and women were shaped and informed by the female working-class workers in their midst. In short, gender is not a separate dimension of identity to which one adds, accumulatively, the dimension of class. Rather, gender is an articulated category, constructed *through and by class*.

Freud was incapable of resolving this inadmissibly class-entangling triad of desire without admitting a full-fledged analysis of class into his theory. Incapable of ascribing the prime originating power of psychosexual development to a working-class woman (as he was compelled to do by the insistent material of his own dreams), he instead represses the nursemaid and displaces her power and his identification with her power, onto identification with the father. In this way, the final elaboration of the Oedipal theory, the nurse has vanished. In her place Freud reinstates the mother as the object of desire and the father as the subject of social and economic power and thereby violently shuts the doors of the family romance on this intrusive and inadmissibly powerful member of the female working class. Finally, the entry of the wife into the female triad enables Freud, through the contract of marriage, to master, as husband, both mother and servant. Thus Freud's elaboration of the theory that was to make his name and fame was secured at the expense of a repression: the erasure of the female domestic worker as a primary originator of sexual and economic identity. As Robbins notes, "it is thanks in large part to the success of this theory that the massive intrusion of desire for servants into the lives of the servant-keeping classes in this period has not attracted more attention."[67]

Thus orthodox Freudian theory is premised on a vision of the family that excludes the historical presence of the female domestic worker, or defines her as an irrelevant accident. But if we restore what Freud wilfully repressed, an altogether different picture emerges. If the boy's earliest identification (sexual and psychological) is with a working-class female and then doubled and contradicted by the presence of the biological mother, the

scenario of individuation will arguably be significantly altered; the boy has to individuate himself from two women, in very different ways. This doubling gives rise to a fragility and uncertainty of identity that is resolved, or at least deferred and managed, primarily by reference to *class* power.

In the Victorian period, I suggest, it is also managed by systematically projecting onto working-class women the ideology of race. The male child's original identification with the female body will always remain as a vestigial but integral element to his own identity. Since accession to masculinity is precarious, it will require constant vigilance and ritualistic reaffirmation. Perhaps this is one reason that the figure of the nurse in late Victorian culture is so frequently invested with 'masculine' attributes and powers. Here the ubiquitous references in Victorian male life to working-class women as "unsexed," "manly," "coarse" and "rude" may find their psycho-analytic (though not their only) dimension. With this in mind, we can return to Munby.

GENDER AND CLASS
A SOCIAL NARRATIVE

Munby was not alone in his obsession with the doubled image of Victorian womanhood. Sandra Gilbert and Susan Gubar's influential *The Madwoman in the Attic* traces the literary etiology of this doubling, whereby "patriarchal tradition" envisages woman's being as split into two: the whore and the madonna, the nun and the sorceress, the maid and the medusa, the wife and the mermaid, the mother and the damned witch.[68] Likewise Nina Auerbach's *The Woman and the Demon* explores how male Victorian iconography abounds with the alliances between woman and faery, women and goblins, women and vampires, women and all the crawling and slithering panoply of cre-ation's mutants: "While right-thinking Victorians were elevating woman into an angel, their art slithered with images of mermaids."[69] As Auerbach sees it, the doubled image of woman and monstrosity admitted the archetypal, mythic power of womanhood: "Powerful images of oppression become images of barely suppressed power."[70]

These critics see the doubled image of women as arising out of an archetypal doubling in consciousness that can be transcended by a defiant act of aesthetic will. Can we not, however, more properly see this doubled image of women that haunts the glassy surfaces of male Victorian texts as arising less from any archetypal doubling in the male unconscious, than from the contradictory (and no less patriarchal) doubling of class that was a daily reality in the households and infancies of these upper-middle-class men? The goblins and faeries that populate male texts might more properly be seen to stream up not from a universal male unconscious but rather from

the historical memory of the female working-class kitchens and back passages, from the laps of the working class nurses and maids who brought the echoing whispers of faery into the middle-class nursery. The images of monsters and mermaids are remnants of an oral tradition borne by working-class women. These images are indeed images of female power, but they are specifically memory traces of female working-class power and are rooted in class divisions and historical mutability. Thus the images of female demons twinned with images of madonnas represent a general class contradiction that was lived out daily within the Victorian household: the contradiction between the barely repressed power of the waged female domestic worker and the relative lack of power of the unwaged wife.

This point is crucial if we are to envisage genuine strategies for political change. Neither Gilbert and Gubar nor Auerbach fully identify the material and economic grounds of the doubling of the female self. For Gilbert and Gubar, escaping from the glass coffins of the patriarchal text entails smashing the mirror and setting women free from the crystal surface, killing both angel and demon and releasing the "real self" into the incandescence of a transfigured future. The emancipatory task remains aesthetic: the female writer can "only do this by revising the Maker's texts."[71] Auerbach, too, envisions the release of women as occurring through an act of transcendental and essentially aesthetic female will. Yet the dynamics of the transfiguration remain misty. The romantic vision of an essential female self exploding in a crystal shower of words and floating free from the glassy confines of the text-mirror remains an aestheticized vision.

Moreover, the heroics of a transcendent, illuminated, self-generating consciousness, unaided by anything but an emancipatory will to self-creation and an aesthetics of metamorphosis, is historically a nineteenth-century middle-class idea, fabricated by a class anxious to create its own discourse of legitimacy without being able to resort to the idea of history or tradition (which was either a lower- or upper-class preserve). The middle class had to assert the freedom to create its being from its own self-generating energy. For Auerbach, women's stepping out of the "imposed frame" of patriarchy requires an act of transcendental will, tapping the "eternal energy of character as perpetual metamorphosis."[72] Yet unless the historical and class contradictions that animate the patriarchal Victorian imagination are taken seriously, this vaunted aesthetic transcendence will remain as inaccessible to most women as the male Victorian myths of middle-class autochthony were to most women. Auerbach's "unbounded future" will remain as resolutely bounded for the vast majority of women in the world—poor and illiterate—as were the variegated visions of male romanticism. Rather, we need to return to the class contradictions that shaped the patriarchal mirror.

THE GHOST IN THE LOOKING GLASS

On July 4, 1863, during the hot summer weeks in which Munby restlessly roamed the London alleys, *Punch* printed a cartoon by Sir John Tenniel that was eloquent of the class frame that bound the mirror image of doubled Victorian women. Titled "The Haunted Lady," or "The Ghost in the Looking Glass," the cartoon made public the scandalous working conditions of London's seamstresses [Fig. 2.4]. In June 1863, at the height of the London "season," a twenty-year-old seamstress, Mary Ann Walkley, collapsed and died from exhaustion after working twenty-six and a half hours without rest. Tenniel's cartoon, published a few weeks later, depicts a lady admiring her image in a full-length mirror and catching in the glass a startled glimpse of a haggard and dying woman slumped in the shadows behind her. Instead of a unified female self, the mirror reflects back the doubled image of Victorian womanhood: above a cascade of lacy flounced skirt (the metonym for decorative idleness) the female body divides into two, a white elbow (sign of the absence of work) and a disheveled working class torso, half-dead from exhaustion. The mirror frames a female hydra,

THE HAUNTED LADY, OR "THE GHOST" IN THE LOOKING-GLASS.

MADAME LA MODISTE. "WE WOULD NOT HAVE DISAPPOINTED YOUR LADYSHIP, AT ANY SACRIFICE, AND THE ROBE IS FINISHED *À MERVEILLE*"

FIGURE 2.4 THE UNCANNY DOUBLING OF GENDER BY CLASS.

a Siamese twin fully expressive of the contradictory and fatal reciprocity of the identity of working class and upper-class women. The glass is situated in the shop, the place of female consumption and exchange, where the labor of the working woman is metamorphosed into the prestige of the upper-class woman. The mirror thereby becomes an icon for the social framing of identity, and the doubled image of Victorian womanhood can less easily be seen as an archetypal doubling in the unconscious than as a symbolic expression of the material division of women by labor and class.

In the "sweated" clothing trades of London, the intricate finery, elaborate corsets, hats, fine feathers and lace cuffs worn by the women of the leisured classes were fashioned by underclass women in the direst need. Subcontracting and undercutting; extremely long hours for miserable pay; and work that was largely manual, repetitive and exhausting, performed in crowded and overheated garrets, gave the name "sweating" to one of the most appallingly exploitative of the female trades. The clothing industry thus expressed the governing contradictions of women's work. On the labor of the women in the sweated trades depended the extravagantly sumptuous dresses of London's idle upper-class women.

This entailed a social semiotics of visibility. For the upper classes, to wake at noon and dance till morning was to be seen to be conspicuously idle; to order in the afternoon a dress to be worn that night was to be seen to be conspicuously wealthy. The drawing room (flaunting artfully decorative furniture and glass display cabinets full of expensive silverware and china) was the space where women were visited in order to be seen to be conspicuously idle, while the public space for the visible display of idleness was the ball. The elaborate and expensive costumery worn by women became the visible icons of male prosperity and class status. At the same time, as Tenniel's cartoon so eloquently expressed, these emblems of upper-class prestige depended on the deadly labor of the female working class.

DANGEROUS CROSSINGS
LABOR AND MONEY

> It is not easy to be done with a civilization of the hand.
>
> —*Roland Barthes*

A number of critics have noticed Munby's libidinal fascination with women's hands.[73] Encountering a working class woman, he would glance compulsively at her reddened, swollen and work-roughened hands, then would return home to savor the pleasure in diary descriptions that are suffused with a deferred erotic glow. Descriptions of female hands return

repetitively throughout the diaries: "I took off my glove (they had no gloves!) to grasp the broad palm. Both . . . had large thick hands, infinitely suggestive to the touch and sight."[74] Doubtless, hands were "infinitely suggestive" for Munby because they visibly expressed the overdeterminations of sex, money and work.

Hands expressed one's class by expressing one's relation to labor. Dainty hands were hands that were unstained by work. The language of gloves spoke of "good breeding," leisure and money, while smooth white hands revealed that one could afford to buy the labor of others. As Hobsbawm put it: "The safest way of distinguishing oneself from the labourers was to employ labor oneself."[75] Thus middle-class women who did indeed spend their days scrubbing, cleaning, polishing and scraping went to incongruous lengths to disguise their work and erase its evidence from their hands. At the same time, hands were floating metonymic icons, the word referring to entire artisanal classes: "dockhands," "farmhands." For this reason, hands were also anachronistic icons, appearing with great symbolic force at the very moment when manual labor (*manus* = hand) was about to be replaced by mechanical labor—the living labor of the hand soon to be replaced by the dead labor of the machine.

Hands represent a *historical* memory trace, a nostalgia for a vanishing economic moment. At the same time, they represent a *psychological* memory trace, a nostalgia for a vanishing sexual moment (that is directly related to the vanishing economic realm). Hands held the memory trace of an earlier fixation—those wet, roughened and reddened working-class hands that bathed, caressed, chastised and fed the Victorian male infants who would rise to power. For this reason they carry the force of a fetish. Male Victorian memoirs are full of memories of the distinctive smell and feel of nurses' hands. Thus sexual memory became shaped around a bodily language of dirt and cleanliness and entered an iconographic affinity in which sex and work became inextricable. Davidoff points out that hands carried explicit sexual connotations: it was hands that did the "dirty work" of masturbation.[76] Hands were also the instruments of chastisement, meting out the economy of pleasure and pain in the flagellatory rituals of which the Victorians were so fond.

Hands were the organs in which Victorian sexuality and the economy literally touched. As Robbins puts it: "What produces the touching of hands is labor."[77] The activity of touching children was work, albeit poorly paid. But what also produces the touching of hands is paying for the work. The master's hand touches the maid's in a fleeting moment of physical intimacy in the exchange of cash, a ritual exchange that confirms and guarantees each time the man's economic mastery over the woman's body, work and time. At the same time, however, it confirms his dependency on

her labor. As we will see, for Munby the paying of money entered the structure of his sexual life with great force.

Steven Marcus has shown that "the imagery in which sexuality was represented in consciousness was largely drawn from the sphere of socio-economic activity and had to do with concerns and anxieties about problems of accumulation, production and excessive expenditure."[78] This connection is partly because, as Foucault has suggested, the middle class lacked a means and therefore had to invent one, for defining itself as a class. Sexuality (one's relation to one's body and the bodies of others) became the language for expressing one's relation to class (one's relation to labor and the labor of others). The middle class thus defined itself as different from the aristocracy and the working classes, who spent, sexually and economically, without moderation and who preferred not to work. It differed by virtue of its sexual restraint, its monogamy (for women only, as Engels notes) and its economic restraint, or thrift. Hence the obsessive power of the relation between sex and money in Victorian minds. By the late nineteenth century treatises against sexuality referred specifically to the way masturbation interfered with a person's ability to work. In 1891, for example, Dr. Remondino attacked the unfortunate foreskin in his *History of Circumcision* and compared circumcision to a "well secured life annuity" and a "better saving investment," that would promote a greater capacity to labor and to save.[79]

DANGEROUS CROSSINGS
CLASS AND GENDER ABJECTION

> Married Men may weep
> And tumble in the ditches,
> Since women are resolved
> To wear the shirt and breeches
>
> —*Popular song from the 1850s*

In Munby's descriptions, the swollen, lumpish redness of women's hands is an image redolent with sexual excitement and tumescence. Hands are intimately related to the spectacle of female labor in which he took such voyeuristic pleasure. But at the same time, what fascinates him in these hands is what he perceives as their lack of femininity: their manliness. He records again and again the first ritualistic moment of his encounters: "I looked instinctively at her hands: they were square and masculine."[80] More than this, the strong, rough, swollen, red, masculine hands made him feel positively feminine by contrast. One August he traveled by train to the Crystal Palace to the Forester's anniversary ("of all others the scene and time to see the English working classes").[81] There he was, as usual,

captivated by the sight of a young working woman's "gloveless hands." Concocting an excuse to take her hand in his, he gasps with the shock of contrast: "Oh ye ballroom partners, what a breadth of massive flesh it was to grasp!" What fascinates Munby in this scene is precisely the confusion of gender roles: "Her right hand lay, a large red lump, upon her light-coloured frock; it was very broad and square & thick—as large and strong & coarse as a sixfoot bricklayer . . . there was nothing feminine about it."[82] By contrast, his own hand seemed "quite white and small by the side of hers."[83] On another occasion he notes how the gangs of stout, black-faced dustwomen made a troop of men riding through Rotten Row in faultless gloves and haughty idleness appear positively feminine by contrast.[84]

Hudson was the first to note Munby's obsession with what he represented as the "masculine" features of working women.[85] A massive, broadbacked, solid farmwoman "tall and strong as a man" was "a creature worth seeing," he exulted. He deplored the fashions that were making the milkwomen "effeminate." Commentators have noted his interest in the masculine boots working women wore. He avidly set down in his diary encounters with working women in which he was made to feel deliciously female. On a trip to Devon to watch the "flither-women" who scaled the sides of cliffs on ropes to collect shell fish, he notes with a certain pleasure: "I, the man of the party, was left in a ridiculous position; a useless spectator of these vigorous athletics."[86] On another trip to the coast to watch the mussel gatherers reveal their "bare brown limbs," he is cut off by the tide and, again not unwillingly, has to surrender "masculine pride" by climbing aboard the back of a stout fisher girl, who bears him through the water. In another diary entry he records being rescued from the importunities of prostitutes by a strong Irish coster girl.

Munby's descriptions of the "manly" features of these women are so insistent that it becomes difficult to recall that these gendered labor distinctions were recent social inventions for his time. It was still a relatively new development in popular and scientific lore to define women who performed menial work as "unsexed." But these discourses were crucial for Munby's fantasy life, for in these women he could enjoy the masculine traits he coveted without endangering his own socially prescribed sense of maleness.

As ever, it was the transgression of gender that fascinated Munby. What entranced him was the spectacle of boundaries crossed—that tit-illating moment when woman was confused with man and man with woman. The voyeuristic spectacle of cross-dressing held him utterly in its thrall. He traveled hundreds of miles across Britain and the continent in search of working women who dressed like men. He went to Yorkshire to watch the way the fishergirls gathered their skirts around their knees in

FIGURES 2.5, 2.6 THE CIRCUS OF GENDER AMBIVALENCE.

improvised trousers. In 1861 he traveled two hundred miles to the Devon coast simply to watch women in canvas trousers gather shellfish. The Wigan pit-brow women, who wore trousers and were scarcely distinguishable from men, held an irresistible attraction for him.

Cross-dressers held a special place in his life. He put an advertisement in the paper for news of a "female sailor" he had heard about and became "extremely excited and desperately anxious" to take time off work in case she called.[87] He visited the police court to witness the examination of a maid-of-all-work who traveled about disguised as a man, smoked cigars and made love to her landlady.[88] He traveled to Strood with a police superintendent to meet a "Richard" Bruce, a woman who wore men's clothes; worked as a docker, sailor and shop lad; lived in male lodgings and had been arrested on her way to Dover to work as a male teacher in France. His diaries recorded in detail the pleasurable shock that these examples of gender confusion always afforded him. A tall young man in Highland costume, his legs bare

from the knee to the calf (always a source of arousal for Munby) turns out to be female. A sturdy, well-knit little acrobat with "nothing weak or feminine about him" turns out to be a girl [Figs. 2.5, 2.6].[89]

The "monkeylike" acrobats drew him again and again to the circuses, where, for a small exchange of cash, he could indulge his voyeurism in comfort and return to record the moment in his dairy: "Lizzie Foster herself was dressed like a male acrobat, in tights, with spangled trunk hose and a sleeveless vest; her dark hair dressed like a woman's."[90] An entry for June reads: "Went to the Circus . . . to see 'Ella'; a splendid creature, tall and well made, with large bright eyes, fine features and dark abundant hair. She is said to be a man in disguise."[91] He derived intense libidinal pleasure from the spectacle of these "naked and unprotected" girls, their bodies entwined with near-nude men, exposed to the eyes and glasses of the spectators.[92] He was also entranced by the sight of cross-dressed or feminized men: "The man himself, Leotard, was beautiful to look upon; being admirably made & proportioned; muscular arms shoulders and thighs; and calf ankle and foot as elegantly turned as a lady's."[93]

On one telling occasion he went to the Egyptian Hall to see an exhibition of Siamese twins. The spectacle of the twinned beings evoked the fundamental dynamic underlying his voyeurism. Perhaps the sight of a human being who is "not completely rounded off from every other" offered an unbidden analogy to his own identity.[94] Staging gender ambiguity under controlled circumstances (the exhibition, the circus) allowed him to master the ambiguities [Figs. 2.7, 2.8]. For Munby, the irresistible lure of working women was that in watching them he could voyeuristically enjoy the masculine traits he coveted, without endangering his own socially prescribed sense of maleness.[95] The circus drew Munby again and again, for it provided him with a controlled arena (itself on the threshold of society) in that the perilous ambiguities of gender could be staged and managed by the exchange of money. The exchange of money was a necessary moment in the scenario, for by the ritual exchange of cash, the perilous exchange of genders could be contained. Munby would ritualistically give working-class women a handful of pennies, the exchange confirming his fantasy of economic mastery over a spectacle that would otherwise have been perilously unmanning.

The point I want to make here is that it was only by reference to the discourse on degeneration and women's work that Munby could ascribe to working-class women these "masculine" attributes. In keeping with the discourse on degeneration, the more menial, paid work a woman did, the more she was manly and unsexed; the more she was a race apart. At the same time, Munby's own psychodynamic history offers a suggestive account of the domestic class dynamics that underlie the discourse on degeneration and the identification of white working-class women with black men.

FIGURES 2.7, 2.8 STAGING GENDER TRANSGRESSION.

SOCIAL AMBIGUITY AND THE DISCOURSE ON RACE

At this point, the third, unbidden dimension in Munby's psychic life emerges: the equation of working-class women with black men of other races. An undated drawing in Munby's sketchbook shows two women facing each other in profile [Fig. 2.9].

One is a lady, one is a collierywoman and each represents a type, a specimen of her class. Yet the class identity of each woman is revealed only by her outer appearance. Thus class identity is revealed to be relational and is revealed thereby as a social invention written in the language of clothes and physical signs. There are two reasons why the women face each other in profile. First, in the logic of the racial narratives of the time, the profile of the face is the most eloquent sign of the essence of the "race." Second, it is necessary that the women look at each other, for their glances recognize and confirm each other as representatives of their classes. The sketch reveals most clearly the reciprocity of identity through the economy of the look. The self comes

into being only through being recognized; yet at the same time (contrary to the Hegelian metaphysics of disembodied consciousnesses) the sketch reveals class identity as the product of unequal social power, shaped and legitimized through socially sanctioned rituals of deference and condescension.

There is, however, a second dimension to the sketch. What appears to be a primary contrast of *class* is represented by a more fundamental contrast in *gender*. Within the symbolic lexicon of Victorian sexuality, the lady is a picture of exaggerated femininity. Her profile is delicate and fine, her hair (Victorian symbol of sexuality and evolutionary achievement) fashionably restrained and coiffured, her skirts elegant and clean. She delicately stretches out a bare, white, imperious hand. In contrast, the collierywoman is the picture of maleness. She wears a man's jacket and torn, filthy trousers. The ragged ends of the trousers reveal thick ankles and enormous boots. Her profile is heavy and darkly obscured beneath a filthy hood. A massive torso looms over equally massive arms and square black hands, many times larger than those of her feminine opposite, grip the tool of her trade—a phallic oil can that protrudes from just below the waist and points at the lady's midriff.

FIGURE 2.9 RACIALIZING CLASS DIFFERENCE.

FIGURE 2.10 ABJECTION: THE DREAD OBJECT OF DESIRE.
Munby's Sketch of Himself with a
Wigan Collierywoman.

Now consider a different sketch [Fig. 2.10]. Again two figures face
each other. The figure on the right is a collierywoman, her appearance
strikingly similar to the figure in the previous sketch. Again the face is
dark and hooded, the shoulders enormously bulky beneath a man's coat.
Vast, splayed thighs clad in men's ragged trousers end in huge work-
ingmen's boots. The figure is turned slightly at an angle to display the
square torso to greatest effect. But standing opposite her where the "lady"
in the previous sketch stood, now Munby himself stands in almost
identical silhouette. In contrast to the "male" figure opposite, his figure
takes on a subtly feminine appearance. His profile is aquiline and pale,
nervous and "well-bred." His delicately tapered hand, like the lady's in
the previous sketch, is outstretched and rests gently on the bridge wall.
His feet, like the lady's, are smaller than the collierywoman's and pointed.
His entire appearance has an aura of frailty, an almost invalid-like
vulnerability next to the collierywoman's sturdy bulk. The striking

analogy between the two sketches reveals an unbidden logic of desire. In terms of the outer shape of the body, Munby reveals a secret identification with the female upper class in relation to the masculinized working-class women.

There is another dimension visible in the sketches that has gone largely unremarked by other commentators. While the collierywoman is the embodiment of gender ambiguity, she also represents a racial crossing, for her most striking feature apart from her "maleness" is her "blackness."[96] She presents a grotesque caricature of the stigmata of racial degeneration: her forehead is flattened and foreshortened; the whites of her eyes stare grotesquely from her black face; her lips are artificially full and pale. Her neck is sunk into her shoulders; her hands are hugely simian, black and improbably large; her calves are foreshortened. Munby's sketch of Boompin' Nelly reveals similar stigmata [Fig. 2.11]. The figure is entirely blackened; she squats hunched and brooding, her colossal arms resting on enormous, widespread, foreshortened legs.

FIGURE 2.11 MUNBY'S SKETCH OF "BOOMPIN'
NELLY," A PIT-BROW WOMAN.

FIGURE 2.12 RACIALIZED PHALLIC WOMAN WITH SHOVEL.

What is the meaning of this third, insistent narrative of race? Munby refers frequently to the "racial" otherness of working-class women. He takes special note of the "black-faced" dustwomen; calls women "fair coolies,"[97] and refers often to working women's "black work" [Figs. 2.12–2.20]. His insatiable interest in gender inversions is fired on learning that in Africa women are warriors, politicians and also laborers and burden bearers.[98] He is intrigued by the women who at that time made a living masquerading as black minstrels and would give them sixpence for their courage in blackening their faces [Fig. 2.21].[99] Thus the dangerous crossings of gender and class are negotiated by projecting onto them the rhetoric of race. One day he records going to the Geographical Society to see a great stuffed gorilla and at once evokes the irresistible analogy of working women and apes: the hands of the gorilla, four to five inches across, remind him of the hands of Amelia Banfield, a farm servant and those of other laboring wenches he had seen.[100]

FIGURE 2.13 RACIALIZING SEXUAL DIFFERENCE.

FIGURE 2.14 THE IRONWORKS WOMAN'S
HOOD AS FETISH MASK.

FIGURE 2.15

FIGURE 2.16

RACE AS FETISH.

FIGURE 2.17

FIGURE 2.18

FIGURE 2.19

FIGURE 2.20

RACE AS FETISH.

FIGURE 2.21 PASSING FOR BLACK.
Munby's Sketch of a Street Minstrel.

IMPERIALISM AND MINING

Working-class women, women, that is, who were paid to work, were figured thereby as inhabiting anachronistic space, embodying a regression to an earlier moment of racial development. Underlying this rhetoric of class and race, however, is a major contradiction in the Victorian economy: the transition from an industrialism based on imperial slavery to industrial imperialism based on waged labor.

Peter Fryer reminds us that there were Africans in Britain before the English.[101] There has always been a small but continuous black presence in Britain. This presence increased after the invasion of the New World and the slavery of the Renaissance, so that in 1601 Queen Elizabeth declared herself "highly disconcerted to understand the great numbers of negroes and blackamoors which . . . are crept into this realm."[102] Nevertheless, despite such regal misgivings, blacks served as trumpeters at the court and the queen's ladies-in-waiting enjoyed disguising themselves as black women

in the masquerades. Toward the end of the sixteenth century, possession of a black slave bestowed prestige and glamour on titled families. In the early seventeenth century, black pages and laundry maids are recorded, though in small numbers, as serving as status symbols in the great mansions of the English gentry. Thus there is a historical analogy between the black slaves of an earlier epoch and the domestic workers of the Victorian period as symbols of class status.

The dawn of the factory system and the consolidation of British capitalism were founded on the flourishing triangular trade in textiles, slaves, sugar and spices. As Hobsbawm put it: "When you say industrialization you say cotton. And when you say cotton you say slavery."[103] Between 1630 and 1807, an estimated 2,500,000 slaves were sold by British slave merchants. The slave trade was "the first principle and foundation of all the rest; the mainspring of the machine, that sets every wheel in motion."[104]

Planters, suddenly rich, returned to Britain with black slaves to display their wealth and prestige, as did a few officers of slave ships and on occasion even seamen. A black child decked in showy, bejeweled livery was a visible emblem of possession, power and fabled imperial fortunes. By the eighteenth century there were about ten thousand or so black people in Britain, working as pages, valets, footmen, coachmen, cooks and maids.[105] Women were cooks, laundry maids, seamstresses and nurses, and some were driven into prostitution by economic hardship. Others eked out a tenacious and precarious existence as beggars, street singers and musicians, often dressed in colorful costumes. And certain famous Africans such as Saadjie Baadman were exhibited as freaks.[106]

At this time, black women became ever more closely associated with an unbridled, lascivious sexuality. The association of black people and sexuality goes back to the Middle Ages: sexuality itself had long been called "the African sin," and black men on colonial maps were frequently represented with exaggeratedly long penises. In Britain itself the institution of slavery had withered away by the 1790s, by no means through any moral abhorrence on the part of the British, but rather through the success of sustained black resistance. Beyond the national boundaries, the British slave trade ended in 1807 and slavery in 1833. At this time, white colonists and planters manifested their fears of losing control over property and labor in an obsessive discourse on the threat of blood-taint through intermarriage. These fears of miscegenation in the colonies bred an anxious, vituperative discourse on white women's dangerous proclivity for black men. In the 1780s, James Tobin noted the "strange partiality shown for them by the lower orders of women."[107]

Munby's association of working-class women with Africans is thus far from idiosyncratic. Rather, he is drawing on a well-established and

pervasive association that had its foundation in the economic underpinnings of the industrial revolution. The deeper meaning of the racial dimension in his fantasy life may best be explored with reference to the Wigan mining women who drew him out of London to watch them as they worked, trousered and filthy, laboriously dragging Britain's coal out of the earth.

GENDER AND MINING

For over thirty years Munby traveled north to see the Lancashire pit-brow women "in their dirt." Yet his fervent interest in these women was more than private whimsy, for as the century drew on pit-women became the center of a ferocious debate over women's work and sexuality. Women had worked the coal mines for centuries, largely as "drawers" in the notorious harnesses and chains dragging the coal tubs through narrow, dripping tunnels—in some places hauling the coal in baskets on their backs up steep staircases to the surface.[108] By 1800 British workers were heaving 80 per cent of the world's coal out of the earth and many of the miners were still women. Then in 1842, in concert with general efforts to drive women out of competition with men for waged work, the scandalous First Report of the Children's Employment Commission on Mines was published. It was quickly followed by the Coalmines Regulation Act that banished women and girls from underground work. But for the rest of the century, women still worked the pit brows at the surface, shoveling coal with picks and spades, loading the railway trucks, pushing and emptying the heavy pit wagons.

The Wigan women epitomized the contradictions in Victorian attitudes to women's work and threw into stark relief the conflict between the image of the idle, ornamental woman and the actuality of female manual labor. Yet much of the outrage vented at the spectacle of trousered women wielding picks and shovels was hypocritical, for their work was often less grueling and less injurious than other occupations. A young maid-of-all-work, for example, could work longer and more exhausting hours carrying buckets of water or scuttles of coal up many flights of stairs, emptying stinking slop pails, scrubbing, cleaning and polishing—all the while isolated from family or community, pitifully paid; and frequently emotionally and physically at the mercy of the men of the household. But domestic work, if often more difficult and more debilitating, was domestic work, hidden in kitchen and scullery—a less visible affront to the emerging ideology of female idleness. And since it was not a field of competition with men, there were no outcries on these women's behalf.

There were other reasons for the hysteria about mining women. Though the new industrial economy was built on cotton, it was powered by

coal. Mining was obviously central to the emergence of capitalism. From the outset, capitalism had been financed by the silver and gold mines of Latin America; coal now fueled industrial imperialism. Yet mining was a contradictory industry. Allan Sekula has made a number of very important points in this regard.[109] Though mining was the primary power behind the primitive accumulation of industrial wealth, it remained a rural industry, lying in remote and deliberately underdeveloped areas. The technology of mining anticipated the factory system, but remained, nonetheless, a largely manual industry well into the nineteenth century. But although it was manual, at a symbolic level it also represented "the prototypical form of industry." And more than any other practice, mining exemplified "the direct domination of nature, the extraction of value from nature by alien means. Mining is the symbolic antithesis of agriculture."[110]

At the same time, in a cultural tradition emerging from the seventeenth century, mining became the metaphor for the scientific and philosophic mastery of the world.[111] It goes without saying, though Sekula is indifferent to gender, that mining also became the metaphor for the male sexual mastery of the world. For all these reasons, mining accrued a potent symbolic charge and, as the century drew on, the spectacle of grimy, muscular, powerful women working in this vital and contradictory industry became more and more intolerable.

As Sekula points out, "the culture of mining communities is frequently both militantly proletarian and rich in a sense of rural continuity and resistance to industrial discipline."[112] To bend this rich, militant, rural culture to the logic of industrial discipline, the world of mining had to be rationalized. And in order to be rationalized, it had to be systematically represented.[113]

RACE AND THE POLICING OF FEMALE LABOR

For these reasons, it is not surprising, then, that the coal miners, particularly the female coal miners, became deeply implicated in the emerging discourse on racial degeneration. After the fifties, the narratives of race and gender elaborated by the racial scientists, policy makers, novelists and social planners of the day offered a powerful source of symbolic representation that was readily drawn upon in the efforts to rationalize and discipline the mining industry. In newspapers, government reports, personal accounts and journals, the pit miners were everywhere represented as a "race" apart, figured as racial outcasts, historically abandoned, isolated and primitive. Cunning Bruce, a Scottish Member of Parliament noted that the mining folk were "looked on as a separate race."[114] The *Morning Leader* described the "hardy race" that pushed and handled trucks as "industrial Amazons."[115] Frances Hodgson Burnett spoke

of their "half savage existence."[116] *The Quarterly Review*, ignoring the fact that women had been miners for centuries, gave vent to hyperbolic astonishment at the spectacle of new racial specimens: "The earth seems now for the first time to have heaved from its entrails another race to astonish and to move us to reflection and to sympathy."[117]

The sight of the mining women conjured up anxious images of racial and sexual degeneration, evoking a cluster of associations between women, madness, sexual abandon and the irrational. One witness described them as "weird swarthy creatures, figures of women, half clad in man's and half clad in women's attire, plunging here and there, as if engaged in some bedlamish saturnalia."[118] Women's work, as before, became the measure for the position of miners in the hierarchy of the British "race," and marked them as lagging behind in the nether regions of racial degradation. Plummer described the Wigan women's work as "a species of labor that forms one of the few remaining links by which our present civilization is united to a barbaric past."[119] Richard Ayton, one of the first to condemn the pits, appealed somewhat sanctimoniously to the British male's supposed racial elevation and gallantry: "The estimation in which women are held is one test of the civilization of a people; and it is somewhat scandalous in a country of gallant men, to see them sacrificed to the rough drudgery of coal mines."[120] Because the women worked—powerfully, visibly, for money— politicians fulminated:

> The backs and limbs of their own countrywomen are being broken and their moral nature corrupted, by a species of slavery in the coal mines more cruel, more degrading and more profligate, than any that obtains among serfs and slaves in any part of the world that the anti-slavery zealots of missionary enterprise have yet discovered to claim money and cash.[121]

The relationship between industrial capitalism and imperialism made itself constantly felt in analogies to slavery and the language of the social explorers. The *Morning Chronicle* (May 7, 1842) depicted the findings of the Children's Employment Commission as a "volume of travels in a remote and barbarous country."[122]

By far the greatest outrage was directed at the "unsexing" of the women. Because the mines represented sexual and technical domination over nature and the mysteries of metallurgy and money, the presence of women penetrating deep into the earth, wielding enormous phallic shovels, provoked deep anxieties about gender misrule. The fact that women and men worked together was a fact "too barbarous to be tolerated." This anxiety was metonymically embodied in the extraordinary fuss over the

women's trousers. In order to work more comfortably and efficiently, the women wore coarse black cloth or cord trousers, striped aprons, open-necked shirts, men's coats and hooded bonnets [Fig. 2.22]. Munby approvingly called them "the belles in breeches," but he was almost alone in his admiration. Most witnesses and visitors fulminated against the "disgusting kind of male attire," the "fustian unmentionables" that threatened the moral fiber of the nation.[123] Examples abound of tirades about the work "absolutely unsexing the women," making them "utterly and coarsely unfeminine" [Fig. 2.23]. Ayton railed against the "most bestial debauchery" that prevailed, the "shameless indecency" of apparel and morals, the women "scorning all kinds of restraints."[124]

The critics assailed the industry more frequently on moral grounds than out of sympathy for the women's working conditions. The Commission feared that this "unfeminine" occupation would lead to "deterioration of character."[125] A farmer giving evidence to the 1867 Royal Commission on Agriculture argued that fieldwork (despite centuries of female agricultural labor of the most strenuous kind) would "almost unsex a woman, in dress,

FIGURE 2.22 A PIT WOMAN WITH
PHALLIC SHOVEL.

FIGURE 2.23 GENDER AMBIGUITY.

gait, manners, character, making her rough, coarse, clumsy, masculine," for she would thereby be unfitted for her duties at home. Indeed, it has become clear that the anxieties about sexual license and the degeneration of motherhood were unfounded. Most of the working women were unmarried and left their waged work when they married. Rather, it seems that underlying the anxious, baritone cries about sexual license lay fear of loss of patriarchal control in the home over the bodies, labor and money of the young women.[126]

IMPERIALISM AND THE URBAN CROWD

In the last decades of the nineteenth century, the urban crowd became a recurring fetish for ruling-class fears of social unrest and underclass militancy. Lurking in the resplendent metropolis, the crowd embodied a "savage" and dangerous underclass waiting to spring upon the propertied

classes. As the embodiment of deviant agency, the crowd became the metonymic symbol of the unemployed and unruly poor; who were associated with criminals and the insane; who were in turn associated with women, particularly prostitutes and alcoholics; who were in turn associated with children; who were associated with "primitives" and the realm of empire. The degenerate crowd occupied a dangerous threshold zone on the border between factory and family, labor and domesticity, where the public world of propertied power and the private world of familial decorum met their conceptual limit. Having escaped the discipline of rational labor, the crowd was depicted as the paradigm of unnatural agency—violently irrational yet hypnotically ductile, savage and bestial, inherently criminal and, above all, female.[127]

Images of female violence suffuse the image of the crowd, despite the fact that the unruly urban crowds were predominantly male. Male crowd behavior, it was held, mimicked social behavior that was typical of women. Tarde, for one, saw the crowd's "fickleness," its revolting "docility," its "gullibility" and its "nervousness" as definitively female. "The crowd," he insisted, "is feminine, even when it is composed, as is usually the case, of males."[128] In the crowd, masculinity lapsed into the degenerate female form of the race. By feminizing the masculine crowd, the language of *gender* became a regulatory discourse for the management of *class*.

At the same time, however, as Barrows has shown, the image of the threatening female crowd reflected genuine male paranoia about insurgent female demands for education, suffrage and work. Barrows sees the crowd as a condensation of fears, an amalgam of paranoias, distortions and hyperboles: "Such patterns of distortion and hyperbole resemble the process Freud later described as central both to neurotic behavior and to 'dream work'."[129] As an exemplary threshold image, the crowd entered the realm of the fetish.

The image of the crowd was also a response to very real under-class threats. The 1880s and 1890s were marked by waves of strikes by match women and dockers, mass demonstrations, anarchist attacks and the Trafalgar Square revolts. Trade union membership swelled and Britain saw the emergence of an independent Labour Party. The fetish image of the crowd as degenerate was a measure of very real ruling-class anxieties about popular resistance, as well as a crucial element in legitimizing the policing of militant working class communities. Defined as the urban paradigm of anachronistic, feminized space, the crowd could legitimately be subject to the action of the state and the regulatory technologies of progress.

But if the anachronistic space of the urban crowd was to be disciplined, it first had to be represented. Technologies of representation were needed to police the unstable boundaries between private and public

and to survey, map and assemble centers of urban militancy into territories of containment. These were the decades of the social explorers, when middle- and upper-middle-class men ventured into the terra incognita of Britain's working-class areas, striking the pose of explorers embarking on voyages into unknown lands. As Godwin put it, these men set out to "brave the risks of fever and other injuries to health and the contact of men and women often as lawless as the Arab or Kaffir."[130] Drawing on popular images of imperial travel, these urban explorers returned from their urban jaunts with a primitive accumulation of "facts" and "statistics" about the "races" living in their midst.

Colonial discourse was systematically deployed to map urban space into a geography of power and containment. The analogy between slum and colony was tirelessly evoked, as was the presiding figure of imperial discovery.[131] The *Eclectic Review* hailed premier explorer Henry Mayhew as having "travelled through the unknown regions of our metropolis and returned with full reports concerning the strange tribes of men that he may be said to have discovered."

Certainly, an earlier generation of industrial writers, John Hollingshead, George Godwin, Charles Manby Smith and John Garwood, had already forged the analogy between colonized lands and working-class communities.[132] As early as 1829, Robert Southey had called London the "heart of your commercial system but it is also the hot bed of corruption . . . the seat of intellect and empire . . . and yet a wilderness wherein they, who live like wild beasts upon their fellow creatures, find prey and cover."[133]

THE URBAN EXPLORERS
PHILANTHROPIC SURVEILLANCE

In the mid-1880s, a new epoch in the "discovery" of the East End took shape. Keating points out that the late Victorian social "explorers" differed from the earlier writers in the "almost total stress placed on the East End slums and the East End workers"—rather than on Manchester, say, or Liverpool.[134] Why the East End particularly? Other areas in London were as poverty-stricken and desperate, but the East End could serve a more potent symbolic role. Sprawling across the Thames as it flowed into the sea, the East End was the conduit to empire—a threshold space, lying exotic, yet within easy reach, on the cusp of industry and empire.

Drawing on the imperial progress narrative and the figure of the journey into the interior, journalists, social workers and novelists figured the East End slums in the language of empire and degeneration—as "swamps" and "wilderness," "shadows," "festers and malignant sores with which the body of society is spotted."[135] The density, size and sprawl of the

tangled slums were equated with jungles, and the language of imperial missionary enterprise was evoked to justify their penetration and their subjection to progress. Journalists and writers who ventured into the slums were seen as missionaries and settlers, bringing light into benighted darkness. The *Eclectic Review* applauded Mayhew, who had unearthed the strange foundations of society and "exposed them to light." In 1890, William Booth, founder of the Salvation Army, published a book that was directly inspired by Henry Morton Stanley's *In Darkest Africa* which he called *In Darkest England and the Way Out.*[136]

Foreshadowing Conrad's colonial landscapes and the landscape of Forster's *A Passage to India*, the urban slums were depicted as epistemological problems—as anachronistic worlds of deprivation and unreality, zones without language, history or reason that could be described only by negative analogy, in terms of what they were not. The strangeness and density of the urban spectacle resisted penetration by the intruder's empirical eye as an enigma resists knowledge. Walter Besant's *All Sorts and Conditions of Men* described the East Enders as having no institutions of their own, no gentry, no theaters—they were describable only by negatives. Like colonial landscapes, the slums were figured as inhabiting an anachronistic space, representing a temporal regression within industrial modernity to a time beyond the recall of memory. Inhabited by people without originary capacity or reason, the East End "has little or no history."[137]

However, this collapse of history was less an attribute of underclass communities than it was a defensive feature of the middle-class interlopers, a sign of the failure of representation, disavowed and projected onto the underclasses as a condition of their racial atavism. The modernity of the middle-class explorer was illuminated by negative contrast with the atavistic archaism of the urban crowd.

At the same time, the images of imperial exploration that suffused journalistic excursions and parliamentary reports offered an imaginary technology of surveillance that both exhorted and justified social intervention. The depiction of the slums as foreign lands created an impression of apartness and distinctiveness that justified the social policy makers' voyages of enlightenment and reform. If these areas were strange, undiscovered and uncharted, they could be represented and disciplined without contest. Like the blank spaces of colonial maps, the working-class communities could—theoretically—be surveyed and contained without competition from working class or militant agency. The language of discovery was a language of disavowal and dispossession, robbing the discovered classes of originary authority and erasing their power to represent themselves as well as their power to make history. The discovered underclasses were figured as coming into being only at the sighting

of the male discoverer, whose generating gaze bestowed on them history and language—at the very moment when the working class insisted on taking militant possession of its own history.

PHOTOGRAPHY AND PANOPTICAL TIME

> A photograph is a secret about a secret. The more it tells you, the less you know.
>
> —*Diane Arbus*

> Not for nothing were pictures of Atget compared with those of the scene of a crime. But is not every spot of our cities the scene of a crime? Every passerby a perpetrator? Does not the photographer—descendant of augurers and haruspices—uncover guilt in his pictures?
>
> —*Walter Benjamin*

Fabian has explored the Western empirical tradition in which to ""visualize" a culture or society almost becomes synonymous for understanding it."[138] The tradition of scientific empiricism formulated by John Locke has as one of its most tenacious tenets the notion that "the perception of the mind is most aptly explained by words relating to the sight."[139] As Fabian puts it: "Objectivism constitutes the social world as a spectacle presented to an observer who takes up a 'point of view' on the action, who stands back so as to observe it and, transferring into the object the principles of his relation to the object, conceives of it as a totality intended for cognition alone, in that all interactions are reduced to symbolic exchanges."[140] This high point of view—the panoptical stance—is enjoyed by those in privileged positions in the social structure, to whom the world appears as a spectacle, stage, performance.

It is a characteristic of industrial modernity to survey and simulate experience. Under modernity, experience took on the character of a spectacle and the chief technology of panoptic surveillance was photography. As John Berger notes: "The speed with which the possible uses of photography were seized upon is surely an indication of photography's profound, central applicability to industrial capitalism. . . . Marx came of age the year of the camera's invention."[141]

The camera was invented in 1839. Three decades later, Berger continues, "photography was being used for police filing, war reporting,

military reconnaissance, pornography, encyclopedic documentation, family albums, postcards, anthropological records (often, as with the indigenous peoples in the United States, accompanied by genocide), sentimental moralizing, inquisitive probing (the wrongly named "candid camera"), aesthetic effects, news reporting and formal portraiture."[142]

The camera embodies the panoptic power of collection, display and discipline. As Sekula wryly notes: "Every work of photographic art has its lurking, objective inverse in the archives of the police."[143] As a technology of surveillance, photography was central to the rationalizing of working-class leisure and work time. As such, it was associated with those other panoptic Victorian phenomena—the exhibition, the museum, the zoo, the gallery, the circus—all of which involve the fetishistic principle of collection and display and the figure of panoramic time as commodity spectacle.

It should not be forgotten that photography emerged as a technology of surveillance within the context of a developing global economy. A circulation of notions can be observed between photography and imperialism. Emissaries of the imperial bureaucracy set out with the explicit, if haphazard, aim of ordering and assembling the myriad world economies into a single commodity culture. In order to centralize the world system, the need grew for a universal currency of exchange, through which the world's economic cultures could be subordinated and made docile. At the same time, to disseminate commodity capital and the "truth" of technological progress to a world audience, a centralized system of cultural communication was called for.

Photography provided the cultural equivalent of a universal currency. Like money, photography promised from the outset to embody a universal language. As one newspaper report exulted: "[Photography] is the first universal language addressing itself to all who possess vision and in characters alike understood in the course of civilization and the hut of the savage."[144] Hailed as superseding the messy enigmas of language and as capable of communicating on a global scale through the universal faculty of vision, photography shifted the authority of universal knowledge from print language to spectacle.

If the camera's claim to truth rested on the science of optics, its effect was to reorder, at a stroke, the hierarchies of world history. "Its truth raises it above all language, painting or poetry. . . . The pictorial language of Mexico, the hieroglyphics of Egypt are now superseded by reality."[145] The technological perfection of the camera and its capacity to replicate reality exactly as it is could, at last, relegate all of the world's languages to the museum of obsolescence, to mutely await the illuminating analysis of Western science. With photography, Western knowledge and Western authority became synonymous with the real.

For racial science, photography promised to provide mechanical and therefore objectively sound "factual" knowledge about racial "types," "specimens" and "tribes." In 1862, the *British Journal of Photography* announced: "Photography will furnish an excellent method of determining the mean proportions of the skulls of the different races of men."[146] For anthropology, photography offered a classificatory system for recording the diversity of the world's peoples into the universal Family of Man. For criminology, photography promised to capture "deviant" physiognomies for detection, incarceration and discipline. For medical science, photography displayed the truth of the diseased and disordered body for eugenic control. For clinical psychoanalysis, photography captured the bodily image of female hysteria, and displayed it to confirm the authority of male science over the female body in the interests of clinical normalization. Photography also promised to halt the passing of time in its tracks. As the photographer Adrien Bonfils exulted: "Progress, the great trifler, will have swiftly brought about the destruction of what time itself has respected . . . before this present that is still the past has forever disappeared, we have tried to fix and immobilize it in a series of views."[147]

The photograph, nonetheless, constituted a crisis in value between the aggressive empiricism of science, bent on achieving a "universal inventory of appearance" (a doctrine of externality) and the romantic metaphysics of inner, individual truth (a doctrine of internality). Again, the contradiction was displaced onto the feminized realm of empire. Colonial photography, framed as it was by metaphors of scientific knowledge as penetration, promised to seek out the secret interiors of the feminized Orient and there capture as surface, in the image of the harem woman's body, the truth of the world.[148]

The Orient was feminized in a number of ways: as mother, evil seducer, licentious aberration, life-giver. Jules Michelet figured the Orient as the "womb of the world."[149] The Saint Simonians saw a journey to Egypt as "no longer a voyage to the Orient, but a voyage towards Woman."[150] Edward Said notes: "Woven through all of Flaubert's Oriental experiences, exciting or disappointing, is an almost uniform association between the Orient and sex."[151] In the feminized arena of empire, the camera offered the delirious promise of resolving the abiding contradictions of industrial modernity: domesticity and empire, private and public, surface and interior, metaphysics and empiricism, hand and machine held captive as spectacle in a single image.

In the colonial image, however, these contradictions could be embodied but not resolved. The colonial photograph (especially in its

mass-produced form as postcard) is contradictory in effect. Promising to capture history at a glance and render the appearance of the world exactly as it is, the camera ironically proliferates the world. Instead of producing a finite catalog of the real, photography expands the territory of surface reality to infinity. The camera thus lures imperial modernity deeper and deeper into consumerism. Hence the intense fetishistic value invested in the colonial photograph.

In the metropolis, the commercial photographic studio became the urban space for mediating these contradictions and for mass producing imperial spectacle for popular consumption. Yet the very technology that was dedicated to reproducing as natural the social distinctions between metropolis and empire, domesticity and industry, private and public, labor and leisure and to distribute these images as natural commodities, was also, paradoxically, the form that would confound those distinctions.

By the 1860s, photography was big business. Photographic studios flourished with astonishing popularity. Cartes were cheap (sometimes as low as a sixpence) and the business of selling them boomed. By the mid-1860s, the number of cartes produced each year ran into millions.[152] People, most often women, were posed before artificial backdrops, often exotic and incongruously out of keeping with the sitter's world, but expressive nonetheless of fantasies of imperial control over space, landscape and interior.

In the photographic studio, exotic time was reproduced as exotic spectacle, as panoptical time. Drooping languidly against a backdrop of pyramids, or an image of palm trees, or next to a Grecian pillar, the sitter seems subtly to inhabit a different temporal zone. In colonial postcards, primitive icons and atavistic relics were arranged around sitters to metonymically signify an anachronistic relation to the technological time of modernity. In the colonial postcard, time is reorganized as spectacle; through the choreographing of fetish icons, history is organized into a single, linear narrative of progress. Photography became the servant of imperial progress.

The photographic studio, however, was itself a contradictory space, inhabiting as it did the thresholds of private and public, artisan and industry, commerce and art, domesticity and empire. The photographic studio, in the labor of rendering these distinctions natural and technically reproducing them for mass consumption, simultaneously displayed them as extravagant artifice, invention and theater. Photographers relied heavily on props, exotic decor and elaborate backdrops. In these domestic interiors, the new middle class posed against elaborately staged public scenes of empire. At the same time, domestic portraits, pornographic images and intimate, interior images were mass-produced for public consumption—in

postcards, newspapers, magazines, billboards, posters and later, advertising. Commodity spectacle, constantly crossing between private and public, began to undermine the very distinctions it was dedicated to uphold as natural. In Chapter 4, I explore this process in more detail in my discussion of the historical emergence of imperial advertising. The situation is not static, however, for in transgressing the boundary between private and public and staging the contradiction as spectacle, the commodity spectacle offers the perpetually deferred hope of resolving the contradiction, luring the spectator deeper and deeper into consumerism.

Photography was both a technology of representation and a technology of power. Maxine du Camp, who accompanied Flaubert to Egypt and Palestine in 1848 and 1849 on one of the best-known photographic tours, explicitly voices the violence inherent in the photographic relation: "I told him [a reluctant sitter] that the brass tube of the lens jutting out from the camera was a cannon, that would vomit a hail of shot if he had the misfortune to move—a story that immobilized him immediately."[153] Another colonial photographer made explicit the calculated use of the camera's fetish power: "I frequently enjoyed the reputation of being a dangerous necromancer and my camera was held to be a dark, mysterious instrument that, combined with my naturally, or supernaturally intensified eyesight gave me power to see through rocks and mountains, to pierce the very souls of the people and to produce miraculous pictures by some black art."[154] The immobility of the sitter conceals behind the surface of the photograph the violence of the colonial encounter. With this in mind, we can return one last time to Munby.

SCOPIC IMPERIALISM AND "THE INSPECTOR"

In the 1870s, on his compulsive meanderings through London's streets, Munby began to notice the little news shops and photographer's windows that sprang up all over London, displaying a welter of startling images of working women and men. Until then, Munby had been in the habit of illustrating his accounts of working women with pen-and-ink sketches, which he carried back to his rooms to savor in libidinal privacy. Photography promised Munby new opportunities for his scopophilic needs and with the intention of amassing a personal archive of the female classes, he resolved to begin a photographic collection. Over the years his collection swelled to more than six hundred photographs and survives as one of the major photographic archives of Victorian women.

Apart from verbs of travel ("went," "passed," "set out"), the verbs that surface repeatedly and ritualistically in Munby's diaries are verbs of surveillance: "watched," "saw" and "looked." Not for nothing did the

FIGURE 2.24 "THE INSPECTOR": MUNBY WITH A WIGAN PIT WOMAN.

Wigan women mockingly nickname the odd intruder who traveled hundreds of miles to visit them "The Inspector" [Fig. 2.24].

Munby visited photographic studios in tireless search of rough, realistic photographs of working women. He visited the Royal Academy and the annual exhibitions of the Photographic Society of London and repeatedly bemoaned the dearth of images of "strong red-handed" wenches.[155] He would ask photographer's doormen to approach passing women and persuade them to pose for a photograph in exchange for a few pence. The arranging of the women's bodies in front of the camera's eye, the spectacle of their discomfort and embarrassment, the touching of hands at the moment of payment, his possession of the images in the privacy of his male room all offered him a simulated, voyeuristic intimacy with working women that was unavailable through any other means. More than anything, the photograph afforded Munby the voyeuristic illusion of penetrating the forbidden spaces of working class female life, but in ways that did not compromise his control over the dangerous crossings of class, race and gender.

What is the relation of power between photographer and sitter? One notes in Munby's voyeurism the pleasure of deferred control. With the camera, his voyeurism achieved the heightened pleasure of technical mastery over women. His diary accounts of photographic sessions reveal a fantasy of sadistic omnipotence over the women who sat for his pleasure. On one occasion, at his behest, a photographer's doorman managed to persuade a bemused and reluctant dustwoman to tramp upstairs to be posed. The occasion reveals a telling inversion of gender identity and a sadistic pleasure underlying his control of the inversion. He records the woman tramping upstairs "like a ploughman," where, much to his amusement, two milliners survey "their coarse masculine sister" in disgust and astonishment. Munby arranges her—carefully keeping his gloves on— with her strong feet before her and delightedly notes the contrast she makes with the other women and implicitly with himself. Most tellingly, he records her discomfort at sitting as "a punishment . . . wuss than a day's work."[156] Having been paid, she tramps off in a "rude manlike way. . . . "[157] As always, Munby feigns innocence in his undertakings, but others are not convinced of his purely sociological intentions. On this occasion, the pornographic logic of his pleasure does not escape the doorman, who whisperingly offers him a woman "with her clothes up." A shabby-genteel man outside likewise approaches him with an offer of a ballet girl or artist, but Munby ostentatiously professes offended disinterest, and later wonders why his desire to photograph a dustwoman should produce these "offensive results."

Hannah Cullwick, as the center of his voyeuristic fantasy life, was soon brought under the camera's eye and Munby noted with pleasure her

apparent submissiveness under his hands: "With what meekness she submitted to be posed and handled and discussed to her face; the coarseness of her hands examined and the best mode of showing them displayed!"[158] Cullwick dressed to be photographed as a "rural maiden," a maid-of-all-work "carrying slop pails," "scrubbing steps," as a "middle-class lady," as an "angel," as a male "slave," and as a gentleman. Yet I will argue in Chapter 3 that the contradictory nature of the fetish conceals a lesson. Despite Munby's grand illusions about Cullwick's "submission," the staging of the photographic fetish meant very different things to them. The value of the fetish was contradictory and Cullwick's far from submissive attempts to manipulate their scenarios reveal an alternative narrative of female agency and power.

Through photography, Munby indulged the illusory fantasy of managing—as spectacle—the dangerous contradictions that marked his childhood identity. From his panoptic position as voyeur, Munby turned the dominant contradictions of his time—between private and public, labor and leisure, empire and metropolis—into a circus of images in which he was both ringmaster and privileged spectator. He could not control these dimensions in reality: neither his family nor his social class would condone his marriage to Cullwick, so the contradictions between his mother and nurse could never be resolved publicly in the figure of wife. Instead, he created a private fetish-world in which he could control these contradictions as spectacles. Munby thus achieved the illusion of mastery over women, as well as over the female dimension of his own identity, through two essential means: voyeuristic control of spectacle (pornographic mastery) and money (economic mastery). Munby's pleasure is thus entirely the pleasure of the exhibitor. The photograph's exhibition value became a private stock of imaginary capital that he hoarded in secret.

The logic of voyeurism and hence part of the logic of the pornographic imagination is founded originally in *loss* of control. The pleasure arises from mastering in fantasy a situation that is fundamentally dangerous and threatening. If a restraint on sexual pleasure provokes anxiety and loss of power, the pleasure of voyeurism involves the deliberate, controlled reenactment of the loss and its subsequent mastery. Voyeurism dramatizes the violation of a threshold: the keyhole, the window, the camera aperture. Voyeurism acknowledges a barrier to pleasure, a limit to power and then transgresses the limit, reclaiming power in a forbidden excess of pleasure. Indeed, the fact that an act is forbidden makes it pleasurable. Voyeurism expresses a refusal to accept a boundary to the self and its pleasures. In short, the barrier (the fear) is intrinsic and necessary to the structure of the pleasure. Hence the repetitive, perpetually deferred pleasure of voyeurism.

Munby's photos of Cullwick reveal an archive of nostalgia. Allan Sekula has said that the experience of the photograph characteristically veers between "nostalgia, horror and an overriding sense of the exoticism of the past."[159] All of these elements are present in Munby's photographs. His photographs are redolent of historical nostalgia for the passing away of female manual labor and thus the passing away of aristocratic mastery over the female serf. He looks at women as if they were a vanishing species, soon to disappear from the face of the earth: "I looked at them with special interest: for I knew that they would be the last of the carboniferous wenches; of the trousered peacoated Brynhilda maidens of the Wigan coalfields, who wear men's clothes and are strong, to do men's work."[160] The photographs reveal nostalgia for complete mastery of the female body in the vanishing world of imperial slavery. At the same time, they are redolent of personal nostalgia for Munby's lost world of symbiotic identity with his nurse and thus nostalgia for the repressed female dimensions of his own identity.

The evocation of the fetish occurs in "an area of sentiment bounded by nostalgia on one end and hysteria on the other."[161] Munby's socially sanctioned power to manage the contradictions of his identity through voyeurism and money enabled him to ward off their perilous implications; but there were telling occasions when he lost control and was plunged into emotional disarray.

His diary records, for example, his helpless fury on coming upon a photograph in *The Pictorial World* of Wigan women at work. The sight struck him "all of a heap": "What right had this artist to poach on my manor, to exhibit my heroines thus and perhaps send people to see and spoil them, or to try and "put them down?" Here, the relation between spectacle and male competition enacted through the medium of the female body is fully manifest. It seems implausible that the intensity of Munby's response flowed simply from an altruistic concern for the well-being of the women, as Hiley suggests. His turmoil at the sight of his "heroines" being seen and exhibited by other men reveals the depth of his emotional need to maintain a monopoly of visual power over the spectacle of women working. Moreover, the language he uses ("poach on my manor") betrays the fact that possessing working women through a phantasmagoria of the spectacle was associated in his fantasy life with possessing an anachronistic class privilege—a male privilege that gave him honorary membership in the manorial upper classes. The image of "poaching" on manorial property reveals an inner logic of possession and propertied class power, maintained through voyeuristic control of the female body at work. Here two contradictory economic orders (the manor and the mine, serfs and waged workers) collapse into one another.

The camera allows Munby to stand at the intersection of two worlds, trespassing across race, class and gender boundaries in a way that no other medium provided. At the same time, Munby's description of the women as "heroines" reveals their role as fictive subjects in an upper-class scenario of which he is the sole author. In short, his power to control the spectacle of the laboring female body is a voyeuristic substitute for economic and psychological control.

"The delight of the urban poet," writes Benjamin, "is love—not at first sight, but at last sight. It is a farewell forever that coincides in the poem with the moment of enchantment." So for Munby the photograph was a farewell forever to a lost world of female labor captured and held in the moment of frozen enchantment. The photograph represented the fetish of urban love at last sight.

IMPERIAL LEATHER

RACE, CROSS-DRESSING AND THE CULT OF DOMESTICITY

3

Wife and servant are the same, but only differ
in the name.

—*Lady Chudleigh*

The wife became the head servant.

—*Friedrich Engels*

In May 1854, at the age of 25, Arthur Munby stopped a maid-of-all-work in the street [Fig. 3.1]. The encounter was as casual as any of the hundreds that filled Munby's wanderings, yet the woman was destined to become his lifelong companion and wife. Almost immediately, Hannah Cullwick and Arthur Munby embarked on an intense but clandestine love affair that lasted the rest of their lives. After nineteen years, they married

secretly, though they lived in the same house for only four years and then, to all appearances, only as master and housemaid.

Cullwick and Munby both record in their diaries that they instantly felt destined for each other.[1] In a sense, it was no accident that the maid-of-all-work and the barrister met in the street. In the promiscuous crowd—that element permanently on the verge of social confusion—classes mingle, strangers brush each other, women and men rub shoulders and part. As Benjamin writes: "A street, a conflagration, or a traffic accident assemble people who are not defined along class lines."[2] Cullwick and Munby took sustenance from the crowd, pitching their strange fantasy life on the borders of social limits—gender and race, paid and unpaid work, domesticity and empire. Their sense of destiny, moreover, bore witness to the social force of the Victorian edicts they so scandalously flouted in private and so decorously affirmed in public. At the same time, the chance encounter, the forbidden meeting across social limits reveals itself as a recurrent theme in the domestic and racial fetishism that structured their lives, indeed, that structured Victorian society at large.

FIGURE 3.1 HANNAH CULLWICK.

FIGURE 3.2 THE SLAVE-BAND.

FIGURE 3.3 FETISHISM ON DISPLAY.

FIGURE 3.4 NOTHING TO USE
BUT HER CHAINS.

FIGURE 3.5 CULLWICK IN HER DIRT.

FIGURE 3.6 CULLWICK CROSS-
DRESSED AS A LADY.

FIGURE 3.7 CLASS TRANSVESTISM.

FIGURE 3.8 CULLWICK CROSS-DRESSED
AS A FARM WORKER.

FIGURE 3.9 GENDER PASSING:
CULLWICK AS A MAN.

FIGURE 3.10 CULLWICK AS AN ANGEL.

FIGURE 3.11 RACE AND GENDER TRANSVESTISM: CULLWICK AS A MALE SLAVE.

Leonore Davidoff has vividly evoked the games and fetish rituals Cullwick and Munby staged for their mutual pleasure when together and relived in their diaries when apart.[3] Munby later excised from his diaries the details of the "training" he claims he gave Cullwick, but we know she chose to address him by the imperial title "Massa" and that she wore a "slave-band" on her wrist and a locked chain around her neck (to which only Munby had the key) as proof of her "bondage" [Figs. 3.2–3.4]. We know that she would kneel, lick his boots and wash his feet to profess her love and servitude.[4] She posed for numerous photographs: as her working self in "her dirt"; cross-dressed as an upper-class lady; as a rural maiden, a man, an angel, a male slave, and "almost nude" and blackened from head to foot as a male chimneysweep [Figs. 3.5–3.11].

When they married secretly after nineteen years, she cross-dressed as an upper-middle class lady and traveled with Munby around Europe. Back in London, she would arrange to theatrically scrub the front

doorsteps on her knees as Munby sauntered down the street, languidly swinging his cane [Fig. 3.12]. He checked in at a boardinghouse where she worked, to be served by her as if they were strangers, then to meet her on the clifftops nearby, kissing and giggling and savoring in secret the knowledge of their forbidden liaison. When they lived within reach of each other, Cullwick visited Munby frequently "in her dirt" after a grueling day's work, her clothes dank and filthy, her face deliberately blackened with boot polish, her hands red and raw; only to pose later that same evening freshly dressed as an upper-class lady in clean finery. They spent happy hours mulling over the ordeals of her workload, ritualistically counting and recounting the incredible number of boots she cleaned. On a couple of occasions at her other employer's house, Cullwick stripped naked except for a blindfold and climbed into the chimney, where she curled in the warm soot "like a dog," savoring the sensation later in her diary for Munby's delectation. Her diary reveals (as his does not) that she also lifted him in her huge, brawny arms, cradled him on her ample lap and "nursed" him like a child.

FIGURE 3.12 DANGEROUS THRESHOLD:
THE DIRT FETISH ON DISPLAY.

Over the years, Cullwick wrote a voluminous diary, first at Munby's behest, later for more complex reasons of her own, in which she recounted the daily regimen of her domestic work and her curious life with Munby. Both of their diaries reveal, though differently, a profound and mutual involvement in a variety of fetish rituals: slave/master (S/M), bondage/discipline (B/D), hand, foot and boot fetishisms, washing rituals, infantilism (or babyism), cross-dressing, and a deep and mutual fascination with dirt. Fundamentally, the scripts for their fantasy life involved theatrically transgressing the Victorian iconographies of domesticity and race, and their fetish rituals took shape around the crucial but concealed affinity between women's work and empire. In what follows, I will argue that their fetishism inhabited the borders of a double disavowal by dominant Victorian society: denial of the value of women's domestic work in the industrial metropolis and the devaluing of colonized labor in the cultures coming under violent imperial rule. What is the meaning of Cullwick and Munby's rituals, belonging as they do in the realm of the fetish? What, in particular, is the relation between fetishism, domesticity and empire?

The Freudian definition of the fetish gives privileged normality to male heterosexuality and the scene of castration. Instead, I wish to explore fetishism as a more complex, historically diverse phenomenon that cannot be reduced to a single, male, sexual narrative of origins. I wish to challenge the primacy of the phallus in the realm of fetishism and open the Freudian and Lacanian theories of fetishism to a more varied and complex history in which class and race play as formative a role as gender.

The presiding contradiction animating Cullwick and Munby's fetishism is, I suggest, the historical dichotomy between women's paid work and women's unpaid work in the home—overdetermined by the contradictions of imperial racism and negotiated by the fetishistic iconographies of slave and master, dirt and cleanliness, rituals of recognition and cross-dressing. In contrast to the idea of fetishism as a quintessentially male preserve, Cullwick takes her place among the countless women for whom fetishism was an attempt—ambiguous, contradictory and not always successful—to negotiate the boundaries of power in ways that do not yield simple lessons about dominance and submission.

The fetish, which inhabits the border of the social and the psychological, throws into sharp relief the invalidity of separating the realms of psychoanalysis and social history. Both psychoanalysis and Marxism took shape around the idea of fetishism as a primitive regression and the disavowal of the social value of domestic work, so it is only fitting that the fetishistic proclivities of an obscure maid-of-all-work should oblige us to begin, again, to renegotiate the relation between

psychoanalysis and social history, women's agency and male power, domesticity and the market.

What follows is less an attempt to empirically recover the past than it is an attempt to intervene strategically in historical narratives of race and fetishism, domesticity and empire, in such a way as to throw into question not only the historical force of these relations in Victorian Britain but also their continuing implication for our time.

NO PYGMALION
AMBIGUOUS AGENT

Munby and his biographer, Derek Hudson, both portray Cullwick as little more than a cloddish, if charming, marionette, a curiosity trained, costumed and controlled by her "Massa," lumbering through her awkward theatrical paces to indulge his pleasures.[5] In later years, Munby claimed it was he who apprenticed Cullwick to drudgery: "training and teaching" her in the "lowest & most servile kind (of work)," initiating her into subservience and the indecorous degradations of their love.[6] When Cullwick refused to "enter society" as his wife, Munby lamented that she had heeded his "training" too well and had become permanently wedded to drudgery. Cullwick is likewise seen by Hudson as little more than the "product of (Munby's) training of her in the ways of salvation through drudgery."[7] Hudson finds, in consequence, that Cullwick's diaries and letters need "be sampled only briefly."[8] Even Leonore Davidoff, in an otherwise excellent essay, presents a one-sided portrait of their relationship and sees Munby as the master of ceremonies of Cullwick's life, the impresario and choreographer of their rituals, Svengali to her Trilby. Hudson and Davidoff thereby both become complicit with Munby's self-congratulatory vision of himself as Pygmalion, sculpting Cullwick's values as if from stone and instilling in her an "over-commitment to drudgery." "In many ways," Davidoff writes, "Hannah was, in fact, a creature of his fancy."[9] As Davidoff sees it, their relationship was conducted "on his terms and ultimately at a very high price." "All this happens," she writes, "at the will of the middle class male protagonist who creates the situation and engineers the transformation."[10] Once more, the maidservant vanishes from the middle-class narrative.[11]

Liz Stanley, however, in an excellent introduction to Cullwick's diaries, protests these patronizing and dismissive portrayals of Cullwick. To accept only Munby's account of matters and to see Cullwick as no more than Munby's creation runs the very real risk of accepting "Victorian sexist and classist thinking as an accurate reflection of the social world as it actually was." Rather, she argues, Munby's writings are "frequently belied

by the reality of experience."[12] Certainly they are belied by Cullwick's frequently contrasting perspectives. There is ample evidence in her diary and in Munby's, if read against the grain, that Cullwick invented as many of the scenarios and scripted as much of the game-playing as Munby did. It is also clear that she received a good deal of pleasure and power from doing so, despite the unremitting disadvantage of her situation. Far from being a passive drudge, she was stubbornly and steadfastly protective of her own interests and fiercely resisted Munby when her needs came into conflict with his. The critical portrayal of Cullwick as hapless jade and abused plaything serves only to annul the self-respect and agency she struggled so long and so stubbornly to achieve, under circumstances of extreme circumscription. Indeed, the erasure of Cullwick's lifelong resistance to limitation presents a sad irony, for one might say that the project that animated her obscure and arduous life was the project of the social recognition of women's domestic work.

Certainly it was not Munby who initiated Cullwick into the ambiguous value of pride in working-class labor, for her beloved mother and working-class community, the church, the charity school, the village and the nearby manor had already shaped the foundations of her identity and her attitudes to work. To see Munby as the only and originary shaper of her identity is to capitulate in a dominant Victorian middle-class fantasy: the fantasy of male, philanthropic surveillance and control over the lives of working-class women. At the same time, Cullwick's relationship with Munby was inevitably informed by the discrepancy between her considerable power within the relationship and her social disempowerment outside it, a discrepancy that Munby was not at all averse to exploiting when he could.

I do not wish, however, to give the impression that Cullwick's relation to Munby was one of libertarian equality and mutual power; such a notion is insupportable. I am interested, rather, in the more difficult question of what kind of *agency* is possible in situations of extreme social *inequality*. Cullwick's life expressed a sustained determination to negotiate power within circumstances of great limitations, in ways that raise questions not about her cross-gender and cross-class relations with Munby, but also about her cross-class and inter-gender relations with her female employers. Within domestic households, the unequal burden of women's work, the mutual recriminations, class harassments and class rebellions took place within a combination of class estrangements and gender intimacies. In short, a major theoretical concern of this chapter is to explore the strategic tension between social constraint and social agency.

In what follows, I wish to question one feminist tendency to see women as unambiguous victims, a tendency that equates agency with context, body with situation, and thus annuls possibilities for strategic refusal. In this

view, Cullwick is reduced to a victimized drudge, exhibited as the embodiment of female degradation and male dominance. If she was not an unambiguous victim, however, she was also not an unambiguous heroine of female revolt. Her circumstances were unremittingly harsh and disadvantageous; yet within their conscription she engaged in a lifelong negotiation of power, throwing continually into question the binary verities of dominance and resistance, victim and oppressor. What, then, of Cullwick's agency and desires in these curious rituals?

Hannah Cullwick's childhood was the commonplace story of a girl destined for a lifetime of service in Britain's ruling households. Daughter of a lady's maid and a saddler, she was born on May 26, 1833, in the Shropshire village of Shifnal. Her mother, Martha Cullwick, worked for the lady of the Hall and her father worked as a stableman. Her parents thus served the vanishing world of the ancient gentry, where power was invested in land, and the landless classes related to the manorial class through ancestral codes of duty, fealty and paternalism. Although Cullwick died in the village of her birth on July 9, 1909, she spent her life as a lower servant moving between the rural manorial estates and the urban houses of the manufacturing elite in London and Margate.[13] In the imperial dockyards, merchant banks, factories and mills, power was invested in capital and the far-flung lootings of empire, and the working class related to the new masters through the unreliable dynamics of the cash nexus. Cullwick's life thus straddled the dwindling world of the gentry and the ascendant world of industrial manufacture and, if her childhood was in almost every respect ordinary, her life would criss-cross some of the deepest faultlines of the Victorian age.

Born in a rustic cottage in Shropshire, Cullwick spent most of her life in the belching cities, working as a pot girl in an inn, as a nursemaid, a kitchen maid, a scullion and drudge and a rural stranger in the huge, begrimed houses of the Victorian urban elite. In the heyday of the "idle woman," she grew muscular with manual labor. Destined by class to wed a laboring man, she married instead a member of the upper-middle-class bureaucracy. As a barrister's wife, Cullwick could have "entered society," but chose instead to live as a maidservant among her own class, spending very little time under the same roof as her beloved husband. In an age when wifely services were void of economic value, she insisted that her husband pay her monthly wages. At a time when most women devoted two-thirds of their lives to raising children, she remained childless. When most women of the age were illiterate, she could read and write and left behind seventeen diaries, which render in intimate detail the Herculean feats of her domestic toil. Her life was nondescript and her death caused no stir, but in retrospect her diaries offer a rare and important testimony to the

life of a Victorian servant. Cullwick's diaries bear invaluable witness to "the last generation of women that did heavy manual labor in large numbers."[14]

In 1851 Cullwick traveled with her employers to London, the rhythms of her life following the class logic of their seasonal migrations.[15] In London a prescient vision in the fire showed her Munby's face. In 1854, she returned to London, where Munby approached her in the street. When she returned again the following year, she found lodgings in a cold, tiny room: "There Massa came to see me again, & there was where I first black'd my face with *oil & lead*."[16] At Cullwick's instigation, the couple began their lifelong career in domestic and racial fetishism and soon after, Cullwick began to write the first of her seventeen diaries.

NOTHING TO USE BUT YOUR CHAINS
S/M AND DOMESTIC POWER

Cullwick and Munby filled their lives with the theatrical paraphernalia of S/M: boots, chains, padlocks, leather, blindfolds, straps, costumes, scripts and photographs—some of them semi-pornographic. Their games included a variety of fetish rituals: transvestism, bondage, foot and leather fetishism, hand fetishism, washing rituals, infantilism, animalism and voyeurism. The primary transformations about which their fantasy games revolved were the central transformations of industrial imperialism: class (servant to mistress), race (white woman to black slave), gender (woman to man), economy (land to city) and age (adult to baby), transformations that were drawn simultaneously from the cult of domesticity and the cult of empire.

As Liz Stanley notes: "Chains, boot-licking and blacking up the better to show the abasement of a slave to a master aren't just images of servitude in a conventional and often religious sense; they are also images replete with sado-masochistic and sexual overtones."[17] Yet Stanley quickly rejects "the usefulness or appropriateness of labeling (their relationship) as sado-masochistic."[18] For, she argues, while people in S/M scenarios may change roles, we see "at any one time whoever is the 'master' has power and whoever is the 'slave' has not." Since Cullwick was neither powerless nor slavish in this "conventional" sense, but was rather "strong, stubborn, independent, assured and competent," the term *sadomasochism*, Stanley contends, has no usefulness for understanding Cullwick and Munby's power games.[19]

Stanley also rejects S/M as no more than the retrospective imposition on the past of images and terminology from the present. Yet it is no accident that the historical subculture of S/M emerged in Europe toward the end of the eighteenth century with the emergence of imperialism in its modern industrial form. As Foucault points out, S/M (which is not simply

synonymous with cruelty or brutality) is a highly organized, ritual subculture that "appeared precisely at the end of the eighteenth century"— a few decades before Cullwick and Munby were born.[20]

Late Victorian racial scientists demonized S/M as the psychopathology of the atavistic individual, a blood flaw and stigma of the flesh.[21] The "sciences" of man—philosophy, Marxism, anthropology, psychoanalysis—sought to contain the irruptive implication of fetishism by projecting it onto the invented zone of "degeneration," figuring it as a regression in historical time to the prehistory of racial degradation, the degeneration of the race writ in the pathology of the soul. S/M, however, is less a biological flaw, or a pathological expression of natural male aggression and natural female passivity, than it is an organized subculture shaped around the ritual exercise of social risk and social transformation. As a theater of conversion, S/M reverses and transforms the social meanings it borrows.

To argue that in S/M "whoever is the 'master' has power and whoever is the slave has not," is to read theater for reality; it is to play the world forward. The economy of S/M, however, is the economy of conversion: master to slave, adult to baby, power to submission, man to woman, pain to pleasure, human to animal and back again. S/M, as Foucault puts it, "constitutes one of the greatest conversions of Western imagination: unreason transformed into delirium of the heart."[22] S/M is a theater of transformation; it "plays the world backward."[23]

Consensual S/M (the collective organization of fetishism) insists on exhibiting the "primitive" (slave, baby, woman) as a *character* in the historical time of modernity. S/M performs the "primitive irrational" as a dramatic script; a theatrical, communal performance in the heart of Western reason. The paraphernalia of S/M (boots, whips, chains, uniforms) is the paraphernalia of state power, public punishment converted to private pleasure. S/M plays social power backward, visibly and outrageously staging hierarchy, difference and power, the irrational, ecstasy, or alienation of the body, placing these ideas at the center of Western reason. S/M thus reveals the imperial logic of individualism and refuses it as fate, even though it does not finally step outside the enchantment of its own magic circle.

Hence the paradox of S/M. On one hand, S/M parades a slavish obedience to conventions of power. In its reverence to formal ritual, it is the most ceremonial and decorous of practices. S/M is high theater: "beautifully suited to symbolism."[24] As theater, S/M borrows its decor, props and costumery (bonds, chains, ropes, blindfolds) and its scenes (bedrooms, kitchens, dungeons, convents, prisons, empire) from the everyday cultures of power. At the same time, with its exaggerated emphasis on costumery, script and scene, S/M reveals that social order is unnatural, scripted and invented.

For Victorian science, nature was the overlord and guarantor of power. Thus for Krafft-Ebing, S/M enacts the male's "natural" sexual aggression and the female's "natural" sexual passivity: "This sadistic force is developed by the natural shyness and modesty of women toward the aggressive manner of the male . . . the final victory of man affords her intense and refined gratification."[25] The outrage of S/M, however, is precisely its hostility to the idea of nature as the custodian of social power. With the utmost artifice and levity, S/M refuses to read power as fate or nature and outrageously reverses the sacramental edicts of power and abandonment. Since S/M is the theatrical exercise of social contradiction, it is self-consciously *antinature*, not in the sense that it violates natural law, but in the sense that it denies the existence of natural law in the first place. S/M presents social power as sanctioned, neither by nature, fate nor God, but by artifice and convention and thus as radically open to historical change. S/M flouts social order with its provocative confession that the edicts of power are reversible. As such, it is a radically *historical* phenomenon.

S/M AND THE CULT OF DOMESTICITY

Cullwick's lifelong power over Munby lay in her theatrical talent for conversion and her power to play the world backward: to switch from maid to mistress, wife to slave, nurse to mother, white woman to black man. She was the dreamed-of combination, the "Blessed Anomalie" that allowed Munby to stage in his own private theater of transformation the fateful early contrasts of gender and class that both perplexed and enthralled him. Munby records his first sighting of her in his diary:

> A country girl, she was, a scullion. . . . A tall erect creature, with light firm step and noble bearing: her face had the features and expression of a high born lady, though the complexion was rosy and rustic, & the blue eyes innocent and childlike: her bare arms and hands were large and strong and ruddy from the shoulder to the finger-tips; but they were beautifully formed. . . . A robust hard-working peasant lass, with the marks of labour and servitude upon her everywhere: yet endowed with a grace and beauty, an obvious intelligence, that would have become a lady of the highest. Such a combination I had dreamt of and sought for; but I have never seen it, save in her.[26]

For Munby, Cullwick was a paragon of ambiguity: a country girl who trod the urban streets, a scullion formed like a high-born lady. She bore the marks of labor, but with aristocratic grace. She was both innocent and worldly-wise. She was a child, but as strong as a man. By playing both

drudge and lady, woman and man, Cullwick offered Munby the delirious promise of embodying in one person the contrast of mother and nurse, woman and man, that so excited him: "Let me," he wrote, "at least work out some of my theories upon this tender servant: let me be refreshed and comforted by a mother's love and by that of one so different."[27] Cullwick's abiding attraction for Munby was her talent to play "either part so well." He recalls her sitting after a day's drudgery "dainty in black silk and drawingroom cap . . . for is she not a servant during the day and a lady in the evening? and fulfills either part so well, that for some time she seems incapable of the other?"[28] "One moment she is the very pattern of a kitchen drudge, awkward and strong, hard at work in sweat and dirt." In the next instant, she transforms herself "into the perfect image of the still and stately queen [Fig. 3.13, 3.14]."[29]

Cullwick offered Munby the illusion of control over the contradictions that shaped his identity. He relished her muscular brawn and her "manliness," that allowed him to feel, by contrast, deliciously "female," yet in such a way as not to endanger his precarious, compulsory

FIGURE 3.13 CULLWICK AS A DRUDGE.

FIGURE 3.14 CULLWICK PASSING AS A LADY.

manhood.[30] And by indulging the fantasy that he was master of their ceremonies, Munby indulged in what John Berger has called the "Pygmalion Promise"—the (infantile) desire to shape another being's life according to the dictates of one's own desires. But since Munby's "mastery" over Cullwick was no more than her theatrical gift to him, which she had the power to withdraw at any time (and did), and since the contradictions that vexed him were social contradictions that could not be resolved at a personal level, the fetish scene was destined to recur again and again.

S/M is a theater of signs. Munby was helplessly fascinated by the visible and written *signs* of Cullwick's domesticity. The representation of domesticity as social and imperial allegory held him in its thrall. Obsessed with writing, Munby demanded that when Cullwick could not appear physically in the "sign" of her dirt, she send him verbal signs instead in the form of her diary. And Cullwick, in turn, learned quickly to use her diary

and her theatrical performances to manipulate Munby's desires and maintain control over him.

Indeed, it was not so much the actuality of female labor that captivated Munby but the *representation* of labor: labor as spectacle, as photograph, as language, as diary, as sketch, as script, as theatrical scene. He and Cullwick played their fetish games around the theatrical para-phernalia of domesticity: brooms, pails, water, soap, dirt—fetishes that cannot, in my opinion, be usefully reduced to a single-minded phallic logic. In their theater of conversion, mundane household objects became invested with profound fetish power, as ambivalent signs of domestic subordination and domestic power. Why the stress on signs?

As a theater of signs, S/M grants temporary control over social risk. By scripting and controlling the *frame* of representation, in other words, the control frame—the diary, the camera, the theatrical scene—the player stages the delirious loss of control within a situation of extreme control. For Munby, loss of control and confusion of social boundary were mediated by an excessive preoccupation with control. He depended deeply on control frames, by which he managed the staging of social risk. Managing the control frame—the photograph, the sketch, the diary, the script, the circus and, in particular, the exchange of money—was indispensable to his sense of mastery over what were otherwise terrifying ambiguities.

S/M is haunted by memory. By reinventing the memory of trauma and staging loss of control in what is really a situation of excessive control, the player gains symbolic power over perilous memory. S/M affords a delirious triumph over memory and, from this triumph, an orgasmic excess of pleasure. But since the triumph over memory is theatrical and symbolic, however intensely felt in the flesh, resolution is perpetually deferred. For this reason, the memory (the scene) will recur for perpetual reenactment, and compulsive repetition emerges as a fundamental structuring principle of S/M.

One tendency within feminism has been to demonize heterosexual S/M as the sanctioned exercise of male dominance over women. "Sadomasochism is self-debasement on all levels that renders wimmin unable to execute truly feminist goals."[31] But, more often than not, S/M culture often reveals the opposite: "In the world of the sadomasochist, there is nothing 'abnormal' about a male being passive and submissive. Indeed, male passivity is by far the most common phenomenon."[32] It is therefore not surprising that Munby was what is, in current parlance, called a "babyist," or "infantilist," relishing, as he did, to be bathed by Cullwick, lifted in her massive arms and rocked and "nursed" on her ample lap like a baby.[33] Perhaps in these encounters Munby could surrender deliriously to the memory of his helplessness in his first nurse's arms, to voyeuristic pleasure at the spectacle of a working woman tending

his passive body and to forbidden recognition of the social power of working-class women.

The contradiction that Munby faced was his dependence on working-class women whom society stigmatized as subservient. By ritually recognizing Cullwick (like his nurse) as socially powerful, he could acknowledge his forbidden childhood identification with powerful femininity, particularly working-class femininity. His foot-washing fetish was an expiation ritual that symbolically absolved him from guilt and "dirt" while simultaneously letting him indulge in the forbidden, voyeuristic spectacle of women's work and women's power. Nonetheless, the recognition of domestic work as valuable was socially taboo and had to be mediated and controlled through carefully prearranged scripts.

On one occasion, for example, Cullwick asked Munby to visit her at her workplace. Once there, he was plunged into agitation and extreme distress. "But to see her stand in a drawing room in her servant's dress and know that she is a servant and that the piano, the books, the pictures belonged to her mistress . . . this I could not endure."[34] Seeing Cullwick in her workplace forced Munby into the agonized recognition that he did not really control, or own, her life. On another occasion he was appalled to visit her workplace and see how truly filthy and exhausted she was. What bothered him to distraction on both occasions was the collapse of his control frame and thus loss of his illusion of mastery over the scene. Seeing Cullwick at work was a forcible reminder that another woman paid her wages, another woman gave her orders. Just as he was thrown into outrage at the sight of another journalist photographing "his" pit-brow-women, the sight of Cullwick at work robbed Munby of his illusion that he controlled the dangerous scenario, and he was flung violently into crisis.

Role switching is a common feature of S/M and in their secret society of the spectacle Cullwick and Munby often switched roles. Most S/M is less "the desire to inflict pain," as Freud argued, than it is the theatrical organization of *social risk*.[35] Contrary to popular perceptions, a great deal of S/M involves no pain at all. Its ritual violations are less violations to the flesh than symbolic reenactments of the memory of violations to selfhood, violations that can take myriad forms. As Weinberg and Kamel argue, "S&M scenarios are *willingly and co-operatively* produced; more often than not it is the masochist's fantasies that are acted out."[36] Many S/M fetishists claim that in fact it is the "bottom" who is in control.

Havelock Ellis points out that much S/M is motivated by love. Far from being the tyrannical exercise of one will upon a helpless other, S/M is more typically collaborative, involving careful initiation rituals, a scrupulous definition of limits and a constant confirmation of reciprocity

that can bind the players in an ecstasy of interdependence: abandonment at the very moment of dependence. But because S/M involves the negotiation of perilous boundaries, any violation of the script is fraught with risk, whereas mutual fidelity to the pledge of trust creates an intimacy of a very intense kind. If at any point control is lost, or the rules of the game transgressed, either of the players can be plunged into panic. Hence the importance and prevalence of scripting in consensual S/M.

THE SLAVE-BAND
REFUSING ABJECTION

For years Cullwick wore a filthy leather "slave-band" on her wrist and a chain and locked padlock around her neck. Her original reason for wearing a strap, she tells us, was to support her wrist after a bad sprain.[37] Later she wore it as a "sign" of her love for and servitude to Munby. When she insisted on wearing the strap while serving dinner, letting it show on her wrist before the invited company, her employer ordered her to remove it. Cullwick declined to obey and was furiously dismissed, preferring, as she proudly records in her diary, to lose her employment rather than take off "the sign that i'm a drudge & belong to Massa."[38] What are we to make of Cullwick's slave-band, belonging as it does in the zone of the fetish?

The fetish embodies a crisis in social meaning. In Cullwick's slave-band, three of the formative contradictions of the Victorian era converge: between slave labor and wage labor; between the private realm of domesticity and the public realm of the market; and between metropolis and empire. In the fetish of the slave-band, race, class and gender overlap and contradict each other; the slave-band, like most fetishes, is overdetermined.

Cullwick's transgression was to wear at dinner (the theater of middle-class consumption and female leisure) the forbidden sign of women's work. Cullwick brought scandalously into crisis the incommensurable relation between the Victorian doctrine that women should not work for profit and the visible sign of female domestic labor: the faint, illicit odor of the kitchen, the stain of dirty water, the mark of labor in imperial leather. Cullwick outraged convention by exhibiting, of her own stubborn volition, the public evidence of women's domestic dirt, banished by Victorian decree to kitchen and back-corridor, cellar and garret—the architecture of the unseen. In refusing to take off her band, Cullwick was refusing the social abjection of her labor and domestic dirt [Fig. 3.15].

For Cullwick, the fetish of the slave-band was specific to the recognition of social value. The idea of concealed labor is fundamental to the Marxist analysis of the commodity fetish. The idea of traumatic fixation upon an intense experience is fundamental to the psychoanalytic notion of the sexual

FIGURE 3.15 DEFIANT DISPLAY.

fetish. Both ideas fuse in the slave-band. In an important observation, William Pietz notes that fetishism often arises from a crisis that "brings together and fixes into a singularly resonant, unified intensity an unrepeatable event (permanent in memory), a particular object and a localized space." Paradoxically, this crisis moment, because of its "degradation from any recognizable value code," becomes "a moment of infinite value."[39] The death of Cullwick's mother was just such an unrepeatable moment; the localized space was the architectural space of upper-class domesticity; and the particular object was the imperial fetish of the slave-band. Here the crisis does involve the mother's body, but not in the way that Freud envisaged.

As a child of fourteen, working away from home as a nursemaid, Cullwick was called without warning from the family schoolroom and was summarily told that both her parents had died of illness a few weeks before. Abandoned to cry alone on the floor where she had fallen and refused leave to return home to help her orphaned brothers and sisters, Cullwick felt that

the death of her beloved mother stripped her life of all value: "It seemed as if my care for life or work was all gone." The crisis took on fetish form, for the violence of the chance encounter with death and her employers' refusal to let her mourn marked a radical break with history and community, costing her not only her family but also the symbolic value of her work and her sense of control over her own life. The death of her mother flung her into intense collision with the power of the upper-class family to subjugate her value to their needs: "I don't think I ever shall [get over it]. I shall never play again or bowl hoops around the garden."[40] Henceforth, her mother would be represented by the striving of a memory: "trying to dream of her ghost."

With the slave-band, Cullwick turned memory into a repeatable object. In photograph after photograph, she posed in such a way as to display her slave-band to maximum effect. Like all fetishes, the slave-band was contradictory, embodying the power of the upper class to enslave her, while at the same time exhibiting her determination to reclaim the value of her work and the memory of her mother. At the "marked site" of her wrist, damaged by the trauma of labor, she transformed bondage into the secret sign of self-assertion. By deliberately letting the filthy band show at dinner, she reclaimed her independence and her right to contract her labor as she pleased. By flouncing out of her employment, she claimed her right to control her own body and her own work. By contracting herself to Munby as his symbolic "slave," she took control, in the symbolic realm, of lack of control in the social realm. Her adamant and entirely unsubservient refusal to take off the band revealed, moreover, that she valued it only as a *symbol* of power over which she had ultimate control. Most importantly, by displaying her wrist filthy with labor, she rejected the stigma of shame attached to domestic work.[41] If the Victorian cult of domesticity voided her work of social recognition, she stubbornly displayed her hands in public to exhibit their *economic* value: "my hands & arms are tho' chief to *me*, to get my living with."[42]

Cullwick's fetishistic attachment to her slave-band expressed, I suggest, a lifelong attempt to reinvent the memory of her mother's domestic value in the eyes of the upper class. The upper-class *undervaluation* of her work found its antithesis in her *overvaluation* of her work. Her slave-band and her profound commitment to domestic labor embodied a compulsive determination to maintain control, at whatever physical cost, of the realm of labor in which she was subordinated.

The cross-cultural experiences marked by the fetish fuse in the slave-band: in the triangular relations among slavery as the basis of mercantile capitalism; wage labor as the basis of industrial capitalism; and domestic labor as the basis of patriarchy. By flagrantly wearing on her body the fetish leather of bonded labor Cullwick threw into question the liberal separation of private and public, insisting on exhibiting her work, her dirt,

FIGURE 3.16 THE PARAPHERNALIA OF
DOMESTIC FETISHISM.

FIGURE 3.17 THE DIRT FETISH.

her *value* in the home: that space putatively beyond both slave labor and
wage labor. Exhibiting her filth as value, she gave the lie to the disavowal
of women's work and the rational, middle-class control of dirt and disorder.

THE DIRT FETISH

Cullwick's employers' principle objection to her band was its dirt. Cullwick
and Munby's rituals—the foot and boot cleaning, the washing rituals,
Munby's voyeuristic desire to see Cullwick "in her dirt," Cullwick's delib-
erate "blacking," the photographs, the slave band—were organized in
complex but repetitive ways around the Victorian dirt fetish [Figs.
3.16–3.18]. Why did dirt exert such a compulsive fascination over their
imaginations, as it did over the Victorian era at large?

Nothing is inherently dirty; dirt expresses a relation to social value
and social disorder. Dirt, as Mary Douglas suggests, is that which

transgresses social boundary.[43] A broom in a kitchen closet is not dirty, whereas lying on a bed it is. Sex with one's spouse is not dirty, whereas conventionally the same act with a prostitute is. In Victorian culture, the iconography of dirt became deeply integrated in the policing and transgression of social boundaries.

Dirt is what is left over after exchange value has been extracted. In Victorian culture, the bodily relation to dirt expressed a social relation to labor. The male middle class—seeking to dismantle the aristocratic body and the aristocratic regime of legitimacy—came to distinguish itself as a class in two ways: it earned its living (unlike the aristocracy) and it owned property (unlike the working class). Unlike the working class, however, its members, especially its female members, could not bear on their bodies the visible evidence of manual labor. Dirt was a Victorian scandal because it was the surplus evidence of manual work, the visible residue that stubbornly remained after the process of industrial rationality had done its work. Dirt is the counterpart of the commodity; something is dirty precisely *because* it is void of commercial value, or because it transgresses

FIGURE 3.18 DOMESTICITY AS EXHIBITION.

the "normal" commercial market. Dirt is by definition useless, because it is that which belongs outside the commodity market.

If, as Marx noted, commodity fetishism flamboyantly exhibits the *overvaluation* of commercial *exchange* as the fundamental principle of social community, then the Victorian obsession with dirt marks a dialectic: the fetishized *undervaluation* of human *labor*. Smeared on trousers, faces, hands and aprons, dirt was the memory trace of working class and female labor, unseemly evidence that the fundamental production of industrial and imperial wealth lay in the hands and bodies of the working class, women and the colonized. Dirt, like all fetishes, thus expresses a crisis in value, for it contradicts the liberal dictum that social wealth is created by the abstract, rational principles of the market and not by labor. For this reason, Victorian dirt entered the symbolic realm of fetishism with great force.

As the nineteenth century drew on, the iconography of dirt became a poetics of surveillance, deployed increasingly to police the boundaries between "normal" sexuality and "dirty" sexuality, "normal" work and "dirty" work and "normal" money and "dirty" money. Dirty sex—masturbation, prostitution, lesbian and gay sexuality, the host of Victorian "perversions"—transgressed the libidinal economy of male-controlled, heterosexual reproduction within monogamous marital relations (clean sex that has *value*). Likewise, "dirty" money—associated with prostitutes, Jews, gamblers, thieves—transgressed the fiscal economy of the male-dominated, market exchange (clean money that has *value*). Like prostitutes and female miners, servants stood on the dangerous threshold of normal work, normal money and normal sexuality, and came to be figured increasingly in the iconography of "pollution," "disorder," "plagues," "moral contagion" and racial "degeneration."

Here a crucial aspect of Victorian imperialism emerges. The relation between the "normal" economy of heterosexual marriage and the "normal" economy of capital exchange was legitimized and made natural by reference to a third term: the invention of the "abnormal" zone of the primitive and the irrational. Money, work and sexuality were seen to relate to each other by negative analogy to the realm of racial difference and empire. Thus, historical contradictions internal to imperial liberalism (the distinctions between private and public; paid work and unpaid work; the formation of the male, propertied individual and the denial that slaves, women and the colonized were "possessive individuals"; between the rational and the irrational) were contained by displacement onto a third term: the term of race. Class and gender distinctions were displaced and represented as natural racial differences across time and space: the difference between the "enlightened" present and the "primitive" past.

Cullwick's slave-band embodies the traces of both personal and historical memory: her own subjugated labor and the slave labor on which

industrial capital was built. By the second half of the seventeenth century, black people brought to Britain by slavers, merchants and plantation owners lived scattered all over England, though they clustered mostly in London. By the turn of the eighteenth century, London and Bristol were thriving slave ports, continuing for another hundred years to garner huge profits from the murderous transport and sale of human beings. In Britain, the possession of a black slave became an emblem of new imperial wealth and advertisements raising a hue and cry after escaped slaves show that they were "customarily obliged to wear metal collars riveted round their necks. Made of brass, copper, or silver, the collar was generally inscribed with the owner's name, initials, coat of arms, or other symbol."[44] At the Lord Mayor's pageant, the annual festival of London's merchant capitalists, black people were obliged to perform in opulent costumes and these fetish collars, exhibiting in public displays of sumptuary excess the wealth of the imperial metropolis and the forced labor on which mercantile capitalism was built.

The slave-collar here embodies a contradiction between the extravagant display of black slaves for their exhibition value and the total denial of the value of their lives and work. Cullwick's slave-collar, as a fetish, thus embodied a double disavowal: the historical erasure both of slave labor and of working-class women's labor as the foundation of modern industrial power. The slave-band and chain-collar brought into the bourgeois home the memory of empire—chains, straps and bondage—at the precise moment when the industrial economy was being transformed from a slave market to a wage market. The fetish slave-band thus stages the history of industrial capital as haunted by the traumatic and ineradicable memory of imperial slavery.

S/M AND RITUALS OF RECOGNITION

S/M performs the failure of the Enlightenment idea of individual autonomy, theatrically staging the dynamics of interdependency for personal pleasure. But S/M is not merely an existential, timeless Hegelian drama of Self and Other, Being and Nothingness. Rather, it is a historical subculture that draws its symbolic logic from changing social contradictions. What is the social logic of Cullwick's pleasure in domestic S/M? "The desire for submission," writes Kamel, "represents a peculiar transposition of the desire for recognition."[45] If Cullwick gave Munby license to negotiate the contradictions of class and gender, Munby gave Cullwick the longed-for ritual recognition of the value of her labor.

When Cullwick was a girl, her identity came into being through paradox. Through an obscure economy of social affirmation by self-

negation and the edicts of class abasement, she learned very early that she would be rewarded only if she denied herself.[46] Performing sanctioned and scripted rituals of obeisance, curtsying and bowing before the gentry, she won affirmation only through negation of self. The need for recognition by the upper class entered her identity with the force of an ineradicable contradiction.[47]

Cullwick inherited a perilous paradox. Her primary source of self-esteem was recognition as a worker. This meant being obedient, sturdy, independent and economically resourceful—but, according to Victorian decree, only if she remained invisible. Domestic work shaped the deepest formation of her self-esteem and the boundaries between herself and others—particularly women.[48] Yet her extraordinary feats of domestic labor were publicly and ritually despised—as filthy work, work without social value. Her beloved, laboring mother—the first to bestow recognition and limits to selfhood—was socially despised as menial and inferior, a vassal to shame. Cullwick knew only too well how dependent the women of the upper class were on her labor: "Miss M . . . was fussy and *whining* like, & yet so small and feeble. It seem'd hard to be provoked so by her, & for me to be patient & meek to one as I could crush with one hand almost & I so much taller nor her . . . & I pitied her too."[49] Yet these helpless women constantly denied her the magical ingredient of social recognition.

Cullwick spent much of her energy performing what can be called rituals of recognition for the upper classes. Bobbing and curtsying, demurely taking a man's hat, theatrically lowering her eyes and voice, leaving a room backward, kneeling to remove the master's shoes, being stepped over by upper-class women—these were ritual performances in which Cullwick ceremonially recognized those who paid her to do so. Her ritualized presence was thus a necessary element in her employers' class identity; yet, by contrast, social recognition of her strength was perpetually deferred. "I somehow never got much praise in service," she remarks sadly.[50] One can call the project that animated her life the project of recognition, at the very moment when female manual labor was being erased from view.

Cullwick repeatedly insists that she *likes* work and likes being working class: "for freedom and true lowliness, there's nothing like being a maid of all work."[51] Her diary contains frequent entries such as the following: "The summer went on and I worked away and enjoyed it."[52] "I *like* the life I lead—working here & just going to M. when I can of a Sunday."[53] She also prefers physical work, which taxes her immense strength and gives her a sense of accomplishment: "So I often clean'd the steps for her & shook the doormats in the square & I really liked it better than making the rolls." Work, especially visible work, was an exhibition of

strength and her capacity to pull off astonishing feats of labor affords her much pleasure. She is inordinately proud of her muscular prowess and enjoys lifting Munby and other men to show off her strength: "I can heave my Master easy & carry him as if he was a child nearly."[54] "I lifted him easily & carried him, & then he lifted me & said I was *heavy*—I am 11 stone."[55] She habitually measured her body to prove her value—an ironic mimicry of the Victorian discourse of degeneration and the fetish for measurement. "My arm is 13 3/4 inches round the muscle," she writes proudly, "& my hand 4 1/2 inches across the inside."[56] On more than one occasion, however, the murderous workload became too much even for her: "Got up & come down to the wretched looking-kitchen & I felt so sick & bad from so much dirt & hard work."[57]

Cullwick was stung to miserable indignation when her employers refused to recognize her Amazonian feats: "I did all I could to show that I liked dirty, hard work, but Mrs Bishop never seemed satisfied, & I wasn't either."[58] "When Miss Margaret come down to give orders she began about the work & said she was surprised that everything wasn't more thoroughly done. I said, 'Well, ma'am, whether you know it or no, I've worked *very* hard . . . a fortnight's nothing to clean a big house like this in. . . . I'd worked harder in the time nor ever I would again for anybody'. . . . She said no more, but left me feeling quite sick with disappointment."[59]

For Cullwick, class recognition seemed to matter more than gender recognition, throwing into question some feminist theories that men alone are privileged owners of the gaze. Apart from Munby, she seldom mentions her male employers. On the rare occasions when upper-class women acknowledge her prowess, she radiates special pride: "She said, 'What *arms* you've got!' I said, 'Why yes, ma'am, I'm pretty strong, & it does me good to fetch the beer in the bracing wind. . . . I came away with my beer feeling quite pleased at being noticed . . . and my arms *did* look big and red & I reckon I weigh'd 11 stone 7 & a 1/2."[60]

Power through being the spectacle of another's gaze is an ambiguous power. It allows one to internalize the gaze of the voyeur and participate in the vicarious enjoyment of their power. Yet it also breeds a corresponding dependency on the one endowed with the social privilege of approval. Feminists have offered sophisticated analyses of the male prerogative of gazing, yet here there is much evidence that upper-class women held that privilege in Cullwick's life. She recalls cleaning the grates, while the Misses Knights watch voyeuristically. "The one in bed call'd me, & she pour'd water onto my black hand to wet the grate with it, & so she wasn't disgusted." The pouring of water effected a baptismal cleansing and exoneration of class debasement ("she wasn't disgusted"), granting Cullwick one of her treasured moments of recognition: "Miss Julia used to

like to see me clean & after sweep. She said she thought it very interesting to see me clean the paint so thoroughly."[61] Her longing for class recognition is assuaged. At the same time, recording such moments in her diary renews her power over Munby.

In the private theater of domestic S/M, Munby bestowed on Cullwick, repeatedly and ritualistically, the rare, dreamed-of recognition of her work: "for he *was* & always *is* interested in my work."[62] Munby figured as the official witness of her concealed domestic value: "I wrote and told him about it all."[63] At such moments, however, a curious metamorphosis transpires. Reading the diary later, Munby is put in an oddly female role, occupying the same position of voyeur of the forbidden spectacle of Cullwick's work as her female employers, precisely that female association which so enflamed and enchanted him. In her fetish rituals with Munby, Cullwick reinvented the *scene* but converted the *terms*, playing the drudge for value. Ostentatiously blacking her face, rubbing grating polish deeply into her hands, taking herself to be photographed, as she did, "in her dirt," Cullwick converted the scene of disavowal into the scene of theatrical display.

AMBIGUITIES OF DEPENDENCE

One cannot exaggerate the influence of Christianity on Cullwick's fetish life. Christianity offered Cullwick the promise of deferred recognition: *God* saw her work, *God* recognized her value. By lowering herself in drudgery, she exalted herself in the eyes of the Master. By working, she accrued spiritual capital, storing up a surplus stock of value in heaven. The economy of Christianity is the economy of conversion: the low exalted, the high made low.[64] Like Christianity, S/M performs the paradox of redemptive suffering and like Christianity, it takes shape around the masochistic logic of transcendence through the mortification of the flesh. Through self-abasement, the spirit finds release in an ecstasy of abandonment. S/M shares with Christianity a theatrical iconography of punishment and expiation: washing rituals, bondage, flagellation, body-piercing and symbolic torture. In both S/M and Christianity, earthly desire exacts strict payment in an economy of penance and pleasure.

The couple's washing rituals, I suggest, allowed Munby to indulge his hand fetishism — watching Cullwick's blackened "male" hands stroke, rub and massage his male extremities. These were purification rituals, an exoneration of guilt and transgression. For Cullwick, these washing rituals were a staged appropriation of Christian pageantry, offering her a delirious advance on her spiritual credit — a stolen taste of what should properly be her exaltation in the hereafter. For both, these fetish rituals express a

negotiation of power for pleasure far more complex than can be captured in easy binaries of victims and oppressors.

For Cullwick, her theatrical displays of submission were a way of negotiating power over Munby as well as a means of gaining ritual control over her own very real social disempowerment. She clearly saw her "enslavement" as ceremonial rather than real—a symbolic gift to Munby that she could retract at any moment. Her diaries show her determined to be mistress of her theater of submission, and she reacted with unmitigated fury when Munby had the temerity to intimate that she really *was* his slave or presumed to treat her as if she really was a drudge. Indeed, Cullwick fiercely defended her right to be mistress of all her theatrical displays of humility, even with other employers. She brooked no injustice from employers, showing great temper when anyone dared suggest that they, rather than she, managed the scenes: "Miss M. said that she was the best judge of that, & I said, 'No, ma'am, you canna tell me about my work so well as I can.' I suppose she saw a little temper in me, the same as I saw in her, for she said, '*Hannah*, you forget your place.' I said, 'No, ma'am, I don't.'"[65] Munby, too, earned her wrath if he presumed to "play" with her patience: "Then resentment like rises up inside me & pride, & will not let me speak nor be pleasant and nice as I want to be."[66]

Munby, nonetheless, liked to indulge the fantasy that he alone was master of their games, an unwarranted arrogance that became a lifelong source of conflict between them. He often tried to insist on complete control over Cullwick; as often, she resisted him. One such misunderstanding nearly brought their relationship to an end. Cullwick was in Munby's chambers working as his housekeeper and did not know a boy was on the stairs. So when Munby insisted on her calling him "Sir," and went upstairs to ring the bell for her, she exploded with rage at his violation of the rules and his unilateral changing of the script. "I thought, Well that is showing off certainly, & I went upstairs with my temper up to its highest, & Munby began to question me about not saying 'sir' to him, as the lad was on the stairs. . . . So I was really in a passion." Munby had desecrated their secret rites, callously violating the boundaries between theater and reality and confusing Cullwick's ceremonial submission with real submission. The magic spell was broken and Cullwick furiously threatened him with an ultimatum: "I declar'd that if M. tantalized me in that way again I would leave him whether we was married or not, for I didn't care a straw for that."

The tragic paradox of Cullwick's life, however, was that Munby gave her the longed-for recognition of working-class value, but only in private. Choosing public recognition as his wife (as he wanted) meant denying her labor power, losing her social mobility and bartering her

independence of spirit. Cullwick never escaped this social paradox; it could be negotiated but not individually resolved. In this way, S/M brings to its limit the liberal promise of social resolution through individual agency alone.

In order to understand more fully the meaning of Cullwick's fetishism, it is necessary to explore the social context in which it found its meaning and against which it set itself as stubborn refusal. This context was the historical invention of the middle class labor of leisure and the invisible servant.

THE LABOR OF LEISURE

> Women have always worked—they have not
> always worked for wages.
>
> —*Sophonsiba Beckenridge*

In a century obsessed with women's work, the idea of the idle woman was born. A commonplace story depicts the middle-class Victorian woman's life as a debauch of idleness. At some point during the eighteenth century, the story goes, the spindle and loom were pried from her fingers and all the "bustling labor" of the previous century—the candle and soap-making, the tailoring, millinery, straw-weaving, lace-making, carding and wool-sorting, flax-beating, dairy and poultry work—were removed piecemeal to the manufactures.[67] By the end of the eighteenth century, Wanda Neff writes, "the triumph of the useless woman was complete."[68] Robbed of her productive labor, the middle-class woman became fitted, we are told, only for an ornamental place in society.[69] There, drooping prettily in the faded perfume of watercolors and light embroidery, she lived only to adorn the worldly ambition of her husband, the manufacturer, the city banker, the shipowner.[70] Ensconced after marriage in a bower of ease, she simply exchanged temporary for permanent uselessness.[71] Closeted in her "cold sepulcher of shame," the virgin in the drawing room blushed at tablelegs and shrank from the pleasures of the body. Her dreamy torpor was ruffled only by hysterical ailments, swooning spells and a plague of obstructive servants.[72] Frigid, neurasthenic and ornamental; wilting in the airless hothouse of Victorian domesticity; fretfully preoccupied by trifles; given to irrationality and hysteria; languishing in ennui; incapable of constancy, decision or stature, the middle-class woman was, until recently, consistently disparaged and her life, as Patricia Branca notes, was dismissed as a "mass of trifles."

At this time, what Nancy Armstrong calls "economic man" and "domestic woman" were born.[73] Secluded in the ethic of purity, Coventry Patmore's "angel in the house" was seen to float in a separate sphere.[74] In the tumult of the commercial marketplace, economic man was seen to live out his destiny as the public actor and maker of history: "eminently the doer, the creator, the discoverer, the defender." Domestic woman was shaped to her destiny as sweet preserver and comforter, the vessel and safeguard of tradition. Until the 1970s, most critics simply repeated verbatim this fictional portrayal of the crushed flower of middle-class womanhood, taking Victorian writers at face value and accepting fictional portraits quite literally as documentary portrayals.[75]

For decades, therefore, it was widely assumed that the visible sign of the Victorian middle-class housewife was the sign of leisure.[76] It was as widely assumed that the "typical" middle-class woman was freed for her conspicuous leisure by employing at least three domestic servants in her home.[77] By common assumption, a typical middle class home was not complete without at least three paid domestics.[78] Yet Patricia Branca, totting up the average yearly wages of a cook, parlormaid, housemaid or nurse, calculates that the family income required to employ this "necessary trinity" was found only in the tiny, elite-upper and upper-middle classes. Most women of the middle class (itself a broad and shifting category, still under formation) would have to have been content harrying, at best, a single callow girl whose life would, most likely, have been a chronicle of interminable labor and pitiful wages.[79] Wives of the small tradesmen, clerks, grocers and plumbers would probably have made do with the services of only one such maid-of-all work. Perhaps wives of professional men could afford two paid servants, while doctors, clergymen, bank managers and successful businessmen might, by the late Victorian period, have employed three.[80] Arguably, then, neither the typical bourgeois lady nor the typical domestic servant really existed. Little regard has been given to the representational discrepancy between Victorian (largely upper middle class) portrayals of women and the myriad, middling domestic situations that took contradictory shape across the span of the century.[81]

While contemporary historians have noted the *symbolic value* of the serving class in the formation of middle-class identity, few have acknowledged the *economic value* of the domestic serving class as labor.[82] What I suggest is that—apart from the tiny, truly leisured elite—idleness was less a regime of inertia imposed on wilting middle-class wives and daughters than a laborious and time-consuming *character role* performed by women who wanted membership in the "respectable" class. For most women whose husbands or fathers could not afford enough servants for genuine idleness, domestic work had to be accompanied by the historically unprecedented

labor of rendering invisible every sign of that work. For most middling women, the cleaning and management of their large, inefficiently constructed houses took immense amounts of labor and energy. Yet a housewife's vocation was precisely the concealment of this work.

Housewifery became a career in vanishing acts. A wife's vocation was not only to create a clean and productive family but also to ensure the skilled erasure of every *sign* of her work. Her life took shape around the contradictory imperative of laboring while rendering her labor invisible. Her success as a wife depended on her skill in the art of both working and appearing not to work. Her parlor game—the ritualized moment of appearing fresh, calm and idle before the scrutiny of husbands, fathers and visitors—was a theatrical performance of leisure, the ceremonial negation of her work. For most women from the still-disorganized middling classes, I suggest, idleness was less the absence of work than a conspicuous labor of leisure.

The architecture of middle-class homes took shape around this paradox. The parlor marked the threshold of private and public, serving as the domestic space for the spectacular (public) metamorphosis of female work into female leisure. The morning call fulfilled the requirement of being *seen*—idle and scrubbed clean of the telltale signs of labor. As a threshold zone, the parlor also became the domestic space for the display of commodity fetishism. The parlor served to conspicuously display the family's "best" household commodities: use value was converted to exhibition value. In lower-middle-class houses, the anxious exhibition of "good" silver, "good" china and "clean" furniture (commodities with exhibition value rather than use value) barely cloaked the shabbiness, overwork and anxiety that lay concealed behind the commodity spectacle of female leisure and male buying power. A fresh and pretty housewife presiding at table disavowed the anxious and sweaty hours of labor, cooking, cleaning and polishing, even with the help of an overworked maid. The dilemma for these women was that the more convincingly they performed the labor of leisure, the more prestige they won. But the prestige was gained not through idleness itself but through a laborious mimicry of idleness.

Certainly it was not the spectacle of leisure that mattered in itself, but the undervaluing of women's work that the spectacle achieved.[83] Hence the Victorian fetish with hands, for hands could betray the traces of female work more visibly than a washable apron or disposable gloves. Housewives were advised to rub their hands at night with bacon fat and wear gloves in bed to prevent smearing the oil on the sheets, an imperative that revealed so fundamental an embarrassment at female work that it had to continue even in sleep.

Clearly the most damaging burden of the erasure of domestic labor fell on servants. The housewife's labor of *leisure* found its counterpart in the servant's labor of *invisibility*. Servants were ordered to remain unseen, completing the filthiest work before dawn or late at night, dodging their employers, keeping to the labyrinthine back passages, remaining, at all costs, out of sight. If they had to appear before their "betters" to answer the master's bell or open the front door to receive a visitor, they were obliged to change instantly from dirty work clothes into fresh, clean white ones — a ritual metamorphosis that rehearsed the century's long transformation of domestic work from the realm of the seen to the unseen.[84] The fetish for clean clothes was eloquent of a systematic attempt to erase from view any visible trace of domestic work. The governesses' white gloves, the maid's white apron, the nanny's white sleeves were fetish emblems of the contradiction between women's paid work and women's unpaid work [Figs. 3.19–3.21]. At the same time, the myriad tools and technologies of work — buckets, brooms, brushes, scuttles, irons, cooking utensils,

FIGURE 3.19 THE DISAPPEARING ACT OF LABOR.

FIGURE 3.20 THE WHITENESS FETISH.

FIGURE 3.21 THE CULT OF
CLEANLINESS.

saucepans, and so on—were laboriously hidden from view. Though a tailor's workroom or a smithy's workshop could be visibly eloquent of labor, the domestic labor of women suffered one of the most successful vanishing acts of modern history.[85]

The wife's labor of leisure and the servant's labor of invisibility served to disavow and conceal within the middle-class formation the economic value of women's work. Female servants thus became the embodiment of a central contradiction within the modern industrial formation. The separation of the private from the public was achieved only by paying working-class women for domestic work that wives were supposed to perform for free. Servants' labor was indispensable to the process of transforming wives' *labor* power into their husbands' *political* power. But the figure of the paid female servant constantly imperiled the "natural" separation of private home and public market. Quietly crossing the thresholds of private and public, home and market, working and middle class, servants brought into the middle-class home the whiff of the

marketplace, the odor of cash. Domestic workers thus embodied a double crisis in historic value: between men's paid labor and women's unpaid labor and between a feudal homestead economy and an industrial wage economy.

Small wonder that female servants in Victorian households came to be figured by images of disorder, contagion, disease, conflict, rage and guilt. For this reason, I suggest, domestic space became racialized as the rhetoric of degeneration was drawn upon to discipline and contain the unseemly spectacle of paid women's work.

THE PRIVATE, THE PUBLIC AND THE BOOT FETISH

If Munby had a fetish for hands, Cullwick had a fetish for boots [Fig. 3.22]. It is not clear when she began to count boots with Munby, but an entry on Tuesday July 31, 1860 reads: "This is the last day of July. I have cleaned 83 pairs of boots." Other entries abound: "We had a very nice evening & we added the boots up." Over the years, Cullwick cleaned an astonishing

FIGURE 3.22 THE BOOT FETISH.

number of boots. "I clean'd 63 pairs of boots last month." Another entry reads: "I've clean'd 66 pairs o' boots this month & 937 pairs in this year." And another: "I have cleaned 95 pairs of boots this month." And another: "That's the least for 3 or 4 years, else I've clean'd a thousand & more every year."[86] Yet Cullwick performed these labors unseen, before the family woke. When she was with Munby she converted the labor of invisibility into a theater of display, turning what Barthes calls the "enumerative obsession," and the fetish for cleaning, into delirium of the heart.[87]

It is commonplace to observe the historic emergence in the nineteenth century of the distinction between the private and the public. However, the separation, if decisive, did not happen overnight and it did not happen naturally. By the end of the seventeenth century, new forms of money drawn from imperial mines and plantations had begun to infuse feudal agriculture and industry and, over the next century, shipowners, manufacturers, bankers and professional men, emboldened by imperial profit, began to define new forms of legitimate rule outside the familial, landowning elite.[88] The ancestral feudal system based on kinship ties, fraternal guilds and patrilineal descent — that is, on the landed patriarchal family — was displaced by a commercial system based on nonfamilial, yet still firmly patriarchal, relations.

There were no laws to prevent the new men of commerce from elbowing their way into the upper echelons of social power, which they gradually did. There were no laws to prevent women from this fledgling class from likewise elbowing their way into power. Yet women didn't. As Catherine Hall notes: "At one level the exclusion of middle class women from the public world of politics is hardly surprising."[89] Traditional barriers against women participating in politics were extensive, so women had never been allowed very active roles in the political sphere in the first place. But, as Hall points out, neither had middle-class men. Why did men from the middling class and not women inveigle their way into public power?

The process of defining the public, political market as male and not female, did not "simply happen by default."[90] As the new commercial and professional men muscled their way into power, they decisively and deliberately excluded middling women from the clubs and taverns, from the Masonic lodges and financial organizations, from the commercial rooms of the pubs, from political rallies and Town Hall meetings, from the Chamber of Manufacturers, from parliamentary and council elections and from the universities; in short, from all institutions of public, commercial power, which were henceforth defined as exclusively male spaces.[91] From the outset, the distinction between private and public (figured as a fait accompli of natural progress) was the result of a systematic regime of displacement and dispossession, not just of women, but also of all non-propertied, European men.

By the nineteenth century, a major transformation was under way as middle-class men laboriously refashioned architectural and urban space to separate, as if by nature, domesticity from industry, market from family. Manufacturers slowly but steadily moved their houses away from the factories, shopkeepers stopped living above their shops, bankers set up separate banking houses and the suburbs were born. The passing of the Company Acts of 1856–1862 finally freed commerce from kinship and the historic distinction between the public realm of business and the private realm of domesticity came into its own. For the first time, political relations (for men) were fully severed from kinship restraints, creating, as if obedient to natural law, the separate spheres of economic man and domestic woman. In ideology at least, the homes of the Victorian middling class became vaunted as a distinct sphere lying naturally secluded from public commerce and thus beyond the abstract principles of the liberal market economy and the regime of rationality.

Insufficient attention, however, has been given to the transformation of households during this period and to the powerful role that the cult of domesticity played in the boundary formation of the incipient middle class. Yet there is considerable evidence that women were centrally, if contradictorily, implicated in the emergence of liberal rationality. Davidoff has argued brilliantly that the nineteenth century witnessed not only the increasing rationalization of factory labor but also the increasing rationalization of the domestic regime.[92] If women, as the first factory workers, were the first to be brought under the rule of rationality in the marketplace, women were also the first to participate in the rationalizing of the home. Nonetheless, excluded from public power by male classical liberal theory, as well as by legal and economic decree, women bore an uneasy and contradictory relation to the rationalizing of domesticity.

THE RATIONALIZING OF DOMESTICITY

Nancy Armstrong has argued powerfully that eighteenth-century conduct books and domestic manuals reveal a contradiction of historic proportions. The books were written as if they addressed a fairly wide readership with consistent social objectives—a middle class that was not yet there. The new genre of the female conduct book, she argues, implied "the presence of a unified middle class at a time when other representations of the social world suggest that no such class existed."[93] What this suggests is that women played a far greater role in the formation of middle-class identity than has been acknowledged. The cult of domesticity was crucial in helping to fashion the identity of a large class of people (hitherto disunited) with clear affiliations, distinct boundaries and separate values—organized

around the presiding domestic values of monogamy, thrift, order, accumulation, classification, quantification and regulation—the values of liberal rationality through which the disunited middling classes fashioned the appearance of a unified class identity.

What was specific to rationality in its nineteenth-century form was its single-minded dedication to the principles of capital accumulation for commercial expansion.[94] The full expansion of imperial commerce was not possible without elaborate systems of rational accounting—surveying, map-making, measurement and quantification—organized around the abstract medium of money into the global science of the surface. By the mid-nineteenth century, the domestic realm, far from being abstracted from the rational market, became an indispensable arena for the creation, nurturance and embodiment of these values. The cult of industrial rationality and the cult of domesticity formed a crucial but concealed alliance.

The middle-class determination to identify happiness with rational order and the clear demarcation of boundaries manifested itself in precise rules not only for assembling the public sphere but also for assembling domestic space.[95] Household arrangements gradually took shape around a geometry of extreme separation and specialization that came to discipline every aspect of daily life. Domestic space was mapped as a hierarchy of specialized and distinct boundaries that needed constant and scrupulous policing.

Spatial boundaries were reordered as the large, communal medieval hall was replaced by arrangements of smaller, highly specialized rooms. By the mid-nineteenth century, what Barthes calls the "sensual pleasure in classification" ruled domestic space—in the labeling of bottles, the careful marking of sheets and clothes, the scrupulous keeping of visitors' books, the regular accounting of stocks, the meticulous measuring of food, the strict keeping of account books.[96] Specialized utensils, technologies and timetables were developed for different stages of cooking and eating. The fetish for rational measurement led to an increase in the use of weights and measures. Food was served in obedience to rigid timetables, announced by the ringing of bells. Unlike the medley of sweet and savory, hot and cold courses served all at once in earlier times, meals now followed strict sequential rules, one course following the other with the proper decorum of rational, linear progress.

Domestic space was increasingly disciplined by the obsessive tidying and ordering of ornaments and furniture. Time was rationalized: servants' workloads and children's daily schedules followed strict routines and timetables. Cleaning schedules were divided into increasingly rationalized and rigid calendars: washing on Monday, ironing on Tuesday, polishing on Wednesday and so on. The domestic day itself was measured into mechanical units, marked by the chiming of clocks and the meticulous ringing of bells. The

clock presided magisterially over the life of the household, perfectly encapsulating the Victorian fetish for measurement, order and boundary.[97] In short, the cult of domesticity became a crucial arena for rationalizing emergent middle-class identity and its presiding values.

Very little is known about the role of women's labor, attitudes, agency and dilemmas in this process. Even less is known about how working-class women negotiated, opposed or appropriated the cult of domesticity and the rationalizing of the household. Cullwick's diaries, I suggest, offer a rare and important insight into these dynamics, all the more valuable for expressing a working-class perspective. If, as I suggest, a central function of liberal rationality and the cult of domesticity was to disavow the social and economic value of women's manual and domestic work, Cullwick's diaries present the remarkable record of a working-class woman's unflagging attempt to negotiate and accommodate to the rationalizing of housework while at the same time doing precisely what liberal rationalism forbade: stubbornly insisting on the visible economic and social value of her labor power. Cullwick's writings and her fetishistic rituals reveal in glimpses and intimations some of the critical contradictions that bring the discourse of rationality and the cult of domesticity to its conceptual limit. Indeed, her diaries reveal that fetishism, far from being the antithesis of rationalism and progress, as was tirelessly claimed, instead came to inform the domestic cult of rationality as its central logic. How, then, does one account for Cullwick's counting rituals?

DOMESTICITY AND THE BOOT-COUNTING FETISH

It is fitting that Cullwick recorded her life and work in a diary, which is the literary genre most appropriate to the logic of linear, rational individualism and the idea of progress. In the diary, progress is seen as the measured, linear development of the private individual.[98] Yet it also bears witness to a contradiction, for the diary, putatively the most private of literary forms, gave formative shape in the eighteenth century to the novel, the most public of literary forms. Cullwick's diary is no exception, for it was written as a private document but intended for Munby's perusal. Indeed, Cullwick's diary as a whole is fully expressive of the fetishistic irrationality that shaped the middle-class cult of domesticity.

If the diary as a genre is dedicated to the idea of the individual, the syntax of Cullwick's early diaries bears witness to an erasure: the sovereign "I" of individual subjectivity is missing. Her truncated and mutilated sentences are driven forward by the relentless repetition of verbs of cleaning and labor, her subjectivity engulfed by the regime of objects. A typical day's entry from her early diary for Saturday July 14, 1860, reads as follows:

Opened the shutters & lighted the kitchen fire. Shook my sooty things in the dusthole & emptied the soot there. Swept & dusted the rooms & the hall. Laid the hearth & got breakfast up. Clean'd 2 pairs of boots. Made the beds and emptied the slops. Clean'd & washed the breakfast things up. Clean'd the plate; cleaned the knives & got dinner up. Clean'd away. Clean'd the kitchen up; unpack'd a hamper. Took two chickens to Mrs Brewer's & brought the message back. Made a tart & picked and gutted two ducks and roasted them. Clean'd the steps & flags on my knees. Blackleaded the scraper in front of the house; cleaned the street flags too on my knees. Wash'd up in the scullery. Clean'd the pantry on my knees & scour'd the tables. Scrubbed the flags around the house & clean'd the window sills. Got tea at 9 for the master & Mrs Warwick in my dirt, but Ann carried it up. Clean'd the privy & passage & scullery floor on my knees. Wash'd the dog & cleaned the sinks down. Put the supper ready for Ann to take up, for I was too dirty and tired to go upstairs. Wash'd in a bath & went to bed without feeling any the worse for yesterday.[99]

In Cullwick's diaries, the inescapable imperative to clean and order objects—shoes, windowsills, knives, flagstones, closets, plates, saucepans, table tops, windows, floors, glasses—consumes her life's energies in an infinity of repetition without progress or perfection. This is what Marx called commodity fetishism: the central social form of the industrial economy whereby the social relation between people metamorphoses into a relation between things. The domestic realm, far from being the antithesis of industrial rationality, is revealed to be entirely structured by commodity fetishism.

Housework is a semiotics of boundary maintenance. Cleaning is not inherently meaningful; it creates meaning through the demarcation of boundaries. Domestic labor *creates* social value, segregating dirt from hygiene, order from disorder, meaning from confusion. The middle class was preoccupied with the clear demarcation of limit and anxiety about boundary confusion—in particular, between private and public—gave rise to an intense fetish for cleaning and a fetishistic preoccupation with what the anthropologist, Victor Turner, calls liminal, or boundary, objects. Servants spent much of their time cleaning boundary objects—doorknobs, windowsills, steps, pathways, flagstones, curtains and banisters, not because these objects were especially dirty, but because scrubbing and polishing them ritually maintained the boundaries between private and public and gave these objects exhibition value as class markers. Glistening doorknobs, freshly washed curtains, spotless windowsills and scrubbed paths—the uncertain objects on the threshold of private and public, upstairs and

downstairs—vividly expressed the boundary between the middle-class home and the public market.[100]

The middle-class fetish for boundary purity surfaced in a peculiarly intense fixation with the cleaning of boots [Figs. 3.23, 3.24]. Boots are threshold objects, carrying traces of streets, fields and markets into polished interiors, confusing public with private, work with leisure, cleanliness with dirtiness and thereby accruing a special fetishistic power. For this reason, maids were especially tasked with keeping their employers' shoes scrupulously clean. At the same time, they had to complete the purification rituals unseen, before the household awoke.

Cullwick and Munby seem to have spent many evenings counting and recounting the extraordinary number of boots she cleaned, in a recurrent ritualistic fetish that continued for years. In these conversion rituals, Cullwick's labor of invisibility is converted into recognition, her exhaustion into leisure, disavowal into agency. Most importantly, Munby acts as official witness to her enormous, disavowed labors. At such moments of delicious recognition, the "I" of agency reappears and her identity takes shape around the ritual of recognition.[101] By licking his boots,

FIGURE 3.23 THE COMMODITY BOOT FETISH.

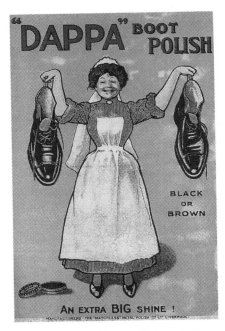

FIGURE 3.24 THE CULT OF BOUNDARY PURITY.

moreover, as she did a couple of times, she turned the secret labor of boot cleaning into outrageous display.

On the other hand, a damaging paradox makes itself felt. The striking difference between the rationalizing of the market and the rationalizing of housework is that the latter is rationalized so as to render women's work invisible and to thereby disavow its economic value. The rationalizing of domestic labor in the nineteenth century involved massive expenditures of effort that went *unquantified* and *uncalculated*, since such work had to be excluded, as far as possible, from the rational market.

Each month, each year, Cullwick's boot counting begins again—at number one. There is no progress in domestic labor, only repetition. Thus on one hand, the boot fetish demands recognition of labor value; on the other hand, it dramatically stages the failure of domestic progress. The boot fetish reveals a slavish obedience to rational form, while at the same time it flagrantly exhibits the fetishistic logic of rationalism itself. Victorian

domesticity simultaneously embodied and belied the enlightenment myth of rational progress. Small wonder that servants and the boundary objects of domestic servitude—boots, aprons, brooms, soap—became infused with intense fetishistic power.

CROSS-DRESSING AND FEMALE FETISHISM

> A person without clothes is a person without language.
>
> —*West African Proverb*

Cullwick's abiding power over Munby was her theatrical talent for conversion. Over the years, she revealed a remarkable capacity for adopting different social identities and costumes at will. As a servant, it was her profession and her pride to stage as natural the theatrical rites and pageantries of middle- and upper-middle class status. One minute she was on her knees scrubbing the grimy floors and closets, her huge arms filthy with fat and water; the next minute she appeared in fresh, dry white, to demurely open the door to a stranger or answer the mistress' bell. One minute she was lifting and carrying menservants around the kitchen table in gales of hilarity, or heaving heavy luggage, buckets of hot water and loaded coal scuttles up three flights of stairs at a time. Next minute she was bobbing and curtsying to her "betters," mimicking servility and performing the exaggerated rites of humility required of her station.

In her relationship with Munby, she transformed her servant's skills at mimicry into high theater and a source of considerable power. She crossdressed as an upper-class mistress, a rural farm worker and a male valet. She costumed herself as a male slave, a chimney sweep, an angel and a fieldhand, and took herself to the photographers to be photographed in her costumery. She cut her hair and dressed as a man and traveled round Europe with Munby as his valet. After they were married, she crossdressed as an upper-class lady and again toured Europe with Munby, this time as his wife. Munby was helplessly enthralled by "her talent to play each part so well."

With her exceptional talent for the ambiguities of identity, Cullwick joins the countless concealed and clandestine female cross-dressers who—according to the edicts of psychoanalytic tradition—do not exist. Robert Stoller proclaims firmly that there is no such thing as the "transvestite woman": "fetishistic cross-dressing" in women is "so rare it is almost nonexistent." Unlike Freud, Stoller argues that women "have no clothing fetish," they simply want to *be* men; a perfectly natural desire.[102] Female cross-dressers cannot be admitted into the house of perversion, for they

throw radically into question the centrality of the phallus as the fetishized object around which transvestism is supposed to be organized. However, not only was Cullwick a lifelong cross-dresser, but her fetishism was organized not around the traumas of phallic identity and erotic displacement (I critique this Freudian theory in Chapter 4) but around the historic contradictions of women's work and the iconography of empire — chains, blacking, dirt, clothes, boots, buckets, water and brushes. While Cullwick may well have received deferred erotic pleasure from her fetishism, understanding her cross-dressing and fetish rituals as an erotics of the castration scene serves only to reduce her life to a masculinist narrative of sexual interest. Instead, I suggest that her fetishism amounted to a sustained attempt to negotiate the perils attending the Victorian erasure of women's work.

Cross-dressing is not only a personal fetish, it is also a historical phenomenon. What one can call sumptuary panic (boundary panic over clothing) erupts most intensely during periods of social turbulence. In the early modern period, sumptuary laws in Europe and Britain took shape around the upheavals in money and social status engendered by imperialism.[103] As spices from the slave plantations and silver and other precious metals from the slave mines engendered new possibilities for mercantile consumption and surplus, new forms of money and consumption — no longer dependent on land and aristocratic power — began to interfere in old forms of political distinction. These changes led to the promulgation of sumptuary laws all over Europe, restricting "the wearing of certain furs, fabrics and styles to members of particular social and economic classes, ranks or 'states'."[104] Clothing became central to the policing of social boundaries, marking out "visible and above all legible distinctions of wealth and rank within a society undergoing changes that threatened to even obliterate social distinctions."[105] Dismantling the aristocratic regime involved, in part, dismantling the aristocratic body as a theater of sumptuary and sexual display.

Sumptuary laws sought to regulate social boundaries by regulating the social legibility of dress.[106] Yet sumptuary laws contain an internal paradox, for the fact that class and rank are made legible by the wearing, or not wearing, of "cloth of gold, silk or purple" reveals the invented nature of social distinction, throwing into visibility the question of both the origins and the legitimacy of rank and power. The bits and pieces of colored cloth that are the legible insignia of degree are also permanently subject to disarrangement and symbolic theft. For this reason, the historical figure of the cross-dresser becomes invested with a potent and subversive power. As Marjorie Garber puts it in her groundbreaking book, the transvestite is "the figure that disrupts."[107]

Garber brilliantly chronicles how "the specter of transvestism, the uncanny intervention of the transvestite, came to mark and indeed to

overdetermine this space of anxiety about fixed and changing identities, commutable or absent selves."[108] Garber refuses to accept the traditional account of transvestism as a medical pathology or biological anomaly—the crisis of the transvestite, she argues, represents the "crisis of category itself."[109] In this way, Garber invites us to take transvestites on their own terms, not as one sex or one gender but as the enactment of ambiguity itself; not even so much a "blurred sex" as the embodiment and performance of social contradiction. The transvestite inhabits the threshold of category distinction, challenging "easy notions of binarity and throwing into question the categories of 'female' and 'male.'"[110] Thus Garber sets herself against the progress narrative theory of cross-dressing, that attempts to uncover a "real" desired identity, either "male" or "female" beneath the transvestite mask. For Garber, by contrast, the transvestite is not equivalent to one sex or another but is rather the figure that inhabits that borderland where oppositions are perpetually disarranged, untidied and subverted.

Nonetheless, Garber herself, by universalizing all cross-dressers as the "figure that disrupts" and by universalizing all fetishes as the phallus ("the phallus is the fetish, the fetish is the phallus"), cannot, in the final analysis, theoretically explain the wealth of diversity that her own anecdotes reveal. Within the single, cramped Lacanian frame into which she consigns all cross-dressers, diversity, ambiguity and difference are paradoxically lost and each cross-dresser becomes, at the theoretical level, a clone of all the others. Her obedient genuflection to a single genesis narrative of phallic ambiguity reduces the rich diversity she marvelously recounts to an abstract economy of one. Garber is therefore unable to account theoretically for distinctions among subversive, conservative or radical transvestite practices and fetishes. Diversity disappears in the perpetual recurrence of the single "primal scene."

In the twilight world of transvestite ambiguity, Cullwick situated her power and her pleasure in that threshold zone where boundaries blur. Her talent for costume, disguise and improvisation was no simple theatrical masquerade; rather, it was a profound engagement with the social edicts that brutally circumscribed her life.

Cullwick celebrated the peculiar freedoms of ambiguity rather than the fixity of one identity. Cross-dressers seldom seek the security of a perfect imitation; rather, they desire that delicious impersonation that belies complete disguise: "something readable, a foot that is too big, a subtle gesture or the peculiar grain of the voice."[111] Thus when Cullwick cross-dresses and is photographed as a "lady," her filthy, callused hand with its dirty strap rests visibly and improbably on her fresh, flounced skirt. Cullwick's insistent display of her hands and strap refuses the historical erasure of women's work. Displaying, in public, the taboo sign of women's private work, she throws into question the naturalness of the categories of

dirty work or clean work, dirty women or clean women, insisting that she "could play either part so well" because both were invention.

It is extremely important to emphasize that Cullwick performed transformations of race and class as well as gender (I explore this theoretically in Chapter 4). Cross-dressed as a "male slave," she posed naked from the waist up, visibly displaying her "masculine" arms and huge shoulders. Yet if she appears quite male, on closer examination the gentle curve of her breasts, half-hidden in the shadows, suggests other possibilities. Again, in the "Rosetti" portrait (hand-tinted for Munby by Rosetti himself, who declared he was sure it was of a "lady") the slave chain lies visibly and incongruously on her gentle bosom.

Cross-dressing became so habitual for Cullwick that she declared in her diary: "I have got into the way of *forgetting* like, whether I am dressed up as a lady or drest in my apron & cotton frock in the street."[112] Gautier captures beautifully the threshold state that transvestism inhabits in a description that could well have been written by Cullwick: "I hardly remembered, at long intervals that I was a woman; . . . in truth, neither sex is really mine. . . . I belong to a third sex, a sex apart, that has as yet no name."[113] Similarly, Cullwick writes of her gender in upper-class houses: "I was the man in the house."

On their trip to Europe as man and wife, she started out from the Temple, where she lived as Munby's housemaid, in her old black bonnet and working clothes, performing a complete change of costume at Folkstone. There at the port, where the boundaries of national custom permitted the safe transgression of class convention, Cullwick donned her "felt hat & plume of cocks feathers and a veil." The ornamental hat and brooch were the necessary, visible signs of class leisure and wealth, while the veil was the insignia both of male property ownership of female sexuality and protection from the elements (and thus the racial and class disgrace of a sun-darkened skin). Returning from Europe, she put her old plaid shawl over her skirt: "I've doffed all my best clothes & put my own on again—very dirty cotton frock & apron and my cap." Her transformations were entirely convincing: "I wasn't noticed coming into the Temple or going out."[114]

"SO MUFFLED UP"
MARRIAGE AND RESISTANCE

> There remain no legal slaves except
> the mistress of every house.
>
> —*J. S. Mill*

Cross-dressing signaled Cullwick's refusal of the niggardly social roles allotted her. Cross-dressed as a man, she could travel unquestioned around

Europe with Munby. Dressed as a working-class woman, she freely entered bars and music halls, enjoying forms of working-class leisure forbidden "proper" women. She could walk about after dark without fear of ruination or reprisal. On the other hand, cross-dressed as a lady, she could enjoy the luxury and adventure of the hotels, holiday resorts and sightseeing trips barred to working-class women.

For this reason, Cullwick dreaded the prospect of marriage to Munby and, for some time, steadfastly refused his insistence that she appear in public as his wife. If for most women, as Christine Delphy argues: "marriage is a contract into unpaid labor," Cullwick's dogged will to independence expressed itself in a powerful, principled resistance to marriage.[115] Because the "outward bond" of the legal license threatened to turn her into Munby's real slave, Cullwick found the prospect of marriage unbearably galling. If, on one hand, she called Munby "Massa" and seemed to genuflect symbolically to Rousseau's dictum that the husband should be a "master for the whole of life"; on the other hand, there is every evidence that she saw Munby's "mastery" as purely theatrical.[116] For this reason, she showed nothing but repugnance at the thought of marrying Munby and entering "proper" society as his wife. When Munby decided that it was high time they married, Cullwick made no bones about her distaste for the idea and relented only when circumstances made it well nigh unavoidable.[117] She was deeply reluctant to move in with Munby and after four unhappy and lonely years under his roof, she moved out again, against his wishes, to continue their relationship more on her terms than his. Marriage, with its apparently permanent settling of heterosexual identity, struck her as unbearably constrictive: "It is too much like being a *woman*," she lamented.

Cullwick's slave-band brings into visibility the triangulated, historic convergence of wife, servant and slave. A long and sorry relation holds between wives and slaves. As Engels points out, the term "family" derives from "famulus," which means slave.[118] The status of women as individuals entered classical liberal theory as a central dilemma. If women, like slaves and children, were to be denied the rights to liberty and property ownership, ideological work had to be done. The solution lay in the distinction between the private and the public. Classical liberal theorists constructed as a *political* right the right to contract within the public sphere, but defined conjugal relations as belonging within the sphere of *nature* and thus beyond contract. The domestic sovereignty of the husband over the wife and thus the exclusion of women from possessive individualism, was justified as deriving from natural, not political, law.[119]

Thus when Munby exults that Cullwick was brought to him by "him who brought Eve to Adam," he speaks in the language, as was only fitting, of the classical liberal contract theorists. For Locke, Adam's sovereignty

over Eve has "a Foundation in Nature for it."[120] In his "First Treatise," Locke argues that Eve's natural subjugation is such that "every Husband hath to order the things of private Concernment in his Family as Proprietor of the Goods and Lands there and to have his Will take place before that of his wife in all things of their common concernment."[121] For Pufendorf, however, conjugal right, while squaring with "the condition of human nature" has to be secured "by her consent, or by a just war." Yet because, for Pufendorf, it is "the most natural thing" for marriages to come about through good will, man's conjugal rights originate in the wife's "voluntary subjection" to the "unequal league" of marriage.[122]

Carol Pateman points out that in these redefinitions of contract law a paradox emerges: women are by nature rendered incapable of equal contract with men under political law (since women are naturally subordinate), yet women can and must make marriage contracts (since marriage was to be seen as a matter of consent, not coercion). Through these debates, liberal theory formed an ideological distinction between individual freedom and the right to contract of the political sphere, and the refusal of the right to such political status within the domestic, conjugal sphere. Thus, as Pateman puts it, marriage remained a legal anomaly in that it "retains a natural status even in civil society."[123]

The invented distinction between the "natural" sphere of the family and the "political" sphere of civic society was indispensable to the formation of middle-class male identity because it was employed to restrict the liberal notion of sovereign individuality to European men of propertied descent. With the alibi of imperial nature, women, slaves, servants and the colonized could be excluded from liberal individuality. The emergence of the rational liberal individual thereby took shape around the reinvention of the domestic sphere as the realm of natural subjugation, just as the realm of the "primitive" was the realm of natural racial subjugation. Domesticity and empire merge as a necessary element in the formation of the liberal imagination.

Cullwick's slave-band was the visible embodiment of these contradictions. The wife's voluntary, verbal submission ("I do") represents a ceremonial display of hegemony as the woman "voluntarily" enters a social relation of inequality with her husband, which grants him henceforth the legal right of coercion over her. In short, the wife's contract is a contract *out* of hegemony *into* coercion.[124] Cullwick's slave-band exposes a fundamental contradiction within classical liberal theory: women are *naturally* like slaves and thus *cannot* make contracts, but women *must* enter into contracts in order to become wives and thereby waive their right to contract-making.

Cullwick tartly brushed aside Munby's patronizing suggestion that she should be grateful to him for marrying her: "Before the visitors came, Munby show'd me a license he had bought—a marriage license—for him

and me, & he said, 'Doesn't this show how much I love you, & what do you say to it?' I told him I had nothing to say about it, but I hoped he would never be sorry for it, nor I. Tho' I seem'd so cool & said so little I really meant what I said. I car'd very very little for the license or being married either."[125] She would not brook Munby's condescending notion of their marriage "as a reward to me for I want no reward," and deeply resented the social reality of the marriage license as an "outward bond": "I seem to hate the word marriage in that sense."[126]

Cullwick's marriage to Munby was in virtually every respect an accumulation of transgressions. By insisting on wages from Munby for her services, by contracting herself out to work as she pleased, by keeping her own money (though she asked Munby to manage it for her), Cullwick set herself against the fundamental edicts of Victorian marital law. Indeed, she put quietly and stubbornly into practice what feminists fought for for the rest of the century: the right to control her body, her labor, her money and her reproductive freedom, all the more remarkable and empowering for the fact that it took place within the context of enormous social disempowerment [Fig. 3.25].

FIGURE 3.25 CULLWICK IN HER LAST YEARS.

By living as Munby's "symbolic slave," while in effect coming and going as she pleased, Cullwick negotiated a degree of power that would otherwise have been well-nigh impossible. By living independently of a marital household, she avoided contracting herself in marriage as a working-class man's legal possession. "I made my mind up that it was best & safest to be a slave to a gentleman, nor wife & equal to any vulgar man."[127] Her marriage to Munby remained a purely titular affair, and she never surrendered her birth name. Most importantly, by refusing to live openly as a wife, Cullwick avoided having children; quite clearly, she had no desire to be a mother. On the contrary, she commented commiseratingly on a cousin of hers: "I was glad I wasn't a mother of a little family like her . . . for after all however natural it's very troublesome & after they grow up generally a great anxiety."[128]

Cullwick would not countenance the ennui and dependence of being a wife nor the sacrifices attendant upon having children: "Ah Ellen—the music's nice, & the easy chair is nice, but for being among the grand folks or drest up like 'em & all that I'd fifty times rather be all black among the grate cleaning. And which is the most lasting of the two, & which is the solidest & real pleasure?" She much preferred the freedom of "downstairs" and frequently relished the freedom of public mobility her low status gave her: "I can work at ease. I can go out & come in when I please. . . . all the years I've walked about London nobody has ever spoke to me wrongly, & I don't think they will if you're drest plain & walk on about your own business."[129]

In these complex ways, the realm of fetishism was for Cullwick an arena of contestation and negotiation. She claimed the right to manipulate the theatrical *signs* of lowliness in order to refuse the legitimacy of their value as *nature*. Far from seeing marriage as the gift of progress, she refused the "grand idea of the nineteenth century" by choosing the value of her work over the muffled ennui and bondage of marriage. Refusing to barter her unruly working-class strength for the halter of respectability, she decked herself in her own symbolic chains and threw dramatically into question the Victorian narrative of progress and the heterosexual Family of Man.

PSYCHOANALYSIS, RACE
AND FEMALE FETISHISM

4

It is an awful thing still to dread the magic that
you contemptuously investigate—to collect folklore
for the Royal Society with a lively belief in all
Powers of Darkness.

—Rudyard Kipling

Could we emancipate ourselves from the bedimming
influences of custom . . . we should see as numerous
tribes of fetish-worshippers in the streets of London
and Paris, as we hear of on the coasts of Africa.

—Samuel Taylor Coleridge

In 1760, a French philosophe, Charles de Brosses, coined the
term *fetishisme* as the term for "primitive religion."[1] In 1867, Marx took the
term *commodity fetishism* and the idea of primitive magic to express the
central social form of the modern industrial economy.[2] In 1905, Freud
transferred the term *fetish* to the realm of sexuality and the domain of the
erotic "perversions."[3] The "sciences of man"—philosophy, Marxism and

psychoanalysis—took shape around the invention of the primitive fetish. Religion (the ordering of time and the transcendent), money (the ordering of the economy) and sexuality (the ordering of the body) were arranged around the social idea of racial fetishism, displacing what the modern imagination could not incorporate onto the invented domain of the primitive. Imperialism returned to haunt the enterprise of modernity as its concealed but central logic.

"The erotic deviant is not the only fetishist familiar to us. Think of the primitive," says William Pietz.[4] Yet this could be said in another way: by inventing the primitive, the idea of deviance in Europe came to serve a peculiarly modern form of social discipline.[5] The invention of *racial* fetishism became central to the regime of sexual surveillance, while the policing of *sexual* fetishism became central to the policing of the "dangerous classes," both in Europe and in the colonies. Colonized peoples were figured as *sexual* deviants, while gender deviants were figured as *racial* deviants. "Fetish-worshippers" in the colonies and sexual fetishists in the imperial metropoles were seen as the visible, living evidence of evolutionary degeneration. Identified as atavistic sub*races* within the human race, fetishists were, all too often, seen as inhabiting an anachronistic space in the linear time of evolutionary progress, warranting and justifying conquest and control. In this way, the imperial discourse on fetishism became a discipline of containment.

As Freud notes: "According to some authorities . . . the aggressive element of the sexual instinct is in reality a relic of cannibalistic desires."[6] According to Freud, erotic fetishes were "with some justice likened to the fetishes in which savages believe that their gods are embodied."[7] Yet Freud was also the first to systematically define fetishism as a question of (male) sexuality alone.[8] As Naomi Schor points out:

> It is an article of faith with Freud and Freudians that fetishism is the male perversion par excellence. The traditional psychoanalytical literature on the subject states over and over again that there are no female fetishists; female fetishism is, in the rhetoric of psychoanalysis, an oxymoron.[9]

In the classical Freudian scenario, women are reduced to a minor function—at best footnoted, then forgotten. Lacan (who might at least have remembered Jeanne d'Arc, France's most famous transvestite) follows Freud in firmly declaring "the absence in women of fetishism."[10] Christian Metz belatedly voices his discomfort with the fact that Freud's theory is restricted to boys, but he goes on to rehearse the commonplace that "the recorded clinical cases of fetishism are for the most part male."[11] Robert

Stoller agrees: "Fetishizing is the norm for males, not for females."[12] Homi Bhabha, in an otherwise important and subtle essay, likewise footnotes his unease that "the body in this text is male."[13] Bhabha proceeds, nonetheless, to analyze symbolic knowledge and the fetishism of colonial discourse as if they are neutral with respect to gender. Bhabha does not concern himself with the possibility that returning the footnoted female to the body of the text might throw radically into question the Lacanian theory of phallic fetishism and the scene of castration itself.[14]

The denial of female fetishism (the fetishistic gesture itself) is less an accurate description than a theoretical necessity that serves to disavow the existence of female sexual agency except on terms prescribed by men. Women like Hannah Cullwick cannot be allowed into the Freudian and Lacanian scene of fetishism (despite the wealth of evidence to the contrary), for recognizing female fetishism radically challenges the magisterial centrality of the phallus and the castration scene. Since Lacan cannot account for female fetishism *and* retain the phallocentricism of his theory, female fetishism cannot be allowed to exist. If women are provisionally admitted into fetishism, it is not as bearers of our own insistent desires, but on strictly male terms, as mimics and masqueraders of male desire. Lacan briefly and grudgingly admits lesbians into the phallic scene by evoking the hoary homophobic myth of "the fantasy of the man as invisible witness," and the "naturalness with which such women appeal to their quality of being men."[15]

I suggest, instead, that female fetishism dislodges the centrality of the phallus and parades the presence and legitimacy of a multiplicity of pleasures, needs and contradictions that cannot be reduced to the "desire to preserve the phallus."[16] At the very least, female fetishism throws into question the Lacanian economy of one: the decree that there be only one trope of desire to which women must genuflect, rather than a myriad, competing desires subordinated by social violence and male edict. The Lacanian fixation on the phallus and the primal scene of castration displays in itself a fetishistic nostalgia for a single, male myth of origins and a fetishistic disavowal of difference.

I remain unconvinced, moreover, that women can simply be *added* to the phallic theory, as some feminists have argued, for female fetishism radically challenges the authority of the castration scene. Moreover, the phallic theory reduces fetishism to a privileged poetics of *sexual* difference and does not admit class or race as crucially formative categories. I do not see racial fetishism as stemming from an overdetermined relation to the castration scene. Reducing racial fetishism to the phallic drama runs the risk of flattening out the hierarchies of social difference, thereby relegating race and class to secondary status along a primarily sexual signifying

chain. I am not convinced that racist, nationalist and patriotic fetishes (flags, crowns, maps, swastikas and so on) can be rendered equivalent to the disavowal of male castration anxiety except by the most wilfully racist and masculinist logic. The racist fetishizing of white skin, black fetishizing of gold chains, the fetishizing of black dominatrices, lesbians cross-dressing as men, the fetishizing of national flags, slave fetishism, class cross-dressing, fetishes such as nipple-clips and bras in male transvestism, leather bondage, PVC fetishism, babyism and so on — these myriad different deployments of fetishistic ambiguity cannot be categorized under a single mark of desire without great loss of theoretical subtlety and historical complexity.

Instead, I call for a renewed investigation that would open fetishism to a more complex and variable history in which racial and class hierarchies would play as formative a role as sexuality. Let me stress, however, that throwing into question the Lacanian fiction of the phallus as the organizing principle for fetishism by no means entails a rejection of psychoanalysis. Rather, I call for a mutually transforming investigation into the disavowed relations between psychoanalysis and social history. Following Freud, fetishism has been relegated primarily to the "private" realm of domestic space (conventionally, the domain of psychoanalysis), while commodity fetishism has been relegated primarily to the "public" realm of market space (conventionally, the domain of male socio-economic history). I wish to contest the *cordon sanitaire* between psychoanalysis and history and to explore fetishism as the historical enactment of ambiguity itself.

Far from being merely phallic substitutes, fetishes can be seen as the displacement onto an object (or person) of contradictions that the individual cannot resolve at a personal level. These contradictions may originate as social contradictions but are lived with profound intensity in the imagination and the flesh. The fetish thus stands at the cross-roads of psychoanalysis and social history, inhabiting the threshold of both personal and historical memory. The fetish marks a crisis in social meaning as the embodiment of an impossible irresolution. The contradiction is displaced onto and embodied in the fetish object, which is thus destined to recur with compulsive repetition. Hence the apparent power of the fetish to enchant the fetishist. By displacing power onto the fetish, then manipulating the fetish, the individual gains symbolic control over what might otherwise be terrifying ambiguities. For this reason, the fetish can be called an impassioned object.

Fetishes may take myriad guises and erupt from a variety of social contradictions. They do not resolve conflicts in value but rather embody in one object the failure of resolution. Fetishes are thus haunted by both

personal and historical memory and may be seen to be structured by recurring, though not necessarily universal, features: a social contradiction experienced at an intensely personal level; the displacement of the contradiction onto an object or person, which becomes the embodiment of the crisis in value; the investment of intense passion (erotic or otherwise) in the fetish object; and the repetitious, often ritualistic recurrence of the fetish object in the scene of personal or historical memory. As composite symbolic objects, fetishes thus embody the traumatic coincidence not only of individual but also of historical memories held in contradiction.

Far from being universally phallic substitutes, fetishes can be any object under the sun. Indeed, European merchants and travel writers wrote disparagingly of the promiscuity of African fetishes, which could be animals, plants, mountains, stones, feathers, or shards of pottery.[17] Refusing the narrow scene of phallic universalism allows one to open fetishism to far more powerful and intricate genealogies that would include both psychoanalytic insights (disavowal, displacement, emotional investment and so on), as well as nuanced historical narratives of cultural difference and diversity. Since beginnings are never absolute, reading fetishism as simultaneously historical and psychoanalytic upsets the reductive assumption of phallic universality and gives rise to far richer possibilities of cultural analysis.

FETISHISM AND IMPERIALISM

> The turn of mind which in a Gold Coast negro would manifest itself in a museum of monstrous and most potent fetishes might impel an Englishman to collect scarce postage stamps or queer walking sticks.
>
> —*Edward B. Tylor*

The Western discourse on fetishism was at least four centuries old before the phallus was singled out as its central, organizing principle.[18] As Pietz points out: "Psychological universalists subsume fetishism to an allegedly universal human tendency toward privileging phallic symbolism. . . . The conception that the fetish's ultimate referent is the phallus was articulated only in the late nineteenth century."[19] The term fetish derives from the medieval Portuguese word *feitiço*, which meant sorcery or magical arts. As Pietz shows, the earliest European discourse on fetishism concerned witchcraft and the clerical denunciation of illicit popular rites and illicit female sexuality. In the late Middle Ages, the Catholic priesthood used the

term to condemn the charms and magical arts practiced by the restive populace and also to discipline wayward female sexuality. At the outset, then, the term was associated with an *excess* of illicit female agency over natural and bodily authority, unlike the Freudian inscription of fetishism as associated with female *lack*. While beginnings are never absolute, reading the fetish as a historical phenomenon upsets the assumption of universality.

If the medieval discourse on the *feitiço* was associated with a discipline of the body and denunciation of illicit popular rites, by the fifteenth century the term had entered the realm of empire. Portuguese explorers trading along the West Coast of Africa used the term *feitiço* to describe the mysterious amulets and ritual objects favored by the African peoples they encountered on their voyages. From *feitiço*, the hybrid term *fetisso* developed and as the centers of European maritime power moved northward from the Portuguese, to the Dutch, to the English and the French, the term *fetisso* moved too, entering the English language in 1625. *Fetisso* took form in the context of an emerging global economy, mediating the unsteady traffic in goods and symbols along the threshold African coastal areas where incompatible European and African systems of value had their first encounters.

Pietz, in a series of brilliant observations, argues that the idea of the fetish emerged as a historical problem in the inhabited, intercultural spaces along the West Coast of Africa in the sixteenth and seventeenth centuries. As Pietz argues, the fetish was "proper to neither West African nor Christian European culture."[20] Rather, it sprang from the abrupt encounter of two radically heterogeneous worlds during the era of mercantile capitalism and slavery. The fetish emerged in the inhabited intercultural spaces created along the West African coast by new trade relations between cultures so radically different as to be almost incomprehensible to each other. These coastal areas served to "translate and transvalue objects between radically different social systems" and were "triangulated among Christian feudal, African lineage and the mercantile capitalist systems."[21] In this triangulated space, fetishism emerged as a creative enactment of an unprecedented situation, coming historically into being alongside the commodity form as it defined itself against two radically different types of noncapitalist society: feudal Christianity and African lineage exchange.

The fetish embodies the problem of contradictory social value. As Europe's mercantile culture began to find a political base in the seventeenth and eighteenth centuries, a new universe of value had to be developed to accommodate and legitimize the new commodity economy. Moreover, this universe of value had to be defined not only against the authority of feudal Catholicism, the medieval clergy and the aristocracy, but also against the

alternative authorities of the myriad non-Western cultures with which the mercantile traders were interacting.

The problem of value emerged in intense form from the beginning of the European voyages to Africa. As Pietz notes, the riddle of value was a persistent theme in encounters along the Guinea Coast. The Venetian trader Alvise da Cadamosto, who sailed to Senegal in the late 1450s, wrote of the blacks of Gambia: "Gold is much prized by them . . . nevertheless, they traded it cheaply, taking in exchange articles of little value in our eyes."[22] The presiding dilemma for both sides of the encounter was to engage in reciprocal economic and cultural relations with peoples whose systems of value were radically different—yet could not simply be swept aside—while at the same time retaining a sense of their own cultural value as inherently legitimate. The psychic, economic and historical perturbation thrown up by this crisis of value was projected onto the fetish as the quintessential problem-object. For both Africans and Europeans, the fetish became the symbolic ground on which the riddle of value could be negotiated and contested.

Pietz offers as one example the Akan goldweights. In response to the impact on trade of the gold-seeking Europeans, gold dust came to circulate through the Akan economy as a measure and store of value. Yet the Akan also used the goldweights as charms and amulets, worn on the body to bring good fortune and health. Thus two systems of value—European commodity value and indigenous social value—were embodied simultaneously in the same object.

In much Enlightenment thinking, the idea of fetishism recurred with insistent and organizing force—as the recurring paradigm for what the Enlightenment was not. For Rousseau, fetish worship marked an infantile stage of human development before subtle distinctions and understandings had developed.[23] For Kant, fetishism exemplified errors of logical causality, against which rational thinking could be mapped.[24] For Linnaeus, the organizing principles of African social life were caprice and a fetishistic tendency toward arbitrary attachment.[25] For de Brosses, fetish-using peoples fell to worshipping objects in and of themselves instead of seeing them as intimations of a rational natural order. For Hegel, the fetish-culture of Africa inhabited that abandoned moment just prior to the emergence of history proper.[26]

For these men, the fetish-lands of Africa embodied a necessary universe of errors against which the Enlightenment could measure its stately progress: errors of logic, of analytical reasoning, of aesthetic judgment, of economic progress and of political legitimacy. In this way, fetishism was primarily a discourse about cultural conflicts in value, which allowed Europeans to do two things. First, they could draw the unfamiliar

and unaccountable cultures of the world into a systematic universe of *negative* value; second, they could represent this universe as deviant and thereby undervalue and negate it. Against this belated, lapsed universe of error, the Enlightenment took illuminated shape. In this way, the discourse on fetishism enabled Enlightenment thinkers to invent new borders between the time of modernity and anachronistic space, becoming in the process a formative element of the Enlightenment project.

By mid-nineteenth century, the fetishism of colonized peoples was a well-established trope within travel and anthropological writings. The classics of Victorian anthropology—J. F. McLennan's "The Worship of Animals and Plants," John Lubbock's *The Origin of Civilization* and Edward B. Tylor's *Primitive Culture*—saw fetish religions as marking the earliest, primitive stages of evolutionary progress.[27] For Tylor, the West African habit of seeing mundane objects as hosts to supernatural forces testified to the "one-sided logic of the barbarian," which in turn marked Africans' inferior evolutionary development.[28] By the latter decades of the century, however, with the expansion of imperial trading and territorial interests, fetishism had entered an expansionist discourse. Fetishism no longer marked other peoples merely as prey to the folly of idolatrous and heathen customs; it was seen as a direct obstacle to progressive market forces and marked these groups for direct imperial intervention and conquest.

Fetishism became a Victorian scandal, in part because it flagrantly rebutted the idea of linear time and progress.[29] The fetish—embodying, as it does, contradiction, repetition, multiple agency and multiple time— exemplifies *repeatable time*: time without progress. Yet by denouncing other fetish cultures as inhabiting a prior moment in the history of progress, Victorian thinkers unwittingly revealed their own fetishistic proclivities. The Great Map of Mankind was a paradox, for it pictured the world as made up of different times that coexist on the same geographical globe. In other words, the anachronistic fetish-lands beyond Europe coexisted in the same time—clock-time—as imperial modernity. Seeing the world as simultaneously inhabiting different time dimensions evoked precisely the fetishistic notion of multiple, discontinuous time that the Enlightenment claimed to have transcended and which it set itself to violently reorder into a global regime of linear time and hierarchical continuity. For this reason, the colonial *mappa mundi* itself recurred ritualistically as a fetish.

The Victorian anthropologist Tylor captures the enchantment of the fetish for imperial modernity in a striking image: "So strong is the pervading influence, that the European in Africa is apt to catch it from the Negro and himself, as the saying is, 'become black.' Thus even yet, the traveller, watching a white companion asleep, may catch a glimpse of some claw or bone or such-like sorcerer's trash secretly fostered around his neck."[30] The

multicolored, colonial map of the world enchanted Europe and became its fetish. Imperial men slept with it under their pillows, guaranteeing illusions of grandeur and dreams of conquest. Europeans carried the parti-colored world map like a charm into unfamiliar zones to ward off decay and the anger of Africans and guarantee the spirit of progress. Propertied men of the bourgeoisie hung it on their walls. Missionaries and explorers undertook inexplicable journeys lured by its blank spaces, and, in 1884, at the Berlin conference, a group of European men sat about a bright map of Africa and divided the continent between them.

With these observations in mind, we can return to the psychoanalytic theory of the fetish.

FREUD AND THE DISAVOWAL OF FEMALE FETISHISM

In the 1880s, Alfred Binet marked a critical shift in the anthropological discourse on fetishism by transferring the term *fetish* to types of sexual "perversion." The term fetishism, he believed, was well suited to certain forms of sexual deviance, in which "the adoration of the savage or negro for fish bones or shiny pebbles" is replaced by the "sexual adoration" of inanimate objects such as nightcaps and high heels.[31] With Binet, a critical transition occurred as fetishism became a switchboard term, mediating between race and sexuality, colony and metropolis. Following Freud's adoption of the term as crucial for an analysis of the "perversions," one witnesses, at the same time, a disciplinary shift as the discourse on fetishism moved from anthropology and the study of religion—out of the invented realm of imperial nature, that is—into psychoanalysis and the realm of metropolitan culture.

How did the Freudian "article of faith" come to exclude both women and race from the recent Western history of fetishism? Drawing on male, psychoanalytic case histories, Freud explains that the fetish is a "penis-substitute"—a surrogate penis created in the little boy's unconscious to compensate for "the woman's (the mother's) penis the little boy once believed in and—for reasons familiar to us—does not want to give up."[32] For Freud, the primal scene of fetishism involves a delusion in the realm of spectacle: the little boy refuses to surrender belief in the mother's penis, which would render her equivalent to the universal, male model of the human body. The spectacle of the woman's *unlikeness*, according to Freud, leaves the boy horror-struck at the possibility of his own castration. The fetish is thus a compromise object: the boy retains belief in the maternal penis, "but he also gives it up; during the conflict between the deadweight of the unwelcome perception and the force of the opposite wish, a compromise is constructed."[33] According to Freud, the little boy disavows what he has (not) seen until a later time, when he is threatened with castration

by the punitive hand of the father forbidding masturbation. The earlier scene of fright is recalled and with it an object (hair, slipper, lace) that was originally near the mutilated female genitals and on which the boy's appalled, averted eyes had accidentally alighted.

Henceforth, as long as the fetish object is kept in view, the mutilated woman can be restored to imaginary wholeness. Nonetheless, the presence of the fetish is a constant reminder of the illusory nature of her wholeness. Freud believed that fetishism thus contains an "aversion to the real female genitals," which are abandoned altogether and replaced by "some other part of the body as the object of their desire—a woman's breast, a foot, or a plait of hair."[34] The fetish becomes both a "permanent memorial" to the horror of castration, embodied not in the male but in the female, as well as "a token of triumph" and safeguard against the threat of castration.[35]

Here, the exalted value of the fetish masks the boy's refusal to accept the female as not equivalent to himself: an *overvaluation* of the surrogate object compensates for the *undervaluation* of women's genitals. Through the fetish, women's sexual difference is converted into male symbolic currency in order for the boy to retain belief in the universal value of the male model. The fetish thus stands as the "permanent memorial" to the breakdown of equivalence in the human form.

Yet Freud does not explain why the fetish object must be read as a substitute for the mother's (absent) penis and not, say, as a substitute for the father's (absent) breasts. Indeed, the logic by which Freud privileges the penis in the scenario of fetishism is itself fetishistic. For Freud, fetishism involves the boy's desire for primal unity when threatened by the spectacle of women's difference, which is then disavowed by fixation on a substitute object. Freud's theory, however, is implicated in the same logic: it locates fetishism in the primal fantasy of castration, thereby disavowing and displacing gender difference and fixating on a single, privileged fetish object, the penis. Women's *difference* is disavowed and misconstrued as *lack*.

On one hand, Freud figures the fetishist's obsession as a delusion, the overvaluation of a surrogate object to compensate for the undervalued female genitalia. Yet Freud also appears to accept, as a perceptual truth, the horror and threat of the castration that is located in the real female genitals; thus he tends to sympathize with the fetishist's delusion.[36] As Linda Williams notes:

> Since Freud's scenario of vision asserts a self-evident perceptual "truth" of female lack, his very explanation originates in a fetishistic misrecognition of a sensuous thing, followed by the creation of a

compensatory substitute, the fetish. It is as if Freud trusts the fetishist's vision in initially judging woman's sexual difference as lack but mistrusts the ability of the fetish to solve the problem of the "truth" it confronts.[37]

According to Freud, moreover, the castration anxiety does not erupt in a single, originary moment in time. The boy inherits the threat of castration only after he has seen the female genitals, of which he is tragically reminded when the father threatens punishment. Thus, male castration remains a symbolic potential, a perpetually deferred threat, rather than an actual anatomical fate.[38] Castration for the girl, however, is figured as her natural anatomical condition. The little girl's task is only to realize the perceptual truth of her flesh, which, when her appointed time arrives, she does "in a flash."[39] In this way, as Kaja Silverman has noted, Freud is at great pains to restrict the scenario of castration to female lack: "one is struck by its single-mindedness, its refusal to acknowledge any lack except that which it attaches to the female genitals."[40]

An economy of more-than-one, which one can call *identity through difference*, is replaced by a male economy-of-one, *identity through negation*. In *Speculum of the Other Woman*, Luce Irigaray argues that the Western male economy depends on a rule of visibility that can only theorize woman as lack, absence and nothingness.[41] If men think of women as castrated versions of themselves, she argues, it is because of a fundamental "hole," a blind spot, in *men's* signifying vision that can see women's desire only as desire for and of, the penis. The phobia of the "nothing to be seen" of woman is actually the male fear that women might not possess the phallic envy that men presume us to possess—that we have, in other words, different desires of our own.[42]

For Freud, genuflecting to the economy-of-one, there is only one libido, which cannot be assigned a specific sexuality. As he sees it, since the "universal" can readily be seen to be synonymous with the "masculine," it can justifiably be called "masculine," while the juxtaposition "feminine libido" "is without any justification."[43] If the little girl is the same as the little boy, that makes her a little boy, not vice versa: "We are now obliged to recognize that the little girl is a little man."[44] If her masturbatory activity is like the little boy's, that makes her clitoris a "penis-equivalent," not the other way round.[45] Freud might have done well to recall one of his own insights into fetishism. As Tim Mitchell points out, the idolator has forgotten something: his own act of projection, of which he must be reminded by memory and historical consciousness.[46]

Not all psychoanalytic theorists have been obedient to Freud's faith in the fetish as compensation for the maternal phallus. For some, as

Janine Chasseguet-Smirgel notes, "separation anxiety and the inability to renounce primary identification with the mother are at the heart of the problem in fetishism."[47] For Weissmann, for one, the chief aim of the fetishist is not genital pleasure but an attempt to overcome separation anxiety by introjecting the good object as a substitute for the good breast. Here, as Weissmann aptly puts it, the fetish "is not only an object but an identification."[48] Wulff, likewise, sees the fetish as linked to the mother's breast as the origin of the phallus, while Sperling argues that the fetish can represent the mother's whole body.[49] Chasseguet-Smirgel argues, in a somewhat different vein, that the fetish inhabits a magical and artful universe, a "marvellous and uncanny world," where feelings of loss and death are assuaged by a "disavowal of the father's genital penis" and a focus on the anal phallus instead.[50]

In my view, these arguments are valuable in opening the scenes of fetishism to more diverse genealogies than the castration scene. Yet they, too, typically assume a male fetishist: "The fetish condenses all the elements separating the son from his mother."[51] Moreover, the purely psychoanalytic approach, whether focusing on the castration scene or on pregenital traumas, is hampered by its reliance on individual aetiologies (exemplified by the genre of the case study) from fully explaining the emergence at certain historical periods of a variety of cultural fetish fashions: collective and group fetishes (Coca-Cola, PVC, swastikas); racial and national fetishes (flags, maps, crowns, national foods, flowers and so on); or fetishes acquired by individuals only in later life. In the final chapter of this book I explore the fetishisms, for example, of national culture: the flags, wagons, maps, costumes and mummeries of national spectacle—fetishes that cannot, I believe, find a single originary explanation in the psychic development of the individual. For the moment, however, my immediate concern is with the Freudian/Lacanian theory, the tradition that has, for the most part, had the deepest influence on feminist theories.

LACAN AND THE DISAVOWAL OF WOMEN'S AGENCY

Following Freud, Lacan proclaims "the absence in women of fetishism." What is the logic of this second disavowal? In Lacan's texts, women are doomed to inhabit the tongueless zone of the Imaginary. We are forbidden citizenship in the Symbolic, exiled from the archives and encyclopedias, the sacred texts and algebras, the alphas and omegas of history. If women speak at all, it is with male tongues, as ventriloquists of phallic desire. If we look, it is with a male gaze. In this way, Lacan's vision bears an uneasy affinity to the nineteenth-century discourse on degeneration, which figured women as

bereft of language, exiled from reason and properly inhabiting the prehistory of the race. For Lacan, as for the discourse on degeneration, women's difference is figured as a *chronological* one; we inhabit an earlier space in the linear, temporal history of the (male) symbolic self. Pre-oedipal space (the space of domesticity) is naturalized by figuring it as anachronistic space: out of time and prior to symbolic history. Women's *historically* gendered relation to *power* is represented as a *formally* different relation to *time*: the imperial gesture itself.

According to Lacan, women do not inhabit history proper. We bear a prepositional relation to history. We are *pre*-Oedipal and *pre*-Symbolic, permanently threatening the male Symbolic with our painted faces and unruly hair. Yet in this theory we are incapable of ever really disrupting anything. Just as, in imperial discourse, white men were the sole heirs to the grand narrative of historical progress, so in Lacanian discourse, men are the sole heirs to the Symbolic. While the discourse on degeneration invented imperial nature to underwrite racial, class and gender difference, Lacan invents the ineffable majesty of the "phallic signifier" governing all social difference, a structural universal, unchanging and inevitable.

Women in Lacan's schema are assigned the position of victim, cipher, empty set—disempowered, tongueless, unsexed. Identified inevitably with the realm of the Other, women are the bearers and custodians of distance and difference but are never the agents and inventors of social possibility. For precisely this reason, we can be the *objects* of fetishism but never the *subjects*. To remain in the Imaginary is to become psychotic, the condition of the madwoman, hair wild. But if woman is Other, how does one begin to talk (as a woman) of different power relations *between* women, not to mention those between socially empowered women and disempowered men? When we speak and act as different women, the Self/Other dichotomy begins to totter and relations with the Other become relations with others.

Lacan shares with imperial discourse the image of woman as riddle. All too often, colonials represented the colonized landscape as feminine, unknowable and unrepresentable. So too in Lacanian theory the feminine is an unrepresentable absence effected by a phallic desire that grounds the signifying economy through exclusion. Women become the Dark Continent, the riddle of the Sphinx—exoticized and implicitly racist images drawn from an Africanist iconography. Constructing women and colonized people as a riddle ("the Woman Question," "the Native Question") allows privileged European men to answer the riddle in terms of their own interests.

There is an uncanny affinity between the Lacanian vision of women as unrepresentable and the imperial narrative that relegated women and the

colonized to the realm of the unrepresentable, the prehistoric, the Dark Continent. Thus we find in some feminist appropriations of Lacan a glamorization of Woman as primitive. For Cixous: "The voice in each woman . . . becomes the echo of the primeval song she once heard."[52] We hear in the "Voice of the Mother . . . a song before the Law, before the breath was split by the symbolic."[53] The riddling nature of women is retained as descriptively valid; only now the value is inverted: "The Dark continent is neither dark nor unexplorable."[54] The Mother's voice is "the deepest, most ancient and adorable of visitations."[55] But the political force of the metaphors of enigmas, riddles and dark continents—inherited as they are from the Victorian discourse on degeneration—is not opened to question. If, in imperial discourse, women were *inferior* because they were atavistic, here women are *superior* because they are atavistic. Nonetheless, the simple inversion of value keeps intact the analogy between women and colonized as prehistoric. Envisioning women as enigmatic denizens of the pre-Oedipal, however, is no less reactionary than figuring colonized peoples as atavistic throwbacks to the prehistory of the race.

The narrative of development and the concept of telos is also fundamental to Lacan. Thwarted yearning, dissatisfaction and lack find meaning only in relation to belief in the essential (if futile) telos of desire. The concept of telos is nowhere more marked than in Lacan's attempts to disavow female fetishism. Just as Freud could not allow clitoral sexuality to exist beyond puberty (for then female sexuality would escape the telos of heterosexual reproduction and the primacy of male genital pleasure), so too Lacan cannot permit female fetishism to exist. "Since it has been effectively demonstrated," he proclaims, "that the imaginary motive for most male perversions is the desire to preserve the phallus which involved the subject in the mother," and since fetishism is the "virtually manifest case of this desire," fetishism *must* be absent in women.[56]

Within a turn of the page, however, Lacan is forced to admit that fetishism *isn't* absent in women, but he tries to salvage the phallic drama in two ways. First, he identifies female fetishism only with lesbians. Second, in a deeply homophobic gesture, Lacan defines lesbians as "disappointed" heterosexuals. "Feminine homosexuality," Lacan announces grandly, "follows from a disappointment which reinforces the side of the demand for love."[57] But the very concept of disappointment in Lacan, like the concept of arrest in Freud, has meaning only in relation to a prior belief in the normative telos of heterosexual desire, in which one is first disappointed, and then turns to lesbianism. Lacan's use of the term *perversion* ("to turn away from") itself implies a normative heterosexual development from which the female subject turns, veering in disappointment to the "mask" and "virile display" of lesbian desire.

Hence the assumption of loss and sacrifice in Lacan's view of lesbian sexuality: the lesbian chooses other women "at the price of her own sex."[58] We can understand a lesbian's sexuality as exacting "a price," the sacrifice "of her own sex," only if we assume that female sexuality is generically heterosexual in the first place. Lacan seems unable to entertain the idea that a lesbian might choose other women to celebrate and expand her sexuality, for to admit such a possibility would be to endorse the refusal of heterosexuality as the only viable social option and to subvert the fiction of one phallus as governing all desire. Lacan's denial of female fetishism, except as lesbian disappointment and loss, again disavows female difference (women as agents of different desires) by rewriting lesbians' active affirmation of women as a negative, disappointed rejection of men. Thus the lesbian becomes an aberrant heterosexual who has not been able to accept her social role as the object of male desire.[59]

Moreover, in speaking of the "naturalness," as he puts it, "with which such women appeal to their quality of being men" as one more proof of the inevitable privileging of the phallic signifier, Lacan undermines (by inscribing as natural) the historically strategic, subversive and by no means universal assumption by some lesbians of male clothing and male hairstyles, a subversion that, far from duplicating heterosexuality in an inevitable female "envy of desire," offers a theatrical exhibition of the unnaturalness and constructedness of heterosexual codes. In the final analysis, as Judith Butler says of Kristeva, Lacan's account of lesbian sexuality "tells us more about the fantasies that a fearful heterosexual culture produces to defend itself against its own homosexual possibilities, than about lesbian experience itself."[60]

Jonathan Dollimore argues that, as a result, "the challenge of the perverse remains inscribed irreducibly within psychoanalysis."[61] What Dollimore calls "the potentially ludicrous position psychoanalysis comes to occupy in its repeated attempts to 'explain' homosexuality as a series of 'unsuccessful' resolutions of the Oedipus complex" itself threatens to push the idea of the Oedipal complex "into inconsistency and even absurdity."[62] "Perversion proves the undoing of the theory which contains it."[63] Dollimore argues, to my mind persuasively, that what is seen as "perversion" offers "a challenge not only to the Oedipal law, but to the entire Oedipal drama as a theory."[64] The fetish returns to challenge the very foundations of the theory that contains it.

REINVENTING THE FATHER

In 1938, Lacan proclaimed (against Engels) that the origins of culture lie within "the paternalist family," and he mourned the demise of the "paternal

imago" in the world about him.[65] Over the following decades, Lacan undertook a sustained effort to reinvent the "paternal imago" at the level of psychoanalytic theory, within the institutional walls of the academy and clinic. One might call his project the reinvention of the father and the Family of Man.

As Jacqueline Rose has astutely pointed out, "the heart of (Lacan's) polemic" is precisely an attempt to counter the feminization of psychoanalysis, which, since Freud, had stressed the importance of "frustrations coming from the mother," and consequently neglected the role of the "castration complex based on paternal repression."[66] In his fiction of the phallus, Lacan had an entirely more paternal narrative in mind.

Lacan, like Freud, authorizes his reinvention of the "paternalist family" by appealing to a single, male narrative of origins—the paternal threat of castration—which he draws from nineteenth-century anthropology. For Lacan, the universal (that is, male) shift towards the father that engenders the Symbolic is inaugurated by the father's prohibition against incest. Lacan follows Freud and Levi-Strauss (who follow the nineteenth-century anthropologists) in affirming that it was "the pact of the primordial law . . . that castration should be the punishment for incest." For Lacan, it is a cultural imperative (rooted in "primordial law") that the mother-child embrace be severed.[67] Yet what is the basis of this universal imperative, which Lacan asserts but does not theoretically justify—appealing only to "primordial law"? Lacan's move is crucial for his theory, since social difference is here engendered. Yet I consider his story implausible for a number of reasons.

Lacan's scenario of castration posits *paternal* intervention against incest as a cultural universal. Women are denied social agency: we are seen to have no motivation for weaning or preventing incest, no social interest in guiding children into separation, no role in helping children negotiate the intricate dynamics of interdependence, nor any capacity for doing so. Yet the activity of overseeing the dialectics of interdependence is precisely what constitutes the gendered division of labor in western cultures and many others besides. There is no room in Lacan's narrow house for women as social agents, nor for mothers and children to gradually recognize each other as both like and unlike, both desired and desiring (identity through difference) in ways that are not reducible to a single, grim, castrating phallic logic (identity through negation).[68]

Lacan's account assumes a universal, fairy-tale family, dwelling apart where neither neighbor nor nurse, policeman nor priest crosses the threshold to interrupt the mother-child embrace until the "name of the father" booms his virile edict of difference. Lacan's classically privatized family is a middle-class heirloom from the nineteenth century. But identity

comes into being through a wider community than the familial household, and the holy trinity beloved of Western psychoanalysis is far from the global norm.[69] The idea of a single, epochal "rupture" engendered by the "name of the father" is a theoretical fiction, invented to ensure the father a more grandiose role in the momentous drama of childraising than contemporary Western society allots him. Thus, I suggest, Lacan, like Freud, is complicit in the fetishistic disavowal (undervaluation) of women's active social intervention in the child's identity and in the fetishistic overvaluation of a male sexual prohibition as the governing and decisive moment in the inauguration of the social self.

Lacan insists that the founding rupture between mother and child is instituted by the symbolic force of the "Law of the Father," which is invested in the Name of the Father. For Lacan, the name of the father is equivalent to the entire symbolic realm, to culture itself. But then the dominant male culture becomes, at a stroke, synonymous with *all* culture. To be the phallus in Lacan's text is to find one's meaning only through the logic of the paternal law; it is to be entirely contained within the terms of phallocentricism.

At the very least, I question the Lacanian dependence on singular categories: "*the* Father," "*the* Law," "*the* Mother," "*the* phallus." Why is there only one formal mark of desire, however internally contradictory? By arguing in the singular, Lacan erases the theoretical possibility of multiple, contradictory and historically changing symbols of desire. Most crucially, there is no room under Lacan's sovereign Name of the Father for a historical investigation of why there is not one patriarchy, but many. Committed to the economy of one, Lacan's Name of the Father cannot account either descriptively or analytically for historical contradictions and imbalances in power *between* men. Nor can it account for the history of masculine powers that are not invested in metaphors of paternity; nor for hierarchical relations between fathers and the state—a relation of particular historical importance for black, colonized and otherwise disenfranchised men. Lacan's erasure of the history of competing patriarchies privileges a single, authoritative narrative of origins and disavows conflicts for power among competing narratives of gendered, racial and class authority. Lacan is curiously indifferent, indeed, to accounting for the institutions of violence that gave the phallus and the patronym their political power in the first place; perhaps because such an account might demand a more challenging engagement with social history than he is willing to undertake.

Lacanians argue that Lacan sees the phallic signifier as internally ambivalent, as the very mark and guarantee of ambivalence itself. Yet, I suggest, by organizing all contradiction under the sign of the *same*, Lacan

effectively subsumes all difference and makes contradictions docile under the universal sovereignty of the phallus, ratifying the very essentialism that he claims to be undermining. As Dollimore aptly puts it: "In Lacan's theory the dialectic is less a process than an energized fixation permanently haunted by loss."[70]

I suggest, indeed, that Lacan reinvented the idea of "the Father" as a universal precisely because the sovereignty of a single presiding "paternal imago" had been threatened in at least three ways: by the feminist critique of patriarchy; by Third World objections to a global order centered in a single, Western authority; and by the fact that the structures of Western bureaucratic states are themselves no longer directly dependent on metaphors of paternity to distribute, manage and justify male power. The state bureaucracy does not directly organize its legitimizing regime through the single *patria potestas* (the political icon of the monarchy). Lacanian psychoanalysis is, I suggest, a rearguard attempt to rescue the potency of the Law of the Father as an abstraction, at the very moment when it is disappearing as a political force.[71] Again, the gesture is fetishistic, disavowing and concealing under the artificial unity of a single, universal patriarchy those differences that might call into question the very concept of the Western Law of the Father.

The paternal imago reinvented by Lacan bears the anachronistic mark of a monotheistic, familial patriarchy. In many respects, Lacan's narrative rehearses a secular and tragic Fall, the Law of the Father booming forth the command of the primordial exile from Eden (but this time withholding redemption). His trinitarian imagination—the impossible Real (like God), the Fall from the Imaginary through the Oedipal drama, the earthly travail of the Symbolic, together with his quasi-theological fixation on a trinitarian family—offers a tragic philosophical replica of the Judeo-Christian narrative. In the male birthing ritual of Christian baptism, a priestly midwife initiates the soul into the citizenship of the Church. Likewise in Lacan, the (male) child enters the Symbolic through the baptismal mirror stage only by leaving the maternal Imaginary behind. Both are male, fetishistic birthing rituals that displace women's childbearing power. Lacan's edict, "there are no things but words," also echoes the Judeo-Christian notion of the world as linguistic allegory: "In the beginning was the word and the word was made flesh."

In Lacan's tragic ontology, of course, the allegory has lost its author. Nonetheless, agency, violence, power and desire are displaced onto "the sign" as its property, its agency ("the violence of the letter"). This involves a fetishistic displacement onto formal symbolic categories of agencies that are more properly speaking the agencies of human communities— communities that are always constituted in and through representation, but

are not reducible *to* language alone. According to Lacan, the individual is subjected to structural laws that stem less from social and economic relations among communities than from formal relations among symbols. As Marx noted, the relation between people comes to be seen as a relation between things.

Judith Butler has argued that the Lacanian narrative warrants description as a tragic ontology and that it is "ideologically suspect" in remaining wedded to "a romanticization or, indeed, a religious idealization of failure, humility and limitation before the Law."[72] "The figure of the paternal law as the inevitable and unknowable authority before which the sexed subject is bound to fail must be read for the theological impulse that motivates it as well as for the critique of theology that points beyond it."[73]

LACAN AND FEMINIST AGENCY

The crucial question for feminists is strategic. If the phallic signifier is unattainable and itself signifies only lack of being, is it possible to disrupt the ordering principle of the Symbolic? Because the phallus is simply a signifier of difference, it has no inherent power in itself; it derives its power from its (veiled) relation to male institutions of power and its merely metaphoric relation to the penis. The penis itself has no power but is invested with symbolic potency only by virtue of men's prior social privilege. In short, the phallus is powerful not because it symbolizes the penis (which it does and doesn't) but because it is the sign of male social power that originates elsewhere. Yet this "elsewhere" is perpetually deferred.

The best Lacan can do is to repeat, tautologically, that men have power because they bear a privileged relation to the phallus and that the phallus has power because it is the sign of male power. It would seem to follow logically that women can acknowledge the power of the phallus, only if we confront the institutions that invest the phallus with power in the first place — institutions that overlap, but also lie beyond the privatized family household and thus beyond the theoretical grasp of psychoanalysis *in its present form*. Nowhere does Lacan investigate the social history of male privilege, nor does he ever suggest that such an investigation be undertaken. Instead, we enter a circle of tautology, in which the explanation is assumed in the description and an historical account of male power is perpetually deferred, if not completely elided. Lacan confers on male power the aspect of a natural and inevitable fate; in consequence, he fails to account for what he sets out to explain: the social engendering of difference.

Mitchell's loyalty to the phallus as the privileged object of our attention limits feminism to a *negative* identification of our powerlessness, our position as "negativity," rather than an exploration of our powers above

and beyond enforced genuflections to the phallic regime. I suggest that it is only by acknowledging our power as well as our disempowerment that we can develop strategies for change.

For Rose, Lacan's insight is his insistence that the phallus is an "impostor." But does Lacan offer an escape route from the domain of the false monarch? At best we can recognize the fictive nature of the phallus, but it is, to adapt Wallace Stevens' phrase, a "necessary fiction" without which the symbolizing function cannot take place. The fraudulence of the phallus is crucially and inevitably implicated in the very structure of the symbolic function itself. Hence the "insolubility" for Lacan of women's subordination. Women may be symbolically subjected rather than actually inferior, but, for Lacan, women's subjection is still "inscribed in an order of exchange of which she [woman] is the object." Herein, Lacan intones gloomily, lies the "fundamentally conflictual and, I would say, *insoluble* character of her position."[74]

Because women have a permanently inadequate relation to the phallic order governing the universal Symbolic, we are doomed to remain inscribed as objects in the order of exchange. According to Lacan, we cannot surmount the order of exchange, "since the symbolic order literally submits her, it transcends her." Women can never intervene in this transcendent order, nor, indeed, can men. There is "something insurmountable" in our subjection. Lacanian psychoanalysis therefore cannot challenge the subordination of women precisely because it constantly reproduces women as inherently and invariably subordinate, destined to reside permanently under the false rule of the pretender phallus. Acknowledging that the phallus is a pretender, however, is not sufficient grounds for a feminist theory of gender power, for no alternative is ever given; indeed, the possibility of an alternative is explicitly denied. Lacan's politics, in the final analysis, are profoundly conservative and pessimistic and incapable of theorizing feminist strategies for change.

FEMINISM AND FEMALE FETISHISM

Some feminists have tried recently to expand the Lacanian family romance to include female fetishism. Yet they, too, have not finally abandoned or challenged the founding castration narrative. Following Freud, Kofman points out that "since there can be no fetish without a compromise between castration and its denial and because the fetishistic split . . . always presumes the two positions, the fetish can in no sense be a single Ersatz of the penis; if there were really a decision in favor of one of the two positions, there would no longer be any need to construct a fetish."[75] The fetish is thus the embodiment, in one object, of two positions:

"castration or its denial." For Kofman, as for Freud, the fetish is an "undecidable compromise." Yet the Freudian compromise seems ordained to oscillate between those two (and only two) decidedly fixed options. Undecidability is thus decisively contained and disciplined, reduced to a recurring male economy of the same: castration (of what appears a decidedly fleshly penis) or its denial.

Following Kofman, Schor argues that the fascination of fetishism for women is the "undecidability" it offers. "If one takes as one of the hallmarks of fetishism the split in the ego (*Ichspaltung*) to which the fetish bears testimony, then it becomes possible to speak . . . of female fetishism."[76] By staging the fetish's oscillation between recognition of castration and denial, women refuse to remain on one or the other side of the threat of castration. Yet this hardly seems to improve things. First, if the fetish is a compromise object, its undecidability is precisely its fascination for men as well. Second, since women do not feel the threat of castration in the first place, female libidinal investment in the fetish remains mysterious, if not downright unaccountable. Although women are admitted as extras into the male drama, the pivotal castration scene itself remains unchanged.

Marjorie Garber, taking Schor's lead but still reading Lacan's script, detaches the penis ("the anatomical object") from the phallus ("the structuring mark of desire") so that the phallus is merely "a stage prop, a detachable object" in fetishism's theater of display. "No one has the phallus." Like Schor, Garber reads the fetish as "a figure for the undecidability of castration . . . a sign at once of lack and its covering over."[77] Thus "the fetish is the phallus; the phallus is the fetish." Female fetishism is invisible, Garber suggests, "because it coincides with what has been established as natural or normal—for woman to fetishize the phallus on men."[78] But if the phallus is not the penis, what is the status of the phrase "on men"? "To deny female fetishism," Garber says, "is to establish a female desire for the phallus on the male body as *natural*."[79] Even if we read the phallus here as the "mark of desire," the anatomical referent to the penis is implicit, if not inescapable. More importantly, for Garber *all* fetishes are phallic fetishes: "Phallic fetishism—which is to say, fetishism."[80] But in this tautology of identity ("the fetish is the phallus, the phallus is the fetish") all fetishes are reduced to a single development narrative and to the same libidinal economy of the one recurring scene.[81] Garber's index readily reveals her Lacanian leaning: there are thirty-one entries for the phallus and twenty-four for the penis, but not a single one for breasts, clitoris or vagina. The absence of breast fetishism in a book on cross-dressing is remarkable, when one considers the prominent role that bras, nipple-clips and breasts (surrogate or otherwise) play in many men's transvestism, not to mention their role in female fetishism. Indeed, Garber's groundbreaking and anecdotally

marvellous book offers ample evidence to contradict her own theoretical dictum that the fetish is always the phallus.

While Garber reduces all fetishism and all transvestism to what she calls a "crisis in category," the few examples of racial transvestism that she garners seem, in particular, to undermine the phallic scene and the overinvestment in the metaphor of castration. If the figure of the trans-vestite is the figure of disruption, Garber risks reducing *racial* transvestism to a secondary function of *sexual* disruption: "the paradox of the black man in America as simultaneously a sign of sexual potency and a sign of emasculation or castration."[82] Here the black woman inhabits that brave, nowhere-place so eloquently summed up in the title: "All the women are white. All the men are black. But some of us are brave."

Fetishes may not always be disruptive or transgressive and can be mobilized for a variety of political ends — some progressive, some sub-versive, some deeply reactionary. No one understood the seductive power of fetish spectacle better than Hitler. The male Victorian middle class was not prevented by its fondness for flagellatory rituals from violently foreclosing the fetish rituals of other cultures. Fetishes such as the pink triangle can be deployed for divergent political ends, some less unde-cidable than others. Rather than marshaling these differences under the reductive sign of the phallus, we might do better to open them to different genealogies.

Although the fetish is a compromise object, it does not necessarily embody only two options. Fetishes can involve triangulated contradictions, or more than three. Different patterns of consumption or forms of violent political closure may effectively contain the disruptive or undecidable power of the fetish. White male fetishes can resonate differently from illicit black or female fetishes. Considerable theoretical rigor and subtlety are lost if all fetishes are reduced to the magisterial phallus: oral fetishes such as pacifiers used by men in "babyist" fetishism; breast fetishes such as nipple-clips or fetish bras; imperial fetishes such as slave-bands and whips; leather and rubber fetishes; national fetishes such as flags, team colors and sport mascots; political fetishes such as crowns and coats of arms; religious fetishes such as crucifixes and holy water; authority fetishes such as uniforms and handcuffs.

Instead of gathering these multifarious fetishes into a single primal scene, we might do better to open the genealogies of fetishism to more theoretically subtle and historically fruitful accounts. The fetishes of other cultures might then no longer have to genuflect to the master narrative of the western family romance. Since fetishes involve the displacement of a host of social contradictions onto impassioned objects, they defy reduction to a single originary trauma or the psychopathology of the individual

subject. Indeed, fetishism might become the theoretical scene of a renewed investigation into the vexed relations between imperialism and domesticity, desire and commodity fetishism, psychoanalysis and social history — if only because the fetish itself embodies the failure of a single narrative of origins.

DOUBLE CROSSINGS

2

SOFT-SOAPING EMPIRE

COMMODITY RACISM
AND IMPERIAL ADVERTISING

5

Soap is Civilization.

—Unilever Company Slogan

Doc: My, it's so clean.
Grumpy: There's dirty work afoot.

—Snow White and the Seven Dwarfs

SOAP AND CIVILIZATION

At the beginning of the nineteenth century, soap was a scarce and humdrum item and washing a cursory activity at best. A few decades later, the manufacture of soap had burgeoned into an imperial commerce; Victorian cleaning rituals were peddled globally as the God-given sign of Britain's evolutionary superiority, and soap was invested with magical, fetish powers. The soap saga captured the hidden affinity between

domesticity and empire and embodied a triangulated crisis in value: the *undervaluation* of women's work in the domestic realm, the *overvaluation* of the commodity in the industrial market and the *disavowal* of colonized economies in the arena of empire. Soap entered the realm of Victorian fetishism with spectacular effect, notwithstanding the fact that male Victorians promoted soap as the icon of nonfetishistic rationality.

Both the cult of domesticity and the new imperialism found in soap an exemplary mediating form. The emergent middle class values — monogamy ("clean" sex, which has value), industrial capital ("clean" money, which has value), Christianity ("being washed in the blood of the lamb"), class control ("cleansing the great unwashed") and the imperial civilizing mission ("washing and clothing the savage") — could all be marvelously embodied in a single household commodity. Soap advertising, in particular the Pears soap campaign, took its place at the vanguard of Britain's new commodity culture and its civilizing mission.

In the eighteenth century, the commodity was little more than a mundane object to be bought and used — in Marx's words, "a trivial thing."[1] By the late nineteenth century, however, the commodity had taken its privileged place not only as the fundamental form of a new industrial economy but also as the fundamental form of a new cultural system for representing social value.[2] Banks and stock exchanges rose up to manage the bonanzas of imperial capital. Professions emerged to administer the goods tumbling hectically from the manufactures. Middle-class domestic space became crammed as never before with furniture, clocks, mirrors, paintings, stuffed animals, ornaments, guns and myriad gewgaws and knicknacks. Victorian novelists bore witness to the strange spawning of commodities that seemed to have lives of their own, and huge ships lumbered with trifles and trinkets plied their trade among the colonial markets of Africa, the East and the Americas.[3]

The new economy created an uproar not only of things but of signs. As Thomas Richards has argued, if all these new commodities were to be managed, a unified system of cultural representation had to be found. Richards shows how, in 1851, the Great Exhibition at the Crystal Palace served as a monument to a new form of consumption: "What the first Exhibition heralded so intimately was the complete transformation of collective and private life into a space for the spectacular exhibition of commodities."[4] As a "semiotic laboratory for the labor theory of value," the World Exhibition showed once and for all that the capitalist system had not only created a dominant form of exchange but was also in the process of creating a dominant form of representation to go with it: the voyeuristic panorama of surplus as spectacle. By exhibiting commodities not only as goods but as an organized system of images, the World Exhibition helped

fashion "a new kind of being, the consumer and a new kind of ideology, consumerism."[5] The mass consumption of the commodity spectacle was born.

Victorian advertising reveals a paradox, however, for, as the cultural form that was entrusted with upholding and marketing abroad those founding middle-class distinctions—between private and public, paid work and unpaid work—advertising also from the outset began to confound those distinctions. Advertising took the intimate signs of domesticity (children bathing, men shaving, women laced into corsets, maids delivering nightcaps) into the public realm, plastering scenes of domesticity on walls, buses, shopfronts and billboards. At the same time, advertising took scenes of empire into every corner of the home, stamping images of colonial conquest on soap boxes, matchboxes, biscuit tins, whiskey bottles, tea tins and chocolate bars. By trafficking promiscuously across the threshold of private and public, advertising began to subvert one of the fundamental distinctions of commodity capital, even as it was coming into being.

From the outset, moreover, Victorian advertising took explicit shape around the reinvention of racial difference. Commodity kitsch made possible, as never before, the mass marketing of empire as an organized system of images and attitudes. Soap flourished not only because it created and filled a spectacular gap in the domestic market but also because, as a cheap and portable domestic commodity, it could persuasively mediate the Victorian poetics of racial hygiene and imperial progress.

Commodity racism became distinct from scientific racism in its capacity to expand beyond the literate, propertied elite through the marketing of commodity spectacle. If, after the 1850s, scientific racism saturated anthropological, scientific and medical journals, travel writing and novels, these cultural forms were still relatively class-bound and inaccessible to most Victorians, who had neither the means nor the education to read such material. Imperial kitsch as consumer spectacle, by contrast, could package, market and distribute evolutionary racism on a hitherto unimagined scale. No preexisting form of organized racism had ever before been able to reach so large and so differentiated a mass of the populace. Thus, as domestic commodities were mass marketed through their appeal to imperial jingoism, commodity jingoism itself helped reinvent and maintain British national unity in the face of deepening imperial competition and colonial resistance. The cult of domesticity became indispensable to the consolidation of British national identity, and at the center of the domestic cult stood the simple bar of soap.[6]

Yet soap has no social history. Since it purportedly belongs in the female realm of domesticity, soap is figured as beyond history and beyond politics proper.[7] To begin a social history of soap, then, is to refuse, in part, to accept the erasure of women's domestic value under imperial capitalism.

It cannot be forgotten, moreover, that the history of European attempts to impose a commodity economy on African cultures was also the history of diverse African attempts either to refuse or to transform European commodity fetishism to suit their own needs. The story of soap reveals that fetishism, far from being a quintessentially African propensity, as nineteenth-century anthropology maintained, was central to industrial modernity, inhabiting and mediating the uncertain threshold zones between domesticity and industry, metropolis and empire.

SOAP AND COMMODITY SPECTACLE

Before the late nineteenth century, clothes and bedding washing was done in most households only once or twice a year in great, communal binges, usually in public at streams or rivers.[8] As for body washing, not much had changed since the days when Queen Elizabeth I was distinguished by the frequency with which she washed: "regularly every month whether she needed it or not."[9] By the 1890s, however, soap sales had soared, Victorians were consuming 260,000 tons of soap a year, and advertising had emerged as the central cultural form of commodity capitalism.[10]

Before 1851, advertising scarcely existed. As a commercial form, it was generally regarded as a confession of weakness, a rather shabby last resort. Most advertising was limited to small newspaper advertisements, cheap handbills and posters. After midcentury, however, soap manufacturers began to pioneer the use of pictorial advertising as a central part of business policy.

The initial impetus for soap advertising came from the realm of empire. With the burgeoning of imperial cotton on the slave plantations came the surplus of cheap cotton goods, alongside the growing buying power of a middle class that could afford for the first time to consume such goods in large quantities. Similarly, the sources for cheap palm oil, coconut oil and cottonseed oil flourished in the imperial plantations of West Africa, Malay, Ceylon, Fiji and New Guinea. As rapid changes in the technology of soapmaking took place in Britain after midcentury, the prospect dawned of a large domestic market for soft body soaps, which had previously been a luxury that only the upper class could afford.

Economic competition with the United States and Germany created the need for a more aggressive promotion of British products and led to the first real innovations in advertising. In 1884, the year of the Berlin Conference, the first wrapped soap was sold under a brand name. This small event signified a major transformation in capitalism, as imperial competition gave rise to the creation of monopolies. Henceforth, items formerly indistinguishable from each other (soap sold simply as soap) would be

marked by their corporate signature (Pears, Monkey Brand, etc). Soap became one of the first commodities to register the historic shift from myriad small businesses to the great imperial monopolies. In the 1870s, hundreds of small soap companies plied the new trade in hygiene, but by the end of the century, the trade was monopolized by ten large companies.

In order to manage the great soap show, an aggressively entrepreneurial breed of advertisers emerged, dedicated to gracing each homely product with a radiant halo of imperial glamour and racial potency. The advertising agent, like the bureaucrat, played a vital role in the imperial expansion of foreign trade. Advertisers billed themselves as "empire builders" and flattered themselves with "the responsibility of the historic imperial mission." Said one: "Commerce even more than sentiment binds the ocean sundered portions of empire together. Anyone who increases these commercial interests strengthens the whole fabric of the empire."[11] Soap was credited not only with bringing moral and economic salvation to Britain's "great unwashed" but also with magically embodying the spiritual ingredient of the imperial mission itself.

In an ad for Pears, for example, a black and implicitly racialized coalsweeper holds in his hands a glowing, occult object. Luminous with its own inner radiance, the simple soap bar glows like a fetish, pulsating magically with spiritual enlightenment and imperial grandeur, promising to warm the hands and hearts of working people across the globe.[12] Pears, in particular, became intimately associated with a purified nature magically cleansed of polluting industry (tumbling kittens, faithful dogs, children festooned with flowers) and a purified working class magically cleansed of polluting labor (smiling servants in crisp white aprons, rosy-cheeked match girls and scrubbed scullions).[13]

Nonetheless, the Victorian obsession with cotton and cleanliness was not simply a mechanical reflex of economic surplus. If imperialism garnered a bounty of cheap cotton and soap oils from coerced colonial labor, the middle class Victorian fascination with clean, white bodies and clean, white clothing stemmed not only from the rampant profiteering of the imperial economy but also from the realms of ritual and fetish.

Soap did not flourish when imperial ebullience was at its peak. It emerged commercially during an era of impending crisis and social calamity, serving to preserve, through fetish ritual, the uncertain boundaries of class, gender and race identity in a social order felt to be threatened by the fetid effluvia of the slums, the belching smoke of industry, social agitation, economic upheaval, imperial competition and anticolonial resistance. Soap offered the promise of spiritual salvation and regeneration through commodity consumption, a regime of domestic hygiene that could restore the threatened potency of the imperial body politic and the race.

In 1789 Andrew Pears, a farmer's son, left his Cornish village of Mevagissey to open a barbershop in London, following the trend of widespread demographic migration from country to city and the economic turn from land to commerce. In his shop, Pears made and sold the powders, creams and dentifrices used by the rich to ensure the fashionable alabaster purity of their complexions. For the elite, a sun-darkened skin stained by outdoor manual work was the visible stigma not only of a class obliged to work under the elements for a living but also of far-off, benighted races marked by God's disfavor. From the outset, soap took shape as a technology of social purification, inextricably entwined with the semiotics of imperial racism and class denigration.

In 1838 Andrew Pears retired and left his firm in the hands of his grandson, Francis. In due course, Francis's daughter, Mary, married Thomas J. Barratt, who became Francis' partner and took the gamble of fashioning a middle-class market for the transparent soap. Barratt revolutionized Pears by masterminding a series of dazzling advertising campaigns. Inaugurating a new era of advertising, he won himself lasting fame, in the familiar iconography of male birthing, as the "father of advertising." Soap thus found its industrial destiny through the mediation of domestic kinship and that peculiarly Victorian preoccupation with patrimony.

Through a series of gimmicks and innovations that placed Pears at the center of Britain's emerging commodity culture, Barratt showed a perfect understanding of the fetishism that structures all advertising. Importing a quarter of a million French centime pieces into Britain, Barratt had the name Pears stamped on them and put the coins into circulation—a gesture that marvelously linked exchange value with the corporate brand name. The ploy worked famously, arousing much publicity for Pears and such a public fuss that an Act of Parliament was rushed through to declare all foreign coins illegal tender. The boundaries of the national currency closed around the domestic bar of soap.

Georg Lukács points out that the commodity lies on the threshold of culture and commerce, confusing the supposedly sacrosanct boundaries between aesthetics and economy, money and art. In the mid-1880s, Barratt devised a piece of breathtaking cultural transgression that exemplified Lukács' insight and clinched Pears' fame. Barratt bought Sir John Everett Millais' painting "Bubbles" (originally entitled "A Child's World") and inserted into the painting a bar of soap stamped with the totemic word *Pears*. At a stroke, he transformed the artwork of the best-known painter in Britain into a mass produced commodity associated in the public mind with Pears.[14] At the same time, by mass reproducing the painting as a poster ad,

Barratt took art from the elite realm of private property to the mass realm of commodity spectacle.[15]

In advertising, the axis of possession is shifted to the axis of spectacle. Advertising's chief contribution to the culture of modernity was the discovery that by manipulating the semiotic space around the commodity, the unconscious as a public space could also be manipulated. Barratt's great innovation was to invest huge sums of money in the creation of a visible aesthetic space around the commodity. The development of poster and print technology made possible the mass reproduction of such a space around the image of a commodity.[16]

In advertising, that which is disavowed by industrial rationality (ambivalence, sensuality, chance, unpredictable causality, multiple time) is projected onto image space as a repository of the forbidden. Advertising draws on subterranean flows of desire and taboo, manipulating the investment of surplus money. Pears' distinction, swiftly emulated by scores of soap companies including Monkey Brand and Sunlight, as well as countless other advertisers, was to invest the aesthetic space around the domestic commodity with the commercial cult of empire.

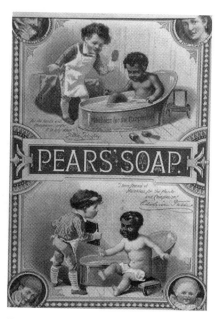

FIGURE 5.1 RACE AND THE CULT OF DOMESTICITY.

THE SOAP

Four fetishes recur ritualistically in soap advertising: soap itself, white clothing (especially aprons), mirrors and monkeys. A typical Pears' advertisement figures a black child and a white child together in a bathroom [Fig. 5.1]. The Victorian bathroom is the innermost sanctuary of domestic hygiene and by extension the private temple of public regeneration. The sacrament of soap offers a reformation allegory whereby the purification of the domestic body becomes a metaphor for the regeneration of the body politic. In this particular ad, a black boy sits in the bath, gazing wide-eyed into the water as if into a foreign element. A white boy, clothed in a white apron—the familiar fetish of domestic purity—bends benevolently over his "lesser" brother, bestowing upon him the precious talisman of racial progress. The magical fetish of soap promises that the commodity can regenerate the Family of Man by washing from the skin the very stigma of racial and class degeneration.

Soap advertising offers an allegory of imperial progress as spectacle. In this ad, the imperial topos that I call panoptical time (progress consumed as a spectacle from a point of privileged invisibility) enters the domain of the commodity. In the second frame of the ad, the black child is out of the bath and the white boy shows him his startled visage in the mirror. The black boy's body has become magically white, but his face—for Victorians the seat of rational individuality and self-consciousness—remains stubbornly black. The white child is thereby figured as the agent of history and the male heir to progress, reflecting his lesser brother in the European mirror of self-consciousness. In the Victorian mirror, the black child witnesses his predetermined destiny of imperial metamorphosis but remains a passive racial hybrid, part black, part white, brought to the brink of civilization by the twin commodity fetishes of soap and mirror. The advertisement discloses a crucial element of late Victorian commodity culture: the metaphoric transformation of imperial *time* into consumer *space*—imperial progress consumed at a glance as domestic spectacle.

THE MONKEY

The metamorphosis of imperial time into domestic space is captured most vividly by the advertising campaign for Monkey Brand Soap. During the 1880s, the urban landscape of Victorian Britain teemed with the fetish monkeys of this soap. The monkey with its frying pan and bar of soap perched everywhere, on grimy hoardings and buses, on walls and shop

fronts, promoting the soap that promised magically to do away with domestic labor: "No dust, no dirt, no labor." Monkey Brand Soap promised not only to regenerate the race but also to magically erase the unseemly spectacle of women's manual labor.

In an exemplary ad, the fetish soap-monkey sits cross-legged on a doorstep, the threshold boundary between private domesticity and public commerce—the embodiment of anachronistic space [Fig. 5.2]. Dressed like an organ grinder's minion in a gentleman's ragged suit, white shirt and tie, but with improbably human hands and feet, the monkey extends a frying pan to catch the surplus cash of passersby. On the doormat before him, a great bar of soap is displayed, accompanied by a placard that reads: "My Own Work." In every respect the soap-monkey is a hybrid: not entirely ape, not entirely human; part street beggar, part gentleman; part artist, part advertiser. The creature inhabits the ambivalent border of jungle and city, private and public, the domestic and the commercial, and offers as its handiwork a fetish that is both art and commodity.

Monkeys inhabit Western discourse on the borders of social limit, marking the place of a contradiction in social value. As Donna Haraway

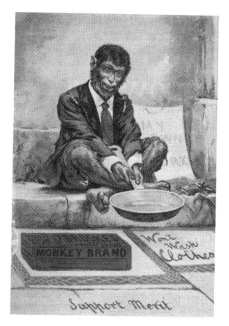

FIGURE 5.2 ANACHRONISTIC SPACE:
THE THRESHOLD OF
DOMESTICITY AND MARKET.

has argued: "the primate body, as part of the body of nature, may be read as a map of power."[17] Primatology, Haraway insists, "is a Western discourse . . . a political order that works by the negotiation of boundaries achieved through ordering differences."[18] In Victorian iconography, the ritual recurrence of the monkey figure is eloquent of a crisis in value and hence anxiety at possible boundary breakdown. The primate body became a symbolic space for reordering and policing boundaries between humans and nature, women and men, family and politics, empire and metropolis.

Simian imperialism is also centrally concerned with the problem of representing *social change*. By projecting history (rather than fate, or God's will) onto the theater of nature, primatology made nature the alibi of political violence and placed in the hands of "rational science" the authority to sanction and legitimize social change. Here, "the scene of origins," Haraway argues, "is not the cradle of civilization, but the cradle of culture . . . the origin of sociality itself, especially in the densely meaning-laden icon of the family."[19] Primatology emerges as a theater for negotiating the perilous boundaries between the family (as natural and female) and power (as political and male).

The appearance of monkeys in soap advertising signals a dilemma: *how to represent domesticity without representing women at work*. The Victorian middle-class house was structured round the fundamental contradiction between women's paid and unpaid domestic work. As women were driven from paid work in mines, factories, shops and trades to private, unpaid work in the home, domestic work became economically under-valued and the middle-class definition of femininity figured the "proper" woman as one who did not work for profit. At the same time, a *cordon sanitaire* of racial degeneration was thrown around those women who did work publicly and visibly for money. What could not be incorporated into the industrial formation (women's domestic economic value) was displaced onto the invented domain of the primitive, and thereby disciplined and contained.

Monkeys, in particular, were deployed to legitimize social boundaries as edicts of nature. Fetishes straddling nature and culture, monkeys were seen as allied with the dangerous classes: the "apelike" wandering poor, the hungry Irish, Jews, prostitutes, impoverished black people, the ragged working class, criminals, the insane and female miners and servants, who were collectively seen to inhabit the threshold of racial degeneration. When Charles Kingsley visited Ireland, for example, he lamented: "I am haunted by the human chimpanzees I saw along that hundred miles of horrible country. . . . But to see white chimpanzees is dreadful; if they were black, one would not feel it so much, but their skins, except where tanned by exposure, are as white as ours."[20]

In the Monkey Brand advertisement, the monkey's signature of labor ("My Own Work") signals a double disavowal. Soap is masculinized, figured as a male product, while the (mostly female) labor of the workers in the huge, unhealthy soap factories is disavowed. At the same time, the labor of social transformation in the daily scrubbing and scouring of the sinks, pans and dishes, labyrinthine floors and corridors of Victorian domestic space vanishes—refigured as anachronistic space, primitive and bestial. Female servants disappear and in their place crouches a phantasmic male hybrid. Thus, domesticity—seen as the sphere most separate from the marketplace and the masculine hurly-burly of empire—takes shape around the invented ideas of the primitive and the commodity fetish.

In Victorian culture, the monkey was an icon of metamorphosis, perfectly serving soap's liminal role in mediating the transformations of nature (dirt, waste and disorder) into culture (cleanliness, rationality and industry). Like all fetishes, the monkey is a contradictory image, embodying the hope of imperial progress through commerce while at the same time rendering visible deepening Victorian fears of urban militancy and colonial misrule. The soap-monkey became the emblem of industrial progress and imperial evolution, embodying the double promise that nature could be redeemed by consumer capital and that consumer capital could be guaranteed by natural law. At the same time, however, the soap-monkey was eloquent of the degree to which fetishism structures industrial rationality.

THE MIRROR

In most Monkey Brand advertisements, the monkey holds a frying pan, which is also a mirror. In a similar Brooke's Soap ad, a classical female beauty with bare white arms stands draped in white, her skin and clothes epitomizing the exhibition value of sexual purity and domestic leisure, while from the cornucopia she holds flows a grotesque effluvium of hobgoblin angels. Each hybrid fetish embodies the doubled Victorian image of woman as "angel in the drawing room, monkey in the bedroom," as well as the racial iconography of evolutionary progress from ape to angel. Historical time, again, is captured as domestic spectacle, eerily reflected in the frying pan/mirror fetish.

In this ad, the Brooke's Soap offers an alchemy of economic progress, promising to make "copper like gold." At the same time, the Enlightenment idea of linear, rational time leading to angelic perfection finds its antithesis in the other time of housework, ruled by the hobgoblins of dirt, disorder and fetishistic, nonprogressive time. Erupting on the margins of the rational frame, the ad displays the irrational consequences of the idea of progress.

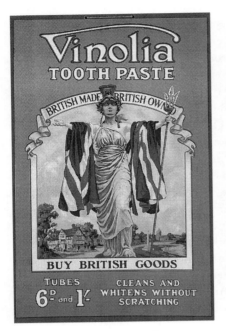

FIGURE 5.3 BRITANNIA AND DOMESTICITY.

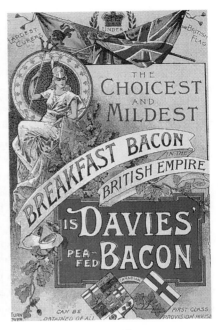

FIGURE 5.4 NATIONAL IMPERIALISM.

The mirror/frying pan, like all fetishes, visibly expresses a crisis in value but cannot resolve it. It can only embody the contradiction, frozen as commodity spectacle, luring the spectator deeper and deeper into consumerism.

Mirrors glint and gleam in soap advertising, as they do in the culture of imperial kitsch at large. In Victorian middle-class households, servants scoured and polished every metal and wooden surface until it shone like a mirror. Doorknobs, lamp stands and banisters, tables and chairs, mirrors and clocks, knives and forks, kettles and pans, shoes and boots were polished until they shimmered, reflecting in their gleaming surfaces other object-mirrors, an infinity of crystalline mirrors within mirrors, until the interior of the house was all shining surfaces, a labyrinth of reflection. The mirror became the epitome of commodity fetishism: erasing both the signs of domestic labor and the industrial origins of domestic commodities. In the domestic world of mirrors, objects multiply without apparent human intervention in a promiscuous economy of self-generation.

Why the attention to surface and reflection? The polishing was dedicated, in part, to policing the boundaries between private and public, removing every trace of labor, replacing the disorderly evidence of working women with the exhibition of domesticity as veneer, the commodity spectacle as surface, the house arranged as a theater of clean surfaces for commodity display. The mirror/commodity renders the value of the object as an exhibit, a spectacle to be consumed, admired and displayed for its capacity to embody a twofold value: the man's market worth and the wife's exhibition status. The house existed to display femininity as bearing exhibition value only, beyond the marketplace and therefore, by natural decree, beyond political power.

An ad for Stephenson's Furniture Cream figures a spotless maid on all fours, smiling up from a floor so clean that it mirrors her reflection. The cream is "warranted not to fingermark." A superior soap should leave no telltale smear, no fingerprint of female labor. As Victorian servants lost individuality in the generic names their employers imposed on them, so soaps erased the imprint of women's work on middle-class history.

DOMESTICATING EMPIRE

By the end of the century, a stream of imperial bric-a-brac had invaded Victorian homes. Colonial heroes and colonial scenes were emblazoned on a host of domestic commodities, from milk cartons to sauce bottles, tobacco tins to whiskey bottles, assorted biscuits to toothpaste, toffee boxes to baking powder.[21] Traditional national fetishes such as the Union Jack, Britannia, John Bull and the rampant lion were marshaled into a revamped celebration of imperial spectacle [Figs. 5.3–5.5]. Empire was seen to be patriotically defended by Ironclad Porpoise Bootlaces and Sons of the Empire soap, while Henry Morton Stanley came to the rescue of the Emin of Pasha laden with outsize boxes of Huntley and Palmers Biscuits.

Late Victorian advertising presented a vista of Africa conquered by domestic commodities.[22] In the flickering magic lantern of imperial desire, teas, biscuits, tobaccos, Bovril, tins of cocoa and, above all, soaps beach themselves on far-flung shores, tramp through jungles, quell uprisings, restore order and write the inevitable legend of commercial progress across the colonial landscape. In a Huntley and Palmers' Biscuits ad, a group of male colonials sit in the middle of a jungle on biscuit crates, sipping tea [Fig. 5.6]. Moving towards them is a stately and seemingly endless procession of elephants, loaded with more biscuits and colonials, bringing tea time to the heart of the jungle. The serving attendant in this ad, as in most others, is male. Two things happen in such images: women vanish from the affair of empire, and colonized men are feminized by their association with domestic servitude.

FIGURE 5.5 NATIONAL FETISHISM.

Liminal images of oceans, beaches and shorelines recur in cleaning ads of the time. An exemplary ad for Chlorinol Soda Bleach shows three boys in a soda box sailing in a phantasmic ocean bathed by the radiance of the imperial dawn [Fig. 5.7]. In a scene washed in the red, white and blue of the Union Jack, two black boys proudly hold aloft their boxes of Chlorinol. A third boy, the familiar racial hybrid of cleaning ads, has presumably already applied his bleach, for his skin is blanched an eery white. On red sails that repeat the red of the bleach box, the legend of black people's purported commercial redemption in the arena of empire reads: "We are going to use 'Chlorinol' and be like de white nigger."

The ad vividly exemplifies Marx's lesson that the mystique of the commodity fetish lies not in its use value but in its exchange value and its potency as a sign: "So far as [the commodity] is a value in use, there is nothing mysterious about it." For three naked children, clothing bleach is less than useful. Instead, the whitening agent of bleach promises an alchemy of racial upliftment through historical contact with commodity culture. The transforming power of the civilizing mission is stamped on the boat-box's sails as the objective character of the commodity itself.

More than merely a *symbol* of imperial progress, the domestic commodity becomes the *agent* of history itself. The commodity, abstracted

FIGURE 5.6 TEA TIME COMES TO THE JUNGLE.

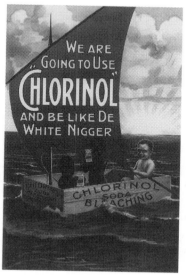

FIGURE 5.7 PANOPTICAL TIME: RACIAL
PROGRESS AT A GLANCE.

FIGURE 5.8 COMMODITY MAGIC AND THE
VANISHING OF WOMEN'S WORK.

from social context and human labor, does the civilizing work of empire, while radical change is figured as magical, without process or social agency. Hence the proliferation of ads featuring magic [Fig. 5.8]. In similar fashion, cleaning ads such as Chlorinol's foreshadow the "before and after" beauty ads of the twentieth century, a crucial genre directed largely at women, in which the conjuring power of the product to alchemize change is all that lies between the temporal "before and after" of women's bodily transformation.

The Chlorinol ad displays a racial and gendered division of labor. Imperial progress from black child to "white nigger" is consumed as commodity spectacle—as panoptical time. The self-satisfied, hybrid "white nigger" literally holds the rudder of history and directs social change, while the dawning of civilization bathes his enlightened brow with radiance. The black children simply have exhibition value as potential consumers of the commodity, there only to uphold the promise of capitalist commerce and to represent how far the white child has evolved—in the iconography of

Victorian racism, the condition of "savagery" is identical to the condition of infancy. Like white women, Africans (both women and men) are figured not as historic agents but as frames for the commodity, valued for *exhibition* alone. The working women, both black and white, who spent vast amounts of energy bleaching the white sheets, shirts, frills, aprons, cuffs and collars of imperial clothes are nowhere to be seen. It is important to note that in Victorian advertising, black women are very seldom rendered as consumers of commodities, for, in imperial lore, they lag too far behind men to be agents of history. Imperial domesticity is therefore a domesticity without women.

In the Chlorinol ad, women's creation of social value through housework is displaced onto the commodity as its own power, fetishistically inscribed on the children's bodies as a magical metamorphosis of the flesh. At the same time, military subjugation, cultural coercion and economic thuggery are refigured as benign domestic processes as natural and healthy as washing. The stains of Africa's disobligingly complex and tenacious past and the inconvenience of alternative economic and cultural values are washed away like grime [Fig. 5.7].

Incapable of themselves actually engendering change, African men are figured only as "mimic men," to borrow V. S. Naipaul's dyspeptic phrase, destined simply to ape the epic white march of progress to self-knowledge. Bereft of the white raimants of imperial godliness, the Chlorinol children appear to take the fetish literally, content to bleach their skins to white. Yet these ads reveal that, far from being a quintessentially African propensity, the faith in fetishism was a faith fundamental to imperial capitalism itself.

THE MYTH OF FIRST CONTACT

By the turn of the century, soap ads vividly embodied the hope that the commodity alone, independent of its use value, could convert other cultures to "civilization." Soap ads also embody what can be called *the myth of first contact*: the hope of capturing, as spectacle, the pristine moment of originary contact fixed forever in the timeless surface of the image. In another Pears ad, a black man stands alone on a beach, examining a bar of soap he has picked from a crate washed ashore from a shipwreck [Fig. 5.9]. The ad announces nothing less than the "The Birth Of Civilization." Civilization is born, the image implies, at the moment of first contact with the Western commodity. Simply by touching the magical object, African man is inspired into history. An epic metamorphosis takes place, as Man the Hunter-gatherer (anachronistic man) evolves instantly into Man the Consumer. At the same time, the magical object effects a gender transformation, for the consumption of the domestic soap is racialized as a male birthing ritual,

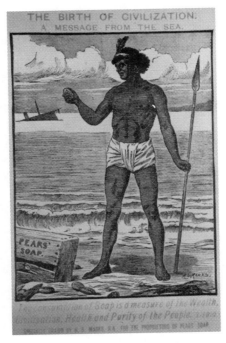

FIGURE 5.9 THE MYTH OF FIRST CONTACT.

with the egg-shaped commodity as the fertile talisman of change. Since women cannot be recognized as agents of history, it is necessary that a man, not a woman, be the historic beneficiary of the magical cargo and that the male birthing occur on the beach, not in the home.[23]

In keeping with the racist iconography of the gender degeneration of African men, the man is subtly feminized by his role as historic exhibit. His jaunty feather represents what Victorians liked to believe was African men's fetishistic, feminine and lower-class predilection for decorating their bodies. Thomas Carlyle, in his prolonged cogitation on clothes, *Sartor Resartus,* notes, for example: "The first spiritual want of a barbarous man is Decoration, as indeed we still see amongst the barbarous classes in civilized nations."[24] Feminists have explored how, in the iconography of modernity, women's bodies are exhibited for visual consumption, but very little has been said about how, in imperial iconography, black men were figured as spectacles for commodity exhibition. If, in scenes set in the Victorian home, female servants

are *racialized* and portrayed as frames for the exhibition of the commodity, in advertising scenes set in the colonies, African men are *feminized* and portrayed as exhibition frames for commodity display. Black women, by contrast, are rendered virtually invisible. Essentialist assumptions about a universal "male gaze" elide a great many important historical complexities.

Marx noted how under capitalism "the exchange value of a commodity assumes an independent existence."[25] Toward the end of the nineteenth century, the commodity itself disappears from many ads, and the corporate signature, as the embodiment of pure exchange value in monopoly capital, finds an independent existence. Another ad for Pears features a group of disheveled Sudanese "dervishes" awestruck by a white legend carved on the mountain face: PEARS SOAP IS THE BEST [Fig. 5.10]. The significance of the ad, as Richards notes, is its representation of the commodity as a magical medium capable of enforcing and enlarging British power in the colonial world, even without the rational understanding of the mesmerized Sudanese.[26] What the ad more properly reveals is the colonials' own fetishistic faith in the magic of brand names to work the causal power

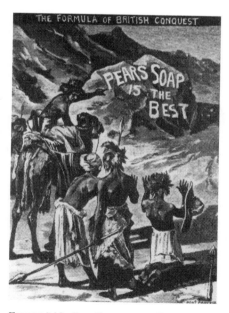

FIGURE 5.10 THE CONQUERING BRAND NAME.

of empire. In a similar ad, the letters BOVRIL march boldly over a colonial map of South Africa—imperial progress consumed as spectacle, as panoptical time [Fig. 5.11]. In an inspired promotional idea, the word had been recognized as tracing the military advance of Lord Roberts across the country, yoking together, as if writ by nature, the simultaneous lessons of colonial domination and commodity progress. In this ad, the colonial map explicitly enters the realm of commodity spectacle.

The poetics of cleanliness is a poetics of social discipline. Purification rituals prepare the body as a terrain of meaning, organizing flows of value across the self and the community and demarcating boundaries between one community and another. Purification rituals, however, can also be regimes of violence and constraint. People who have the power to invalidate the boundary rituals of another people thereby demonstrate their capacity to violently impose their culture on others. Colonial travel writers, traders, missionaries and bureaucrats carped constantly at the supposed absence in African culture of "proper domestic life," in particular Africans' purported lack of hygiene.[27] But the inscription of Africans as dirty and undomesticated, far from being an accurate depiction of African cultures, served to legitimize the imperialists' violent enforcement of their cultural and economic values, with the intent of purifying and thereby subjugating the unclean African body and imposing market and cultural values more useful to the mercantile and imperial economy. The myth of imperial commodities beaching on native shores, there to be welcomed by awestruck natives, wipes from memory the long and intricate history of European commercial trade with Africans and the long and intricate history of African resistance to Europe and colonization. Domestic ritual became a technology of discipline and dispossession.

The crucial point is not simply the formal contradictions that structure fetishes, but also the more demanding historical question of how certain groups succeed, through coercion or hegemony, in foreclosing the ambivalence that fetishism embodies by successfully imposing their economic and cultural system on others.[28] Cultural imperialism does not mean that the contradictions are permanently resolved, nor that they cannot be used against the colonials themselves. Nonetheless, it seems crucial to recognize that what has been vaunted by some as the permanent undecidability of cultural signs can also be violently and decisively foreclosed by superior military power or hegemonic dominion.

FETISHISM IN THE CONTEST ZONE

Enlightenment and Victorian writers frequently figured the colonial encounter as the journey of the rational European (male) mind across a

liminal space (ocean, jungle or desert) populated by hybrids (mermaids and monsters) to a prehistoric zone of dervishes, cannibals and fetish-worshippers. Robinson Crusoe, in one of the first novelistic expressions of the idea, sets Christian lands apart from those whose people "prostrate themselves to Stocks and Stones, worshipping Monsters, Elephants, horrible shaped animals and Statues, or Images of Monsters."[29] The Enlightenment mind was felt to have transcended fetish worship and could look indulgently upon those still enchanted by the magical powers of "stocks and stones." But as Mitchell notes, "the deepest magic of the commodity fetish is its denial that there is anything magical about it."[30] Colonial protestations notwithstanding, a decidedly fetishistic faith in the magical powers of the commodity underpinned much of the colonial civilizing mission.

Contrary to the myth of first contact embodied in Victorian ads, Africans had been trading with Europeans for centuries by the time the British Victorians arrived. Intricate trading networks were spread over west and north Africa, with complex intercultural settlements and long

FIGURE 5.11 IMPERIAL PROGRESS AS COMMODITY SPECTACLE.

histories of trade negotiations and exchanges, sporadically interrupted by violent conflicts and conquests. As John Barbot, the seventeenth-century trader and writer, remarked of the Gold Coast trade: "The Blacks of the Gold Coast, having traded with Europeans since the 14th century, are very well skilled in the nature and proper qualities of all European wares and merchandise vended there."[31] Eighteenth-century voyage accounts reveal, moreover, that European ships plying their trade with Africa were often loaded not with "useful" commodities but with baubles, trinkets, beads, mirrors and "medicinal" potions.[32] Appearing in seventeenth-century trade lists, among the salt, brandy, cloth and iron, are items such as brass rings, false pearls, bugles (small glass beads), looking glasses, little bells, false crystals, shells, bright rags, glass buttons, small brass trumpets, amulets and arm rings.[33] Colonials indulged heavily in the notion that, by ferrying these cargoes of geegaws and knick-knacks across the seas, they were merely pandering to naive and primitive African tastes. Merchant trade lists reveal, however, that when the European ships returned from West Africa, they were laden not only with gold dust and palm oil but also with elephant tusks, "teeth of sea-horses" (hippopotami), ostrich feathers, beeswax, animal hides and "cods of musk."[34] The absolute commodification of humanity and the colonial genuflection to the fetish of profit was most grotesquely revealed in the indiscriminate listing of slaves amongst the trifles and knick-knacks.

By defining the economic exchanges and ritual beliefs of other cultures as "irrational" and "fetishistic," the colonials tried to disavow them as legitimate systems. The huge labor that went into transporting cargoes of trifles to the colonies had less to do with the appropriateness of such fripperies to African cultural systems than with the systematic undervaluation of those systems with respect to merchant capitalism and market values in the European metropolis.

A good deal of evidence also suggests that the European traders, while vigorously denying their own fetishism and projecting such "primitive" proclivities onto white women, Africans and children, took their own "rational" fetishes with the utmost seriousness.[35] By many accounts, the empire seems to have been especially fortified by the marvelous fetish of Eno's Fruit Salt. If Pears could be entrusted with cleaning the outer body, Eno's was entrusted with "cleaning" the inner body. Most importantly, the internal purity guaranteed by Eno's could be relied upon to ensure male potency in the arena of war. As one colonial vouched: "During the Afghan war, I verily believe Kandahar was won by us all taking up large supplies of ENO's FRUIT SALT and so arrived fit to overthrow half-a-dozen Ayub Khans."[36] He was not alone in strongly recommending Eno's power to restore white supremacy. Commander A. J. Loftus, hydrographer to His

Siamese Majesty, swore that he never ventured into the jungle without his tin of Eno's. There was only one instance, he vouched, during four years of imperial expeditions that any member of his party fell prey to fever: "and that happened after our supply of FRUIT SALT ran out."[37]

Fetishism became an intercultural space in that both sides of the encounter appear occasionally to have tried to manipulate the other by mimicking what they took to be the other's specific fetish. In Kenya, Joseph Thomson posed grandly as a white medicine man by conjuring an elaborate ruse with a tin of ENO's for the supposed edification of the Masai: "Taking out my sextant," he records with some glee:

> and putting on a pair of kid gloves—that accidentally I happened to have and that impressed the natives enormously, I intently examined the contents . . . getting ready some ENO'S FRUIT SALT, I sang an incantation—in general something about "Three Blue Bottles"—over it. My voice . . . did capitally for a wizard's. My preparations complete and Brahim [sic] being ready with a gun, I dropped the Salt into the mixture; simultaneously the gun was fired and, lo! up fizzed and sparkled the carbonic acid . . . the chiefs with fear and trembling taste as it fizzes away.[38]

While amusing himself grandly at the imagined expense of the Masai, Thomson reveals his own faith in the power of his fetishes (gloves as a fetish of class leisure, sextant and gun as a fetish of scientific technology and Eno's as a fetish of domestic purity) to hoodwink the Masai. "More amusing," however, as Hindley notes, is Thomson's own naivete, for the point of the story is that "to persuade the Masai to take his unfamiliar remedies, Thomson laid on a show in which the famous fruit salt provided only the 'magic' effects."[39] ENO's power as domestic fetish was eloquently summed up by a General Officer, who wrote and thanked Mr. Eno for his good powder: "Blessings on your Fruit Salt," he wrote, "I trust it is not profane to say so, but I swear by it. There stands the cherished bottle on the Chimney piece of my sanctum, my little idol—at home my household god, abroad my vade mecum."[40] The manufacturers of Eno's were so delighted by this fulsome dedication to their little fetish that they adopted it as regular promotional copy. Henceforth, Eno's was advertised by the slogan: "At home my household god, abroad my vade mecum."

In the colonial encounter, Africans adopted a variety of strategies for countering colonial attempts to undervalue their economies. Amongst these strategies, mimicry, appropriation, revaluation and violence figure the most frequently. Colonials carped rancorously at the African habit of making off with property that did not belong to them, a habit that was seen not as a

form of protest, nor as a refusal of European notions of property ownership and exchange value, but as a primitive incapacity to understand the value of the "rational" market economy. Barbot, for example, describes the Ekets as "the most trying of any of the Peoples we had to deal with. . . . Poor Sawyer had a terrible time; the people had an idea they could do as they liked with the factory keeper and would often walk off with the goods without paying for them, that Mr Sawyer naturally objected to, usually ending in a free fight, sometimes my people coming off second best."[41] Richards notes how Henry Morton Stanley, likewise, could not make Africans (whom he saw primarily as carriers of western commodities) understand that he endowed the goods they carried with an abstract exchange value apart from their use value. Since these goods "lack any concrete social role for them in the customs, directives and taboos of their tribal lives, the carriers are forever dropping, discarding, misplacing, or walking away with them. Incensed, Stanley calls this theft."[42]

From the outset, the fetishism involved an intercultural contestation that was fraught with ambiguity, miscommunication and violence. Colonials were prone to fits of murderous temper when Africans refused to show due respect to their flags, crowns, maps, clocks, guns and soaps. Stanley, for one, records executing three African carriers for removing rifles, even though he admits that the condemned did not understand the value of the rifles or the principle for which they were being put to death.[43] Other carriers were executed for infringements such as dropping goods in rivers.

Anecdotes also reveal how quickly colonial tempers flared when Africans failed to be awestruck by the outlandish baubles the colonials offered them, for it wasn't long before the non-Europeans' curiosity and tolerance turned to derision and contempt. In Australia, Cook carped at the local inhabitants' ungrateful refusal to recognize the value of the baubles he brought them: "Some of the natives would not part with a hog, unless they received an axe in exchange; but nails and beads and other trinkets, that, during our former voyages, had so great a run at this island, were now so much despised, that few would deign so much to look at them."[44]

De Bougainville similarly recalls how a native from the Moluccas, when given "a handkerchief, a looking-glass and some other trifles . . . laughed when he received these presents and did not admire them. He seemed to know the Europeans."[45] As Simpson points out: "The handkerchief is an attribute of 'civilization,' the tool for making away with the unseemly sweat of the brow, the nasal discharge of cold climates and perhaps the tears of excessive emotion." The white handkerchief was also (like white gloves) the Victorian icon of domestic purity and the erasure of signs of labor. The Moluccan's refusal of handkerchief and mirror

expressed a frank refusal of two of the central icons of Victorian middle-class consumerism.[46]

In some instances, elaborate forms of mimicry were created by Africans to maintain control of the mercantile trade. As the Comaroffs point out, the Tlhaping, the southernmost Tswana, having obtained beads for themselves, tried to deter Europeans from venturing further into the interior by mimicking European stereotypes of black savagery and portraying their neighbors as "men of ferocious habits" too barbaric to meddle with.[47]

In the imperial contest zone, fetishes embodied conflicts in the realm of value and were eloquent of a sustained African refusal to accept Europe's commodities and boundary rituals on the colonials' terms. The soap saga and the cult of domesticity vividly demonstrates that fetishism was original neither to industrial capitalism nor to precolonial economies, but was from the outset the embodiment and record of an incongruous and violent encounter.

THE WHITE FAMILY OF MAN

COLONIAL DISCOURSE AND THE REINVENTION OF PATRIARCHY

6

Until the 1860s South Africa was, from the imperial point of view, a far-flung outpost of scant allure. In 1867, however, an Afrikaner child chanced upon the first South African diamond. The discovery of the diamond fields at once drew "this most stagnant of colonial regions" into the eddies of modern imperial capitalism and "a land that had seen boat-load after boat-load of emigrants for New Zealand and Australia pass it

unheeding by now saw men tumbling on to its wharves and hurrying up country to the mines."[1]

Among these new arrivals was Henry Rider Haggard, an obscure youth of nineteen, who, after a few years of unremarkable service in the colonial administration, returned to Britain to become the most spectacularly successful novelist of his time.[2] In 1885, a few months after the carving up of Africa among the "lords of humankind" at Berlin, Haggard published *King Solomon's Mines*, instantly and easily outselling all his contemporaries.[3] *She* appeared soon after, in 1887, to a riotous fanfare of applause. Almost overnight, this obscure youth had become an author of unparalleled commercial success and renown.[4]

King Solomon's Mines was intimately concerned with events in South Africa following the discovery of diamonds and then gold: specifically, the reordering of women's sexuality and work in the African homestead and the diversion of black male labor into the mines. The story illuminates not only relations between the imperial metropolis and the colonies but also the refashioning of gender relations in South Africa, as a nascent capitalism penetrated the region and disrupted already contested power relations within the homesteads. Despite recent recognition that some of the crucial conflicts in the nineteenth century took place over the African homestead economy, for the most part the story of women's work and women's resistance has been shunted to the sidings of history. Because women were the chief farmers, they were the primary producers of life, labor and food in the precolonial era.[5] Their work was thus the single most valuable resource in the country, apart from the land itself. Yet we know very little about how precolonial societies were able to subordinate women's work and as little about the changes wrought on these societies by colonial conquest and the penetration of merchant and mining capital.

Haggard's *King Solomon's Mines* offers an unusual glimpse into some of the fundamental dynamics of that contest. The novel was in large part an attempt to negotiate contradictions in the colonial effort to discipline female sexuality and labor, both in the European metropolis and in the colonies. The conflicts between male and female generative power and between domesticity and imperialism, were not only the obsessive themes of Haggard's work but also a dominant preoccupation of his time. Much of the fascination of Haggard's writing for male Victorians was that he played out his phantasms of patriarchal power in the arena of empire, and thus evoked the unbidden relation between male middle- and upper-middle-class power in the metropolis and control of black female labor in the colonies. In this way, *King Solomon's Mines* becomes more than a Victorian curiosity; instead, it brings to light some of the fundamental contradictions of the imperial project as well as African attempts to resist it.

In what follows, I explore how Haggard—both as a member of the colonial administration and as a writer—sought to resolve these contradictions within a narrative that takes the form of a journey, beginning with a mythology of racial and gender degeneration, reinventing the Family of Man in the cradle of empire, and culminating in the regeneration of the authority of the white father in the historical form of the English upper-middle-class gentleman. In other words, I explore the reordering of black labor and the black family and argue that this reordering was legitimized by two primary discourses of the time: the discourse on progress and degeneration; and the invented tradition of the white father at the head of the global Family of Man. It is crucial, however, that these discourses not be seen as monolithic impositions on a hapless people. Even less should they be seen as mere functional reflexes of the needs of the colonial state. Rather, the discourses themselves were at every moment contests for social power—shaped as much by African responses to the encroaching state as they were a product of colonial power.

THE FALL OF THE FAMILY OF MAN
A BIOGRAPHICAL NARRATIVE

Haggard was born in 1856 into one of the few scripts written for a man of his class. Son of a colonial mother raised in British India and a Norfolk Tory from the rural gentry, his life and work would take significant shape from the contradictions embodied in his parents: the withering of the ancient squirearchy as national power shifted from land to manufacturing; and the rise of the new imperialism. He reached manhood during the Great Depression of the 1870s—an era that saw the calamities of industrial poverty and the megalomania of the new imperialism. Suspended between a declining class and an ascendant imperialism, Haggard was in many respects peculiarly well placed to produce, as he did, the narratives of male degeneration and restitution that were to become the most widely read novels of his time.

"A Tory to the backbone," Haggard's father, Squire William Meybohm Haggard, "reigned at Bradenham like a king," living off the land in the patriarchal manner of the ancient squirearchy—the last of his family to do so.[6] Haggard inherited from his father his own "dynastic sense": "To leave a son and lands for him to inherit, to perpetuate his name, these were strong prepossessions with him."[7] But the relations among male generation, naming and the inheritance of land, were peculiarly vexed for Haggard—a vexation he shared, as it turned out, with a whole generation of late Victorian, upper-middle-class men. Haggard was a younger son, disinherited from the patriarchal seat by the stern laws of primogeniture

and entailment. His own son, Jock, was to die in youth, to Haggard's unstaunchable grief. Haggard started to write in the 1880s, during a period when the idea of paternal origins—instituting male power at the head of the family—had become increasingly problematic. Fervently attached to the dynastic ambitions of his family and class but frustrated in these ambitions by historical change, Haggard took consolation in the only recourse available to a man of his generation: playing out his anachronistic phantasms of paterfamilial class power in the arena of empire. One might call the project that consumed his life and work the restoration of the father and the Family of Man.

The poetics of male authorship is not just a poetics of creativity but a poetics of possession and control over the issue of posterity. It involves the production of a hierarchy of power. In Haggard's case, the constellation of images of paternity, succession and hierarchy that informs the idea of authorship was particularly troubled and suggestive. Thwarted in his ambitions as a son and as a father, he became an "increaser" and "founder" by fathering an astonishing body of letters—forty-two romances, twelve novels, ten works of non-fiction and a two-volume autobiography. He thus succeeded in perpetuating the male family name—not through the medium of land or the succession of male offspring but through authorship. "There is what I shall be remembered by," Haggard declared.[8] Yet at once an anomaly emerges. As it turns out, Haggard derived his literary talents and hence his power to propagate the male family name, not from his father but from his mother. By Haggard's own account, his mother, Ella Doveton Haggard, "possessed very considerable capacity for a literary career. . . . Had circumstances permitted I am sure she would have made a name." However, Haggard added approvingly, her life was "all love and self-sacrifice."[9] It is therefore fitting that Haggard should discharge the guilt he evidently felt for usurping his mother's generative authority by publishing, a year after her death, a memorial volume of her work titled *Life and Its Author*. In short, the authority and continuity of the male family name and the male inheritance of property were secured at the expense of a repression: the repression of the mother as a source of life and authority.

Haggard's well-nigh pathological anxiety about female generative authority is a thematic undercurrent coursing through most of his work. Yet it would appear to have derived much of its intensity from class as well as gender contradictions. We know that Haggard recalled that an unscrupulous nurse would terrify him into obedience as a child with a "disreputable rag-doll" of "hideous aspect," boot-button eyes and hair of black wool—the racial anxieties are also clear.[10] Haggard called the doll "She-Who-Must-Be-Obeyed," and this fetish symbol of an ominous and

inexplicable authority, female and working class, would haunt him until he was compelled to ward it off with an act of ideological exorcism in *She*.

Indeed, Graham Greene recalled that it was *King Solomon's Mines* that prompted him, at the age of nineteen, to study the appointments list of the Colonial Office and set out in colonial service. Recalling that fateful influence, he recaptures the paranoia that suffused the figure of Gagool: "Didn't she wait for me in dreams every night, in the passage by the linen cupboard, near the nursery door?" It was the "incurable fascination" of Gagool, her bare yellow skull and wrinkled scalp, that had lured him to Sierra Leone and that he remembered when lying sick with fever in Liberia.

The astonishing popularity of *King Solomon's Mines* has led Sandra Gilbert to ask: "What, after all, worried Rider Haggard so much that he was driven to create his extraordinary complex fantasy about Her and Her realm in just six volcanically energetic weeks? Why did thousands and thousands of Englishmen respond to his dreamlike story of Her with as much fervor as if he had been narrating their own dreams?"[11] If, as Gilbert argues, the charisma of the book arose from its exploration of three nineteenth-century preoccupations—the "New Woman," Egypt and spiritualism—certainly much of Haggard's compulsion to create his "ceremonial assertion of phallic authority" also stemmed from his inability to resolve a social contradiction that marked his time and his class: the presence within the family of the female domestic worker.[12]

At least one of the dynamics underlying Haggard's fear of female generative authority stemmed from his inability to resolve the class doubling of gender that shaped the upper-middle-class family. For Haggard, as for so many others, the contradictions between the ideology of female idleness and the actualities of female manual labor, between paid and unpaid domestic work, between the sexuality of the Dresden china "madonna" and the working-class "whore," between the invention of female inferiority and the experience of female power, were most vividly and dangerously embodied in the living presence within the upper-class family of the female domestic servant. *King Solomon's Mines* was in large part, I suggest, an attempt to resolve the class doubling of gender in the metropolis, compounded by the conflicts over female labor and sexuality in the colonies.

DEGENERATION
THE CRISIS OF ORIGINS

Haggard shared with his upper-middle-class Victorian culture an unusually intense preoccupation with origins. But to the evident discomfort of his daughter-biographer, the family stock on record was felt not to be entirely

"sound." The "accursed blood" of his Russian-Jewish great-grandmother had bequeathed to the Haggard stock "more than a hint of mental instability."[13] The female, Jewish "blood-flaw" was betrayed in the tell-tale stigmata of long nose, high cheekbones and tilted eyes—the inherited reminders of the debility that flowed in the family veins.[14] But if the "blood-taint" was evoked within the well-established poetics of race and degeneration, the family records also suggest that the anxiety that underlay Haggard's childhood reputation as a degenerate dolt was more properly speaking the anxiety of *class* demise.

Arriving eighth out of ten children and reaching adolescence at the moment of the fall in the value of land, Haggard was in his family's eyes the living emblem of the possible lineal decline that was foretold by the bad blood. Squire Haggard bitterly derided his disappointing younger son as "fit only to be a greengrocer" and predicted that his dullness of mind would find its more natural station with the lower orders.[15] In view of dwindling family resources and in view of Haggard's lack of promise near the end of a robust line of boys, the squire decided that Haggard, alone of seven sons, would not receive a public school education. He was sent instead to Ipswich Grammar School, then to a tutor in London, then on to the crammer, Scoones. Much has been made of Haggard's early degeneracy—by himself, his family, his biographers and critics—perhaps because the narrative of his early degeneracy became a critical element in what would turn out to be an undeniably successful performance in paterfamilial restoration. At the time, this performance could be played out only in the arena of empire.

In the public and political debates of the late nineteenth century, the swelling superfluity of women and men was figured as a malady and contagion in the national body politic that could be countered by leeching off the bad fluid and depositing it in the colonies. At the same time, much of this interest in colonial emigration was figured within the image of the family. Not a few of the "riddlings of society," as Haggard called them, came from the depressed gentry and the upper classes. If J. A. Froude, Victorian historian and essayist, was confident that the gentry as a system of social order, land tenure and male patrilineal inheritance was "as secure as the succession of the seasons," his passionate speech delivered in its defense to the Philosophical Institution in 1876 betrayed at least an intuition of impending calamity.[16] Yet it seems that Froude's faith in the security of the gentry lay less in the guarantee of nature than in the comforting presence of Britain's waiting colonies. In the colonies, Froude urged, "is the true solution of the British land question. . . . The home of the French peasant is France. . . . The home of the Scot or the Englishman is the whole globe."[17] As he saw it, Britain's ancient patriarchal orders

could be protected from civil discontent by packing the discontented off to
the colonies:

> You who are impatient with what you call a dependent position at
> home, go to Australia, go to Canada, go to New Zealand, or South
> Africa. There work for yourselves. There gather wealth. . . . Come
> back if you will as rich men at the end of twenty years. Then buy an
> estate for yourselves. . . . People that country, people any part of any
> of our own colonies, from the younger sons who complain that there
> is no room for them at home. . . . Spread out there and everywhere.
> Take possession of the boundless inheritance that is waiting for you.[18]

The relation between inheritance and the colonies was no idle metaphor
but betrayed a very real social connection between the land crisis and the
solution of imperialism.

In the Haggard family annals the blood-taint of degeneration was
viewed as manifesting itself in a global footlooseness—a geographical
straying from type. As a belated son, Haggard took his place in the
Victorian script written for the younger or ill-begotten sons of good family,
the male offspring of the clergy and the swelling numbers of the unem-
ployed and working-class poor. These were the men whom Froude labeled
"the Bohemians of the four continents." Hannah Arendt called them "the
superfluous men"—the ragbag surplus of men and women to whom an
industrializing Britain could offer no place.

Indeed, Haggard was destined to become a very good example of
the species of Englishman whom Froude urged to go out and people the
earth. In 1875 Squire William wrote to his neighbor, Sir Henry Bulwer,
newly appointed lieutenant-governor of Natal and asked him to take the
unpromising Haggard into his services. Bulwer agreed and Haggard, then
nineteen years old, sailed in August 1875 as an obscure member of
Bulwer's staff to the Cape Colony.

THE REGENERATION OF THE FAMILY OF MAN
AN IMPERIAL NARRATIVE

Although Haggard was mediocre and disinherited in Britain, once he
stepped onto South African soil, he rose immediately into the most
exclusive white elite of the country. His appointment to the colonial
administration was nothing more glamorous than housekeeper to the
largely male family of white bureaucrats in Pietermaritsburg, Natal. But
as general factotum to Sir Henry Bulwer, tasked with handling the
"champagne and sherry policy" of Natal's small brass-band and cavalry

administration, his prestige and self-esteem were enormously enhanced.[19] Standing discreetly at the elbow of the paramount white authority in Natal, he was a far cry from the hapless dolt at Scoones. Indeed, a local newspaper announced the new arrival in Cape Town of a "Mr. Waggart."

Haggard's regenerative arrival in South Africa is illuminating in this respect, for the turnabout in his career rehearses a critical moment in late male Victorian culture: the transition, that Said identifies, from filiation to affiliation. Haggard's redemption in the colonial service vividly rehearses this transition from failed filiation within the feudal family manor—essentially a failure of class reproduction—to affiliation with the colonial bureaucracy. Through affiliation with the colonial administration, he was quite explicitly compensated for his loss of place in the landed, patriarchal family and was, moreover, provided with a surrogate father in the form of Theophilus Shepstone, Natal's Administrator of Native Affairs. Haggard was in this respect representative of a specific moment in imperial culture, in which the nearly anachronistic authority of the vanishing feudal family, invested in its sanctioned rituals of rank and subordination, was displaced onto the colonies and reinvented within the new order of the colonial administration.

This displacement gives rise to a paradox. One witnesses in the colonies a strange shadow-effect of the state of the family in Britain. George Orwell once acidly described the British ruling class as "a family with the wrong members in control." Drawing on the by now well-established figure of organic degeneration, he had a vision of Britain ruled over by a decrepit family of "irresponsible uncles and bedridden aunts."[20] Yet, as Williams notes, what Orwell regretted was not so much the existence of a ruling family but rather its decay of ability. The image of the family as the model of social order had so powerful a hold over Orwell's imagination that he could not yet dispense with it in favor of a notion such as class, and he could express his unease only in terms of biological decay. At the same time, for Orwell, a family ruled by irresponsible uncles and bedridden aunts was a pathological family, for the father was nowhere to be seen. It did not seem noteworthy, either to Orwell or to Williams, that the image also admits no mother.

Here an important relation makes itself felt. Orwell saw the social group from which he came, the great service families, "pushed down in importance by the growth of the centralized bureaucracy and by the monopoly trading companies."[21] The failure of the idea of filiation within the great landed and service families stemmed in part from the growth of the imperial bureaucracy, which not only usurped the social function of the service families, displacing administrative power beyond the network of the family but also seriously undermined the image of the patriarchal paterfamilias as ultimate originary power. Yet if the growth of the bureaucracy unseated the

patriarch as the image of centralized and individual male power, one witnesses in the colonies the reinvention of the tradition of fatherhood, displaced onto the colonial bureaucracy as a surrogate, restored authority. In other words, the figure of the paterfamilias was most vigorously embraced in the colonies at just that moment when it was withering in the European metropolis. The colony became the last opportunity for restoring the political authority of fatherhood, and it is therefore not surprising that one finds its most intense expressions in the colonial administration, the very place that threatened it. Nor is it surprising that the reinvention of the patriarch in the colonies took on a pathological form.

PATRIARCHAL REGENERATION
KING SOLOMON'S MINES

Allan Quartermain — gentleman, hunter, trader, fighter and miner (named, not accidentally, after a father surrogate who had befriended Haggard as a youth) — began to write "the strangest story" that he knows for prophylactic reasons, as an act of biological hygiene. A confounded lion having mauled his leg, he is laid up in Durban in some pain and is unable to get about. Writing the book will relieve some of the frustration of his impotence — it will return him to health and manhood. Further, he will send it to his son, who is studying to be a doctor at a London hospital and is therefore obliged to spend a good deal of his time cutting up dead bodies. Quartermain intends his imperial adventure to breathe "a little life into things" for his boy, Harry, who will as a result be better fitted to pursue the technology of sanitation, the task of national hygiene, the restoration of the race. The book will thus be a threefold narrative of imperial recuperation, embracing three realms and moving from one to the other in a certain privileged order: from the physical body of the white patriarch restored in the colonies to the familial bond with the son/doctor in Britain to the national body politic. At the same time, the narrative reveals that the attempted regeneration of late Victorian Britain depended on the reordering of labor in the colonies; in this case, the attempted reconstruction of the Zulu nation through control of female reproductive and labor power.

The task of paterfamilial restoration that motivates the narration of the journey to King Solomon's Mines finds its analog in the motivation for the fictional journey itself. Quartermain, Captain Good and Sir Henry Curtis set out for King Solomon's Mines primarily to find Sir Henry's younger brother, Neville. Left without a profession or a penny when his father died intestate, Neville quarreled with Sir Henry and set off for South Africa in search of a fortune — a small mimicry of the flight of many of the distressed gentry to the colonies. At the end of the novel Neville is found in the wilderness, clad in

ragged skins, his beard grown wild, his leg crushed in an accident—a living incarnation of the degeneration and wounded manhood thought to imperil the white race when abandoned too long in the racial "wilderness." Thus at both the level of the telling of the story and of the story told, the narrative is initiated through a double crisis of male succession and is completed with the regeneration of ruptured family bonds, promising therewith the continuity, however tenuous, of the landed patriarch.

Yet as it happens, Haggard's family romance of fathers, sons and brothers regenerating each other through the imperial adventure is premised on the reordering of another family: the succession of the Kukuana royal family. This reordering requires the death of the "witch-mother" Gagool. Only with her death is female control over generation aborted and the "legitimate" king restored, presided over by the regenerated white "fathers," who will carry away the diamonds to restore the landed gentry in Britain.

In *King Solomon's Mines* we find the two theories of human racial development that I traced in Chapter 1. Both are intimately dependent on each other and both are elaborated within the metaphor of the family. On one hand, the narrative presents the historical decline from white ("Egyptian") fatherhood to a primordial black degeneracy incarnated in the black mother. On the other hand, the narrative presents the story of the familial progress of humanity from degenerate native "child" to adult white father. Haggard shared the popular notion that civilization as embodied by colonials was hazardous to the African, who, "by intellect and by nature . . . is some five centuries behind. . . . Civilization, it would seem, when applied to black races, produces effects diametrically opposite to those we are accustomed to in white nations: it debases before it can elevate." Most crucially, the dynamic principle that animates the hierarchy of racial and gender degeneration, transforming a static depiction of debasement into a narrative of historical progress, is the principle of imperial conquest.

FEMINIZING THE "EMPTY LANDS"

The journey to King Solomon's mines is a genesis of racial and sexual order. The journey to origins, as Pierre Macherey points out, is "not a way of showing the absolute or beginning but a way of determining the genesis of order, of succession."[22] Donna Haraway has observed that the colonial safari was a kind of traveling minisociety, an icon of the whole enterprise of imperialism fully expressive of its racial and sexual division of labor.[23] It is therefore fitting that Quartermain's party consists of three white gentlemen; a Zulu "gentleman" ("*keshla*" [sic] or "ringed man"), who nevertheless lags in development some five hundred years behind the whites; three Zulu

"boys," still in a state of native "childhood" in relation to the whites; and the racially degenerate "Hottentot," Ventvogel. Thus we set out with the Family of Man in place, fully expressive of fixed divisions of class and race, with the female entirely repressed—a fitting racial hierarchy with which to reinvent the genesis of the species.

True to the trope of anachronistic space, the journey into the interior is, like almost all colonial journeys, figured as a journey forward in space but backward in time. As the men progress, they enter the dangerous zones of racial degeneration. Entering the fever lands and the place of the tsetse fly, the men leave their sick animals and proceed on foot. On the edge of the burning desert that stretches between them and Solomon's blue mountains, they cross into the borderlands of pathology. Stepping into the desert, they step into the zone of prehistory. Their journey across the untenanted plain traces an evolutionary regression from adult virility into a primordial landscape of sun and thirst inhospitable to all except insect life. True to the narrative of recapitulation that underlies the journey, the men slowly slough off their manhood. The sun sucks their blood from them; they stagger like infants unable to walk and escape death only by digging a womb-hole in the earth, in which they bury themselves.

Notably, Ventvogel here enters his proper racial element. "Being a Hottentot," and therefore untouched by the sun, his "wild-bred" instincts awaken and he sniffs the air "like an old Impala ram." Uttering guttural exclamations, he runs about and smells out the "pan bad water" (39). Again in keeping with the narrative of recapitulation, adult racial degeneration to the primitive state of the "Hottentot" is accompanied by sexual degeneration to the "female" condition, and both states are attended by linguistic degeneration to an infantile state of preverbal impotence. As we know from the map, the "pan bad water" represents the corrupted female head. At this point, just over the perilous threshold of race, the place of prehistory merges with the place of the female. The landscape becomes suddenly feminized—the sky blushes like a girl, the moon waxes wan and at the very moment that Ventvogel smells the bad water, the men lay eyes for the first time on Sheba's Breasts.

Here, the prescribed narrative of racial, sexual and linguistic degeneracy confirms itself. At the sight of the mountains "shaped exactly like a woman's breasts," their snowy peaks "exactly corresponding to the nipple on the female breast," Quartermain plunges into the condition of reduced manhood and linguistic degeneration characteristic of the "Hottentot"/female state. He "cannot describe" what he saw: "Language seems to fail me. . . . To describe the grandeur of the whole view is beyond my powers" (38, 39). This crisis of representation is a ritualistic moment in the colonial narrative whereby the colonized land rises up in all its

unrepresentability, threatening to unman the intruder: "I am impotent even before its memory." Yet this is a subterfuge, a pretense of the same order as writing "cannibals" on the colonial map, for Quartermain contains the eruptive power of the black female by inscribing her into the narrative of racial degeneracy.

As the men leave the plains of prehistory and scale Sheba's Breasts, Ventvogel's racial debility begins to tell. "Like most Hottentots" he cannot take the cold and freezes to death in the cave on Sheba's nipple, proving himself unfit to accompany the other men on their journey to the restoration of the paternal origin. At the same time, his death discloses a prior historical failing. In the cave where Ventvogel dies, they find, in fetal position, the frozen skeletal remains of the Portuguese trader, Jose da Silvestre. These remains are a memento of the racial and class unfitness of the first wave of colonial intruders in these parts and thereby a historical affirmation of the superior evolutionary fitness of the English gentry over the Portuguese trader. To inscribe this liminal moment of succession into history, Quartermain takes up da Silvestre's "rude pen," the "cleft-bone" signifying mastery and possession: "It is before me as I write—sometimes I sign my name with it" (45).

Standing aloft on Sheba's Breasts, the men reenter history. Monarchs of all they survey, their proprietary act of seeing inscribes itself on the land.[24] Leaving Ventvogel and the tongueless zone of prehistory, they reenter language. Nevertheless, this moment is not a moment of origin but rather the beginning of a historical return and regression, for the journey has already been made. As Macherey has observed, the colonial journey "cannot be an exploration in the strict sense of the word but only discovery, retrieval of a knowledge already complete."[25] The landscape before them is not originary—it cannot find its principle of order within itself. "The landscape lay before us like a map," written over with European history. The mountain peaks are "Alplike"; Solomon's Road looks at first like "a sort of Roman road," then like Saint Gothard's in Switzerland. The landscape is not, properly speaking, African, because it is already the subject of conquest. One of the tunnels through which the men pass is carved in ancient statuary, one "exceedingly beautiful" representing a whole battle-scene with a convoy of captives being marched off in the distance. Thus, "the journey . . . is disclosed as having ineluctably happened before. . . . To explore is to follow, that is to say, to cover once again, under new conditions, a road already actually travelled. . . . The conquest is only possible because it has already been accomplished."[26]

Macherey's observations are important because if the narrative of origins is, more properly speaking, the genesis of an order and a hierarchy and if the order the white men intend to impose is that of colonization and

the primary stages of the primitive accumulation of capital, then their conquest finds its legitimacy only by virtue of the fact that the conquest had already taken place at a previous moment in history. King Solomon, whom Haggard regarded as white, had already proved his titular right to the treasure of the mines, had already carved his road over the land. All that had to be accomplished to succeed to the treasure was a demonstration of *family* resemblance. A poetics of blood inheritance had to be written whereby the white gentlemen could succeed as rightful heirs to the riches.

ANACHRONISTIC SPACE

As it happens, like the land they inhabit, the Kukuanas are discovered not to be an originary people. They are the people of whom the character Evans had spoken: degenerate descendants of an ancient civilization "long since lapsed into barbarism." Their ancestors had swept down from "the great lands that lie there" to the north, identified as Egypt by the traces of "Egyptian-like sculptures" that mark the terrain like signatures. These original people had been white, in keeping with the popular fantasy of Haggard's time that the Egyptian civilization, the cradle of humanity, was not truly African. Possessed of the arts of mining, roadmaking, statuary and writing, and a knowledge of the value of diamonds, these wanderers had built a city and put to work the servile black race living near the diamond fields. The Kukuanas, a hybrid racial mix, are lost in racial amnesia, having forgotten their august origins and the arts that flowed from them and are now reduced simply to protecting the treasure and keeping the roads clear of grass. Nevertheless, they are not entirely debased. True to the pseudo-scientific narratives of race, the women (typically thought to be the "conservative" element, retaining ancestral traces longer than males) reveal physiological features eloquent of their lost white ancestry—a certain dignity of bearing, their lips "not unpleasantly thick," their hair "rather curly than woolly," and an instinctive atavistic admiration for the "snowy loveliness" of Good's skin (58). These atavistic traces of a superior founding race elevate them, we are told, above the Natal Zulus. Unlike the Zulus, who we learn are an even more degenerate offshoot of the Kukuanas, they do not squat near the ground on their haunches but sit on stools, a recurrent measure of racial worth in travel writing of the time.

At once the family metaphor of recapitulation asserts itself. King Twala is descended from a patriarch of the corrupted generic name Kafa. Infadoos, King Twala's brother, describes himself as "but a child," a racial child bereft as much of the historical memory of his forefathers as of the value of the diamonds and gold, which are to him mere childish baubles, "bright stones, pretty playthings." Moreover, the Kukuana royal family is

itself dangerously degenerate—offering a spectacle of familial disorder run amok. In the features of King Twala's face one reads the degeneration of the race. He is a black embodiment of the putative stigmata of debasement, excessively fat, repulsively ugly, flat-nosed, one-eyed, "cruel and sensual to a degree" (64). His degeneracy manifests itself most clearly in his indiscriminate sensuality. His is an unlicensed polygyny. "Husband of a thousand wives," his access to women is unbridled; his family bears every mark of transgression and flaw and the land groans out under his "red ways" (53, 69).

The Kukuana royal family is in every aspect a family defiled. Most significantly, the principle of disorder and familial defilement is female. It is immediately apparent that King Twala's reign is illegitimate, the corruption founded on a female presumption—the mother's attempt to control the issue of generation and descent. Born a weaker twin, a sign of organic decay, as Haggard saw it, Twala had usurped his legitimate brother's place with the connivance of his mother. According to ethnographic and popular lore of the time, with which Haggard was evidently familiar, the Nguni were in the habit of putting to death the second-born of twins. What seems to have caught Haggard's imagination in this notion was the direct threat that twins were thought to pose to the life of the father. As A. T. Bryant notes, it was believed that "if both twins lived, their father would surely die."[27] Josiah Tyler explains: "If twins were born, one is immediately destroyed lest the father die."[28] "This twin business," as Bryant calls it, served Haggard's interests by figuring a perilous threat to patriarchal continuity. With the help of Gagool, the *isanusi* (healer) and Twala's mother, Twala assumed kingship in flagrant violation of the customs of the people. In short, female interference in the succession of male inheritance had plunged the land into chaos.

THE ARCHAIC MOTHER
COLONIAL ABJECTION

It is not surprising that the *isanusi*, Gagool, represents the nadir of degeneration. Haggard's description of her, eloquent of a profound racial and sexual anxiety, is a thumbnail catalogue of the stigmata of debasement associated with African women. Gagool is so old that she is barely human. Yet her age rehearses a regression, traversing time backward to a point where the human has become bestial. A "wizened, monkey-like figure," she has lost the erect bearing of the adult and creeps on all fours. Everything about her is simian: her slit of a mouth; her prognathous jaw; her sunken nose; her bare, yellow and projecting skull; her deep yellow wrinkles; her gleaming black eyes; her skinny claw. Her racial regression

to bestiality recapitulates the familiar regression to childhood: she is "no larger than . . . a year-old child" (67). The regression is complete when, after her prophetic announcement of the racial superiority of the whites, she falls into foaming convulsions, the condition of insane pathology most closely associated with women.

Yet Gagool's preternatural knowledge places the men entirely in her power. Her merest touch during the "witch-smelling" is equivalent to a ritual castration. Once touched, a man "dragged his limbs as though they were paralyzed and his fingers, from which the spear had fallen, were limp as those of a man newly dead" (75). Repeatedly and ritualistically invoked by her female *isanusis* as the "mother, old mother" of the land, she holds all power of life and death. What appears to have appalled Haggard was the mortal consequences for men of the power of female generation. "What is the lot of man born of woman?" the crowd chants. "Death!" comes the reply. To compound matters, "she and only she knows the secret of the 'Three Witches'" (113). The last point is important for the clear impression it gives of the overdetermined sources of Haggard's profound anxiety, in which psychosexual, class and racial paranoia fuses with an unbidden knowledge that the secret of the production of mineral wealth in South Africa and thus the hoped-for regeneration of Britain, did indeed lie in the generative labor power of women.

For Haggard, moreover, Gagool's preternatural knowledge seemed reminiscent of the alternative authority of the female mediums at the London seances he had attended and which had so unnerved him that he had been forced to stop going. As Gilbert points out, the dark current of mysticism that flowed through the late nineteenth century, culminating in the publishing in 1877 of Madame Blavatsky's *Isis Unveiled*, emphasized alternative intellectual possibilities of female rule and misrule. It is no accident that Haggard embodied this frightful possibility in the South African *isanusi*. Colonial documents are eloquent on the unease with which white male administrators regarded the African *isanusis*, who were predominantly female. *King Solomon's Mines* amounts to an elaborate, paranoid effort to ward off the frightful melding of mother, working-class domestic servant and black woman through a narrative disciplining of female reproductive power.

COMMODITY FETISHISM AND THE MALE BIRTHING RITUAL

A crisis of inheritance in the royal family erupts, and a blood rivalry between brothers climaxes in a battle. Umbopa, who signifies his legitimacy by recognizing the racial "fatherhood" of the Englishmen, is at the same time

revealed to bear around his loins the mark of a snake, the fetish of kingship. After the battle, the white men settle the crisis of legitimacy through a ceremony of monarchical inauguration, which places Umbopa at the head of the nation on two conditions: that he recognize their racial patrimony in the diamonds, and that he swear fealty to four edicts that fundamentally curtail the monarch's right of access to the women's labor. Twala had earlier justified the sacrifice of the women in terms of the continuity of the male house: "Thus runs the prophecy of my people: 'If the king offers not a sacrifice of a fair girl on the day of the dance of maidens to the old ones who sit and watch on the mountains, then shall he fall and his house.'" In other words, the house of the father depends on the ritualized control of women; should this power be halted and with it control of the female *isanusis*, the power of the Kukuana monarch would be severely curtailed. The novel concludes with an extraordinary narrative effort to legitimize the reordering of generative authority in the black polity and the diversion of the surplus riches into the pockets of the white gentlemen.

Only Gagool knows the secret entrance to the mines, a psycho-sexual image needing no elaboration. Entry to the narrow passage is guarded by huge, nude Phoenician colossi. Over the door of the treasure chamber the men read their racial patrimony, the title deed to ownership of the diamonds: "We stood and shrieked with laughter over the gems that had been found for *us* thousands of years ago and saved for *us* by Solomon's long-dead overseer. . . . We had got them" (129). In other words, the patrimony is a found inheritance based on racial family resemblance to the "white" Egyptians. Not incidentally, the patrimony is inscribed in Hebrew. Haggard was party to the common notion that "Zulus resemble Jews in customs." "The origin of the Zulus is a mystery, nobody knows from whence they come, or who were their forefathers but it is thought they sprang from Arab stock and many of their customs and ceremonies resemble those of the Jews."[29] Haggard's anti-Semitism, of a piece with his antipathy to mining capitalists and his conviction that imperialism should be in the hands of the landed gentry, placed Jews in a region of racial belatedness that they shared with the Zulus. (The Jewish Holly, in *She*, reveals a number of the simian stigmata thought to be shared by Jews and Africans.) At the same time, the necessary labor of black diggers to extract the diamonds is rendered invisible. Thus the first principle of repression is completed.

Immediately afterward, the mother Gagool is crushed beneath the rock and at once a ritualistic moment in the male colonial narrative asserts itself. With the death of the mother, the men are reduced to a condition of infancy. They are plunged into darkness and are forced to crawl about on hands and knees. "All the manhood seemed to have gone out of us" (131).

What follows is an extraordinary fantasy of male birthing, culminating in the regeneration of white manhood. With great difficulty, the men find the entrance to the back passage to the pit. After hours of agonizing labor and toil, they finally clamber out of the dark tunnel and tumble head over heels into the air, covered in blood and mud, crying for joy, unable to walk but bathed in the rosy glow of dawn.

There is one final note to this story. In a burst of anal frenzy before leaving the womb/tomb, Quartermain stuffs his pockets with diamonds — diamonds, we are told, that are as large as "pigeon eggs." These pigeon eggs are fertile symbols of two new reproductive orders. According to this phantasmic narrative of white patriarchal regeneration, the white men give birth to the new economic order of imperial mining capitalism, while repressing the labor of black men and at the same time placing the process in the hands of the gentry. They have accomplished a new form of human reproduction, an autochthonous male birthing that annuls the mother. Finally, the pigeon eggs become the means for regenerating the declining gentry, for they allow Quartermain, like Haggard himself, to return to Britain and buy a landed estate. Thus the adventure of imperial capitalism restores the landed gentleman to the head of the Family of Man — which remains nevertheless a pathological family, for it still admits no mother.

In this way, *King Solomon's Mines* figures the reinvention of white imperial patriarchy through a legitimizing racial and gender poetics. It invents a regenerated white patriarch who institutes and controls a subservient and racially belated black king, who will grant the whites racial superiority and their patrimonial entitlement to the diamonds. It reorganizes production and reproduction within the black family by usurping the chief's unbridled control of the lives and labor of women. And it violently negates the principle of black female generative power (both productive and reproductive). Yet this Victorian bestseller might remain simply a fictional oddity were it not for the fact that it is symptomatic of fundamental tendencies emerging in the culture of conquest at the time.

INVENTING TRADITIONS
WHITE FATHERS AND BLACK KINGS

Natal, where Haggard found himself in 1875, was one of the most unpromising of British colonies. Lacking any vital raw materials for export and lying hundreds of miles from the markets of Cape Town, it was poor, isolated and vulnerable. During the early years of the nineteenth century, the area had seen much turbulence and distress as local chiefdoms rivaled each other for land and power under the pressure of narrowing environmental resources. Between 1816 and 1828, the Zulu leader Shaka

had fashioned from the upheavals a formidable military kingdom that drew into its orbit many smaller clans, destroying or scattering the rest in a great chain effect of disruption (the *mfecane*). The small bands of fierce Boer nomads pushed into this cleared buffer zone in the 1830s. The British, however, had been granted land on the coast by Shaka and bristled at the prospect of Port Natal falling into the hostile hands of the Voortrekkers. They hastily summoned troops from the Cape and snatched Natal from the Boers in 1843. Nevertheless, the British were reluctant to lose the Boers themselves, for they needed denser settlement to counter the potentially overwhelming presence of the Zulus in Zululand which hemmed them in to the north (the principle source, with Zimbabwe, of Haggard's Kukuanaland). The British offered the Boers huge farms over the heads of the indigenous Africans, but many Boers preferred to trek inland once more, becoming absentee owners or selling their land to speculators. Huge areas of land in Natal were left fallow and untended, yet closed to settlement. This was the paradox that plagued Natal's white farmers: a shortage of land in a vast country of thousands of acres and a shortage of labor in a land with a population of thousands of Africans.

After the discovery of diamonds in 1867 and gold in 1884 the paradox deepened as black labor left for the mineral fields and better wages of the interior. Haggard, in 1882, in his first published writing, *Cetywayo and His White Neighbours*, called this paradox "the unsolved riddle of the future, the Native Question."[30] It is this riddle that *King Solomon's Mines* attempts to resolve, revealing in the process that the problems of land and labor are rooted in the fundamental question of who was to control the women's labor—an issue fought out at a number of levels: between black women and men within the Zulu homestead, among black men and between white colonists and black men.

Many elements of the Zulu family drama are present in *King Solomon's Mines*. In 1856 a crisis had broken out over the rightful heir of the Zulu king, Mpande, a struggle that prefigured the crisis of male succession reenacted in the novel. As in Haggard's tale, the blood rivalry between Mpande's sons, Cetshwayo and Mbulazi, climaxed in a battle in 1856; an eyewitness account of the actual battle provided Haggard with many of the details he used for the battle scene in the novel. Haggard's depiction of the degenerate usurper king, Twala, is resonant of racist images of Cetshwayo as a gorilla-like monster in the popular illustrated papers. In both the novel and its historical counterpart, moreover, white men interfere in the crisis of male inheritance and arrogate to themselves the powers of white *patria potestas*. This gives them the authority to inaugurate what they believe will be a subservient black monarch, on terms favorable to the colonial state.

In the historical case, Cetshwayo emerged as victor and Shepstone visited the Zulu court to confer official blessings on him in 1861. However, instead of the adulatory welcome he confidently expected, Shepstone, like Haggard's heroes, only narrowly avoided death. Nevertheless, the parties were reconciled and in September 1873 Shepstone proceeded to enact a pompous ceremony of monarchical recognition that he alone took seriously. Cetshwayo was proclaimed king with a great deal of pomp and ritual invented by Shepstone for the occasion. Shepstone saw himself grandly "standing in the place of Cetshwayo's father and so representing the nation" and enunciated four articles that he regarded as necessary for putting an end to "the continual slaughter that darkens the history of Natal." These articles are strikingly similar to the articles of control Haggard's heroes would demand in *King Solomon's Mines.*

Shepstone clearly felt he had been instituted as nominal founding father of the Zulu nation, and he and Haggard made a good deal of rhetorical fuss of his new status as father of the Zulus. The coronation was not simply Shepstone's whimsy, however, but was a symptomatic replica of the invented traditions of monarchical inauguration that colonials were enacting all over British Africa. In what Terence Ranger has called "the invented tradition of the 'Imperial Monarchy'" the colonists—lacking, as they did, a single body of legitimating ritual—offered Africans a fantastic mummery of tinsel and velvet royalty that bore scant resemblance to the political reality of the British monarchy.[31] In Britain the monarch had shrunk to a ceremonial figurehead. The centers of political power lay elsewhere, on the desks of industrial magnates, in the corridors of parliament, in the shipyards and mills. In the African colonies, however, the figure of the king rose to its feet and walked abroad again. The anachronistic ideology of the imperial monarchy became a widespread administrative cult, full of invention and pretense, of which Shepstone's coronation of Cetshwayo (like Haggard's coronation of Umbopa) were symptomatic.

Ranger calls "the 'theology' of an omniscient, omnipotent and omnipresent monarchy . . . almost the sole ingredient of imperial ideology as it was represented to the Africans."[32] He thereby neglects, however, what was arguably the most authoritative and influential of all invented rituals in the colonies: the patriarch, or landed paterfamilias. Most significant in political impact, moreover, was the newly invented hierarchy between the white "father" and the black king.

In colonial documents, for example, Shepstone is referred to with ritualistic insistence as the "father-figure" of Natal. Sir Henry Bulwer called him "one of the Colonies' earliest fathers—the very Nestor of the Colony."[33] Shepstone was generally referred to by black people (no

doubt obliging his fantasy) as "Somtsewu," which, as Jeff Guy says, "notwithstanding much speculation on its meaning along the lines of 'mighty hunter' . . . is a word of Sesotho origin meaning 'Father of Whiteness'."[34] Haggard, like Shepstone himself, understood the name to carry the entirely unfounded implication that the Zulus regarded Shepstone as the originary potentate of the black people themselves: Shepstone is "par excellence their great white chief and 'father'." In a message to Lobengula, chief of the Ndebele, Shepstone announced portentously: "The Lieutenant Governor of Natal is looked upon as the Father of all."[35]

Shepstone took the title of father and everything that sprang from it in terms of political authority very seriously indeed, not only as a title but as a political and administrative practice that had serious consequences for the history of South Africa. One example from many can suffice. In the 1850s he and Bishop Colenso of Natal, before their famous squabble, hatched a megalomaniacal plot to solve the "native question" by founding a Black Kingdom (like Kukuanaland) south of Natal, over which they would rule autocratically as founding patriarchs—each embodying, respectively, the absolute powers of "Father of the Church" and "Father of the state." In a letter to members of the Church of England, Colenso claimed he was called "Sokuleleka" ("Father of Raising Up") and "Sobantu" ("Father of the People"). Not to be outdone, Shepstone would be "Father of Whiteness." Both men thus arrogated to themselves, as Haggard's heroes do, all powers of male generation and succession. Their roles would be nothing less than the generators of civilization and the regenerators of the ancient Family of Man.

Shepstone manipulated the invented traditions of fathers and kings, mimicking allegiance to certain customs of Zulu chieftainship, while retaining for himself the superior status of father—the same solution to conflicting patriarchies that Haggard's tale rehearses. Thus Shepstone drew on an ideology of divine fatherhood as preordained and natural, the founding source of all authority. The black king, on the other hand, was his symbolic reproduction, mortal, invested with authority only by virtue of his mimicry of the originary power of the father.

For these reasons, I suggest, the reinvention of fathers and kings in South Africa can be seen as a central attempt to mediate a number of contradictions: between the imperial bureaucracy and the declining landed gentry in Britain; between the colonial ruling patriarchy and the indigenous patriarchies of precapitalist polities; and last but most significantly, between women and men of all races. Here we come across the final and most important dynamic underlying both Haggard's tale and the emergent economy of the colonial state.

Shepstone's policy was based on an intimate sense of the precarious balance of power in Natal and Zululand. He knew that the frail colony could ill afford to antagonize the Zulus and that it lacked the military muscle and the finances to forcibly drive black men off their lands and into wage labor. As the missionary Henry Callaway asked ruefully, "How are 8000 widely scattered whites to compel 200,000 coloureds to labor, against their will?"[36] Out of this riddle rose the exceptionally vituperative discourse on the degenerate "idleness" of the blacks. Of all the stigmata of degeneration invented by the settlers to mark themselves from the Africans, the most tirelessly invoked was idleness: the same stigma of racial unworth that Haggard saw as marking the Kukuana's degeneration and loss of title to the diamonds.

It is scarcely possible to read any travel account, settler memoir or ethnographic document without coming across a chorus of complaints about the sloth, idleness, indolence or torpor of the natives, who, the colonists claimed, preferred scheming and fighting, lazing and wanton lasciviousness to industry. Typical is Captain Ludlow's remark on visiting the Umvoti Mission Station: "The father of the family leant on his hoe in his mielie garden, lazily smoking his pipe. . . . It is amusing to watch one of them pretending to work."[37] Haggard saw the racial hatred of whites rooted in this stubborn abstraction of African labor: "The average white man . . . detests the Kaffir and looks on him as a lazy good-for-nothing, who ought to work for him and will not work for him."[38]

The idea of idleness was neither descriptively accurate of the laboring black farmers nor new. The settlers brought with them to South Africa the remnants of a three-hundred-year-old British discourse that associated poverty with sloth. Beginning in the sixteenth century in Britain, an intricate discourse on idleness had emerged, not only to draw distinctions between laboring classes but also to sanction and enforce social discipline, to legitimize land plunder and to alter habits of labor. After 1575, the unemployed or unruly poor, for example, were no longer banished beyond the city walls but were dragooned into "houses of correction" where they were treated as a resource to meet the needs of the growing manufactures. Walling up discontent and fettering the desperate during the crises of unemployment, the houses of confinement, often attached to manufactures and providing them with labor, also taught new habits and forms of industry. It appears that many of the inmates of the houses of correction were women, suggesting that the houses were threshold institutions, mediating the gradual transfer of productive labor from the family to the factory.

The discourse on idleness is, more properly speaking, a discourse on work—used to distinguish between desirable and undesirable labor.

Pressure to work was, more accurately, pressure to alter traditional habits of work. During the land revolution and the war on the cottages of the eighteenth century, Official Board of Agriculture reports of the time praised the land enclosures for robbing the lower orders of economic independence, thereby forcing laborers to work every day of the year. At the same time, the discourse on idleness is also a register of labor resistance, a resistance then lambasted as torpor and sloth.

Colonists borrowed and patched from British discourses and couched their complaints in the same images of degeneracy, massing animal menace and irrationality familiar to European descriptions of the dangerous urban underclasses. The missionary Aldin Grout wrote to James Kitchenham: "They see our tools and our work but seldom ask a question about these or express a wish to do the other." Lady Barker opined: "It is a new and revolutionary idea to a Kaffir that he should do any work at all." James Bryce agreed: "The male Kaffir is a lazy fellow who likes talking and sleeping better than continuous physical exertion and the difficulty of inducing him to work is the chief difficulty that European mine-owners in South Africa complain of."

But the African pastoralists differed markedly from the uprooted and immiserated British proletariat with which the settlers were familiar. The Africans still enjoyed a measure of self-sufficiency and were, on the whole, better farmers than the white interlopers.[39] As Slater notes, "many whites in fact came to depend upon African agricultural produce for their very subsistence."[40] Settler fortunes were constantly imperiled by the self-sufficiency of the black farmers. Complaints about black sloth were as often complaints about different habits of labor. If black people entered into wage relations for whites, it was often reluctantly or briefly, to earn money, buy guns or cattle, then to return home. Thus the discourse on idleness was not a monolithic discourse imposed on a hapless people. Rather it was a realm of contestation, marked with the stubborn refusal of Africans to alter their customs of work as well as by conflicts within the white communities.

Most importantly, I suggest, the assault on African work habits was at its root an assault on polygyny and the women farmers: the fundamental dynamic underlying both *King Solomon's Mines* and the native policy of Natal. The question, bitterly contested for decades, was who was to benefit from women's labor.

MARRIAGE, MAIDENS AND MINES

One need not look far to see that the root of the problem of black labor lay in women's role in production. When Froude visited Natal, he noted grimly: "The government won't make the Kaffirs work." Then at once he

came upon the cause of the problem. Male "indolence," he saw, was rooted regrettably but inevitably in the "detestable systems of polygamy and female slavery."

> My host talks much and rather bitterly on the Nigger question. If the Kafir would work, he would treble his profits. . . . It is an intricate problem. Here in Natal are nearly 400,000 natives. . . . They are allowed as much land as they want for their locations. They are polygamists and treat their women as slaves, while they themselves are idle or worse.[41]

Missionaries and colonists voiced their repugnance for polygyny in moral tones, placing it firmly within the discourse of racial degeneration. The practice of polygyny was seen to mark African men, as Haggard had marked King Twala, as wallowing in the depths of sexual abandon: the "African sin." Yet colonial documents readily reveal that the assault on polygyny was an assault on African habits of labor that withheld from the resentful farmers the work of black men and women. The excess labor that a black man controlled through his wives was seen as a direct and deadly threat to the profits of the settlers. As Governor Pine complained: "How can an Englishman with one pair of hands compete with a native with five to twenty slave wives?"[42] Likewise, Haggard's knowledge of women's productive power animates his fear of Gagool in *King Solomon's Mines*.

Black women in Natal became the ground over which white men fought black men for control of their land and labor. As Guy has shown, precapitalist societies in southern Africa depended on the control of *labor power*, rather than the control of *products*. The fundamental unit of Zulu society was the homestead (*umuzi, imizi*), in which a single male (*umnumzana*) held authority over his wife or wives, their children, livestock, gardens and grazing lands. Each homestead was more or less independent, with women growing food on land held in trust for the chief of the clan. Each wife worked her own fields, living with her children in a separate house that took its name from her. A strict gendered division of labor prevailed, as women did most of the agricultural and domestic work—hoeing, planting, gathering and tending the crops, building and tending the houses, making implements and clothes, taking care of the daily cooking and the houses, as well as the bearing and raising of the children. The men broke the ground in the first stages, made some of the implements and tended the cattle. In short, the homestead was based on the systematic exploitation of women's labor and the transformation of that labor into male social and political power.

The symbolic means for transforming woman's work into male power was the *ukulobolo*, or marriage exchange. A new homestead was formed

when a man was given permission to leave the royal barracks, or his father's homestead and marry a wife from a different clan. The marriage was formalized by the transfer of *lobolo* from the new husband to the wife's father, usually in the form of cattle. Colonialists berated this system as base and commercial; but it was, rather, a ceremonial exchange that guaranteed the transfer of a woman's labor and sexuality. If she did not produce children or the work expected, the cattle could be reduced in number, or returned and the marriage dissolved. At the same time, the cattle could be retained if the new husband was seen to ill-treat his wife. Nevertheless, the society was not egalitarian and most of the homesteads had only one or two wives. Power in the form of cattle and wives was gathered in the upper reaches of the chiefly lineages, and chiefs distributed power back down the social hierarchy by controlling the distribution of cattle and wives to their sons and loyal supporters. *Lobolo* was thus a symbolic, rather than a commercial, exchange whereby women's labor power was embodied in movable herds of cattle and exchanged among men across time and space.

At the same time, it is of the greatest significance that women's work freed men to fight in the Zulu army. The relation between women's labor and the Zulu fighting force is crucial. Women in the family homesteads provided a surplus of food for themselves and for the men in the barracks. The unequal distribution of women allowed male power to be hierarchically ranked within an arena of male competition for the basic resource of labor power. Thus whoever controlled the regulation of marriage controlled the power base of the economy. The dominant class was men over the marriageable age, the subordinate class women and children. Guy calls this "a fundamental cleavage so deep it can usefully be called one of class," but the fundamental division was gender, for a male child could leave the subordinate class at a certain age when he entered into marriage with a woman, that is, into a gendered division of labor in which he exploited his wife's labor power.

In *Cetywayo*, Haggard devoted a good deal of space to polygyny, which he recognized as lying at the heart of Zulu power. In a metaphor that nicely expressed the relation between matrimonial and military power, he advised: "Deprive them of their troops of servants in the shape of wives and thus force them to betake themselves to honest labor like the rest of mankind."[45] Tampering with the circulation of women was thus tantamount to severing the jugular vein of male Zulu power.

Indeed, this approach was precisely Shepstone's policy. In the face of the bitter ire of the farmer-settlers, Shepstone doggedly pursued a policy of segregation, administration and compromise. In the reserves, wretchedly apportioned as they were, blacks were allowed to retain access to land under "customary law" (as were the Kukuanas in Haggard's tale). The

communal household was to be retained, since black resistance to changes in polygyny proved too tenacious. But the family would be gradually modified by diverting the profits of female labor out of the homestead into the colonial treasury in the form of hut and marriage taxes.

Knowing that an outright ban on polygyny was impractical, both Shepstone and Haggard favored a hut tax. The hut tax was, in fact, a tax on wives and thus the surest means of driving African men into wage labor. By legislating control of the rates of the hut taxes over the years, the Shepstone administration tried to take control of the traffic in women's work out of black men's hands, while driving these men into work on the white farms and mines. This put an administrative fetter on polygyny even as it turned the women's labor power into a sizable source of revenue for the dwindling treasury. The tax on women's labor would in fact become the principle source of revenue for the state. Significantly, what this fact reveals is that there was no objection to exploiting marriage and women's work as a commercial transaction as long as white men and not black men benefited from it. At the same time, to administer this gradual process of cultural attrition, ductile chiefs would be appointed to supervise and implement the process.

However, in 1876 the situation abruptly changed. The discovery of diamonds marked a new imperial initiative in southern Africa as Lord Carnarvon, British Secretary of State for the Colonies, hatched a scheme to confederate South Africa. Shepstone was given the responsibility of annexing the Transvaal and it was Haggard himself who raised the British flag over a reluctant Boer republic in 1876. The annexation shattered the uneasy balance between the Boers, Natal and the Zulus and set in train a series of events that led inexorably to the invasion of Zululand. Both Shepstone and Haggard deplored the invasion on the practical grounds that it was untimely and doomed to disaster. They remained convinced that the surest way to control the labor and land of South Africa was by segregation, indirect rule through selected chiefs, and the regulated diversion of labor from the reserves into the state economy.

Indeed, Haggard's fantastical tale is faithful to Shepstone's political blueprint for Zululand—Kukuanaland would remain territorially separate but in effect a "black colony" of Natal, while a compliant black leader who accepted the racial patrimony of the whites would be installed. True to Shepstone's segregationist policy, white men would not be allowed to settle there. At the same time, true to Haggard's own class loyalties—though not to the outcome of history—the booty from the mines would be placed in the hands of the landed gentry, not in the hands of the mining capitalists. Finally, the labor of black women is hidden from history, rendered as invisible as Gagool crushed beneath the rock.

In this way, *King Solomon's Mines* figures the reinvention of white imperial patriarchy through a legitimizing racial and gender politics. It asserts a white patriarch in control of a subservient black king, who grants white racial superiority and entitlement to the diamonds. It reorganizes production and reproduction within the black family by usurping the chief's control of the lives and labor of women. At the same time, it violently negates the African women's sexual and labor power.

Indeed, the Victorian obsession with treasure troves and treasure maps is a vivid example of commodity fetishism—the disavowal of the origins of money in labor. Finding treasure implies that gold and diamonds are there simply to be discovered, thereby denying the work of digging them out of the earth and thus the contested right to ownership. In the treasure fetish, money is seen to breed itself—just as in Haggard's tale the men give birth to themselves in the mine-womb.

Thus the narrative of phallic regeneracy is assured by the control of women in the arena of empire. The plundering of the land and the minerals is given legitimacy through the erasure of the mother and the reinvention of white patriarchy within the organic embrace of the regenerated Family of Man. It is only fitting, therefore, that Haggard was himself enabled (by the fantastically approving British reception of his tale of phallic and racial regeneration) to buy the landed estate from which he had been disinherited.

OLIVE SCHREINER

THE LIMITS OF COLONIAL FEMINISM

7

Olive Schreiner's life was distinguished by paradox. Born in 1855 to missionary parents in an obscure corner of colonial South Africa, she consecrated herself to an impassioned refusal of empire and God. At the age of eight she shook her fist at the heavens and reneged on the church. Though a daughter of empire, she devoted her life and writings to championing the dispossessed, abetting the Boers against the British during

the Anglo-Boer War (1899–1902) and the Africans against both. Schooled in discipline and decorum and destined from childhood for domesticity, she flouted Victorian and parental decree by becoming a feminist, a bestselling writer and one of the most sought-after intellectuals of her time.[1]

Schreiner's life spanned the heyday of South African mining colonialism, the rise and demise of the late Victorian industrial empire and the outbreak of World War I. Migrating restlessly between colonial South Africa and fin-de-siècle Britain, she was unusually well positioned to testify—as she did in her novels, essays, political writings and activism—to the major tumults of her time: the discovery of precious minerals in South Africa, the crises of late-Victorian industrialism, the socialist and feminist upheavals of the fin de siècle, the Anglo-Boer War and the great European conflagration of World War I. Her books were written, as she put it, "in blood"; amounting to an impassioned and lifelong denunciation of social injustice in the colonies and Britain and a fierce defense of the dis-empowered: Africans and Boers, prostitutes and Jews, working-class women and men. In this respect, Schreiner was exceptional in her time.

At the age of fifteen, Schreiner joined the pell-mell rush to the diamond fields, where amongst the tents, brothels and tin shanties of New Rush she witnessed at first hand the convulsions of colonial capitalism. Sailing to Britain in 1881, she saw in the fetid slums and rookeries of the East End the calamities of late-Victorian industrialism. The publication in Britain of her novel, *The Story of an African Farm*, won her overnight fame, the admiration of some of the great luminaries of her time and the distinction of being the first colonial writer to be widely acclaimed in Britain.

In 1889, Schreiner returned to South Africa as a celebrity, but she immediately pitched her solitary voice against the swelling crescendo of British jingoism, publicly condemning the notorious Jameson Raid and Rhodes' bloody mauling of Mashonaland. From newspaper and podium, she decried the British ravaging of the Afrikaners during the Anglo-Boer War and the clandestine blood brotherhood of mining capitalism and Afrikaner nationalism that was spawned soon after. The British interned her during the war for her Boer sympathies, and the Afrikaners in turn vilified her for supporting the Africans.

Schreiner's life and writings were crisscrossed by contradiction. Solitary by temperament, she hobnobbed with celebrities. Hungering for recognition, she shrank from the publicity when it came. Insisting on women's right to sexual pleasure, she suffered torments in confronting her own urgent desires. At odds with her imperial world, she was at times the most colonial of writers. Startlingly advanced in her anti-racism and political analysis, she could fall on occasion into the most familiar racial stereotypes. Revering monogamy, she waited until she was in her forties to

marry. After she found "the perfect man," she chose to spend most of her married life apart from her husband. Haunted by longing for a home, she wandered from continent to continent, farm to city, unable to settle. She was a political radical yet aligned with no party. A belligerent pacifist, she supported the Boers in their armed struggle against the British and the African National Congress when it emerged in 1912.

By exploring with the utmost passion and integrity what it meant to be both colonized and colonizer in a Victorian and African world, Schreiner pushed some of the critical contradictions of imperialism to their limits and allows us thereby to explore some of the abiding conflicts of race and gender, power and resistance that haunt our time.

DOMESTIC COLONIALISM AND THE CIVILIZING MISSION

Schreiner was born on March 24 1855, to an English Dissenting mother and a German Lutheran father in a mud-floored house on a mission called Wittebergen, which lay in a remote African reserve on the borders of Basutoland. The tiny cluster of buildings stood solitary in the veld, scourged by lightning, the red wind of the Karoo and a sun that struck like a damnation. The Schreiners' closest neighbors were the AmaFingo, Sotho and some few surviving Khoisan. The nearest post office was a hundred miles away.

In 1837—the year that Queen Victoria ascended the throne— Rebecca Lyndall married Gottlob Schreiner. Born into the plush sobriety of a Dissenting Yorkshire parsonage, Schreiner's mother, Rebecca, had been carefully groomed for her destiny as adornment to a middle-class man's career. As befitted a daughter of the cloth, she was bequeathed the demure accomplishments proper to her class: French and Italian, singing, drawing and a generous exposure to books. Cultivated and brilliant, she wanted to be a doctor, but, as a girl, her education was intended to fit her to be decorative, not practical, and the portals of university and hospital were closed to her. By her own account, her parents' house was a sad place of cold meats and catechism, sinners and psalms. Destined for the "listless half-awake" slumber of bourgeois marriage and maternity, she glimpsed in empire the radiant promise of escape.[2] At one of her father's services, she met a young German missionary, Gottlob Schreiner and agreed almost at once to marry him. Within three weeks of marrying, they had sailed for South Africa.

At once, the Schreiners took their place in an imperial narrative already two centuries in the making. In the nineteenth century, as the white nomads pushed steadfastly east and north, borne rapidly on their wasteful

system of farming, land become scarce, tensions flared over cattle and water and chafing wars broke out along the frontiers. When the British took over the Cape in 1806, most of the settlers were Dutch, so the British government sponsored the arrival of thousands more settlers in the 1820s to stimulate farming and swell the British presence on the frontiers. It was along these same frontiers that missionaries were settled to serve as a buffer between the colonials and the Africans, and it was there amongst a settlement of KhoiKhoi in the Eastern Cape that Olive Schreiner's parents had their first mission station.[3]

Rebecca's life there refuted in almost every detail the stereotype of the faded, crushed petal of Victorian womanhood; the bourgeois ideology that her daughter later passionately denounced in her writings. At the same time, her life bore witness to the subtle betrayals of both empire and the cult of domesticity. During the wedding, the minister had brusquely torn the garland from Rebecca's bonnet. The frivolity of flowers was improper for a missionary wife, and the clergyman's rebuke foretold a life plucked bare of frippery and frills. On the Schreiners' arrival in South Africa, the illusions of empire were as rudely snatched away. From the moment of beaching at the wind-tossed Cape, until she died a rancorous and destitute invalid in a convent, Rebecca's life was an inclement round of woe.

By all accounts, Gottlob Schreiner, Olive's father, sinned only in his lack of greed and guile. Son of a German village shoemaker, he had given up cobbling at the age of eighteen and set out to join the missionary throng. After an unpromising beginning, he was ordained into the London Missionary Society, then the largest evangelical institution peddling its spiritual wares in the arena of empire. Gottlob arrived in South Africa in 1837, the same year as the Great Trek and took his place among "the superfluous men," as Haggard called them, the imperial ragbag of unemployed poor, the younger or ill-gotten sons of the clergy and fallen gentry, for whom an industrializing Europe had no place.

Nothing in Rebecca's background could have prepared her for the trials that awaited her. For decades she and Gottlob trekked from mission to mission, lumbering in ox wagons across the scorching wastes of the frontier with their large family. Dogged by disappointment and poverty, natural hazards and the anger of Africans, Rebecca's only revenge was fanaticism and her only solace the perpetually deferred promise of heaven.

Rebecca ruled her mission household with unswerving ferocity. Pregnant for the better part of two decades, she had delivered eleven children by the time Olive arrived. Two boys died in infancy and just before Olive's birth a third son died. Rebecca found solace only in pacing frantically backward and forward in the churchyard until Olive was born. In a macabre requiem, Schreiner was named after her three dead brothers:

Olive Emilie Albertina Schreiner. Her identity thus took its first shape around a female grief and the mourning of a lost male identity.

For Rebecca, the fanaticism of the civilizing mission cloaked a severe crisis in social identity, and her fall from class represented in miniature a more general crisis in the legitimacy of colonial power. Lacking the class accoutrements of the croquet, the cricket, the brass bands and the sundowners of the colonial gentry, Rebecca could distinguish herself from the Africans and the Boers only by a frank racism, an unswerving sexual Puritanism, a diet of self-denial and a regimen of guilt. Schreiner described her mother's fall from class in the language of domestic commodity, likening her to a grand piano shut up and mistakenly "used for a common dining room table."[4]

More than Gottlob, Rebecca saw herself as the avenging angel of a punitive God. There is evidence that she abused her children, whipping them furiously for the smallest sin. The children were forbidden to speak Dutch, for English was the language of the racially elect and the borders of racial difference had to be violently policed. Schreiner's earliest memory is of receiving fifty vicious lashes from her mother at the age of five for swinging on a door handle and using a taboo Dutch word, exclaiming: "Ach, it is so nice outside." The unfathomable injustice of the thrashings was the major reason she became a freethinker and why, at the age of eight, without precedent or example, she swept the heavens clear of her parents' creed and refused any longer to go to church. Schreiner learned the lesson of domestic violence and with it an "unutterable bitter rebellion" against "God and man." Henceforth, she would always feel an outcast and a pariah.

COLONIALISM AND GENDER AMBIGUITY

Identity comes into being through community and from the outset Schreiner's earliest relations with her family were shaped by an obscure economy of feminine identity through denial. Like Cullwick, she learned very young that she would be rewarded with her mother's love only if she denied herself. As a result she fell into the quandary of winning affirmation only through a ritualistic negation of self, the sad logic of Christian masochism that left its mark on her life long after she rejected Christian dogma. Far from being a sacred refuge, the domestic realm held only martyrdom and betrayal.

Schreiner's identity was fashioned around a tortuous logic of gender rebellion and guilt, autonomy and punishment. Pleasure in the body, she learned, could be answered inexplicably by an annihilating pain. Transgressing the threshold of domesticity brought violent retribution and an

unholy alliance reigned between forbidden words and power. She discovered in language a magician's power to conjure from nowhere the miracle of her mother's approval. The sorcery of writing promised the radical project of self-justification and autonomy. Yet language was also the realm of peril, for words were always linked to transgression. Transgression offered the shimmering promise of autonomy and the potency of self-creation, but it also threatened her with the catastrophe of negation, of herself or another. In language the boundaries of selfhood were permanently ambiguous and words could occasion, as she well knew, the swift annihilation of rejection and retribution, a sense that deeply shaped her future relations with her public. Moreover, her brother, Will, eavesdropped on her, then retold her stories to the family at dinner and claimed them for his own. The male appropriation of language drove Schreiner into convulsions of rage and imbued in her a precocious sense of storytelling as a gendered contest over authorship and authority.

Negotiating the boundaries between private and public, identity and difference, desire and punishment, self and other became a lifelong activity fraught with peril. If the cult of domesticity charged women, in particular, with the maintenance of boundaries between private and public, domesticity and empire, marriage and market, all Schreiner's writings testify to the punitive cost this exacted from women. Throughout her writing, boundary images preside: doorsteps and windows, seashores and deathbeds, noon and midnight. Characteristically, her imagination was pitched at the dangerous borders between domesticity and wilderness, love and autonomy, obedience and scandal.

Servants and visitors were struck by the eerie spectacle of Schreiner as a young child pacing feverishly back and forth on the verandah, hair disheveled, hands clenched behind her back, mumbling stories to herself— in a small mimicry of her mother's desperate pacing in the graveyard before giving birth. There on the verandah, the threshold between domesticity and empire, Schreiner began the radical project of reinventing identity through narrative. Throughout her life, she paced in this way, driving neighbors and landladies to distraction with her restless tread. Indeed, pacing to and fro between extremes can be seen to be the quintessential activity of Schreiner's life.

From an early age, Schreiner swung between an agnostic vision of the "awful universe" as capricious and blind and a contrary belief in a universal "truth" driving the destiny of planets. Unable as a child to resolve the dilemmas that beset her, Schreiner became afflicted by phobias, feeling her inability to resolve the paradoxes with the force of an inconsolable grief. She lay awake at night crying and shouting, then clambered under

her bed to lie face down on the cold floor for hours in a paralysis of dread. She found relief from the "agony thinking there was no Hereafter" only in biting and mauling her hands and beating her head against the wall until she was insensible.[5] Schooled in sacrifice, she went into the veld one day to solicit a final answer from God, an event she recreates in *The Story of an African Farm*. On an altar of twelve flat stones she offered up a fat lamb chop and waited in the sacrificial heat for the torch of God. But the conflagration never came and in a paroxysm of disbelief, she smeared her body with dung. At the very moment of abandoning Christianity, she rehearsed the masochistic logic of Christianity, mortifying the body in a desperate bid for salvation from mortification of the soul. Inflicting punishment on herself preempted the power of the mother to punish her and at the same time licensed her own wilful mutinies.

Her "desperate romps" of anger and bewilderment were an hysterical protest against her unacceptable situation as female. From an extremely early age, Schreiner saw her suffering as gendered: "When I was a young girl—a child, I felt this awful bitterness in my soul because I was a woman."[6] The main force of her refusal of her colonial world came from a deeply felt sense of feminine exile, and much of her motivation to write stemmed from her desire to invent an alternative community beyond the betrayals of colonial domesticity. For Schreiner, the invention of the boundary between private and public so central to the maintenance of middle-class colonial power held only frustration and outrage.

Schreiner's childhood was marked by a sense of solitude that could be assuaged only by flight into fantasy and the autonomy of self-creation. As a girl she was destined to live in political and economic exile within her privileged white culture. As Lyndall cries in *The Story of an African Farm*: "To be born a woman is to be born branded. To the man the world cries 'Work! To woman it says: Seem.'"[7] Lyndall's image of the girl sitting beside the window, her pale cheek pressed wistfully against the pane, symbolizes the invisible glass barriers that stand between women and the world. Her furious, failed attempt to smash the windowpane and pry open the stubborn shutters bears witness to Schreiner's bleak sense of the barriers facing women's power. If domestic colonialism fetishized glass as the icon of spiritual advance and rational knowledge as penetration, for Schreiner (as for Charlotte and Emily Bronte) window glass symbolized the often fatal limits to female power. For these women, glass became a symbol not of progress, but of female mutilation, domestic frustration and betrayal.

Unable to find clues to the social history of her loneliness, she took refuge in the solitary vocation of language. In books she glimpsed the delirious possibility that her solitude was not the affliction of an accursed infidel, but rather the mark of a persecuted community of truth-seekers and

seers. When the family lived near Cradock, one of the garrison towns strung along the northern frontier, Schreiner was allowed to rifle at will through the local, privately endowed library, a freedom not available to many white girls of her time and certainly not to African women or men.

Schreiner's lifelong sense of exile was very much the outcome of the social alienation of the colonial intruder in a foreign land. As a white colonial, she was exiled from the Africans around her. Her blasphemy and disbelief had exiled her from her family. Her niggardly colonial culture would neither recognize nor nourish her intelligence and power. Nonetheless, colonial life bequeathed to Schreiner, as a white child, a greater measure of physical freedom than that enjoyed by most British girls of her class and time. Easily dodging the overworked Africans and her distracted mother, she found in the vast veld the promise of redemption from the limits of her situation.

Beyond the sepulchral mission lay an immense, hot country of cactus and red sand, flat rocks and aromatic thorn trees, where the only sounds were the cries of the sheep and the cough of baboons from the crags. In this beloved place of mimosa and mirage, Schreiner wandered the streambeds and stood alone with her small bewilderments under a blue cathedral of sky. There she developed her precocious talent for introspection: "In such a silence," she later wrote, "one could only think and think." Nature baptized her with a new divinity: pondering the crystal drops of the ice plant and the spoor of leopard in the sand, tracing the enigma of origins in fossils and the scarlet veins of an ostrich heart, she came to read in nature the hidden hieroglyphics of God.

Born of colonial stock, Schreiner inherited a Bible and a European culture out of place with the African history of her beloved Karoo. With her renunciation of the Bible, she lost forever the dialogue of prayer and inherited instead a haunting sense of exile and solitude. Yet she was incapable of abandoning all solace and projected onto the steadfast immensity of sky and veld the metaphysical silhouette of the lost religion. The tendrils of the palm fern, the tracery of ants in the sand, the mierkat's small footfall all offered an alternative allegory of God. If the thunderous male God of the Bible had lost his voice, it was now ventriloquized through a feminized Nature. Nature drew her close "with that subtle sympathy which binds together all things and to stones and rocks gives a speech which even we can understand."[8]

The weird, compelling beauty of the Karoo gave Schreiner the lifelong respite of a metaphysical solace: "The Universe is One and It lives!"[9] A monist vision of the cosmos animates all her writing with a mystical faith in "the unity of all things."[10] In her favorite allegory, "The Ruined Chapel," an angel of God exposes a human soul to an unbelieving man. The man discovers "in its tiny drop" the whole universe, the inner nature of stars,

lichen, crystals, the outstretched fingers of infants. Gazing at the fully naked soul, he shudders and whispers: "It is God."[11] In *The Story of an African Farm* Waldo moves his hands "as though he were washing them in the sunshine." So too Schreiner found absolution for unbelief in the sacrament of sun.

Schreiner's sacrament of sun, however, blinded her to the colonial cast of her mystical monism. The vast veld gave her metaphysical grounds for her longing for the infinite, but also concealed the very real history of colonial plunder that gave her privileged access to this immensity. There was nothing infinite about the Karoo; it was fenced by missionary intrusion, colonial land laws, the history of dispossession and colonial rout. Schreiner's theological skepticism would always be tempered by a mystical faith in the divinity of the cosmos. Yet this faith was won at the cost of ignoring for some time the history of colonialism. In Schreiner's rhapsodies to the infinite, it was easy to forget she was walking on plundered land.

Schreiner's childhood bewilderments might have been less decisive had they not been overdetermined by the crises and contradictions of her colonial situation. Her father's life was in every sense marginal. As a German, Gottlob was an outsider to both the British and the Dutch. As a colonial, he was an outsider to the Africans. The white farmers bitterly resented him for training the Africans in industrial skills, for the natives, they thought, were predestined to be no more than hewers of wood and drawers of water. Though Gottlob was an honorary member of the white elite, the fiction of racial superiority was belied by his sheer lack of talent for any occupation and the consequent chronic poverty and distress of his family.

Contrary to the cult of domestic colonialism, Schreiner's family lived scarcely better than the fairly prosperous African farmers around them. Contrary to patriarchal dogma, her mother was the dominant power in the household. Contrary to Christian dogma, her parents' faith was rewarded only by "disaster and disaster and trouble." The Victorian Family of Man was a mockery and a failure. All things considered, the evidence of Schreiner's life could admit no easy evangelism and the failure of empire to keep its promise bred in her a precocious pessimism.

At this time, the family narrative took shape around the disgrace of the colonial father. Meandering from mission to mission, Gottlob Schreiner was beset by failure and financial distress. In 1865, the same year that her baby sister, Ellie, died, after a number of dismissals and censures, he was finally expelled from the ministry for infringing a ban on trading. After twenty-seven years of mission work, the aging and inept preacher tried his hand at commerce. Ambling about the country on horseback, he peddled eggs, hides, coffee and pepper to the Africans, but one after the other his stores failed and hounded by debt and disgrace, he surrendered to his creditors and plunged into destitution. The family scattered. Rebecca went

to live in an outbuilding, and she and Gottlob spent the rest of their lives leaning on the charity of their children. Olive was farmed out to her older brother, Theo, a headmaster at Cradock, under whose tyrannical tutelage her life became a "hell on earth." Theo imbued in her a lasting sense of her intellect as a deformation and a crime: "He turned away so utterly when I began to think."[12] At about this time Schreiner began to write.

From the outset, race formed an acutely ambiguous dimension of her early rebellion. Schreiner was caught in a paradox she would never fully resolve. Her mystical monism assuaged her loneliness and sense of exile, but was at odds with the social history of racial and gender difference that shaped her experience. Her pantheism, for all its emotional integrity, was very much a metaphysical abstraction. As an abstraction, it served to conceal and thereby ratify, the very real imbalances in social power around her. The most troubling presence of these imbalances appears in her work on the racial doubling of the mother figure.

RACE AND THE DOUBLED MOTHER

Schreiner swore she never had a mother, yet in fact a number of mother figures attended her childhood. There is a ritualistic moment in almost all of Schreiner's writings, when a child frantic with despair is spoken to and calmed by nature. Schreiner's god of nature, however, is not a male god, but is consistently feminized. I wish to stress, however, that this female nature is also white and *anglicized*. In Schreiner's allegories and novels, nature is a projection of a white female principle, figured as a long-robed mother bending over and smoothing her child's disheveled hair.

Schreiner's early reluctance to look squarely at the politics of race is rendered most vividly and problematically in the figure of the hostile, ominous and unsympathetic "Hottentot" (Khoikhoi) who stalks through many of her stories.[13] More than anything else, it was to the shadowy presence of the African women in the household that Schreiner owed whatever fragile sense of privilege she had. Yet this presence was paradoxical. Some of Schreiner's experiences of the limits to power were at the hands of punitive black women. As a white child, she held potential racial power over the African workers in the home; but these women possessed a secret and appalling power to judge and punish her. *The Story of an African Farm*, "The Prelude" to *From Man to Man* and many of Schreiner's early stories are haunted by the figure of the angry "old Ayah," a reflection, however oblique and denied, of the domestic resistance and resentment of African women—a resistance and an ambiguity that would throw radically into question Schreiner's monistic longing for a humanist unity, then later, a universal, feminist solidarity.

Almost without exception, black women in Schreiner's fiction are servants. In *The Story of an African Farm*, Africans pass like fitful shadows through the white people's lives, unnamed and without identity. The notion that they might have lives of their own is not entertained. In "The Prelude" to *From Man to Man*, the African woman is simply called Old Ayah. She has no name; she bears only a labor category (nurse) and the identity of servitude. In Schreiner's fiction, the black woman stands at the threshold of domesticity as a figure of intense ambivalence.

For Schreiner, as for most colonials, African women serve principally as boundary markers. Their chief labor function is to perform boundary work. They stand at thresholds, windows and walls, opening and shutting doors: "Old Ayah opened the door."[14] In "The Prelude," the white child asks the African nurse to let her out. "The handle was too high for her. The woman let her out."[15] The black women minister to colonial and domestic boundary rituals, marking day from night, order from disorder and life from death. They scrub verandahs, clean windows, wash clothes, welcome newcomers and generally mediate the traffic between colonials and between Africans and colonials, marking by their presence and maintaining through their labor the newly invented borders between private and public, family and market, race and race.

In "The Prelude," the Old Ayah, rather than the white mother, polices the inclement barriers between black and white, guaranteeing racial difference and decorum: "'Get down from that wall, child , will you! . . . You'll be burnt as black as a Kaffir before your mother gets up. Put your kappie on!'"[16] In a curious reversal of colonial dogma, African women preside over the civilizing mission and the cult of domesticity: "'And get your face washed and your hair done . . . and tell Mietjie to put you in a clean dress and white pinafore.'"[17] At a symbolic level, Schreiner's tales express the unbidden recognition that African women hold the keys to the domestic power of white people: "Old Ayah locked the door and put the key into her pocket."[18] Yet, like Freud, Schreiner never brings this insight to fictional or theoretical fruition. Instead, I suggest, she displaces her rage at the cult of domesticity onto black servants.

Why are African women figures of such ambivalence for Schreiner? In her more mature political writing and activism, Schreiner was unusual in her anti-racism and sympathy for black people, yet in her fiction Africans are, more often than not, forbidding ciphers. In the eyes of her fictional white children especially, African women bear an aspect of vengeful authority. *From Man To Man* portrays the Old Ayah, not the "little" English mother, as the ominous figure of domestic prohibition: "Old Ayah . . . shook her by the shoulder. 'What are you doing here? Couldn't you see, if the door was locked, that you weren't to get in here?

. . . Aren't you a wicked, naughty, child.'" The "little mother" by contrast is gentle and accommodating. The white father, to all intents and purposes, is absent.

In Schreiner's fiction, one witnesses a displacement and a double disavowal. Schreiner's own mother, the evidence attests, was cold and punitive, prone to fits of temper and what her husband called "inflammation of the brain." Contrary to patriarchal decree, she, rather than Gottlob, wielded authority in the family. Bearing twelve children in twenty-four years, she suffered acute domestic deprivation, living without domestic comforts, often without sanitation, sometimes even without a home. Even when they found temporary respite at Wittebergen, where Olive was born, Rebeccah was bent under an overwhelming regime of domestic work: whitewashing the rooms; sewing clothes, curtains and sheets; making shoes; cooking; sweeping and cleaning; growing produce and raising children, while pregnant every second year. For the Schreiners, the cult of domesticity was a betrayal and a grief and their household a place of constricted rage.

Much of the inspiration for Schreiner's writings appears to have sprung from a desire to redeem the mutilation of her mother's life. Both Rebekah in *From Man to Man* and Lyndall in *The Story of an African Farm* are named after her mother. As Antoinette in Jean Rhys' *Wide Sargasso Sea* says: "Names matter." Names reflect the obscure relations of power between self and society and women's names mirror the degree to which our status in society, is relational, mediated by our social relation to men: first father, then husband. At the age of sixteen, Schreiner summarily changed her name. She had been called Emily since birth, but she insisted that she was to be called Olive from then on. Schreiner associated "Olive" with her mother's family, and her willful change of name expressed a newfound determination that she would be the one to fashion her own identity. Later, when she married, Schreiner refused the symbolic surrender of women's autonomy in names and insisted that Cronwright, her husband, take her name, while she kept her own. The choice of the mother's name and the fictional naming of her characters after her mother expressed an intense identification with her mother's history and thwarted power. Nonetheless, the redemption of the (white) mother figure held very real paradoxes, of which the major dimension was race.

In her fiction, I suggest, Schreiner splits the ambiguous power of the mother both to love and to punish, and projects it onto three distinct figures, which take their historical meaning from colonial hierarchy: the good English mother, the repulsive Boer Tannie and the surrogate mother figure of the ominous black nurse. Quite unlike Schreiner's own mother, the English mother is a sanitized figure, loving and mild. In *The Story of an*

African Farm, where there is no mother proper, Tant (Aunt) Sannie is a gross parody of women's punitive power. It is telling, here, that the figure of negative femininity is Afrikaans, not English. Schreiner thus manages the dilemma of female betrayal by projecting it either onto the figure of the degenerate Boer (a racist British stereotype she would later vehemently oppose), or onto the hostile but safely distanced figure of the African woman. In her fiction, in other words, Schreiner redeems the idea of the white mother, but only at the cost of black women.

Schreiner's redemption of the white mother is won at the expense of a double disavowal: denial of the historical memory of her own mother's anger and denial of the agency of black women—beyond their subservience, that is, to the logic of the colonial narrative. In "The Prelude," the white child's uncomprehending grief at the death of her newborn sister is projected away from the white mother onto the black nurse as the principle of difference and death. "'You are killing it like the other one!'" Rebekah cries. "Rebekah turned her eyes onto the old Ayah and gazed at her. . . . 'I hate you so!' she said."[19]

RACE, MIMICRY AND THE ABJECTION OF BLACK WOMEN

One can add a further dimension. In Chapter 2, I argued that Munby, like many other male Victorians, managed the class divisions of domestic labor by projecting them onto the invented domain of race. How, in the colonies, does the racial division of domestic labor, overdetermined by class, play itself out in the identity of a white child? If, as I argue, British middle-class identity took formative shape around the abjected labor of working-class women (repudiated but indispensible), in the colonies the contradictions of identity were deeply fractured by race. White children—nursed, tended, caressed and punished by black maids and nurses—receive the memory of black women's power as an ambiguous heritage. Part of the white child's earliest identity is structured around the strength and authority, however restricted, of the black mother figure. Coming to adolescence, however, white children are obliged, by colonial decree, to detach themselves from identification with the African women with whom they have been so intimate and thus also from significant aspects of their own identity. Black women come to form the abjected, inner limit of the white child's identity: rejected but constitutive. In the process, a number of morbid symptoms appear.

Schreiner's fictional portrayal of African women betrays an unresolved recognition of their anger and strength, as well as resentful memories of their power over her. In later life, Schreiner confessed to

Havelock Ellis her phobic loathing of eating in front of strangers. In "The Prelude" Rebekah is similarly tormented by the African women who look from their corners with strong, steady disapproval while she eats. The black women, derisive and insulting, have a terrible power to objectify and negate the white child's identity: "They talked of her as if she were a stone wall. 'Look at her now!', said the Kaffir maid, 'How she eats! She's trying to devour the spoon'. . . . It hurt her so that they talked of her."[20] In Schreiner's fiction, the angry Ayah "casts a long dark shadow on the wall."[21]

The power of black women is a colonial secret. White domestic life enfolds itself about this secret, as its dreaded, inner shape. Displaced and denied, its pressure is nonetheless felt everywhere, managed by multiple rituals of negation and abasement, suffused with unease. The invisible strength of black women presses everywhere on white life so that the energy required to deny it takes the shape of neurosis. Laboring by day to uphold the white cult of domesticity, black women are shunted by night to tiny backyard *khaya's* (homes) without water, sanitation, heat or light. The furtive intimacies between black women and their white charges; the forbidden liaisons between black women and their white male employers; the fraught relations of acrimony, strained intimacy, mistrust, condescension, occasional friendships and coerced subservience that shape relations between African women and their white mistresses ensure that the colonial home is a contest zone of acute ambivalence.

Schreiner gives her African characters no agency beyond the colonial narrative. The black servants are reflector figures, casting light or shadow on the white people, their imaginations wholly absorbed in the colonial drama, assisting the white's comings and goings, bearing witness to their scenes, but never acting in their own regard. They have no family life of their own; their houses are a shadowy tumble on the edge of domesticity, marking the limits of colonial space. Their genealogies are broken; their names, like their children, are stolen from them. They facilitate plot, but only as vehicles, not as agents.

Semi-domesticated Griet, with her yellow petticoats and her clowning mimicry, embodies Schreiner's half-formed sense of the myriad forms of African women's domestic resistance. Luce Irigaray first suggested that mimicry might be a form of women's revenge. With her "small, yellow-brown Bushman face, with its touch of Hottentot," with her yellow dress and unruly ways, Griet serves in part as the parodic embodiment of domestic mimicry: "giving pretended orders to the Kaffir maids"; or howling, "covering her face with her pinafore . . . but partly peering out from the side of her pinafore now and then to see what effect her grief had."[22] In her campaign of hate against the white woman, Veronica, Griet wages a small solo war of domestic disruption, ruining the food with too much salt, putting frogs in the bath,

dropping cups, severing the garden plants at the root, "setting Veronica the cracked plate at teatime and the bluntest knife at dinner; and . . . putting a small drop of aloes into the coffee."[23]

In colonial homes, African women perform myriad such small acts of refusal: in work slowdowns, in surreptitiously taking or spoiling food, in hiding objects, in chipping plates, in scolding or punishing children, in revealing domestic secrets, in countless acts of revenge that their white employers identify as laziness, clumsiness, incompetence, gossip, and theft. In her sympathetic portrayal of Griet's rites of rebellion, Schreiner shows an astute understanding of women's hidden, domestic refusals, but Griet's resistant force is contained and diminished by her childish status, her failure to change anything and her early disappearance from the text. If Griet turns domestic colonialism into parody, she nonetheless remains a sad testimony to the need for caution against too lyrically glamorizing the subversive power of mimicry and hybridity.

While *From Man to Man* is a fiery denunciation of the traitorous cult of domesticity, Schreiner seems moved only by its impact on white women. The colonial underpinnings of slave labor and the dragooning of African women into domestic service in her white heroine's households passes unexplored. Even Griet's familial origins are buried in a throw-away comment. One of the few Africans to be named, the mischievous little Khoikhoi girl "had been got from her drunken mother a little while before for a pair of old shoes and a bottle of wine."[24] Despite Schreiner's towering indignation at the fact that "All women have their value in coins," the white sisters' intimate involvement in the coercion of child-slave labor passes unremarked and is never brought into literary focus as a moral dilemma for feminism.

It may of course be argued that anachronistic moral hindsight serves little purpose, considering the colonial context when Schreiner wrote. Nonetheless, it is worth noting that her anguished denunciation of the commodification of white women in prostitution and marriage does not extend to the domestic commodification of African women by these same white women, who escape her literary censure.

What, then, does Schreiner make of black motherhood? Despite her preoccupation with the self-sacrificial sacraments of maternity, Schreiner arranges her plots so that the two black children who are named, are removed from their (drunken, uncaring and otherwise unfit) black mothers into the hands of kindly white women. Griet scampers through the colonial plot like an elfin waif, seemingly untouched by her dramatic coercion into labor and her separation from her mother, serving merely as a vehicle for the reader's merriment and sympathy with the white heroines.

If the male colonial narrative is fatally corrupt, Schreiner seems to suggest that civilization can be redeemed through the self-sacrificial

graces of white motherhood. However, there is no room for the black mothers in her fiction; once their role in providing children for the plot has passed, they disappear without trace. The white mother, it seems, can redeem African childhood, but only at the expense of the black mother. When Rebekah adopts the mixed-race offspring of her husband's adulterous affair with their black serving girl, the black mother (who may well have resented the snatching of her child by the white wife of her white lover) is conveniently portrayed as unsympathetic, uncaring and malicious and can therefore be packed off without compunction. The mixed-race woman, or *mestiza*, throws flagrantly into question the "purity" of the oppositions of black and white.[25] Thus Rebekah's adoption of her husband's illegitimate daughter is so designed as to illuminate her spiritual largesse; nonetheless, she raises this "daughter" to call her "mistress." The child's origins remain a family secret—to the child, to her white father and to her half-sisters and -brothers. The household, like the narrative, enfolds itself about the denial of the black mother, and the idea of the maternal is fissured by race.

For all Schreiner's blistering critique of the middle-class ideology of the family, white motherhood in *From Man to Man* is rhetorically constructed as the norm. In the process, black women are elided. This elision creates an abiding paradox, for it fractures Schreiner's monism and her yearning for a universal feminism. The repression of African women disrupts the text, surfacing again in the narrative as an excess, in the unresolved form of the African women's anger. In the liminal, angry figures of African women, Schreiner's feminism finds its aesthetic and political limit.

MINES, MARKET AND MARRIAGE

In the semi-autobiographical 'Prelude,' written years later in a flash of intuition, we find almost all the obsessive themes around which Schreiner's writing would revolve. A "little mother" groans in the agony of childbirth. Abandoned in the spellbound heat of a mission garden, a child uncovers her head to the forbidden sun and makes her way to a secret place in the veld, where in a small allegory of the mother's labor of creation, she builds a tiny house of stone. There she waits for a visitation that never comes. This is an almost ritualistic moment in the colonial narrative whereby a solitary self sits alone in the wilderness waiting for communion. Bereft of response, she cups her fingers into the shape of a mouse and projects herself into an other-self, confusing the boundary of flesh and symbol, self and other and in this commerce with creativity redeems the lost moment. Returning to the house, the child crosses a forbidden boundary, climbs through a closed window and finds in the cool, dim room a sleeping child. Careful not to wake her, she

bequeaths the child her gifts: an alphabet book, a Bushman stone, a silver needle and thread, a Queen Victoria's head and a chocolate. Thereby she symbolically restores to her sister the sacred elements stolen from women: writing, history, creative labor, political power and sensual pleasure. Yet the gift-giving is aborted, for her sleep next to her sister is interrupted by the wrathful "Old Ayah," the unforgiving midwife of death and difference, who berates her for her trespass and furiously points out that the baby is dead. Returning to the veld, the girl lies under a tree, cradling in her arms a book instead of a baby and enters a series of dreams within dreams in which the eternal symmetry of the cosmos and her unity with nature is revealed to her. From the house, there comes the cry of a newborn child.

In this small parable of female creativity one finds many of the themes that would preoccupy Schreiner: her sense of exile from social community redeemed by a revelation of cosmic unity, the interdependence of women, the fluid sliding between the roles of mother and child, the allegorical association between writing and childbirth, her projection of the principle of difference onto the anger of African women and her sense of writing as a radical project of self-creation and self-justification.

At this very time, when Schreiner was beginning the lifelong task of fashioning her own identity, a new economy began to be forged in South Africa. So it is not surprising that the contradictions of her society entered her life and writings with overwhelming force.

In 1871, a surveyor's wife, while on a picnic, chanced upon a diamond, revealing at a stroke the world's richest deposit of blue diamond-bearing kimberlite. The discovery sparked the New Rush and, within a few months, thousands of frantic diggers were gouging a huge hole in the bare hillside. Next to the hole a town called Kimberley was born. From the town emerged a small syndicate of ambitious white capitalists jockeying for control of the riches. From the syndicate was formed the De Beers Consolidated Mines Company, a monolithic corporation destined to control two-thirds of the world's entire stock of diamonds. One of the most flamboyant and ambitious of these men was Cecil John Rhodes, a vicar's son from England and future Prime Minister of the Cape, who summed up the spirit of the age when he said: "I would annex the stars, if I could."

In 1872 Olive Schreiner, destined to become one of Rhodes' most famous and vexing antagonists, joined her brothers at New Rush in the pell-mell dash for the diamonds. Standing on the rim of the gaping, noisy hole, among the black diggers and their frenzied white overseers, Schreiner witnessed the beginning of a new and cataclysmic economic dispensation for South Africa.

Those who were called the "diggers" at New Rush were nothing of the kind. The diggers were white, but did no digging: the men who actually dug were black. At the same time, Africans were violently denied possession of the diamonds they dug from the earth. A law was quickly rushed into force by the white invaders: no African would ever be allowed to own, buy or sell a single diamond.

Britain, until then indifferent to the region, quickly threw its paramountcy over the territory and Lieutenant Governor Keate of Natal, supposedly adjudicating between the rival claims of the Boers and the Africans for the land, awarded the fields to a tractable man of Khoi descent called Witbooi. Without further ado, Witbooi requested and received British citizenship, whereupon the diamond fields passed immediately and conveniently into British hands. At the diamond fields in 1872, amidst the hubbub and tumult of the new history, Schreiner began to write in earnest. She was seventeen.

From about this time, Schreiner became tormented by incessant bouts of asthma. Beaten as a child for speaking out of turn, unable as an adolescent to discuss religion, politics or philosophy with her family and unable to speak to anyone about an obscure sexual calamity that befell her at this time, her lifebreath turned inwards, cheated and strangled like her words. In a sense, asthma offered Schreiner a way of voicing her voice-lessness. A form of symbolic protest, her asthma was a kind of convulsive bellowing for help. Indeed, Schreiner would often express frustration at people's inability to interpret her malady allegorically: "It's as much my mind as my body."[26] Illness features prominently in her novels, yet medical reasons are never given: illnesses are emotional affairs, physical protests against insoluble conflicts. By heaving and gasping for breath, by physically exhibiting her suffocation and voicelessness in a voice like a "rusty bellows," she was attempting to give voice to her inability to speak. A woman deprived of love, she wrote, could only live a "half-asphyxiated" life.[27]

Asthma was a portmanteau malady, rich in paradoxical meaning. It gave Schreiner a motive for mobility as well as an excuse for failure. It gave her power over people when she appeared at her most vulnerable. As soon as a relationship became stifling, asthma allowed her to pack up and leave. Asthma absolved her of the female sin of self-sufficiency, allowing her to punish herself and thus preempt the punishment of others.

WHITE ABJECTION
THE GOVERNESS AS BOUNDARY MARKER

Living among the tents and shacks of New Rush in 1872, Schreiner began to write *Undine*, a fierce rebuttal of male colonial decree and a

contorted effort to reinvent the scope of women's identity in a world mismanaged by men.

Undine, the daughter of a devout Boer family, is beset, like Schreiner, by precocious disbelief and suffers, like Schreiner, the scourge of social stigma for her temerity and tomboy ways. Militantly "unwomanly," she refuses to genuflect to convention or creed and flouts at every turn her family's dogmas and decorum. She forgets to wear her bonnet in the flaming sun, risking a dark complexion—the ungodly sign of racial and gender transgression. She scandalizes propriety by rescuing her monkey, Socrates, from a tree, enacting a small, allegorical rehearsal of Schreiner's lifelong effort to rescue the right to natural intelligence and freedom of the body for women. Yet if *Undine* is a vehement defense of female mutiny, the narrative also bears testimony to the tragic limits to women's revolt and initiates Schreiner's abiding theme of the impasse between love and autonomy.

At the diamond fields, Undine discovers that she is the victim of a perilous exclusion. Like Africans, she is barred from the white male scramble over the diamonds and the economy of mining capitalism. Denied the right to labor, land and profit, peering into the forbidden depths of the mine, she mourns: "If she had been a man, she might have thrown off her jacket and set to work instantly, carrying the endless iron buckets and coils of rope."[28] Henceforth she knows that money, public autonomy and sexual power are reserved for white men, while her allotted fare is dependency and servitude, ill health and grief and her only profession the vocation of matrimony.

Here we come at once upon the obsessive theme about which much of Schreiner's writing turns: "All women have their value in coins."[29] Throughout her life, Schreiner responded to the matrimonial trade in women and the rites of domestic dependence with loathing and fear. She insisted that domesticity was commodification and marriage was a market. As she put it, "the unenviable fate of both women and pictures is to be bought and sold by men."[30] Undine's only access to capital is vicarious: bartering her body to Albert Blair's unsavory father on condition he make over a tidy sum of money, she is seduced and betrayed by the false promise of matrimony and ends her life betrothed only to grief.

If *Undine* answers in the negative, the book prefigures the necessity of a far more incendiary, if at that moment unimaginable, revolt. In *Undine*, Schreiner was indifferent to the racial question of the plundered profits of the diamonds. Undine's rebellion is not matched by any more radical racial or class rebellion and her understanding of her social situation remains stillborn. Frustrated by her inability to express the truth of her situation, Schreiner denounced the book as unformed and incomplete and later begged Havelock Ellis to have it burned.

Schreiner herself was destined for domesticity. Denied the pulpit of her father and the political podium of her brothers and because no husband was imminent, Schreiner worked as a governess from the age of fifteen to twenty-two in colonial homes. Schreiner's early experience in domestic service gave significant shape to her later feminism, and an acute understanding of the contradiction between paid and unpaid work animates *Woman and Labor*.

As Mary Poovey has written, the Victorian governess was "like the middle-class mother in the work she performed, but like both a working-class woman and man in the wages she received."[31] She was necessary to uphold the domestic ideal of leisured monogamy, but she also threatened to destroy it. Lest her domestic loyalties be divided, she had to be unmarried. Yet an unmarried woman was an affront to nature: a temptation to men, a threat to wives, a danger to herself. In intimate liaison with her charges, she was obliged to appear asexual. Like a lady, yet not a lady, like a maid, yet not a maid, she was tasked with presiding over the contradictions of the domestic sphere as if they were a decree of nature. Small wonder that the governess was widely perceived as a social problem.[32] In the colonies, to compound matters, the starched white governess stood between wretchedly paid black women and privileged but unpaid white wives, mediating acute social differences within a common identity of labor. In the colonial family, the fractures in the domestic scene became severe.

The colonial governess was in every sense a threshold creature. Graced with an education, she did not have the opportunity to use it. Racially a member of the white elite, she was in reality a member of the serving class. She was protected by racial privilege but not by economic security. She lodged among black servants, but not with them. She was paid for work, which the housewife did for free. All in all, the white governess embodied some of the most abiding contradictions of the colonial economy of female labor. In this sense, the white governess, like the African maid, is an abjected figure: rejected but necessary, the boundary and limit of domestic colonialism. But the historical abjection of the white governesses is played out differently from the abjection of black women, in such a way as to throw into question any appeal to abjection as an invariant universal.

In March 1875, at the age of twenty, Schreiner took a position as governess in the Fouche family on a remote farm in the Karoo called Klein Ganna Hoek. There she lived in a single mud-floored room under the roof of the kitchen, washing in the cold water of a nearby stream. The roof of her room leaked, so she sat under an umbrella, scribbling and jotting, and it was there at Ganna Hoek, in the stolen, exhausted hours after work, that she wrote most of what would eventually be called *The Story of an African Farm*.

The Story of an African Farm is a towering denunciation of the unholy trinity of empire, family and God—the three grandiose illusions that had graced Schreiner's infancy with their radiance, only to become the traitorous figures of her despair. The animating vision of the book is the failure of the cult of progress and the Family of Man to keep their promises, and the radical significance of the book lies in Schreiner's conviction that a critique of the violence of colonialism also entails a critique of domesticity and the institution of marriage.

From the outset, the colonial farm is figured as pathological. The colonial family is in disarray. The failure of filiation is everywhere apparent. The white father has vanished, lingering only as an obsolete afterimage in the figure of Otto, the quixotic, dreaming German overseer modeled on Schreiner's own father, who is soon to die, unable to bequeath to the future the patrimony of paternal authority or to redeem history. There is no mother. The household is presided over by a grossly animalistic and monstrous aunt, Tant Sannie, a deformation of maternal power. Lyndall is an orphan, Waldo a disinherited son. Although Schreiner offers no explicit critique of the white ownership of the farm, it is clear that there will be no legitimate colonial heir to the future. The movement of the plot is flight: from the patriarchal house and the economy of colonial agriculture. Waldo flees to the coast and Lyndall flees to the mines, but the ultimate destination is death. Neither marriage, empire nor God can redeem the colonial narrative.

The Story of an African Farm begins, like many of Schreiner's allegories, pitched under a midnight moon, a complex symbol of the uncertain half-light of transcendence. The moon promises but does not ensure redemption, casting its eerie radiance over the ostrich farm, which lies under the rule of sleep. Waldo, son of the hapless Otto, lies awake in the wagon-house, swathed in solitude, listening with dread to the clicking clock. The clock is a repeated motif in Schreiner's tales: almost all of Schreiner's children lie in the dark, spellbound by fear of the clock's metronome, measuring time with death: "Eternity; eternity; Die! Die! Die!"[33]

For Schreiner, the clock is a grotesque fetish of Victorian industrial progress: mechanical, mundane, deadly. If male colonials extolled the redemptive fetish of clock-time, for Schreiner the missionary bell tolls death; the clock, like the multiplication table, the ancient arithmetic, the Latin grammar, offers only the cold algebra of reason. For Schreiner, the colonial fetish for rational time and progress is a macabre aberration of the spirit. The soul, however, "has seasons of its own; periods not found in any calendar." The singular struggle of Schreiner's novel, indeed the struggle of much of Schreiner's life, is to render an alternative, redemptive calendar of the soul.

FEMALE ALLEGORY IN THE RUINS OF HISTORY

It is not surprising that Schreiner preferred the literary form of allegory. All her writings are allegories: "Except in my own language of parables I cannot express myself."[34] All her plots are interrupted by allegories, parables and dreams that flash their crystalline uncertainties like prisms, refracting themes and images in myriad directions and dispersing their irregular radiance slantingly across the linear progress of plot. From the outset Schreiner wanted her writing to imitate the unpredictable disorder and imprecision of life: "the method of life we all lead. Here nothing can be prophesied. There is a strange coming and going of feet. Men appear, act and react upon each other and pass away." [35]

Waldo, like Schreiner, is afflicted with insomnia of the soul. For Waldo, as for all allegorists, the world is the word made flesh: "Has it never seemed to you that the stones were *talking* with you?" In the beginning was the Word and nature is the book of God, a divine script destined to be read by visionaries and poets. Nature is the "open secret." The fossil footprints of great birds, the skeletons of fish, the filaments of a spider's web are miniature allegories of an unchanging reality that animates all things: "All true facts of nature or the world are related." Under the allegorist's gaze, the varied and multitudinous forms of life dissolve into a many-colored, many-shaped singular form of existence: the thorn tree sketched against a midwinter sky has the same form as the tracery of crystals in a rock, which has the same form as the beetle's tiny horns. The human body, too, is a hieroglyph, offering hints and intimations of divine meaning. The underlying unity of all things is revealed in this beautiful similitude of form: "How are these things related that such deep union should exist between them all?"[36]

For Waldo, books, like nature, reveal "the presence of God." Books offer the delirious, imperial promise of knowing the final secrets of the world: "why the crystals grow in such beautiful shapes, why lightning runs to the iron, why black people are black." Books offer Waldo, as they did Schreiner, a refuge from cosmic abandonment and the scourge of loneliness; books reveal men and women to whom not only "kopjes" and stones were calling out imperatively, "What are we and how came we here? Understand us and know us," but to whom "the old, old relations between man and man . . . could not be made still and forgotten. . . . So he was not alone, not alone."[37]

Yet, as Walter Benjamin has intimated, allegory is always shadowed by its dark side.[38] The allegorical vision is guaranteed by an occult faith that the relation between words and things is cosmically ordained. Yet the allegorical project is inherently ambiguous. *Allegory* has its etymological origins in the Greek words *allos* and *agoreuei*: to speak in public of other, or

secret, things. Allegory's power is precisely this doubleness; it speaks to the chosen few of secret truths and conceals them from the profane. All allegories involve a doubling or even multiplying of a text by another. "Art," as Schreiner put it, "says more than it says." Yet, allegory, as a result, is paradoxical and perilous, its ambiguity always threatening to undermine its intelligibility. When Tant Sannie finds Waldo's book on political economy, his precious "pollity-gollity-gominy" is unintelligible to her, and she feeds it to the bonfire.

Hence the tragic quality of allegory. "Words are very poor things."[39] Oblique and strangely incomplete, with its origin in exegesis, allegory both solicits and frustrates the desire for original meaning. Words are the sacred emissaries of truth, but they are never fully adequate to their burden and thus both illuminate and obscure meaning: "If I say that in a stone, in the wood, in the thoughts of my brain, in the corpuscles of a drop of blood under my microscope, in a railway engine rushing past me in the veld, I see God, shall I not be darkening counsel with words?"[40]

Allegory, moreover, lies on the cusp of memory and forgetting; pointing beyond itself to an originary history that at every moment threatens to vanish. In Walter Benjamin's words: "An appreciation of the transience of things and a concern to rescue them for eternity is one of the strongest impulses in allegories."[41] Here we come directly upon one of Schreiner's central motivations to write: the desire to rescue history, the flesh and language from oblivion—her cry "not to let the thing die!" Language was a passionate rebuttal of the intolerable enigma of death and the inevitable process of dissolution and decay. Allegory offered Schreiner the promise that language could redeem matter—as she believed as a child, talking for days into her dead sister's grave. Hence Schreiner's entirely modernist fascination with ruins, with the breathing dead, the interred living. As Lyndall remarks darkly in *The Story of an African Farm*: "Not all that is buried is dead."

Yet, for Waldo, "writhing before the inscrutable mystery," such intimations of immortality are repeatedly imperiled by the catastrophic possibility that all is illusion: "no God! not anywhere!" Wandering clumsy and ragged in the veld, he scans the stubborn sky and sand for signs of God, yearning "for a token from the inexorably Silent One." Here Waldo rehearses a recurrent, almost ritualistic moment in colonial narratives, in which the solitary self, standing dumbfounded before an inexpressible landscape, cries out "This *I*, what is it?" "For an instant our imagination seizes it; we are twisting, twirling, trying to make an allegory. . . . Then suddenly a loathing comes to us; we are liars and hypocrites." That man in the pulpit lies! The brass-clasped hymn book lies! The leaves of the Bible drop blood; the stones do not give voice to God.

Waldo's crisis, which Schreiner figures as the existential crisis of the universal soul, is more properly speaking a crisis of colonial legitimacy. The sorrow of finitude that haunted Schreiner is a peculiarly colonial predicament. The colonial intruder who cannot find words to fit the landscape stands in a world gone suddenly quiet. The effort to give voice to a landscape that is felt to be unspeakable because it inhabits a different history creates a deep confusion, a kind of panic, which can be warded off only by adopting the most extreme of defensive measures. A colonial culture, as Dan Jacobson has said, "is one which has no memory."[42] Cut off from the metropolis and arrogantly ignorant of indigenous culture, estranged from all tradition, the colonial is marooned in a time bereft of history. Allegory, for Schreiner, expressed the hope of redeeming history and the will to remember; it was a stratagem against oblivion. Yet at the same time, her imperial faith that a singular universal meaning animates the world, that the radiance of a "naked simplicity" imbues the colonial landscape with intelligible form, also confirms the degree to which, despite herself, she was still a colonial writer.[43]

DOUBLE CROSSINGS
THE IMPERIAL METROPOLIS

For seven years Schreiner worked as a governess in colonial homes. Then in 1881, she left South Africa for Britain, to fulfill her long desire to be a doctor. From childhood, Schreiner had shared her mother's thwarted ambition to enter medicine: "I could not remember a time when I was so small that it was not there in my heart." As a child in the veld, she dissected the crimson hearts of ostriches and sheep, unfolding their sacred centers "with a startled feeling near akin to ecstasy." The scarlet, lacy filaments and mysterious chambers of blood yielded intimations of infinity and the allegorical promise that "In the center of all things is a Mighty Heart."[44]

If part of Schreiner's ambition to be a doctor flowed from her imperial desire to penetrate to the heart of the universe, it also flowed from a stubborn determination to redeem her mother's disappointed life. Thus Schreiner took her place in women's historic attempt to reclaim the traditionally female skill of healing, so violently wrenched from them in the centuries before. Medicine offered Schreiner the hope of reconciling the conflict between her imperial and (conventionally) male "impulse to span the infinite" and the (conventionally) female activities of duty, service and compassion.[45] Becoming a doctor, she hoped, could satisfy her "hunger for exact knowledge of things as they are,"[46] and at the same time rescue her from the guilt of her intelligence. "A doctor's life is the most perfect of lives; it satisfies the craving to know and also the craving to serve."[47]

In South Africa, however, the medical profession was jealously closed to women and black men. In Britain a medical college had recently opened its doors to white women, so in 1881, at the age of twenty-six, Schreiner reversed the trajectory of her mother's life and traveled back to the metropolis, carrying with her two completed manuscripts: *Undine* and *The Story of an African Farm* and an unfinished work called *Saints and Sinners*.

The years Schreiner spent in Britain (1881–1889) were momentous ones. Social crises of shocking magnitude were reverberating throughout the country and its colonies. The land crisis loomed, as economic power passed from the ancient gentry to the desks of manufacturers and mining magnates. Vast industrial fortunes were made in the great shipyards and belching mills, while mass unemployment and strikes, the diseases of poverty and the Great Depression, signaled a profound crisis in class relations. The first socialist party, the Democratic Federation, was formed in 1881, the same year Schreiner arrived in Britain.

The class crisis was matched by an acute crisis in gender relations. Mutinous women were crowding and buckling the doors of male privilege. For decades, working-class women had militated for fairer working rights and conditions. Now middle-class women were clamoring for better education, the right to paid work, the right to the franchise. The Married Women's Property Act was passed in 1882, the Guardianship of Infants Act in 1886 and women won the right to divorce in France in 1884. The "New Woman" became for many men a deeply feared and derided figure, emblematic of social chaos and misrule.[48] Masculinity itself was under contest, with the discovery of the Cleveland male brothel in 1889, the trial of Oscar Wilde in 1895 and the pathologizing of homosexuality. Ruling-class men lashed back, rioting at Cambridge to oppose women's admission to the brotherhood and voting overwhelmingly at the Oxford Union against the admission of women to the BA degree in 1896. The police drove their horses against the suffragettes, who were arrested, beaten and violently force-fed in the prisons. Gladstone opposed the amendment to the Reform Bill that might have granted women suffrage, and the franchise became a dead issue until 1905.

The metropolitan calamities were compounded by crises in the colonies: sporadic rebellion and chronic agrarian unrest in Ireland, the upheavals in the Caribbean, the aftershocks of the 1857 Rebellion in India and the ignominious defeat of General Gordon by an Islamic fundamentalist at Khartoum in 1885. The Great Depression coincided, not accidentally, with the rise of the new imperialism. In 1886 gold was discovered in South Africa. That same year, the heads of the European powers sat down at a table in Berlin and carved up Africa among them; not one African leader was present.

In 1883, *The Story of an African Farm* was published under the pseudonym Ralph Iron, to instant acclaim. The obscure colonial governess became one of the most sought-after intellectuals of her time. Gladstone sent his congratulations; George Moore and Oscar Wilde were eager to meet her; Edward Aveling reviewed the book favorably in *Progress*; Rider Haggard praised it as among the most meaningful of the age; Sir Charles Dilke, the politician, compared it with *Pilgrim's Progress* and a Lancashire working woman voiced its importance for women: "I think there is hundreds of women what feels like that but can't speak it, but *she* could speak what we feel." Hugh Walpole declared it marked an epoch "as scarcely any other book can do."[49]

Schreiner was soon invited to join the elite coterie of the Men and Women's Club. Karl Pearson, famous eugenicist and enthusiast of empire, founded the club in 1885, inspired, it seems, by both matrimonial and scientific ambitions to gather about him an assemblage of socialist and feminist intellectuals. The club's aims were to discuss, without emotion or prurience, the great sexual issues of the time: prostitution and pornography, marriage and monogamy and, above all, the vexing and inevitable "Woman Question." The women of the club were mostly middle-class philanthropists and reformers, single, demure and a trifle intimidated by the overbearing men. The men were tweedy Oxbridge types who moved easily between the old-boy enclaves of the aristocratic clubs and the radical Bohemia of London's avant-garde. By and large, the club was elitist in its atmosphere. The odor of cigar and port and the faded perfume of philanthropy hung about its discussions, despite its revolutionary agenda and scandalous topics. In this decorous Victorian setting, with its pretensions to rational sobriety, Schreiner's loud gestures and extravagant voice, flashing eyes and passionate tirades disquieted some of the more primped and coiffured members, who privately patronized her as a colonial upstart who had lived too long among "coarse and brutal natures." "A lot of old maids and manhaters," she called them.[50]

The privileged language of the club was Darwinism. The object was to discover the precise and scientific nature of women's role in the evolutionary advancement of the race and to bring the alarming feminist upheavals under male scrutiny and guidance. Feminism was seen as the maidservant of evolution, necessary but dangerously fickle. Women's proper vocation was service to the species, their rights secondary to their duties: "We must first . . . settle . . . what would be the effect of her emancipation on her function of race reproduction before we can talk of her rights," Pearson proclaimed grandly.[51] Schreiner, unused to Victorian restraint, was quick to criticize Pearson's condescension and inconsistencies. Women, as Schreiner rightly noted, were seen by the male club

members as the objects, not subjects, of study, while male sexuality was a natural given. The male insistence on the language and "revealed truth" of science shrouded the men's own imprecisions, their vested interests and unconscious desires. Charlotte Wilson likewise scolded Pearson roundly for his entirely unwonted assumption that women's lusts were less than men's. Women's chastity, she argued, was "a hard battle," enforced by male society and won only at the cost of extreme toil. Nevertheless, Schreiner's frank independence of mind did not prevent her from developing an equally frank but calamitous passion for Pearson. A cold fish by all accounts, Pearson was bent on keeping his fixation with female sexuality under the wraps of scientific pretension. Obsessed with race survival and scathingly scornful of the female "shopping dolls" of the middle class, he publicly advocated female sexual power, but was clearly unmanned in reality by passionately sexual and intellectual women. Schreiner's relationship with Pearson became increasingly unsteady; he rebuffed her advances with characteristic iciness and she left the club in emotional disarray.

Nonetheless, the club offered Schreiner an unprecedented arena for enriching and expanding her ideas on women's sexuality and labor. During these years she wrote many of the dreams and allegories that would be published in *Stories, Dreams and Allegories*. At this time, she also worked almost continuously on *From Man to Man*, the novel in which she gave fictional form to the twin obsessions about which much of her writing revolves: marriage and prostitution. This was the book of her heart: "I love it more than I love anything in the world, more than any place or person."[52] Dedicated to her dead baby sister and later to her own dead daughter, *From Man to Man* is an impassioned homage to women. "The most womanly book that ever was written," as Schreiner wryly put it, the novel is "the story of a prostitute and of a married woman who loves another man and whose husband is sensual and unfaithful."[53]

PROGRESS AND THE FAMILY OF MAN

Set in colonial South Africa and London, *From Man to Man* is a radical rebuttal of the presiding tenets of late Victorian and colonial society: evolutionary Darwinism, the imperial ideology of racial and gender degeneration and the bourgeois Victorian institution of the sexual double standard. The thematic center of the book is the dialectical relation between monogamy ("for women only," as Engels put it) and prostitution (for men only). In this fictional account of two sisters, one wretchedly bound in marriage to a careless philanderer, the other a prostitute, Schreiner adamantly refuses the Victorian dichotomy of Madonna housewife and

whore. For Schreiner, like Engels, the matrimonial trade in women's bodies was the "crassest prostitution" and marriage without love "the uncleanest traffic that defiles the world."[54] At the same time, prostitution was a source of unceasing grief and anger for her. The singular outrage was that the professions of marriage and prostitution were well-nigh the only vocations open to the majority of women.

Born into the luxuriant beauty and torpor of a Cape colonial farm and hungering restlessly for knowledge of the world, Rebekah can attempt to escape the inertia of her parents' colonial life only through marriage. In Cape Town her husband indulges in a careless round of amorous affairs with their African maidservant, actresses, pimply schoolgirls and respectable matrons. Rebekah is forbidden the balls and parties, lest she discover her husband's infidelity and attempt to do the same. The novel is a scorching, grief-stricken indictment of the lethal tradition of the sexual double standard. Baby-Bertie, Rebekah's sister, is seduced by her beloved tutor, who immediately bolts for Europe, and when she confesses this indiscretion to her fiancé, she is again summarily abandoned. As in *The Story of an African Farm* the movement of plot is flight from the family and social constraint. Bertie escapes to her sister in Cape Town, where she becomes the pretty darling of society until a jealous socialite discloses her shame to the world. Ostracized and vilified, she takes up with a wealthy Jew, who sets her up in a boudoir before throwing her to the streets and a life in prostitution.

From Man to Man bitterly condemns the suffocation of the female intellect in matrimony. Immured in the matrimonial house, Rebekah is encaged in her tiny closet of a study; her writings dwindle to a trickle of fragments and outlines. Muffled in the torpor of maternity, she is condemned to soliloquy. Neglected and alone, pacing feverishly in her airless study, she expounds the same creed of cosmic monism that sustained Schreiner through the blank atheism of despair: "Rebekah is me; I don't know which is which anymore."[55] In the central allegorical chapter, Rebekah ventriloquizes Schreiner's challenge to the "old Christian conception" of the universe as the creation of a single, male "individual Will," capricious and violent, capable on a whim of reducing the "shreds and patches and unconnected parts" of existence to nothingness. Refusing to be the figment of a single, male mind, Rebekah offers an alternative vision of cosmic unity: the sheen on a bird's feather, the tilt of the planets, the rainbow lights in a crystal all partake of the great universal life. The prism flings light on the sun; the fossil illuminates the structure of the hand that holds it. Every fragment is a tiny allegory of the whole truth, enigmatic yet redolent with meaning.

Yet here we come upon the familiar paradox in Schreiner's vision. Rebekah finds phantasmagoric solace for her very real social alienation by projecting onto the "great, pulsating, always interacting whole" of the

285

universe the hope of metaphysical communion. The problem of social community is thus deferred and postponed and her historical, gendered travail is rendered as a universal condition of the human soul. The book initially poses marriage as a social problem, then displaces the dilemma of female community onto the metaphysical realm. As a consequence, no social solution to the problem of marriage is offered.

Schreiner's critique of the Victorian institution of matrimony was fundamentally economic. As she saw it, marriage in its present form was a "barbaric relic of the past," but she was always baffled when people reviled her as an advocate of free love or radical promiscuity. On the contrary, she protested, from the age of thirteen she had held the view that the only ideal was "the perfect mental and physical life-long union of one man with one woman." True marriage—a sacred and deathless thing—was a mutually contracted monogamy. "No kind of sex relationship can be good and pure but marriage."[56] The legal and ceremonial aspects of marriage, however, were "a mere bagatelle."[57] True marriage was a question of mutual mental, spiritual and erotic fulfillment. But the Victorian institution of marriage as it stood was no more than the symbolic and contractual surrender of a woman's sexual, property and labor rights into the hands of a man. As a result, it was deeply inconsistent with women's freedom and Schreiner herself feared she could never marry under such a system: "If I am to live I must be free."

The fundamental issue was economic. A true marriage, "the most holy, the most organic, the most important sacrament of life," should be entirely "independent of monetary considerations." "The woman should be absolutely and entirely monetarily INDEPENDENT OF THE MAN."[58] Without economic independence, women had no power and no form of redress. Here Schreiner went beyond the emergent feminist critique of marriage, which tended to focus on sexual and emotional exploitation. Unlike most Victorian feminists who came from comfortable middle-class homes, Schreiner's own class background was so contradictory and her economic situation so precarious, that she was more aware than most that the real issue was "the sex purchasing power of the male."

Schreiner was most vehement in her denunciation of the paucity of professional options available to women outside of marriage. To those who argued that women were free to choose not to marry, she retorted, as Lyndall does in *The Story of an African Farm*: "Yes—and a cat set afloat on a pond is free to sit in the tub till it dies there." Lyndall, who refuses to marry without true love, is forced to iron and wash men's shirts for a pittance until she starves to death. To those who argued that women did not want independence, she retorted: "If the bird does like its cage and does like its sugar and will not leave it, why keep the door so very carefully shut?"

At the same time, Schreiner was almost alone among her contemporaries in insisting that women's sexual needs are as urgent and compelling as men's. Women's desires were laced and corseted, crimped and curtailed, while men were given privileged access to prostitution, the marriage market and the double standard. For a woman, unlike a man, premarital or adulterous sex was fraught with punitive dangers. In a world without dependable contraception or legal, safe abortion, "a woman's character is like gossamer."[59] If a woman bartered her virginity outside the matrimonial contract, she was seen by God and the world as having squandered forever her moral and social credit. Bertie having spent her virginity, has no recourse but to become a "kept woman," languishing in opulent ease among the scarlet cushions and chandeliers, the ornamental kittens and ribbons of the Jew's apartment, prone to ennui and weeping fits. The radical thrust of the book, however, is that Bertie's luxurious confinement and Rebekah's martyred solitude are merely different kinds of prostitution. Indeed, Bertie's strange, rich laugh at the end hints at a fate more free and vital than the suffocating tedium of her velvet jail.

The second related theme of *From Man to Man* is prostitution. "All other matters seem to me small compared to matters of sex and prostitution is its most agonizing central point."[60] Prostitution held a lifelong fascination and horror for Schreiner. She identified very deeply with prostitutes themselves. At one level, they figured for her as the mirror projection of her own sexual guilt: she clearly felt she had prostituted herself with Gau and her fictional portrayal of Bertie's social ostracism and frantic flight from social shame was a semi-autobiographical attempt to exorcise the trauma of Schreiner's own feelings of ostracism following the Gau fiasco. The novel offers thereby some insight into Schreiner's own incessant patterns of flight.

Yet it is Schreiner's distinction that, almost alone of her contemporaries, she gives prostitution a social history. *From Man to Man* is a massive refusal of the dominant Victorian stereotype of prostitution as a genetic flaw, an atavistic regression and racial pathology of the body politic. Schreiner locates prostitution historically alongside the institution of monogamous matrimony and the fetish of virginity. "The man with the long purse" has the buying power; women are driven by economic duress into bartering their sexual services for profit.

In her obsession with prostitution Schreiner was very much a Victorian. Until the 1850s the widespread tolerance of prostitution was reflected in the absence of any serious legislation to curtail it. But from the 1850s onwards, a discourse on sexuality and venereal disease entered parliamentary debate with great heat and ferocity and became ever more deeply informed by constructions of race, gender and imperialism. In the 1860s the notorious Contagious Diseases Acts were passed and were only

repealed after a national avalanche of protest. The Acts were designed less to abolish prostitution than to place control of sex work in the hands of the male state. The initial impetus came from the recent blows to male national self-esteem in the arena of empire. The argument ran that the real threat to the prowess and potency of the national army lay in the syphilitic threat that prostitutes supposedly posed to the genital hygiene of the army. If women who served the garrison towns could be forcibly examined and cordoned off, the purity of the army and of respectable middle-class patrons could be assured. The Acts therefore gave police the right to forcibly impose physical examinations, registration and incarceration on working-class women thought to be working as prostitutes in designated garrison and naval towns. At the same time, the regulation of sexual behavior served as a means of policing the unruly working-class population at large.

In 1885, a few years after Schreiner arrived in Britain, W. T. Stead set London aflame with his lurid revelations about child prostitution, published as "The Maiden Tribute of Modern Babylon."[61] Stead's tales of hapless virgins entrapped by lascivious aristocratic roues gave middle-class women a language in which to express for the first time the sexual distress, frustration and secret terrors of Victorian marriage. As a result, the prostitute became the projection of middle-class anxieties and hypocrisy. Prostitutes' own voices, lives, motives and powers were swept away in the electrifying storm of middle-class outrage and voyeurism.

Schreiner was all too Victorian in that prostitutes figured in her writings as objects of grief and rage. Like many Victorian women, she had virtually no knowledge of prostitutes' real lives, and her identification with them, intense and heartfelt as it was, served as a projection of her own very real sense of sexual exploitation and vulnerability. Like most Victorians, she saw prostitution as a reflex of male sexual needs, and it never occurred to her that sex work could also be a form of resistance to patriarchal control in the family and marriage, as well as to economic distress and social immobility. For many women prostitution was preferable to marriage and expressed a stubborn refusal of precisely the "sex-parasitism" that Schreiner condemned in the marriage of convenience.

Certainly, Schreiner was never able to resolve satisfactorily the tension between her feminist and socialist understanding, on one hand, with her Spencerian faith in a cosmic unity and design governing the universe, on the other. For the remaining span of her life, Schreiner carried the manuscript of *From Man to Man* about with her, working and reworking the remarkable book, able neither to finish nor abandon it. In the same way that she carried the small white coffin of her dead baby with her, unable to entrust it to the earth, she couldn't entrust "this greatly loved offspring of her mature mind" to the public.[62] Closure

eluded her and she died with it unfinished. As was only fitting, the scandalous, incomplete book was published posthumously; for, as Lyndall says in *The Story of an African Farm*: "We can say things to the dead that we cannot say to the living."

By the middle of 1889, Schreiner had made up her mind to return to South Africa. In 1886 gold was discovered in the Transvaal. A year before, Rhodes had formed the De Beers Consolidated Mines Company and in 1889 he received a charter from the imperial government to operate in Rhodesia. In October that same year, Schreiner set sail for South Africa.

WOMAN AND LABOR

The country was brewing for war, though few besides Schreiner could see it. Schreiner settled in the lonely town of Matjesfontein. There she formed the habit of meeting traveling politicians on the station platform to engage in deep conversation before the train departed. There, too, she began a series of brilliant and prophetic articles on South African political life, later collected in *Thoughts on South Africa*. In 1892, Schreiner met Samuel C. Cronwright, a farmer and former member of the Cape Parliament and married him two years later. He was priggish and pedantic, yet every inch the colonial male. Schreiner was clearly the dominant party, obliging Cronwright to leave his beloved farm and move to Kimberley on account of her asthma. In 1895, at the age of forty, she gave birth to her longed-for baby girl. The child lived only until morning, to Schreiner's lifelong and unstaunched grief.

The baby's death coincided with national crisis. Afrikaner agitation against British maneuvers in the Transvaal began to swell. Schreiner and Cronwright publicly denounced the incipient capitalist and Afrikaner Bond brotherhood and condemned Rhodes' African policy of dispossession, a brutal policy neatly summed up in his frank admission: "I prefer land to natives." Schreiner vehemently opposed the Flogging Bill, for which Rhodes voted: "Edward," she wrote to Edward Carpenter, "you don't know how bad things are in this land; we flog our niggers to death and wealth is the only possible end and aim in life."[63]

In 1895 she and her husband wrote *The Political Situation* — a Cassandra document that cried out presciently, if fruitlessly, against the "small and keen body of men amalgamating into rings and trusts" who were quickly settling "their hands round the mineral wealth of the country." In 1899 Schreiner published her antiwar pamphlet, *An English South African's View of the War* and delivered speeches as part of the women's protest movement in the Cape.

Schreiner did everything she could to alert the public in Britain and South Africa to the impending calamity. She sent cables, held interviews, attended congresses against annexation and suffered a heart attack under the pressure. During the war, at women's congresses, she vehemently protested the British burning of the Boer farms and the infamous concentration camps into which the British herded Afrikaner women and children. Schreiner was by all accounts an incendiary public speaker — when she spoke, as one record had it, "she was transfigured into flame."

The thrust of her great prose collection, *Thoughts on South Africa*, is a fiercely protective defense of the Boers. Having lived among the Afrikaners as a governess, she had "learned to love" them, particularly the Boer woman, who was "the true citadel of her people."[64] She voiced her admiration of Boer women in the language of the international women's movement, praising their rugged strength and labor and urging them never to give up their wagon-whips and white caps for croquet mallets and hats with paper flowers: "The measure of its women is ultimately the measure of any people's strength and resistile power."[65] Although, she wrote, the Boers had admittedly been cut off from the Enlightenment, they were also untouched by the "god of commerce." In her paeans to the Boers, Schreiner refused the dominant British stereotype of Afrikaners as a racially fallen, idle and degenerate race, but her arguments were riven by a fundamental flaw. In her sentimental fidelity to the besieged Boers, she represented the war as an agon between two white cultures and the fundamental issue of the preeminent African claim to the land and minerals went for the moment ignored. The Afrikaners were ferocious racists and their labor practices were by and large appalling. Yet Schreiner was uncritical of the Boer Republics until after the war, when she saw them coming to power and no longer felt they needed her protection: "It is the Boers who are top dog now."[66]

While the Anglo-Boer War was shaking the country, Schreiner wrote her great prose work, *Woman and Labor*. She had begun a book on the "Woman Question" in her youth, despite her isolation from any feminist inspiration. Motivated only by her own precocious sense of gendered travail, she had set herself the task of uncovering the historical clues to the "hidden agony" of her life. In all the decades that followed, she worked continuously at this monumental "sex book," until 1888, when she had only the last division to complete.

The first thing to note about the "sex book" is the sheer immodesty of its scope. Like Engels' *Origin of the Family, Private Property and the State*, the book was frankly audacious in its attempt to embrace the whole of human history in a grand global schema. Borrowing its form from the *Bildungsroman* and the narrative of evolution, the book attempted to chronicle the

epic unfolding of the world historical condition of women. Beginning in prehistory, the narrative traced the shambling climb of humanity from the viscid, ameboid night through the tumultuous centuries into the rattle and glare of industrialism.

The second feature to note about Schreiner's "sex book" is that almost none of it survives. The introduction to *Woman and Labor* is a truncated requiem to the lost labor and the lost years. In 1899 Schreiner left Johannesburg because of ill health. Two months later, the Anglo-Boer War broke out and martial law confined her to the Colony. In her absence, British soldiers broke into her study, forced open her desk and lit a bonfire in the center of the room with all her papers. When she returned, the great intellectual labor of her life was a bundle of charred and blackened scraps that fell to ash as she touched them. She had no copy.

Some months later, interned by the British for her pro-Boer sentiments in a house on the outskirts of a village, surrounded by armed guards and a high barbed-wire fence, forbidden reading material or news, Schreiner resolutely forced her thought "from the horror of the world . . . to dwell on some abstract question" and rewrote from memory one chapter of the larger book of twelve. Published as *Woman and Labor* in 1911, the chapter was a broken shard of the original monument, yet it was hailed by many prominent feminists of her generation as the "Bible of the Women's Movement."

The circumstances of the writing of *Woman and Labor* bear tragic testimony to the gist of its argument. Incomplete and mutilated, radical and incendiary and, above all, stubbornly and triumphantly rebellious, the book amounted to a miniature allegory of her life. Condemned to labor in the shuttered dark, forbidden consort with the public world of news and history, surrounded by the male technology of violence, Schreiner's life and labor were subject to the disfiguring violence of male imperatives.

The fundamental point of the book is the attempt to give women's labor and women's subjection a social history. Schreiner dismantles the popular notion of women's subjection as universal, natural and inevitable. The stories of women's disempowerment and revolt are historical and political: the lessons of gender are not written immemorially in the blood. Moreover, women have power and women resist; they are not the mute and passive sufferers of victimization. But the effects of and potential for resistance take different forms in different social moments and are shaped by the enabling conditions of the time.

For Schreiner, rifling through the ancient and modern tomes of biology and science, medicine and botany, the lesson of evolution was that "sex relations may assume almost any form on earth." In the majority of species, she argued, the female form exceeds the male in size and often in predatory nature. Nor are parenting tasks inherently female in nature.

Contrary to the dominant Victorian notion that saw the male hunter as the herald of history, Schreiner gave women historical agency, offering the life-giving mother, who, carrying both child and fodder, stood erect to take history forward. Nonetheless, Schreiner never fully threw off the evolutionist mantle. As she saw it, the custodian of progress is "ancient Mother nature sitting as umpire." Here the familiar contradiction emerges: she debunks the ancestral opposition between a male culture and female nature, but then reinvents history as presided over by a beneficent and natural female force.

Woman and Labor has been best remembered for Schreiner's analysis of women's labor and the condition of "sex-parasitism" to which many women were then condemned. The fundamental voice of the book is the imperative: *"Give us labour and the training which fits for labour!"*[67] Schreiner demanded that all labor be opened to women, and that women reclaim their ancient economic power. Henceforth, there was no fruit in the garden of knowledge that women were not determined to eat.

> From the judge's seat to the legislator's chair; from the statesman's closet to the merchant's office; from the chemist's laboratory to the astronomer's tower, there is no post or form of toil for which we do not intend to fit ourselves.[68]

Moreover, contrary to Victorian dogma, women had always worked: "We hoed the earth, we reaped the grain, we shaped the dwellings, we wove the clothing, we modeled the earthen vessels."[69] In the now famous slogan of the feminist movement: "Women have always worked; we have not always worked for wages." As herbalists and botanists, women were the "first physicians of the race." As childbearers, they bore the race on their shoulders. But as society progressed in technical skills, she wrote, men no longer spent their lives in fighting and returned from the hunt to invade the women's realm. The spinning wheels were broken, the hoes and grindstones were taken from women's hands, the rosy milkmaids vanished. Women's "ancient field of labor" shrank and they were condemned to a passive and incessant "sex-parasitism" upon the male.

Yet there are points where Schreiner's sense of historical agency is uncertain. She does not question the gendered division of labor between hunting and agriculture, nor does she offer a systematic theory of historical change. No reason is given why men should want to wrest economic control from women, nor why they were able to. Beyond a vaguely Spencerian notion of inevitable progress, Schreiner lacks a theory of gender conflict and a theory of historical change.

Nonetheless, Schreiner's radical challenge was to oppose the doctrine of separate spheres and the emergent Victorian image of the idle woman. She denounced Victorian middle-class hypocrites who opposed women's waged work because of their role as "Divine Childbearer" yet felt no anguish for the "woman who, on hands and knees at ten pence a day, scrubs the floors of the public buildings." For the Victorian male, she noted, "that somewhat quadrupal position is for him truly feminine."[70] Such men were not disturbed by the old tea drudge bringing them tea in bed, but rather by the woman doctor with an income who spent the evening smoking and reading. Schreiner's insight here is into the class hypocrisy of the objection to women's work: men only wanted women exiled from the prestigious, powerful and profitable realms of labor. As Lyndall cries in *The Story of an African Farm*, "When we ask to be doctors, lawyers, lawmakers, anything but ill-paid drudges, they say, No."

Schreiner's fierce indignation was directed also at the systematic inequities of women's recompense for "equal work equally well performed." She was unusual among feminists for her recognition, born from the contradictions in her own class background, that the idleness of middle-class women depended on the vast, invisible labor of working-class women, both black and white. "Domestic labor, often the most wearisome and unending known to any section of the human race, is not adequately recognized or recompensed."

She was also exceptional in her insistence that women's sexual needs are as powerful as men's. Yet here, too, Schreiner's arguments are ambiguous, for she deplores the ravages of celibacy, yet also sees sex as a sacred sacrament, properly taken only within monogamous love. Yet, in a world lacking anything close to reliable contraception; where abortion was a grisly, agonizing and often fatal last resort; where loss of virginity outside of marriage carried, as she well knew, a catastrophic social stigma, Schreiner knew that women were condemned to a social situation in which they could not take sexual control. The material conditions were not yet present for a fundamental transformation of sexual relations. Schreiner, in fact, never condemns the monogamous, heterosexual family. Her views on male homosexuality were no more enlightened than the prevailing depictions of perversion and pathology, and there seems to be no record of her taking any interest in lesbianism.

Schreiner's special distinction, however, lies in the extraordinary foresight of African politics that she developed at this time. Yet, despite the brilliance of her political essays, they remain by far the most neglected aspect of all her writing—a neglect stemming no doubt from the very ethnocentricism and racism she attempted to challenge.

During these decades in South Africa, Schreiner formulated a view unique to herself alone: that the labor question and the "native question" were inseparable. Her analysis of race was founded on an analysis of class and she saw the African and land questions as an extension of the "Labour Question of Europe," only deeply complicated by race. Almost alone, she recognized that the fundamental issue was land: in order to understand South Africa's political problems, "the first requisite is a clear comprehension of their land."

All too often, Schreiner's views on Africans are blemished by condescension and a patronizing pity. In her political analyses, however, she was often ahead of her time. As early as 1891 she had foreseen some form of union among the various states and even predicted the date, 1910—off by exactly five months. She foresaw that the country was "bound ultimately to become free, self-governing, independent and republican," only decades before South Africa did indeed become a republic, albeit a racially exclusive one. More profoundly, she argued that solutions such as separate territories for the different South African peoples were unthinkable, despite the fact that the Bantustan solution would be systematically implemented only after 1948. She recognized Africans "as the makers of our wealth," and deplored the shunting of the Africans into reserves, locations and slums. She stressed the political indivisibility of all South African peoples, anticipating by decades the non-racial position of the African National Congress. Indeed, she argued that the distinctive bond uniting all South Africans "is our mixture of race itself" (*Thoughts on South Africa*). She recognized the problem of a racially divided working class, which even the South African Communist Party didn't see in the 1920s, when white workers mobilized under the banner "Workers Unite for a White South Africa."

Schreiner forecast, moreover, that a time would come when the future of the world would be in the hands of the American and Russian nations. She was, at the same time, vehemently opposed to the virulent anti-Semitism that contaminates much white South African culture and insisted on the need for recognizing the invaluable contribution of the Jewish people to the world. She was prescient in deploring the senseless slaughter of African wildlife and in calling for conservation and wildlife reserves ("Our Wasteland in Mashonaland").

It is to Schreiner's lasting credit and distinction that she was both a political activist and a political writer. In the last years of her life, she struggled to implement her vision of racial and gender equality within the political activism of the international suffrage movement. The Women's

Enfranchisement League hailed her as the genius of the suffrage movement of South Africa. She was in close contact with the British Suffrage movement through radical friends like Constance Lytton and Emmeline Lawrence. It is also to Schreiner's credit that she alone insisted that the franchise could not be seen as a gender issue alone. She was fully aware that the issue was as much an issue of class and race. When the Women's Enfranchisement League, a white, middle-class group, refused to demand a nonracial franchise, she resigned in outraged protest in 1913—the year of the notorious Land Act by which black South Africans were allocated a meager 13 per cent of the most broken, arid and devastated land in the country.

Indeed, in all her writings and political work, Schreiner took the contradictions of colonialism and women's situation under colonialism to the very edge of historical transformation. Yet, as she herself well knew, social transformation is a collective issue and no single visionary is capable of inaugurating a new epoch. Perhaps no more fitting epigraph can be found than Antonio Gramsci's lines: "The old is dying and the new cannot be born; in this interregnum there arises a great diversity of morbid symptoms."[71]

Schreiner left South Africa for the Continent in 1913, a year after the African National Congress was formed and was traveling in Germany when the darkening cataclysm of World War I engulfed the globe. In 1920 she sailed back to South Africa, a year after the Peace Treaty of Versailles. She died as she had lived, in a boarding room between homes, alone, a book against her heart, her pen still held firmly in her hands, her eyes steadfastly open to the darkness around her.

DISMANTLING THE MASTER'S HOUSE

3

THE SCANDAL OF HYBRIDITY

BLACK WOMEN'S RESISTANCE
AND NARRATIVE AMBIGUITY

8

Advocating the mere tolerance of difference between
women is the grossest reformism. It is a total denial of the
creative function of difference in our lives. Difference
must be not merely tolerated, but seen as a fund of
necessary polarities between which our creativity can
spark like a dialectic. Only then does the necessity for
interdependency become unthreatening. Only within that
interdependency of different strengths, acknowledged
and equal, can the power to seek new ways of being in
the world generate, as well as the courage and sustenance
to act where there are no charters.

—*Audre Lorde*

The day after Christmas during South Africa's "year of fire,"
when the Soweto uprising of 1976 was still shaking the country, a black
woman whom we have to call "Poppie Nongena," though that is not her
real name, arrived at the door of Elsa Joubert, a white Afrikaans writer
and mother. Nongena was in great distress. The township from which she
had fled was in turmoil. Conservative vigilantes armed by the police were

on the rampage and thousands of people had taken flight into the bush and surrounding townships. The police were searching for Nongena's brother on charges of murder, and she had spent the night huddled with her children in the wind-torn bushes of the Cape Flats.

While the black townships burned, Joubert herself was about to go on holiday with her family. For some time previously, she had been casting about for a topic for a new book. During the unsettling days of the rebellion, the idea of writing something about the Bantustans had sent her to pass offices, hospital clinics, schools and churches, interviewing and watching, but nothing had struck her with quite the force of Nongena's story. So the two women came to an agreement. Joubert would transcribe and edit Nongena's life story and, should the book sell, the proceeds would be divided equally between them. Nongena needed money for a house and Joubert's cautious estimate of a couple of thousand rands was an undreamed-of windfall. Over a period of six months, Nongena returned three times a week to tell her story in a series of taped interviews. The story emerged in fragments and patches, pieced together by Nongena's unflagging and extraordinary memory. Two years later, it was published in Afrikaans under the title *Die Swerfjare van Poppie Nongena*. Translated by Joubert herself, the book reappeared in English in 1980 as *The Long Journey of Poppie Nongena* and became an overnight sensation.[1]

THE SCANDAL OF HYBRIDITY

In many respects, it is a scandalous book. Nothing like it had ever appeared in South Africa. Firstly, it is a political scandal, for it speaks of the life of a very poor black woman, telling of her childhood shuttling from shantytown to shantytown, child labor in a white-owned fish factory, reluctant marriage, the births and miscarriages of her children in wind and sand, the bad infinity of work for white families, her husband's health broken by poverty and fatigue, the domestic violence of despairing men wedded to drink, the tightening of the influx and pass laws for women, the police raids and evictions, the refusals to leave, the ignominies and ordeals at the pass offices, forced removal to the desolation of the Ciskei Bantustan, the forbidden returns, the dogged perseverance, the family loyalties and survivals—and finally the nationwide rebellion of 1976, "the revolt of the children."

If the book is a political scandal, it is also a literary scandal. All stories of genesis are stories of political power and all publication involves a delegation of authority. Edward Said points out that the word *author* itself springs from the same etymological roots as *authority* and is attended by potent notions of engendering, mastery and property. The entry into autobiography, particularly, is seen as the entry into the political authority

of self-representation. The narrative of a very poor black woman taking possession of her history via the privileged male sanctum of the South African publishing world was a scandal in itself. At the same time, the book tramples underfoot any number of aesthetic expectations. At once auto-biography, biography, novel and oral history, the narrative is also none of these; it is a generic anomaly. Moreover, as the doubled-tongued collaboration of two women, it flouts the Western notion of the individual engendering of narrative. Finally, it is a female collaboration across the forbidden boundary of race, if a decidedly problematic one. So the book's unruly political substance, its birth in the violent crucible of the uprising, its doubled and contradictory female authorship, its violation of racial, gender, class and aesthetic boundaries all amounted to a flagrant challenge to a number of white male certainties.

Yet the book was met by a standing ovation in the white community. It won three major literary awards within a week, was reprinted three times in six months and was soon translated into English, French, Spanish and German—an astonishing welcome for any book in Afrikaans, let alone a book by two women. *Rapport*, an Afrikaans Sunday paper, serialized the entire narrative, as did some white English women's magazines. Conservative cabinet ministers read it; business leaders read it; housewives and schoolteachers read it. Well over a hundred reviews, articles, letters and reports debated, discussed and analyzed it. It has never been banned. Most black readers and critics have applauded it. Yet for the most part the white left has ignored it. What is the meaning of this paradox?

The most striking feature of the articles and reviews that flooded the newspapers and magazines was the unanimous stridency with which the book was declared to be *apolitical*. In an important paper, David Schalkwyk garnered a sample of the reviews that urgently blare the book's lack of politics.[2] I offer a summary handful of comments: "Elsa Joubert's book is *never* political," declared Maureen Pithey of the *Cape Times*. "Its honesty is apolitical," approved Lynne Burger of the *Eastern Province Herald*. "The book is furthermore no political accusation," Audrey Blignaut hastened to assure his readers. "Politics do not enter in," agreed Colin Melville of *The Star*.[3] Other examples abound.

Yet the unanimity of these reviews is riven with inconsistency. On one hand, Audrey Blignaut could offer the book's literariness as evidence that it is "no political accusation." As he put it, the book is "not a sociological report. It is a work of literature." On the other hand, a letter to *Die Burger* could offer as its evidence for the book's lack of politics precisely the opposite view. The book is apolitical not because it is literary, but because it is not. It is "a fairly objective report rather than a novel."[4] I wish to refuse the national whitewashing of the narrative as apolitical by

exploring the contradictory politics of the book's reception and the ambiguous politics of female collaboration across the boundaries of racial and class difference.

WHITEWASHING AMBIGUITY
THE POLITICS OF RECEPTION

> The mortal sin in criticism is not so much to have an ideology as to be quiet about the fact that you have one.
>
> —*Roland Barthes*

The public reception of *Poppie Nongena* as apolitical had its own political logic. The separation of politics and literature is a political separation with a real social history. As Raymond Williams has pointed out, the flight into aestheticism is "above all related to a version of society: not an artistic consciousness but a disguised social consciousness in which the real connections and involvements with others could be plausibly overlooked and then in effect ratified."[5] In South Africa the cleavage of politics and literature has taken a peculiarly paradoxical form, and it is out of these paradoxes that the anomalous reception of *Poppie Nongena* arose.

What South African novelist Andre Brink has called *Poppie Nongena*'s "unique topicality" arose in part from the fact that the "group of people in the center of the story are not only Afrikaans speaking Xhosas, but in actual fact refer to themselves as *Afrikaners*."[6] Ampie Coetzee, an Afrikaner himself, noted that most of the Afrikaans reviewers gave the book prominence first and foremost because it was written not in English, or in an African language, but in Afrikaans. The *Cape Times* agreed: "In this book black Afrikaners speak with their own authentic voices. . . . Poppie Nongena . . . was born Afrikaans."[7] Indeed, for Joubert, who did not know any African languages, the fact that she and Nongena shared Afrikaans as their first language was the enabling condition of the book. "Elsa Joubert emphasizes that Poppie is Afrikaans-speaking and how through her she became acquainted with the Afrikaans of Afrikaans-speaking blacks."[8] Yet, as a collaboration in Afrikaans between a black and a white woman the book straddles some of the deepest fault-lines of Afrikaner nationalism.

It has never been easy to ban or dismiss an Afrikaans book, however irksome. The Afrikaans language carries an almost mystical potency in the Afrikaans mind. As I discuss in more detail in Chapter 9, after the Anglo-Boer War (1899–1902), the tattered remnants of the bloodied Boer communities had to be forged into a national counterculture if they were to survive in the new British capitalist state.[9] In the early decades of the

twentieth century a revamped Afrikaans became the unifying national language for a white brotherhood of embittered farmers and workers; a frustrated petit bourgeoisie; and a small, ambitious clique of capitalists. In this society the Afrikaans writer stands in an ambiguous position. Afrikaans writers such as Joubert are seen as the midwives of the "national soul," and are accorded unusual power. Both revered and feared, the Afrikaans writer is granted a great deal of social importance and a certain political immunity. One of the most famous Afrikaans writers, Andre Brink, could comment in the 1960s, at the end of a decade of bannings, detentions, censoring, murders and suicides of black writers: "The Afrikaans writer . . . still has the uneasy knowledge that although the authorities loathe his guts, no official action has been taken against an Afrikaans book (yet)."[10]

There is a second dimension. The fact that Afrikaans was also the first language of a couple of million so-called coloreds would remain a stubborn thorn in the flesh of Afrikaner nationalism. In 1976 the black community rejected with unmistakable vehemence a state decree that math and social science be taught in Afrikaans. A few years later, the Nationalists would attempt their most ambitious and fatal attempt to draw into the laager a brethren of the Afrikaans-speaking so-called coloreds. Thus a book in which a Xhosa woman and her fragmented family speak Afrikaans as their first language could not simply be tossed into the flames. Rather, a far more difficult task of political disinfection had to be performed.

A countrywide effort of white nationalist hygiene began. The few voices that attempted to investigate the book's complex and ambiguous politics were drowned out in the unanimous hubbub proclaiming that the book had no politics at all, that it was universal, that it dealt with "family issues" and therefore lay beyond the provenance of politics and history proper. At the same time, a well-established critical discourse that defined great literature as apolitical lay ready to hand. In the prevailing white South African liberal aesthetic, based in the universities and white literary journals, politics was seen as a squalid activity made up of venal party polemics and pamphleteering and riven with prejudice, self-interest, cliché and mundanity. Great literature, on the other hand, was seen as transcending the mediocre noon of everyday, inhabiting an inscrutable, hermetic realm of essential and timeless truths. Works of art that embody these truths are the gifts of individual genius and exemplify a unity of vision, wholeness of experience, immanent and universal value, irony of tone, complexity of form, cultivated sensibility and moral discrimination untainted by the platitudes of political dogma. Thus ran the familiar liberal aesthetic inherited by white academics trained in the Leavisite school.

It should not be forgotten that the historical separation of literature and politics began at the moment in Western history when women began

to read and write in large numbers. As the "damned mob of scribbling women," in Nathaniel Hawthorne's dyspeptic phrase, entered the public literary domain, literature was defined as separate from politics. Similarly, as colonized countries wrestled their way into independence after World War II; and as women and men of color entered the universities in significant numbers, insisting on defining an alternative to the enshrined white male subjectivity; at just that moment, the requiem was rung on the subject. At the very moment that disenfranchised voices forcibly clamored for the privilege of defining their own identity and authority, "the author" was declared dead.

Most important for my purposes was the argument that *Poppie Nongena* is apolitical because it is primarily concerned with a woman's attempt to keep her family together. If politics has been separated from art, it has also been separated from the family. As one newspaper put it, the book is apolitical because the people described in it are intent only "on obtaining a pass, keeping the family together somehow."[11] In this view, the family is seen to inhabit a sphere set apart from organized politics and history. Thus women's resistance to the Bantustan policy, to the passes, to domestic violence and the plunder of their labor could be dismissed as beyond the proper provenance of organized politics and beyond the realm of history. In what must be one of the most risible comments on the book to date, *Die Burger* announced that the book was apolitical because "Poppie's problems are generally human ones, they are universal."[12]

The problem of being a minor in the eyes of the law, under the permanent tutelage of a male relative; the problem of being "endorsed out" of one's home on marriage and forced to depart for the strangeness of one's husband's Bantustan often hundreds of miles away; the problem of being ineligible for residence rights without the signature of a male relative; the problem of carrying babies to term, giving birth and raising children under the most perilous of circumstances; these are problems that are not faced by white men or white women. They are not even faced by black men. Far from being universal problems, they are problems that face black women alone and have been written into South African statute books at identifiable historical moments. Only by the most contorted efforts can they be whitewashed as the universal dilemmas of "Greek tragedy."[13]

Arguably, the most disturbing act of complicity with the book's reception was Joubert's own insistence that the book is apolitical. She has been widely cited as calling it nothing more than "a pure human interest story."[14] "The point is," she avows, "it is not a political book. I wrote it because the theme was one that interested me. I wanted to bring across the person as a human being. And that is as far as my interest goes." A headline

in *Die Oosterlig* happily assured its readers: "Politics Not Her Motive," as if clearing Joubert of some sordid misdemeanor.[15] Again and again, major papers trumpeted the evidence of authorial intention (what, one wonders, did Nongena think?). One cannot wish Joubert's prevarications away as the tongue-in-cheek caution of a writer in fear for her life or craft. Unlike Nongena, she was in no imaginable danger. Rather, her life as a woman and mother lent her a gender affinity and a very genuine empathy for Nongena, but her recently won place in the world of the white male intelligentsia underscored her loyalty to an ideology of aesthetic detachment from politics. She could go so far and no farther.

Joubert's contradictory position was also shaped by a general crisis in the liberal intelligentsia. As I argue in more detail in Chapter 9, during the 1970s one witnessed, for the first time in South Africa, a courting of black writers by white writers and critics, who attempted to borrow the authenticity of black writers to compensate for their own dwindling legitimacy. The privilege of education can breed a sense of isolation and a sense of unrepresentativeness—sharpened into urgency by the Soweto rebellion. Speaking through the voice of the disempowered becomes, in part, a way of lessening the marginalization of privilege.

The public whitewash of *Poppie Nongena* as apolitical arose, then, from the ways in which the contradictions of the moment fused and shaped each other: Joubert's conflicting gender and class loyalties, the peculiar immunity of the Afrikaans writer, the contradictions within Afrikaner nationalism, the black rejection of Afrikaans, the ambiguous position of the liberal intellectual, the historical separation of the political realm from the aesthetic realm and the historical definition of the family and the female as outside politics proper.

Marnea Lazreg, an Algerian feminist writing about the power of interpretation, has the following to say: "A feminist engaged in the act of representing women who belong to a different culture, ethnic group, race, or social class wields a certain power over them; a power of interpretation. However, this power is a peculiar one. It is borrowed from the society at large which is male centered."[16] I wish to explore the relations of interpretive and narrative power that hold between Joubert and Nongena and will do so by exploring the vexed politics of autobiography and oral history. What are the relations of power between a black and a white South African woman when an oral narrative is transcribed, selectively edited and published? In exploring this question, I am aware that I, too, am inevitably and problematically implicated in the politics of interpretation. In the pages that follow I wish to explore the implications for feminism of this contradiction, a contradiction that enters the book initially as a generic riddle.

Duke: And what is her history?
Viola: A blank, my lord.

—Shakespeare

Forme is power.

—Hobbes

The reception of *Poppie Nongena* is eloquent of the degree to which a text is an event under contest. Reading is a dynamic practice that occurs across time and takes the form of a relationship between the text and different readers' class, race and gender loyalties; educational, cultural and personal histories; and different expectations and habits of thought. Literary texts are historical events, which differ from other events in that they are organized according to aesthetic as well as other criteria. Every text is in this way *a situation in progress*.

Despite their unanimity in applauding *Poppie Nongena*'s lack of politics, critics have been vexed by their inability to tuck the book into the procrustean bed of male tradition. Soon after the narrative's publication, a small squabble broke out in an Afrikaans literary journal over its style. The Afrikaans critic Gerrit Olivier lambasted Joubert for her muddled narrative mode and her slip-shod, uneven and fragmented style. Richard Rive, a black critic, countered by accusing Olivier of pettiness, of trafficking in trivia and dwelling on niceties of form when what mattered was the political power of the book.[17] Olivier's charges of formal impropriety are charges that have been thrown at women's heads for some time: the absence of a centered narrative voice, the lack of closure, the failure of formal finesse and finish. Rive's defense, on the other hand, dismisses the book's narrative form as an aesthetic irrelevancy and repeats thereby the cleavage of politics and aesthetics. I wish to refuse both positions and argue that the book's narrative mode is inseparable from its social and political concerns.

What, then, are we to call this text? Is it a novel? An autobiography? A biography? An oral history? An oral autobiography? Its chameleon quality has perplexed its readers. It has been claimed for fiction and has been dubbed "a human novel," "a religious novel," a "novel" with "a revolutionary perspective," and "*literature* proper."[18] It has also been claimed for nonfiction: defined as "a sober report," "good reportage," "based solely on facts."[19] Andre Brink offered a compromise and borrowed Norman Mailer's term *faction*—a label summarily rejected by Jean Marquard on the grounds that it insinuated inauthenticity. "Faction," Marquard writes, is "a

mixture (as the name suggests) of 'fact' and 'fiction,' whereas Poppie does not depart from 'truth' (as defined by Poppie's rendition) at any stage. . . . The novel therefore is of a documentary kind."[20]

The contradictions in the book's status are most visible where they are most vigorously repressed: on the cover and copyright page. As if the spectacle of a black and a white woman collaborating across race and class were too unseemly, not one publisher has published the book as a collective narrative nor given Nongena coauthorial status. The story has been marketed as a novel *by* Joubert *about* Nongena. Except for a woefully inadequate and easily missed prefatory note, Nongena's crucial engendering role is entirely erased, and she is contained in the title as nothing more than Joubert's fictive creature. Readers might be forgiven for assuming (as many do) that Nongena is Joubert's novelistic invention. Indeed, on the white male left this has often been given as a reason for dismissing the book as a suspect, if well-intentioned, fabrication by a white woman.

The narrative is riven by contradiction. Paradoxically, Joubert's claim to the authenticity of "her novel" entails erasing her own role as novelist. Her "novel," she claims, is authentic because it is no more than a factually accurate record of Nongena's own life history: "I kept myself out of the story, held it up as a kind of mirror to reality." Joubert also states: "I knew at once: no travelogue, no allegory, but the stark truth, the story of this woman's life. This was where my study, my research, my travels in my own country had been leading to."[21] If the book is "no allegory, but the stark truth," on what grounds can Joubert call the book a novel and claim the status of single author?

Joubert's use of the Aristotelian metaphor of art as mimetic surface to life's truth and her image of herself as merely holding the "mirror" to the "reality" of Nongena's life evades the political and aesthetic questions raised by her own editorial interventions and thereby obscures the ambiguous politics of female collaboration with which the narrative is inscribed and visibly marked.

Moreover, Joubert's claims are contradictory. She insists she is nothing more than a mimetic reflector, delivering the stark truth of Nongena's authentic speaking voice without mediation or intrusion. Yet when she wishes to argue the book's lack of politics, she arrogates to herself the privilege of authorial intention. This contradiction appears most strikingly on the copyright page. Joubert's prefatory note reads:

> This novel is based on the actual life story of a black woman living in South Africa today. Only her name, Poppie Rachel Nongena, born Matati, is invented. The facts were related to me not only by Poppie herself, but by members of her immediate family.

This note and the copyright on the same page are thus entirely at odds. The prefatory note testifies to Joubert's absence of invention. The copyright, however, grants her legal entitlement to the narrative as sole creator. To call a narrative a novel is to raise expectations of a fictional or inventive treatment of events. Yet Joubert claims that her "novel" is based only on the "facts" of an actual life story. "Only her name, Poppie Rachel Nongena, born Matati, is invented." Can the invention of one name turn a life history into a work of fiction? By the same token, what fiat of white arrogance allows Joubert to claim the engendering status of author for herself? What legal concept of narrative ownership entitles her to sole possessive power of copyright, when the narrative is manifestly and in every way the collective production of two women? Indeed, the idea of individual textual property (a concept that emerged in the eighteenth century as writers for the first time found themselves able to earn a livelihood from the sale of their books to the public) marks a general historical contradiction within South African culture—between a decidedly imperialist notion of individual textual authority and indigenous notions of communal and performative culture that entail a dispersed sense of narrative creativity.

Nongena did indeed insist on a pseudonym, presumably out of fear for herself and her family. Joubert has kept Nongena's real name and identity secret, despite being hounded by international interviewers and journalists to divulge her identity. Nonetheless, it would have been perfectly feasible to publish the narrative as a collaboration. Instead, the erasure of Nongena's identity and name, in contrast to Joubert's instant access to an international literary name, bears eloquent witness to the imbalances in racial and class power between the two women and their different relations to the state. By publishing this troublesome narrative as a white woman's novel about a black woman, the scandal of female collaboration across race is hushed, the hierarchy restored, the boundaries redrawn. The cover and copyright page are thus fully expressive of the politics of excision and amnesia that has marked the extraordinary reception of the book as a whole.

To dismiss the narrative as a white woman's apolitical novel is, therefore, to be complicit in the conservative politics that shaped the publication and reception of the book and to acquiesce in the erasure of Nongena's engendering role. Such an erasure of what Abena Busia has called "the endangered body" of the black woman preempts any serious discussion of the deeply problematic theoretical, political and cultural issues the book raises.

The marketing of the book as a novel is directly contradicted by the narrative itself, which is deeply scored by its collective engendering, as well

as by textual signs of the imbalances of racial and class power that govern the collaboration. What then are we to call this text? Since *Poppie Nongena* appears to be the life history of a woman as told by herself, it is in many important respects an oral autobiography transcribed to print. Yet the narrative does not observe Philippe Lejeune's "autobiographical pact" between the identity of the speaking "I," the main character, and the author.[22] It retains the personal texture and idioms of Nongena's first-person voice, but it is also a thing of print, mediated by Joubert's editorial interventions and a second narrative voice. Nor can it simply be subsumed under the category of biography. As a biographer might, Joubert checked and rechecked every detail of Nongena's lifestory; she traveled to every place mentioned in the story, interviewing wherever possible everyone who is mentioned in the story and speaking when possible to Nongena's family members. But, unlike most biographers, she constantly read the narrative back to Nongena, who corrected her and advised changes and revisions. Moreover, unlike most biographies, at least a third of the narrative is in the first person. What then are we to make of this paradoxical text? What are the politics of female authorship and what are the politics of race and gender when women collaborate across the boundary of race from positions of unequal power? If the paradoxes of the book's ambiguous politics are to be examined, the text's status as a collaborative narrative needs to be explored.

BRUSHING HISTORY AGAINST THE GRAIN

Jean Marquard has pointed out that *Poppie Nongena* predated by a number of years the emergence in South Africa of what has been dubbed "history from below," "people's history" and "oral history." Yet, largely because of the book's gendered origins and the politics of its marketing and reception, the narrative has not received the serious attention as an oral testimony that other later forms of oral history have received.

In South Africa the "new history" emerged largely in response to the massive growth of extraparliamentary activism, in the independent unions and in community organizations that have been mobilized irrepressibly around the country over the issues of rent, transport, housing and education. The new history has taken at least three directions. On one hand, largely empirical politically radical academic histories have explored such topics as the rise and fall of the African peasantry, the making of the black proletariat, the different histories of Zulu, Xhosa, Pedi and so on. These histories are written by highly trained white academics for a specialized academic readership. On the other hand, histories such as those produced by the Labor History Group; illustrated booklets in English,

Zulu and Xhosa; *Learn and Teach*, and so on, are written for a popular mass readership by intellectuals or community activists committed to putting their training and expertise at the service of the communities. Finally, there are histories produced by nonacademics, workers and students for worker publications and community broadsheets such as *Fosatu Worker News* and *Izwi lase Township*, as well as popular comic-book representations of history, which attempt to put the writing and reading of history in the hands of the communities themselves.

Oral history, both in South Africa and elsewhere, offered the delirious promise of brushing history against the grain, in Walter Benjamin's famous phrase. It promised to restore the vivid, ordinary lives of those who saddled the colonials' horses, who hammered out the railways and dug up the diamonds, who washed the settlers' babies and cooked the evening meals. Oral history promised a more democratic history. As Paul Thompson argues: "It gives back to the people who made and experienced history, through their own words, a central place."[23] New areas of social life such as family histories and domestic power relations, the myriad forms of popular culture, or the dynamics of informal social groupings such as squatter communities and shebeens—hitherto secret, taboo, or neglected—were opened to public history.

Oral history is not simply a new technique for recovering the past in its purity. Rather, it invites a new theory of the representation of history. Not only is history produced as much by miners, prostitutes, mothers and farmworkers as by the heroes of history-writing, but the recording of history is both the outcome of struggle and the locus of struggle itself. Without doubt, oral history is potentially a technology for reproducing political memory, a technology accessible for the first time to the silenced, the inaudible, the disenfranchised: women, the working class, ordinary people. But oral histories themselves are not necessarily progressive, nor are all the uses to which oral narratives may be put, as the reception of *Poppie Nongena* exemplifies. The representation of history, including oral history, is itself a contested historical event. The collection and preservation of human memory is less a technique for increased historical accuracy, than it is a new, contested technology for historical power.

Accuracy in history is a *genre*. Empiricism is a mode of ordering past experience according to certain rhetorical and disciplinary conventions. The quest for the "real" past is as utopian as Alice's quest for the white rabbit, which glances anxiously at its watch before vanishing. History is always late. Empirical oral history, if defined as the effort "simply to preserve and collect human memories"[24] is a mode of historical taxidermy, a technology of reproducing past events in a permanent stasis of life-likeness. Empiricism privileges the idea of history as a series of pure,

recoverable events, a notion that can be upheld only by radically depoliticizing the dynamics of power that underlie the activities of history-making. As Frantz Fanon put it, "Objectivity, for the native, is always directed against him."[25] Oral history may also conceal a poetics of nostalgia. In its empirical guise, oral history fulfills the nostalgic desire to represent history whole, to preserve, to embalm: it is a politics of reproduction. It represents the aggressive desire for historical completion and coherence that characterizes all archives. The oral archive can thus become a political instrument for the bureaucratization of working lives, serving as a visible monument to the power of the bureaucracy as a system of ordering knowledge and delegating authority.

The production of oral history is a technology of power under contest and as such cannot be isolated from the context of power from which it emerges. Oral history involves the technological reproduction of people's memories; the unstable life of the unconscious; the deformations, evasions and repressions of memory, desire, projection, trauma, envy, anger, pleasure. These obscure logics cannot be wished away as the irksome impurities of oral history but should be integrated into oral history as a central part of the process. No oral history is innocent of selection, bias, evasion and interpretation. Very real imbalances of power remain in current contexts. Oral histories frequently perpetuate the hierarchy of mental and manual labor of the societies from which they emerge: the hierarchy that ranks those who work and speak differently from those who think and write. In many oral histories, the multiple authorship of the narrative is submerged in the executive, choreographing authority of the "historian." The oral narrator becomes a Svengali's Trilby, at the beck and call of the master of ceremonies, bestowing prestige and glamour on the historian's professional name, without herself benefiting one whit.

In the cover, packaging and presentation of *Poppie Nongena*, Nongena is undoubtedly Trilby to Joubert's Svengali. Nongena is presented as Joubert's fictional creature and most people who are unaware of the circumstances of the book's production read it as a white woman's novel and dismiss it as deeply suspect on those grounds. Nevertheless, to accept this at face value is to accept the woeful whitewashing politics of the book's publication and to acquiesce in the erasure of Nongena's creative authority. Indeed, the narrative itself expresses a far more complex hierarchy of relations than its packaging suggests, and much of the great value and interest of the book lies in the way these shifting imbalances of power—the paradoxes and ambiguities arising from its doubled authorship, the contradictions between the two women's relation to apartheid—are integrated into the texture of the narrative itself.

Teresa de Lauretis argues that to pose the question of gender as arising from a fundamental sexual difference between men and women, or as arising more abstractly from signification and discursive effects (from *difference*, where "woman" comes to figure *difference tout court*) has the effect of universalizing gender opposition and making it impossible to articulate differences among and within women. She calls instead for a "subject constituted in gender, to be sure, though not by sexual difference alone, but rather across languages and cultural representations; as subjects en-gendered in the experience of race and class, as well as sexual relations; a subject, therefore, not unified but rather multiple and not so much divided as contradicted."[26] Gender is thus the representation of changing social relations: "It presents an individual for a class."[27] The "subject of feminism" is therefore "one whose definition or conception is in progress" and cannot be found in identities alone, but rather in the politics of alternative social, political and communicative forms, in political practices of self-representation that illuminate the "contradictory, multiple construction of subjectivity."[28]

Similarly, Biddy Martin writes of "recent autobiographical writings that work against self-evidently homogeneous conceptions of identity," writings in which lesbianism, for one, comes to figure as something other than a totalizing self-identification and something other than exclusively psychological.[29] Here the appeal is to institutional analyses of social and cultural power rather than a focus on identity alone. The importance of these points is that they allow us to examine women's narratives in the context of theories and politics of social transformation rather than an ahistorical psychology or poetics of identity.

A singular identity (whether gender, race, class or sexual preference) cannot guarantee political correctness. Feminist agency should be sought not in a homogeneous psychology of identity alone (the lesbian, woman of color, working-class female life) but through a politics of organization and strategy which takes into account the myriad differences and loyalties that crisscross women's lives with conflicting passions. Audre Lorde writes:

> As a Black lesbian feminist comfortable with the many different ingredients of my identity and a woman committed to racial and sexual freedom from oppression, I find that I am constantly being encouraged to pluck out some one aspect of myself and present this as a meaningful whole, eclipsing or denying the other parts of self. But this is a destructive and fragmenting way to live.[30]

Feminism should be enacted where these conflicting loyalties emerge and intersect under specific historical circumstances. We can thereby avoid the

reduction of politics to a poetics of the flesh, an erotics of power mysteriously transcending historical difference, which itself masks differences of power among women as well as similarities of power and disempowerment between women and men (of different race, class and nation).

In South Africa very little is known about how ordinary women like Nongena lived out the ruptures and changes in apartheid, and even less is known about how women resisted these changes and engaged in contests for power.[31] Oral narratives such as Nongena's are thus of great importance in expressing, in however oblique or mediated a form, some insight into the myriad hidden experiences of women. At the same time, such narratives offer deep-reaching challenges to a number of Western theories about the formation of selfhood, narrative authority and social identity.

In the history of the West, autobiography is the genre most closely associated with the idea of the potency of self-identity, metonymically expressed in the signature: the emblem of a unique, unrepeatable and autonomous identity, created at a stroke of the metaphorical pen(is).[32] Typically, the Western male autobiography, in its dominant form, has been seen as the unfolding heroics of a single mind. As James Olney puts it: "Separate selfhood is the very motive of creation."[33]

It is commonly argued that autobiography's rise had to do with the historical evolution of the self-conscious (western, male) individual during the Renaissance. Gusdorf, for one, takes the flowering of wonder after the Copernican revolution at the (male) self's individual destiny as evidence of the *evolutionary* flowering into self-consciousness of the European race. As he sees it, other cultures that have not awakened to autobiography have not awakened to history proper. Falling under the long spell of the idea of progress, Gusdorf claims that "primitives" (lacking autobiography and fearful of their image in the mirror) lag behind the Western "child of civilization" and reveal thereby that they have not yet emerged from "the mythic framework of traditional teachings . . . into the perilous domain of history."[34] His claim is explicitly male and explicitly imperialist: "It would seem that autobiography is not to be found outside our cultural area; one would say that it expresses a concern peculiar to Western man, a concern that has been of good use in his systematic conquest of the universe."[35] Yet, as Leila Ahmed points out, "autobiography is an anciently known form in Islamic-Arabic letters" (examples predating Western ones appear as early as 1111 AD). Gusdorf's claim is therefore, "at least with respect to Islamic and Arabic civilization, quite simply incorrect."[36]

Indeed, what Gusdorf portrays as a grand racial awakening to the individual's "autonomous adventure" of selfhood may be seen instead as the historical emergence of the ideology of possessive individualism. This ideology served a new merchant and trading class eager to challenge

traditional modes of legitimacy invested in the medieval papacy, the monarchy and the landed aristocracy. Possessive individualism was a rhetoric of selfhood invented by certain elected males and defined at the expense of the autonomy and freedom of other disempowered groups, most notably women, but also certainly including men.

Women have seldom been allowed to share the delights of Gusdorf's "autonomous adventure" of individual selfhood; female inventions of the self have been typically subject to the careful and violent amnesias of male tradition.[37] Moreover, a number of feminists have argued recently that the many autobiographies written by women over the centuries are different from those written by men.[38] Women's autobiographies, it is argued, do not as a rule genuflect to the theology of the centered individual nor to the idea of a chronological whole, tending rather to be irregular, anecdotal, fissured and polyphonous.[39] Mary Mason has shown how, in many female autobiographies, the single identity of the speaking self splinters into a multiple fluidity of identification. Despite their myriad variations, she argues, female autobiographies typically present the self as *identity through relation*.[40] This relation is not one of dependency or mastery but rather of *recognition*, whereby disclosure of the self emerges through identification with some other, who may be a person, family or community.[41] Identity is thereby represented as coming to being through community rather than as the individual heroics of the self unfolding in solitude.

Yet, I would argue that the fluidity, unsteadiness, achronology and obliqueness that do indeed characterize such texts as *Poppie Nongena* can be understood neither in terms of a universal theory of an *écriture féminine* arising from a poetics of the flesh; nor as eloquent of a pre-oedipal, libidinal insurgency and unbounded female selfhood, as argued by some Western feminists.[42] Rather, *Poppie Nongena* offers a number of challenges to the Eurocentric assumptions of the latter theory.

Some feminists have been justly skeptical of the idea of a universal, female gynesis, fearful that it runs the risk of being fatally essentialist, formalist and utopian.[43] There is a very real danger in baptizing certain texts with the holy water of a new female privilege, erasing historical and cultural variations and subsuming the multiplicity of women's lives into a single, privileged and, as it happens, white, middle-class vision. The category of "woman" is a social construction, and the visible ruptures in women's narratives are expressive of ruptures in social experience. Narrative differences are eloquent not of anatomical destiny and design but of the daily difficulties women experience in negotiating their lives around the magisterial forms of male selfhood.[44]

It is important to note that many of the characteristics of autobiographies that have been defined as female are shared by autobiographies

written by people of color, female and male and by working-class men. Thus Mason's claim that nowhere do we find men's autobiographies exhibiting the features of female texts is true only of the privileged tradition of empowered European males. Susan Stanford Friedman has pointed out that community identity frequently marks the autobiographies both of women and minorities.[45] It becomes important, therefore, not to speak of autobiographies in terms of essences or experience: "women's autobiography," "lesbian autobiography," "black autobiography." Identity is not an essence that can be distilled and revealed in a single genre or category. Such terms make it very difficult to articulate differences among members of different communities or within communities themselves. Identity is socially constructed and men of color, for example, sharing many of the conditions of deprivation and dismissal faced by white women, evince comparable difficulties negotiating their way around the privileged conventions of sanctioned selfhood.

Nellie MacKay points out, "in all aspects of its creation, early black autobiography altered the terms of the production of Western autobiography as they had been defined by the dominant culture."[46] Audre Lorde, the African-Caribbean/New York lesbian writer and poet, suggests in the title of her book *Zami: A New Spelling of My Name* the fundamental inadequacy of the term autobiography and of Western conventions of selfhood for rendering the lives of women of color.[47] She calls *Zami* a "biomythography" and thereby invites the reader into a new relation to the idea of a lifestory. The neologism *biomythography* yields a number of rich glosses. *Mythography* dispels at a stroke any nostalgia for autobiographical exactitude. At the same time, the term suggests life through mythography, the life of the future born from the collective refashioning of the past. Moreover, what the term *biomythography* leaves out is as significant as what it includes. Lorde's refusal to employ the prefix "auto" as the single, imperious sign of the self expresses a refusal to posit herself as the single, authoritative, engendering voice in the text. Instead, her lifestory is the collective, transcribed life of a community of women—not so much a perfect record of the past as a fabulated strategy for community survival.

THE POLITICS OF GENDER AND SOCIAL IDENTITY

The first word of *Poppie Nongena* is "we." To open the book is to notice immediately an absence—the centered, univocal speaking "I" of canonized male autobiography has vanished. This is how the book begins:

> We are Xhosa people from Gordonia, says Poppie. My mama
> used to tell us about our great-grandma Kappie, a rich old woman

who grazed her goats on the koppies this side of Carnarvon. . . .
She told our mama about the old days. . . . We saw the Boers
coming on horseback, she said. . . . And then Jaantjie rode away
with them. . . . Jaantjie, take the horses and flee, the Boer shouted
when he saw the English soldiers . . . but by then, old woman—
so he came and told our great-grandma Kappie—your child was
dead (11).

From the outset, the book denies the reader a privileged point of obser-
vation, such a center as the voluble "I" of autobiography once afforded.
Opening the book, one hears a polyphony of female voices, the ancestral
reverberations of great-grandmothers, grandmothers and mothers mingling,
redoubling and echoing almost indistinguishably within one another. The
story-recorder's voice encloses Nongena's voice; Nongena, speaking in the
narrative present remembers her mother's voice, who remembered in turn
the voice of great-grandma Kappie, who remembered the words of the
Boers and the man who came to tell her her son had died, long ago in the
old days during the upheavals of the white people's wars. *Poppie Nongena*
differs in this respect from the black male mission-school autobiographies of
the 1960s, which generally open with the "I" of individual, if embattled, male
identity.[48] In *Poppie Nongena* the life history does not flow from an originary
moment in the birth of the individual. Rather, Nongena's birth is announced
obliquely, in the third person, only after the larger community of women
shaping her identity has been identified: "Lena's fourth child was brought to
Ouma Hannie who called her Poppie" (13).

The opening pages of Nongena's narrative are eloquent of the
unnaturalness of individual identity. From the outset, the construction of
identity as collective enters the reader's experience of the narrative as *form*.
Poppie Nongena's oral memory, bequeathed through the mother's line,
recalls what the state would erase: the stubborn collective memory of
precolonial plenty as rich great-grandma Kappie grazed her goats in the
hills of the Karoo. But after the turn of the century, Nongena's family, like
millions of other black South Africans, was forced off the land by the
ruinous land and hut taxes. Buffeted by the Anglo-Boer War, losing their
livestock to disease and their men to the white people's wars, they were
reduced to migrant laborers, landless and rightless, shuttling from
shantytown to shantytown, selling their labor for pittances on the white
farms and fishing ports.

Ouma Hannie's children scattered—one to the farms, one to the
white people's war—and the broken trajectory of the remainder of the
family followed the inexorable economic logic of the railway looping
together the fishing ports on the Atlantic, the merchant port at Cape Town

and the mines in the interior. It was a family in transition, suspended between the remembered bounty of pastoral autonomy and the immiseration of wage labor. In the contradictions of this transition, different social forms of identity emerged.

The opening pages of *Poppie Nongena* are a bewildering welter of family names, places and kin relations. Voices merge, separate and merge again with other voices. The difficulty of the reading comes to mirror the singular ordeal of keeping the family together. One struggles to remember who everyone is, identify who is speaking, remember in which place they are now living. One is constantly obliged to turn to the female genealogy at the opening of the book for guidance and is thus at every moment reminded that familial and social identity are laborious constructions. What holds the community of identity together is the labor of oral memory, borne through the women's tenacious will to remember and to speak. Oral memory is a refusal of the dismemberment of history, a laborious life-giver. Memory, in Don Mattera's words, is a weapon.[49] It is a device against oblivion, a strategy for survival.

The permeable, collective construction of identity in *Poppie Nongena* is most visibly marked by the absence of any quotation marks to distinguish one voice from the other. As the narrative progresses, the reader is invited to adjust rapidly to a welter of voices and narrative identities. Identity comes to be experienced as a constant reshaping of the boundaries of selfhood; indeed, it comes to be seen as the shifting outcome of community experience rather than any singularity of being. To continue reading, one is obliged to abandon the liberal nostalgia for a centered, sovereign perspective and a single, presiding consciousness. Instead, one is invited to yield to an alternative notion of reciprocal, relational and unstable identity. This unsteady metamorphosis of boundaries is quite different from the fractured, dismantled identity of Western postmodernism, which has as its silhouette a tragic nostalgia for the centered, humanist individual. In *Poppie Nongena*, identity is experienced as communal, dynamic and shifting, rather than as fractured, immobile and solitary. The boundaries of the self are permeable and constantly open to historical change. In this way the narrative offers a number of challenges to hegemonic theories of autobiographical narrative and identity.

INVENTING THE FAMILY

From the beginning, Nongena's narrative renders untenable any notion that identity is a natural category. Obedient to tradition, all Ouma Hannie's daughters were married by force, including Nongena's mother, Lena: "that was the way the parents used to do it in those days. My mama

didn't want my pa" (12). Machine Matati paid lobola (bride price) to Ouma Hannie, fathered four children, abandoned the family, went to war and was never seen again. "He never looked after my children like a father should, [Lena] told Ouma Hannie. I have no tears to weep for Machine Matati" (33). Machine Matati was not exceptional. It is estimated that during the early decades of the twentieth century, three-quarters of all black men lived apart from their families for over half the year, driven by land hunger, poverty, taxes and desperation to the towns and cities. Yet the consequences for women of this massive dismembering of their families were contradictory.

On one hand, the structure of labor within the black homestead enabled women to resist proletarianization longer than men. Because they were the traditional agriculturists, they could stubbornly remain to work the land and fend for their communities while the men scattered to sell their labor on the wage markets. Women remained independent of the axis of capitalist formation for longer periods and so were capable of greater militancy and refusal. Thus it happened that women and not men successfully refused the passes in 1913.[50] At the same time, however, black women bore the brunt of their families' efforts to survive and suffered most intimately the cruelties of poverty, starvation and disease, the unemployment, malnutrition and infant deaths of the countryside. Men might appear briefly once a year at the most, stay for a couple of weeks, and then vanish, perhaps for years, perhaps forever. Yet in the absence of men, women became more autonomous and self-sufficient. This is how it was in Poppie Nongena's family.

In the narrative, Ouma Hannie presides as a ragged matriarch over the marriages and births of her children and grandchildren, taking in her grandchildren and rearing them as she had reared her own. Lena, Nongena's mother, is forced to work for a white family in a town over a hundred miles away, so Nongena and her brothers live with their grandmother among the chicken coops and sandy streets of the shantytowns, selling rags and bones or doing laundry for whites. Ouma Hannie is "very strict with her children" (14); it is she who wields authority in the family. She decides the marriages; she controls the ceremonies of lobolo; she takes the lobolo money for her daughter's marriage.

Nongena's family becomes a constantly changing locus of struggle and division, both within the family over women's domestic work and between the family and the state. The boundaries of the family shift ceaselessly; kinship relations are fluid. It is a family without fathers and there is no natural mother: "We loved ouma more, more than our own mama," says Nongena (17). The identity of motherhood is multiple and shifting—as is the case for most South Africans. As Johanna Masilela,

childminder, says of the children in her charge: "They took me as their real, real mother. Because they don't know their mothers. They used to see their mothers late in the afternoon. I was their mother."[51] When Ouma Hannie takes sleep-in domestic work with a white family, Nongena and her brothers are farmed out among relatives in different towns. When Nongena's mother eventually returns to try to reassemble the family, her son, Mosie, "called kleinma Hessie mama because he had lived with her so long" (36); and Lena scolds Poppie: "Ag now, don't you know your brother, that's Mosie, over there" (35). The idea of the natural nuclear family, presided over by a single male, loses all semblance and splinters out into the world. Grandmothers are mothers; cousins are sisters; brothers are forgotten; there is no father; mothers are strangers and then mothers again. Together and apart, Nongena's loose family shuttles from town to town — then settles briefly at Lambert's Bay on the icy Atlantic, where they sell their labor in the fish factory.

The fluidity or multiplicity of identity born of this situation does not represent a mutilation or deformity of identity. Rather it is eloquent of a resilient and flexible capacity to cross the uncertain boundaries of self and community. The fluidity and reciprocity of narrative identity in the story, the merging and division of voices, arises therefore neither from formal ineptitude nor from some organic *jouissance* of the female body, but rather from a social situation where identity is experienced as reciprocal, constructed and collective. Identity emerges from a community of experience rather than from a transcendent unity of being. The narrative shiftings and slidings manifest this reciprocity and fluidity of collective identity.

Here one might invoke in passing the work of Nancy Chodorow, who argues that cultural patterns of childrearing give rise to different boundary experiences in males and females. In households where women are the primary caretakers, girls "come to define themselves as continuous with others; their experience of self contains more flexible or permeable ego boundaries. Boys come to define themselves as more separate and distinct, with a greater sense of rigid ego boundaries and differentiation."[52] According to Chodorow the young girl comes to experience a sense of "self in relationship."[53] While Chodorow undoubtedly does not pay sufficient attention to cultural variations in family relations, she makes an important departure from theories of archetypal gender difference by locating different boundary experiences in the historical and hence mutable, social structures of childrearing and domestic divisions of labor.

Nevertheless, the narrative's polyphony of identities does not reveal a utopian democracy of storytelling. The story does not express the disappearance of power but rather its redistribution under contest. Identity

319

does not transcend power; it comes into being through ceaseless contest and results in a dispersal and realignment of power rather than a vanishing of power.

This realignment of power is visibly expressed in the matrilineal genealogy that appears in the frontispiece, a reinvented family tree that bears at its head a single matriarch and reckons descent through the female line. Genealogies are presented less as accurate records of family relations than they are records of political power. Generally it is the victors who record history and inscribe their genealogies; generally these genealogies are male. The opening pages of *Poppie Nongena*, however, reckon history through the female line of grandmothers and mothers, dispersing authority through a female community and thereby figuring a different engendering of hierarchy and a different notion of who authors history. The reinvention of genealogy is summed up in Nongena's Xhosa name: "Ntombizodumo, which means girl born from a line of great women" (13). The reckoning of family genealogy through the mother's line marks the beginning of a new contest for familial and historical power.

The dispersal and realignment of female power is most vividly manifested in the dispersal and realignment of the authority of narrative voice. Much of the interest of the narrative lies in its blurring of all distinctions between "truth" and "fiction," "autobiography" and "biography," "novel" and "oral history." An autobiography, conventionally, raises expectations that the self who recounts the tale and the author of the autobiography are at least referentially the same. Yet, as we have seen, the "I" of Nongena's tale and the "Joubert" of authorial copyright are not identical. Moreover, there are at least three narrators in what is essentially a heteroglossic and collective tale. Nongena speaks in the first person with the immediacy of oral storytelling as if recorded verbatim during the interview: "Auk! when it rained, we had to take off our shoes Ag, but it was so sad to be back in my house again" (80, 168). On a number of occasions, her speaking voice explicitly evokes Joubert's presence as interviewer and listener, explaining Xhosa or Afrikaans words or customs that she knows are unfamiliar to Joubert: "Grootma means a sister of your ma that's older than she is and kleinma is her younger sister" (12). Sometimes her comments bear vestigial traces of Joubert's questions: "At what time we started work? Now that was just when the boats came in" (50). Thus Joubert's cultural ignorance and the dialogic and public context of the narrative beginnings are inscribed in the text.

The second narrator is not identical with Joubert's interviewing voice but functions in some sense as an omniscient narrator: "Those years, 1966, 1967, the police were very hot, says Poppie." Nevertheless, this intermediary narrator is strictly speaking not always an omniscient

narrator, for it functions on occasion as an echo of, without being identical to, Joubert's interview voice:

> The three sons of Lena had English names as well. Philip, Stanley and Wilson. Perhaps it was Machine Matati from Mafeking, who went to war for the English, who chose these new names. No, says Poppie, it was not just our pa who was educated, our ma had some learning too.

The first three sentences could be either Nongena's testifying voice or the intermediary narrator, but because of the unusual syntax, they lean towards Nongena's voice. The fourth sentence ("Perhaps it was Machine Matati . . .) is an oblique narrative echo of a question by Joubert, but is not recorded verbatim as her direct speech. At other moments the intermediary narrator frames the voices of other members of Nongena's family, taken from Joubert's interviews and not from Nongena: "It's too much for Poppie, says Lena, to work in the factory and to look after her brothers and nurse her grandmother. She's not even fifteen years old (60) I wasted my time at the Catholic school, Mosie says later" (40).

In the narrative these voices merge and alternate rapidly, sometimes blending indistinguishably, sometimes separating and becoming relatively distinct, but without ever being distinguished by quotation marks. Sometimes voices merge within a single sentence; sometimes they vacillate rapidly from sentence to sentence or paragraph to paragraph. Sometimes the narrator switches without warning from first to third person within a single paragraph:

> I left the job at Mr Pullens because of the baby and so I had to stay at home to look after it. The child was breast fed and it's hard to give a suckling child to someone else to look after. This child was only four months younger than my ma's last child, her girlchild called Georgina, whom we still call Baby. Poppie's child was born in the house. A Xhosa district nurse, nurse Bam, helped her. It was a girl and they christened her Rose in the Holy Cross church. Her Xhosa name was Nomvula, meaning child born on the day it rained.

The first three sentences are obviously first person, the fourth changes abruptly to third person, as does the fifth, but the last two sentences could be either. Often the narrative switches point of view without warning from paragraph to paragraph. A paragraph in the third person begins: "When Poppie grew too big" (15), and is followed without announcement or identification by a paragraph in Nongena's first person voice: "Our house

was built partly of reeds and clay" (15). At certain critical moments the narrative switches to second person: "You have to weep. You take it so much to heart" (73). More infrequently, an intermediate narrator emerges that has been alternately dubbed "free indirect speech," "erlebte rede," and "narrated monologue," a transitional narrative form that hovers between first and third person: "She did not trust this earth; it looked dark and wet" (198). "Poppie was a big girl now" (26). Here the present-tense deictics ("this," "now,") mark the narrator as not identical with an omniscient narrator, but rather colored by the point of view of the first-person voice.[54]

Moreover, tenses slide constantly and unpredictably throughout the narrative. Sometimes the first person is in the past tense: "I was scared of the strange people and didn't look around too much" (78). Sometimes the first person is in the present tense: "I cannot move, my feet are stone. I can see his blood on the road, but I cannot do anything" (128). Sometimes tenses switch in midsentence: "It was a horrible place, I'm not used to such houses" (78).

The lack of quotation marks throughout the narrative places a great responsibility on the reader to make rapid adjustments in identity and time. Quotation marks testify to an ideology of language as individual property. As textual markers, they enclose and fence certain arrangements of words as the property of a single speaker. Language enters the provenance of possessive individualism and distinct identity. In contrast, *Poppie Nongena*, rather than embodying isolated and separate identities, invites one to experience narration along a dynamic, collective continuum of voices and identities, which are at moments distinct and at moments inseparable. More than anything, the narrative is deeply inscribed by its oral and dialogic conditions of production and by the fluctuations of person and time that characterizes oral memory. Instead of a single, individual style, it establishes what Jameson has called a collective "interpersonal rhetoric."[55]

The narrative began as an oral narrative and oral memory is from the outset collaborative and multitongued. In addition, the conditions under which Nongena's story came into being were public, performative and dialogic. The narrative form is, therefore, neither the expression of a damaged consciousness nor the mark of female aesthetic ineptitude. If, therefore, one is to understand the confusion and reinvention of narrative and identity boundaries in *Poppie Nongena*, one must situate the narrative in the social conditions under which it emerged, particularly the ruptured shapes of family and community life. The narrative unsteadiness bears witness to the onslaught on black communities by the state and is neither the sign of formal ineptitude, as Olivier argued, nor of formal irrelevance, as Rive argued. Nor can the narrative ruptures be seen simply as eloquent of an archetypal, pre-oedipal *jouissance* of the word, as figured in some

Western feminist literary theories. Rather the ruptures and reinventions of narrative boundaries coincide with the ruptures and reinventions of the black community, emerging out of the social conditions of the time. The narrative's originality reveals a resistant, dynamic, protean and collective identity, expressing in its stubborn reinvention of collective identity a tenacious refusal to break.

"THIS PASS BUSINESS"
MARRIAGE AND THE PASS LAWS

The narrative ruptures in *Poppie Nongena* bear witness in part to the collision of two economies in her familial household. In such households, residual patterns of labor power and division remain from the precolonial domestic economy, existing alongside and in contradiction with, the industrial economy of waged domestic work. Households are ruptured by a gendered conflict within the domestic economy over women's work and by an overdetermined and uneven racial, class and gendered conflict between the household as a dynamic community and the apartheid state. The household economy thus remains paradoxical for women, for it can be both a place of community resistance to the state and a place of internal gender conflict between men and women—over work, food, sexuality and power. Family households are thus situations under contest. As Heidi Hartman argues, the family is much less a social unit with shared interests than it is a "locus of struggle"—a changing constellation of power that takes different shapes at different social moments.[56]

In South Africa, women's social identity is mediated by the marriage relation. Nongena's marriage is a threshold ceremony, a metamorphosis that takes symbolic form in the ritualized changing of clothes. The symbolic crossing over to other clothes marks an economic crossing—the transfer of Nongena's labor from her mother's family to her husband and through him to his family.[57] "You know you have not married only the man, you have married into his family (72). . . . They expect you to work for them" (74). Marriage for Nongena is fundamentally, in Christine Delphy's phrase, "a contract into unpaid labor."[58] The unsteadiness and in-betweenness of her new identity within the marital relation is expressed within the narrative itself by rapid shifts in point of view. At this transitional point, the narrative begins to slide uncertainly between detached omniscient narration, first person and second person, a threshold mode suspended between I and she that emerges here for the first time.

As soon as Nongena marries Stone, her legal status changes irrevocably. Her individual identity is erased; henceforth her civic status is secondary, relational and mediated, yoked by law to her husband's status.

This dependent status is most calamitously expressed in her relation to the pass laws. At the same time, Nongena's determination to keep her marriage and family together represents a long refusal of the migrant labor system on which apartheid has been based. Women's efforts to keep the family together thus cannot be dismissed as "antisocial" or conservative in any simple sense.[59]

These were the turbulent 1950s. The Nationalist party swept triumphantly into power in 1948 and began to systematize the Bantustan system. By the Land Acts of 1913 and 1936 a scant 13 percent of the most arid and broken land was allocated to black South Africans, though they comprise 75 percent of the people. The Bantustans consist of eighty-one scattered scraps of land, parceled along invented "national" lines into ten so-called "independent homelands."[60] The migrant labor system of apartheid depends on a gendered division of labor in which the majority of women, defined in the notorious official terminology as the "superfluous appendages" of men, are penned up in the Bantustans, forcibly barred from the wage economy or permitted to enter it only under parlous conditions.

As early as 1913, the state saw fit to issue passes to black women, who responded with such unexpected, vehement and organized fury that the idea was hastily dropped and would not be broached again for another four decades. In the 1930s laws were passed that forbade a woman entry into a town unless she was certified as the wife or daughter of a man who had been working in that area continuously for two years.[61] In 1937 even the wife or daughter of a legal resident could be certified only if she could prove that housing was available and since housing had been deliberately frozen, such proof became virtually impossible. In 1952 the first real attempt was made to bring women to heel. It was mostly women who faced the unexampled trauma of constant arrests, forced removals, evictions and banishments. As Nongena put it: "They were keen on catching the women" (88). Women's refusal to leave was met by unswerving police violence. The women were arrested, shunted onto trains and buses, their frail cardboard and corrugated iron shanties smashed. Nongena herself was hauled off by the police.

The fundamental state strategy was to close its pincers on the black families. The migrant labor policy was at heart a policy about the family and about controlling the reproduction and division of labor within the family. The state's intentions were blunt and succinct: "The policy of this government is to reduce the number of African families in the Western Cape."[62] The fundamental conflict was the control of women's "surplus" and reproductive labor.

The institution of marriage became a direct weapon of state control. Any woman's right to remain in an urban area became dependent on a male relative and the consequence of marriage for a woman like Nongena was

often catastrophic. Despite the fact that she had been born in the Cape and had lived there all her life, she was now, in the eyes of the law, the "superfluous appendage" of her husband and could remain in the Cape only if he had work and a house to shelter her. Failing those conditions, she would be summarily endorsed out to the Bantustan to which her husband had been allocated.

Nongena's marriage makes her a perpetual foreigner in her own part of the country—stripped of all residence rights. For five years, in the exhausted hours of her time off from domestic work, Nongena trudges to pass offices to plead for a permit to stay, waiting for buses, standing heavy with pregnancy in queues, appealing, negotiating with the white bureaucrats, granted a week perhaps at a time, returning a week later, then a month, then seven days, then two months, then nothing, then returning again, wearing out her feet, trudging home through the dark and threatening bushes at night, shaking with fatigue, with papers for perhaps another week, then perhaps a month, or only a handful of days. Her years are measured out according to the fickle, despotic calendar of the white bureaucrat's stamp. "The dates, carved on the ridges of the stamp, can be turned by a twist of his fingers" (184). Every successful bus ride, every fresh stamp is one more rite of defiance, one more act of refusal.

For seven years, then ten, she stakes out her stubborn refusal of state decree, until in the late 1960s she is finally and unanswerably told to leave. In 1964, in an act of inexpressible cruelty, amendments were made to the Urban Areas and Bantu Labor Act, which made it virtually impossible for a woman to qualify for the right to remain in an urban area. Wives and daughters of male residents were now no longer permitted to stay unless they too were legally working. F. S. Steyn, member for Kempton Park, put the matter bluntly: "We do not want the Bantu woman here simply as an adjunct to the procreative capacity of the Bantu population."

It became a life of running to hide. Nongena and the other women hide under beds or in lavatories and wardrobes, or take cover in the bushes until the police have gone. Finally, Nongena's permit is torn into little pieces and thrown at her. Nine months pregnant with her last child, Nongena yields, gives birth, is sterilized and agrees to leave for Mdantsane camp, a stark and sterile place in the Ciskei, still empty of people, where she is allocated a one-room, raw cement house with no ceilings, no water and no electricity, fourteen miles by bus to the white city of East London.

At this point in the narrative, the paradoxes of Nongena's relation to her family become perilous. Her sense of identity, always inextricable from her relation to community, begins to unravel. Her isolation becomes a searing and private martyrdom, unseen and unacknowledged, and the narrative registers her perceptual crisis and rending of selfhood in

mixed tenses, sudden unpredictable shifts and slidings in person and mergings of voice.

Nongena embarks on an increasingly desperate and futile attempt to shield her scattered family from the conflagration about to overwhelm the country. Finally, during the countrywide turmoil of the Soweto rebellion, the "year of fire, year of ash," she discovers that her plight is also a national plight. For the first time, her sense of community extends beyond her own embattled family: "Let the roof of the goal cover the whole location, let the whole of the location become a goal" (353). Finally, she admits that "the revolt of the children" is inevitable and unavoidable: "And if my children had to be drawn into this thing, then that is what they were born to. And who can take from their path that to which they were born?" (355).

The stubborn presence of women outside the Bantustans represents a flagrant and sustained political challenge to the foundations of apartheid. For this reason, women's struggles over housing, rents, passes and families cannot be cordoned off, as they so frequently are, as apolitical "women's issues" or "family issues." The women's creation of the forbidden squatter communities, their refusal to leave their children, men and families, signals a profound refusal to bend to the power of the state, a massive act of political resistance, written untidily but indelibly across the face of white South Africa.

MEMORY IS THE WEAPON

Poppie Nongena's narrative can perhaps be seen as most closely akin to the Latin American *testimonios*. In an important article, Doris Sommer argues that the "testimonial," a life told to a journalist or anthropologist for political reasons, cannot simply be subsumed under the category of autobiography and she has identified a number of distinctive features that closely resemble *Poppie Nongena*.[63] The testimonial's most salient feature, she notes, is "an implied and often explicit 'plural subject,' rather than the singular subject we associate with traditional autobiography." As is the case with *Poppie Nongena* the narrator's "singularity achieves its identity as an extension of the collective." Yet the plural voice is plural not in the sense of speaking for, or being representative of the whole but in the sense that it cannot be heard outside its relation to communities (in Nongena's case, the family, church and finally the national revolution). The reader is thus invited to participate in a branching network of relationships that spreads away from all centers and across many dimensions of time.

The testimonial is always dialogic and public, with a collective rather than an individual self. As in Nongena's narrative, testimonials visibly present a staging of social difference in which a privileged scribe records

the unprivileged oral testament. Testimonials thus have an oral and performative quality that other autobiographies do not, bearing the imprint of both speakers' voices, the doubled nature of the writing and the dispersed authority of voice. "For unlike the private and even lonely moment of autobiographical writing, testimonials are public events." By the same token, "testimonials are related to the general text of struggle . . . [and] are written from interpersonal class and ethnic positions."

Because of the collective and public nature of the testimonial narrative, the reader's identification with the narrative persona is always deferred. In *Poppie Nongena* the rapid vacillation of person and voice prevents any easy identification with any single perspective. Nongena's relation to her probable readers is inevitably problematic, involving as it does transgressions of class, racial and gender affinities, not to mention language and country. No simple unanimity of readership is remotely imaginable, and the narrative acknowledges this historical imbalance with its refusal to yield a single consoling point of identity. In effect, this technique calls on the reader to enter into collaboration with the collective history. The reader is invited to extend the historical community, and that extension is not simply the embrace of a given community but involves active participation, the labor of identification and, above all, hard choices about the politics of social transformation.

Had Joubert dispensed with the intermediary narrator and rendered the narrative entirely in the first person, she would effectively have erased a crucial dimension of the narrative's condition of production, concealing her own interventions and selections and masquerading as a far more innocent and passive amanuensis than she really is—although she does attempt this in the self-contradictory prefatory note. As it is, the narrative reveals itself to be profoundly paradoxical in its beginnings, production and reception. It preserves its doubled production and heteroglossic nature far more visibly than many other oral histories that seek to diminish or entirely erase the interventions and selections of the oral historian. The relation between the two women is undeniably one of racial and imperial power, cross-hatched and contradicted by empathy and identification based on gender, shared language and motherhood. To will away Joubert's voice and yearn for Nongena's unmediated voice is to hanker after an anachronistic Western notion of individual purity and creative singularity. We may balk at being refused identification with a single self, but through this refusal we are invited into an altogether different notion of identity, community, narrative power and political change.

While it seems that Nongena does most of the talking, in fact only 30 percent of the book is her own voice; the rest comprises Nongena's ventriloquizing of her family's voices and Joubert's record of her oral

interviews with these family members, all orchestrated by Joubert's narration. To some extent, the inequity inherent in Joubert's virtuoso orchestration of Nongena's story is offset by the textual record of Joubert's own questions that reveal her ignorance. There are moments inscribed in the narrative when Nongena corrects Joubert's assumptions or questions: these moments are not elided as they so often are in oral history. The constant shifting of voices in the narrative, refuses us identification with one voice. At no point can empowered readers assume an easy identification with Nongena and thus forget their own privilege in a cathartic identification with the voice of the disempowered. The imbalance in power between the two women scores the narrative and the reader is obliged as a result to experience the discomfort of these imbalances as a central experience of the reading itself and to be conscious at every moment of the contradictions underlying the process of narrative collaboration. No one, not even Joubert, is allowed a finally privileged perspective. The reader is thus denied a consoling organizing perspective and is forced to yield to a sense that all narrative and all history arise from a community of effort and of social construction, which is shaped by uneven relations of power.

Most oral histories do not record these contradictions; they erase the historian's editorial interventions and preserve the "voice" of the narrator in artificial purity, while the invisible historian is given executive authority. In contrast, the imbalances between Nongena and Joubert are inscribed in the narrative itself, becoming an integral part of the reading experience and hence avoiding the politics of concealment that generally operates in empirical oral histories. The imbalances are flagrantly there, unavoidable and vexing, contradictory and irresoluble, insisting on interpretive contest and political analysis. Moreover, the narrative resists any effort to imagine that the imbalances between the two women could be resolved by a more equitable redistribution of purely narrative identity. Rather, the uncertainty of its ending acknowledges finally that narrative transformation has to be attended by full social transformation.

Narrative itself cannot be the only tool for transforming the master's house. Rather the social and political context of the engendering of narrative has to be massively transformed: a radical, active, political transformation. The politics of memory and authorship are inextricably entangled with the politics of institutional power in all its forms: family households, domestic labor, education, publishing and reception. History is a series of social fabulations that we cannot do without. It is an inventive practice, but not just any invention will do. For it is the future, not the past, that is at stake in the contest over which memories survive.

"AZIKWELWA" (WE WILL NOT RIDE)

CULTURAL RESISTANCE
IN THE DESPERATE DECADES

9

In the colonial context the settler only ends his work of breaking in the native when the latter admits loudly and intelligibly the supremacy of the white man's values. In the period of decolonization, the colonized masses mock at these very values, insult them and vomit them up.

—*Frantz Fanon*

On the winter morning of June 16, 1976, fifteen thousand black children marched on Orlando Stadium in Soweto, carrying slogans dashed on the backs of exercise books. The children were stopped by armed police who opened fire and thirteen-year-old Hector Peterson became the first of hundreds of schoolchildren to be shot down by police in the months that followed. If, nearly two decades later, the meaning of Soweto's "year of

fire" is still contested,[1] it began in this way with a symbolic display of contempt for the unpalatable values of Bantu education, a public rejection of the "culture of malnutrition" with which blacks had been fed.[2] The local provocation for the Orlando march was a ruling that black children be taught arithmetic and social studies in Afrikaans—the language of the white cabinet minister, soldier, pass official, prison guard and policeman. But the Soweto march sprang from deeper grievances than instruction in Afrikaans, and the calamitous year that passed not only gave rise to a rekindling of black political resistance but visibly illuminated the cultural aspects of coercion and revolt.

The children's defacement of exercise books and the breaking of school ranks presaged a nationwide rebellion of uncommon proportion. The revolt spread across the country from community to community, in strikes, boycotts and street barricades. It represented in part the climax of a long struggle between the British and Afrikaner interlopers for control over an unwilling black populace. At the same time, it was a flagrant sign of the contestation of culture, an open declaration by blacks that cultural value, far from shimmering out of reach in the transcendent beyond, would now be fought for with barricades of tires, empty classrooms and precocious organization.

After Soweto, new forms of artistic creation appeared across the country. Poetry groups burgeoned in the black townships, creating poetic forms that were by received standards "unliterary" and incendiary, written in "murdered" English, formally inelegant and politically indiscreet. Yet, as it turned out, the new poetry reached a far wider audience in South Africa than poetry ever had before, posing an unsettling threat to the legitimacy of white settler aesthetics on South African soil and giving rise to an unusually intense debate on the nature of aesthetic value and its relation to what might broadly be termed politics.

The most visible sign of the new Soweto poetry was the launching of *Staffrider* magazine in 1978 by Ravan Press. A "staffrider" is the township name for one who—in mimicry of railway staff—boards at the last minute the dangerous trains hurtling workers to the white city, snatching free rides by clambering onto the roofs or by hanging from the sides of the overcrowded coaches. A staffrider poet, as the editorial of the first issue explained, is thus a "skelm of sorts," a miscreant hanging at an acute angle to official law and convention.[3] Tenacious and precarious, at odds with state decree, a black poet becomes a "mobile, disreputable bearer of tidings."[4] More than anything else, the staffrider poet is figured as part of a group in motion, destined to arrive suddenly in the midst of white urban centers.

From the outset, *Staffrider* flouted almost every decorum of sacerdotal authority. A fierce rebuttal of white poetic standards, the magazine paraded an aesthetics of calculated defiance and collectivity. Not only did its literary contents and format—a mosaic of poems, photography, articles, graphics,

oral history and short stories—effectively challenge the prestige of the "literary," but its methods of creation and distribution revolutionized periodical publishing in South Africa.

Staffrider was literature in a hurry. Partly because of the nervous post-Soweto climate of surveillance and bannings, it named no editors and placed responsibility for speedy distribution in the hands of township groups and small shops. *Staffrider* had to be a magazine "that would move very quickly without drawing too much attention to itself . . . a contradiction in normal publishing terms."[5] Carefully egalitarian from the outset, the magazine was intended to air the work of the growing number of poets around the country who were writing collectively and to do so in a way that allowed the art groups themselves to choose the poems to be published. In other words, editorial policy and content lay very much in the hands of readers and writers beyond the publishing house. As Mike Kirkwood, director of Ravan Press, explained, "Nobody wanted the kind of editorial policy that comes from the top: 'We've got a policy. We've got standards. If you fit in with this policy, come up to these standards, we'll publish you.'"[6]

Not surprisingly, the state took immediate umbrage and the first issue was banned—the Publications Directorate justifying its actions on the grounds that some of the poems undermined "the authority and image of the police."[7] Nor was the state alone in its displeasure. Members of the white literary establishment were piqued by the appearance of a magazine that could brazenly announce: "Standards are not golden or quintessential: they are made according to the demands different societies make on writers and according to the responses writers make to those demands."[8] Soweto poetry became, as a result, the locus of a fierce debate over the value of black culture and the politics of black aesthetics, not only in the white academy and white publishing houses but also in black classrooms and universities, community halls, poetry groups and private homes. At stake was whether aesthetic value could any longer be seen to emanate from the text itself, a transcendental immanence somehow detached from the squalor of politics and "the shame of the ideological." In South Africa, as elsewhere, though perhaps more flagrantly, the question of value became entangled with the history of state and institutional power; the history of publishing houses and journals; the private and public histories of black and white intellectuals, teachers, writers and evangelists; and the changing relation between the black intermediate class and the worker and oral poets—the Xhosa *iimbongi*, or the migrant Sotho *likheleke*, "the people of eloquence."[9] Questions of education, constituency and audience were evoked and therewith the possibility that value is not an essential property of a text but a social relation between a work and its audience, constituted rather than revealed and endorsed or outstripped by successive orders of power.

It was a joy to recite and listen
to the grandeur of Shakespeare . . .
The spoken word or phrase or line
was the thing, damn the dialectic.

—*Es'kia Mphahlele*

The first full generation of black writers in English were the Sophiatown writers of the 1950s, years Lewis Nkosi dubbed the "fabulous decade."[10] Sophiatown was a freehold suburb close to the heartland of white Johannesburg, where blacks could still own land. Poor and very violent, a jumble of pot-holed streets and shacks, Sophiatown was at the same time a genuine community where the loyal neighborliness of social life and the huge street armies allowed the police only a precarious foothold. Crowded with varied social groupings, it was hospitable both to militant defiance and middle-class dreams, attracting the elite of the black entertainment and political underworld to its shebeens and jazz clubs, and becoming, as the writer Nat Nakasa put it, "the only place where African writers and aspirant writers ever lived in close proximity, almost as a community."[11] From exile Miriam Tlali would voice a common nostalgia for the lost Sophiatown that would survive only a few more years before the Nationalists moved in to destroy it: "Sophiatown. That beloved Sophiatown. As students we used to refer to it proudly as 'the center of the metropolis' . . . The best musicians, scholars, educationists, singers, artists, doctors, lawyers, clergymen" came from there.[12]

In the 1950s Sophiatown became the center for a vital and jazzy generation of black writers. In 1951, a few years after the Nationalists rose to power, *Drum*, the first magazine for black writing in English, was launched with funds from Jim Bailey, son of Sir Abe Bailey, the Rand gold and racehorse millionaire. Alongside the mimeographed broadsheet, the *Orlando Voice*, *Drum* became the mouthpiece of writers such as Nkosi, Nakasa, Can Themba, Todd Matshikiza, Es'kia Mphahlele, Casey Motsisi, Henry Nxumalo and Bloke Modisane, who produced a spate of fiction, autobiography, poetry and journalism. With this outpouring came a new aesthetic and a new politics of value. *Drum* "was coming into a real literary renaissance. . . . People were really writing furiously. . . . There was . . . a new kind of English being written. Significantly, it was the black man writing for the black man. Not addressing himself to the whites. Talking a language that would be understood by his own people."[13]

Nonetheless, if the Sophiatown writing paraded a "new kind of English," it was one riven with ambivalence toward the august relics of a white European tradition still lingering in the schools. Educated for the

most part in the English-run church schools and uneasily straddling the worlds of black and white culture, the black writer and intellectual at this time could still rub shoulders, despite official opprobrium, with some mostly liberal and mostly English whites. This ambiguous situation, which set these writers entirely apart from the later Soweto generation, left a mark on their writing and on their notions of aesthetic value. The governing paradox of their situation was that the aesthetic that they fashioned with passion and difficulty was shaped not only by their own desires but also by the fact that the Sophiatown intelligentsia became at that time the last real battlefield on which the English and the Afrikaners fought for sway over the cultural values of the black intermediate class.

Violence in colonized cultures is not always unlettered. In the colonies, as Frantz Fanon knew, the policeman and soldier by their immediate presence "maintain contact with the native and advise him by means of rifle butts and napalm not to budge." These same colonies also need the tactful squadrons of moral teachers, advisers and bewilderers to coax the colonized into admitting the legitimacy and "universality" of the rulers' values.[14] Rule by gunpowder and whip is blended with forms of cultural cajolement that create an atmosphere of deference and complicity, immeasurably easing the burden of policing. As a result a divided complicity springs up between the lords of humankind and the colonized elite. The colonized intellectual, "dusted over by colonial culture," comes to play a checkered role in the life of the people.[15]

In South Africa the persuasive culture during the colonial period was that of the British settlers, who, after the freeing of the slaves in 1834, began in the new mission schools and churches to groom a tiny black elite to walk abroad as evangelists, catechists and peddlers of European ways of life.[16] The Afrikaners were forced by their rout during the Anglo-Boer War to genuflect to the same British culture, but they soon began their long refusal in a nationalist crusade that they won politically in 1948 and continued to wrestle for culturally throughout the 1950s. As a result, the situation of the black intellectual and artist became unusually pinched as the British and Afrikaners, in their long slow tussle over land and labor, also vied jealously for control over black culture.

Over the years the British and Afrikaner struggle for sway over black lives and values would take different but related shapes, in a tango of mutual embrace and recoil. This ongoing conflict made the situation of the black intellectual an anomalous one. Born of black parents but schooled and salaried by the English, steeped in white culture but barred at the door, contemptuous of Afrikaners, respectful of white English capital, often knowing Shakespeare but not the language of the people, in love with the township but identifying with the world of the mind, the

Western-educated black writer learned to live at more than one social level at a time and, standing in perpetual imbalance, created a form of writing that was divided against itself.

The politics of value that emerged was torn and contradictory. Nakasa, a journalist for *Drum* and *Golden City Post*, the first black journalist on the *Rand Daily Mail* and one of the first of the "wasted people" to leave the country into exile, called himself ironically "a native from nowhere" and asked "Who am I? Where do I belong in the South African scheme of things? Who are my people?"[17] Son of a Pondo, he did not know his father's people. Brought up speaking Zulu, he cast off his mother's language as unfit for the times. Mphahlele, educated before the Bantu Education Act of 1953 depredated an already ravaged black schooling system, bears similar witness to the paradox of his generation's position. The library of the Johannesburg boarding school he attended in 1935 offered him the shimmering promise of a world of white culture magically protected from "the vulgarity, the squalor, the muck and smell of slum life" of Marabastad, his black Pretoria location.[18] Poetry, which his English teachers had taught him "must be about trees, birds, the elements," offered him a "refuge in the workshop of mind" from the rusted tin shacks and streets filthy with children's stools and, since there was no one a fledgling black writer could go to for advice, he learned to "[write] verse out of a book as it were," a white book.[19]

Writing in the heady atmosphere of postwar liberal humanism, before Sharpeville made such values untenable, the Sophiatown writers attempted to wed the aesthetic values of these two incongruent worlds: the vitality of township life and the glamorous, if niggardly, allure of a white culture they could glimpse but not grasp: "the location shebeen and the Houghton soiree."[20] For Nakasa, the cult of the illegal black shebeen gave writing its dash and substance, but he longed for the "techniques of Houghton" to grace black writing with the formal "discipline" it lacked.[21] Yet this distinction between the Dionysian pulse of black life and the Apollonian discipline of white form was a familiar one, imbibed from a ready European tradition. Probably more than any other black writer of that time, Nkosi's taste for black writing was soured by his fidelity to European literary standards; measured by these, the black scene, as he saw it, quite desperately lacked "any significant and complex talent."[22] He scoffed at the "bottomless confusion" of attempts by African intellectuals to refashion an image of themselves from their ravaged cultures.[23] Most lamentable, as far as he was concerned, was the unnatural African proclivity for breeding art with politics, which produced sorry generic hybrids: "the journalistic fact parading outrageously as imaginative literature."[24]

Plagued in these ways by conflicts of allegiance and aesthetic value; theoretically obedient to the cleavage of art and politics, yet hopeful that the

multiracial courtship of white and black liberal artists "might yet crack the wall of apartheid;"[25] disparaging traditional culture, yet equivocally fascinated by township life, the early *Drum* writers couched their exposures of farm atrocities, township dissent and prison life in a style that was often flamboyant with "the grand Shakespearean image."[26] Sporting a studied sardonic detachment, these writers for the most part regarded the African nationalist movements with a certain amusement and were regarded in turn with misgiving. Intimate with English mining capital and courted by English liberals, lacing their politics with "cheese-cake, crime, animals, babies,"[27] at no time, as David Rabkin points out, did the *Drum* writers bring their scrutiny to bear on the migrant labor system or the conditions of the African mine workers.[28]

If Mphahlele could call *Drum* "a real proletarian paper," this was only in part true, for the aesthetic of the Sophiatown writers was by all appearances the style of individual heroics.[29] In *Home and Exile*, Nkosi recalls with nostalgia that in both one's personal and aesthetic life "one was supposed to exhibit a unique intellectual style."[30] For Nkosi, as for Nakasa, it was the liberal promise of gradual admission into the "new and exciting Bohemia" of the multiracial suburban parties of Johannesburg that gave life and writing much of their savor.[31] Nakasa hankered for a "common" or universal rather than a black experience, for an uncolored aesthetic unity of vision and for a culture that emanated "from a central point in the social structure."[32] But the alluring Bohemia of Houghton as the radiating point of a central and universal artistic vision was a dream of cultural glamour that the state began to legislate further and further out of reach.

At about this time the Nationalists began to prise open the handclasp of the black and white liberals, wagging "a finger of cold war at white patrons"[33] of multiracial poetry readings, music and theater and barring writers such as Nkosi, Nakasa and Modisane from the palaces of white entertainment. In *Blame Me on History*, Modisane voiced his despair that as his white friends gradually stopped inviting him to their homes or visiting him in Sophiatown, South Africa "began to die" for him.[34] The state increasingly made the fata morgana of a universal artistic vision a mockery, but Nakasa, for one, could not throw off the inherited cultural cringe that "virtually everything South African was always synonymous with mediocrity."[35] In 1964 he joined a steady trickle of writers into exile, where he later surrendered to the unlivable contradictions of his position and threw himself from a skyscraper window in New York.

Beyond the reach of the mission schools and the English-owned newspapers and journals, however, a rich and polyphonic black culture — oral art, township musicals and theater, South African jazz and jive, *marabi*, *kwela* and *mbaqanga* — was sustaining and renewing itself under conditions of considerable difficulty. David Coplan's pathbreaking *In Township Tonight*

pays tribute to the musicians, poets, dancers, actors and comedians who, in the churches, shebeens, dance halls and mine compounds of urban South Africa, fashioned the nascent shape of a national culture. Drawing on performance traditions from all over the subcontinent Africans had carried with them to the cities of diamonds and gold —*eDiamini*, Kimberley and *eGoli*, Johannesburg— a heritage of intricate rural cultures from which a proletarian populace living "by their wits in the shadows and shanties of the mushrooming locations," created as time passed "hybrid styles of cultural survival."[56]

Sotho migrant workers, for example, walking or riding in buses hundreds of miles to the cities and mines, drew on traditional forms of Sotho praise poetry (*lithoko*) to fashion a modern genre of oral performance, *sefela* (plural form *lifela*), which could somehow negotiate the intractable contradictions between home and mine.[37] An anomalous, threshold oral poetry, on foot in the shebeens of the city and in the villages, *sefela* gives rise, perhaps unavoidably, to the governing narrative theme of travel and to such elaborate liminal images as the train:

> Hlanya le mabant a litsepe,
> Hanong ho eona ho le ho fubelu,
> Ihloana la tollo ha le bonoe
> Liporor li otla maloanloahla
> Mahlephisi a lla likoto-koto
> Poncho tsa bina,
> "Ielele-ielele!"
> Ea phulesa eaka e ea re lahla
> Terence ea chesetsa maqaqa naha,
> Ha 'metlenyana ha chela lilaong.

> Madman with iron belts,
> Inside its mouth [furnace], such fiery redness,
> Its eye [lamp] is blinding,
> Trainrails beat rattling, [cars] coupled together,
> The rattling railjoints sang,
> "Ielelel-ielele!"
> It pulled out as if it would throw us off-board
> The train set aflame the humble country Boers' fields,
> Rabbits roasted alive in their holes.[38]

The exclusion and denigration of these forms of emergent urban culture within both black and white communities are themselves acts of political exclusion and a crucial part of the politics of evaluation. Such exclusion fosters a misleading sense of the representativeness of the Sophiatown

writing in its most self-consciously "literary" manifestations as well as critical indifference to the scantily understood traffic of influence not only between traditional and contemporary oral poetry but also between these forms and poems composed for print. One might usefully compare, for example, two poems published by Sol Plaatje in 1920 that indicate the tugging of two incommensurate traditions that would gradually infuse and influence each other over the years.

> Speak not to me of the comforts of home,
> Tell me of the Valleys where the antelopes roam;
> Give me my hunting sticks and snares
> In the gloaming of the wilderness;
> Give back the palmy days of our early felicity
> Away from the hurly-burly of your city,
> And we'll be young again—aye:
> Sweet Mhudi and I.[39]

The poem's self-consciously literary eloquence, uneasy submission to imported metrical and rhyming patterns and implausible literary cliche offer a curious contrast with the following invocation to an alternative oral lyric source, which draws, if incompletely, on oral patterns of repetition and parallelism, incantation and interjection:

> Yet, keep and feed the sprite,
> Especially the hairy sprite;
> Yebo! yebo!
> He'll show us how to crack magic out of poles
> So that we'll scatter and slay our enemies,
> Then nobody will do us harm
> While we use this wonderful charm;
> Yebo! yebo!
> Let the hairy spirit live
> Let him live, let him live.
> Yebo! yebo!
> Yebo! yebo![40]

Nevertheless, if the glamour of Sophiatown as "the place of sophisticated gangsters, politicians and intellectuals" chiefly satisfied a small and relatively privileged coterie of intellectuals and writers,[41] this glamour cast its radiance and influence over an entire generation, and it was this group of writers that the state would soon turn to destroy.[42]

The political climate of the 1950s was unruly. The National party had triumphed in 1948 and now set about the dogged implementation of

modern apartheid. Black resistance to the Suppression of Communism Act of 1950, to racial classification under the Population Registration Act, to petty apartheid on trains, to the passes and to the manifold indignities and scourges flared in the Defiance Campaign in 1952, the most successful organized resistance the ANC was ever to stage and this resistance met with the unswerving brunt of Nationalist wrath.

The Nationalist policy of "tribal" segregation in the Bantustans was by now under way and, partly to prevent urban blacks from identifying too intimately with the urban environment and its values, partly to uproot what they not inaccurately felt were the seedbeds of resistance in the freehold suburbs and partly to place the heel of state control more firmly on migrant labor, the Nationalists began the razing of the black freehold townships. The first and most famous to be destroyed was Sophiatown.

THE DESTRUCTION OF SOPHIATOWN AND THE DESPERATE DECADE

> At night you see another dream
> White and monstrous;
> Dropping from earth's heaven,
> Whitewashing your own black dream
>
> —*Mafika Gwala*

On February 9, 1955, eight trucks and two thousand armed police rolled into Sophiatown to begin the forced evictions to Soweto that would, despite fragile and futile resistance, last six years.[43] Over the next decade the demolition across the country of "black spots" and the removal of the people to dreary, gridded townships would satisfy the state's cold dream of utterly rational control. White architects were notified that the layout of black townships should obey principles ensuring the utmost surveillance and control: roads had to be wide enough to allow a Saracen tank to turn; houses had to be lined up so that firing between them would not be impeded.[44] At the same time, the houses and highways of black art began to be policed just as vigilantly, and the situation of the black artist began subtly to change.

In 1953 black education was taken from provincial and largely English control and placed in the hands of the national Department of Native Affairs. In a speech before the senate in June 1954, H. F. Verwoerd, architect of these cultural removals and graphic designer of the new layout of the artistic life of black South Africa, was quite frank about the aims of the Bantu Education Act: "The Natives will be taught from childhood to realize that equality with Europeans is not for them. . . . There is no place

for him [the Bantu] above the level of certain forms of labour."[45] Henceforth blacks would have "ethnically" separate schools, syllabi, teachers, languages and values. In 1959 the Extension of University Education Act parceled out the different ethnic groups to different universities. The Bantu Education Act, like the destruction of Sophiatown, was a crucial event in the history of black culture not simply because it began the transfer of black education from hegemonic English control to more flagrantly coercive Afrikaner Nationalist hands but also because it threatened the alliance between the black and white liberals and drove the white-educated black artists back into their communities. More blacks would now receive a deliberately impoverished schooling, with the effect of leveling out some of the differences between the tiny educated elite and the vast illiterate populace that had existed before. From then on, blacks would be subjected more efficiently than ever to what Malefane calls a calculated policy of "cultural malnutrition." This policy would have a marked effect on black literature and would bring about significant changes in notions of aesthetic value.

In 1960 the Pan-Africanist Congress (PAC) anti-passlaw campaign ended calamitously at Sharpeville. The ANC and PAC were banned and both resistance movements went underground and into exile. The destruction of Sophiatown foretold the almost total erasure of public black writing in the sixties as the state flexed the full measure of its muscle in a decade of bannings, detentions and torture, crushing the last illusions of liberal reform. Bannings, exile and death throttled an entire generation of writers and the "long silence" of the 1960s began. This silence was in some ways more apparent than real, for it has been pointed out that in terms of sheer volume more poetry was written during the 1960s than the 1950s, though this poetry was not published until later.[46] The Publications and Entertainment Act (1963) extended legal state censorship to cultural affairs within the country and in 1966 most of the black writers who had already gone into exile were listed under the Suppression of Communism Act, even though most of them were liberals of one cast or another: Matshikiza, Themba, Modisane, Mphahlele, Nkosi, Cosmo Pieterse and Mazisi Kunene. Forty-six authors were gagged by the Government Gazette Extraordinary of April 1, 1966, which forbade the reading, reproduction, printing, publication, or dissemination of any speech, utterance, writing or statement of the banned. In exile both Themba and Arthur Nortje followed Nakasa in suicide.

Nevertheless, the effect on black writing was not solely deleterious. In 1963, the same year that Nelson Mandela was banished to Robben Island, a black literary journal called *The Classic* opened in Johannesburg. It was named not in honor of a patrimony of excellence enshrined in the white canonical classic but, ironically and anticanonically, after *The Classic* laundromat behind which the journal began in an illegal shebeen.

The Classic, edited by Nakasa before he went into voluntary exile, began to publish the first of the Soweto poets.

Sharpeville and its aftermath ushered in a period of calculated refusal of canonized white norms and standards. The South African liberal aesthetic, itself never whole or complete and already strained by its distance from European traditions, began to fray and unravel. Most white English poets, increasingly edged from cultural power, comforted themselves in their isolation with the contradictory faith that the lonely poetic voice was also the eloquent mouthpiece of universal truth—a faith that became increasingly untenable for educated black writers not only barred from the white definition of the universal but also standing, at this point, somewhat uneasily within their own communities. During this period a marked change in aesthetic values took place as black literature became steadily more radical and polarized.

The poets of the generation after the Bantu Education Act had to begin from scratch. Their predecessors were in exile and their work silenced. As Tlali wrote in "In Search of Books," "They say writers learn from their predecessors. When I searched frantically for mine there was nothing but a void. What had happened to all the writings my mother had talked about?"[47] Nevertheless, the Bantu Education Act, zealously shielding blacks from the blandishments of European culture, had done black writing an unwitting service, for the Soweto writers of the 1970s sidestepped many of the conflicts of cultural fealty that had plagued the Sophiatown generation. Carlos Fuentes has spoken of the problem for the North American writer of warding off the ghosts of the European tradition, "hanging from the chandeliers and rattling the dishes."[48] Similarly, white South African poets, unhoused by history, spent decades knitting their brows over their vexed relation to a European tradition that both was and was not theirs. The Soweto poets, bereft of Donne, Milton, Wordsworth, Eliot, had no such ghosts to lay to rest.

The pre-Soweto generation, nurtured on what now seemed an artificially literary eloquence, had suffered a different form of cultural malnutrition. Sipho Sepamla, for one, "brought up on Shakespeare, Dickens, Lawrence, Keats and other English greats," envies the Soweto poets' ignorance of Western tradition: "I would have liked to have been fed on Mphahlele, La Guma, Themba, Nkosi. I would have liked to have laid my hands on the 'unrewarding rage' of Richard Wright, James Baldwin, LeRoi Jones. . . . It would seem my emptiness, my rootlessness, my blindness is all that is supposed to keep me in my place."[49] At the same time, within the country the Black Consciousness movement had begun to shatter the long quiescence of the 1960s.

Soweto poetry was born in the cradle of Black Consciousness and has to be seen within this milieu. Black Consciousness began largely as a

campus movement in 1968 and spanned almost a decade until the banning, after Soweto, of all Black Consciousness organizations in October 1977. Mobilizing black students around the rallying cry of color and the slogan, "Blackman, you are on your own," Black Consciousness was at this stage the dream of the elite black urban petit bourgeoisie, a movement of students, professionals, intellectuals, artists and a few members of the clergy.[50] In 1972 the South African Student Organization (SASO) tried to breach the gulf between the intellectual elite and the people of the ordinary black community and in 1972 formed the Black People's Convention in an effort to give Black Consciousness nationwide clout. But the appeal to the community was uncertain and contradictory and, partly because the tendrils it extended to organized workers were always slender, it never grew into a mass organization.

The question of cultural values took center stage as literacy campaigns, black theater and poetry readings were fostered in the belief that cultural nationalism was the road to political nationalism. Because shedding canonized white norms and values was imperative, whites had to be barred and all white values challenged and replaced. As Steve Biko put it, "Black culture . . . implies freedom on our part to innovate without recourse to white values."[51] Politically, early Black Consciousness was reformist rather than radical, a blend of moderates, Christian anticommunists, liberals and black entrepreneurs. It was chronically masculine in orientation (calling for "the restoration of black manhood"), without an analysis of class or gender and strongly anti-Marxist: "We are not a movement of confrontation but a movement of introspection."[52]

The Black Consciousness movement has as a result been rebuked for being politically naive and theoretically inconsistent, for placing its faith in a timeless black soul and the personal growth of the individual. But at the same time, as the poet Mafika Gwala put it: "Everywhere it was surveillance. It seemed that reading and cultural topics were the only things to sustain one."[53] At a time when many political organizations and people were being scotched, black poetry helped revive and sustain resistance to white culture. "The brooding was replaced by an understanding of hope."[54] Moreover, as the Nationalists drove wedge after wedge between the so-called different ethnic groups, Black Consciousness and the resurgence of black cultural values embraced all embattled groups including so-called coloreds, Indians and Asians, within the term black. For all its undoubted political shortcomings, which became most telling and costly during the Soweto revolt, Black Consciousness provided a rallying cry, a powerful and necessary incitement. As the writer Essop Patel put it, "Black Consciousness provided the initial impetus in the rejection of art as an aesthetic indulgence. Once the black poet freed himself from Eurocentric literary conventions, then he was free to

create within the context of a national consciousness. The black poet's starting point was the articulation of the black experience."[55]

CROAKING CURSES
THE NEW SOWETO POETRY

> and when I'm supposed to sing
> I croak curses.
>
> —*Zinjiva Winston Nkondo*

Black poetry flourished at this time, becoming what Gwala called a "jaunt in search of identity."[56] Not surprisingly, the first Soweto poetry shared many of the dilemmas of the Black Consciousness movement. Not the least of its problems was that it was written, though in protest, in English, with a privileged white audience in mind and thus bore the subtle onus of having to curtail itself for the liberal press.

The English literary establishment was beginning to listen to black poets with half an ear. White poets had trickled back from their lonely jaunts into the veld looking for roots and were now writing a little uneasily about black men honing their *pangas* in the woodshed. In 1971 Lionel Abrahams took a publishing gamble and printed Oswald Mtshali's phenomenally successful *Sounds of a Cowhide Drum*, sparking at the same time an agitated debate on the value of black poetry and provoking a number of white critics to fits of discriminating judgment bordering on incivility.[57]

Until the 1970s, the white and almost exclusively male British canon was troubled only by mild internal differences over value in the English-speaking universities, remaining squarely within an imported Leavisite tradition. In 1959 Oxford University Press could publish *A Book of South African Verse* that featured thirty-two white male and four white female poets, yet not one black writer of either sex. Until the 1970s, the presiding liberal aesthetic faith—in individual creativity, immanent and universal literary values, unity of vision, wholeness of experience, complexity of form, refined moral discrimination untainted by political platitude, irony, taste, cultivated sensibility and the formal completion of the work of art—had for the most part been artificially cordoned off from black experience by segregated education, severe censorship of texts, bannings of writers and blocking of distribution.

From the 1970s onward, however, white liberals began to court black poets while simultaneously having for the first time to defend the presiding liberal tenets within the English-speaking universities at the level of ideology, in an unprecedented flurry of reviews, debates, articles, conferences and so on. In other words, if some black poetry was to be selectively ushered into the canon, it was only if it could be shown at the

door to exhibit certain requisite values which, in turn, had to be vociferously announced without betraying the selective and interested nature of these values. The first phase of reforming the canon thus began with its circumspect expansion to include some black texts previously ignored but now revealed to exhibit certain features shared with the already existing white tradition.

Mtshali's seminal *Sounds of a Cowhide Drum*, for example, was met with a hearty round of applause for his deployment of some of the familiar favorites of the Leavisite tradition. Mtshali was commended for his ironic and individual voice in lines such as:

> Glorious is this world,
> the world that sustains man
> like a maggot in a carcass.

He was praised for his strength of feeling, moral energy, liberation of imagination and the originality of his concrete images in a poem such as "Sunset":

> The sun spun like
> a tossed coin.
> It whirled on the azure sky,
> it clattered into the horizon,
> it clicked in the slot,
> and neon-lights popped
> and blinked "Time expired",
> as on a parking meter

or in:

> a newly-born calf
> is like oven-baked bread
> steaming under a cellophane cover.[58]

Nadine Gordimer's rapturous preface to the first edition invoked Blake and Auden. When Mtshali was reproved for falling short, however, it was for his lack of formal and intellectual complexity, his failure to meld form and content and his paeans to the African past, which cost him "universality."

Mtshali stood at that contested moment when English hegemony was yielding reluctantly to Nationalist coercion. His parents were teachers at a Catholic mission school, where he had received a thoroughly English schooling. But the Bantu Education Act denied him entry to a white university and, refusing to go to the black one allocated him, he was

working as a scooter-messenger when *Sounds of a Cowhide Drum* was published. Lodged as he is between the intellectual elite, the black intermediate class and the Black Consciousness milieu in general, he has been taken to task by more radical black poets of the later Soweto generation for bathing in romantic reverence for the "timeless relics" of his past, as in the titular poem of his collection:

> I am the drum on your dormant soul,
> cut from the black hide of a sacrificial cow.
> I am the spirit of your ancestors . . . [59]

For Mtshali the task of the poet was to immortalize the "debris of my shattered culture" and to reclaim the "timeless existence and civilization" of precolonial South Africa, a timeless idyll that others have argued never existed.[60] At the same time, his outraged images of the bloodied baby torn by township curs, the calloused washerwoman, the drunk with mouth dripping vomit, were tempered with a rural yearning and—as critics noted with some relief—with a critical but essentially Christian message. Mtshali's liberal audience was well disposed to criticism of the Nationalist state, onto which it displaced its own impotency and doubts, but, firmly situated within the state's institutions and lacking any authentic hope for the future, was not ready to overthrow it.

In a period of record unemployment and a steady barrage of work stoppages, there began a spate of cultural forums and conferences—the Theatre Council of Natal (TECON), the SASO Conference on Creativity and Black Development (1972), the Black Renaissance Convention at Hammanskraal (1974). A flurry of black poetry collections appeared and most were summarily banned: Kunene's *Zulu Poems* (1970), Kereopetse Kgositsile's *My Name Is Afrika* (1971), *Seven South African Poets* (1971), James Matthews and Gladys Thomas' *Cry Rage* (1972), Mongane Serote's *Yakhal'inkomo* (1972) and *To Whom It May Concern: An Anthology of Black South African Poetry* (1973). Hostile, impassioned and well beyond the pale of accepted aesthetic standards, the new Soweto poetry was an intemperate, jangling, often hallucinatory depiction of "the terrible canopy of nightmares" that shadowed ghetto life:

> THEY stole the baritone
> Wifey eats her own head-bone
> She squeezes a stony brow into the spoon
> Children may nibble the pap-like moon.[61]

Most significantly, as the new poetry poached liberally on jazz and jive rhythms, black Americanisms, township vernacular, and the gestural,

musical and performative aspects of oral traditions, notions such as the integrity of the text and the test of time came to be rendered increasingly irrelevant. Much of this transitional poetry was still written for print but was beginning to evince signs of an imminent abandonment and destruction of the text:

> I leave in stealth
> and return in Black anger
> O—-m! Ohhhhmmmm! O-hhhhhhmmmmmmm!!![62]

and:

> You've trapped me whitey! Meem wanna ge aot Fuc
> Pschwee e ep booboodubooboodublllll
> Black books,
> Flesh blood words shitrrr Haai,
> Amen.[63]

The Soweto poets' refusal to see poetry in the Coleridgean sense as that which contains "within itself" the reason why it is so and not otherwise was, moreover, resonant with the powerful, if embattled, traditions of oral poetry within black culture. In African oral poetry the focus is on the performance in its social context, on the function of the performance in society, almost to the exclusion of transmission of the text over time.

> The poet serves as a mediator between the ruler and the ruled, as an inciter, a molder of opinion, a social critic. He is not only concerned to chronicle the deeds and qualities of the ancestors of his contemporaries, he also responds poetically to the social and political circumstances confronting him at the time of his performance.[64]

Not only did the yardsticks of immanent value brandished by white critics bear scant resemblance to the traditions of the Xhosa *izibongo* and *Ntsomi*, the Sotho *lithoko* and *sefela*, but white critics' failure to recognize the presence within contemporary poetry of such oral infusions left them ill equipped to pass judgment either on the poems themselves or on their social roles and contexts.[65] Ignorant of the intricate traditions of repetition and parallelism that hold in oral poetry, white critics disparaged black poetry on more than one occasion for falling into cliche and repetitious image. Moreover, as Ursula Barnett and others have shown, "often we find in the imagery of black poetry a complicated system of symbols which works on several levels and requires a knowledge of history, myth and legend."[66] Drawing on powerful oral traditions of communality of theme

and performance, energetic audience participation and conceptions of the poet as lyric historian and political commentator, black poetry was making the case, as Tony Emmett has put it, for its study "on its own terms and it is in the light of the oral, political and communal facets of black poetry that the most penetrating criticism is likely to be made."[67]

Serote's "Hell, well, Heaven," for example, resembles the pulse of *marabi* music's segmental repetition of basic riffs, sharing its "predisposition for the merciless two or three cord vamp":

> I do not know where I have been,
> But Brother,
> I know I'm coming.
> I do not know where I have been,
> But Brother,
> I know I heard the call.[68]

The lines reveal as well the influence of gospel and *makwaya,* choral music developed by mission-educated Africans from American popular song and European and traditional African elements.[69] The musical influence of township jazz is both thematically and rhythmically fundamental to a great deal of Soweto poetry:

> Mother,
> my listening to jazz isn't leisure
> It's a soul operation[70]

These musical traces evoked the defiant and restorative worlds of the *marabi* dances, jazz clubs, shebeens and music halls and heralded the increasingly performative and communal nature of black poetry:

> Up and up
> on a wild horse of jazz
> we galloped on a network
> of blue notes
> delivering the message:
> Men, Brothers, Giants![71]

A defiant celebration of the bitter bane of color, Soweto poetry awoke in the state an exact revenge. Though the English poet Douglas Livingstone was confident that poetry is "certainly not going to change the world," the state was not about to take chances.[72] The Minister of Justice, Jimmy Kruger, spoke ominously of poems "that kill" and responded in kind.[73] Many of the collections were suppressed and not a few of the poets were detained.

Mthuli Shezi, playwright and vice chairman of the Black People's Convention in 1972, died after being pushed under a train in a trumped-up dispute with a railway official.

In 1974 Portuguese colonial rule in Africa collapsed. In South Africa a rally in support of Mozambique's victorious Frelimo was banned, and nine leaders were given long sentences. Gwala recalls that in the same year the University of Cape Town hosted a conference on the new black poetry, inviting him and some other black poets to take "black poetry to Whitey's territory."[74] Debating on the phone with Onkgopotse Tiro whether to accept the invitation, Gwala had joked that all of southern Africa was now "terry country." That same day Tiro was blown up in Botswana by a parcel bomb sent by the South African state and when Gwala heard the news he decided not to attend. His personal gesture expressed a general change in direction, as Black Consciousness turned a cold shoulder on white liberalism. The frayed threads in South African culture began to give as black poetry and Black Consciousness tugged far more insistently than before. Mtshali voiced this change of heart: "I once thought I could evangelize and convert whites But . . . I have now turned to inspire my fellow blacks . . . to seek their true identity as a single solid group."[75]

The search for identity as a solid group faced black intellectuals with a choice akin to that sketched out by Antonio Gramsci: at critical moments traditional intellectuals, indirectly tied to the establishment yet considering themselves independent, have to choose whether to cast their lot with the ascendant revolutionary class as organic intellectuals. In Gwala's words:

> The purpose here today is to see to it that the intellectual decides whether to uphold superior status or is ready to phase himself out of the role of being carrier of a white official culture. It is here that we have to accept and promote the truth that we cannot talk of Black Solidarity outside of class identity. Because as our black brother has put it, it is only the elite that are plagued by the problem of identity. Not the mass of the black people. The common black people have had no reason to worry about black-ness. They never in the first place found themselves outside or above their context of being black. But the student, the intel-lectual, the theologian, are the ones who have to go through foreign education and assimilate foreign ethical values. later when weighed against the reality of the black situation, this alienates them from their people.[76]

347

At the same time, the question of group identity is bedeviled by more than the problem of class relations between the educated writer and the "mass

of the black people," for it is already apparent that the overwhelming underrepresentation of women (as Gwala's drift of pronoun betrays) in the poetry and debates raises serious questions about education, community attitudes, access to publishing channels, public status and mobility in the communities, gendered conflicts of interests and power and so on, as issues that have as crucial a bearing on the question of value as might any "aesthetic question alone."[77]

PERFORMANCE POETRY AND COMMUNITY RESISTANCE

> Let them cough their dry little academic coughs.
>
> —*Richard Rive*

When James Matthews and Gladys Thomas brought out *Cry Rage*, "critics hyena-howled. It was not poetry, they exclaimed."[78] The profusion of black poetry could not, however, be ignored; neither could it any longer be pinched and squeezed to meet canonical requirements. It began to pose a discomforting threat not only to some of the most cherished values of the established aesthetic but also the very idea of the canon itself. Critics became more vocal in their complaints: black poets were trampling on every propriety of the English language, sacrificing formal decorum for the "red haze of revenge lust"[79] and the "'rat-tat-tat' of machine guns" of pro-test.[80] As Alan Paton would have it, "a writer is, more often than not, a private creature,"[81] whereas black writers, seduced by "the portentously-conceived category 'Black,'" tended chronically to "group-thinking."[82] Livingstone felt that blacks would face considerable difficulty surviving "the harsh glacier of time" and would have trouble qualifying for "the toughest definition of a poet . . . a man who has been dead for 100 years and one of his works is still read"—a tough definition indeed for black female poets.[83] These were the four general charges leveled against black writing in the 1970s: sacrifice of the intrinsic rules of the craft for political ends, formal ineptitude, loss of individual expression and originality and hence sacrifice of longevity.

In return Gwala asked, "Questions crop up. Questions such as: what moral right does the academic have to judge my style of writing? What guidelines outside the culture of domination has he applied?"[84] Unwilling to give ground in the struggle for "command" over the English language, white critics peppered their reviews of black poetry with quibbles over formal lapses, "bad" grammar and the decline of standards. Black poets rejoined that "there has never been such a thing as pure language,"[85] and Sepamla urged, "If the situation requires broken or 'murdered' English, then for God's sake

one must do just that."[86] The critical skirmishes over grammatical niceties concealed the much more serious question of who had the right to police township culture. Black poetry was in fact a very conscious flouting of received notions of formal elegance: poets were forging their own precepts from forms of township speech unfamiliar and therefore unnerving to white critics. Black poetry was often a hybrid medley of English, *tsotsitaal*[87] and black Americanisms, with blends of black South African languages:

> Once upon a bundu-era
> there was mlungu discrimination
> as a result of separate masemba . . . [88]

The language of white officialdom was mocked, insulted and inverted: "Your dompas is dom to pass you/Your X-mas gift: 72 hours."[89]

Black poets were equally suspicious of Paton's claim that politics destroyed the sovereignty of the intrinsic "rules of the craft."[90] Frankie Ntsu kaDitshego/Dube's poem "The Ghettoes" argues figuratively that the apolitical stance is itself a political act:

> Those who claim to be non-smokers are wrong
> The place is polluted with smoke from
> Chimneys
> Trucks
> Hippos
> Gun-excited camouflage
> dagga-smokers
> and burning tyres
> Non-smokers are smokers too![91]

In more ways than one, black poetry posed a serious challenge to notions of the poem as a freestanding creation, judged excellent if obedient to immanent rules radiating from within the craft. For black poets, the notion of the canon as the patrimony of excellence, bequeathed from generation to generation by the finest of minds and borne unscathed through history, was rendered indefensible by the very circumstances in which they were living. In his poem "The Marble Eye" Mtshali parodied the formal completion of the work of art housed in tradition's mausoleum:

> The marble eye
> is an ornament
> coldly carved by a craftsman
> to fill an empty socket
> as a corpse fills a coffin.[92]

Given the conditions of township life, the poem could no longer pretend to mimic the burnished completion of a well-wrought urn or the jeweled finish of an icon. Gwala for one called for "an art of the unattractive,"[93] and N. Chabani Manganyi argued that the "unified image" sanctioned by literary tradition was an unforgivable indulgence.[94] Against Paton's commonplace claim that protest would damage the fine formal filigree of the artwork, these poets charged that the paramount value of their poetry was neither ontological nor formal but strategic. Strategic change rather than the test of time became the reiterated principle. "In our ghetto language there can be no fixity. The words we use belong to certain periods of our history. They come, they assume new meanings, they step aside."[95] Gwala was equally unimpressed by the lure of immortality. Publication was not the sole aim: "What mattered would be the spoken word. Whether it lay hidden under mats or got eaten by the rats would be a different story."[96]

Most significantly, the performative, gestural and dramatic traces in much of the poetry evinced its gradual transformation from a printed "literary" phenomenon to a social performance, from text to event, replete with theatrical, gestural and oral traces:

> Soon they are back again
> Arriving as bigger black battalions
> with brows biceps brains
> trudging the 'white' soil: phara-phara-phara!

And the kwela-kwela cop:

> 'These Bantus are like cheeky flies:
> Youffr-ffr-ffrrr with Doom!'
> And see them again![97]

Much of the new Soweto poetry bore witness to what Raymond Williams described as "the true crisis in cultural theory" in our time, that is, the conflict "between [the] view of the work of art as object and the alternative view of art as a practice."[98] For most black poets, and there are exceptions, aesthetic value is neither immanent nor genetic but rather what Terry Eagleton has called "transitive," that is, "value for somebody in a particular situation. . . . It is always culturally and historically specific."[99] Supporting, albeit independently, many of the theoretical arguments on value in the work of Western critics such as Eagleton, Catherine Belsey, Tony Bennett, Stuart Hall, Paul Lauter, Francis Mulhern, Barbara Herrnstein Smith and Jane Tompkins,[100] the Soweto poets claimed that

the literary canon is less a mausoleum of enduring truths, less a *thing*, than it is an uneven, somersaulting social practice scored by contestation, dissension and the interests of power.

Beset by censorship, by strictly curtailed access to commercial publishing channels, and by the dangers of identification and subsequent harassment, and inheriting to boot powerful traditions of communal performance, black Soweto poetry began to evince the calculated destruction of the text.[101] More and more, black poetry is composed for a black listening audience rather than an overseas readership in ways that create poetic forms less vulnerable to censorship and easier to memorize, the spoken word spreading more quickly, more widely and more elusively than printed texts. Poetry has taken flight from the literary magazines and has been performed increasingly at mass readings, United Democratic Front rallies, funerals, memorial services, garage parties, community meetings and musical concerts, sometimes to the accompaniment of flutes and drums, drawing on oral traditions and miming customs.

Mbulelo Mzamane points out that many black poets, while quite unknown to white South Africans, have vast followings in Soweto, Tembisa, Kwa-Thema.[102] Flouting the prestige of the literary, this "poetry turned theater," transient, immediate, strategic, beloved and popular, overturns the essentialist question of "what constitutes good literature" and insists that it be recast in terms of what is good for whom and when it is good and why. Tenacious in the face of great distress, wary of some of the more moderate demands of early Black Consciousness, politically more radical in its demands yet relentlessly plagued by problems of gender, engaging at every moment the difficulties and bounty of its multiple traditions, the transitional black South African poetry faced considerable formal and social challenges.

After the 1970s, black poets were no longer solely intent on desecrating those Western norms they felt to be invalid, vomiting them up and insulting them; they were also engaged in the necessarily more difficult yet more positive endeavor of fashioning poetic values defensible in terms other than those simply of opposition and resistance to white values. Forcing poetry and criticism to step outside the magic circle of immanent value, into history and politics where criteria of judgment remain perpetually to be resolved, black poets of the 1980s were no longer content to snatch impudent rides on the dangerous trains of white tradition. Instead they increasingly expressed a collective refusal to ride at all until the trains are theirs: "azikwelwa," we will not ride.

NO LONGER IN A FUTURE HEAVEN

NATIONALISM, GENDER AND RACE

10

The tribes of the Blackfoot confederacy, living along what is now known as the United States/Canadian border, fleeing northward after a raiding attack, watched with growing amazement as the soldiers of the United States army came to an sudden, magical stop. Fleeing southwards, they saw the same thing happen, as the Canadian mounties reined to an abrupt halt. They came to call this invisible demarcation the "medicine line."

—Sharon O'Brien

All nationalisms are gendered, all are invented and all are dangerous—dangerous not in Eric Hobsbawm's sense of having to be opposed, but in the sense that they represent relations to political power and to the technologies of violence.[1] Nationalism, as Ernest Gellner notes, invents nations where they do not exist and most modern nations, despite their appeal to an august and immemorial past, are of recent invention.[2]

Benedict Anderson warns, however, that Gellner tends to associate invention with falsity rather than with imagining and creation. Anderson views nations, in his all too famous phrase, as "imagined communities"— in the sense that they are systems of cultural representation whereby people come to imagine a shared experience of identification with an extended community.[3] As such, nations are not simply phantasmagoria of the mind but are historical practices through which social difference is both invented and performed. Nationalism becomes, as a result, radically constitutive of people's identities through social contests that are frequently violent and always gendered. Yet, if the invented nature of nationalism has found wide theoretical currency, explorations of the gendering of the national imaginary have been conspicuously paltry.

All nations depend on powerful constructions of gender. Despite many nationalists' ideological investment in the idea of popular *unity*, nations have historically amounted to the sanctioned institutionalization of gender *difference*. No nation in the world gives women and men the same access to the rights and resources of the nation-state. Rather than expressing the flowering into time of the organic essence of a timeless people, nations are contested systems of cultural representation that limit and legitimize peoples' access to the resources of the nation-state. Yet, with the notable exception of Frantz Fanon, male theorists have seldom felt moved to explore how nationalism is implicated in gender power. As a result, as Cynthia Enloe remarks, nationalisms have "typically sprung from masculinized memory, masculinized humiliation and masculinized hope."[4]

George Santayana, for one, gives voice to a well-established male view: "Our nationalism is like our relationship to women: too implicated in our moral nature to be changed honourably and too accidental to be worth changing." Santayana's sentence could not be said by a woman, for his "our" of national agency is male, and his male citizen stands in the same symbolic relation to the nation as a man stands to a woman. Not only are the needs of the nation here identified with the frustrations and aspirations of men, but the representation of male *national* power depends on the prior construction of *gender* difference.

For Gellner, the very definition of nationhood rests on the *male* recognition of identity: "Men are of the same nation if and only if they recognize each other as being from the same nation."[5] For Etienne Balibar, such recognition aligns itself inevitably with the notion of a "race" structured around the transmission of male power and property: "Ultimately the nation must align itself, spiritually as well as physically or carnally, with the "race," the *"patrimony"* [my emphasis] to be protected from all degradation." Even Fanon, who at other moments knew better, writes: "The look that the native turns on the settler town is a look of

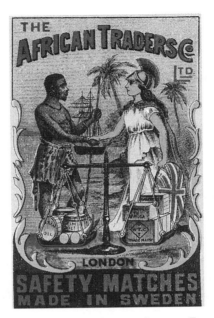

FIGURE 10.1 THE CLASP OF IMPERIAL TRADE.

lust . . . to sit at the settler's table, to sleep in the settler's bed, with his wife if possible. The colonized man is an envious man."[6] For Fanon, both colonizer and colonized are here unthinkingly male, and the Manichean agon of decolonization is waged over the territoriality of female, domestic space.

All too often in male nationalisms, gender difference between women and men serves to symbolically define the limits of national difference and power between men [Figs. 10.1,10.2]. Excluded from direct action as national citizens, women are subsumed symbolically into the national body politic as its boundary and metaphoric limit: "Singapore girl, you're a great way to fly." Women are typically constructed as the symbolic bearers of the nation [Fig. 10.3], but are denied any direct relation to national agency. As Elleke Boehmer notes in her fine essay, the "motherland" of male nationalism thus may "not signify 'home' and 'source' to women."[7] Boehmer notes that the male role in the nationalist scenario is

typically "metonymic"; that is, men are contiguous with each other and with the national whole. Women, by contrast, appear "in a metaphoric or symbolic role."[8] Yet it is also crucial to note that not all men enjoy the privilege of political contiguity with each other in the national community.

In an important intervention, Nira Yuval-Davis and Floya Anthias identify five major ways in which women have been implicated in nationalism:

—as biological reproducers of the members of national collectivities
—as reproducers of the boundaries of national groups (through restrictions on sexual or marital relations)
—as active transmitters and producers of the national culture
—as symbolic signifiers of national difference
—as active participants in national struggles[9]

Nationalism is thus constituted from the very beginning as a gendered discourse and cannot be understood without a theory of gender power. Nonetheless, theories of nationalism reveal a double disavowal. If male theorists are typically indifferent to the gendering of nations, feminist analyses

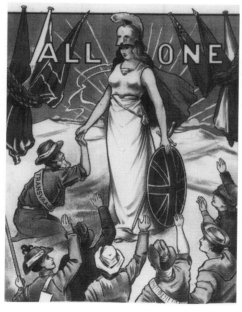

FIGURE 10.2 WOMAN AS NATIONAL BOUNDARY MARKER.

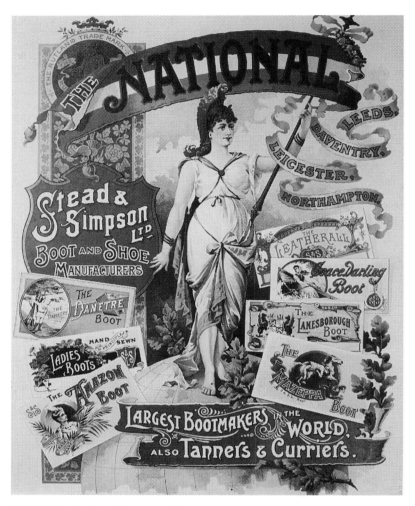

FIGURE 10.3 GENDER UPHOLDING NATIONALISM.

of nationalism have been lamentably few and far between. White feminists, in particular, have been slow to recognize nationalism as a feminist issue. In much Western, socialist feminism, as Yuval-Davis and Anthias point out, "Issues of ethnicity and nationality have tended to be ignored."[10]

A feminist theory of nationalism might thus be strategically four-fold: (1)investigating the gendered formation of sanctioned male theories; (2)bringing into historical visibility women's active cultural and political participation in national formations; (3)bringing nationalist institutions into critical relation with other social structures and institutions; and (4) at the same time paying scrupulous attention to the structures of racial, ethnic and class power that continue to bedevil privileged forms of feminism.

THE NATIONAL FAMILY OF MAN
A DOMESTIC GENEALOGY

A paradox lies at the heart of most national narratives. Nations are frequently figured through the iconography of familial and domestic space. The term nation derives from *natio*: to be born. We speak of nations as "motherlands" and "fatherlands." Foreigners "adopt" countries that are not their native homes and are naturalized into the national "family." We talk of the "Family of Nations," of "homelands" and "native" lands. In Britain, immigration matters are dealt with at the Home Office; in the United States, the president and his wife are called the First Family. Winnie Mandela was, until her recent fall from grace, honored as South Africa's "Mother of the Nation." In this way, despite their myriad differences, nations are symbolically figured as domestic genealogies. Yet, as I argued in the earlier chapters of this book, since the midnineteenth century in the West at least, the family itself has been figured as the antithesis of history.

The family trope is important for nationalism in at least two ways. First, it offers a "natural" figure for sanctioning national *hierarchy* within a putative organic *unity* of interests. Second, it offers a "natural" trope for figuring national time. After 1859 and the advent of social Darwinism, Britain's emergent national narrative took increasing shape around the image of the evolutionary Family of Man. The family offered an indispensable metaphoric figure by which national difference could be shaped into a single historical genesis narrative. Yet a curious paradox emerged. The family as a *metaphor* offered a single genesis narrative for national history while, at the same time, the family as an *institution* became void of history and excluded from national power. The family became, at one and the same time, both the *organizing figure* for national history and its *antithesis*.

In the course of the nineteenth century, the social function of the great service families were displaced onto the national bureaucracies, while the image of the family was projected onto these nationalisms as their shadowy, naturalized form. Since the subordination of woman to man and child to adult was deemed a natural fact, hierarchies within the nation

could be depicted in familial terms to guarantee social difference as a category of nature. The metaphoric depiction of social hierarchy as natural and familial—the "national family," the global "family of nations," the colony as a "family of black children ruled over by a white father"—depended in this way on the prior naturalizing of the social subordination of women and children within the domestic sphere.

In modern Europe, citizenship is the legal representation of a person's relationship to the rights and resources of the nation-state. But the putatively universalist concept of national citizenship becomes unstable when seen from the position of women. In post-French revolution Europe, women were incorporated directly into the nation-state not directly as citizens, but only indirectly, through men, as dependent members of the family in private and public law. The Code Napoleon was the first modern statute to decree that the wife's nationality should follow her husband's, an example other European countries briskly followed. A woman's *political* relation to the nation was thus submerged as a *social* relation to a man through marriage. For women, citizenship in the nation was mediated by the marriage relation within the family. This chapter is directly concerned with the consequences for women of this uneven gendering of the national citizen.

THE GENDERING OF NATION TIME

A number of critics have followed Tom Nairn in naming the nation "the modern Janus."[11] For Nairn, the nation takes shape as a contradictory figure of time: one face gazing back into the primordial mists of the past, the other into an infinite future. Deniz Kandiyoti expresses the temporal contradiction with clarity: "[Nationalism] presents itself both as a modern project that melts and transforms traditional attachments in favour of new identities and as a reflection of authentic cultural values culled from the depths of a presumed communal past."[12] Bhabha, following Nairn and Anderson, writes: "Nations, like narratives, lose their origins in the myths of time and only fully realize their horizons in the mind's eye."[13] Bhabha and Anderson borrow here from Walter Benjamin's crucial insight into the temporal paradox of modernity. For Benjamin, a central feature of nineteenth-century industrial capitalism was the "use of archaic images to identify what was historically new about the 'nature' of commodities."[14] In Benjamin's insight, the mapping of Progress depends on systematically inventing images of archaic time to identify what is historically new about enlightened, national progress. Anderson can thus ask: "Supposing 'antiquity' were, at a certain historical juncture, the *necessary consequence* of 'novelty?'"[15]

What is less often noticed, however, is that the temporal anomaly within nationalism—veering between nostalgia for the past and the

impatient, progressive sloughing off of the past—is typically resolved by figuring the contradiction in the representation of *time* as a natural division of *gender*. Women are represented as the atavistic and authentic body of national tradition (inert, backward-looking and natural), embodying nationalism's conservative principle of continuity. Men, by contrast, represent the progressive agent of national modernity (forward-thrusting, potent and historic), embodying nationalism's progressive, or revolutionary principle of discontinuity. Nationalism's anomalous relation to time is thus managed as a natural relation to gender.

In the nineteenth century, the social evolutionists secularized time and placed it at the disposal of the national, imperial project. The axis of *time*, as I argue in more detail in Chapter 1, was projected onto the axis of *space* and history became global. Now not only natural space but also historical time was collected, measured and mapped onto a global science of the surface. In the process history, especially national and imperial history, took on the character of a spectacle.

Secularizing time has a threefold significance for nationalism. First figured in the evolutionists' global Family Tree, the world's discontinuous nations appear to be marshaled within a single, hierarchical European Ur-narrative. Second, national history is imaged as naturally teleological, an organic process of upward growth, with the European nation as the apogee of world progress. Third, inconvenient discontinuities are ranked and subordinated into a hierarchical structure of branching time—the progress of "racially" different nations mapped against the tree's self-evident boughs, with "lesser nations" destined, by nature, to perch on its lower branches.

National time is thus not only *secularized*, it is also *domesticated*. Social evolutionism and anthropology gave to national politics a concept of natural time as familial. In the image of the Family Tree, evolutionary progress was represented as a series of anatomically distinct family types, organized into a linear procession, from the "childhood" of "primitive" races to the enlightened "adulthood" of European imperial nationalism. Violent national change takes on the character of an evolving spectacle under the organizing rubric of the family. The merging of the racial evolutionary Tree and the gendered family into the Family Tree of Man provided scientific racism with a simultaneously gendered and racial image through which it could popularize the idea of linear national Progress.

Britain's emerging national narrative gendered time by figuring women (like the colonized and the working class) as inherently atavistic—the conservative repository of the national archaic. Women were not seen as inhabiting history proper but existing, like colonized peoples, in a permanently anterior time within the modern nation. White, middle-class

men, by contrast, were seen to embody the forward-thrusting agency of national progress. Thus the figure of the national Family of Man reveals a persistent paradox. National Progress (conventionally the invented domain of male, public space) was figured as familial, while the family itself (conventionally the domain of private, female space) was figured as beyond history.

One can safely say, at this point, that there is no single narrative of the nation. Different groups (genders, classes, ethnicities, generations and so on) do not experience the myriad national formations in the same way. Nationalisms are invented, performed and consumed in ways that do not follow a universal blueprint. At the very least, the breathtaking Eurocentricism of Hobsbawm's dismissal of Third World nationalisms warrants sustained criticism. In a gesture of sweeping condescension, Hobsbawm nominates Europe as nationalism's "original home," while "all the anti-imperial movements of any significance" are unceremoniously dumped into three categories: mimicry of Europe, anti-Western xenophobia and the "natural high spirits of martial tribes."[16] By way of contrast, it might be useful to turn at this point to Frantz Fanon's quite different, if also problematic, analysis of the gendering of the national formation.

FANON AND GENDER AGENCY

As male theorists of nationalism go, Frantz Fanon is exemplary, not only for recognizing gender as a formative dimension of nationalism but also for recognizing—and immediately rejecting—the Western metaphor of the nation as a family. "There are close connections," he observes in *Black Skin, White Masks* "between the structure of the family and the structure of the nation."[17] Refusing, however, to collude with the notion of the familial metaphor as natural and normative, Fanon instead understands it as a cultural projection ("the characteristics of the family are projected onto the social environment") that has very different consequences for families placed discrepantly within the colonial hierarchy.[18] "A normal Negro child, having grown up within a normal family, will become abnormal on the slightest contact with the white world."[19]

The challenge of Fanon's insight is threefold. He throws radically into question the naturalness of nationalism as a domestic genealogy. At the same time, he reads familial normality as a product of social power—indeed, of social violence. Fanon is remarkable for recognizing, in this early text, how military violence and the authority of a centralized state borrow on and enlarge the domestication of gender power within the family: "Militarization and the centralization of authority in a country automatically entail a resurgence of the authority of the father."[20]

Perhaps one of Fanon's most provocative ideas is his challenge to any easy relation of identity between the psychodynamics of the unconscious and the psychodynamics of political life. The audacity of his insight is that it allows one to ask whether the psychodynamics of colonial power and of anti-colonial subversion can be interpreted by deploying (without mediation) the same concepts and techniques used to interpret the psychodynamics of the unconscious. If the family is not "a miniature of the nation," are metaphoric projections from family life (the Lacanian "Law of the Father," say) adequate for an understanding of colonial or anticolonial power? Fanon himself seems to say no. Relations between the individual unconscious and political life are, I argue, neither separable from each other nor reducible to each other. Instead, they comprise crisscrossing and dynamic mediations, reciprocally and untidily transforming each other, rather than duplicating a relation of structural analogy.

Even in *Black Skin, White Masks*, the most psychological of Fanon's texts, he insists that racial alienation is a "double process."[21] First, it "entails an immediate recognition of social and economic realities." Then, it entails the "internalization" of inferiority. Racial alienation, in other words, is not only an "individual question" but also involves what Fanon calls a "sociodiagnostic."[22] Reducing Fanon to a purely formal psychoanalysis, or a purely structural Marxism, risks foreclosing precisely those suggestive tensions that animate, in my view, the most subversive elements of his work. These tensions are nowhere more marked than in his tentative exploration of the gendering of national agency.

Gender runs like a multiple fissure through Fanon's work, splitting and displacing the "Manichean delirium" to which he repeatedly returns. For Fanon, the colonial agon appears, at first, to be fundamentally Manichean. In *Black Skin, White Masks*, he sees colonial space as divided into "two camps: the white and the black."[23] Nearly a decade later, writing from the crucible of the Algerian resistance in *The Wretched of the Earth*, Fanon once again sees anticolonial nationalism as erupting from the violent Manicheanism of a colonial world "cut in two," its boundaries walled by barracks and police stations.[24] Colonial space is split by a pathological geography of power, separating the bright, well-fed settler's town from the hungry, crouching casbah: "This world . . . cut in two is inhabited by two different species."[25] As Edward Said puts it: "From this Manichean and physically grounded statement Fanon's entire work follows, set in motion, so to speak, by the native's violence, a force intended to bridge the gap between white and non-white."[26] Yet the fateful chiaroscuro of race is at almost every turn disrupted by the criss-crossings of gender.

Fanon's Manichean agon appears at first to be fundamentally male: "There can be no further doubt that the real Other for the white man is

and will continue to be the black man." As Homi Bhabha writes: "It is always in relation to the place of the Other that colonial desire is articulated."[27] But Fanon's anguished musings on race and sexuality disclose that "colonial desire" is not the same for men and women: "Since he is the master and more simply the male, the white man can allow himself the luxury of sleeping with many women But when a white woman accepts a black man there is automatically a romantic aspect. It is a giving, not a seizing."[28] Leaving aside, for the moment, Fanon's complicity with the stereotype of women as romantically rather than sexually inclined, as giving rather than taking, Fanon opens race to a problematics of sexuality that reveals far more intricate entanglements than a mere doubling of "the Otherness of the Self." The psychological Manicheanism of *Black Skin, White Masks* and the more political Manicheanism of *The Wretched of the Earth* are persistently inflected by gender in such a way as to radically disrupt the binary dialectic.

For Fanon, the envy of the black man takes the form of a fantasy of territorial displacement: "The fantasy of the native is precisely to occupy the master's place."[29] This fantasy can be called a *politics of substitution*. Fanon knows, however, that the relation to the white woman is altogether different: "When my restless hands caress those white breasts, they grasp white civilization and dignity and make them mine."[30] The white woman is seized, possessed and taken hold of, not as an act of *substitution*, but as an act of *appropriation*. However, Fanon does not bring this critical distinction between a politics of substitution and a politics of appropriation into explicit elaboration as a theory of gender power.

As Bhabha astutely observes, Fanon's *Black Skin, White Masks* is inflected by a "palpable pressure of division and displacement"—though gender is a form of self-division that Bhabha himself fastidiously declines to explore.[31] Bhabha would have us believe that "Fanon's use of the word "man" usually connotes a phenomenological quality of humanness, inclusive of man and woman."[32] But this claim is not borne out by Fanon's texts. Potentially generic terms like "the Negro" or "the Native"—syntactically unmarked for gender—are almost everywhere immediately contextually marked as male: "Sometimes people wonder that the native, rather than giving his wife a dress, buys instead a transistor radio;"[33] " . . . the Negro who wants to go to bed with a white woman;"[34] " . . . the Negro who is viewed as a penis symbol."[35] The generic category "native" does not include women; women are merely possessed by the (male) native as an appendage: "When the native is tortured, when his wife is killed or raped, he complains to no one."[36]

For Fanon, colonized men inhabit "two places at once." If so, how many places do colonized women inhabit? Certainly, Bhabha's text is not

one of them. Except for a cursory appearance in one paragraph, women haunt Bhabha's analysis as an elided shadow—deferred, displaced and dis-remembered. Bhabha concludes his eloquent meditation on Fanon with the overarching question: "How can the human world live its difference? how can a human being live Other-wise?"[37] Yet immediately appended to his foreword appears a peculiar Note. In it Bhabha announces, without apology, that the "crucial issue" of the woman of color "goes well beyond the scope" of his foreword. Yet its scope, as he himself insists, is bounded by nothing less than the question of *humanity*: "How can the human world live its difference? how can a human being live Other-wise?" Apparently, the question of the woman of color falls beyond the question of human difference, and Bhabha is content simply to "note the importance of the problem" and leave it at that. Bhabha's belated note on gender appears after his authorial signature, after the time and date of his essay. Women are thus effectively deferred to a nowhere land, beyond time and place, outside theory. If, indeed, "the state of emergency is also a state of emergence," the question remains whether the national state of emergency turns out to be a state of emergence for women at all.[38]

To ask "the question of the subject" ("What does a man want? What does the black man want?"), while postponing a theory of gender, presumes that subjectivity itself is neutral with respect to gender.[39] From the limbo of the male afterthought, however, gender returns to challenge the male question not as women's "lack," but as that excess that the masculine "Otherness" of the Self can neither admit nor fully elide. This presumption is perhaps nowhere more evident than in Fanon's remarkable meditations on the gendering of the national revolution.

At least two concepts of national agency shape Fanon's vision. His anticolonial project is split between a Hegelian vision of colonizer and colonized locked in a life-and-death conflict and an altogether more complex and unsteady view of agency. These paradigms slide discrepantly against each other throughout his work, giving rise to a number of internal fissures. These fissures appear most visibly in his analysis of gender as a category of social power.

On the one hand, Fanon draws on a Hegelian metaphysics of agency inherited, by and large, through Jean-Paul Sartre and the French academy. In this view, anticolonial nationalism irrupts violently and irrevocably into history as the logical counterpart to colonial power. This nationalism is, as Edward Said puts it, "cadenced and stressed from beginning to end with the accents and inflections of liberation."[40] It is a liberation, moreover, that is structurally guaranteed, immanent in the binary logic of the Manichean dialectic. This metaphysics speaks, as Terry Eagleton nicely phrases it, "of the entry into full self-realization of a unitary subject known

as the people."[41] Nonetheless, the privileged national agents are urban, male, vanguardist and violent. The progressive nature of the violence is preordained and sanctioned by the structural logic of Hegelian progress.

This kind of nationalism can be called an *anticipatory nationalism*. Eagleton calls it nationalism "in the subjunctive mood," a premature utopianism that "grabs instinctively for a future, projecting itself by an act of will or imagination beyond the compromised political structures of the present."[42] Yet, ironically, anticipatory nationalism often claims legitimacy by appealing precisely to the august figure of inevitable progress inherited from the Western societies it seeks to dismantle.

Alongside this Manichean, mechanical nationalism, however, appears an altogether more open-ended and strategically difficult view of national agency. This nationalism stems not from the inexorable machinery of Hegelian dialectics but from the messy and disobliging circumstances of Fanon's own activism, as well as from the often dispiriting lessons of the anticolonial revolutions that preceded him. In this view, agency is multiple rather than unitary, unpredictable rather than immanent, bereft of dialectical guarantees and animated by an unsteady and nonlinear relation to time. There is no preordained rendezvous with victory; no single, undivided national subject; no immanent historical logic. The national project must be laboriously and sometimes catastrophically invented, with unforeseen results. Time is dispersed and agency is heterogeneous. Here, in the unsteady, sliding interstices between conflicting national narratives, women's national agency makes its uncertain appearance.

In "Algeria Unveiled," Fanon ventriloquizes—only to refute—the long Western dream of colonial conquest as an erotics of ravishment. Under the hallucinations of empire, the Algerian woman is seen as the living flesh of the national body, unveiled and laid bare for the colonials' lascivious grip, revealing "piece by piece, the flesh of Algeria laid bare."[43] In this remarkable essay, Fanon recognizes the colonial gendering of women as symbolic mediators, the boundary markers of an agon that is fundamentally male. The Algerian woman is "an intermediary between obscure forces and the group."[44] "The young Algerian woman . . . establishes a link," he writes.[45]

Fanon understands brilliantly how colonialism inflicts itself as a *domestication* of the colony, a reordering of the labor and sexual economy of the people, so as to divert female power into colonial hands and disrupt the patriarchal power of colonized men. Fanon ventriloquizes colonial thinking: "If we want to destroy the structure of Algerian society, its capacity for resistance, we must first of all conquer the women."[46] His insight here is that the dynamics of colonial power are fundamentally, though not solely, the dynamics of gender: "It is the situation of women that

was accordingly taken as the theme of action."[47] Yet, in his work as a whole, Fanon fails to bring these insights into theoretical focus.

Long before Anderson, Fanon recognizes the inventedness of national community. He also recognizes the power of nationalism as a *scopic* politics, most visibly embodied in the power of sumptuary customs to fabricate a sense of national unity: "It is by their apparel that types of society first become known."[48] Fanon perceives, moreover, that nationalism, as a politics of visibility, implicates women and men in different ways. Because, for male nationalists, women serve as the visible markers of national homogeneity, they become subjected to especially vigilant and violent discipline. Hence the intense emotive politics of dress.

Yet a curious rupture opens in Fanon's text over the question of women's agency. At first, Fanon recognizes the historical meaning of the veil as open to the subtlest shifts and subversions. From the outset, colonials tried to grant Algerian women a traitorous agency, affecting to rescue them from the sadistic thrall of Algerian men. But, as Fanon knows, the colonial masquerade of giving women power by unveiling them was merely a ruse for achieving "a real power over the man."[49] Mimicking the colonial masquerade, militant Algerian women deliberately began to unveil themselves. Believing their own ruse, colonials at first misread the unveiled Algerian women as pieces of "sound currency" circulating between the casbah and the white city, mistaking them for the visible coinage of cultural conversion.[50] For the *Fidaï*, however, the militant woman was "his arsenal," a technique of counterinfiltration, duplicitously penetrating the body of the enemy with the armaments of death.

So eager is Fanon to deny the colonial rescue fantasy that he refuses to grant the veil any prior role at all in the gender dynamics of Algerian society. Having refused the colonial's desire to invest the veil with an essentialist meaning (the sign of women's servitude), he bends over backward to insist on the veil's semiotic innocence in Algerian society. The veil, Fanon writes, was no more than "a formerly inert element of the native cultural configuration."[51] At once the veil loses its historic mutability and becomes a fixed, "inert" element in Algerian culture: "an undifferentiated element in a homogeneous whole."[52] Fanon denies the "historic dynamism of the veil" and banishes its intricate history to a footnote, from where, however, it displaces the main text with the insistent force of self-division and denial.[53]

Fanon's thoughts on women's agency proceed through a series of contradictions. Where, for Fanon, does women's agency begin? He takes pains to point out that women's militancy does not precede the national revolution. Algerian women are not self-motivating agents, nor do they have prior histories or consciousness of revolt from which to draw. Their initiation in the revolution is learned, but it is not learned from other women

or from other societies, nor is it transferred analogously from local feminist grievances. The revolutionary mission is "without apprenticeship, without briefing."[54] The Algerian woman learns her "revolutionary mission instinctively."[55] This theory is not, however, a theory of feminist spontaneity, for women learn their militancy only at men's invitation. Theirs is a *designated agency*—an agency by invitation only. Before the national uprising, women's agency was null, void, inert as the veil. Here Fanon colludes not only with the stereotype of women as bereft of historical motivation, but he also resorts, uncharacteristically, to a reproductive image of natural birthing: "It is an authentic birth in a pure state."[56]

Why were women invited into the revolution? Fanon resorts immediately to a mechanistic determinism. The ferocity of the war was such, the urgency so great, that sheer structural necessity dictated the move: "The revolutionary wheels had assumed such proportions; the mechanism was running at a given rate. The machine would have to be complicated."[57] Female militancy, in short, is simply a passive offspring of male agency and the structural necessity of the war. The problem of women's agency, so brilliantly raised as a question, is abruptly foreclosed.

Women's agency for Fanon is thus agency by designation. It makes its appearance not as a direct political relation to the revolution but as a mediated, domestic relation to a man: "At the beginning, it was the married women who were contacted. Later, widows or divorced women were designated."[58] Women's first relation to the revolution is constituted as a domestic one. But domesticity, here, also constitutes a relation of possession. The militant was, in the beginning, obliged to keep "his woman" in "absolute ignorance."[59] As designated agents, moreover, women do not commit themselves: "It is relatively easy to commit oneself The matter is a little more difficult when it involves designating someone."[60] Fanon does not consider the possibility of women committing themselves to action. He thus manages women's agency by resorting to contradictory frames: the authentic, instinctive birth of nationalist fervor; the mechanical logic of revolutionary necessity; male designation. In this way, the possibility of a distinctive feminist agency is never broached.

Once he has contained women's militancy in this way, Fanon applauds women for their "exemplary constancy, self-mastery and success."[61] Nonetheless, his descriptions of women teem with instrumentalist similes and metaphors. Women are not women, they are "fish"; they are "the group's lighthouse and barometer," the *Fidaï*'s "women-arsenal."[62] Most tellingly, Fanon resorts to a curiously eroticized image of militarized sexuality. Carrying the men's pistols, guns and grenades beneath her skirts, "the Algerian woman penetrates a little further into the flesh of the Revolution."[63] Here, the Algerian woman is not a victim of rape but a masculinized rapist.

As if to contain the unmanning threat of armed women—in their dangerous crossings—Fanon masculinizes the female militant, turning her into a phallic substitute, detached from the male body but remaining, still, the man's "woman-arsenal." Most tellingly, however, Fanon describes the phallic woman as penetrating the flesh of the "revolution," not the flesh of the colonials. This odd image suggests an unbidden fear of emasculation, a dread that the arming of women might entail a fatal unmanning of Algerian men. A curious instability of gender power is here effected as the woman are figured as masculinized and the male revolution is penetrated.

Fanon's vision of the political role of the Algerian family in the national uprising likewise proceeds through contradiction. Having brilliantly shown how the family constitutes the first ground of the colonial onslaught, Fanon seeks to reappropriate it as an arena of nationalist resistance. Yet the broader implications of the politicizing of family life are resolutely naturalized after the revolution. Having recognized that women "constituted for a long time the fundamental strength of the occupied," Fanon is reluctant to acknowledge any gender conflict or feminist grievance within the family prior to the anticolonial stuggle, or after the national revolution.[64] Although, on the one hand, he admits that in "the Algerian family, the girl is always a notch behind the boy," he quickly insists that she is assigned to this position "without being humiliated or neglected."[65] Although the men's words are "Law," women "voluntarily" submit themselves to "a form of existence limited in scope."[66]

The revolution shakes the "old paternal assurance" so that the father no longer knows "how to keep his balance," and the woman "ceased to be a complement for man."[67] It is telling, moreover, that in his analysis of the family, the category of mother does not exist. Women's liberation is credited entirely to national liberation and it is only with nationalism that women "enter into history." Prior to nationalism, women have no history, no resistance, no independent agency.[68] And since the national revolution automatically revolutionizes the family, gender conflict naturally vanishes after the revolution. Feminist agency, then, is contained by and subordinated to national agency, and the heterosexual family is preserved as the "truth" of society—its organic, authentic form. The family is revolutionized, taken to a higher plane through a Hegelian vision of transcendence, but the rupturing force of gender is firmly foreclosed: "The family emerges strengthened from this ordeal."[69] Women's militancy is contained within the postrevolutionary frame of the reformed, heterosexual family, as the natural image of national life.

In the postrevolutionary period, moreover, the tenacity of the father's "unchallengeable and massive authority" is not raised as one of the "pitfalls" of the national consciousness.[70] The Manichean dialectic—as generating an inherently resistant agency—does not, it seems, apply to gender. Deeply

reluctant as he is to see women's agency apart from national agency, Fanon does not foresee the degree to which the Algerian National Liberation Front (FLN) will seek to co-opt and control women, subordinating them unequivocally once the revolution is won.

A feminist investigation of national difference might, by contrast, take into account the dynamic social and historical contexts of national struggles; their strategic mobilizing of popular forces; their myriad, varied trajectories; and their relation to other social institutions. We might do well to develop a more theoretically complex and strategically subtle genealogy of nationalisms.

With these theoretical remarks in mind, I wish now to turn to the paradoxical relation between the invented constructions of family and nation as they have taken shape within South Africa in both black and white women's contradictory relations to the competing national genealogies. In South Africa, certainly, the competing Afrikaner and African nationalisms have had both distinct and overlapping trajectories, with very different consequences for women.

NATIONALISM AS FETISH SPECTACLE

Until the 1860s, Britain had scant interest in its unpromising colony at the southern tip of Africa. Only upon the discovery of diamonds (1867) and gold (1886) were the Union Jack and the redcoats shipped out with any real sense of imperial mission. But very quickly, mining needs for cheap labor and a centralized state collided with traditional farming interests and out of these contradictions, in the conflict for control over African land and labor, exploded the Anglo-Boer War of 1899–1902.

Afrikaner nationalism was a doctrine of crisis. After their defeat by the British, the bloodied remnants of the scattered Boer communities had to forge a new counterculture if they were to survive in the emergent capitalist state. From the outset, this counter-culture had a clear *class* component. When the Boer Generals and the British capitalists swore blood-brotherhood in the Union of 1910, the ragtag legion of "poor whites" with few or no prospects, the modest clerks and shopkeepers, the small farmers and poor teachers, the intellectuals and petite bourgeoisie, all precarious in the new state, began to identify themselves as the vanguard of a new Afrikanerdom, the chosen emissaries of the national *volk.*[71]

However, Afrikaners had no monolithic identity to begin with, no common historic purpose and no single unifying language. They were a disunited, scattered people, speaking a medley of High Dutch and local dialects, with smatterings of the slave, Nguni and Khoisan languages — scorned as the *kombuistaal* (kitchen-language) of house-servants, slaves and

women. Afrikaners therefore had, quite literally, to invent themselves. The new, invented community of the *volk* required the conscious creation of a single print-language, a popular press and a literate populace. At the same time, the invention of tradition required a class of cultural brokers and image-makers to do the inventing. The "language movement" of the early twentieth century, in a flurry of poems, magazines, newspapers, novels and countless cultural events, provided just such an invention, fashioning the myriad Boer vernaculars into a single identifiable Afrikaans language. In the early decades of the twentieth century, as Isabel Hofmeyer has brilliantly shown, an elaborate labor of "regeneration" was undertaken as the despised *Hotnotstaal* (Hottentot's language) was revamped and purged of its rural, "degenerate" associations and elevated to the status of the august mother-tongue of the Afrikaner people. In 1918, Afrikaans achieved legal recognition as a language.[72]

At the same time, the invention of Afrikaner tradition had a clear *gender* component. In 1918 a small, clandestine clique of Afrikaner men launched a secret society with the express mission of capturing the loyalties of dispirited Afrikaners and fostering white male business power. The tiny, white brotherhood swiftly burgeoned into a secret countrywide mafia that came to exert enormous power over all aspects of Nationalist policy.[73] The gender bias of the society, as of Afrikanerdom as a whole, is neatly summed up in its name: the *Broederbond* (the Brotherhood). Henceforth, Afrikaner nationalism would be synonymous with white male interests, white male aspirations and white male politics. Indeed, in a recent effort to shore up its waning power, the Broederbond has decided to admit so-called colored Afrikaans speakers into the brotherhood. All women will, however, continue to be barred.

In the voluminous Afrikaner historiography, the history of the *volk* is organized around a male national narrative figured as an imperial journey into empty lands. As I discuss in more detail in Chapter 1, the myth of the empty land is simultaneously the myth of the virgin land—effecting a double erasure. But the empty lands are in fact peopled, so the contradiction is contained by the invention, once more, of anachronistic space. The colonial journey is figured as proceeding forward in *geographical* space, but backward in *racial* and *gender* time, to a prehistoric zone of linguistic, racial and gender degeneration. At the heart of the continent, a historic agon is staged as degenerate Africans "falsely" claim entitlement to the land. A divinely organized military conflict baptizes the nation in a male birthing ritual, which grants to white men the patrimony of land and history. The white nation emerges as the progeny of male history through the motor of military might. Nonetheless, at the center of the imperial gospel stands the contradictory figure of the *volksmoeder*, the mother of the nation.

FIGURE 10.4 THE WHITE FAMILY OF MAN.

INVENTING THE ARCHAIC
THE *TWEEDE* (SECOND) *TREK*

The animating emblem of Afrikaner historiography is the Great Trek, and each trek is figured as a family presided over by a single, epic male patriarch. In 1938, two decades after the recognition of Afrikaans as a language, an epic extravaganza of invented tradition enflamed Afrikanerdom into a delirium of nationalist passion. Dubbed the *Tweede Trek* (second trek), or the *Eeufees* (centenary), the event celebrated the Boers' first mutinous Great Trek in 1838 away from British laws and the effrontery of slave emancipation. The Centenary also commemorated the Boer massacre of the Zulus at the Battle of Blood River. Nine replicas of Voortrekker wagons were built—a vivid example of the reinvention of the archaic to sanction modernity. Each wagon was literally baptized and named after a male Voortrekker hero. No wagon was named after an adult

woman, although one was called, generically, *Vrou en Moeder* (wife and mother). This wagon, creaking across the country, symbolized woman's relation to the nation as indirect, mediated through her social relation to men, her national identity lying in her unpaid services and sacrifices, through husband and family, to the *volk*.

Each wagon became the microcosm of colonial society at large: the whip-wielding white patriarch prancing on horseback, black servants toiling alongside, white mother and children sequestered in the wagon—the women's starched white bonnets signifying the purity of the race, the decorous surrender of their sexuality to the patriarch and the invisibility of white female labor [Fig. 10.4].

The wagons rumbled along different routes from Cape Town to Pretoria, sparking along the way an orgy of national pageantry and engulfing the country in a four-month spectacle of invented tradition and fetish ritual [Figs. 10.5–10.10]. Along the way, white men grew beards and white women

FIGURE 10.5 GENDER AND THE NATIONAL FETISHES.

FIGURE 10.6 THE MYTH OF THE EMPTY LANDS.

FIGURE 10.7 THE RACIAL DIVISION OF LABOR.

FIGURE 10.8 INVENTING THE ARCHAIC.

donned the ancestral bonnets. Huge crowds gathered to greet the trekkers. As the wagons passed through the towns, babies were named after trekker heroes, as were roads and public buildings. Not a few girls were baptized with the improbable but popular favorites: *Eeufesia* (Centenaria) or *Ossewania*, (from *ossewa*, ox wagon). Children scrambled to rub grease from the wagon axles onto their handkerchiefs. The affair climaxed in Pretoria in a spectacular marathon with Third Reich overtones, led by thousands of Afrikaner boy scouts bearing flaming torches.

The first point about the *Tweede Trek* is that it invented white nationalist traditions and celebrated unity where none had existed before, creating the illusion of a collective identity through the political staging of vicarious *spectacle*. The second point is that the Nationalists adopted this ploy from the Nazis. The *Tweede Trek* was inspired not only by the Nazi creed of *Blut und Boden* but by a new political style: the Nürenberg politics of fetish symbol and cultural persuasion.

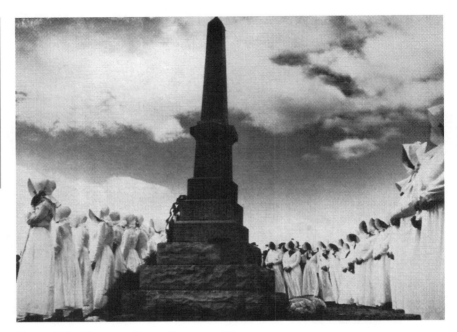

FIGURE 10.9 WOMEN AS RACIAL BOUNDARY MARKERS.

In our time, national collectivity is experienced preeminently through spectacle. Here I depart from Anderson, who sees nationalism as emerging primarily from the Gutenberg technology of print capitalism. Anderson neglects the fact that print capital has, until recently, been accessible to a relatively small literate elite. Indeed, the singular power of nationalism since the late nineteenth century, I suggest, has been its capacity to organize a sense of popular, collective unity through the management of mass national *commodity spectacle*.

In this respect, I argue, nationalism inhabits the realm of fetishism. Despite the commitment of European nationalism to the idea of the nation-state as the embodiment of rational progress, nationalism has been experienced and transmitted primarily through fetishism — precisely the cultural form that the Enlightenment denigrated as the antithesis of Reason. More often than not, nationalism takes shape through the visible, ritual organization of fetish objects — flags, uniforms, airplane logos, maps,

anthems, national flowers, national cuisines and architectures as well as through the organization of collective fetish spectacle—in team sports, military displays, mass rallies, the myriad forms of popular culture and so on [Fig. 10.9]. Far from being purely phallic icons, fetishes embody crises in social value, which are projected onto and embodied in, what can be called impassioned objects. Considerable work remains to be done on the ways in which women consume, refuse or negotiate the male fetish rituals of national spectacle.

The *Eeufees* was, by anyone's standards, a triumph of fetish management, from the spectacular regalia of flags, flaming torches and patriotic songs to incendiary speeches, archaic costumes and the choreographing of crowd spectacle and everywhere visible the unifying fetish of the wagon. More than anything, the *eeufees* revealed the extent to which nationalism is a theatrical performance of invented community: the *Eeufees* was a calculated and self-conscious effort by the *Broederbond* to paper over the myriad regional, gender and class tensions that threatened it. As a fetishistic displacement of difference, it succeeded famously, for the *Tweede*

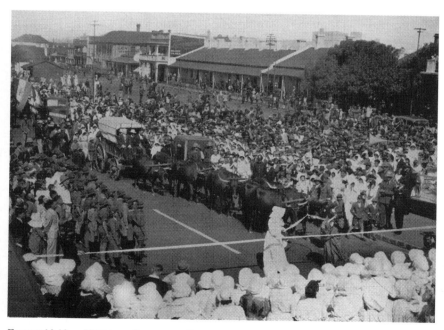

FIGURE 10.10 NATIONAL BOUNDARY RITUAL.

Trek's success in mobilizing a sense of white Afrikaner collectivity where none before existed was a major reason, though certainly not the only one, for the Nationalists' triumphant sweep to power in 1948.[74]

Yet, as Albert Grundlingh and Hilary Sapire note, historians have shown scant interest in explaining the overwhelming emotional euphoria elicited by the celebrations, tending instead to collude with the mythologizing of Afrikaners as inherently atavistic and temperamentally given to quaint anthropological rituals.[75] Certainly, as Grundlingh and Sapire suggest, "it was economic insecurity . . . that made Afrikaners susceptible to the cultural and political blandishments of the 'second Trek'."[76] The idea of the symbolic trek had originated amongst the recently urbanized Afrikaner railway workers, who had very good reason to feel that their position was precarious in the new English-dominated state. Very quickly, moreover, the insecure scattering of Afrikaans-speaking petit-bourgois professionals and intellectuals—teachers, civil servants, lawyers, members of the clergy, writers and academics—eagerly embraced their vocation of choreographing the symbolic trek, with all the renewed prominence and prestige that attended their status as cultural brokers imbued with the mission of unifying the *volk*.

Nonetheless, the *Tweede Trek* was not simply the lurid, melodramatic offspring of ethnic insecurity and class fission. Grundlingh and Sapire point out that there were rival mythologies—socialism and "South Africanism" being the most prominent—that were as eager to capture the loyalties of the poor whites. The *Tweede Trek*, however, enjoyed a number of stunning advantages. For those dispirited and disoriented Afrikaners, who had so recently trekked from the rural areas to the mines, railyards and sweatshops of urban South Africa, the *Tweede Trek* offered a potent symbolic amalgam of disjointed times, capturing in a single fetish spectacle the impossible confluence of the modern and the archaic, the recent displacement and the ancestral migration.

Rather than enacting a backward-looking, atavistic ceremony of ancestral cult worship, the *Tweede Trek* can rather be read as an exemplary act of modernity: a theatrical performance of Benjamin's insight into the evocation of archaic images to identify what is new about modernity. Photographs of the *Eeufees* vividly capture the doubling of time consequent upon this evocation of the archaic, as anachronistic ox-wagons jostle amongst the motorcars and women in white *kappies* mingle with the modern urban crowd. Unlike socialism, then, the *Tweede Trek* could evoke a resonant archive of popular memory and a spectacular iconography of historical travail and fortitude, providing not only the historical dimension necessary for national invention but also a theatrical stage for the collective acting out of the traumas and privations of industrial dislocation.

The *Tweede Trek* also dramatized a crisis in the poetics of historical time. The ox-wagon embodied two distinct notions of time. First, it represented the linear time of imperial progress, figured as a forward-thrusting journey traced across the space of the landscape, obedient to the unfolding telos of racial advance and the rational mapping of measurable space. Second, it embodied in the same fetish object of the wagon a quite different notion of recurring, nonlinear time: the divinely preordained event rehearsed once more in the zone of historical nature. For recently urbanized Afrikaners, these two overlapping, but conflictual, figures of time: pastoral, cyclical time (the time of rural nostalgia) and modern, industrial time (the time of mechanical simulacrum and repetition) were marvelously embodied in the single icon of the ox-wagon.

As they passed through towns, the wagons were driven through wet concrete to immemorialize their tracks, petrifying history as an urban fossil—exemplifying the modern compulsion to collect time in the form of an object; history as palimpsest: "in such a way," as Theodor Adorno put it, "that what is natural emerges as a sign for history and history, where it appears most historical, appears as a sign for nature."[77]

The *Tweede Trek* had another advantage. Tom Nairn has pointed out, in the British context: "Mobilization had to be in terms of what was there; and the whole point of the dilemma was that there was nothing there—none of the economic and political institutions of modernity. The middle-classes, therefore, had to function through a sentimental culture sufficiently accessible to the lower strata now being called to battle."[78] Lacking control of the institutions of modernity, Afrikaners mobilized through the one institution with which they were intimate and over which they still held precarious control: the family. Not only was much of the folk-memory and sentimental culture of the Great Trek fostered through the family, but its centralizing iconography and the epic social unit was familial. Perhaps this also goes some way toward explaining the zest with which Afrikaner women participated in the national pageantry that would soon write them out of power.

From the outset, as the *Eeufees* bore witness, Afrikaner nationalism was dependent not only on powerful constructions of racial difference but also on powerful constructions of gender difference. A racial and gendered division of national creation prevailed whereby white men were seen to embody the political and economic agency of the *volk*, while women were the (unpaid) keepers of tradition and the *volk*'s moral and spiritual mission. This gendered division of labor is summed up in the colonial gospel of the family and the presiding icon of the *volksmoeder* (mother of the nation). In photographs in the Gedenkboek [Figs. 10.3–10.9], women serve as boundary markers visibly upholding the fetish signs of national difference and visibly embodying the iconography of race and gender purity. Their

starched white bonnets and white dresses set a stark chiaroscuro of gender difference against the somber black of the men's clothes. Photographic captions hail women in the Victorian iconography of cleanliness, purity and maternal fecundity as the gatekeepers of the nation.

The *volksmoeder*, however, is less a biological fact than a social category. Nor is it an ideology imposed willy-nilly on hapless female victims. Rather, it is a changing, dynamic ideology rife with paradox, under constant contest by men and women and adapted constantly to the pressures arising from African resistance and the conflict between Afrikaner colonialists and British imperialists.

THE INVENTION OF THE *VOLKSMOEDER*

The Anglo-Boer War (fundamentally a war over African land and labor) was in many respects waged as a war on Boer women. In an effort to break Boer resistance, the British torched the farms and lands and herded thousands of women and children into concentration camps, where twenty-five thousand women and children perished of hunger, desolation and disease. Yet after the Anglo-Boer War, the political power of the fierce Boer women was muted and transformed. In 1913, three years after Union, the *Vrouemonument* (women's monument) was erected in homage to the female victims of the war. The monument took the form of a circular domestic enclosure, where women stand weeping with their children.

Here, women's martial role as fighters and farmers was purged of its indecorously militant potential and replaced by the figure of the lamenting mother with babe in arms. The monument enshrined Afrikaner womanhood as neither militant nor political, but as suffering, stoical and self-sacrificing.[79] Women's disempowerment was figured not as expressive of the politics of gender difference, stemming from colonial women's ambiguous relation to imperial domination, but as emblematic of national (that is, male) disempowerment. By portraying the Afrikaner *nation* symbolically as a weeping woman, the mighty male embarrassment of military defeat could be overlooked and the memory of women's vital efforts during the war washed away in images of feminine tears and maternal loss.

The icon of the *volksmoeder* is paradoxical. On the one hand, it recognizes the power of (white) motherhood; on the other hand, it is a retrospective iconography of gender containment, containing women's mutinous power within an iconography of domestic service. Defined as weeping victims, white women's activism is overlooked and their disempowerment thereby ratified.

Yet, in the early decades of this century, as Hofmeyer shows, women played a crucial role in the invention of Afrikanerdom. The family

household was seen as the last bastion beyond British control and the cultural power of Afrikaner motherhood was mobilized in the service of white nation-building. Afrikaans was a language fashioned very profoundly by women's labors, within the economy of the domestic household. "Not for nothing," as Hofmeyer notes, "was it called the 'mother tongue.'"

In Afrikaner nationalism, motherhood is a political concept under constant contest. It is important to emphasize this for two reasons. Erasing Afrikaner women's historic agency also erases their historic complicity in the annals of apartheid. White women were not the weeping bystanders of apartheid history but active, if decidedly disempowered, participants in the invention of Afrikaner identity. As such they were complicit in deploying the power of motherhood in the exercise and legitimation of white domination. Certainly, white women were jealously and brutally denied any formal political power but were compensated by their limited authority in the household. Clutching this small power, they became implicated in the racism that suffuses Afrikaner nationalism. For this reason, black South African women have been justly suspicious of any easy assumption of a universal, essential sisterhood in suffering. White women are both colonized and colonizers, ambiguously complicit in the history of African dispossession.

"NO LONGER IN A FUTURE HEAVEN"
GENDER AND THE ANC

African nationalism has roughly the same historical vintage as Afrikaner nationalism. Forged in the crucible of imperial thuggery, mining capitalism and rapid industrialization, African nationalism was, like its Afrikaner counterpart, the product of conscious reinvention, the enactment of a new political collectivity by specific cultural and political agents. But its racial and gender components were very different, and African nationalism would describe its own distinct trajectory across the century.

In 1910, the Union of South Africa was formed, uniting the four squabbling provinces under a single legislature. Yet at the "national" convention, not a single black South African was present. For Africans the Union was an act of profound betrayal. A color bar banished Africans from skilled labor and the franchise was denied to all but a handful. And so, in 1912, African men descended on Bloemfontein from all over South Africa to protest a Union in which no black person had a voice. At this gathering, the South African Natives National Congress (SANNC) was launched, soon to become the African National Congress.

At the outset the ANC, like Afrikaner nationalism, had a narrow class base. Drawn from the tiny urban intelligentsia and petite bourgeoisie, its members were mostly mission-educated teachers and clerks, small

businessmen and traders, the mimic-men whom Fanon described as "dusted over with colonial culture." As Tom Lodge shows, they were urban, antitribal and assimilationist, demanding full civic participation in the great British empire rather than confrontation and radical change.[80] Although Lodge does not mention this fact, they were also solidly male.

For the first thirty years of the ANC, black women's relation to nationalism was structured around a contradiction: their exclusion from full political membership within the ANC contrasted with their increasing grassroots activism. As Frene Ginwala has argued, women's resistance was shaped from below.[81] While the language of the ANC was the *inclusive* language of national unity, the Congress was in fact *exclusive* and hierarchical, ranked by an upper house of chiefs (which protected traditional patriarchal authority through descent and filiation), a lower house of elected representatives (all male) and an executive (always male). Indians and so-called coloreds were excluded from full membership. Wives of male members could join as "auxiliary members" but were denied formal political representation as well as the power to vote. Their subordinate, service role to nationalism was summed up in the draft constitution of the SANNC (later the ANC), which presented women's political role within nationalism as mediated by the marriage relation and as replicating wives' domestic roles within marriage: "All the wives of the members . . . shall ipso facto become auxiliary members It shall be the duty of all auxiliary members to provide suitable shelter and entertainment for delegates to the Congress."

In 1913, the white state saw fit to impose passes on women in an effort to preempt their migration to the cities. In outraged response, hundreds of women marched mutinously on Bloemfontein to fling back their passes and for their temerity met the full brunt of state wrath in a barrage of arrests, imprisonment and hard labor. Women's insurgence alarmed both the state and not a few African men. Nonetheless, the climate of militancy gave birth to the Bantu Women's League of the African National Congress, which was launched in 1918, drawing by and large, but not solely, on the tiny, educated, Christian elite. Thus, from the outset, women's organized participation in African nationalism stemmed less from the invitation of men than from their own politicization in resisting the violence of state decree.

At this time, however, women's potential militancy was muted and their political agency domesticated by the language of familial service and subordination. Women's volunteer work was approved insofar as it served the interests of the (male) "nation," and women's political identity was figured as merely supportive and auxiliary. As President Seme said: "No national movement can be strong unless the women volunteers come forward and offer their services to the nation." Nonetheless, women's national mission was still trivialized and domesticated, defined as providing

"suitable shelter and entertainment for members or delegates." At women's own insistence, the ANC granted women full membership and voting rights in 1943. It had taken thirty-one years.

After the Urban Areas Act of 1937, which severely curtailed women's movements, new insistence began to be voiced for a more militant and explicitly political national women's organization: "We women can no longer remain in the background or concern ourselves only with domestic and sports affairs. The time has arrived for women to enter the political field and stand shoulder to shoulder with their men in the struggle."[82] In 1943, the ANC decided that a Women's League should be formed, yet tensions would persist between women's calls for greater autonomy and men's anxieties about losing control.

During the turbulent 1950s, however, the ANC Women's League thrived. This was the decade of the Defiance Campaign, the Freedom Charter, the Congress Alliance and the Federation of South African Women. In 1956 thousands of women marched on Pretoria to once more protest passes for women and the Women's Charter was formed, calling for land redistribution; worker benefits and union rights; housing and food subsidies; the abolition of child labor; universal education; the right to vote; and equal rights with men in property, marriage and child custody. It is seldom noted that this charter preceded the Freedom Charter and inspired much of its substance.

Within African nationalism, as in its Afrikaans counterpart, women's political agency has been couched in the presiding ideology of motherhood. Winnie Mandela has long been hailed as "Mother of the Nation," and the singer Miriam Makeba is reverently addressed as "Ma Africa." The ideologies of motherhood in Afrikaner and ANC nationalism differ, however, in important respects.[83] Motherhood is less the universal and biological quintessence of womanhood than it is a social category under constant contest. African women have embraced, transmuted and transformed the ideology in a variety of ways, working strategically within traditional ideology to justify untraditional public militancy. Unlike Afrikaner women, moreover, African women appealed to a racially inclusive image of motherhood in their campaigns to fashion a nonracial alliance with white women. A Federation of South African Women pamphlet of 1958 exhorted white women: "In the name of humanity, can you as a woman, as a mother, tolerate this?" In 1986, Albertina Sisulu appealed impatiently to white women: "A mother is a mother, black or white. Stand up and be counted with other women."

Over the decades, African women nationalists, unlike their Afrikaner counterparts, have transformed and infused the ideology of motherhood with an increasingly insurrectionary cast, identifying themselves more and more as the "mothers of revolution." Since the 1970s, women's local rites of defiance

FIGURE 10.11 THE MILITANT MOTHER.

have been mirrored on a national scale in rent and bus boycotts, organized squatter camps, strikes, antirape protests and community activism of myriad kinds. Even under the State of Emergency, women have everywhere enlarged their militancy, insisting not only on their right to political agency but also on their right of access to the technologies of violence [Fig.10.11].

Black women's relation to nationalism has thus undergone significant historical changes over the years. At the outset, women were denied formal representation; then their volunteer work was put at the service of the national revolution, still largely male. Gradually, as a result of women's own insistence, the need for women's full participation in the national liberation movement was granted, but their emancipation was still figured as the handmaiden of national revolution. Only recently has women's empowerment been recognized in its own right as distinct from the national, democratic and socialist revolution. Nonetheless, the degree to which this rhetorical recognition will find political and institutional form remains to be seen [Fig. 10.12].

FEMINISM AND NATIONALISM

For many decades, African women have been loath to talk of women's emancipation outside the terms of the national liberation movement.[84] During the 1960s and 1970s, black women were understandably wary of the middle-class feminism that was sputtering fitfully to life in the white universities and suburbs. African women raised justifiably sceptical eyebrows at a white feminism that vaunted itself as giving tongue to a universal sisterhood in suffering. At the same time, women's position within the nationalist movement was still precarious and women could ill afford to antagonize men so embattled, who were already reluctant to surrender whatever patriarchal power they still enjoyed.

In recent years, however, a transformed African discourse on feminism has emerged, with black women demanding the right to fashion the terms of nationalist feminism to meet their own needs and situations.[85] On May 2, 1990, the National Executive of the ANC issued a historic "Statement on the Emancipation of Women," which forthrightly proclaimed: "The experience of other societies has shown that the emancipation of women is not a by-product of a struggle for democracy, national liberation or socialism. It has to be addressed within our own organisation, the mass democratic movement

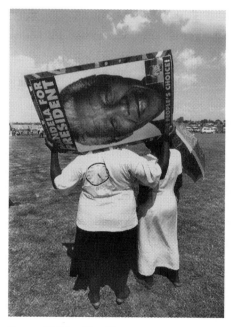

FIGURE 10.12 THE HANDMAIDENS OF NATIONAL UNITY:
WHEN WILL THEIR TIME COME?

and in the society as a whole." The document is unprecedented in placing South African women's resistance in an international context; in granting feminism independent historic agency; and in declaring, into the bargain, that all "laws, customs, traditions and practices which discriminate against women shall be held to be unconstitutional." If the ANC remains faithful to this document, virtually all existing practices in South Africa's legal, political and social life will be rendered unconstitutional.

A few months later, on June 17, 1990, the leaders of the ANC Women's Section, recently returned to South Africa from exile, insisted on the strategic validity of the term feminism: "Feminism has been misinterpreted in most third world countries . . . there is nothing wrong with feminism. It is as progressive or reactionary as nationalism. Nationalism can be reactionary or progressive. We have not got rid of the term nationalism. And with feminism it is the same." Feminism, they believed, should be tailored to meet local needs and concerns.

Yet very real uncertainties for women remain. So far, theoretical and strategic analyses of South Africa's gender imbalances have not run deep. There has been little strategic rethinking of how, in particular, to transform labor relations within the household and women are not given the same political visibility as men. At a Congress of South African Trade Unions (COSATU) convention, trade union women called for attention to sexual harrassment in the unions, but their demand was brusquely flicked aside by male unionists as a decadent symptom of "bourgeois imperialist feminism." Lesbian and gay activists have been similarly condemned as supporting life-styles that are no more than invidious imports of empire.[86]

There is not only one feminism, nor is there only one patriarchy. Feminism is imperialist when it puts the interests and needs of privileged women in imperialist countries above the local needs of disempowered women and men, borrowing from patriarchal privilege. In the last decade, women of color have been vehement in challenging privileged feminists who don't recognize their own racial and class power. In an important article, Chandra Mohanty challenges the appropriation of women of color's struggles by white women, specifically through the use of the category "Third World Woman" as a singular, monolithic and paradigmatically victimized subject.[87]

Denouncing all feminisms as imperialist, however, erases from memory the long histories of women's resistance to local and imperialist patriarchies. As Kumari Jayawardena notes, many women's mutinies around the world predated Western feminism or occurred without any contact with Western feminists.[88] Moreover, if all feminisms are derided as a pathology of the West, there is a very real danger that Western, white feminists will remain hegemonic, for the simple reason that such women have comparatively privileged access to publishing, the international media, education and money. A good deal of this kind of feminism may well be inappropriate to women

living under very different situations. Instead, women of color are calling for the right to fashion feminism to suit their own worlds. The singular contribution of nationalist feminism has been its insistence on relating feminist struggles to other liberation movements.

All too frequently, male nationalists have condemned feminism as divisive, bidding women hold their tongues until after the revolution. Yet feminism is a political response to gender conflict, not its cause. To insist on silence about gender conflict when it already exists is to cover and thereby ratify women's disempowerment. Asking women to wait until after the revolution serves merely as a strategic tactic to defer women's demands. Not only does it conceal the fact that nationalisms are from the outset constituted in gender power, but, as the lessons of international history portend, women who are not empowered to organize during the struggle will not be empowered to organize after the struggle. If nationalism is not transformed by an analysis of gender power, the nation-state will remain a repository of male hopes, male aspirations and male privilege [Fig. 10.13].

All too often, the doors of tradition are slammed in women's faces. Yet traditions are both the outcome and the record of past political contests as well as the sites of present contest. In a nationalist revolution, both women

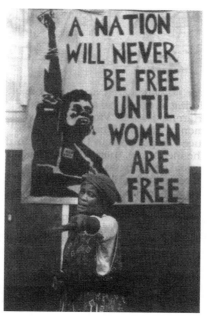

FIGURE 10.13 No Longer in a Future Heaven.

and men should be empowered to decide which traditions are outmoded, which should be transformed and which should be preserved. Male nationalists frequently argue that colonialism or capitalism has been women's ruin, with patriarchy merely a nasty second cousin destined to wither away when the real villain expires. Yet nowhere has a national or socialist revolution brought a full feminist revolution in its train. In many nationalist or socialist countries, women's concerns are at best paid lip service, at worst greeted with hilarity. If women have come to do men's work, men have not come to share women's work. Nowhere has feminism in its own right been allowed to be more than the maidservant to nationalism.

A crucial question thus remains for progressive nationalism: Can the iconography of the family be retained as the figure for national unity, or must an alternative, radical iconography be developed?

GENDER AND "THE NEW SOUTH AFRICA"

In recent times, "the new South Africa" has been hailed with almost as much gusto as "the new world order," and with as little reason. Panicked by the sinking economy and the sustained bravery of the Mass Democratic Movement, F. W. de Klerk, South Africa's canny prime minister, orchestrated Nelson Mandela's walk from prison and lifted the ban on the ANC. Now the elite of the ANC sit around polished tables cutting the cards of the future with de Klerk's Nationalists.

Yet for many black South Africans very little has changed. As Lauretta Ngcobo's novel about black women under the migrant system suggests, whatever the future shape of South Africa, little is likely to change for millions of people, particularly for women. *And They Didn't Die*, South Africa's first major novel about the "surplus people," is a scathing indictment of the migrant system and a timely warning against too glibly heralding the death of apartheid. Spanning the years between the Sharpeville massacre of 1960 and the State of Emergency of the 1980s, the novel addresses two unprecedented issues: life in the forgotten rural areas and the politics of motherhood.

Daughter of a rural mother and a migrant father, Jezile is born, like Ngcobo herself, in the killing fields of a Bantustan. Impossibly hot in summer, wretchedly cold in winter, the black reserve of Sigageni lies in the long corridor running down from the snows of the Drakensberg mountains. A vast, bleak valley strewn with mudhuts and shanties, the ruined land is burdened with too many people, too many cattle and goats and can no longer support the basic needs of life. In summer, aloes bleed on the hills and the heat torches and shrivels the crops. In winter, winds knife down the corridor, tearing at the women's flimsy cotton wrappings and buffeting the shivering herds. The men of Sigageni spend their lives hundreds of miles

away in workers' barracks in white cities. The women of Sigageni spend their lives waiting. The women are experts at waiting—for husbands, for rain, for unborn children. While they gather dung for the fire, they wait; while they plough the stony earth, they wait. They wait while they bear children and grow old. They sit in the dust, eyeing the road that might bring them a husband, a parcel of children's clothes, a pay-check.

In 1960 the women of Sigageni stop waiting. First burning their passes, then torching a black sellout's house, the women ignite a slow conflagration that eventually lands them in prison and engulfs the entire community in war. Ngcobo's unsparing novel offers the unprecedented insight that motherhood is a political issue. For women in the Bantustans, children are their security: an insurance of the flesh, bringing husbands, perhaps, back from the city once a year along the via dolorosa to the reserves.

And They Didn't Die chronicles the previously untold predicaments of women caught between custom, white law and the migrant system. Much of the power of the novel lies in Ngcobo's talent for complication and nuance and her refusal of dogma. If for Jezile, children are the promise of bounty, for her friend Zenzile, starving and solitary in her mud hut, each new child is a calamity of the flesh. Zenzile dies spectrally thin in childbirth, abandoned by her husband Mthebe for the crimson-lipped ladies of the city.

In a hospital room nicknamed "the slaughter house" by the white nurses, Jezile's longed-for daughter, S'naye ("we have her") is finally born. Her husband, Siyalo is thrown out of work because of his wife's political activities and is permanently endorsed out of industrial South Africa to the dying reserve. When Jezile and the women of Sigageni are flung into prison, Siyalo and his mother battle to keep the starving S'naye alive. One of the most poignant sections of the book chronicles the anguished weaning, then starving, of babies plucked from detained mothers. Prison means not only mortification and rape, but also return to babies with bloated bellies and skeletal limbs. Driven to desperation by the sight of his dying baby, Siyalo steals milk from the swollen udders of the white farmer's cows. A black herdsman betrays him, and he is sentenced to ten years imprisonment for what the white court sees as the political act of fomenting rural anarchy.

Some of the novel's bleakest and bravest moments deal with the politics of female sexuality. The left, whether black or white, has tended to deny the female body a place in politics. While men may find release in the cities, the sexual torments of lonely women—"the daily longings and ever-present temptations and attendant disgrace"—are generally ignored. When, after her time in jail, Jezile travels to Bloemfontein to work as a domestic servant, the sight of swollen yellow peaches plunges her into the delirium of inadmissible desires. Under the inclement laws of custom, an untimely pregnancy by adultery is as catastrophic for women as childlessness. In Bloemfontein,

Jezile's white employer rapes her; she gives birth to a light-skinned child and returns to Sigageni. But her mother-in-law MaBiyela, custodian of custom, sees rape and the white child as a crime of the female flesh and casts Jezile out. When Siyalo returns from prison, he refuses to see her.

And They Didn't Die explores what happens when women start asking questions: about cattle and the land, about female power, about tradition, about violence, about sex. When, at the end, Jezile murders a white policeman for trying to rape her daughter, the book asks what happens when women take the weapons of revenge into their own hands. Jezile's violation of white law frees her to violate customary law and she finally confronts Siyalo and tells him how her pale son was born.

In the final analysis *And They Didn't Die* asks all South Africans: What is going to happen to the women of the rural areas?

> We, the women in the rural areas, need to know why we are here when our husbands are there; why we starve when South Africa is such a large and wealthy country and what might happen to us if we keep on asking these questions.

Now, if de Klerk's "white paper" goes into effect and the land laws are scrapped, it is argued that there will be nothing to stop Africans from buying up seaside property, moving into imitation Spanish villas or sinking swimming pools in their own back yards. Nothing, that is, except terminal poverty. Meanwhile no provision is being made for the millions of people already condemned to oblivion in the Bantustans. The Freedom Charter promises that the land will belong to those who work it. Since, in South Africa, women do most of the farming, will the land therefore be given to them? Or, as in so many other postindependence countries, will the property rights, the technology, the loans and aid, be given to men? When these questions are answered, perhaps we can begin to talk about a new South Africa.

Frantz Fanon's prescient warnings against the pitfalls of the national consciousness were never more urgent than now. For Fanon, nationalism gives vital expression to popular memory and is strategically essential for mobilizing the populace. At the same time, no one was more aware than Fanon of the attendant risks of projecting a fetishistic denial of difference onto a conveniently abstracted "collective will." In South Africa, to borrow Fanon's phrase, national transformation is "no longer in a future heaven." Yet the current situation gives sober poignancy, especially for women, to the lines from Giles Pontecorvo's famous film on the Algerian national war of liberation, *The Battle of Algiers*: "It is difficult to start a revolution, more difficult to sustain it. But it's later, when we've won, that the real difficulties will begin."

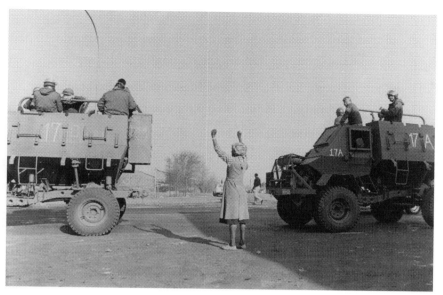

FIGURE 10.14 LONE WOMAN PROTESTS AS TROOPS OCCUPYING HER TOWNSHIP
ROLL BY IN MILITARY VEHICLES CALLED "HIPPOS."
Soweto, July 1985.

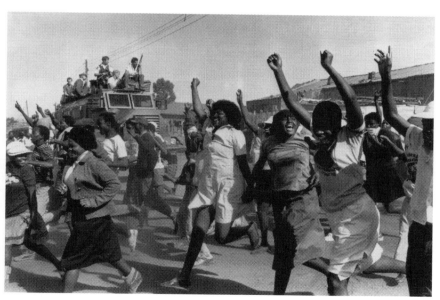

FIGURE 10.15 FUNERAL CROWDS DEFY POLICE IN THE TOWNSHIP.
1986.

POSTSCRIPT

THE ANGEL OF PROGRESS

His face is turned towards the past The angel would like to stay, awaken the dead, and make whole that which has been smashed. But a storm is blowing from Paradise; it has got caught in his wings with such violence that the angel can no longer close them. This storm irresistibly propels him into the future to which his back is turned, while the pile of debris before him grows skyward. This storm is what we call progress.

— Walter Benjamin

How do we account for the curious proliferation of "post" words in the last few years in intellectual life, not only in the universities but in newspaper columns and on the lips of media moguls? In the case of *postcolonialism*, at least, part of the reason is its academic marketability. While admittedly another PC word, postcolonialism is arguably more palatable and less foreign-sounding to skeptical deans than "Third World Studies." It

also has a less accusatory ring than "Studies in Neocolonialism," say, or "Fighting Two Colonialisms." It is more global, and less fuddy-duddy, than "Commonwealth Studies." The term borrows, moreover, on the dazzling marketing success of the term *postmodernism*. As the organizing rubric of an emerging field of disciplinary studies and an archive of knowledge, the term *postcolonialism* makes possible the marketing of a whole new generation of panels, articles, books and courses. The enthusiasm for "post" words, however, has ramifications beyond the corridors of the university. The recurrent, almost ritualistic incantation of the prefix *post* is a symptom, I believe, of a global crisis in ideologies of the future, particularly the ideology of progress.

The first seismic shift in the idea of progress came with the abrupt shift in U.S. Third World policy in the 1980s. Emboldened in the 1950s by its economic "great leap forward" (space, again, is time), the United States was empowered to insist globally that other countries could progress only if they followed the U.S. road to mass-consumption prosperity. W. W. Rostow's "Non-Communist Manifesto" envisaged the so-called developing nations as passing through similar stages of development out of tradition-bound poverty; through an industrialized modernization overseen by the United States, the World Bank and the International Monetary Fund (IMF); to mass-consumer prosperity. Nonetheless, except for the Japanese "miracle" and the Four Tigers (Taiwan, Singapore, Hong Kong and South Korea), the vast majority of the world's populations have, since the 1940s, come to lag even further behind the consumer standards set by the west.[1]

Then, between 1979 (the second oil shock) and 1982 (the Mexican default), the world economy began to creak. Increasingly, it became clear that the United States was no longer destined to be the only economic power of the future. Hobbled by its phenomenal debts and increasingly diminished by the twin shadows of Japan and Germany, the United States summarily abandoned the doctrine of global progress and development. During the Reagan era, the United States instituted instead a bullying debt-servicing policy towards poorer countries, bolstered by aggressive market competition with them, and defended by sporadic fits of military gangsterism, as in Grenada and Panama. The cataclysmic war in the Persian Gulf served only to underscore the point.

For many poorer countries, the shift in U.S. policy meant abandoning overnight the fata morgana of capitalist progress and settling for chronically stricken positions in the global hierarchy. Henceforth, they could aspire only to tighten their belts, service their debts and maintain some credit. In 1974, Africa's debt-service ratio was a manageable 4.6 percent. Thirteen years later it had rocketed to 25 percent. But the collapse of the U.S. model of progress has also meant the collapse, for many

regimes, of the legitimacy of their national policies in the panicky context of worldwide economic crisis, ecological calamity and spiraling popular desperation. Perhaps one reason, at least, for the burgeoning populist appeal of Islamic fundamentalism is the failure of other models of capitalist or communist progress. As a senior Libyan aide, Major Abdel-Salam Jalloud, has said of the destiny of the FIS in Algeria: "It's impossible to turn back. The FIS has an appointment with history; it will not miss it."[2]

A monotonously simple pattern has emerged. Despite the hauling down of colonial flags in the 1950s, revamped economic imperialism has ensured that the United States and the former European colonial powers have become richer, while, with a tiny scattering of exceptions, their ex-colonies have become poorer.[3] In Africa before decolonization, World Bank projects were consistently supportive of the colonial economies. Since formal decolonization, contrary to the World Bank's vaunted technical "neutrality" and myth of expertise, projects have aggressively favored the refinement and streamlining of surplus extraction, cash crop exports and large-scale projects going to the highest bidders, thereby fostering cartels and foreign operators and ensuring that profits tumble into the coffers of the multinational corporations. During 1986, Africa lost $19 billion through collapsed export prices alone. In 1988 and 1989, debt-service payments from the Third World to the United States were $100 billion.[4] At the same time, as Fanon predicted, Third World kleptocracies, military oligarchies and warlords have scrambled over each other to plunder the system. To protect these interests, the tiny, male elites of developing countries spent almost $2.4 trillion on their militaries between 1960 and 1987, almost twice the amount of the entire Third World debt.[5] Now, after the 1980s "desperate decade" of debt, drought and destabilization, the majority of Third World countries are poorer than they were a decade ago.[6] Twenty-eight million Africans face famine, and in countries like Mozambique, Ethiopia, Zaire and the Sudan the economies have simply collapsed.

The U.S. development myth has had a grievous impact on global ecologies. By 1989, the World Bank had $225 billion in commitments to poorer countries, on condition that those countries, in turn, endure the purgatory of "structural adjustment," export their way to progress, cut government spending on education and social services (with the axe falling most cruelly on women), devalue their currencies, remove trade barriers and raze their forests to pay their debts.[7] Under the financial spell of the United States (and now Japan), and in the name of the fairy tale of unlimited technological and capital growth, the World Bank engineered one ecological disaster after another: the Indonesian Transmigrasi program, the Amazonian Grande Carajas iron-ore and strip-mining project, the Tucurui Dam deforestation project, and so on. The Polonoroeste scheme in Brazil carved a

paved highway through Amazonia, luring timber, mining and cattle ranching interests into the region with such calamitous impact that in May 1987 even the President of the World Bank, Barber Conable, confessed that he found the devastation "sobering."[8]

The Four "miracle" Tigers have paid for progress with landscapes pitted with poisoned water, toxic soil, denuded mountains and dead coral seas. In "miracle" Taiwan, an estimated 20 percent of the country's farmland is polluted by industrial waste, and 30% of the rice crops contain unsafe levels of heavy metals, mercury and cadmium.[9] A World Bank report in 1989 concluded gloomily that adjustment programs carry the by-product that "people below the poverty line will probably suffer irreparable damage in health, nutrition and education."[10] Now Japan, insatiably hungry for timber and raw resources, is the major foreign aid donor, to the tune of $10 billion. In short, the World Bank and IMF road to progress has proved a short road to what Susan George has called "a fate worse than debt."

To compound matters, the collapse of the U.S. myth of progress was swiftly followed by the collapse of the Soviet Union, which dragged down with it an entire master narrative of communist progress. The zig-zag of Hegelian-Marxist progress, managed by a bureaucratic command economy, was thought destined to arrive ineluctably at its own utopian destination. The toppling of the Soviet empire has meant, for many, the loss of a certain privileged relation to history as the epic unfolding of linear, if spasmodic, progress, and with it the promise that the bureaucratic communist economy could one day outstrip the United States in providing consumer abundance for all. As a result, there has also been some loss of political certitude in the inevitable role of the male (and, as it turns out, white) industrial working class as the privileged agent of history. If the bureaucracy of the Soviet Union fell, it was not under the weight of popular, industrial mobilization but rather under the double weight of its economic corruption and manic military spending. The irony is not lost that the ascendant economies of Japan and Germany were historically denied the unsupportable burden of the arms race. Thus, despite the fact that men are slaughtering each other around the globe with increased dedication, there has been a certain loss of faith in masculine militarism as the inevitable guarantee of historical progress. For the first time in history, moreover, the idea of industrial progress impelled by technocratic development is meeting the limits of the world's natural resources.

Ironically, the last zone on earth to embrace the Enlightenment ideology of capitalist development may be the one now controlled by Boris Yeltsin and his allies. The world has watched awestruck as Yeltsin and his fellow travelers swerved dizzyingly off the iron road of the centralized, communist command economy and lurched bumpily onto the capitalist

road of decentralization, powered no longer by the dialectic as the motor and guarantee of progress, but by tear-away competition and mad marketeering. Never mind that this swerve is likely to unleash a disaster on a scale comparable to the famines that followed the original Bolshevik revolution, nor that the rough beast that slouches out of the chaos may not be Western capitalism at all, but a particularly grisly form of fascism.

For both communism and capitalism, progress was both a journey forward and the beginning of a return; for as in all narratives of progress, to travel the road of progress was to cover, once again, a road already traveled. The metaphor of the "road" or "railway" guaranteed that progress was a fait accompli. The journey was possible because the road had already been made (by God, the Dialectic, the Weltgeist, the Cunning of History, the Law of the Market, Scientific Materialism). As Hegel decreed, progress in the realm of history was possible because it has already been accomplished in the realm of truth. But now, if the owl of Minerva has taken flight, there is widespread uncertainty as to whether it will return.

The collapse of both capitalist and communist teleologies of progress has resulted in a doubled and overdetermined crisis in images of future time. The uncertain global situation has spawned a widespread sense of historic abandonment, of which the apocalyptic, time-stopped prevalence of "post" words is only one symptom. The storm of progress had blown for communism and capitalism alike. Now the wind is stilled, and the angel with hunched wings broods over the wreckage at its feet. In this calm at "the end of history," the millenium has come too soon, and the air seems thick with omens.

Francis Fukuyama has declared history dead. Capitalism, he claims, has won the grand Hegelian agon with communism, and is now "post-historic." Third World countries lag behind in the zone of the "historic," where matters are decided by force.[11] Far from the "end of history" and the triumph of United States consumer capitalism, however, the new order of the day is most likely to be multipolar competition among the four currently decisive regions of the world: Japan, the United States, Fortress Europe and the Middle East. The arms trade will continue as the military-industrial wizards of Armageddon turn their attention from cold war scenarios to multiple, dispersed wars of attrition, fought by the U.S. mercenary army and other proxies and paid for by Japan and Germany. Within the United States, with the vanishing of international communism as a rationale for militarism, new enemies will be found: the drug war, international terrorism, Japan, feminists, the PC hordes and tenured radicals, undocumented workers, lesbians and gays, and any number of international ethnic targets.

For this reason, there is some urgency in the need for innovative theories of history and popular memory, particularly mass-media memory. Asking what *single* term might adequately replace "postcolonialism," for

example, begs the question of rethinking the global situation as a *multiplicity* of powers and histories that cannot be marshaled obediently under the flag of a single theoretical term, be it feminism, Marxism, or postcolonialism. Nor does intervening in history mean lifting, again, the mantle of progress or the quill pen of empiricism. "Objectivity, for the native," as Fanon said, "is always against him." Rather, a proliferation of historically nuanced theories and strategies is called for, which may enable us to engage more effectively in the politics of affiliation, and the currently calamitous dispensations of power. Without a renewed will to intervene in the unacceptable, we face the prospect of being becalmed in a historically empty space in which our sole direction is found by gazing back spellbound at the epoch behind us, in a perpetual present marked only as "post."

NOTES

NOTES TO INTRODUCTION

1. Henry Rider Haggard, *King Solomon's Mines* (London: Dent, 1885).
2. Haggard, *King Solomon's Mines*, pp. 74, 84.
3. Haggard, *King Solomon's Mines*, p. 118.
4. Even Edward Said's enormously important and influential *Orientalism* does not explore gender as a category constitutive of imperialism. Likewise, Peter Fryer's vast and crucial history of black people in Britain, *Staying Power*, is well-nigh silent about women, as is Paul Gilroy's valuable analysis of black popular culture, *There Ain't No Black in the Union Jack*. Edward Said, *Orientalism* (New York: Vintage, 1978); Peter Fryer, *Staying Power: The History of Black People in Britain* (London: Pluto Press, 1984); Paul Gilroy, *There Ain't No Black in the Union Jack: The Cultural Politics of Race and Nation* (London: Hutchinson, 1987).
5. For a comprehensive overview, see Ann Laura Stoler, "Carnal Knowledge and Imperial Power: Gender, Race, and Morality in Colonial Asia," in Micaela di Leonardo, ed., *Gender and the Crossroads of Knowledge: Feminist Anthropology in the Postmodern Era* (Berkeley: University of California Press, 1991), pp. 51–100.
6. For regional and historical analyses of the impact of colonialism on women, see Mona Etienne and Eleanor Leacock, eds., *Women and Colonization* (New York: Praeger, 1980); Delia Jarrett Macaulay, "Black Women's History," paper presented at the Women's History Conference, London, June 1991; Nancy Hafkin and Edna Bay, eds., *Women in Africa: Studies in Social and Economic Change* (Stanford: Stanford University Press, 1976);

 Cherryl Walker, ed., *Women and Gender in Southern Africa to 1945* (Cape Town: David Philip, 1990); Hazel Carby, "On the Threshold of Women's Era. Lynching, Empire and Sexuality in Black Feminist Theory," *Critical Inquiry* 12, 1 (1985): 262–277.
7. For regional and historical analyses of colonial women, see Helen Callaway, *Gender, Culture and Empire: European Women in Colonial Nigeria* (London: Macmillan, 1987); Jackie Cock, *Maids and Madams* (Johannesburg: Ravan Press, 1980); Jean Comaroff and John Comaroff, "Christianity and Colonialism in South Africa," *American Ethnologist* 13 (1986): 1–22; Beverley Gartrell, "Colonial Wives: Villains or Victims?" in Hillary Callan and Shirley Ardner, eds., *The Incorporated Wife* (London: Croom Helm, 1984); and Irene Silverblatt, *Moon, Sun and Witches: Gender Ideologies and Class in Inca and Colonial Peru* (Princeton: Princeton University Press, 1987).
8. Hazel Carby, "White Women Listen! Black Feminism and the Boundaries of Sisterhood," in Center for Contemporary Cultural Studies, eds., *The Empire Strikes Back: Race and Racism in 70s Britain* (London: Hutchinson, 1982).
9. bell hooks, *Ain't I a Woman? Black Women and Feminism* (London: Pluto Press, 1982).
10. Valerie Amos and Pratibha Parmar, "Challenging Imperial Feminism" *Feminist Review* 17 (Autumn 1984): 5. This book is deeply indebted to this critique, which is now extensive. For important analyses of Western feminism in relation to colonialism, see Chandra T. Mohanty, "Under Western Eyes: Feminist Scholarship and Colonial

Discourses," *Feminist Review* 30 (Autumn 1988): 61–88; Kum-Kum Bavnani and Margaret Coulson, "Transforming Socialist Feminism: The Challenge of Racism," *Feminist Review* 23 (1986): 81–92; Marnea Lazreg, "Feminism and Difference: The Perils of Writing as a Woman on Women in Algeria," *Feminist Studies* 14, 3 (1988): 81–107; and Gayatri Chakravorti Spivak, "French Feminism in an International Frame," in her book *In Other Worlds: Essays in Cultural Politics* (New York: Methuen, 1987). See also Spivak's *The Post-Colonial Critic: Interviews, Strategies, Dialogues*, ed. Sarah Harasym (New York: Routledge, 1990) and the special issue on "Feminism and the Critique of Colonial Discourse," *Inscriptions* 3/4 (1988). For a more general analysis of white women and racism, see Vron Ware, *Beyond the Pale: White Women, Racism and History* (London: Verso, 1992).

11. Joan W. Scott, *Gender and the Politics of History* (New York: Columbia University Press, 1988), p. 32. As Denise Riley puts it: "'being a woman' is also inconstant, and can't provide an ontological foundation." Denise Riley, *"Am I That Name?" Feminism and the Category of "Women" in History* (Basingstoke: Macmillan, 1989), pp. 1–2. For an important critique of both gender and racial essentialism, see Diana Fuss, *Essentially Speaking. Feminism, Nature and Difference* (New York: Routledge, 1989).

12. Cora Kaplan, *Sea Changes: Culture and Feminism* (London: Verso, 1989), p. 27. Scott likewise notes: "The use of gender emphasizes an entire system of relationships that may include sex but is not directly determined by sex nor directly determining of sexuality." *Gender and the Politics of History*, p. 32.

13. Michel Foucault, *History of Sexuality*, vol.1, trans. Richard Howard (New York: Vintage, 1980), p. 22.

14. Foucault, *History of Sexuality*, vol.1, p. 23.

15. bell hooks, "Travelling Theories: Travelling Theorists," *Inscriptions* 5 (1989): 162.

16. For a historical exploration of whiteness as ethnicity, see Catherine Hall, *White, Male and Middle Class: Explorations in Feminism and History* (Cambridge: Polity Press, 1992).

17. Norman Harris, "'Who's Zoomin' Who': The New Black Formalism," *The Journal of Midwest Modern Language Association* 20, 1 (September 1987): 37–45. See also Joyce A. Joyce, "'Who the Cap Fit': Unconsciousness and Unconscionableness in the Criticism of Houston A. Baker, Jr. and Henry Louis Gates," *New Literary History* 18, 2 (Winter, 1987): 379. Two critical collections addressing these issues are Henry Louis Gates, Jr., ed., *"Race," Writing and Difference* (Chicago: University of Chicago Press, 1986), and Gates, ed., *Black Literature and Literary Theory* (New York and London: Methuen, 1984). See also Gates, *Figures in Black: Words, Signs, and the "Racial" Self* (Oxford: Oxford University Press, 1987); Kwame Anthony Appiah, "The Uncompleted Argument: DuBois and the Illusion of Race," *Critical Inquiry* 12, 1 (Autumn, 1985): 21–37, and Appiah, *In My Father's House: Africa in the Philosophy of Culture* (London: Methuen, 1992); Hortense Spillers, "Mama's Baby, Papa's Maybe: An American Grammar Book," *Diacritics* (Summer 1987): 65–95. In the British context, see Stuart Hall's "Cultural Identity and Diaspora" in Jonathan Rutherford, ed., *Identity: Community, Culture and Difference* (London: Lawrence and Wishart, 1990), pp. 222–237. In the same collection, see Kobena Mercer's analysis of postmodern notions of identity in "Welcome to the Jungle: Identity and Diversity in Postmodern Politics," pp. 43–71; and Pratibha Parmar, "Black Feminism: The Politics of Articulation," in Rutherford, *Identity*, pp. 101–126. On race as a category, see Paul Gilroy, *There Ain't No Black in the Union Jack: The Cultural Politics of Race and Nation* (London: Hutchinson, 1987). For a discussion of the problems of race as a category, and a call for ethnic as an alternative, see Floya Anthias and Nira Yuval-Davis, "Contextualising Feminism: Gender, Ethnic and Class Divisions," *Feminist Review* 15 (Winter 1983).

18. Paul Gilroy, *The Black Atlantic: Modernity and Double Consciousness* (Cambridge, Mass.: Harvard University Press, 1993), p. x.

19. Houston A. Baker, "Caliban's Triple Play," *Critical Inquiry* 13, 1 (Autumn 1986): 186.

20. Frantz Fanon, *The Wretched of the Earth* (London: Penguin, 1963), p. 29.

21. Gallery brochure, "The Hybrid State Exhibit," Exit Art, 578 Broadway, New York (Nov. 2–Dec. 14, 1991).

22. Quoted by Susan Buck-Morss, *The Dialectics of Seeing: Walter Benjamin and the Arcades Project* (Cambridge, Mass.: The MIT Press, 1989), p. 90.

23. Buck-Morss, *The Dialectics of Seeing*, p.79.

24. Sara Suleri, quoted in Appiah, *In My Father's House*, p. 253.

25. See Appiah's excellent analysis of the torsions of postmodernism and post-colonialism in "The Postcolonial and the Postmodern," *In My Father's House*, pp. 221–254. See also Ken Parker, "Very Like a Whale: Postcolonialism between Canonicities and Ethnicities," Social Identities I, I (Spring 1995).

26. Bill Ashcroft, Gareth Griffiths and Helen Tiffin, *The Empire Writes Back: Theory and Practice in Post-colonial Literatures* (Routledge: London, 1989), p. 24.

27. "We use the term 'post-colonial,' however, to cover all the culture affected by the imperial process from the moment of colonization to the present day." Ashcroft, Griffiths and Tiffin, *The Empire Writes Back*, p. 2.

28. For an astute analysis of postcolonial theory, see Robert Young, *White Mythologies: Writing History and the West* (London: Routledge, 1990).

29. Edward Said, *Orientalism*, p. 6.

30. Said, *Orientalism*, p. 207.

31. Eve Kosofsky Sedgwick, *Between Men: English Literature and Male Homosocial Desire* (New York: Columbia University Press, 1985).

32. See Gauri Viswanathan's analysis of how "events in the peripheries reshaped and determined domestic relations," in "Raymond Williams and British Colonialism: The Limits of Metropolitan Cultural Theory," in Dennis L. Dworkin and Leslie G. Roman, eds., *Views Beyond the Border Country: Raymond Williams and Cultural Politics* (New York: Routledge, 1993), p. 220. For a comprehensive historical analysis, see D. K. Fieldhouse,

The Colonial Empires: A Comparative Survey from the Eighteenth Century (Basingstoke: Macmillan, 1965), esp. Ch. 9.

33. Gilroy, *Black Atlantic*, p. 2.

34. Spivak, "The Rani of Sirmur," in Francis Barker et al., eds., *Europe and its Others*, vol. 1 (Essex: University of Essex, 1985), p. 131. See also Spivak's useful critique of what she calls "chromatism" (reducing race to the question of skin color) in "Imperialism and Sexual Difference," *Oxford Literary Review* 8 (1986): 235.

35. I am not, of course, suggesting that Spivak herself thinks this, which would do little justice to the subtlety and importance of her analyses of postcolonialism.

36. Scott, *Gender and the Politics of History*, p. 6.

NOTES TO CHAPTER 1

1. Quoted in Peter Fryer, *Staying Power: The History of Black People in Britain* (London: Pluto Press, 1984), p. 139.

2. John Leo Africanus, *A Geographical Historie of Africa*, trans. John Pory (London: Georg. Bishop, 1600), p. 38.

3. Francis Bacon, *New Atlantis: A Worke Unfinished*, in Francis Bacon, *Sylva sylvarum or, a natural history in ten centuries* (London: William, 1670), p. 26.

4. John Ogilby, *Africa: Being an Accurate Description of the Regions of Aegypt, etc.* (London: Tho. Johnson, 1670), p. 451.

5. Edward Long, *The History of Jamaica*, (London: T. Lowndes, 1774), pp. 382–383.

6. Winthrop D. Jordan, *White Over Black: American Attitudes Toward the Negro, 1550–1812* (New York: W. W. Norton, 1977), p. 7.

7. *The Modern Part of the Universal History*, vol. V (T. Osborne etc., 1760), pp. 658–9.

8. *The Modern Part of the Universal History*, p. 659.

9. Sir Thomas Herbert, *Some years travel into divers parts of Africa, and Asia the Great* (London: R. Scot, 1677), p. 18.

10. Edward Long, *Candid Reflections* (London: T. Lowndes, 1772), p. 48.

11. William Smith, *A New Voyage to Guinea* (London: John Nourse, 1745), pp. 221–222.

12. The term "fabulous geography" is

Michael Taussig's, in *Shamanism, Colonialism and the Wild Man: A Study in Terror and Healing* (Chicago: The University of Chicago Press, 1987), p. 15. Joseph Conrad first coined the term "militant geography" in his essay "Geography and Some Explorers," in *Last Essays* (London: J. M. Dent & Sons, 1926), p. 31. For a history of the demise of colonial slavery, see Robin Blackburn, *The Overthrow of Colonial Slavery; 1776–1848* (London: Verso, 1988).

13. Benjamin Farrington, *The Philosophy of Francis Bacon: An Essay on Its Development from 1603 to 1609 With New Translations of Fundamental Texts* (Chicago: Chicago University Press, 1964), p. 62. See Ludmilla Jordanova, *Sexual Visions: Images of Gender in Science and Medicine Between the Eighteenth and Twentieth Centuries* (New York: Harvester Wheatsheaf, 1989). See also E. F. Keller, *Reflections on Gender and Science* (New Haven: Yale University Press, 1985), especially chs. 2 and 3; Susan Griffin, *Woman and Nature: The Roaring Inside Her* (New York: Harper & Row, 1978); and Genevieve Lloyd, *The Man of Reason: "Male" and "Female" in Western Philosophy* (Minneapolis: Minnesota University Press, 1984).

14. Farrington, ibid., p. 62. For the gendering of Bacon's vision of science, see Carolyn Merchant, *The Death of Nature: Women, Ecology and the Scientific Revolution* (San Francisco: Harper and Row, 1980), especially ch. 7.

15. Francis Bacon, *Novum Organum* in *The Works of Francis Bacon*, James Spedding, Robert Ellis, and Douglas Heath, eds. (London: Longmans, 1870), p. 82.

16. Goethe, *Faust*, Part 1, quoted in Jordanova, *Sexual Visions*, p. 93.

17. Rene Descartes, *Discourse on Method and the Meditations* (Harmondsworth: Penguin, 1968), p. 78.

18. Mary Douglas, *Purity and Danger* (London: Routledge & Kegan Paul, 1966), p. 63.

19. Victor Turner, *The Ritual Process: Structure and Anti-Structure* (Ithaca: Cornell University Press, 1969).

20. Turner, *The Ritual Process*, p. 95.

21. Douglas, *Purity and Danger*, p. 78.

22. Douglas, *Purity and Danger*, p. 79.

23. See Peter Hulme, "Polytropic Man: Tropes of Sexuality and Mobility in Early Colonial Discourse," in Francis Barker et al., eds., *Europe and Its Others*, vol. 2. (Essex: University of Essex, 1984). Also Louis Montrose, "The Work of Gender in the Discourse of Discovery," *Representations* 33 (Winter 1991): 1–41. For European images of America, see Hugh Honour, *The New Golden Land: European Images of America from the Discoveries to the Present Time* (New York: Pantheon Books, 1975), ch. 4.

24. Hulme, "Polytropic Man," p. 21

25. Jonathan Swift, "On Poetry: A Rhapsody" (1733), quoted in Peter Barber and Christopher Board, *Tales from the Map Room: Fact and Fiction About Maps and Their Makers* (London: BBC Books, 1993), p. 20.

26. Hulme, (1984), ibid, p. 21.

27. Montrose, "The Work of Gender," p. 4.

28. Luce Irigaray, *Speculum of the Other Woman*, trans. Gillian C. Cill (Ithaca: Cornell University Press, 1974), p. 23.

29. Irigaray, *Speculum of the Other Woman*, p. 23.

30. Irigaray, *Speculum of the Other Woman*, p. 74.

31. Mary Louise Pratt, *Imperial Eyes: Travel Writing and Transculturation* (New York: Routledge, 1992), p. 204.

32. For a fine and detailed discussion of gendered imperial metaphors in film see Ella Shohat, "Gender and the Culture of Empire: Toward a Feminist Ethnography of the Cinema," *Quarterly Review of Film and Video*, 13, 1–3 (Spring 1991): 45–84. For an analysis of the gendering of the American frontier see Annette Kolodny, *The Lay of the Land: Metaphors as Experience and History in American Life and Letters* (Chapel Hill: University of North Carolina Press, 1975); and *The Land Before Her: Fantasy and Experience of the American Frontiers, 1630–1860* (Chapel Hill: University of North Carolina Press, 1984). See also Henry Nash Smith, *Virgin Land: The American West as Symbol and Myth* (Cambridge: Harvard University Press, 1971).

33. *McClures Magazine* 13 (May–October 1899).

34. Pratt, *Imperial Eyes*, p. 134.

35. Pratt, *Imperial Eyes*, p. 15.

36. Pratt, *Imperial Eyes*, p. 36.

37. Jean and John L. Comaroff, "Home-Made Hegemony: Modernity, Domesticity, and Colonialism in South Africa," in Karen Hansen, ed., *African Encounters with Domesticity* (New Brunswick: Rutgers University Press, 1992), p. 39.

38. Hansen, *African Encounters with Domesticity*, p. 3.

39. Hansen, *African Encounters with Domesticity*, p. 23.

40. For an analysis of colonial domesticity in Southern Africa, see Jean and John L. Comaroff, pp. 37–74.

41. Johannes Fabian, *Time and the Other: How Anthropology Makes Its Object* (New York: Columbia University Press, 1983), p. 15.

42. Jacques Benigne Bossuet, *Discours sur l'histoire universelle.* Quoted in Fabian, *Time and the Other*, p. 4.

43. Fabian, *Time and the Other*, p. 96.

44. Dolf Sternberger, following Walter Benjamin, saw in the popular Victorian phenomenon of the panorama, a popularization of Darwin's theory as a "panorama of evolution." In the panoramic image, history looks like a "natural progression" from ape to man, so that "the eye and the mind's eye can slide unhindered, up and down, back and forth, across the pictures as they themselves 'evolve'." Quoted in Susan Buck-Morss's excellent book *The Dialectics of Seeing: Walter Benjamin and the Arcades Project* (Cambridge, Mass.: The MIT Press, 1990), p. 67.

45. Quoted in Buck-Morss, *The Dialectics of Seeing*, p. 127.

46. Joseph-Marie Degerando, *The Observation of Savage Peoples*, F.C.T. Moore, ed. (Berkeley: University of California Press, [1800] 1969).

47. William Pietz, "The Problem of the Fetish, II" *Res* 13 (Spring 1987), p. 45.

48. Sander Gilman, *Difference and Pathology: Stereotypes of Sexuality, Race and Madness* (Ithaca: Cornell University Press, 1985), p. 45.

49. Baartman was exhibited around Europe for five years. In 1829 a nude "Hottentot" woman, the "Hottentot Venus," was the prize attraction at a ball given by the Duchess du Barry in Paris.

50. Freud, "Fetishism," in *The Standard Edition of the Complete Psychological Works of Sigmund Freud*, trans. James Strachey, vol. VII (London: The Hogarth Press, 1927), p. 157. See Luce Irigaray's critique of the Freudian pathologizing of female sexuality, in *Speculum of the Other Woman*, pp. 13–139.

51. Friedrich Engels, *The Condition of the Working Class in England*, trans. W. O. Henderson and W. H. Chaloner, (Stanford: Stanford University Press, [1844] 1958), p.4.

52. Engels, *The Condition of the Working Class in England*, p. 8.

53. Engels, *The Condition of the Working Class in England*, p. 161.

54. Engels, *The Condition of the Working Class in England*, p. 145.

55. Engels, *The Condition of the Working Class in England*, p. 161.

56. Engels, *The Condition of the Working Class in England*, p. 33.

57. Engels, *The Condition of the Working Class in England*, pp. 361, 420.

58. Edward Said, *The World, the Text, and the Critic* (Cambridge, Mass.: Harvard University Press, 1983), p. 19.

59. The degenerate classes were not perceived as synonymous with the "respectable" working classes, who had availed themselves of the benefits of sober and diligent toil during the comparative boom of the late 1860s and early 1870s. As Henry Mayhew neatly put it: "I shall consider the whole of the metropolitan poor under three separate phases, according as they will work, they can't work, and they won't work." Henry Mayhew, "Labour and the Poor," *Chronicle*, October 19, 1849.

60. See Sander Gilman, ed., *Degeneration: The Dark Side of Progress* (New York: Columbia University Press, 1985), p. xiv. See also Gilman, *Difference and Pathology: Stereotypes of Sexuality, Race and Madness*, (Ithaca: Cornell University Press, 1985); Nancy Stepan, "Race and Gender: The Role of Analogy in Science," *Isis* 77 (June 1986): pp. 261–277; and Richard D. Walter, "What Became of the Degenerate? A Brief History of a Concept," *Journal of the History of Medicine and the Allied Sciences* 11 (1956): pp. 42–49.

61. Gareth Stedman Jones, *Outcast London*

(New York: Pantheon, 1971), p. 11. See also Henry Mayhew, *London Labour and the London Poor*, III, John Rosenberg, ed., (New York: Dover, 1968), pp. 376–377; Gertrude Himmelfarb, *The Idea of Poverty* (New York: Vintage Books, 1985), p. 361.

62. Mayhew, *London Labour*, p. 167.

63. Thomas Plint, *Crime in England: Its Relation, Character and Extent, as Developed from 1801 to 1848* (New York: Arno, [1851] 1974), pp. 148–149.

64. See Anna Davin, "Imperialism and Motherhood," *History Workshop*, 5 (Spring 1978): 9 – 65.

65. Ann Laura Stoler, "Carnal Knowledge and Imperial Power: Gender, Race, and Morality in Colonial Asia," in Micaela di Leonardo, ed., *Gender and the Crossroads of Knowledge: Feminist Anthropology in the Postmodern Era* (Berkeley: University of California Press, 1991), p. 74.

66. Stoler, "Carnal Knowledge and Imperial Power: Gender, Race, and Morality in Colonial Asia," p. 78.

67. It is no accident that Darwin entitled his work *On the Origin of Species* rather than, say, the origin of man.

68. Jones, *Outcast London*, p. 313.

69. Quoted in Stephen Jay Gould, *The Mismeasure of Man* (New York: Norton, 1981), p. 21.

70. See Samuel G. Morton, "Value and the Word Species in Zoology," *American Journal of Science and Arts* 11 (May 1851): p.275; and Gould, ibid., p.73.

71. Prompted by fears of miscegenation and the free movement of black people after the abolition of slavery in America and the colonies, and arguing from the evidence of the Egyptian mummies, polygenesists held that different races had always been fixed and separate creations properly at home in different zones and climates of the world. Freed slaves, for example, were seen as "doomed to degenerate as they moved northward into white, temperate territory, and as they moved socially and politically into freedom." Stepan, "Race and Gender," p. 100.

72. Gould, *The Mismeasure of Man*, p. 73.

73. Gould, *The Mismeasure of Man*, p. 74.

74. In the 1820s, Samual G. Morton had begun to gather together his vast collection of human skulls from around the world, blending an untiring measurement of their cranial capacities with his own special flair for interpretive invention and ingenuity, elaborating on this basis his famous treatise on the character of race, *Crania Americana* (Philadelphia: John Pennington, 1839).

75. See the selections from Haeckel in Theodore D. McCown and Kenneth A. R. Kennedy, eds., *Climbing Man's Family Tree: A Collection of Writings on Human Phylogeny, 1699 to 1971*, (Engelwood Cliffs, N. J.: Prentice, 1972), pp. 133–148. For a detailed discussion, see Gould, *Ontogeny and Phylogeny* (Cambridge, Mass,: Harvard University Press, 1977), esp. pp. 126–135.

76. Gould, *The Mismeasure of Man*, p. 114. Gould points out that recapitulation became the enabling idea for the late-nineteenth-century obsession with retracing the evolution of ancestral lineages and played a vital role not only in the professions of embryology, comparative morphology and paleontology but also in the articulation of psychoanalytic theory.

77. *The Mismeasure of Man*, p. 326.

78. *The Mismeasure of Man*, p. 320.

79. G. A. Henty, *By Sheer Pluck: A Tale of the Ashanti War* (London: Blackie and Son, 1884), p. 118.

80. John Beddoe, *The Races of Britain: A Contribution to the Anthropology of Western Europe* (Bristol: J. W. Arrowsmith, 1885). On the racial stereotyping of the Irish, see L. Perry Curtis, Jr., *Apes and Angels: The Irishman in Victorian Caricature* (Newton Abbot: David and Charles, 1971); Richard Ned Lebow, *White Britain and Black Ireland: The Influence of Stereotypes on Colonial Policy* (Philadelphia: Institute for the Study of Human Issues, 1976); and Thomas William Hodgson Crosland, *The Wild Irishman* (London: T. Werner Laurie, 1905).

81. Molinari's phrase "une variété de nègres blancs" appeared in translation in a leader in *The Times* of London on September 18, 1880. See Curtis, *Apes and Angels*, p. 1.

82. Philip Luckombe, *A Tour Through Ire-*

land: Wherein the Present State of That Kingdom is Considered (London: T. Lowndes, 1783), p. 19.

83. David Lloyd, *Nationalism and Minor Literature* (Berkeley: University of California Press, 1988), p. 3.

84. Claire Wills, "Language Politics, Narrative, Political Violence," in "Neocolonialism," ed. Robert Young, *The Oxford Literary Review* 13 (1991): 21.

85. Wills, "Language Politics," p. 56.

86. See also Richard Kearney, ed. *The Irish Mind* (Dublin: Wolfhound Press, 1985); L. P. Curtis, Jr., *Anglo-Saxons and Celts: A Study of Anti-Irish Prejudice in Victorian England* (Bridgeport: Conference on British Studies of University of Bridgeport, 1968); Seamus Deane, "Civilians and Barbarians" *Ireland's Field Day* (London: Hutchinson, 1985), pp. 33–42.

87. Seth Luther, for example, was confident that "the wives and daughters of the rich manufacturers would no more associate with a factory girl than they would with a negro slave," *Address to the Working Men of New England*, pamphlet reprinted in Philip Taft and Leo Sten, eds., *Religion, Reform and Revolution. Labor Panaceas in the Nineteenth Century* (New York: Arno, 1970), p. 1.

88. William Booth, *In Darkest England and the Way Out* (London: International Headquarters of the Salvation Army, 1890); William Barry, *The New Antigone* (London: Barry, 1887).

89. Gustave le Bon, *La Psychologie des Foules* (1879), pp. 60–61. Quoted in Gould, (1981), p. 105; English trans. from Robert K. Merton, *The Crowd: A Study of the Popular Mind* (New York, Viking, 1960).

90. See Stepan, "Race and Gender."

91. Carl Vogt, *Lectures on Man: His Place in Creation and in the History of the Earth* ed. James Hunt, (London: Longman, Green and Roberts, 1864), p. 81. For the analogy of the "pathological" sexuality of "lower races" and women, see Eugene S. Talbot, *Degeneracy: Its Causes, Signs and Results* (London: W. Scott, 1898), p. 319–323. See also Havelock Ellis, *Man and Woman: A Study of Secondary Sexual Characteristics* (London: Black, 1926), pp. 106–7. For the work-

ing of the analogy in scientific discourse, see Stepan, "Race and Gender," pp. 261–277. For the relation between female sexuality and degeneration, see Jill Conway, "Stereotypes of Femininity in a Theory of Sexual Evolution," *Victorian Studies* 14 (1970): 47–62; and Fraser Harrison, *The Dark Angel: Aspects of Victorian Sexuality* (London: Sheldon, 1977).

92. Philip Thickness thought that black people in Britain, "their legs without any inner calf, and their broad flat foot, and long toes . . . have much the resemblance of the Orang Outang, or Jocko . . . and other quadrupeds of their own climate," *A Year's Journey through France and Part of Spain*, second edition (1778): 102–105. Quoted in Fryer, p. 162.

93. Charles Kingsley, author of *Westward Ho* and *The Water Babies* wrote after a trip to Sligo in 1860: "I am haunted by the human chimpanzees I saw along that hundred miles of horrible country To see white chimpanzees is dreadful; if they were black, one would not feel it so much." Letter to his wife, 4 July, 1860, in *Charles Kingsley: His Letters and Memories of His Life*, ed. Francis E. Kingsley, (London: Henry S. King and Co, 1877), p. 107.

94. I explore the relation between prostitution, race and the law in "Screwing the System: Sexwork, Race and the Law," in *Boundary II* 19, 2 (Summer 1992): 70–95.

95. See Gilman's analysis of the racializing of prostitutes in *Difference and Pathology*.

96. Mary Louise Pratt uses the term "monarch-of-all-I-survey" to describe the imperial stance of converting panoramic spectacle, especially at the moment of "discovery," into a position of authority and power.

97. Buck-Morss, *The Dialectics of Seeing*, p. 128.

98. If the World's Fairs were largely festivities for the paying middle class, vigorous efforts were made to encourage workers to the mass consumption of commodities as spectacle. Assembled under one roof, the workers of the world could admire and gawk at the marvels they had produced but could not themselves own. In 1867, 400,000 French workers were

given free tickets to the Paris Fair; foreign workers were housed at government expense. Susan Buck-Morss, *The Dialectics of Seeing*, p. 86.

99. I am grateful to Luke Gibbons, who writes about this toy in "Race Against Time: Racial Discourse and Irish History," in "Neocolonialism," ed. Robert Young, *Oxford Literary Review* 13 (1991): p. 95.

100. Gibbons, "Race Against Time," p. 95.

101. Gibbons, "Race Against Time," p. 95.

102. Kobena Mercer, "Reading Racial Fetishism: The Photographs of Robert Mapplethorpe," in Emily Apter and William Pietz, eds., *Fetishism as Cultural Discourse* (Ithaca: Cornell University Press, 1993), p. 324.

103. Mercer, "Reading Racial Fetishism," p. 324.

104. Luce Irigaray, *This Sex Which Is Not One*, trans. by Catherine Porter (Ithaca: Cornell University Press, 1985), p. 76. Irigaray here develops Joan Riviere's idea of femininity as masquerade.

105. Irigaray, *This Sex Which Is Not One*, p. 76.

106. Irigaray, *This Sex Which Is Not One*, p. 76.

107. Homi K. Bhabha, "Of Mimicry and Man: The Ambivalence of Colonial Discourse" *October* 28 (Spring 1984): 126.

108. Bhabha, "Of Mimicry and Man," p. 130.

109. Frantz Fanon, *The Wretched of the Earth* (London: Penguin, 1963), p. 47. For an analysis of Naipaul's use of the term mimicry, see Rob Nixon, *London Calling: V. S. Naipaul, Postcolonial Mandarin* (Oxford: Oxford University Press, 1992), especially ch. 6.

110. T. B. Macaulay, "Minute on Education," in William Theodore de Bary, ed., *Sources of Indian Tradition*, vol. II (New York: Columbia University Press, 1958), p. 49.

111. Bhabha, "Of Mimicry and Man," p. 126.

112. Bhabha, "Of Mimicry and Man," p. 127.

113. "The *menace* of mimicry is its *double* vision which in disclosing the ambivalence of colonial discourse also disrupts its authority." Bhabha, "Of Mimicry and Man," p. 129.

114. "The success of colonial appropriation depends on a proliferation of inappropriate objects that *ensure its strategic failure*" (my emphasis). Bhabha, "Of Mimicry and Man," p. 127.

115. In this essay, formal abstractions appear to have agency: *representation* marginalizes the monumentality of history; *mimicry's* ambivalence disrupts colonial authority; *difference* menaces colonial authority; *desire* has strategic objectives.

116. Homi K. Bhabha, "Difference, Discrimination, and the Discourse of Colonialism," in Francis Barker et al., eds., *The Politics of Theory* (Colchester: University of Essex, 1983), p. 205.

117. Homi K. Bhabha, "Signs Taken for Wonders: Questions of Ambivalence and Authority under a Tree Outside Delhi, May 1817," in Francis Barker et al., eds. *Europe and Its Others*, vol. I (Colchester: University of Essex, 1985), p. 162.

118. Joseph Conrad, *Heart of Darkness* (London: Penguin, [1902] 1973), p. 52.

119. Conrad, *Heart of Darkness*, p. 52.

120. Conrad, *Heart of Darkness*, pp. 48–51.

121. Rudyard Kipling, *Kim* (London: Penguin [1901] 1987), p. 7.

122. Marjorie Garber, *Vested Interests: Cross-Dressing and Cultural Authority* (New York: Routledge, 1992).

123. Garber, *Vested Interests*, p. 103.

124. Garber, *Vested Interests*, p. 125.

125. Garber, *Vested Interests*, p. 121.

126. Garber, *Vested Interests*, p. 271

127. Stuart Hall, "Pluralism, Race and Class in Caribbean Society," in *Race and Class in Post-Colonial Societies* (Paris: UNESCO, 1977): 150–182.

128. Julia Kristeva, *Powers of Horror: An Essay on Abjection*, trans. by Leon S. Roudiez (New York: Columbia University Press, 1982).

129. Kristeva, *Powers of Horror*, p. 9.

130. Kristeva, *Powers of Horror*, p. 9.

131. Kristeva, *Powers of Horror*, p. 4.

132. Robert Young, *White Mythologies: Writing History and the West* (London: Routledge, 1990), p. 152.

NOTES TO CHAPTER 2

1. Derek Hudson, *Munby, Man of Two Worlds: The Life and Diaries of Arthur J. Munby, 1812–1910* (Cambridge: Gambit, 1974), p. 437. See also Michael Hiley,

Victorian Working Women: Portraits From Life (Boston: David R. Godine, 1979).

2. Munby, Diary, in Hudson, *Munby*, p. 436.

3. Munby, Diary, in Hudson, *Munby*, p. 438.

4. Munby, Diary, in Hudson, *Munby*, p. 99.

5. Munby, Diary, in Hudson, *Munby*, p. 37.

6. From a letter signed "A.J.M," in *The Wigan and District Advertiser*, Saturday, January 30, 1886, p. 2. Quoted in Hiley, *Victorian Working Women*, p. 14.

7. Munby, Diary, in Hudson, *Munby*, p. 126.

8. Letter to Mrs. R. B. Litchfield, July 6, 1879. Quoted in Hudson, *Munby*, p. 398.

9. Munby, Diary, in Hudson, *Munby*, p. 8.

10. See Leonore Davidoff's brilliant essay, "Class and Gender in Victorian England," in *Sex and Class in Women's History*, eds., Judith L. Newton, Mary P. Ryan and Judith R. Walkowitz (London: Routledge & Kegan Paul, 1983), p. 43. Davidoff notes how Munby in his poetry compares women with domesticated animals who have been "broken in" by men.

11. Munby, Diary, in Hudson, *Munby*, p. 11.

12. Munby, Diary, in Hudson, *Munby*, p. 11.

13. Walter Benjamin, *Charles Baudelaire: A Lyric Poet in the Era of High Capitalism* (London: Verso, 1973), p. 36.

14. Benjamin, *Charles Baudelaire*, p. 175.

15. Benjamin, *Charles Baudelaire*, p. 174.

16. Benjamin, *Charles Baudelaire*, p. 36.

17. Benjamin notes: "Interpersonal relationships in big cities are distinguished by a marked preponderance of the activity of the eye over the activity of the ear." *Charles Baudelaire*, p. 38.

18. Walter Benjamin, *Reflections* (New York: Harcourt Brace Jovanovich, 1978), p. 3.

19. Benjamin, *Reflections*, p. 6. For a fine analysis of gender and the city, see Elizabeth Wilson, *The Sphinx in the City: Urban Life, the Control of Disorder and Women* (London: Virago Press, 1991).

20. Quoted in Benjamin, *Charles Baudelaire*, p. 40.

21. Munby, Diary, in Hudson, *Munby*, p. 97.

22. Munby, Diary, in Hudson, *Munby*, p. 116.

23. Munby, Diary, in Hudson, *Munby*, p. 35.

24. Munby, Diary, in Hudson, *Munby*, p. 79.

25. Leonore Davidoff, "Class and Gender," p. 33.

26. Davidoff, "Class and Gender," p. 33.

27. Munby, Diary, 1862. Quoted in Hiley, *Victorian Working Women*, p. 21.

28. Munby, Diary, Tuesday, June 11, 1861, in Hudson, *Munby*, p. 99.

29. Munby, Diary, Friday, November 23, 1860, in Hudson, *Munby*, p. 83.

30. Eric Hobsbawm, *The Age of Capital* (London: Abacus, 1977), p. 286. See also Hobsbawm, *The Age of Empire, 1875–1914* (London: Weidenfeld and Nicolson, 1987), pp. 180–181. As John Fletcher Clews Harrison observes: "The essence of middle-classness was the experience of relating to other classes or orders of society. With one group, domestic servants, the middle class stood in a very special and intimate relationship: the one fact played an essential part in defining the identity of the other." *The Early Victorians, 1832–51* (New York: Praeger, 1971), p. 110. An important part of defining the middle-class's relation to the working class was to elaborate rituals of deference (bowing, walking out of a door backwards, lowering the eyes). The occupation of butler, for example, was more than anything else a "deference occupation," involving the exchange of money in payment for the ceremonial recognition of upper-class power. See Bruce Robbins' account of the role of servants in literature in *The Servant's Hand: English Fiction from Below* (New York: Columbia University Press, 1986).

31. Ida Bauer, Freud's "Dora," recalls her sexual intimacies with the governesses in the house. Freud, *Dora: An Analysis of a Case of Hysteria* (New York: Collier Books, 1963), p. 78.

32. Eugene S. Talbot, *Degeneration: Its Causes, Signs and Results* (London: Scott, 1898), p. 361.

33. Freud, *The Standard Edition of the Complete Psychological Works of Sigmund Freud*, trans. James Strachey, vol. VII (London: The Hogarth Press, 1905), p. 180.

34. Freud, "Female Sexuality," *Standard Edition*, vol. XXI (1931), pp. 232–233.

35. Quoted in Jonathan Gathorne-Hardy, *The Rise and Fall of the British Nanny* (London: Weidenfeld and Nicolson, 1972), p. 17. The vicious nanny of Compton MacKenzie's *Sinister Street* was probably based on memories of his own nanny.

36. Quoted in Gathorne-Hardy, *The Rise and Fall of the British Nanny*, p. 26. Like many children, Churchill slept in his nanny's bedroom; was washed, changed, dressed, fed and educated by her; and for the first eight years of his life virtually never left her side. Nanny Everest chose Churchill's clothes, his friends, his books, his food and even the schools he attended.

37. As Nancy Chodorow observes: "Being a mother, then, is not only bearing a child—it is being a person who socializes and nurtures. It is being a primary parent or caretaker." *The Reproduction of Mothering: Psychoanalysis and the Sociology of Gender* (Berkeley: University of California Press, 1978), p. 11.

38. Gathorne-Hardy, *The Rise and Fall*, p. 78.

39. Quoted in Gathorne-Hardy, *The Rise and Fall*, p. 78.

40. Mary Lutyens, *To Be Young: Some Chapters of Autobiography* (London: Rupert Hart-Davis, 1959), p. 15.

41. Jim Swann, "Mater and Nanny: Freud's Two Mothers and the Discovery of the Oedipal Complex," *American Imago: A Psychoanalytic Journal* (Spring 1974): pp. 1–64. See also Kenneth A. Grigg, "'All Roads Lead to Rome': The Role of the Nursemaid in Freud's Dreams," *Journal of the American Psychoanalytic Association*, 21 (1973): 109.

42. Letter to Fliess, October 3, 1897, in Jeffrey Moussaieff Masson, trans. and ed., *The Complete Letters of Sigmund Freud to Wilhelm Fliess, 1887–1904* (Cambridge, Mass.: Harvard University Press, 1985), p. 268.

43. Freud, *Complete Letters*, p. 268.

44. Swann, "Mater and Nanny," p. 17.

45. Freud, Letter to Fliess, October 4, 1897, *Complete Letters*, p. 269.

46. Freud, *Complete Letters*, p. 269.

47. Freud, *Complete Letters*, p. 269.

48. Freud, "From the History of an Infantile Neurosis," *Standard Edition*, vol.

XVII ([1914] 1918), p. 119.

49. Freud, "From the History of an Infantile Neurosis," p. 119.

50. Freud, "From the History of an Infantile Neurosis," p. 119.

51. Freud, Letter to Fliess, *Complete Letters*, p. 269.

52. Freud, *Collected Letters*, p. 268.

53. Freud, *Collected Letters*, February 9, 1898, p. 299.

54. See Steven Marcus, *The Other Victorians: A Study of Sexuality and Pornography in Mid-Nineteenth Century England* (New York: New American Library, 1964), pp. xiii, 221.

55. Freud, *Collected Letters*, p. 269.

56. Freud, Letter to Fliess, October 15, 1897, *Collected Letters*, p. 271.

57. Freud, *Collected Letters*, p. 271.

58. Swann, "Mater and Nanny," p. 39.

59. Freud, Letter to Fliess, May 31, 1897, *Collected Letters*, p. 249.

60. Freud, *The Interpretation of Dreams*, vol. 4/5, *Standard Edition*, p. 238.

61. Freud, 1909, 41.

62. Peter Stallybrass and Allon White, *The Politics and Poetics of Transgression* (London: Methuen, 1986), p. 153.

63. Jane Gallop has noted that the nurse constituted the greatest threat to the homogeneity of the family. "The family never was, in any of Freud's texts, completely closed off from questions of economic class [The nurse] is so much a part of the family that the child's fantasies (the unconscious) do not distinguish 'mother or nurse'." *The Daughter's Seduction: Feminism and Psychoanalysis* (Ithaca: Cornell University Press, 1982), p. 144.

64. Freud, *Dora: An Analysis of a Case of Hysteria* (New York: Collier Books, 1963), p. 78.

65. Jane Gallop, *The Daughter's Seduction*, p. 146.

66. In her excellent essay "Freud's Dora, Dora's Hysteria," Maria Ramas restores the significance of the maid-servant in Freud's most famous failure and points out that femininity was linked with service especially with respect to sexuality, "a fantasy of heterosexuality as a service due men, and one explicitly based on submission and degradation." "Freud's

Dora, Dora's Hysteria," in Charles Bernheimer and Claire Kahane, eds., *In Dora's Case. Freud—Hysteria—Feminism* (New York: Columbia University Press, 1985), p. 175. Freud's choice of the name "Dora" for Ida reveals the deformation and disavowal of working-class identity required to maintain class difference. Steven Marcus points out that Freud named Ida "Dora" after the housemaid in his own family who had to change her name because she had the same name as Freud's sister. The homology of names, suggestive as it was of an unacceptable homology of identity, had to be erased. By naming Ida "Dora," Freud was implicitly acknowledging his desire to oblige Ida to take a substitute and surrogate identity in order to preserve the decorum of the heterosexual family romance.

67. Robbins, *The Servant's Hand*, p. 196.

68. Sandra Gilbert and Susan Gubar, *The Madwoman in the Attic: The Woman Writer and the Nineteenth Century Literary Imagination* (New Haven: Yale University Press, 1979).

69. Nina Auerbach, *The Woman and the Demon: The Life of a Victorian Myth* (Cambridge, Mass.: Harvard University Press, 1982), p. 7.

70. Auerbach, *The Woman and the Demon*, p. 7.

71. Gilbert and Gubar, *The Madwoman in the Attic*, p. 76.

72. Auerbach, *The Woman and the Demon*, p. 228.

73. Hudson, *Munby*, p. 16; Robbins, *The Servant's Hand*, p. 2; Davidoff, "Class and Gender," p. 41.

74. Munby, Diary, in Hudson, *Munby*, p. 134.

75. Eric Hobsbawm, *Industry and Empire* (Harmondsworth, England: Penguin, 1968), p. 85.

76. Davidoff, "Class and Gender," p. 41.

77. Robbins, *The Servant's Hand*, p. 20.

78. Marcus, *The Other Victorians*, p. xiii.

79. Dr. P. C. Remondino, *History of Circumcision from the Earliest Times to the Present,* (London: F.A. Davis, 1891).

80. Munby, Diary, in Hudson, *Munby*, p. 70.

81. Munby, Diary, in Hudson, *Munby*, p. 71.

82. Munby, Diary, in Hudson, *Munby*, p. 71.

83. Munby, Diary, in Hudson, *Munby*, p. 71.

84. Munby, Diary, in Hudson, *Munby*, p. 194.

85. Munby, Diary, in Hudson, *Munby*, p. 71.

86. Munby, Diary, in Hudson, *Munby*, p. 256.

87. Munby, Diary, in Hudson, *Munby*, p. 85.

88. Munby, Diary, in Hudson, *Munby*, p. 110.

89. Munby, Diary, in Hudson, *Munby*, p. 254.

90. Munby, Diary, in Hudson, *Munby*, p. 254.

91. Munby, Diary, in Hudson, *Munby*, p. 175

92. Munby, Diary, in Hudson, *Munby*, p. 286.

93. Munby, Diary, in Hudson, *Munby*, p. 97.

94. Munby, Diary, in Hudson, *Munby*, p. 266.

95. See Davidoff, "Class and Gender," p. 49.

96. Davidoff has commented on the equation of servants with dirt and pollution. The equation of dirt with blackness; and blackness with filth, sin, baseness and ugliness within a long symbolic tradition in the West. And she notes the enlarged symbolism after the sixteenth century with the Dark Continent and slavery. But there is more at play here than simply the evocation of a long symbolic tradition. "Class and Gender," p. 44.

97. Munby, Diary, in Hudson, *Munby*, p. 174.

98. Munby, Diary, in Hudson, *Munby*, p. 185.

99. Munby, Diary, in Hudson, *Munby*, p. 157.

100. Munby, Diary, in Hudson, *Munby*, p. 102.

101. Peter Fryer, *Staying Power: The History of Black People in Britain* (London: Pluto Press, 1984), p. 1.

102. Fryer, *Staying Power*, p. 10.

103. Hobsbawm, *Industry and Empire*, p. 36.

104. Hobsbawm, *Industry and Empire*, p. 38.

105. Fryer, *Staying Power*, p. 72.

106. See Sander L. Gilman, *Difference and Pathology: Stereotypes of Sexuality, Race and Madness* (Ithaca: Cornell University Press, 1985), ch. 3. See also Ben Shephard, "Showbiz Imperialism: The Case of Peter Lobengula," in John M. Mackenzie, ed., *Imperialism and Popular*

Culture (Manchester: Manchester University Press, 1986), pp. 94–112.

107. Fryer, *Staying Power*, p. 162.

108. Angela John, *By the Sweat of Their Brow: Women Workers at Victorian Coal Mines* (London: Routledge, 1984), ch. 1.

109. Allan Sekula, *Photography Against the Grain: Essays in Photo Works — 1973–1983* (Halifax: Press of the Nova Scotia College of Art and Design, 1984). pp. 193–268.

110. Sekula, *Photography Against the Grain*, p. 204

111. Sekula, *Photography Against the Grain*, p. 204.

112. Sekula, *Photography Against the Grain*, p. 204.

113. Sekula, *Photography Against the Grain*, p. 204.

114. Quoted in John, *By the Sweat of their Brow*, p. 26.

115. Quoted in John, *By the Sweat of their Brow*, p. 218.

116. Quoted in John, *By the Sweat of their Brow*, p. 187.

117. Quoted in John, *By the Sweat of their Brow*, p. 45.

118. Quoted in John, *By the Sweat of their Brow*, p. 27.

119. Quoted in Hiley, *Victorian Working Women*, p. 50.

120. Quoted in Hiley, *Victorian Working Women*, p. 31.

121. Quoted in Hiley, *Victorian Working Women*, p. 45.

122. *The Morning Chronicle*, May 7 1842.

123. Quoted in Hiley, *Victorian Working Women*, p. 180.

124. Quoted in Hiley, *Victorian Working Women*, p. 30.

125. John, *By the Sweat of Their Brow*, p. 190.

126. The unease expressed by the men was also an index of women's resistance. There were uneasy reports of women fighting men, and being strong enough to win. Women were described as pugilistic and militant and violently resisting their banishing from the mines. Indeed, John points out that part of the reason women wearing men's clothes were assailed was because they made it easier for women barred from the mines to evade detection by police or inspectors.

127. See Susanna Barrows, *Distorting Mirrors: Visions of the Crowd in Late Nineteenth Century France* (New Haven: Yale University Press, 1981).

128. Barrows, *Distorting Mirrors*, p. 47.

129. Barrows, *Distorting Mirrors*, p. 192.

130. George Godwin, *London Shadows*, p. 1. See Peter J. Keating, *The Working Classes in Victorian Fiction* (New York: Barnes and Noble, 1971), ch. 2.

131. See Deborah Epstein Nord, "The Social Explorer as Anthropologist: Victorian Travellers Among the Urban Poor," in William Sharpe and Leonard Wallock, eds., *Visions of the Modern City: Essays in History, Art, and Literature* (New York: Columbia University Press, 1983).

132. See Keating, *The Working Classes*, chs. 1 and 2.

133. Sir Robert Southey, *Sir Thomas More: or, Colloquies on the Progress and Prospects of Society* (London: Murray, 1829) p. 108.

134. Keating, *The Working Classes*, p. 105.

135. George Godwin, *Town Swamps and Social Bridges* (New York: Humanities Press, [1859] 1972), p.1.

136. William Booth, *In Darkest England and the Way Out* (London: International Headquarters of the Salvation Army, 1890).

137. Walter Besant, *All Sorts and Conditions of Men* (New York: Harper, 1882), p. 18.

138. Johannes Fabian, *Time and the Other: How Anthropology Makes its Object* (New York: Columbia University Press, 1983), p. 106.

139. Quoted Fabian, *Time and the Other*, p. 227.

140. Fabian, *Time and the Other*, p. 227.

141. John Berger, *About Looking* (New York: Pantheon, 1980), p. 48.

142. Berger, *About Looking*, p. 52.

143. Sekula, *Photography*, p. 79.

144. "The Daguerreolite," in the *Daily Chronicle* (Cincinnati) vol. 1, 38 (January 17, 1840): 1.

145. "The Daguerreolite," p. 1.

146. Quoted in Sarah Graham Brown, *Images of Women: The Portrayal of Women in Photography of The Middle-East, 1860–1950* (London: Quartet, 1988), p. 48.

147. Quoted in Brown, *Images Of Women*, p. 45.

148. See Malek Allouilla, *The Colonial Harem* (Minneapolis: Minnesota Press, 1986).

149. Quoted in Brown, *Images of Women*, p. 7.

150. Quoted in Brown, *Images of Women,* p. 7.
151. Said, *Orientalism* (New York: Vintage, 1978), p. 17.
152. Hiley, *Victorian Working Women,* p. 63
153. Quoted in Brown, *Images of Women,* p. 36.
154. Quoted in Brown, *Images of Women,* p. 60.
155. Hiley, *Victorian Working Women,* p. 66.
156. Quoted in Hudson, *Munby,* p. 117.
157. Quoted in Hudson, *Munby,* p. 118.
158. Quoted in Hudson, *Munby,* p. 72.
159. Sekula, *Photography,* p. 199.
160. Hiley, *Victorian Working Women,* p. 72.
161. Sekula, *Photography,* p. 72.

NOTES TO CHAPTER 3

1. Cullwick writes that before she met Munby, God showed her his face in a fiery vision. Munby similarly exults: "For on the 26th May, 1854, she was brought to me . . . by him who brought Eve to Adam." Liz Stanley, *The Diaries of Hannah Cullwick: Victorian Maidservant* (New Brunswick: Rutgers University Press, 1984), p. 1. Munby, Diary, in Derek Hudson, *Munby, Man of Two Worlds: The Life and Diaries of Arthur J. Munby 1812–1910* (Cambridge: Gambit, 1974), p. 76.
2. Walter Benjamin, *Charles Baudelaire: A Lyric Poet in the Era of High Capitalism* (London: Verso, 1973), p. 62.
3. Leonore Davidoff, "Class and Gender in Victorian England," in Judith L. Newton, Mary P. Ryan and Judith R. Walkowitz, eds., *Sex and Class in Women's History* (London: Routledge & Kegan Paul, 1983), pp. 16–71. See also Davidoff's brilliant work on domestic relations in "Above and Below Stairs," *New Society* 26 (1973): 181–83; and "Mastered for Life: Servant and Wife in Victorian and Edwardian England," *Journal of Social History* 7 (1974): 406–28. I am indebted throughout these pages to Davidoff's work as well as to her collaborative, groundbreaking work with Catherine Hall, *Family Fortunes: Men and Women of the English Middle Class, 1780–1850* (London and Chicago: Hutchinson and Chicago University Press, 1987).
4. Munby was a devotee of Ruskin, and Carlyle's notions of elevation through servitude became the basis for what he regarded as his "training" of Cullwick in the lessons of domestic submission (though he had no intention of applying Carlyle's principles to himself).
5. Hudson acknowledges that the Munby diaries are as much hers as his, but he proceeds to well-nigh ignore hers, and effectively erases Cullwick's perspective.
6. Munby, Diary, July 19, 1894. Quoted in Stanley, *Diaries of Hannah Cullwick,* p.12. Munby excised the descriptions of these "trainings" from his diary.
7. Hudson, *Munby,* p. 70.
8. Hudson, *Munby,* p. 4.
9. Davidoff, "Class and Gender," p. 58.
10. Davidoff, "Class and Gender," pp. 38, 40.
11. It is worth noting, moreover, that Munby is accorded, by all these critics, the social status of an adult, referred to as Munby, while Cullwick is infantilized and denied full social status by being referred to only as "Hannah."
12. Stanley, *Diaries of Hannah Cullwick,* p. 11.
13. Stanley, *Diaries of Hannah Cullwick,* p. 2.
14. Stanley, *Diaries of Hannah Cullwick,* p.1. For interpretations of women's work, and of the relations between women's work and economic development, see Davidoff and Hall, *Family Fortunes*; Patricia Branca, *Women in Europe Since 1750* (London: Croom Helm, 1978); Joan W. Scott and Louise Tilly, *Women, Work and Family* (New York: Holt, Reinhart and Winston, 1978); Sally Alexander, "Women's Work in Nineteenth Century London: A Study of the Years 1820–1850," in Juliet Mitchell and Ann Oakley, editors, *The Rights and Wrongs of Women* (Harmondsworth: Penguin, 1976); Sandra Burman, ed., *Fit Work for Women* (New York: St. Martin's Press, 1979); Barbara Taylor, "The Men are as Bad as Their Masters . . . : Socialism, Feminism and Sexual Antagonism in the London Tailoring Trade in the 1830s," in Newton, Ryan and Walkowitz, eds., *Sex and Class,* pp. 187–220; Christine Delphy, trans. Diana Leonard, *Close to Home: A Materialist Analysis of Women's Oppression* (Amherst: University of Massachusetts

Press, 1984); and Angela John, *By the Sweat of Their Brow: Women Workers at Victorian Coal Mines* (London: Routledge, 1984).

15. Munby graduated from Trinity College, Cambridge, in 1851, the same year Cullwick arrived in London, and entered Lincoln's Inn in June. For the next five years he lived in lodgings, then entered the chambers on the first floor of 6 Fig Tree Court in the Temple in 1857, which he would retain until his death. On January 2, 1859, Munby began employment as a clerk with the Ecclesiastical Commission.

16. Stanley, *Diaries of Hannah Cullwick*, p. 40.

17. Stanley, *Diaries of Hannah Cullwick*, p. 14.

18. Stanley, *Diaries of Hannah Cullwick*, p. 15.

19. Stanley, *Diaries of Hannah Cullwick*, p. 15.

20. Michel Foucault, *Madness and Civilization* (1961; rpt. London: Routledge, 1993). Let me emphasize here that by S/M, I refer to the subculture of consensual, reciprocal S/M and not to involuntary abuse. I am also aware that these do not mark absolute extremes but rather a continuum, and that some relationships inhabit the twilight threshold in between.

21. For a detailed exploration of S/M, see my essay on S/M and gender power, "Maid to Order: Commercial S/M and Gender Power," in Pamela Church Gibson and Roma Gibson, eds., *Dirty Looks* (London: British Film Institute, 1993), pp. 207–231.

22. Foucault, *Madness and Civilization*, p. 124.

23. Erving Goffman, *Frame Analysis* (New York: Harper and Row, 1974), p. 36.

24. Paul H. Gebhard, "Sadomasochism," in Thomas Weinberg and G. W. Levi Kamel, *S and M: Studies in Sadomasochism* (Buffalo: Prometheus Books, 1983), p. 39.

25. Richard von Krafft-Ebing, "From *Psychopathia Sexualis*," in Weinberg and Kamel, *S and M*, p. 27.

26. Munby, Diary, May 26, 1854, in Hudson, *Munby*, p. 15.

27. Hudson, *Munby*, p. 70. Robert L. Stevenson, likewise, called his nanny: "My second Mother, my first wife/ The Angel of my infant life" in Janet Adam Smith, ed., *Collected Poems* (London: Rupert-Hart Davis, 1951), p. 36l.

28. Hudson, *Munby*, p. 329.

29. Hudson, *Munby*, p. 108.

30. Munby's own attempts to pose as a working-class man were short-lived and were greeted with much hilarity by Cullwick.

31. In Robin Ruth Linden et al., eds., *Against Sadomasochism: A Radical Feminist Analysis* (San Francisco: Frog in the Well, 1982), p. 28.

32. Male "bottoms" will frequently enact scripts framed by the "degradation" of female domesticity: compulsive sweeping, cleaning, laundering, under a regime of verbal taunts, insults, and calumnies. Some dominatrixes keep "pets" who regularly do their housework. See McClintock, "Maid to Order," pp. 207–231

33. Munby's fetish for infantilism is a common one in S/M: "There's a whole area of deviant behaviour called Babyism where the client likes to dress up in a nappy, suck a giant dummy or one of her breasts and just be rocked." Allegra Taylor, *Prostitution: What's Love Got to Do with It?* (London: Optima, 1991), p. 39.

34. Hudson, *Munby*, p. 116.

35. Freud, *Three Essays on the Theory of Sexuality* (New York: Basic Books, 1962), p. 23.

36. Weinberg and Levi Kamel, *S and M*, p. 20.

37. Stanley, *Diaries of Hannah Cullwick*, p. 307.

38. Hudson, *Munby*, p. 184.

39. William Pietz, "The Problem of the Fetish, II," *Res* 13 (Spring 1987): p. 34.

40. Stanley, *Diaries of Hannah Cullwick*, p. 37.

41. As Cullwick observes, "I have hardly ever met wi' a servant yet who wasn't ashamed o' dirty work." Stanley, *Diaries of Hannah Cullwick*, p. 96.

42. Stanley , *Diaries*, p. 76.

43. Mary Douglas, *Purity and Danger* (London: Routledge and Kegan Paul, 1966). See also Davidoff, "The Rationalization of Housework," in Diana Leonard and Sheila Allen, eds., *Sexual Divisions Revisited* (Basingstoke: Macmillan, 1991), p. 63.

44. Peter Fryer, *Staying Power: The History of*

Black People in Britain (London: Pluto Press, 1984), p. 22. The commercial signs of tobacconists and innkeepers often featured black people as the fetish signs of the trade in humans. Black slaves owned by titled families were customarily decked in showy livery, jeweled eardrops, laced cuffs and ornate waistcoats and breeches.

45. Weinberg and Kamel, *S and M*, p. 56

46. "I went out to service too soon—before I really understood the meaning of it— and at the Charity school i was taught to curtsey to the ladies and gentlemen and it seem'd to come natural to me to think them *entirely* over the lower class and if it was our place to bow and be at their bidding." Stanley, *Diaries of Hannah Cullwick*, p. 35.

47. When she worked away from home, some of her earliest lessons in identity were lessons in affirmation through great feats of labor: "She (Mrs Phillips) always prais'd me after I'd clean'd the red brick floor on my hands & knees & scour'd the big white tables in the kitchen. And I could clean the dining room & the bright long hall, & the door steps & all before breakfast." *Diaries of Hannah Cullwick*, p. 74.

48. Her first motive for labor had been to please her mother. Cullwick adored her mother, living for her in the delight of self-sacrifice and hard work: "I'd bin thinking how I sh'd work & make her happy for she sh'd have all my money." *Diaries of Hannah Cullwick*, p. 82. The money she earned by hard work won her mother's love and compensated Cullwick for the anguish of separation. Money was the hidden sign of upper-class recognition; on returning home, she exchanged this token for her mother's open approval.

49. *Diaries of Hannah Cullwick*, p. 89.

50. "I like being alone in my kitchen and my work." *Diaries of Hannah Cullwick*, pp. 43–44. "Because I didn't feel fit to have a kitchen-maid under me, 'cause I wanted to do the washing up & the roughest work myself." *Diaries of Hannah Cullwick*, pp. 49, 74

51. *Diaries of Hannah Cullwick*, p. 143 Cullwick's diaries make it clear that she worked to satisfy her need for inner worth. When the lady's maid once asked her: "'Hannah, why *do* you work so *hard*?'" she answers: "I said how I did it really to please myself." *Diaries of Hannah Cullwick*, p. 47.

52. *Diaries of Hannah Cullwick*, p. 48.

53. *Diaries of Hannah Cullwick*, p. 170.

54. *Diaries of Hannah Cullwick*, p. 167.

55. *Diaries of Hannah Cullwick*, p. 124. One night on the way home, she is accosted by three drunk gentlemen, who insult and try to fondle her, but she rebuffs them and threatens to hurt them instead.

56. *Diaries of Hannah Cullwick*, p. 127.

57. *Diaries of Hannah Cullwick*, p. 171.

58. *Diaries of Hannah Cullwick*, p. 171.

59. *Diaries of Hannah Cullwick*, p. 173.

60. *Diaries of Hannah Cullwick*, p. 64.

61. *Diaries of Hannah Cullwick*, p. 46.

62. *Diaries of Hannah Cullwick*, p. 79.

63. *Diaries of Hannah Cullwick*, p. 179.

64. Cullwick practiced humility less because it reflected submission than because it reflected strength. "I heard Mr Bellow say once in a sermon," writes Cullwick, "that *humility* was strength." *Diaries of Hannah Cullwick*, p. 66.

65. *Diaries of Hannah Cullwick*, p. 164.

66. *Diaries of Hannah Cullwick*, p. 176.

67. Wanda Fraiken Neff, *Victorian Working Women: An Historical and Literary Study of Women in British Industries and Professions, 1832–1850* (New York: Columbia University Press, 1929).

68. Neff, *Victorian Working Women*, p. 186.

69. "Dismissed from the dairy, the confectionary, the store-room, the still-room, the poultry-yard, the kitchen-garden, and the orchard," as Margaretta Grey put it, she shut the doors of laboring society behind her and repaired upstairs for the rest of the century to languish on sofas in haughty listlessness. Quoted in Pearsall, p. 97,

70. Neff, *Victorian Working Women*, p. 187. Her duty, if one recalls Ruskin's disturbing and memorable essay, "Of Queens Gardens," was simply "to assist in the ordering, in the comforting, and in the beautiful adornment of the state." "Of Queens Gardens," in E. T. Cook and A. D. O. Wedderburn, eds., *The Complete Works of John Ruskin*, (London, 1902–1912.), vol. 18, p. 122.

71. Baldwin Brown exhorted women to comfort their "world-weary men" in a home "like a bright, serene, restful, joyful nook of heaven in an unheavenly world." *Young Men and Maidens: A Pastoral for the Times* (London: Hodder and Stoughton, 1871) pp. 38–9.

72. E. P. Hood, *The Age and Its Architects: Ten Chapters on the English People, in Relation to the Times* (London, 1850, 1852), quoted in Walter Houghton, *The Victorian Frame of Mind* (New Haven: Yale University Press, 1957), p. 354.

73. Nancy Armstrong, "The Rise of the Domestic Woman," in Nancy Armstrong and Leonard Tennenhouse, eds., *The Ideology of Conduct: Essays in Literature and the History of Sexuality* (London: Methuen, 1987).

74. Home, as imagined in Ruskin's exemplary and roseate evocation, became "the place of Peace; the shelter, not only from all injury, but from all terror, doubt, and division." The fortified embrace of Ruskin's "little rose-covered wall" barricaded the hearth from the bloodied bruit and conflict of trade. Secluded within this "sacred place, a vestal temple," true womanliness offered a "centre of order, the balm of distress, and the mirror of beauty." Beyond the wall of domesticity, "the wild grass to the horizon, is torn up by the agony of men, and beat level by the drift of their life-blood." "Of Queens Gardens," pp. 60, 72, 76.

75. Neff, *Victorian Working Women*, p. 187. Neff sums up a prevailing view: "The practice of female idleness spread through the middle-class until work for women became a misfortune and a disgrace." Sir Charles Petrie obediently follows suit, though with no apparent compunction to cite his source: "It became the sign of a man's importance that he kept his women-folk in idleness The example spread through the middle-class, until work for women became a misfortune and a disgrace." Petrie concludes: "Few aspects of modern society are as well documented as the middle-class woman of the nineteenth century, with whom contemporary fiction so largely dealt The

Victorian heroine was an almost standardized product." *The Victorians* (New York: Longmans, 1961). J. A. Banks's influential *Prosperity and Parenthood* only further expanded the idea that the very formation of middle-class identity depended on aping the "paraphernalia of gentility" of the upper class, at the heart of which was the idea of the "idle woman," and he has been followed in this by critic after critic. J. A. Banks, *Prosperity and Parenthood: A Study of Family Planning Among the Victorian Middle Classes* (London: Routledge, 1954).

76. "The lifestyle of the bourgeois lady," as Jeffrey Weeks puts it, "was purchased at the expense of a large class of servants." Jeffrey Weeks, *Sex, Politics and Society: The Regulation of Sexuality Since 1800* (London: Longman, 1981), p. 40. The keeping of servants was seen by many historians as the principle source of middle-class identity. In 1899 Seebohm Rowntree took "the keeping or not keeping of domestic servants" as the dividing line between the "working classes and those of a higher social scale." Quoted in Pamela Horn, *The Rise and Fall of the Victorian Servant* (Stroud: Alan Sutton, 1986), p. 17. As the wife of an English surgeon insisted: "I must not do our household work, or carry my baby out: or I shall lose caste. We must keep a servant." Horn, p. 18. J. F. C. Harrison concurs that employing servants "went to the very heart of the idea of class itself."

77. In 1975, Patricia Branca began to question the image of the middle-class woman as "an odd museum piece," disparaged either as the butt of criticism or the object of a patronizing sympathy. Critically analyzing domestic, cooking, child-care and housekeeping manuals, Branca began to ask questions about the verisimilitude of the fictional idle woman and the referential authority of the critics' sources. Patricia Branca, *Silent Sisterhood: Middle-class Women in the Victorian Home* (London: Croom Helm, 1975).

78. Branca, *Silent Sisterhood*, p. 186

79. In Anthony Trollope's *Last Chronicle of Barset* the family struggles to maintain one servant while their carpets are in

rags and the furniture broken.

80. Privileged members of the upper middle classes, such as large farmers or well-heeled rectors, might have enjoyed the services of a coachman or gardener, a cook, a nursemaid and a couple of housemaids, while the traditional servant-keeping classes, the aristocracy and the large landed families, often kept "armies" of retainers so large that they constituted "a settlement as large as a small village." Branca, *Silent Sisterhood*, p. 20.

81. See Davidoff and Hall, *Family Fortunes*.

82. E. P. Thompson, for example, notes that domestic work was the largest labor category for women apart from agricultural work, yet he pays no attention whatsoever to the history and conditions of this work. *The Making of the English Working Class* (New York: Vintage, 1966). See Joan Scott's excellent critique of Thompson's gender politics in Scott, *Gender and the Politics of History* (New York: Columbia University Press, 1988), ch. 4.

83. Here one can question Irigaray's notion of mimicry as resistance. This may sometimes be the case; at other times it may not.

84. This was an exhausting aggravation for over-burdened workers and a common source of complaint. Davidoff, "Class and Gender," p. 54.

85. The very definition of a "lady" came to be her distance from profit. "A Lady . . . must not work for profit or engage in any occupation that money can command." "The occupations of women engaged in any business or profession . . . must be fully stated. No entry should be made in the case of wives, daughters or other female relatives wholly engaged in domestic duties at home." Quoted in Sandra Burman, *Fit Work For Women*, p. 67.

86. *Diaries of Hannah Cullwick*, pp. 110, 116, 147.

87. Roland Barthes, *Sade, Fourier, Loyola* (New York: Farrar, Straus and Giroux, 1976).

88. H. Perkin, *The Origin of Modern English Society, 1780–1880* (London: Routledge & Kegan Paul, 1969).

89. Catherine Hall, "Private Persons Versus Public Someones: Class, Gender and Politics in England, 1780–1850," in Terry Lovell, ed., *British Feminist Thought: A Reader* (Oxford: Basil Blackwell, 1990), p. 52.

90. Hall, "Private Persons," p. 52.

91. In 1832, the prefix "male" was inserted for the first time into voting legislation, "thus making crystal clear something which had always been assumed previously, that in naming the propertied as those with the vote it was men of property who were being demarcated, not women." Hall, "Private Persons," p. 52.

92. Leonore Davidoff, "The Rationalization of Housework," pp. 59–94.

93. Armstrong, "The Rise of the Domestic Woman," pp. 96–141.

94. Max Weber, *The Protestant Ethic and the Spirit of Capitalism* (London: Unwin University Books, 1971), p. 235. Quoted in Davidoff, "The Rationalization of Housework." The virtues of a rationalized domestic economy hark back to the morality of Roman husbandry and appear again in European monasticism and again in Puritan and Nonconformist tracts. As Weber put it: "The Reformation took Christian asceticism and its methodical habits out of the monasteries and placed them in the service of active life in the world."

95. Davidoff and Hall, *Family Fortunes*.

96. Barthes, *Sade, Fourier, Loyala*, p. 3.

97. A popular maxim gave eloquent expression to the suffusing of domestic time with rational measurement and commodification: "Lost yesterday, somewhere between sunrise and sunset/ Two golden hours, each set with sixty diamond minutes."

98. The diary came into its own in the eighteenth century, ordering time no longer according to the agricultural rhythms of suns and moons, harvests and seasonal ritual but by the mechanically measured rules of rational industry.

99. *Diaries of Hannah Cullwick*, p. 91

100. Davidoff and Hall, *Family Fortunes*, p. 382.

101. On occasion, Cullwick offered to clean other men's boots in public, much to their astonishment: "Shall I wash your

feet, Sir?" she asked. "I knelt down to show him I was quite *ready* to do 'em . . .he seemed quite *surprised* at me, & said, 'Yes, I shd like it.' While I did them he looked at me as if he could hardly believe his eyes." *Diaries of Hannah Cullwick*, p. 65. Again, Cullwick turns forbidden work into public spectacle, finding value in degradation.

102. Robert J. Stoller, *Observing the Erotic Imagination* (New Haven: Yale University Press, 1985), p. 155.

103. Marjorie Garber, *Vested Interests: Cross-Dressing and Cultural Authority* (New York: Routledge, 1992), p. 21. As Garber notes (though she does not discuss the relation to empire): "the term sumptuary is related to "consumption"—the flaunting of wealth by those whose class or other social designation made such display seem transgressive," p. 21.

104. Garber, *Vested Interests*, p. 25.

105. Garber, *Vested Interests*, p. 26.

106. William Jerdan, ed., "The Rutland Papers," in *Camden Society Publications*, # 22, p. 247. Quoted in Garber, *Vested Interests*, p. 26.

107. Garber, *Vested Interests*, p. 70.

108. Garber, *Vested Interests*, p. 32.

109. Garber, *Vested Interests*, p. 17.

110. Garber, *Vested Interests*, p. 10. Garber argues persuasively that critics of cross-dressing such as Elaine Showalter, Stephen Greenblatt, Sandra Gilbert and Susan Gubar have tended, in different ways, to "look away from the transsexual as transvestite" seeking a core gender identity beneath the transvestite mask.

111. Garber, *Vested Interests*, p. 149.

112. *Diaries of Hannah Cullwick*, p. 274.

113. Quoted in Garber, *Vested Interests*, pp. 329–330.

114. *Diaries of Hannah Cullwick*, p. 266

115. Christine Delphy, *Close to Home*, p. 92.

116. Jean Jacques Rousseau, *Emile, or on Education*, trans. by A. Bloom (New York: Basic Books, 1979), p. 404.

117. *Diaries of Hannah Cullwick*, p. 188.

118. In Greek and Roman tradition, the family was, by definition, that extended community of people over which the pater familias had sovereign jurisdiction, owning the rights of life, property and labor of wives, slaves and children.

The comparison of wives and slaves continued after the late seventeenth century. Mary Astell opined that all "women were born slaves."

119. Pateman, *The Sexual Contract*, p. 51

120. Quoted in Pateman, *The Sexual Contract*, p. 52.

121. Pateman, *The Sexual Contract*, p. 53.

122. Pateman, *The Sexual Contract*, p. 51

123. Pateman, *The Sexual Contract*, p. 55.

124. Under the law, wives were classed with criminals, idiots and minors. Under coverture, a woman's personal property passed into the absolute possession of her husband. Legally, he could dispose of it in any way he chose. He could legally leave neither his wife nor children anything in his will. If a husband died intestate, the wife received only half at best. If the wife died intestate, all her property remained his absolutely. A wife could not enter into contracts except as her husband's agent. Under coverture, then, marriage was tantamount to systematic, legalized theft.

125. *Diaries of Hannah Cullwick*, p. 253.

126. *Diaries of Hannah Cullwick*, p. 253. Cullwick's loathing for the "outward bond" of marriage is bluntly echoed by Daniel Defoe's *Roxana*, whose heroine proclaims: "The very Nature of the Marriage-Contract was, in short, nothing but giving up Liberty, Estate, Authority, and every-thing, to the Man, and the Woman was indeed a mere Woman ever after, that is to say, a Slave." Quoted in Pateman, p. 120.

127. *Diaries of Hannah Cullwick*, p. 273.

128. *Diaries of Hannah Cullwick*, p. 238.

129. *Diaries of Hannah Cullwick*, p. 181.

NOTES TO CHAPTER 4

1. Charles de Brosses, *Du Culte des dieux fetiches, ou parallele de l'ancienne religion de l'Egypte avec la religion actuelle de Nigritie*, (Geneva: 1760). See William Pietz's brilliant account of the "sinister pedigree" of the term *fetish* in "The Problem of the Fetish, I," *Res* 9 (Spring 1985): 5–17. I am deeply indebted to Pietz's analysis of fetishism here and in his following articles, "The Problem of the Fetish, II, *Res* 13 (Spring 1987): 23–46; and "The Problem of the Fetish, IIIa,"

Res 16 (Autumn 1988): 105–124.

2. Karl Marx, *Capital,* vol. I. See Robert C. Tucker, ed., *The Marx-Engels Reader,* (New York: W. W. Norton, 1978), pp. 319–29.

3. Sigmund Freud, *Three Essays on the Theory of Sexuality,* in James Strachey, trans. and ed., *The Standard Edition of the Complete Psychological Works of Sigmund Freud,* vol. VII (London: Hogarth Press, 1901–1905), pp. 153–155, 171. Alfred Binet was the first to give fetishism sexual currency in "Le Fetischisme dans l'amour" in *Etudes de psychologie experimentale* (Paris: Octave Doin, 1888).

4. William Pietz, "The Historical Semantics of Fetishism: A Phenomenological Introduction," unpublished manuscript.

5. Jonathan Dollimore points out that perversion originally meant religious and spiritual sins, and was not associated with sexuality for many centuries. Jonathan Dollimore, *Sexual Dissidence: Augustine to Wilde, Freud to Foucault* (Oxford: Clarendon Press, 1991), p. 127.

6. Freud, *Three Essays on the Theory of Sexuality,* p. 159.

7. Freud, *Three Essays on Sexuality,* p. 154–55.

8. Freud, "Fetishism," *The Standard Edition of the Complete Psychological Works of Sigmund Freud,* vol. XXI. ([1927] 1963), pp. 149–157. Later Freud would contradict himself: "All women are clothes fetishists."

9. Naomi Schor, "Female Fetishism: The Case of George Sand," in Susan R. Suleiman, ed., *The Female Body in Western Culture* (Boston: Harvard University Press, 1986), p. 365.

10. Jacques Lacan, "Guiding Remarks for a Congress on Feminine Sexuality," in Juliet Mitchell and Jacqueline Rose, eds., trans. Rose, *Feminine Sexuality: Jacques Lacan and the Ecole Freudienne,* (New Tork: Macmillan, 1982), p. 96.

11. Christian Metz, *The Imaginary Signifier* (Bloomington: Indiana University Press, 1982), p. 84.

12. Robert J. Stoller, *Observing the Erotic Imagination* (New Haven: Yale University Press, 1985), p. 35.

13. Homi K. Bhabha, "The Other Question," *Screen,* 24, 6 (November/ December 1983): 18. Bhabha sees fetishism as involving the relation to castration and thus defers "the question of women's relation to castration and access to the symbolic" until he has worked out "its implications for colonial discourse."

14. Bhabha follows Freud in reading "the fetish object as the substitute for the mother's penis" and "the scene of fetishism" as reactivating "the anxiety of castration and sexual difference." "The Other Question," p. 26.

15. Lacan, in *Feminine Sexuality,* p. 97.

16. Lacan, in *Feminine Sexuality,* p. 96.

17. See Willem Bosman, in John Ralph Willis, ed., *A New and Accurate Description of the Coast of Guinea* (London: Cass, 1967), p. 376. G. W. F. Hegel noted disapprovingly: "it may be an animal, a tree, a stone, or a wooden figure." G. W. F. Hegel, *The Philosophy of History,* trans. J. Sibree (New York: Dover, 1956), p. 94.

18. See Pietz, "The Problem of the Fetish, I," pp. 5–17.

19. Pietz, "The Problem of the Fetish, I," p. 6.

20. Pietz, "The Problem of the Fetish, II," p. 24.

21. Pietz, "The Problem of the Fetish, I," p. 6.

22. Quoted in Mary Kingsley, *West African Studies* (London: Macmillan, 1899), p. 234.

23. Jean Jacques Rousseau, *Emile* (London: J. M. Dent, 1974).

24. Immanuel Kant, *Observations on the Feeling of the Beautiful and the Sublime,* trans. John T. Goldthwait (Berkeley: University of California Press, 1964).

25. Carolus Linnaeus, *A General System of Nature Through the Three Grand Kingdoms of Animals, Vegetables, and Minerals* vol. 1. (London: 1806). See also Richard H. Popkin, "The Philosophical Basis of Eighteenth Century Racism," in Harold E. Pagliaro, ed., *Studies in Eighteenth-Century Culture: Racism in the Eighteenth Century* (Cleveland: Cape Western Reserve, 1973).

26. Hegel, *The Philosophy of History.*

27. J. F. McLennan, "The Worship of Animals and Plants," *Fortnightly Review* 6 and 7 (1869–1870); John Lubbock, *The Origin of Civilization and the Primitive*

Condition of Man (London: 1870); Edward B. Tylor, *Primitive Culture: Researches into the Development of Mythology, Philosophy, Religion, Language, Art and Custom* (London: John Murray, 1871).

28. Tylor, vol. 11, *Primitive Culture*, pp. 144–45.

29. For an excellent analysis of Victorian fetishism, see David Simpson, *Fetishism and Imagination: Dickens, Melville, Conrad* (Baltimore: Johns Hopkins University Press, 1982), especially ch. 1. See also Alasdair Pettinger, "Why Fetish?" *New Formations* 19 (Spring 1993): 83–93, for a discussion of race and nineteenth century theories of fetishism.

30. Tylor, vol. 11, *Primitive Culture*, p. 45.

31. Alfred Binet, "Le Fetischisme dans l'amour," p. 3.

32. "Fetishism," in *Sexuality and the Psychology of Love*, ed. by Philip Rieff (New York: Collier, [1927] 1963), p. 152–53.

33. Freud, "Fetishism," p. 153.

34. Freud, "Fetishism," p. 153.

35. Freud, "Fetishism," p. 153.

36. "Probably no male human being is spared the fright of castration at the sight of the female genital. Why some people become homosexual as a consequence of that impression, while others fend it off by creating a fetish, and the great majority surmount it, we are frankly not able to explain." Freud, "Fetishism," pp. 154–155. See Linda Williams's brilliant critique of Freudian and Marxist theories of fetishism in *Hard Core: Power, Pleasure and the Frenzy of the Visible* (Berkeley: University of California Press, 1989), p. 105 and ch. 4.

37. Williams, *Hard Core*, p. 105.

38. "It is not until later, when some threat of castration has obtained a hold upon him, that the observation becomes important to him." Freud, "Some Psychical Consequences of the Anatomical Distinction Between the Sexes," in *Standard Edition*, vol. XIV (1925), p. 19.

39. Freud, "Some Psychical Consequences of the Anatomical Distinction Between the Sexes," p. 19.

40 Kaja Silverman, *The Acoustic Mirror: The Female Voice in Psychoanalysis and Cinema* (Bloomington: Indiana University Press, 1988), p. 14.

41. Luce Irigaray, *Speculum of the Other Woman*, trans. by Gillian C. Gill (Ithaca: Cornell University Press, 1986), pp. 46–49.

42. Thus, for Irigaray, the denial of female sexuality is a denial that something different (a woman) is needed to guarantee the reproduction of the same, the procreation of the son with the same name as the father.

43. Freud, "Femininity," in *Freud on Women*, p. 131

44. Freud, "Femininity," p. 347.

45. Freud, "Femininity," p. 347.

46. Tim Mitchell, *Iconology: Image, Text, Ideology* (Chicago: University of Chicago Press, 1986), p. 84.

47. Janine Chasseguet-Smirgel, *Creativity and Perversion* (New York: W. W. Norton & Company, 1985), p. 83. Chasseguet-Smirgel notes that clinical observation does not support Freud's contention that the fetish spares the fetishist from becoming a homosexual (p. 80). I am grateful to Steven Marcus for alerting me to this material.

48. P. Weissmann, "Some Aspects of Sexual Activity in a Fetishist," *The Psychoanalytic Quarterly* 32 (1957): 374–92.

49. M. Wulff, "Fetishism and Object-Choice in Early Childhood," *The Psychoanalytic Quarterly* 15 (1946): 450–71. M. Sperling, "Fetishism in Children," *The Psychoanalytic Quarterly* 32 (1950): pp. 374–92. See also D. W. Winnicott, "Transitional Objects and Transitional Phenomena," *The International Journal of Psychoanalysis* 34 (1953): 89–97.

50. Chasseguet-Smirgel, *Creativity and Perversion*, pp. 81, 87, 88.

51. Chasseguet-Smirgel, *Creativity and Perversion*, p. 87.

52. Helene Cixous, "The Laugh of the Medusa," in Sneja Gunew, ed., *A Feminist Reader in Knowledge* (London: Routledge, 1991), p. 25.

53. Cixous, "The Laugh of the Medusa," p. 27.

54. Cixous, "The Laugh of the Medusa," p. 228.

55. Cixous, "The Laugh of the Medusa," p. 34.

56. Lacan, in *Feminine Sexuality*, p. 96.

57. Lacan, in *Feminine Sexuality*, p. 85.

58. Lacan, in *Feminine Sexuality*, p. 97.

59. Certainly, from Freud to Lacan, from Irigaray to Gallop, accounting for the changing histories of lesbian and gay identity has not been the strong point of psychoanalysis—from Irigaray's dubious comments on gay identity, to Gallop's negative and homophobic distrust of gay men: "I distrust male homosexuals," Gallop admits, "because they choose men over women just as do our social and political institutions." Here Gallop defines gay identity negatively, that is, as a rejection of women, rather than as a positive identification with men in ways that cannot be simply equated with heterosexual male dominance.

60. Judith Butler, *Gender Trouble: Feminism and the Subversion of Identity* (New York: Routledge, 1990), p. 87.

61. Dollimore, *Sexual Dissidence*, p. 173.

62. Dollimore, *Sexual Dissidence*, p. 197

63. Dollimore, *Sexual Dissidence*, p. 197

64. Dollimore, *Sexual Dissidence*, p. 198.

65. Lacan, "La Famille," in Henry Wollon, ed., *Encyclopédie française*, vol. 8. Republished as *Les Complexes familiaux dans la formation de l'individu: Essai d'analyse d'une fonction en psychanalyse* (Paris: Navarin, 1984).

66. Rose, in Mitchell and Rose, *Feminine Sexuality*, p. 37.

67. Rose, in Mitchell and Rose, *Feminine Sexuality*, p. 38. As Rose puts it: "The duality of the relation between mother and child must be broken. . . . In Lacan's account, the phallus stands for that moment of rupture. It refers mother and child to that dimension of the symbolic which is figured by the father's place."

68. See Irigaray, *Speculum of the Other Woman*, p. 36

69. Frantz Fanon, *Black Skin, White Masks*, trans. Charles Lam Markmann (London: Pluto Press, 1986), p. 63.

70. Dollimore, *Sexual Dissidence*, p. 202

71. As Guy Hocquenghem puts it: "At a time when capitalist individualization is undermining the family by depriving it of its essential social functions, the Oedipus complex represents the internalization of the family institution."

Quoted in Dollimore, (1991), p. 208.

72. Butler, *Gender Trouble*, p. 56.

73. Butler, *Gender Trouble*, p. 57.

74. Quoted in Mitchell and Rose, *Feminine Sexuality*, p. 45. My emphasis.

75. Sarah Kofman, *The Enigma of Woman: Woman in Freud's Writings*, trans. by Catherine Porter, (Ithaca: Cornell University Press, 1980), p. 73.

76. Schor, "Female Fetishism," p. 26.

77. Marjorie Garber, *Vested Interests: Cross-Dressing and Cultural Anxiety* (New York: Routledge, 1992), p. 121.

78. Garber, *Vested Interests*, p. 125.

79. Garber, *Vested Interests*, p. 125.

80. Garber, *Vested Interests*, p. 125.

81. Garber, *Vested Interests*, p. 121.

82. Garber, *Vested Interests*, p. 271

NOTES TO CHAPTER 5

1. Karl Marx, "Commodity Fetishism," *Capital*, vol. 1, (New York: Vintage Books, 1977), p. 163.

2. See Thomas Richards's excellent analysis, *The Commodity Culture of Victorian Britain: Advertising and Spectacle, 1851–1914* (London: Verso, 1990), especially the introduction and ch. 1.

3. See David Simpson's analysis of novelistic fetishism in *Fetishism and Imagination: Dickens, Melville, Conrad* (Baltimore: Johns Hopkins University Press, 1982).

4. Richards, *The Commodity Culture*, p. 72.

5. Richards, *The Commodity Culture*, p. 5.

6. In 1889, an ad for Sunlight Soap featured the feminized figure of British nationalism, Britannia, standing on a hill and showing P. T. Barnum, the famous circus manager and impresario of the commodity spectacle, a huge Sunlight Soap factory stretched out below them. Britannia proudly proclaims the manufacture of Sunlight Soap to be: "The Greatest Show On Earth." See Jennifer Wicke's excellent analysis of P. T. Barnum in *Advertising Fiction: Literature, Advertisement and Social Reading* (New York: Columbia University Press, 1988).

7. See Timothy Burke, "'Nyamarira That I Loved': Commoditization, Consumption and the Social History of Soap in Zimbabwe," *The Societies of Southern*

Africa in the 19th and 20th Centuries: Collected Seminar Papers, no. 42, vol. 17 (London: University of London, Institute of Commonwealth Studies, 1992), pp. 195–216.

8. Leonore Davidoff and Catherine Hall, *Family Fortunes: Men and Women of the English Middle Class* (Routledge: London, 1992).

9. David T. A. Lindsey and Geoffrey C. Bamber, *Soap-Making. Past and Present, 1876–1976* (Nottingham: Gerard Brothers Ltd, 1965), p. 34.

10. Lindsey and Bamber, *Soap-Making*, p. 38. Just how deeply the relation between soap and advertising became embedded in popular memory is expressed in words such as "soft-soap" and "soap opera." For histories of advertising, see also Blanche B. Elliott, *A History of English Advertising* (London: Business Publications Ltd., 1962); and T. R. Nevett, *Advertising in Britain. A History* (London: Heinemann, 1982).

11. Quoted in Diana and Geoffrey Hindley, *Advertising in Victorian England, 1837–1901* (London: Wayland, 1972), p. 117.

12. Mike Dempsey, ed., *Bubbles: Early Advertising Art from A. & Pears Ltd.* (London: Fontana, 1978).

13. Laurel Bradley, "From Eden to Empire: John Everett Millais' Cherry Ripe," *Victorian Studies* 34, #2 (Winter 1991): 179–203. See also, Michael Dempsey, *Bubbles*.

14. Barratt spent £ 2200 on Millais' painting and £ 30,000 on the mass production of millions of individual reproductions of the painting. In the 1880s, Pears was spending between £ 300,000 and £ 400,000 on advertising alone.

15. Furious at the pollution of the sacrosanct realm of art with economics, the art world lambasted Millais for trafficking (publicly instead of privately) in the sordid world of trade.

16. See Jennifer Wicke, *Advertising Fiction*, p. 70.

17. Donna Haraway, *Primate Visions: Gender, Race, and Nature in the World of Modern Science* (London: Routledge, 1989), p. 10.

18. Haraway, *Primate Visions*, p. 10.

19. Haraway, *Primate Visions*, p. 10–11.

20. Charles Kingsley, Letter to his wife, 4 July 1860, in *Charles Kingsley: His Letters and Memories of His Life*, Francis E. Kingsley, ed., (London: Henry S. King and Co, 1877), p. 107. See also Richard Kearney, ed. *The Irish Mind* (Dublin: Wolfhound Press, 1985); L. P. Curtis Jr., *Anglo-Saxons and Celts: A Study of Anti-Irish Prejudice in Victorian England* (Bridgeport: Conference on British Studies of University of Bridgeport, 1968); and Seamus Deane, "Civilians and Barbarians," *Ireland's Field Day* (London: Hutchinson, 1985), pp. 33–42.

21. During the Anglo-Boer War, Britain's fighting forces were seen as valiantly fortified by Johnston's Corn Flour, Pattisons' Whiskey and Frye's Milk Chocolate. See Robert Opie, *Trading on the British Image* (Middlesex: Penguin, 1985) for an excellent collection of advertising images.

22. In a brilliant chapter, Richards explores how the imperial conviction of the explorer and travel writer, Henry Morton Stanley, that he had a mission to civilize Africans by teaching them the value of commodities "reveals the major role that imperialists ascribed to the commodity in propelling and justifying the scramble for Africa." Richards, *The Commodity Culture*, p. 123.

23. As Richards notes: "A hundred years earlier the ship offshore would have been preparing to enslave the African bodily as an object of exchange; here the object is rather to incorporate him into the orbit of exchange. In either case, this liminal moment posits that capitalism is dependent on a noncapitalist world, for only by sending commodities into liminal areas where, presumably, their value will not be appreciated at first can the endemic overproduction of the capitalist system continue." Richards, *The Commodity Culture*, p. 140.

24. Thomas Carlyle, *Sartor Resartus* in *The Works of Thomas Carlyle*, vol. I (London: Chapman and Hall, 1896–1899), p. 30.

25. Marx, "Theories of Surplus Value," Quoted in G. A. Cohen, *Karl Marx's Theory of History: A Difference* (Princeton: Princeton University Press, 1978), pp. 124–25.

26. Richards, *The Commodity Culture*, pp. 122–23.

27. But palm-oil soaps had been made and used for centuries in west and equatorial Africa. In *Travels in West Africa* Mary Kingsley records the custom of digging deep baths in the earth, filling them with boiling water and fragrant herbs, and luxuriating under soothing packs of wet clay. In southern Africa, soap from oils was not much used, but clays, saps and barks were processed as cosmetics, and shrubs known as "soap bushes" were used for cleansing. Mary H. Kingsley, *Travels in West Africa* (London: Macmillan, 1899). Male Tswana activities like hunting and war were elaborately prepared for and governed by taboo. "In each case," as Jean and John Comaroff write, "the participants met beyond the boundaries of the village, dressed and armed for the fray, and were subjected to careful ritual washing (go foka marumo)." Jean and John Comaroff, *Of Revelation and Revolution: Christianity, Colonialism and Consciousness in South Africa*, vol. 1 (Chicago: University of Chicago Press, 1991), p. 164. In general, people creamed, glossed and sheened their bodies with a variety of oils, ruddy ochres, animal fats and fine colored clays.

28. For an excellent exploration of colonial hegemony in Southern Africa see Jean and John Comaroff, "Home-Made Hegemony: Modernity, Domesticity and Colonialism in South Africa," in Karen Hansen, ed., *Encounters With Domesticity* (New Brunswick: Rutgers University Press, 1992), pp. 37–74.

29. Daniel Defoe, *The Farther Adventures of Robinson Crusoe*, in *The Shakespeare Head Edition of the Novels and Selected Writings of Daniel Defoe*, vol. 3 (Oxford: Basil Blackwell, 1927–1928), p. 177.

30. For an excellent analysis of commodity fetishism, see W. J. T. Mitchell, *Iconology: Image, Text, Ideology* (University of Chicago Press: Chicago, 1986), p. 193. See also Wolfgang Fritz Haug, *Critique of Commodity Aesthetics: Appearance, Sexuality and Advertising in Capitalist Society*, trans. Robert Bock (Minneapolis: University of Minnesota Press, 1986). See

Catherine Gallagher's review essay in *Criticism* 29, 2 (1987): pp. 233–42. On the ritual character of commodities, see Arjun Appadurai, ed., *The Social Life of Things: Commodities in Cultural Perspective* (Cambridge: Cambridge University Press, 1986). See also Sut Jhally, *The Codes of Advertising: Fetishism and the Political Economy of Meaning in the Consumer Society* (London: Routledge, 1990); and, for the language of commodification, see Judith Williamson, *Decoding Advertisements: Ideology and Meaning in Advertising* (London: Marian Boyars, 1978).

31. Cited in Mary H. Kingsley, *Travels in West Africa*, p. 622.

32. Simpson, *Fetishism and Imagination*, p. 29.

33. "Trade Goods Used in the Early Trade with Africa as Given by Barbot and Other Writers of the Seventeenth Century," in Kingsley, *Travels in West Africa*, pp. 612–25.

34. Kingsley, *Travels in West Africa*, p. 614.

35. Fetishism was often defined as an infantile predilection. In Herman Melville's *Typee*, the hero describes the people's fetish-stones as "childish amusement . . . like those of a parcel of children playing with dolls and baby houses." *The Writings Of Herman Melville*, The Northwestern-Newberry Edition, Harrison Hayford, Hershel Parker and G. Thomas Tanselle, eds. (Evanston: Northwestern University Press; Chicago: The Newberry Library, 1968), pp. 174–77.

36. D. and G. Hindley, *Advertising in Victorian England*, p. 99.

37. D. and G. Hindley, *Advertising in Victorian England*, p. 98.

38. D. and G. Hindley, *Advertising in Victorian England*, p. 98.

39. D. and G. Hindley, *Advertising in Victorian England*, p. 98.

40. D. and G. Hindley, *Advertising in Victorian England*, p. 99.

41. Kingsley, *Travels in West Africa*, p. 594.

42. Richards, *The Commodity Culture*, p. 125.

43. Richards, *The Commodity Culture*, p. 125.

44. James Cook, vol. 2, *A Voyage to the Pacific Ocean, Undertaken by the Command of His Majesty, for Making Discoveries in the Northern Hemisphere* (James Cook: London, 1784), p. 10.

420

45. Lewis de Bougainville, *A Voyage Round the World, Performed by the Order of His Most Christian Majesty, in the Years 1766, 1767, 1768, and 1769*, trans. John Reinhold Forster (London: 1772), p. 360.

46. Barbot admits that the Africans on the west coast "have so often been imposed on by the Europeans, who in former ages made no scruple to cheat them in the quality, weight and measures of their goods which at first they received upon content, because they say it would never enter into their thoughts that white men . . . were so base as to abuse their credulity . . . examine and search very narrowly all our merchandize, piece by piece." It did not take long, it seems, for Africans to invent their own subterfuges to hoodwink the Europeans and win the exchange. By Barbot's account, they would half-fill their oil casks with wood, add water to their oil, or herbs to the oil to make it ferment and thus fill up casks with half the oil. Kingsley, *Travels in West Africa*, p. 582.

47. Jean and John L. Comaroff, *Of Revelation and Revolution*, p. 166.

NOTES TO CHAPTER 6

1. C. W. De Kiewet, *A History of South Africa: Social and Economic* (London: Oxford University Press, 1941), p. 119.

2. Haggard was in South Africa from 1875 to 1881. In 1876 he personally raised the British flag over a disgruntled Transvaal.

3. Henry Rider Haggard, *King Solomon's Mines* (London: Signet, 1965). All further references to this edition are cited in the text by page number.

4. *King Solomon's Mines* was reprinted four times in the first three months, sold 31,000 copies in the first year and has never been out of print since its publication. *She*, too, was an instant bestseller and has been translated into over twenty languages and made into numerous films and plays as well as an opera. It too has not been out of print in Britain in the last century. Ella Shohat discusses film versions of both novels in "Gender and the Culture of Empire: Toward a Feminist Ethnography of the Cinema," *Quarterly Review of Film and Video*, 13, 1–3 (Spring 1991): 45–84.

5. See Jeff Guy, "Gender Oppression in Southern African Precapitalist Societies," in Cherryl Walker, ed., *Women and Gender in Southern Africa to 1945* (London: David Philip, 1990), pp. 33–47.

6. Henry Rider Haggard, *Days of My Life* (London: Longmans Green and Co., 1926), p. 24.

7. Lilias Rider Haggard, *The Cloak That I Left* (London: Hodder and Stoughton, 1951), p. 16.

8. Haggard, *Days of My Life*, p. 64.

9. Haggard, *Days of My Life*, pp. 18, 46.

10. Haggard, *Days of My Life*, p. 56.

11. Sandra Gilbert, "Rider Haggard's Heart of Darkness," *Partisan Review* 3 (1983): p. 1.

12. Gilbert, "Rider Haggard's Heart of Darkness," p. 44.

13. L. Haggard, *The Cloak That I Left*, p. 24.

14. L. Haggard, *The Cloak That I Left*, p. 25.

15. L. Haggard, *The Cloak That I Left*, pp. 23, 25, 26, 27.

16. J. A. Froude, *Short Studies on Great Subjects* (London: Longmans, 1890).

17. Froude, *Short Studies*, p. 289.

18. Froude, *Short Studies*, p. 308.

19. Haggard, *Days of My Life*, p. 36.

20. George Orwell, in S. Orwell and I. Angus eds., *The Collected Essays, Journalism and Letters of George Orwell*, vol. 11 (London: Secker and Warburg, 1968), p. 67.

21. Raymond Williams, *George Orwell: A Collection of Critical Essays* (Engelwood Cliffs: Prentice Hall, 1975), p. 20.

22. Pierre Macherey, *A Theory of Literary Production* (London: Routledge & Kegan Paul, 1978), p. 265.

23. Donna Haraway, *Primate Visions: Gender, Race and Nature in the World of Modern Science* (London: Routledge, 1989), p. 52.

24. See Mary Louise Pratt's fine analysis of this trope in *Imperial Eyes: Travel Writing and Transculturation* (New York: Routledge, 1992).

25. Macherey, *A Theory of Literary Production*, p. 183.

26. Macherey, *A Theory of Literary Production*, p. 183.

27. A. T. Bryant, *Olden Times in Zululand and*

Natal (London: Longmans, 1929), p. 640.

28. J. Tyler, *Forty Years Among the Zulus* (Struik: Cape Town, 1971), p. 104.

29. Haggard, *Cetywayo and His White Neighbours* (London: Trubner and Co, 1882), p. 53.

30. Haggard, *Cetywayo*, p. 281. See also Jeff Guy, *The Destruction of the Zulu Kingdom* (Johannesburg: Ravan Press, 1982); and H. Slater, "The Changing Pattern of Economic Relations in Rural Natal, 1838– 1914," in Shula Marks and A. Atmore, eds., *Economy and Society in Pre-Industrial South Africa* (London: Longmans, 1980).

31. Terence Ranger, "The Invention of Tradition in Colonial Africa," in Eric Hobsbawm and Terence Ranger, eds., *The Invention of Tradition* (Cambridge: Cambridge University Press, 1983). See also David Cannadine, "The Context, Performance and Meaning of Ritual: The British Monarchy and the 'Invention of Tradition,' 1820–1977," in Hobsbawm and Ranger. For an excellent exploration of the invention of Zulu tradition, see Shula Marks, *The Ambiguities of Dependence: Class, Nationalism and the State in Twentieth Century Natal* (Johannesburg: Ravan Press, 1986).

32. Ranger, *The Invention of Tradition*, p. 212.

33. Quoted by Ruth E. Gordon, *Shepstone: The Role of the Family in the History of South Africa, 1820–1890* (Cape Town: Balkema, 1968), p. 309.

34. Guy, *The Destruction of the Zulu Kingdom*, p. 51(n).

35. Haggard, *Days of My Life*, p. 9.

36. Henry Callaway, *A Memoir*, ed. M. S. Benham (London: 1896), p. 88.

37. W. R. Ludlow, *Zululand and Cetywayo* (London: Simpkin, Marshall, 1882), p. 18.

38. Haggard, *Cetywayo*, p. 57.

39. Patrick Harries, "Plantations, Passes and Proletarians: Labor and the Colonial State in Nineteenth Century Natal," *Journal of Southern African Studies* 13, 2, 375.

40. Slater, *The Changing Patterns*, p. 156.

41. Froude, *Short Studies*, p. 370–71.

42. Quoted in H. J. Simons, *African Women: Their Legal Status in South Africa* (Evanston: Northwestern University Press, 1968), p. 21.

43. Haggard, *Cetywayo*, p. 52.

NOTES TO CHAPTER 7

1. For primary biographical material on Schreiner, I have drawn on Ruth First and Ann Scott's excellent biography, *Olive Schreiner* (New York: Schocken Books, 1980); Samuel C. Cronwright-Schreiner, *The Life of Olive Schreiner* (London: Unwin, 1924); Johannes Meintjes, *Olive Schreiner: Portrait of a South African Woman* (Johannesburg, 1965); and Zelda Friedlander, *Until the Heart Changes: A Garland for Olive Schreiner* (Cape Town, 1967). See also Nadine Gordimer "'The Prison-House of Colonialism,' Review of Ruth First and Ann Scott's *Olive Schreiner*," *Times Literary Supplement*, London, 1980. See also Susan Gardner's critical review of First and Scott's biography, "'No Story, No Script, Only The Struggle': First and Scott's *Olive Schreiner*," *Hecate* 7, 1 (1981): 40–61. For Schreiner's letters, see S. C. Cronwright-Schreiner, ed., *The Letters of Olive Schreiner, 1876–1920* (London: Unwin, 1924); and Richard Rive *Olive Schreiner: Letters 1871–99* (Oxford: Oxford University Press, 1988).

2. Cronright-Schreiner, *The Letters of Olive Schreiner*. All further references to this text will be cited as *Letters*.

3. For an excellent account of missionary politics and culture, see Jean and John Comaroff, *Of Revelation and Revolution: Christianity, Colonialism and Consciousness in South Africa* (Chicago: University of Chicago Press, 1991).

4. Cronright-Schreiner, *The Life of Olive Schreiner*. All further references to this text will be cited as *Life*.

5. *Letters*, p. 56. For a detailed analysis of Schreiner's philosophical ideas, see Joyce A. Berkman, *The Healing Imagination of Olive Schreiner* (Massachusetts, 1989), and J. Berkman,"The Nurturant Fantasies of Olive Schreiner," *Frontiers* 2, 3 (1977): 8–17.

6. *Letters*, June 27, 1908.

7. Olive Schreiner (under the pseudonym

Ralph Iron) *The Story of an African Farm: A Novel* (London: Hutchinson, 1910), p. 43.

8. Schreiner, *Story of an African Farm*, p. 65.

9. Schreiner, *Story of an African Farm*, p. 123.

10. Schreiner, *Story of an African Farm*, p. 76.

11. Olive Schreiner, *Stories, Dreams and Allegories* (London: Unwin, 1923).

12. *Letters*, p. 97.

13. For analyses of Schreiner's attitudes to race and/or imperialism, see Carol Barash, "Virile Womanhood: Olive Schreiner's Narratives of a Master Race," *Woman's Studies International Forum* 9, 4, (1986); J. Berkman, *Olive Schreiner: Feminism on the Frontier* (St. Albans, VT: Eden Press Women's Publications, 1979); John Van Zyl, "Rhodes and Olive Schreiner, *Contrast* 21 (August 1969); and Cherry Wilhelm, "Olive Schreiner: Child of Queen Victoria, Stories, Dreams and Allegories," *English in Africa* 6, 2 (1979): 63–69.

14. Olive Schreiner, *From Man to Man* (London: Virago Press, [1926] 1989), p. 68.

15. Schreiner, *From Man to Man*, p. 27.

16. Schreiner, *From Man to Man*, pp. 59–60.

17. Schreiner, *From Man to Man*, p. 42.

18. Schreiner, *From Man to Man*, p. 34.

19. Schreiner, *From Man to Man*, p. 71.

20. Schreiner, *From Man to Man*, p. 66.

21. Schreiner, *From Man to Man*, p. 73.

22. Schreiner, *From Man to Man*, pp. 106–15.

23. Schreiner, *From Man to Man*, p. 127.

24. Schreiner, *From Man to Man*, p. 104.

25. Gloria Anzaldua points out that the "focal point or fulcrum, that juncture where the mestiza stands, is where phenomena tend to collide." La Conciencia de la Mestiza, *Borderlands/ La Frontera* (San Francisco: Spinsters, Aunt Lute, 1987), p. 80.

26. *Letters*, p. 102. For an excellent analysis of the gendered history of illness and madness, see Elaine Showalter, *The Female Malady: Women, Madness and English Culture: 1830–1980* (New York and London: Pantheon and Virago, 1989).

27. Quoted by Jane Graves, preface to Olive Schreiner, *Woman and Labor* (London: Virago Press, 1978).

28. Olive Schreiner, *Undine* (London: Benn, 1929), p. 34.

29. Schreiner, *Undine*, p. 38.

30. Schreiner, *Undine*, p. 73.

31. Mary Poovey, *Uneven Developments: The Ideological Work of Gender in Mid-Victorian England* (Chicago: University of Chicago Press, 1988), p. 127.

32. In a fine essay on Jane Eyre and the governess, Poovey points out that the widespread perception that governesses were a "problem" was disproportionate both to the actual hardships they suffered and to the small numbers of women affected. While certainly considerable, the governesses' afflictions were far less than those of working-class servants, who received far less attention and sympathy. Poovey, *Uneven Developments*, p. 127.

33. Schreiner, *Story of an African Farm*, p. 48.

34. *Life*, p. 107.

35. Schreiner, *Story of an African Farm*, p. 94.

36. Schreiner, *Story of an African Farm*, p. 128.

37. Schreiner, *Story of an African Farm*, p. 78.

38. Walter Benjamin, *The Origin of German Tragic Drama*, trans. John Osborne, (London: New Left Books, 1977).

39. *Letters*, p. 64.

40. *Life*, p. 176.

41. Benjamin, *Origin of German Tragic Drama*, p. 57.

42. Dan Jacobson, introduction to Schreiner, *Story of an African Farm*, p. 3.

43. *Letters*, p. 239.

44. Schreiner, *The Story of an African Farm*, p. 98.

45. Schreiner, *The Story of an African Farm*, p. 91.

46. Schreiner, *From Man to Man*, p. 85.

47. *Letters*, p. 145.

48. On the "New Woman," see Elaine Showalter, *Sexual Anarchy. Gender and Culture at the Fin de Siecle* (London: Viking, 1990), ch. 3. On Schreiner and the New Woman, see Linda Dowling, "The Decadent and the New Woman in the 1890's," *Nineteenth Century Fiction* 33 (March 1979): pp. 434–53; Sandra M.

Gilbert and Susan Gubar *Sexchanges* (New Haven: Yale University Press, 1989); and Gilbert and Gubar, *No Man's Land* (New Haven: Yale University Press, 1986).

49. First and Scott, *Olive Schreiner*, p. 198.

50. *Letters*, p. 76.

51. See Judith Walkowitz's excellent analysis of the Men and Women's Club in *City of Dreadful Delight: Narratives of Sexual Danger in Late Victorian London* (London: Virago Press, 1992), pp. 135–69. See also Showalter, *Sexual Anarchy*, pp. 47–58; Betty Fradkin, "Olive Schreiner and Karl Pearson," *Quarterly Bulletin of South African Library* 31, 4 (June 1977): 83–93; Fradkin, "Havelock Ellis and Olive Schreiner's 'Gregory Rose'," *Texas Quarterly* 21, 3 (Fall 1978): 145–53; Sheila Jeffreys, *The Spinster and Her Enemies: Feminism and Sexuality, 1880–1930* (London: Pandora, 1985); and Kevles Daniel, *In the Name of Eugenics: Genetics and the Uses of Human Heredity* (New York: Knopf, 1985).

52. *Letters*, p. 256.

53. *Letters*, p. 139.

54. Schreiner, *Story of an African Farm*, p. 91.

55. *Letters*, p. 92.

56. *Letters*, p. 83.

57. *Letters*, p. 126.

58. *Letters*, p. 178.

59. Schreiner, *From Man to Man*, p. 267.

60. *Letters*, p. 156.

61. See Walkowitz's analysis of "The Maiden Tribute" in *City of Dreadful Delight*, chs. 3 and 4.

62. *Life*, p. 94.

63. *Letters*, p. 236.

64. Schreiner, *Thoughts on South Africa* (London: Unwin, 1923), p. 79.

65. Schreiner, *Thoughts on South Africa*, p. 26.

66. *Letters*, p. 243.

67. Schreiner, *Woman and Labor* (London: Virago Press, 1978), p. 33.

68. Schreiner, *Woman and Labor*, p. 96.

69. Schreiner, *Woman and Labor*, p. 34.

70. Schreiner, *Woman and Labor*, p. 57.

71. Antonio Gramsci, *Prison Notebooks*, quoted by Nadine Gordimer, *July's Peo-*ple (London: Penguin, 1981), p. 1.

NOTES TO CHAPTER 8

1. Elsa Joubert, *Poppie Nongena* (London: Coronet, 1981). All further references to this edition are cited in the text by page number.

2. David Schalkwyk, "The Flight from Politics: An Analysis of the Reception of *Poppie Nongena*," *Journal of Southern African Studies* 12, 2 (April 1986): 183–195.

3. *The Cape Times*, August 7, 1980. *Eastern Province Herald*, April 17, 1979. *Die Beeld*, November 20, 1978 (trans. Schalkwyk); *The Star*, October 1, 1980.

4. *The Star*, October 1, 1980; *Die Burger*, January 16, 1979.

5. Raymond Williams, *George Orwell* (New York: 1971), p. 56.

6. *Rapport*, December 3, 1978.

7. *The Cape Times*, December 6, 1978.

8. *Rapport*, December 3, 1978.

9. The creation of this Afrikaans constituency demanded the conscious invention of a single print-language, a popular press, a literate populace and an active intellectual class. As Isabel Hofmeyr has shown, the *taalbeweging* (language movement) of the early twentieth century represented just such an invention, refashioning the myriad Boer vernaculars into a single, identifiable Afrikaners language, while purging it of its working-class, rural associations. During the 1960s, with power confidently clenched in Afrikaans fists, an unabashedly phallic monument to Afrikaans was erected as testimony to the engendering potency of the language.

10. Andre Brink, *Writing in a State of Siege* (New York: Summit Books, 1983), p. 36.

11. *The Cape Times*, December 6, 1978.

12. Letter to *Die Burger*, January 16, 1979, trans. Schalkwyk.

13. Letter to *The Argus*, March 14, 1978.

14. *Rand Daily Mail*, January 4, 1979.

15. *Die Oosterlig*, March 9, 1979.

16. Marnea Lazreg, "Feminism and Difference: The Perils of Writing as a Woman on Women in Algeria," *Feminist Studies* 14, 1 (Spring 1988): 81–107.

17. Jean Marquard, "Poppie," *English Studies in Africa* 28 (1985): 135–41.

18. *The Sowetan*, July 18, 1981. *Die Beeld*, March 22, 1979. *Die Oggenblad*, February 28, 1979. *Rapport*, December 3, 1978.

19. Dust jacket to 1980 edition of *Poppie Nongena*; *Sunday Times*, December 3, 1978. *Rapport*, February 14, 1979.

20. Marquard, "Poppie," p. 137.

21. Marquard, "Poppie," p. 137. Elsa Joubert in M. J. Daymond, J. U. Jacobs, and Margaret Lenta, eds., *Momentum: On Recent South African Writing* (Pietermaritzburg: University of Natal Press, 1984), p. 60.

22. Philippe Lejeune, *L'Autobiographie en France* (Paris: Armand Colin, 1971), subsequently modified in *Pact autobiographique* (Paris: Seuil, 1976).

23. Paul Thompson, "History and Community," in David K. Dunaway and Willa K. Baum, eds., *Oral History: An Interdisciplinary Anthology* (Nashville, Tenn.: American Association for State and Local History, 1984), p. 39.

24. Samuel Hand, "Some Words on Oral Histories," in Dunaway and Baum, *Oral History*, p. 52.

25. Frantz Fanon, *The Wretched of the Earth* (New York: Grove Press, 1963), p. 77.

26. Teresa de Lauretis, *Technologies of Gender: Essays on Theory, Film and Fiction* (Bloomington: Indiana University Press, 1987), pp. 1–2.

27. De Lauretis, *Technologies of Gender*, p. 5.

28. De Lauretis, *Technologies of Gender*, p. 5.

29. Biddy Martin, "Lesbian Identity and Autobiographical Difference[s]," in Bella Brodski and Celeste Schenke, eds., *Life/Lines: Theorizing Women's Autobiography*, (Ithaca: Cornell University Press, 1988) p. 82.

30. Audre Lorde, "Age, Race, Class and Sex: Woman Redefining Difference," in *Sister Outsider: Essays and Speeches*, (Trumansburg: The Crossing Press, 1984), pp. 120–21.

31. An important exception is Cheryll Walker, *Women and Resistance in South Africa* (London: Onyx Press, 1982). See also Jo Beall, Shireen Hassim and Alison Todes, "A Bit on the Side?: Gender Struggles in the Politics of Transformation in South Africa," *Feminist Review* 33

(Autumn 1989). Frene Ginwala, "ANC Women: Their Strength in the Struggle," *Work in Progress* 45 (November/December 1986): 11–14. Jacklyn Cock, *Maids and Madams* (Johannesburg: Ravan, 1980); and Mamphela Ramphele and Emile Boonzaaier, "The Position of African Women: Race and Gender in South Africa," in Boonzaaier and J. Sharp, eds., *South African Keywords* (Cape Town: David Philip, 1988), pp. 153–66.

32. See Sandra Gilbert and Susan Gubar, *The Madwoman in the Attic: The Woman Writer and the Nineteenth Century Literary Imagination* (New Haven: Yale University Press, 1979), ch. 1, for the metaphor of writing as phallic power.

33. George Gusdorf, all too often regarded as the premier don of autobiographical theory, calls autobiography an "apologetics or theodicy of the individual being," and speaks of autobiography's affinity with the silver-backed Venetian mirrors: henceforth the mirror-text would reflect back the narcissistic image of the master self. See Gusdorf, "Conditions and Limits of Autobiography," in James Olney, ed., *Autobiography: Essays Theoretical and Critical* (Princeton: Princeton University Press, 1980), pp. 32, 39. Olney defines the autobiographer in terms of a separate and unique (male) selfhood. The autobiographer is "surrounded and isolated by his own consciousness, an awareness grown out of a unique heredity and unique experience." *Metaphors of Self: The Meaning of Autobiography* (Princeton: Princeton University Press, 1972), pp. 22–23.

34. Gusdorf, "Conditions and Limits of Autobiography," pp. 29, 30, 33.

35. Gusdorf, "Conditions and Limits of Autobiography," p. 29.

36. Leila Ahmed, "Between Two Worlds: The Formation of a Turn-of-the-Century Egyptian Feminist," in Brodski and Schenke, *Life/Lines*, p. 54.

37. In America, as Carolyn Heilbrun observes, it has only been since 1980 that male critics have bothered to speak of the innumerable women's autobiographies that do exist. Carolyn G. Heilbrun, "Women's Autobiographical Writings: New Forms," in *Prose Studies* 8, 2 (Sep-

tember 1985): p. 14. James Olney's 1980 collection, for example, devotes a solitary essay to women's autobiographies, while fifteen essays were devoted to male autobiographies. Paul Fussel's account of World War I autobiographies neglects to mention a single female autobiography, though by one estimate there were at least thirty substantial female accounts of the war. See Lidwien Heerkens, "Becoming Lives: English Women's Autobiographies of the 1930's," M.A. thesis, University of Leicester, 1984.

38. Mary Mason, for one, claims: "Nowhere in women's autobiographies do we find the patterns established by the two prototypical male autobiographers, Augustine and Rousseau; and conversely male writers never take up the archetypal models of Julian, Margerey Kemp, Margaret Cavendish, and Anne Bradstreet." "The Other Voice: Autobiographies of Women Writers," in Olney, *Autobiography*, p. 210.

39. Estelle C. Jelinek, ed., *Women's Autobiography: Essays in Criticism* (Bloomington: Indiana University Press, 1980), p. 17. Neither, it is argued, do women's autobiographies flourish at the high points of male history—revolutions, battles and national upheavals—but wax according to the climactic changes of other histories. Typically, male autobiographies reinvent the lives of military leaders, statesmen and public figures, while, as Conway points out, there are no models for women recounting successful political lives, no models for the public admission of ambition and no models for the "proper" stages of a career.

40. Mason, "The Other Voice," p. 210.

41. Mason, "The Other Voice," p. 210.

42. French feminist critics such as Julia Kristeva, Luce Irigaray, and Helene Cixous have, in different ways, discerned in women's writing a female bodily residue of insurgent pleasures and rebellions, which evade cultural edicts and erupt mutinously in semiotic discourse: unruly, gestural, rhythmic, repetitive, oral, preOedipal and unbounded. See Julia Kristeva, "Oscillations," trans. in Elaine Marks and Isabelle de Courtivron, eds., *New French Feminisms:*

An Anthology (Amherst: University of Massachusetts Press, 1980); Luce Irigaray, "Ce Sexe qui n'en est pas un," trans. in Marks and Courtivron; and Helene Cixous, "Sorties," trans. in Marks and Courtivron.

43. Ann Rosalind Jones, "Writing the Body: Toward an Understanding of l'Ecriture Feminine," in Elaine Showalter, ed., *The New Feminist Criticism. Essays on Women, Literature, Theory,* (New York: Pantheon, 1985). The notion of an unbounded *écriture féminine* is trammeled in the same binary opposites it opposes—preserving the dualistic idea of the male as rational, solipsistic and centered; the female as organic, cosmic, rhythmic and unbounded—but reversing the values. Paeans to a female language of anatomy are eerily akin to ancestral male dogmas that idolize woman as body, nature, unreason, empathy, selflessness.

44. Ann Jones asks, for example, whether women of color, who have been marginalized in very different ways from white women, experience body and language as white women do. Which women will be allowed to write the new body? What would the idea of refashioning the world through a semiotic *jouissance* of the written word mean to women from oral cultures, to women going blind making microchips, to women without access to abortion or contraception, to the millions of genitally mutilated women in the world? "Writing the Body," p. 371.

45. Susan Stanford Friedman, "Woman's Autobiographical Selves: Theory and Practice," in Shari Benstock, ed., *The Private Self: Theory and Practice in Women's Autobiographical Writings* (Chapel Hill: University of North Carolina Press, 1988), p. 38.

46. Nellie MacKay, "Race, Gender and Cultural Context in Zora Neale Hurston's *Dust Tracks on a Road*," in Brodski and Schenke, *Life/Lines*, p. 176.

47. Audre Lorde, *Zami: A New Spelling of My Name* (New York: Crossing Press, 1982), p. 139.

48. Both Es'kia Mphahlele and Bloke Modisane's autobiographies attempt, in different ways, to reinvent a trajectory

of selfhood compatible with the liberal notion of the (white, male) individual self. Both fail; their autobiographies end with the abandonment of their families and flight into exile. By no means was this necessarily an easier choice; but it was a choice shaped in part by their mission school inheritance, their class positions as educated men and the traitorous heritage of Western liberalism that did not fulfill its promise to them. See Ezekiel Mphahlele, *Down Second Avenue* (London: Faber, 1959); Bloke Modisane, *Blame Me on History* (Cape Town: A. D. Donker, 1986).

49. Don Mattera, *Memory Is the Weapon* (New York: Beacon, 1988).

50. See Julia Wells, "Why Women Rebel: A Comparative Study of South African Women's Resistance in Bloemfontein (1913) and Johannesburg (1958)," *Journal of Southern African Studies* 10, 1 (1984): 55–70.

51. "'Let Me Make History Please': The Story of Johanna Masilela, Childminder," in Belinda Bozzoli, ed., *Class, Community and Conflict* (Johannesburg: Ravan Press, 1987), p. 472.

52. Nancy Chodorow, *The Reproduction of Mothering: Psychoanalysis and the Sociology of Gender* (Berkeley: University of California Press, 1978), p. 169.

53. Chodorow, *Reproduction of Mothering*, p. 169.

54. See Ann Banfield, "The Formal Coherence of Represented Speech and Thought," *PTL: A Journal for Descriptive Poetics and Theory of Literature* 3 (1978): 289–314; and Dorrit Cohn, "Narrated Monologue: Definition of a Functional Style," *Comparative Literature* 14, 2 (1966): 97–112.

55. See Doris Sommer, "Not Just a Personal Story: Women's *Testimonios* and the Plural Self," in Bella Brodski and Celeste Schenke, eds., *Life/Lines: Theorizing Women's Autobiography*, p. 118.

56. Heidi Hartman, "The Family as the Locus of Gender, Class, and Political Struggle: The Example of Housework," *Signs* 6, 3 (Spring 1981): 366–94.

57. The subjugation of female labor to males and elders within the ceremony of marriage is enshrined in a Zulu proverb that sums up the symbolic meaning of the change of clothing: "*akuqhala-qhala lahlul' isidwaba*"—no defiant woman ever defeated a leather skirt.

58. As Christine Delphy has argued, a married woman's class is typically defined not by her *economic* relation to production, but by her *social* relation to her husband: "Women's relation to class is indirect: mediated by the marriage relation." Thus marriage for women is fundamentally an entry into a "labor relation": "Marriage is the institution by which gratuitous work is extorted from a particular category of the population, women-wives." Marriage is the institution that legalizes the domestic appropriation of women's work. *Close to Home: A Materialist Analysis of Women's Oppression*, trans. and ed. Diana Leonard (Amherst: University of Massachusetts Press, 1984), pp. 68, 87, 63, 77.

59. As Kum-Kum Bhavnani and Margaret Coulson put it: "In the context of racist oppression, black families are often not 'anti-social' in the sense used by Barrett and McIntosh but can become not only a base for solidarity but also a struggle against racism." "Transforming Socialist Feminism: The Challenge of Racism," *Feminist Review*, 23 (June 1986): p. 89. Similarly, Valerie Amos and Pratibha Parmar point out that black women have very different relations to welfare, to immigration, to schools, and the police "Challenging Imperial Feminism" *Feminist Review* 17 (Autumn 1984): p. 5. Not all family households are equal in the eyes of the law. See also Barrett and McIntosh, "Ethnocentrism and Socialist-Feminist Theory," *Feminist Review* 20 (June 1984).

60. Here nearly twelve million people, most of whom are women and children, live under conditions of deprivation that are barely possible to describe. The euphemistic term "national homeland" serves the ideological function, moreover, of providing a language of legitimation founded in an invented discourse on the family.

61. See Josette Cole, *Crossroads: The Politics of Reform and Repression, 1976–1986* (Johannesburg: Ravan Press, 1987) for an

important account of the politics of women's squatter communities in the Cape.

62. S. A. Rogers, quoted in Cole, *Crossroads*, p. 7. The policy for limiting the African presence, as it unfolded between 1962 and 1969, had a double strategy directed specifically at women: no more houses would be built, and work for women would be made virtually impossible. Between 1966 and 1976 fewer than four thousand houses were built. In 1974 the (Orwellian) Department of Community Development set the shortage of houses at forty thousand for colored people alone. At this time, the squatter presence swelled: by 1974 there would be an estimated thirty-seven squatter camps in the Peninsula alone.

63. Sommer, "Not Just a Personal Story," p. 118.

NOTES TO CHAPTER 9

1. At least three general analyses of the Soweto uprising have emerged: deeper ANC involvement in the community; strains on the educational system, unemployment and recession with greater industrial militancy stemming from the strikes in the early 1970s; and the emergence of Black Consciousness ideology. See Tom Lodge, *Black Politics in South Africa Since 1945* (Johannesburg: Longmans, 1983), pp. 321–62.

2. See M. K. Malefane, "'The Sun Will Rise': Review of the Allah Poets at the Market Theatre, Johannesburg," *Staffrider* (June/July 1980); reprinted in Michael Chapman, *Soweto Poetry* (Johannesburg: 1982), p. 91.

3. "About *Staffrider*," (editorial), *Staffrider* 1 (May/June 1978); reprinted in Chapman, *Soweto Poetry*, p. 125.

4. Michael Kirkwood, quoted in Ursula A. Barnett, *A Vision of Order: A Study of Black South African Literature in English, 1914–1980* (Amherst, Mass.: The University of Massachusetts Press, 1983), p. 37.

5. Nick Visser, "'*Staffrider*: An Informal Discussion': Interview with Michael Kirkwood," *English in Africa* 7 (Sept. 1980), reprinted in Chapman, *Soweto Poetry*, p. 129. *Staffrider* was conceived in 1977 during discussions with groups

such as the Mpumulanga Arts Group. One of the best known of these groups, the Medupe Writers, with a membership of over two hundred, had taken poetry readings to the schools and communities and was promptly banned in October 1977, along with the South African Students' Organization, the Black People's Convention and other Black Consciousness organizations.

6. Visser, "'*Staffrider*.'".

7. *Staffrider* (May/June 1978), quoted in Barnett, *A Vision of Order*, p. 38.

8. *Staffrider* (July/August 1978); quoted in Barnett, *A Vision of Order*, p. 38.

9. See David B. Coplan, *In Township Tonight! South Africa's Black City Music and Theater* (London: Longmans, 1985).

10. Lewis Nkosi, "The Fabulous Decade," *Home and Exile and Other Selections* (London: Longman, 1983), pp. 3–24.

11. A shebeen is an illegal house of entertainment, usually run by a woman, selling beer and liquor to black people.

12. Miriam Tlali, *Muriel at Metropolitan* (Johannesburg: Ravan Press, 1975), p. 70.

13. N. Chabani Manganyi, "'The Early Years': Interview with Es'kia Mphahlele," *Staffrider* (Sept./Oct. 1980); reprinted in Chapman, *Soweto Poetry*, p. 42.

14. Frantz Fanon, *The Wretched of the Earth*, trans. Constance Farrington (London: Penguin, 1963), pp. 33–34.

15. Fanon, *Wretched of the Earth*, p. 47.

16. See Baruch Hirson, *Year of Fire, Year of Ash: The Soweto Revolt, Roots of a Revolution?* (London: Zed Press, 1979), ch. 1.

17. Nat Nakasa, "Writing in South Africa," *The Classic* I, 1 (1963), p. 77; reprinted in Chapman, *Soweto Poetry*, p. 37.

18. Es'kia Mphahlele, "My Experience as a Writer," in M. J. Daymond, J. U. Jacobs and Margaret Lenta, eds., *Momentum: On Recent South African Writing* (Pietermaritzburg: Natal University Press, 1984), p. 75.

19. Mphahlele, "My Experience," p. 76.

20. Chapman, intro. *Soweto Poetry*, p. 16. Houghton is one of Johannesburg's lavish white suburbs. In *Blame Me on History* (1963; rpt. New York: Simon and Schuster, 1986), Bloke Modisane admitted that he had wanted acceptance

"in the country of my birth; and in some corner of the darkened room I whisper the real desire: I want to be accepted into white society. I want to listen to Rachmaninov, to Beethoven, Bartok and Stravinsky," p. 35.

21. Nakasa, "Writing in South Africa," p. 37.

22. Nkosi, *Home and Exile*, p. 131.

23. Nkosi, "White on Black," *Observer*, April 1, 1962, p. 46.

24. See Mbulelo Mzamane in Daymond, Jacobs and Lenta, eds., *Momentum*, p. 302. The silky taboo of white Johannesburg women became, for Nkosi at least, the promised loot of collaboration with white liberals in league against the Nationalist state, and when he at last came "subtly to despise white South Africans," it was the renunciation of white women that smarted most: "The image of the white female beauty is one that rings most frequently the cash register of the Negro psyche. In any case, we all know how notoriously alluring women of the ruling class have always proved to be for aspiring revolutionaries, black or white" (*Home and Exile*, pp. 23, 150). In the cash nexus of Nkosi's psyche, aspiring revolutionaries were apparently strictly male and revolution a Manichean struggle between male races over the spoils of white female beauty—the untiring and magnificent role of black women in resistance found no place.

25. See Robert Mshengu Kavanagh, *Theatre and Cultural Struggle in South Africa* (London: Zed Books, 1985), p. 62.

26. Mphahlele, "My Experience," p. 79.

27. Mphahlele, "My Experience," p. 60.

28. See David Rabkin, "*Drum* Magazine (1951–1961) and the Works of Black South African Writers Associated With It," Ph. D dissertation, University of Leeds, 1975, p. 57.

29. Manganyi, "Interview with Es'kia Mphahlele," p. 42.

30. Nkosi, *Home and Exile*, p. 9.

31. Nkosi, *Home and Exile*, p. 17.

32. Nakasa, "Writing in South Africa," p. 37.

33. Mphahlele, *Down Second Avenue* (London, 1959), p. 182.

34. Modisane, *Blame Me on History*, p. 57.

35. Nakasa, "Writing in South Africa," p. 36.

36. See Coplan, *In Township Tonight*!

37. The *lifela* performance is a public competition during which two or more poets (*likheleke*, "eloquent persons") display the desired criteria of their craft: sustained extemporary eloquence, originality of figure and metaphor, musical patterning, the aptness of donated or borrowed formulaic elements and the refashioning of shared experience into aesthetic form.

38. Molefi Motsoahae, "Madman with iron belts." I am indebted here to Coplan, "Interpretive Consciousness," The quotation is from his translation.

39. Solomon Tshekisho Plaatje, "Sweet Mhudi and I," *Mhudi: an Epic of South African Native Life a Hundred Years Ago* (Lovedale: The Lovedale Press, 1933); reprinted in Tim Couzens and Essop Patel, eds., *The Return of the Amasi Bird: Black South African Poetry, 1891–1981* (Johannesburg: Ravan Press, 1982), pp. 49–50.

40. Plaatje, "Song," reprinted in Couzens and Patel, *Return of the Amasi Bird*, p. 45.

41. Nakasa, "Writing in South Africa," p. 5.

42. See Lodge, *Black Politics*, p. 95

43. See Lodge, *Black Politics*, ch. 4.

44. See Hirson, *Year of Fire, Year of Ash*, p. 184.

45. Hendrik F. Verwoerd, Policy of the Minister of Native Affairs, June 7, 1954, *Verwoerd Speaks: Speeches 1948–1966*, in A. N. Pelzer, ed. (Johannesburg: Tafelberg, 1966).

46. See Couzens and Patel, *Return of the Amasi Bird*, p. 10.

47. Tlali, "In Search of Books," *Star*, July 30, 1980; reprinted in Chapman, *Soweto Poetry*, p. 45.

48. Carlos Fuentes, "The Art of Fiction LXVIII," *Paris Review*, 23 (Winter 1981): 149.

49. Sipho Sepamla, "The Black Writer in South Africa Today: Problems and Dilemmas," *New Classic* 3 (1976); reprinted in Chapman, *Soweto Poetry*, p. 116

50. See Hirson, *Year of Fire, Year of Ash*, pp. 60–114; Lodge, *Black Politics*, pp. 321–62.

51. Steve Biko, "Black Consciousness and the Quest for a True Humanity," in

Basil Moore, ed., *Black Theology: The South African Voice* (London: C. Hurst and Co., 1973), p. 45. See also Biko's *I Write What I Like* (London: Heinemann, 1979); and "White Racism and Black Consciousness," in Hendrik W. van der Merwe and David Welsh, ed., *Student Perspectives on South Africa* (Cape Town: David Philip, 1972), pp. 190–202.

52. Drake Koka, quoted in "Inside South Africa: A New Black Movement Is Formed," *Sechaba* 7 (March 1973): 5.

53. Mafika Gwala, "Writing as a Cultural Weapon," in Daymond, Jacobs and Lenta, *Momentum*, p. 37.

54. Gwala, "Writing as a Cultural Weapon," p. 40.

55. Patel, "Towards Revolutionary Poetry," in Daymond, Jacobs and Lenta, *Momentum*, p. 85.

56. Gwala, "Writing as a Cultural Weapon," p. 38.

57. Some of the reasons for the cultural shift and for the success of Mtshali's book — the first book of poems by anyone, black or white, ever to make a commercial profit — lay in the external interest taken in Africa as one African nation after another won independence. But it is one of the stubborn quirks of decolonization that as Europe decamped from African soil, the literary scramble for Africa began — with Western publishing houses vying for black writers. Inside South Africa, some white liberals, increasingly inched into inconsequence, also saw fit to throw in their lot with black protest.

58. Oswald Mtshali, "High and Low," "Sunset," "A Newly-Born Calf," *Sounds of a Cowhide Drum* (London: Oxford University Press, 1972), pp. 28, 24, 13.

59. Mtshali, *Sounds of a Cowhide Drum*, p. 78.

60. Mtshali, "Black Poetry in Southern Africa: What It Means," *Issue: A Quarterly Journal of Africanist Opinion* 6 (Spring 1976); reprinted in Chapman, *Soweto Poetry*, p. 107.

61. Anonymous, "They Took Him Away," *Staffrider* (March 1978).

62. Gwala, *Jol'iinkomo* (Johannesburg: Ad. Donker, 1977), p. 68.

63. Mongane Serote, "Black Bells," *Yakhal'inkomo* (Johannesburg: Renoster, 1972), p. 52.

64. Jeff Opland, "The Isolation of the Xhosa Oral Poet," in Landeg White and Tim Couzens, eds., *Literature and Society in South Africa* (New York: 1984), pp. 175, 176–77.

65. See Ruth Finnegan, *Oral Literature in Africa* (Oxford: Oxford University Press, 1970); Harold Scheub, *The Xhosa Ntsomi* (Oxford: Oxford University Press, 1975); Elizabeth Gunner, "Songs of Innocence and Experience: Women as Composers and Performers of Izibongo, Zulu Praise Poetry," *Research in African Literatures* 10 (Fall 1979): 239–67; Mbulelo Mzamane, "The Uses of Traditional Oral Forms in Black South African Literature," in White and Couzens, *Literature and Society in South Africa*, pp. 147–60; and Coplan, *In Township Tonight!* and "Interpretive Consciousness."

66. Barnett, *A Vision of Order*, p. 43.

67. Tony Emmett, "Oral, Political and Communal Aspects of Township Poetry in the Mid-Seventies," *English in Africa* 6 (March 1979); reprinted in Chapman, *Soweto Poetry*, p. 183.

68. Serote, "Hell, well, Heaven," *Yakhal' inkomo*, p. 16.

69. D. K. Rycroft, "Melodic Imports and Exports: A Byproduct of Recording in South Africa," *Bulletin of the British Institute of Recorded Sound* (1956); quoted in Coplan, *In Township Tonight!* p. 106.

70. Gwala, "Words to a Mother," *Staffrider* (May/June 1978).

71. Mtshali, "Riding on the Rainbow," *Sounds of a Cowhide Drum*, p. 26.

72. Douglas Livingstone, "The Poetry of Mtshali, Serote, Sepamla and Others in English: Notes Towards a Critical Evaluation," *New Classic* 3 (1976); reprinted in Chapman, *Soweto Poetry*, p. 160.

73. Jimmy Kruger, *The Star*, 14 Sept. 1977; quoted in Emmett, "Aspects of Township Poetry," p. 176.

74. Gwala, "Writing as a Cultural Weapon," p. 43.

75. Barnett, "Interview with Oswald Mtshali," *World Literature Written in English* 12 (1973); reprinted in Chapman, *Soweto Poetry*, p. 100.

76. Gwala, "Towards the Practical Manifestation of Black Consciousness,"

in *Black Renaissance: Papers from the Black Renaissance Convention*, ed. T. Thoahlane (Johannesburg: Ravan Press, 1975), p. 31.

77. There is little work on the specific position of black female poets. See Liz Gunner, "Songs of Innocence and Experience."

78. James Matthews, in Daymond, Jacobs and Lenta, *Momentum*, p. 73.

79. Lionel Abrahams, "Political Vision of a Poet," *Rand Daily Mail*, June 17, 1974; reprinted in Chapman, *Soweto Poetry*, p. 74.

80. Livingstone, "The Poetry of Mtshali," p. 160.

81. Alan Paton, in Daymond, Jacobs and Lenta, *Momentum*, p. 90.

82. Abrahams, "Black Experience into English Verse: A Survey of Local African Poetry, 1960–70," *New Nation* 3 (Feb. 1970); reprinted in Chapman, *Soweto Poetry*, pp. 138–39.

83. Livingstone, "The Poetry of Mtshali," p. 157.

84. Gwala, in Daymond, Jacobs and Lenta, *Momentum*, p. 48.

85. Gwala, in Daymond, Jacobs and Lenta, *Momentum*, p. 43.

86. Sepamla, "The Black Writer," p. 117.

87. *Tsotsitaal* is an urban African dialect spoken by all African proletarians, especially by younger members of street gangs. Coplan argues that *tsotsi* is a corruption of the American term "zoot suit," *In Township Tonight!* p. 271.

88. Mothobi Mutloatse, "Bundu Bulldozers," quoted in Chapman, *Soweto Poetry*, p. 170. *Mlungu* means "white man"; *masemba* means "shit."

89. Anonymous, "It's Paati to Be Black," *Staffrider* (March 1978). *Dompas* refers to the hated passes; *dom* is Afrikaans for "stupid."

90. Paton, in *Momentum*, p. 89.

91. Frankie Ntsu kaDitshego/Dube, "The Ghettoes," *Staffrider* (July/August, 1979).

92. Mtshali, *Sounds of a Cowhide Drum*, p. 78.

93. Gwala, "Towards a National Theatre," *South African Outlook* (Aug. 1973); quoted in Chapman, intro., *Soweto Poetry*, p. 21.

94. Chapman, intro., *Soweto Poetry*, p. 21.

95. Gwala, "Writing as a Cultural Wea-pon," p. 48.

96. Gwala, "Writing as a Cultural Weapon," p. 37.

97. Anonymous, "It's Paati to Be Black." *Kwela*-kwela is a township name for the large police pickup vans. See Coplan, *In Township Tonight!* pp. 157–60, for the origins of the term. *Doom* is an insecticide spray.

98. Raymond Williams, *Problems in Materialism and Culture* (London: Verso, 1980), pp. 47–48.

99. Terry Eagleton and Peter Fuller, "The Question of Value: A Discussion," *New Left Review* 142 (Nov./Dec. 1983): 77.

100. See, for instance, Eagleton, "Aesthetics and Politics," *New Left Review* 107 (Jan./Feb. 1978): 21–34; *Criticism and Ideology: A Study in Marxist Literary Theory* (London: New Left Books, 1978); and "Criticism and Politics: The Work of Raymond Williams," *New Left Review* 95 (Jan./Feb. 1976): 3–23; Tony Bennett, *Formalism and Marxism* (London: Methuen and Co., 1979), and "Marxism and Popular Fiction," *Literature and Popular History* 7 (Fall 1981): 138–65; Stuart Hall, "Cultural Studies: Two Paradigms," in Bennet et al., eds., *Culture, Ideology and Social Process: A Reader* (London: Methuen, 1981), pp. 19–37; Barbara Herrnstein Smith, "Contingencies of Value," *Critical Inquiry* 10 (Sept. 1983): 1–36, and "Fixed Marks and Variable Constancies: A Parable of Literary Value," *Poetics Today* 1 (Autumn 1979): 7–31; Paul Lauter, "History and the Canon," *Social Text* 12 (Fall 1985): 94–101; Francis Mulhern, "Marxism in Literary Criticism," *New Left Review* 108 (Mar./Apr. 1979): 77–87; and Peter Widdowson, "'Literary Value' and the Reconstruction of Criticism," *Literature and History* 6 (Fall 1980): 139–50.

101. The performative and popular aspects of this poetry distinguish it from the Western postmodernist deconstruction of the text.

102. See Mbulelo Mzamane, "Literature and Politics among Blacks in South Africa," *New Classic* 5 (1978); reprinted in Chapman, *Soweto Poetry*, p. 156. See also: Liz Gunner, "A Dying Tradition?

African Literature in a Contemporary Context" *Social Dynamics* 12(2), 1986, pp. 31–38, and Ari Sitas, "Traditions of Poetry in Natal," in Liz Gunner, ed., *Politics and Performance in South Africa: Theatre, Poetry and Song* (Johannesburg: Wits. University Press, 1994). "Azikwelwa," (we will not ride), is a slogan expressing peoples' refusal to ride on state transport during the bus and train boycotts.

NOTES TO CHAPTER 10

1. See Eric Hobsbawm's critique of nationalism in *Nations and Nationalism Since 1780* (Cambridge: Cambridge University Press, 1990).

2. Ernest Gellner, *Thought and Change* (London: Weidenfeld and Nicholson, 1964) and *Nations and Nationalism* (Oxford: Blackwell, 1983).

3. Benedict Anderson, *Imagined Communities* (London: Verso, 1983, 1991), p. 6.

4. Cynthia Enloe, *Bananas, Beaches and Bases: Making Feminist Sense of International Politics* (Berkeley: University of California Press, 1989), p. 44.

5. Gellner, p. 117.

6. Fanon, *The Wretched of the Earth*, trans. Constance Farrington (London: Penguin, 1963), p. 30.

7. Elleke Boehmer, "Stories of Women and Mothers: Gender and Nationalism in the Early Fiction of Flora Nwapa," in Susheila Nasta, ed., *Motherlands: Black Women's Writing from Africa, the Caribbean and South Asia* (London: The Women's Press, 1991), p. 5.

8. Boehmer, "Stories of Women and Mothers," p. 6.

9. Nira Yuval-Davis and Floya Anthias, eds., *Women-Nation-State* (London: Macmillan, 1989), p. 7.

10. Yuval-Davis and Anthias, *Women-Nation-State*, p. 1.

11. Tom Nairn, *The Break-up of Britain* (London: New Left Books, 1977).

12. Deniz Kandiyoti, "Identity and Its Discontents: Women and the Nation" *Millennium: Journal of International Studies* 20, 3 (1991): 431.

13. Homi K. Bhabha, ed., *Nation and Narration* (London: Routledge, 1991), p. 1.

14. Susan Buck-Morss, *The Dialectics of Seeing: Walter Benjamin and the Arcades Project* (Cambridge, Mass.: MIT Press, 1990), p. 67.

15. Buck-Morss, *The Dialectics of Seeing*, xiv.

16. Hobsbawm, *Nations and Nationalism*, p. 151.

17. Frantz Fanon, *Black Skin, White Masks*, trans. Charles Lam Markmann (London: Pluto Press, 1986), p. 141.

18. Fanon, *Black Skin, White Masks*, p. 142.

19. Fanon, *Black Skin, White Masks*, p. 143.

20. Fanon, *Black Skin, White Masks*, pp. 141–42.

21. Fanon, *Black Skin, White Masks*, p. 13

22. Fanon, *Black Skin, White Masks*, p. 13.

23. Fanon, *Black Skin, White Masks*, p. 10.

24. Fanon, *The Wretched of the Earth*, p. 29.

25. Fanon, *The Wretched of the Earth*, p. 30.

26. Edward Said, *Culture and Imperialism* (London: Chatto and Windus, 1993), p. 326.

27. Bhabha, introduction to Fanon, *Black Skin, White Masks*, p. ix.

28. Fanon, *Black Skin, White Masks*, p. 46.

29. Fanon, *Black Skin, White Masks*, p. 46.

30. Fanon, *Black Skin, White Masks*, p. 63.

31. Bhabha, intro. to Fanon, *Black Skin, White Masks*, p. ix.

32. Bhabha, intro. to Fanon, *Black Skin, White Masks*, p. xxvi.

33. Fanon, *Black Skin, White Masks*, p. 81.

34. Fanon, *Black Skin, White Masks*, p. 16.

35. Fanon, *Black Skin, White Masks*, p. 159.

36. Fanon, *Black Skin, White Masks*, p. 92.

37. Bhabha, intro. to Fanon, *Black Skin, White Masks*, p. xxv.

38. Bhabha, intro. to Fanon, *Black Skin, White Masks*, p. xi.

39. Bhabha, intro. to Fanon, *Black Skin, White Masks*, p. xi.

40. Said, *Culture and Imperialism*, p. 89.

41. Terry Eagleton, "Nationalism. Irony and Commitment," in Terry Eagleton, Fredric Jameson and Edward Said, *Nationalism, Colonialism and Literature* (Minneapolis: University of Minnesota Press, 1990), p. 28.

42. Eagleton, "Nationalism," p. 25.

43. Frantz Fanon, "Algeria Unveiled," in *A Dying Colonialism*, trans. Haakon Chevalier (New York: Grove Press,

1965), p. 42.

44. Fanon, "Algeria Unveiled," p. 37.
45. Fanon, "Algeria Unveiled," p. 53.
46. Fanon, "Algeria Unveiled," pp. 37–38.
47. Fanon, "Algeria Unveiled," p. 38.
48. Fanon, "Algeria Unveiled," p. 35.
49. Fanon, "Algeria Unveiled," p. 39.
50. Fanon, "Algeria Unveiled," p. 42.
51. Fanon, "Algeria Unveiled," p. 46.
52. Fanon, "Algeria Unveiled," p. 47.
53. Fanon, "Algeria Unveiled," p. 63.
54. Fanon, "Algeria Unveiled," p. 50.
55. Fanon, "Algeria Unveiled," p. 50.
56. Fanon, "Algeria Unveiled," p. 50.
57. Fanon, "Algeria Unveiled," p. 48.
58. Fanon, "Algeria Unveiled," p. 51.
59. Fanon, "Algeria Unveiled," p. 48.
60. Fanon, "Algeria Unveiled," p. 49.
61. Fanon, "Algeria Unveiled," p. 54.
62. Fanon, "Algeria Unveiled," pp. 54, 58.
63. Fanon, "Algeria Unveiled," p. 54.
64. Fanon, "Algeria Unveiled," p. 66.
65. Fanon, "Algeria Unveiled," p. 105.
66. Fanon, "Algeria Unveiled," p. 66.
67. Fanon, "Algeria Unveiled," p. 109.
68. Fanon, "Algeria Unveiled," p. 107.
69. Fanon, "Algeria Unveiled," p. 116.
70. Fanon, "Algeria Unveiled," p. 115.
71. For accounts of the rise of Afrikaner-dom, see Dunbar T. Moodie, *The Rise of Afrikanerdom: Power, Apartheid, and the Afrikaner Civil Religion* (Berkeley: University of California Press, 1975), and Dan O' Meara, *Volkskapitalisme: Class, Capital and Ideology in the Development of Afrikaner Nationalism 1934–1948* (Cambridge: Cambridge University Press, 1983).
72. Isabel Hofmeyer, "'Building a Nation from Words: Afrikaans Language, Literature and Ethnic Identity, 1902–1924" in Shula Marks and Stanley Trapido, eds., *The Politics of Race, Class and Nationalism in Twentieth Century South Africa* (London: Longmans, 1987), p. 105.
73. See Dunbar Moodie, *The Rise of Afrikanerdom*, and Dan O'Meara, *Volkskapitalisme.*
74. The degree to which the eeufees papered over fatal divisions within the white populace became most manifest in 1988, when during the height of the State of Emergency two competing Treks set out to reenact the reenactment,

each sponsored by two bitterly rivalrous white nationalist parties.

75. Albert Grundlingh and Hilary Sapire, "From Feverish Festival to Repetitive Ritual? The Changing Fortunes of the Great Trek Mythology in an Industrializing South Africa, 1938–1988," *South African Historical Journal* 21 (1989): 19–37.
76. Grundlingh and Sapire, "From Feverish Festival," p. 24.
77. Theodor Adorno, *Gesammelte Schriften,* vol. 1. pp. 360–361. Quoted in Susan Buck-Morss, *The Dialectics of Seeing,* p. 59.
78. Tom Nairn, *The Break-up of Britain,* p. 340.
79. See Elsabie Brink, "Man-made Women: Gender, Class and the Ideology of the Volksmoeder," in C. Walker, ed., *Women and Gender in Southern Africa to 1945* (London: James Currey, 1990), pp. 273–92.
80. See Tom Lodge, "Charters from the Past: The African National Congress and Its Historiographical Traditions," *Radical History Review* 46/7 (1990): 161–89.
81. Frene Ginwala, *Agenda,* 8 (1990): 77–93.
82. J. Mpama, *Umsebenzi,* June 26, 1937.
83. See Deborah Gaitskell and Elaine Unterhalter, "Mothers of the Nation: A Comparative Analysis of Nation, Race and Motherhood in Afrikaner Nationalism and the African National Congress," in Nira Yuval-Davis and Floya Anthias, *Women-Nation-State.*
84. The ANC delegation to the Nairobi Conference on Women in 1985 declared: "It would be suicidal for us to adopt feminist ideas. Our enemy is the system and we cannot exhaust our energies on women's issues."
85. At a seminar titled "Feminism and National Liberation," convened by the Woman's Section of the ANC in London in 1989, a representative from the South African Youth Congress (SAYCO) exclaimed: "How good it feels that feminism is finally accepted as a legitimate school of thought in our struggles and is not seen as a foreign ideology."
86. For a groundbreaking book on the history, politics and culture of lesbian and gay life in South Africa, see Edwin Cameron and Mark Gevisser, eds., *Defiant Desire: Gay and Lesbian Lives in South*

Africa (New York: Routledge, 1994).

87. Chandra T. Mohanty, "Under Western Eyes: Feminist Scholarship and Colonial Discourses" in Chandra T. Mohanty, Ann Russo and Lourdes Torres, eds. *Third World Women and the Politics of Feminism* (Bloomington: Indiana University Press, 1991), p. 52.

88. Kumari Jayawardena, *Feminism and Nationalism in the Third World* (London: Zed Press, 1986).

NOTES TO POSTSCRIPT

1. See Giovanni Arrighi, "World Income Inequalities and the Future Of Socialism," *New Left Review* 189 (September/October, 1991): 40.

2. *The Guardian*, Tuesday, January 14, 1992, p. 9.

3. The international monetary system set up at the Bretton Woods Conference in 1944 excluded Africa (still colonized) and most of what is now called the Third World, and was designed to achieve two explicit objectives: the reconstruction of Europe after the second World War, and the expansion and maintenance (especially after decolonization) of international trade in the interests of the colonial powers and America. The president of the World Bank and the deputy managing director are always American, while by tradition the managing director is European. See Cheryl Payer, *The Debt Trap: The International Monetary Fund and the Third World* (New York: Monthly Review, 1974) and Payer, *The World Bank: A Critical Analysis* (New York: Monthly Review, 1982).

4. Robin Broad, John Cavanagh and Walden Bello, "Sustainable Development in the 1990's," in Chester Hartman and Pedro Vilanova, eds., *Paradigms Lost: The Post Cold War Era.*

5. Broad, Cavanagh, and Bello, "Sustainable Development," p. 100. Calculations are based on figures in Ruth Leger Sivard, *World Military and Social Expenditures 1989* (Washington DC: World Priorities, 1989), p. 6. A few African socialist states, like Angola and Mozambique, tried to dodge the IMF and World Bank's blandishments until national economic mismanagement and South Africa's regional maulings forced them to bend the knee.

6. The World Bank has concluded that "fifteen African countries were worse off in a number of economic categories after structural adjustment programs A World bank study found that the debt-ridden developing countries under structural adjustment programmes performed as well as non-recipients less than half the time." Robin Broad, John Cavanagh, and Walden Bello, "Sustainable Development," p. 96.

7. See Susan George, "Managing The Global House: Redefining Economics," in Jeremy Legget, ed., *Global Warming: The Greenpeace Report* (Oxford: Oxford University Press, 1990).

8. Barber Conable, speech to the World Resources Institute, Washington DC, May 5, 1987. Cited in G. Hancock, *The Lords Of Poverty* (London: Macmillan, 1989), p. 131.

9. Broad, Cavanagh, and Bello, "Sustainable Development," p. 91

10. Broad, Cavanagh, and Bello, "Sustainable Development," p. 95.

11. Francis Fukuyama, "Forget Iraq—History Is Dead," *The Guardian*, August 12, 1990, p. 3.

LIST OF ILLUSTRATIONS

CHAPTER THREE:
IMPERIAL LEATHER

INDEX

post-(prefix), 11, 12, 394

power and desire, in Victorian metropolis, 75–131

Pratt, Mary Louise, 29, 400n31

"The Prelude" (Schreiner), 267, 270

Primitive Culture (Tylor), 188

prostitutes, Victorian stereotypes of, 53, 56

prostitution, Schreiner's views of, 285, 287–288

psychoanalysis: abjection and, 71–74; disavowal of class and, 89–91; female fetishism and, 181–203; fetishism and, 138

Publications and Entertainment act (1963), 339

Pufendorf, on conjugal rights, 178

R

race: as category, 396n17; doubled mother and, 267–270; doubling of origins and, 306–309; as fetish, 110; gender, autobiography, and, 312–315; gender, class, and, 4–9; gender, nationalism, and, 351–394; money, sexuality, and, 1–17; policing of female labor and, 115–118; polygenesist view of, 400n71; social ambiguity and, 104–111

racial degeneration, 42, 43; as form of social domination, 43, 44

racial fetishism, cross-dressing, hybridity, and, 65–69

racist fetishes, 184

Rand Daily Mail (South Africa), Nakasa as first black journalist for, 334

Ranger, Terence, on British colonialism in South Africa, 250

Ravan Press, 330, 331

recapitulation theory, of Haeckel, n76, 50, 400n75

Renaissance, militant geography of, 23

resistance, prostitution as form of, 288

Rhodes, Cecil John, 274, 289

Richards, Thomas, on World Exhibition (1851), 208

Robbins, Bruce, 94, 405n30, 407n63

Rose, Jacqueline, on Lacan, 196, 200

Rostow, W. W., "Non-Communist Manifesto", 390

Royal Commission on Agriculture (1867), 117–118

Ruskin, John, on home, 409n70, 410n74

S

sadomasochism. *See* slave/master fetish rituals; S/M scenarios

Said, Edward: on etymology of "author", 300;

on filiation and affiliation, 44–45, 239; on nationalism, 363; *Orientalism*, 14, 124, 395n4

Saints and Sinners (Schreiner), 282

Santayana, George, on nationalism, 353

Sapire, Hilary, on Afrikaners' Second Trek, 376

Sartre, Jean-Paul, 363

SASO Conference on Creativity and Black Development (1972), 344

Schor, Naomi, on fetishism, 182, 201

Schreiner, Gottlob, 260, 261, 266–267, 269

Schreiner, Olive, 17, 258–295; *An English South African's View of the War*, 289; early life, 258–260, 263–266; in England, 281–284; feminine identity of, 262–263; as governess, 277, 281; illness of, 275, 289; *From Man to Man*, 267, 268, 272, 273, 284–289; marriage of, 289; *The Political Situation*, 289; "The Prelude", 267, 268, 270; *Saints and Sinners*, 282; *Stories, Dreams and Allegories*, 284; *The Story of an African Farm*, 259, 264, 266, 268, 269–270, 277, 278–281, 282, 286, 289, 293; *Thoughts on South Africa*, 289, 290, 294; *Undine*, 275–276, 282; *Woman and Labor*, 277, 290–293; as writer, 267–274

Schreiner, Rebecca Lyndall, 260, 261–262, 266–267, 269

Scott, Joan, 7, 16, 398n11, 399n36, 409n14, 413n82

Second Trek, of Afrikaners, 370–378

Sedgwick, Eve, 14, 399n31

Sekula, Allan: on mining, 115; on photography, 123, 130

Sepamla, Siphio, 340, 348–349

Serote, Mongane: "Hell well, Heaven", 346; *Yakhal'inkomo*, 344

Seven South African Poets, 344

"sex book", Schreiner's *Woman and Labor* as, 290, 291

sexual degeneration, 401n91; feared, in women miners, 116, 118

sexuality: of black women, 41–42, 113; implicit in Haggard map, 3; Victorian introduction to, by domestic servants, 85–86, 87–89, 94, 403n31; Victorian views, 77; of women, Schreiner's views on, 293

Shaw, George Bernard, memories of mother, 86–87

Sheba's Breasts (mountain peaks in *King Solomon's Mines*), 1, 3, 22, 242–243

She (Haggard), 418n4

Shepstone, Theophilus: as Haggard's

This book was designed
and typeset by Leslie Sharpe
with Hermann Feldhaus
at Cave.

The text face is Cochin,
designed by the printers
and type founders
Deberny & Peignot
in the early 1900s.

Display lines are set
in Matrix, designed by
Zuzana Licko in the late 1980s
and issued by Emigre Graphics.

Printed and bound
on acid-free paper
by Braun/Brumfield, Inc.